IMPRESSIONIST
AND
POST-IMPRESSIONIST
PAINTINGS
IN SOVIET MUSEUMS

IMPRESSIONIST
AND
POST-IMPRESSIONIST
PAINTINGS
IN SOVIET MUSEUMS

Facts On File Publications
New York, New York ● Oxford, England

INTRODUCTORY ARTICLE BY MARINA BESSONOVA

NOTES BY ANNA BARSKAYA, MARINA BESSONOVA,
EVGENIA GEORGIEVSKAYA, ASIA KANTOR-GUKOVSKAYA,
VILENA MKRTCHAN, KALERIA PANAS,
AND ANATOLY PODOKSIK

TRANSLATED FROM THE RUSSIAN BY YURI PAMFILOV

DESIGNED BY ILDUS FARRAKHOV

Published in North America by
Facts on File, Inc., 460 Park Avenue South,
New York, N. Y. 10016

Copyright © Aurora Art Publishers, Leningrad, 1985

Library of Congress Cataloging in Publication Data

Barskaia, A. G.
 Impressionist and post-impressionist paintings
 in Soviet museums.

 Bibliography: p.
 Includes index.
 1. Impressionism (Art) — France. 2. Painting, French.
 3. Painting, Modern — 19th century — France.
 4. Post-impressionism (Art) — France.
 5. Painting, Modern — 20th century — France.
 6. Painting — Soviet Union. 7. Art museums — Soviet Union.
 I. Bessonova, M. A. (Marina Aleksandrovna)
 II. Georgievskaia, E. B. (Evgeniia Borisovna) III. Title.
 ND547.5.I4B36 1985 759.05′4′07407 84-26063

 ISBN 0-8160-1189-3

Printed and bound in the USSR

CONTENTS

Soviet collections of French paintings and drawings of the late nineteenth and early twentieth centuries are considered to be among the world's finest. They are composed chiefly of works from the celebrated private collections of two Moscow connoisseurs, Sergei Shchukin and Ivan Morozov, who associated closely with French artists and critics. In purchasing works by as yet unrecognized French painters they relied largely on intuition and help from their long-standing contacts with such Paris dealers as Durand-Ruel, Druet, Vollard, Bernheim Jeune and, later, Kahnweiler.

During the second half of the nineteenth century, Russian artists and art critics took a keen interest in every new trend in French painting and literature. In 1879 Emile Zola, acting upon Ivan Turgenev's advice, accepted the post of art critic for the St. Petersburg journal *Vestnik Evropy* (*European Herald*), to which he then regularly contributed. Concurrently, the Impressionist movement came to the attention of the Russian press, which included articles by Zola analysing the works of Impressionist painters. In the 1880s Symbolism and the Art Nouveau movement in the decorative arts and architecture became popular in Russia, largely through the work of René Ghil and Odilon Redon. A French poet and journalist, Ghil was a special correspondent for *Vesy* (*The Balance*), a journal of the Russian Symbolists, to which both writers and artists contributed. Odilon Redon, some of whose illustrations for the periodical are reproduced in this volume, was also a major contributor.

Indeed, artistic connections between France and Russia were hardly restricted to the visual arts. André Antoine, a pioneer in modern dramatic art who founded the Parisian Théâtre-Libre in 1887, staged Leo Tolstoy's *The Power of Darkness* in Paris. In 1898 Tolstoy presented his aesthetic views, in his famous essay, *What Is Art?*, which influenced both Russian and European thought, especially in France. "I think art, more than any other field of creative endeavour, is most adversely affected by conservatism. As a manifestation of Man's spiritual life, it should be of the moment and reflect the spirit of the time. We should only know where to look for it; we ought to look for it not in the past but in the present." Tolstoy wrote these lines at a time when the French public had come to realize the greatness of the Russian novel as created by Tolstoy and, later, the greatness of the Russian short story and drama as created by Anton Chekhov. In 1902 Maxim Gorky's play *The Lower Depths*, staged by Konstantin Stanislavsky, was shown in France and met with tremendous success. In 1904 it was translated into French and the following year was produced at the Théâtre Nouveau in Paris. By 1908, Maeterlinck's *Blue Bird* was produced in Russia by Stanislavsky.

The innovations in Russian literature and drama paved the way for the emergence of new trends in painting. Russian artists sought new means of expression. The urge for experimentation, the presentiment of imminent social upheavals, stimulated a new perception of the revolutionary achievements in turn-of-the-century French art. Valentin Serov, who often visited France, shows, particularly in his early work, a certain affinity to the spirit of the Impressionists. Konstantin Korovin, perhaps the most consistent of Russian Impressionists, applied himself in earnest to a study of the new artistic system. At the beginning of the century, he produced his famous series of views of the Parisian boulevards. Among these, *The Lights* — scenes of Paris at night — were conspicuous for their finesse and perfection. Their distinctive style and dynamic portrayal of the ambiance of Parisian life place Korovin's works on a par with the celebrated series of Paris views by Camille Pissarro or Claude Monet. Such Russian artists as Korovin, Serov and Victor Borisov-Musatov absorbed Impressionist attitudes and demonstrated a profound understanding of modern French art.

Borisov-Musatov came closest of all to the Nabis; his pupils, Martiros Saryan and Pavel Kuznetsov, inherited their master's love for the French painterly manner. Indeed, the works of Saryan, Kuznetsov and Mikhail Larionov display a pronounced French influence, evident in the lighter tones, the rejection of sombre hues and chiaroscuro, and the use of radiant, saturated colours. While Saryan's earlier works show an affinity to the Fauves, Larionov's still lifes manifest more traceable influences of the later Impressionists. Kuznetsov fell under the spell of Paul Gauguin, whose paintings he had seen in the Shchukin and Morozov collections. Gauguin aroused Kuznetsov's interest in the Orient, in the distant countries innocent of European civilization. Saryan wrote that after seeing contemporary French paintings at the Shchukin and Morozov galleries he had felt an irrepressible surge of inspiration.

However, Russian artists never depended directly upon the French school. Rather, during the 1910s the two schools of painting moved along parallel lines in their use of open colour and in their general attitude to problems of colouring. Despite the obviously different ways of life, environment and socio-political systems, the processes occurring in French and Russian culture and in the psychological make-up of both nations were similar.

The exhibition of Russian art that was held at the Salon d'Automne in 1906 was, in fact, the first direct confrontation of the art and artists of both countries. This important event was made possible thanks to the efforts of certain Russian painters and art patrons, who had lived for years in Paris and who were familiar with contemporary French art. The exhibition was sponsored by Sergei Diaghilev, publisher of the journal *Mir Iskusstva* (*World of Art*), who later organized the highly successful Russian Seasons in Paris. French artists visiting the exhibition could see examples of old Russian painting and the latest productions of their Russian counterparts, and discover the genius of Mikhail Vrubel and Kuzma Petrov-Vodkin. Meanwhile Russian artists met the Fauves and saw the Cézanne retrospective.

Ilya Mashkov, Piotr Konchalovsky and Robert Falk, who had all previously stayed in Paris, returned to Russia with plenty of valuable impressions. Four years later, they united into the Bubnovy Valet (Jack of Diamonds) group, which carried forward the Fauvist and Cubist tendencies of French painting.

Unlike their French colleagues, the Jack of Diamonds artists were aggressive and rebellious. They assimilated and reinterpreted Cézanne's treatment of objects, with elaborate counterpoints between shapes and textures, as well as adopting his spatial structure. The still lifes of Mashkov and Konchalovsky, emphasizing the object and its texture, frankly displayed their ostentatious painterly manner, harsh colouring and a tendency to reduce the colour scale to that of the broadside print (the Russian *lubok*) or folk toy. These artists delighted in popular art, in the art of the street, which was undoubtedly stimulated by the discovery of naive painters, such as Le Douanier Rousseau in France and the Georgian Niko Pirosmani in Russia. For professionals like Ilya Mashkov, Alexander Shevchenko, Natalia Goncharova, Pablo Picasso and André Derain, these two artists personified a generous spontaneity and sincerity and, at the same time, the fearsome power of the mob. The discovery of Polynesian and African sculpture heightened the fascination of the naive world of Rousseau and Pirosmani for both Russian and French artists. This discovery markedly affected the emergence of Cubism, a major phenomenon in twentieth-century art. Rousseau and Pirosmani formed a connecting link between twentieth-century painting and the "unspoiled" art of old. Only the avid interest of the Russian art world in the latest French painting can explain Shchukin's purchase of several great Rousseau canvases.

After 1904 Russian collectors increasingly bought contemporary French paintings which, though underestimated in the country of their origin, met with critical acclaim in Moscow and thus became integrated into Russian art. Moscow periodicals of the early twentieth century, especially *Zolotoye Runo* (*The Golden Fleece*) and *Apollon* (*Apollo*), published reproductions of paintings of the new

French school with comments which also highlighted artistic problems of the day. Catalogues of the French paintings in the Shchukin and Morozov collections appeared. The Impressionists drew the attention of such noted Russian scholars as Yakov Tugendhold, Sergei Makovsky and, from the early 1920s, Boris Ternovetz. Moscow art historians regarded contemporary French painting as a landmark in twentieth-century art, and thus played a major role in establishing its international repute.

Sergei Shchukin came from a rich family of Moscow businessmen; his four brothers were also art collectors. Already at a mature age, he began collecting French painting in the late 1890s. By then his father, a leading Moscow manufacturer of textiles and drapery, had died and Sergei had become head of the Shchukin Trading House. In 1891 he bought a house in Bolshoi Znamensky Lane (now No. 8, Grizevets Street), where he subsequently established his gallery of modern French paintings.

His first acquisition was a study for Puvis de Chavannes's *Poor Fisherman*, a picture greatly acclaimed in Paris in the mid-1890s. He then purchased several genre pieces by Charles Cottet and Lucien Simon, who used to paint in fishermen's villages in Brittany. Although done in a traditional nineteenth-century manner, their works depicted novel motifs and their narrative character — a feature that never failed to appeal to the Russian intellectual — apparently attracted Shchukin. Until the late 1890s he either knew little about the Impressionists, Cézanne, Van Gogh and Gauguin, or was prejudiced against them. However, in 1897 Fiodor Botkin, one of his mother's relatives, who had spent many years in Paris, drew his attention to Claude Monet's landscapes exhibited by Durand-Ruel. Their pictorial merits won Shchukin's sincere admiration, and Monet became his favourite artist. He purchased an early Monet, *Lilac in the Sun*, the first Impressionist painting to reach Moscow. It was soon followed by several more brilliant canvases from Monet's famous series of *Haystacks*, *Cliffs*, *Views of Rouen Cathedral* and *Water-lilies*. Thus Shchukin assembled some of the more interesting pieces characteristic of every stage in Monet's artistic career up to the early twentieth century. He continued to buy Monet landscapes from Durand-Ruel until 1904; in 1901, for example, he acquired *Vétheuil*, and in 1904, *Seagulls*, which Monet had just sent to the dealer for sale. Around this time Shchukin also purchased a smaller version of *Luncheon on the Grass* (*Le Déjeuner sur l'herbe*), which is now at the Pushkin Museum of Fine Arts in Moscow (only separate portions of the larger canvas have survived). In 1899 he evidently persuaded his brother Piotr to buy from Durand-Ruel Monet's *Lady in the Garden*, which Piotr later presented to him. Shchukin's collection of Monets attracted numerous art lovers; artists came from Paris to see it.

Shchukin also built an extensive collection of other Impressionist painters. In 1898, for example, Durand-Ruel acquired for him Camille Pissarro's *Place du Théâtre-Français. Spring*. Later, Shchukin bought a picture from Pissarro's well-known series, *Avenue de l'Opéra*. A separate room in Shchukin's gallery was allocated to Renoir. Through Durand-Ruel, a number of superb Renoir canvases were acquired for Piotr Shchukin and later found their way into Sergei Shchukin's gallery. They included *Nude*, *Lady in Black* and *Girls in Black*. Incidentally, all the Degas pastels that presently grace the Pushkin Museum in Moscow — his *Blue Dancers*, among others, and the remarkable oil, *Dancer Posing for a Photographer* — come from Sergei Shchukin's collection.

In the early years of the twentieth century, Shchukin's attention was drawn to the Post-Impressionist trend in French painting. He saw the retrospective shows of Cézanne and Gauguin in Paris, and became an enthusiastic admirer of Gauguin's Polynesian pictures. The two Tahitian periods of Gauguin's work are excellently illustrated in the sixteen canvases that he bought and hung in his Moscow house, close to one another, almost like icons in an iconostasis. He was conscious of the decorative aspect of Gauguin's pictures, and appreciated his complex, at times indecipherable imagery, preferring such conceptually charged compositions as *The Ford* (*The Flight*), the still life *Sunflowers*, *Gathering Fruit*, *The Queen* (*The King's Wife*), *Her Name is Vaïraumati* and *Baby* (*The Nativity*).

Shchukin possessed several outstanding Cézannes. In 1904 he bought from Durand-Ruel the celebrated *Pierrot and Harlequin* (*Mardi Gras*), upon which the Pushkin Museum justly prides itself today. Some pictures, such as *Self-portrait*, *Landscape at Aix* (*Mount Sainte-Victoire*), one of Cézanne's later works, and *The Smoker*, came from the famous collection of Ambroise Vollard. Shchukin also owned a superb portrait by Cézanne, *Lady in Blue*. Among the Van Gogh masterpieces from the Shchukin collection are *Portrait of Dr. Rey*, *Ladies of Arles* (*Reminiscence of the Garden at Etten*) and *Lilac Bush*. By purchasing Gauguins, Van Goghs and Cézannes, Shchukin sought to present each of these great forerunners of twentieth-century art in all his complexity. Several paintings in the Shchukin collection came from the brush of two Neo-Impressionists, Paul Signac and Edmond Cross.

However important all of Shchukin's above-mentioned acquisitions may have been, he is mostly famous for his collection of Matisses. Before World War I, when Matisse was hardly known in French art circles, the Moscow patron was the young artist's chief buyer. He acquired most of Matisse's pre-Fauve paintings that are reproduced in this volume. In 1904 he brought to Moscow the landscape *Bois de Boulogne* and the still life *Crockery on a Table*. In fact, one might say that Shchukin discovered Matisse; after 1908, he began to buy his works regularly. At about this time, he first met the artist in Paris and in 1911, Matisse accepted Shchukin's invitation to visit Moscow. In Shchukin's drawing-room Matisse personally hung all the twenty-one canvases then in his host's possession. It was this room that the collector used to call his "fragrant garden". The focal point was the large painting depicting the artist's atelier at Issy-les-Moulineaux. Flanking it, and thus forming a triptych, were *Corner of the Studio* and *Nasturtiums and "The Dance"*.

At their first meeting, Shchukin commissioned two large panels, *The Dance* and *Music*, intended to decorate the entrance hall of his Moscow house. These are justly considered to be Matisse's central works of 1910. At that time — Matisse had yet to paint the panels for the Barnes Foundation in Merion, Pa., U.S.A. — the Shchukin gallery was the only one in the world to contain examples of the artist's monumental and decorative work.

By allocating two separate rooms to his Gauguins and Matisses, Shchukin foresaw one of the main aspects of contemporary painting, namely its ability to transform man's habitual environment. Paintings could help to turn the dull interiors of urban dwellings into "gardens". These were the beginnings of a synthesis of architecture and painting, on the one hand, and art and environment, on the other; art was first entrusted with the important function of spatial organization.

During the same years Shchukin, who had by this time become familiar with the best of young Parisian Bohemians centred around Montmartre, began to collect the work of the young Picasso, another great innovator whose genius came into full bloom on French soil. Enlisting the services of Daniel Kahnweiler, a prominent dealer and theoretician of modern art, Shchukin bought a large number of Picasso's works from his Blue, pre-Cubist and Cubist periods. Today, towards the close of the twentieth century, we can appreciate fully the tremendous role European dealers played in promoting the innovative ideas of the French avant-garde. Each combined his profession of *marchand* with profound art studies, and they were all, in effect, the first serious critics of modern European painting. The names of Paul Durand-Ruel, a staunch advocate of Impressionism, of Ambroise Vollard, who discovered Cézanne and Rouault and urged Picasso to create a remarkable series of etchings, and of Daniel Kahnweiler, who was the first to assess the unique significance of the Cubist experiments of Picasso and Braque, are of paramount importance for the history of modern art in Europe. A major contribution to its development was also made by art collectors. Wilhelm Uhde, a German resident in Paris, built up a magnificent collection of naïve paintings and discovered Le Douanier Rousseau. The Morozov and Shchukin brothers created oases of modern French culture in Moscow, in the very heart of Russia. The parallel efforts of these progressive intellectuals, who purchased the works of as yet un-

recognized artists, were a phenomenon of far-reaching consequence for modern painting. Canvases by French artists that had found their way into Russia, Germany, Great Britain and the United States played a key role in the emergence of national schools of avant-garde art. It was no accident that Picasso, wanting sitters for his programmatic Cubist portraits, chose Kahnweiler, Vollard and Uhde, whom he portrayed as thinkers of a new type. Kahnweiler sold to Shchukin such early Picasso masterpieces as *Old Jew and a Boy*, *The Embrace*, *The Visit* (*Two Sisters*), *Portrait of Soler*, *Portrait of the Poet Sabartés*, and *The Absinthe Drinker*. Shchukin had fifty-one Picassos including, apart from his early works, a number of Cubist canvases, from the *Nudes* of the transitional period to examples of Synthetic Cubism and collage. In the room which he allotted to his Picassos, Shchukin also installed some primitive African sculptures of the kind that the artist himself admired.

Shchukin's last acquisitions were of some pictures by Le Douanier Rousseau. This alone demonstrates his bold, diverse tastes. The works of Rousseau, who died in obscurity in 1910, had just begun to gain renown with the avant-garde of the French artistic milieu. Apollinaire, whom Shchukin may have known personally, did much to promote Rousseau's fame. The portrait of Apollinaire and Marie Laurencin, *The Poet and His Muse*, may have been a token of the artist's gratitude; Shchukin bought this portrait, together with several canvases by Marie Laurencin. Shchukin's small collection of naive art appealed to many Russian artists, particularly Mikhail Larionov, Natalia Goncharova and Vladimir Tatlin, themselves enthusiastic explorers of the art of the Primitives.

On Sundays Shchukin opened his gallery to the public at large, and mixed freely with the visitors to listen to their animated comments.

The Morozov brothers, also celebrated Moscow collectors, came from a family of textile manufacturers. Mikhail Morozov (1870—1903), the elder son of the owner of the textile mills in Tver, was an art and literary critic, and the first Russian to buy French paintings produced during the latter half of the nineteenth century. From 1890, he developed an interest in the Impressionists and their precursors. Starting with 1893, his house in Glazovsky Lane (now No. 9, Lunacharsky Street) saw periodical gatherings of artists and art lovers; among the participants were Konstantin Korovin, Mikhail Vrubel and Valentin Serov. Under their influence, Mikhail Morozov came to appreciate the coloristic merits of modern French painting. In the late 1890s he bought from Sergei Shchukin Edouard Manet's *The Bar*, a beautiful study painted with a striking freshness. His subsequent acquisitions included Monet's landscape *Poppy Field* and Renoir's well-known full-length *Portrait of the Actress Jeanne Samary*. In 1898 the Paris music-hall star, Yvette Guilbert, toured Moscow. By that time Toulouse-Lautrec had done his series of lithographs and pastels of her. Yvette's singing enchanted Morozov, and having caught sight of one of her portraits by Toulouse-Lautrec in the Bernheim-Jeune Gallery in Paris, he bought it on the spot. Between 1900 and 1903, that is, in Gauguin's lifetime, he bought two of the artist's Tahitian compositions, *Landscape with Two Goats* and *The Canoe* (*A Tahitian Family*), and also Van Gogh's canvas, *Seascape at Saintes-Maries*. Morozov's collecting ardour was unfortunately cut short by his untimely death in 1903.

Mikhail Morozov inspired his younger brother, Ivan (1871—1921), with his enthusiasm for painting. While a student at the Ecole Polytechnique Supérieure in Paris, Ivan made friends with many artists and for several years spent from 200,000 to 300,000 francs annually to buy French paintings, engaging an agent for the purpose. In the summer of 1903 he acquired from Durand-Ruel Sisley's *Frosty Morning in Louveciennes*, thus starting his collection. He then purchased some more Sisley landscapes, notably *The Garden of Hoschedé* and *River Banks at Saint-Mammès*.

Ivan Morozov preferred Impressionists and Post-Impressionists. His favourite artists were Sisley, Renoir, Monet, Pissarro, and Cézanne. In choosing French landscapes for his collection, he was often guided by the tastes of landscape painters from the Union of Russian Artists. At the outset he sought

the advice of Valentin Serov, Konstantin Korovin and Sergei Vinogradov. Unlike the temperamental Sergei Shchukin, who was prone to hazardous choice and to swift change, Ivan Morozov judiciously desired to possess only outstanding works of art. This difference was reflected in their respective galleries. While Shchukin's house afforded a sanctuary to budding Moscow artists who always animatedly discussed the pictures exhibited, the Morozov gallery, in the Prechistenka Street (now No. 21, Kropotkin Street), was open only to a select coterie of connoisseurs.

Morozov built a true museum of modern French art, in which he invested heavily. However, relying too much on artists' advice, at times he greatly erred; thus, he allowed Serov to dissuade him from buying Edouard Manet's *National Celebration on the Occasion of the World Exhibition of 1878*, which Ambroise Vollard had especially set aside for him. Nevertheless, his conservative tastes did not prevent him from amassing a unique collection.

By 1907 Morozov had acquired Pissarro's *Ploughland*, a canvas displayed at the exhibition of the Société Anonyme des Artistes Peintres, Sculpteurs, Graveurs in 1874, the First Impressionist exhibition. Of the several pieces bought before 1907, Renoir's study for the *Portrait of the Actress Jeanne Samary*, from the collection of the sitter's husband, deserves special mention. Morozov's activity reached its peak in 1907—1908. In addition to the Impressionists, the acquisitions of those years included works by Van Gogh, Gauguin, Cézanne, Signac and Bonnard. Van Gogh's well-known painting, *The Red Vineyard at Arles*, was acquired on Serov's suggestion. About the same time Morozov purchased his first Gauguin, *Landscape with Peacocks*, and then the world-famous *Café at Arles*, one of the artist's early masterpieces, and *Woman Holding a Fruit*. Morozov owned eighteen superb pieces by Cézanne, an artist he held in special esteem. These included the celebrated early *Girl at the Piano (Overture to* Tannhäuser*)*, *Still Life with Peaches and Pears*, and such late works as *Mount Sainte-Victoire* and *Great Pine near Aix*. His acquisition of several excellent Monets — *Le Boulevard des Capucines*, decorative panels with views of the garden at Montgeron, and the wonderful townscape *Waterloo Bridge. Effect of Mist* — further enriched his collection. Morozov also bought some lovely Renoirs — the landscape *Bathing on the Seine. La Grenouillère, In the Garden. Under the Trees of the Moulin de la Galette*, and the captivating *Girl with a Fan*.

In 1906, at the Salon des Indépendants and in the house of Baron Cochin in Paris, the Russian collector first saw decorative compositions by Maurice Denis. He knew that Denis admired Cézanne, and made a point of introducing himself. They soon met at the latter's suburban studio, where Morozov bought several Cézannes, as well as Denis's own *Bacchus and Ariadne*, and he commissioned at once a pendant piece for it (*Polyphemus*). Later, he asked Denis to decorate the large music salon in his Prechistenka house in Moscow. This resulted in a unique ensemble that was the handiwork of several illustrious Nabis. In a letter of 21 July 1907, Denis told Morozov that he had chosen *The Story of Psyche* as the subject of his mural panels. He went to Italy to do sketches for the purpose. In 1909, after Denis had specially visited Moscow to see the architecture of the interior, the panels were finally installed in the music salon. He called Morozov's attention to the work of Aristide Maillol, and the latter was commissioned to do four large bronzes to complement the Denis panels. In his turn, Denis made eight ceramic vases for this room.

Bonnard's well-known triptych *The Mediterranean* was also commissioned by Morozov and hung in the vestibule of his house. Bonnard, incidentally, soon became one of Morozov's favourites. The collector corresponded with him and frequently visited his studio in Paris. As the result of several more commissions, Morozov came to possess a collection of Bonnard's work of the mid-1910s. The interest that Russian artists and collectors evinced in Bonnard and Denis is due largely to the fact that in their paintings the Nabis reflected the Symbolist ideas of contemporary writers and poets. In his series on different religious and mystical subjects, Denis sought to create a modern version of church frescoes,

while Bonnard strove to dissolve the material world and human figures in the element of colour, thus creating an illusion of nature. Despite their stylistic differences, one can speak of a conceptual affinity between Denis and Bonnard, on the one hand, and Gauguin and Matisse, on the other. Moscow collectors and artists played a vital part in the realization of their concepts in Russia.

Between 1911 and 1912 Morozov acquired, through Vollard, Matisse's early still life, *The Bottle of Schiedam*. By this time the Moscow collector had met the artist and, like Sergei Shchukin, already held him in high esteem. In his letters Matisse repeatedly invited Morozov to visit his atelier and gave him valuable advice on what to buy. Morozov had long hoped to have some Matisse landscapes. When in Morocco, the artist painted for Morozov three pictures that formed the famous Moroccan triptych. In a letter to Morozov, now kept in the Pushkin Museum archives in Moscow, Matisse enclosed a sketch of how the triptych should be hung.

Ivan Morozov bought only three Picassos — *Harlequin and His Companion*, *Girl on a Ball* and *Portrait of Ambroise Vollard*. Today we are fully aware of their importance in the artist's œuvre.

In Paris, Morozov regularly visited the Salon d'Automne and the Salon des Indépendants, buying all Fauvist work that caught his eye. For his active collecting of French paintings he was elected an honorary member of the Salon d'Automne society and received the order of the Legion of Honour.

Among other prominent Russian collectors of French art was the landscape painter Ilya Ostroukhov. He owned the *Portrait of Antonin Proust* by Edouard Manet, the pastel *Woman at Her Toilette* by Degas, watercolours by Jean-Louis Forain and bronze sculptures by Auguste Rodin. A true connoisseur, he befriended many Parisian artists. In 1912 Matisse sent him his study *Nude* with a dedicatory inscription.

The Moscow collectors' clan likewise included the Riabushinsky brothers, Mikhail and Nikolai, both bankers. Mikhail Riabushinsky's collection contained Pissarro's *Boulevard Montmartre. Afternoon Sun*. Nikolai Riabushinsky published the journal *Zolotoye Runo* (*The Golden Fleece*) and established a salon of the same name. The *Golden Fleece* shows were popular with French sculptors and artists who sent their works to be exhibited there. These exhibitions of Russian and French art attracted many names. Thanks to Nikolai Riabushinsky, works by Braque and Le Douanier Rousseau, for example, were shown in both Moscow and St. Petersburg while their paint was still fresh. As a rule, Nikolai Riabushinsky bought pictures straight from exhibitions.

After the October 1917 Revolution, the collections of Sergei Shchukin and Ivan Morozov were nationalized and their galleries opened to the public. The Shchukin collection in Znamensky Lane received the official name of the First Museum of Modern Western Painting, and the Morozov collection formed the Second Museum of Modern Western Painting. In 1923 both galleries were merged into the State Museum of Modern Western Art, and all the pictures were amassed in the former Morozov house. Boris Ternovetz, a prominent art historian and sculptor, was made the museum's Curator; he held this office for several years and did much to establish regular contacts with art collectors and museums in Western Europe.

Between 1923 and 1930 the art museums of Moscow and Leningrad were reorganized and their stocks redistributed, in order to arrange exhibitions on a truly scholarly basis, and to fill the lacunae in the collections of each. The Hermitage had little in the way of late nineteenth- and early twentieth-century Western European art, while Moscow museums had few Old Masters. The Hermitage sent to Moscow 460 paintings, including works by Rembrandt, Rubens, Van Dyck, Jordaens, Titian, Poussin, Watteau and Chardin, and in its turn received numerous paintings by Monet, Pissarro, Sisley, Cézanne, Van Gogh, Gauguin, Matisse, Picasso and other artists from the Museum of Modern Western Art in Moscow. After the latter was closed in 1948, its collection was split up between the Pushkin Museum and the Hermitage. Today these brilliant works of modern art grace the permanent exhibitions in both museums.

This book presents a wide selection of Impressionist and Post-Impressionist paintings in Soviet museums, encompassing a period of revolutionary discoveries in art, from the late 1860s and early 1870s to the onset of the twentieth century, from the earliest efforts of Edouard Manet and such artists as Renoir, Monet and Cézanne, to the works of Picasso and Matisse. The authors believe 1905 — the year in which Cézanne produced his last paintings and Fauvism emerged — to have been the watershed in the development of French art; although, of course, no movement may be presented in strict chronological sequence. It is for this reason that this volume also includes works by Denis, Bonnard, Vuillard and Vallotton done during the 1910s, the most productive period for the Nabis, although they were organized as a group in the 1880s. The decorative series of Denis and Bonnard illustrate the logical culmination of a basic tendency characteristic of the transitional Post-Impressionist stage, implying the emergence of an integrated decorative monumentality based on the harmony of pure colour and linear pattern. In their pictorial treatment, however, which betrays an obvious debt to the style-forming principles of the Art Nouveau movement and Symbolist poetry, they are more of the nineteenth century. Also reproduced are paintings done by Matisse before 1905 (i.e. before he became the undisputed leader of the Fauves) and closely related to the experiments of such Neo-Impressionists as Paul Signac and Henri-Edmond Cross. Last, but certainly not least, come works from Picasso's Blue and Pink periods, done prior to 1907 when he created his first Cubist compositions.

The paintings of Henri Rousseau, who died in 1910, may also go beyond the chronological limits of this volume, as they do not always permit accurate dating. The heritage of this unique painter should, in the authors' opinion, be viewed *in toto*.

Edouard Manet and the artists of his circle belonged to a new social type of artist, not bound by and independent of official commissions. Each was free to choose his own themes and his own method. They could openly express their tastes and predilections, and advocate their vision of the world; this meant they could afford to be completely sincere, and tackle the problems of the day using a modern pictorial language. The two major achievements of Manet and his colleagues lay in new psychological content and new painterly techniques. Manet took his characters from among his contemporaries. Their social status, however low it might have been, did not prevent them from challenging philistine notions of virtue and order. Indeed, Manet and his followers were the first to introduce the concept of intellectuality as pivotal to the human personality and a theme worthy of painting. Manet's programmatic works of the 1860s marked a time of change in the history of modern culture. They split viewers and critics into friends and foes, and paved the way for the Indépendants and the Salons des Refusés. Society was no longer indifferent to painting; it felt involved, drawn into a dispute concerning the limits of poetical fiction or of what Baudelaire called "bold imagination". Manet's work transcends his time. Unfortunately, his major paintings are not to be found in Soviet collections. He is represented by two sketches, *Portrait of Antonin Proust* and an oil study, *The Bar*, which art historians date to the late 1870s and refer to Manet's mature period.

Edgar Degas, with his acute powers of observation and interest in contemporary reality, stood close to the Impressionists. He first learned of their innovative approach in Manet's studio. Like the Impressionists, he employed bright, pure colours and introduced a number of bold compositional devices. However, landscape — that principal domain of the Impressionists — left him cold. He ridiculed the legion of *plein-airists* littering beautiful scenery with their easels, and was sceptical of *plein-air* effects, distrusting superficial, fleeting impressions of nature. He preferred to portray subjects in mo-

tion, and he spent hours with his sketchbook or camera at the racetrack, at ballet rehearsals, and backstage. By depicting figures in an unexpected foreshortening, or presenting in one picture several figures in different postures, he sought to convey the dynamic rhythm of contemporary life. The gestures and facial expressions he portrayed reflect the psychology of a transitional epoch. Degas is represented in Soviet museums by pictures of horse-races, dancers and women at their toilette. Art historians have noted his predilection for depicting not the actual performance but rehearsals, not the races but the preparations for them. By watching the daily exercise of the jockeys and dancers he was able to "pinpoint" their movements and facial expressions, and thus convey a variety of natural postures and gestures. In one of his pastels, *Exercising Racehorses*, Degas imparts a distinctive character to the movement of each horse and rider, fusing everything into one rhythmic whole. Like his other pictures of horse-races, this pastel radiates an optimistic mood redolent of Impressionist landscapes.

All the works by Degas reproduced in this edition were done after 1880 — except for the unique Moscow pastel, *Dancer Posing for a Photographer*, dating back to the 1870s. The image could not be less photogenic. Even though the dancer struggles to assume a ballet pose before the mirror, her attempts merely emphasize its strained absurdity. It may well be that in his sober contemplation Degas broke the dance down into separate elements or that, when seated in the auditorium, he saw the performance in all its disjointedness, visible as a rule only during the rehearsals. The subject of the Moscow pastel is not confined solely to the portrayal of the dancer. In place of the stereotype furnishings of a photographer's studio, Degas chooses as the backdrop a window opening out on to Parisian rooftops. The soft silvery light streaming from outside seems to envelop both the interior and the dancer in an ethereal haze. This fusion of an outdoor scene with an interior creates one of the most expressive effects achieved in modern painting before Matisse. Degas's keenly analytical vision of the world paved the way, in a sense, for the emergence of Cubism. Thus, in the 1920s Fernand Léger, working on his abstract film, *Le Ballet Mécanique*, undoubtedly drew inspiration from Degas's works, especially from his *Miss La La at the Cirque Fernando* (National Gallery, London).

The Pushkin Museum's pastel *Blue Dancers* enjoys well-deserved fame. It has been proved that each of the three figures was borrowed, and depicted in reverse, from the photographic negatives made by Degas, which are now in the Bibliothèque Nationale in Paris. Although the artist has brought together all his favourite ballet gestures and movements, we see a dance that has nothing in common with the classical ballet. The dancers' attitudes are too abrupt and awkward; yet, in the artist's mind, there must have been a certain logic in their uncoordinated but quite natural gestures and movements. In their "dance" he has glimpsed the hectic rhythms of the coming age.

His pastels of nudes at their toilette form a series that the artist himself aptly termed "a suite of naked women, bathing, washing, drying themselves, rubbing themselves down, combing their hair or having it combed". This facetious title further demonstrates Degas's analytical scrutiny of ordinary human activity. As Lionello Venturi has rightly pointed out, this prosaic suite incorporates many gems of form-cum-light. Among the pastels that Moscow collectors acquired, *Woman Combing Her Hair* is conspicuous for its high artistic merit.

Soviet museums possess a number of remarkable Impressionist landscapes — *Bathing on the Seine. La Grenouillère* and *In the Garden. Under the Trees of the Moulin de la Galette* by Renoir, *Le Boulevard des Capucines* and *Lilac in the Sun* by Monet, *Village on the Seine. Villeneuve-la-Garenne* and *Frosty Morning in Louveciennes* by Sisley. All of them were done by the young painters in the 1870s, when they had their first exhibitions.

Both Renoir and Monet travelled a long road of artistic exploration, often changing their manner and style, but the works produced by them when the Impressionist movement was in its infancy rank among their supreme achievements. Their early landscapes captivate by the spontaneity of impression

and the vigour of the brushwork. Today these sunlit pictures can inspire joy and nostalgia. The title of A. Ballony-Rewald's recently published book, *The Lost World of the Impressionists*, is therefore no accident. Indeed, these works have a special appeal for our generation. The artists have left to posterity truthful, heartfelt representations of what is no longer to be seen — sailboats on the Seine, open-air dance floors in the heart of Paris and vineyards in its suburbs, the semi-rustic Montmartre, such favourite public places as La Grenouillère, and the bustle of fin-de-siècle urban life. This "lost world" springs back to life on Impressionist canvases.

The same ambiance is characteristic of the portraits produced in the 1870s and the early 1880s. Though they may lack depth, such brilliant Renoir canvases as the *Portrait of the Actress Jeanne Samary* or *Girl with a Fan* proclaim the Impressionist approach to portraiture, whose aim was to capture the fleeting moods and inimitable facial expressions of the charming sitters. The Moscow pictures — *Jeanne Samary*, *Girls in Black*, *In the Garden* — were painted, like *The Swing* (Musée du Jeu de Paume, Paris), in Montmartre, where Renoir rented a little house with an overgrown garden in the 1880s. His friends, including Jeanne Samary, often sat for him there. Renoir frequented the Moulin de la Galette, where young Parisians went for amusement and where girls from all over the city came weekly to dance. There Renoir painted his superb *Moulin de la Galette* (Musée du Jeu de Paume, Paris). More than any other artist, Renoir delighted in the atmosphere of happiness, youthful exuberance and friendliness that reigned in Montmartre. His portrayals of young women radiate a joie de vivre and strike the viewers by the freshness of their dazzling colours; this is especially true of the Hermitage pictures, *Girl with a Fan* and *Lady in Black*.

During the same stage in his career Renoir painted portraits aimed to please the official critics of the Salons. The Hermitage *Portrait of Jeanne Samary* provides some insight into this approach. The full-length figure set against a sumptuous background evokes the formal portrait, but the deliberate self-assertion of the model in the ceremonial portrait is tempered here by the vivacious facial expression and the buoyant colours. For Renoir, Salon portraiture was more than a tribute to fashion. He was attracted by the possibility of imparting to an easel painting a decorative quality; a tendency he had ever since his youth. However, this had already implied a departure from Impressionist techniques.

By the mid-1880s Renoir had reached a critical point. A past master of delicate tonal values, adept at conveying an ethereal haze and the trembling reflections of sunlight, he now rejected blurred contours, striving towards a clear and well-delineated form. In 1881 he went to Italy to study the grand style of the celebrated Renaissance painters. Succumbing to their spell, he developed a classical style known as *style aigre*. This period is represented in Soviet collections by the Hermitage painting *Child with a Whip*. A desire to balance the composition, accentuate the contours and schematize the colours is combined here with the artist's favourite technique of depicting patches of sunlight rippling through the leaves.

The landscapes of Alfred Sisley, in contrast to other Impressionists, require a long and close scrutiny. He was never preoccupied with the theory of colour or the problems of visual perception. His landscapes seek above all to convey the mood. Although his œuvre contains a great variety of landscape motifs, he did not combine them into series as, for example, did Monet or Pissarro. His individual style underwent no dramatic changes. In the mid-1880s he began to employ broader, more dynamic brushwork, abandoning his former fragmented spatial delineation. This new attitude is evident in such landscapes as *Windy Day at Veneux*, *River Banks at Saint-Mammès* and *The Skirts of the Fontainebleau Forest*, although ultimately his manner has not changed.

The early landscapes of Camille Pissarro reveal influences of Corot and Daubigny. The sensitive and poetic treatment of nature in the landscapes of the Barbizon painters was compatible with Pis-

sarro's own lyrical talent. In 1874 he and Claude Monet were among the initiators of the First Impressionist exhibition, where Pissarro displayed five landscapes, including *Ploughland*. Throughout his career he upheld a scholarly, serious approach to the expressive potential of painting. A dedicated Impressionist, who helped to organize and took part in all Impressionist exhibitions, acting frequently as a peacemaker, Pissarro never tired of perfecting his pictorial techniques. Having an open mind and definitely democratic aspirations, he was deeply involved with the social issues of the day. He demonstrated a rare perspicacity in his attitude towards the young Cézanne and Gauguin, who opposed the Impressionists. For his part, Pissarro also sought to achieve synthesis in his painting, and to touch upon eternal themes. In the 1880s he was greatly influenced by Divisionism and by Seurat's theories of "optical mixtures". He produced some very interesting drawings and paintings on farmwork motifs, in which he came closest to developing a synthetic style. Although this period is not illustrated in Soviet collections, Pissarro's later landscape, *Autumn Morning in Eragny*, provides some insight into this stage in the artist's work. Divisionism, however, did not hold his interest for long. Aware that illustrations to physical theories might "inhibit the spontaneity of sensation", and lead to the decline of concrete images and emotional landscape painting, he turned again to townscapes in the 1890s, producing his series of Paris and Rouen views. This period is represented in Soviet museums by three excellent canvases, each of which conveys the throbbing rhythm of urban life that the Impressionists always tried to recreate in their work. His *Boulevard Montmartre*, with its continuous stream of passers-by, is flooded by midday sunshine breaking through the spring clouds; the *Avenue de l'Opéra* gleams in the silvery haze of rain and snow, *La Place du Théâtre-Français* is alive with the freshness of spring foliage and the joyful bustle of the crowd.

The work of Claude Monet is amply represented in Soviet collections, from *Luncheon on the Grass* (*Le Déjeuner sur l'herbe*), one of his earliest compositions, to *Seagulls*, a landscape done in 1904. Monet's large canvas, *Luncheon on the Grass*, was conceived in emulation of the celebrated Manet painting of the same title that was exhibited at the Salon des Refusés. Monet, apparently displeased with his effort, later cut the canvas into three parts, so that the Moscow version is the only one to retain the artist's original concept. Monet painted his picture for the 1866 Salon and, probably impelled by his youthful ambition, tried to do better than the recognized leader of the new school. However, his version cannot stand comparison with Manet's profound and innovative concept. In Monet's work we see an ordinary and pleasant picnic in a suburban setting.

At about this time Monet painted his *Lady in the Garden*, a canvas to which he attached great significance. In it he attempted to cope with the problem of lighting; a problem he worked on, together with Renoir, at Argenteuil and Bougival throughout 1869.

In his landscapes *Lilac in the Sun* and *Le Boulevard des Capucines*, Monet came close to transcending the isolated character of easel painting. He aimed at an integration of painting with other arts. To the Third Impressionist exhibition he sent several large panels designed for interior decoration. Among them were *Corner of the Garden at Montgeron* and *The Pond at Montgeron*.

In the years that followed, Monet produced not only paintings remarkable for their meticulous brushwork and diverse texture, but also pictures in a more generalized manner, akin to decorative panels. Thus, his 1886 seascape, *The Rocks of Belle-Île*, shows a dynamic texture and a clear sense of three-dimensionality, whereas his *Cliffs at Etretat*, of the same date, is emphatically flat and decorative. In the latter, the natural forms demonstrate no palpable texture; the cliffs, sea and sky merge into one pictorial whole. This method reached its culmination in the seascape *Steep Cliffs near Dieppe* (The Hermitage).

In 1883 the artist settled in Giverny. The Hermitage collection contains one of his earliest views of Giverny, in which the haystack in the foreground also serves as the starting point for an in-depth,

17

panoramic composition. The Pushkin Museum's *Haystack at Giverny* and the Hermitage's *Poppy Field*, while reflecting different fleeting states of light, are notable for the intensity of their blues, greens and reds; the whole scene is filled with sunshine.

A prominent feature in Monet's art is his predilection for series of landscapes on the same subject, each picture recording one inimitable, fleeting instant. The series dedicated to Rouen Cathedral was painted in the 1890s. Two pictures from this series which are in the Pushkin Museum present the façade of the Cathedral at different times of day. They both abound in the most delicate gradations of tonal values and indicate Monet's intense absorption in what he saw. The task of presenting a probing and impartial study of an object, one he assiduously accomplished during a number of days, may perhaps compare only with Andy Warhol's experiment; almost eighty years later, he filmed the different atmospheric effects on the façade of Empire State Building in New York.

In the late 1890s Monet painted a series of landscapes in which he sought to render the finest effects of light and air and which foreshadowed a group of canvases depicting London fogs.

In the early years of the twentieth century, Monet's landscapes become purely decorative. Forms lose their configuration; objects melt into the enveloping haze. This type of landscape is illustrated by the Pushkin Museum's painting *Vétheuil*. Its composition is arranged not in depth but vertically; the reflection in the water enhances the illusory quality of the scene which seems to dissolve in a golden-pink mist.

The distinctive features of Monet's late period found their most complete expression in his views of London. In *Waterloo Bridge. Effect of Mist* and *Seagulls*, the silhouettes of the bridge and of the Houses of Parliament are barely discernible in the thick mist, whose effect is conveyed with great skill.

Any account of late nineteenth-century art would be incomplete if it failed to describe the works of Cézanne, Van Gogh and Gauguin in Soviet museums.

The Cézanne collection opens with the *Interior with Two Women and a Child*, done in the artist's early, so-called dark, or romantic, manner. This interior scene, which is typical of the young Cézanne in its somewhat constrained execution, has one point indicative of his highly individual treatment of spatial relationships, a feature that was to dominate his later work: the figure of the girl moving towards the table differs in scale from the figures of the two women; it seems to be in another dimension. Indeed, in this interior — one of the artist's earliest, immature efforts — we do not find any geometrically defined, box-like space. This is rather an emotional space, not unlike that seen in works by the naive artists.

A genuine masterpiece from Cézanne's early period is the Hermitage *Girl at the Piano*, a version of the now non-extant *Overture to "Tannhäuser"*. In it we have again a difference in scale between the figures, the same disintegration of the stage-like, closed-in space, even to the point of replacing it by an alternating sequence of parallel flat objects. As the late Anna Barskaya so aptly remarked in her essay on Cézanne (see *Paul Cézanne*, Aurora Art Publishers, Leningrad, 1975, p. 15), "the actual space of the interior proves to be too small to accommodate everything the painter wants to put into it. Cézanne breaks down this space and constructs a new one in which we see not only the physical but also the spiritual life of its occupants".

The years from 1872 to 1879 are usually referred to as Cézanne's Impressionist period. In 1872 he and Pissarro went to Pontoise to work *en plein air*. The still life *Flowers in a Blue Vase* exemplifies the artist's quest for new colour combinations as the basis for his composition. However, neither in this still life nor in the landscape *Road at Pontoise* do we find the colour reflections and sunlight effects favoured by the Impressionists. In both landscapes and still lifes, Cézanne sought to build forms through colour, not to dissolve them in colour.

18

Starting with the 1880s Cézanne explored the problem of constructing a solid volume, an integrated spherical space within the limits of still life and landscape. Each particular motif served to embody the idea of the unity of the universe, to reflect its perpetual evolution. Such masterpieces as *Fruit, Still Life with Curtain*, and *Still Life with Peaches and Pears* illustrate Cézanne's experiments in the still-life sphere. Art historians have repeatedly emphasized that by concentrating on the still life Cézanne broke with Impressionism. His still lifes demonstrate the eternity of matter, the unity of its diverse elements, and the possibility for reciprocal transformations. His early still life *Fruit* already displays the essential components of his work: the fruits are geometrically shaped and set at the edge of the kitchen table, while the crumpled table-cloth rises up like a mountain, its folds seeming to possess a flexibility that shatters the traditional notion of the "stillness" of objects in a still life. With Cézanne, the ultimately generalized, even schematic volumes are anything but static. In both *Still Life with Peaches and Pears* and *Still Life with Curtain*, objects and space are fused in a complex pattern. The fruits seem to roll down the table, not simply lie on it, while the table-cloth hangs as if suspended in space, into which the viewer is also drawn.

Cézanne's approach matured in his later landscapes. The Hermitage picture *The Banks of the Marne* (*Villa on the Bank of a River*), with its frontal construction and reflection in the water, invites comparison with Claude Monet's *Vétheuil*. But in Monet's Impressionist canvas the reflection seems to dematerialize the houses on the banks, transforming everything into a phantom image, whereas in Cézanne's painting the water acquires a tangible solidity, and the reflection does not differ in its structure from the objects reflected. Everything in nature is seen by the artist as in a perpetual state of flux, with the viewer in the centre. Similar unity of nature's forces is to be observed in the Pushkin Museum's version of *The Banks of the Marne*. Here the artist strives further to attain a harmony between the diagonally arranged, receding perspective and the flat surface of the canvas. Cézanne simultaneously models this in-depth perspective by means of colour on a vertical plane, thus intensifying its impact upon the viewer; he introduces, as it were, an additional temporal dimension. The spatial relationships in another Moscow landscape, *The Aqueduct*, obey the same laws; here the effect of depth is emphasized by the different scaling of the objects and, at the same time, is offset by colour modelling along the vertical plane. In the *Mount Sainte-Victoire* landscapes these compositional devices serve to produce a truly cosmic image of the universe. The Cézannes in the Soviet collections enable art historians to trace all the stages the artist went through in his efforts to achieve this objective, from his early panoramic *Plain by Mount Sainte-Victoire* to the magnificent *Landscape at Aix*, painted shortly before his death.

The Moscow and Leningrad museums display several Cézanne pictures containing portrayals of man, an inseparable part of Creation to him. *Pierrot and Harlequin* (*Mardi Gras*), whose tense, unbalanced composition anticipates Expressionism and Cubism, enjoys well-deserved fame. Expressionist and Cubist hints are especially evident in the *Lady in Blue*, making us realize how greatly the Russian artists of the Jack of Diamonds group are indebted to Cézanne's experiments. Cézanne's *Smokers* series best reveals his understanding of man's part in Creation. Like the Renaissance artists, he succeeded in immortalizing his contemporaries.

To fuse man with nature, to make the human figure the compositional pivot of the universe was something that Cézanne undertook only in his late period, in the *Bathers* series. The small Pushkin Museum study *Bathers* is important because it demonstrates his first efforts along these lines.

The several Van Goghs in Soviet museums — from the earliest pictures painted in Arles to the last ones, done just before the artist's death in Auvers — are indisputable masterpieces.

In 1888 Van Gogh moved from Paris to Arles, in Provence, where he began to work with feverish speed, for several hours every day, and produced a great number of pictures distinguished by

a highly individual manner, unlike that of the Paris Impressionists. He painted in oils directly on canvas, using no preliminary charcoal sketches. The vigorous dabs in *Seascape at Saintes-Maries* provide a good example of his manner. He was able to complete a picture in one sitting, to infuse it with an inner emotion and inject a dynamic quality into the most trivial of motifs. Van Gogh painted each picture with his very "sweat and blood". Painting a picture was, for him, living a life. "Even if it is not a real life, I'm still almost as happy as if it was the ideally real life," the artist wrote in one of his letters (see *Verzamelde Brieven van Vincent van Gogh*, 4 vols., Amsterdam, Antwerpen, 1952—54, 507), and this confession is the epitome of his attitude to his own work. Such absolute fusion of art with life was attained, after Van Gogh, by Picasso.

At Arles, around the same time, Van Gogh decided to do a portrait à la Japanese, as the local type of girl evoked memories of Japan (or rather of Japanese prints), and the novels of Pierre Loti. As a tribute to Japanese fashion, he entitled the portrait *La Mousmé* — a teenage girl from a teahouse. Preserved in the Pushkin Museum is a sketch for this portrait, one of his best drawings. By employing a reed pen to draw lines of various thickness, Van Gogh outlined the girl's figure with his favourite flexible, meandering patches and circles reminiscent of the way children draw the sun.

In the autumn of 1888 Gauguin came to Arles. Under his influence, as well as that of Bernard's and Anquetin's experiments with Cloisonnism (thus termed because of the resemblance to *cloisonné* enamels), Van Gogh painted several pictures of women walking. Of these works, done in a schematic, synthetic manner, the Hermitage *Ladies of Arles* (*Reminiscence of the Garden at Etten*) is the most famous. However, the artist's independent and violent nature clashed with the well-ordered rationale of Cloisonnism, so that in the foreground of this picture we see a chaotic conglomeration of paints squeezed out of tubes on to canvas and merging at a distance into a flowerbed.

A striking contrast to the well-balanced stylization of Cloisonnism is provided by Van Gogh's *The Red Vineyard at Arles*, a gem of the Arles period. It is a picture filled with explosive, flaming reds and incandescent sunlight, and pervaded with the foreboding of impending tragedy. It is a cry of the artist aware that it is his fate to be doomed to complete isolation. Shortly thereafter, Van Gogh violently quarrelled with Gauguin, and had a nervous breakdown; he cut off his ear lobe and had to be taken to the Arles hospital. Félix Rey, the doctor who took care of him there, looks at us from a Moscow portrait.

The period of Van Gogh's confinement to the Saint-Rémy asylum is illustrated in Soviet museums by two major works revealing the antinomy of his world outlook, *Lilac Bush* and *The Convict Prison*. Whereas the latter picture symbolizes distress and despair, the *Lilac Bush* is perceived as a triumphant paean to divine nature and the beauty of Creation; it is the embodiment of the spiritual vigour of the human mind. If in *Seascape at Saintes-Maries* the brushwork betrays a youthful fervour and temperament, in the *Lilac Bush* each stroke comes from the impulsive yet inspired hand of a painter who unravelled the mystery of artistic creation. By "living a lifetime" with each new picture, the artist extended, as it were, the limits of natural time. One of Van Gogh's last masterpieces, *Landscape at Auvers after the Rain*, stands out for its truly cosmic vision. When the artist's life was ending and his personal world was confined to the asylum, the time/space continuum in his painting reached unprecedented scope. In *Landscape at Auvers* Van Gogh's tragic world outlook is sublimated to the extreme; it may be seen as antipodal to his *Starry Night* (Paul Rosenberg Gallery, Paris). In each painting earth and sky are fused into one, but in *Starry Night* the sky descends upon the earth in a devastating tornado, whereas in the *Landscape at Auvers* it is the earth that reigns supreme, taking on the appearance of a calm, clear sky.

The earliest Gauguin to reach Russia was the small still life *Fruit*, done after the artist's trip to Martinique in 1887. It already has certain features of the Synthetic style which Gauguin evolved in

Pont-Aven. In 1888 the artist joined Van Gogh in Arles. *Café at Arles*, painted when he was staying with Van Gogh, is in the Pushkin Museum in Moscow. It provides a notion of how Gauguin treated the theme of a night café and incorporates a portrait of their neighbour, Mme Ginoux. Conveying the drab atmosphere of a billiards room, Gauguin did not seek to create any highly emotional images, of the type seen in *Night Café* by Van Gogh (Museum of Modern Art, New York).

All other Gauguin paintings from the extensive Morozov and, particularly, the Shchukin collection, stem from the artist's first and second Tahitian periods. *Conversation* and *The Big Tree* (*At the Foot of a Mountain*), painted shortly after Gauguin arrived in the Polynesian Islands, bear the stamp of his immediate impressions. Hence his partial return to Impressionism, with its verisimilitude of treatment, its generalization of motifs, its preservation of depth and distant planes, and its reflections of light. The same can be said of the famous picture *Woman Holding a Fruit* (*Where Are You Going?*), which shows a Tahitian woman holding a fruit reminiscent of a water-vessel. However, the spontaneity of sensation here is deceptive. The squatting woman in front of the cabin recalls Persian miniatures, while the light-coloured arabesques, traced on the ground as if by a single stroke of the brush, are obviously borrowed from Japanese prints. Finally, the image of the Tahitian woman, whose naked body resembles a ripe fruit, carries a symbolic message of fertility.

During his first stay in Tahiti, Gauguin already avoided overly informative portrayals, trying to grasp the essence of nature as an orderly system. In the Pushkin Museum's picture *Are You Jealous?* the Tahitian women are depicted on the bank of a pool; however, earth and water are completely schematic and are reduced to a mesh of tense patches of colour. In Gauguin's view, the pictorial plane was a substance capable of generating an infinite number of forms, an active field of force incorporating the structures of all the objects depicted, and one to which they may return to become a plane once again. Gauguin made this discovery in Pont-Aven; in Tahiti his Synthetic technique acquired a new lease on life. It enabled him to control the elemental play of the natural forces and the splendour of an exotic environment (seen, for instance, in his *Landscape with Peacocks* or *Pastorales Tahitiennes*), a splendour so fragrant and spell-binding for the European that he can easily fall victim to its poisonous charms. On the other hand, the devices the Synthetic style allowed made for the unusual tenor of the landscape depicted, for its break with the forms and colour combinations so familiar to the European eye. They transformed Tahitian scenery into the symbol of another reality, a figment of the artist's imagination; they transformed it into the land of "sweet dreams". They made Oceania even more exotic than it actually was.

In the course of his second stay in Tahiti Gauguin produced works of profound content; one is tempted to compare them to "painted notions", akin to the primary elements which, in his opinion, constituted the languages of Oceania. Recalling here Shchukin's idea of a Gauguin "iconostasis", we may say that Gauguin created a sort of "Bible in pictures". This comparison is fully justified, because in Tahiti Gauguin sought the Promised Land. The deliberately simple Tahitian scenes evoke the Gospel motifs, e.g. *Baby* (*The Nativity*) or *The Great Buddha*. Portrayed in the background of the latter picture are episodes from the Last Supper; the painting as a whole symbolizes the fusion of two great world religions and reflects the Tahitian myth of the end of the world.

In several Gauguin paintings (*The Queen*, *Gathering Fruit*, *Woman Carrying Flowers* and *Three Tahitian Women against a Yellow Background*) we see some strange plants reminiscent of buds. They are at once buds and fruits, swollen, about to split open and eject seeds or clusters of flowers. They are thus symbols of fertility. Replying to a letter from Strindberg, who had refused to write the foreword to the catalogue of Gauguin's exhibition, the artist explained his technique: "This world, which no Cuvier or botanist could have discovered, is a Paradise that I alone have touched" (see *Lettres de Gauguin à sa femme et à ses amis*, Paris, 1946, p. 263). Branches burdened with fruit, fruit lying on

the ground and the plant-buds in the famous canvas *Gathering Fruit* stand forth as elements symbolizing Paradise after the Fall, a paradise full of life-giving sources. The Tahitians are not merely people who have come to gather fruit, but full-blooded figures in Gauguin's paradise. The left-hand part of the picture presents the world before the Temptation and Fall — Paradise in the full sense of the word — while the right-hand part is the Earth, fertile and reproductive, yet doomed to death. Serving as a reminder of death is a horseman — a symbolic image which has often been a matter of dispute in literature on Gauguin. The sinister image of Death in the guise of a horseman recurs in *The Ford* (or *The Flight*), painted two years before the artist's own death and reflecting the last stage in his life — his flight from Tahiti to the Island of Dominica.

Gathering Fruit is one of the three pictures that the artist conceived as parts of a fresco; the other two, *Where Do We Come From? What Are We? Where Are We Going To?* and *Preparations for a Feast* (*Faa Iheihe*) are now in the Boston Museum of Fine Arts and the Tate Gallery in London.

By virtue of their manifold meaning Gauguin's works are akin to nineteenth-century art in general and European Symbolism in particular. Gauguin is known to have admired Puvis de Chavanne and Odilon Redon. In some cases he even borrowed elements of their compositions as prototypes; an example of this is provided by the famous still life *Sunflowers*, also done in the twilight of the artist's life. The All-Seeing Eye in the dark background above the basket of sunflowers is reminiscent of Redon's drawings and pastels. Yet, despite the affinity of themes and subjects, Gauguin and the Symbolists spoke two different languages. In contrast to the latter's sophisticated mode of expression, Gauguin preferred the vivid tongues of the primitive peoples with their full-blooded imagery. But despite the extent to which the artist's language depended on that of the peoples of Oceania (although he realized that their traditional way of life had been affected in some measure by civilization), this did not turn him into a Primitive. It would be wrong to think that Gauguin limited his task to just one more attempt to treat the sempiternal themes. In the painting *Her Name Is Vaïraumati*, the Maori myth of the god Horo meeting the beautiful Vaïraumati is depicted twice. The genuine mythological characters are represented in a Polynesian wood-carving that is visible in the background, but the artist's Tahitian inscription refers to the young woman seated on a bright carpet; she is Vaïraumati, mother of the human race, but she is also a *vahine*, a woman of easy virtue.

In analysing Gauguin's work one should not concentrate exclusively on the overriding nature of its decorative colourfulness and unrestrained play of pure form. Indeed, these aspects conceal the representational and conceptual fabric. However, neither should we regard these two facets too seriously, as there is still another facet — the artist's playful imagination, his ironical detachment. The interaction of these three facets brings Gauguin fully in line with twentieth-century art.

The importance of Soviet collections of the Nabis has been noted before. The work of Odilon Redon, who in his later years produced several huge decorative panels, can be — in its purely painterly aspect — related to Nabi pictures, although Redon did not associate himself with any of the existing art groups. He placed imagination above all theories, contending that all art is the creation of the subconscious. His own art was close to Symbolism. Redon's Soviet-owned works — two pastels, *Day and Night* and *Profile of a Woman in the Window*, and the large canvas *Spring* — are characteristic specimens of his poetical fantasies.

The Neo-Impressionists are represented in Soviet collections by Paul Signac and Edmond Cross. Their landscapes should not be regarded as dead and dry schemes. *The Pine Tree at Saint-Tropez* by Signac and *Around My House* by Cross, with their dots of colour distributed over the surface in a strictly balanced manner, delight the eye by their contrasting play, conveying the light-and-air medium. Two other Signac paintings, *Harbour at Marseilles* and *Sandy Seashore*, are more restrained and delicate, radiating a poetic enchantment. Although the name of Cross is often overshadowed by

such leading figures of Divisionism as Seurat and Signac, such pictures as *Around My House* and *View of Santa Maria degli Angeli near Assisi* demonstrate the refined taste and consummate artistry of this consistent Divisionist. No wonder the young Matisse owed so much to his influence.

The autodidact artist Henri Rousseau stands apart in turn-of-the-century French painting. Along with Cézanne, Van Gogh and Gauguin, Rousseau epitomized one of the main trends in twentieth-century art. The discovery of Rousseau by Pablo Picasso and his fellow artists in Montmartre coincided with an awakened interest in pre-Renaissance French art, which was also dubbed "primitive". Medieval French painting and early African and Latin American art was contrasted by the new generation of artists to post-Renaissance painting, with its so-called right perspective and almost photographic representation, hopelessly compromised by academic Salon art. In this context, Rousseau was a throw-back to the sources of French art, to the age of the Master of Moulins and the celebrated miniature artists. The avant-garde painters saw Rousseau's greatness in his lack of professionalism. For all its seeming naivety, however, Rousseau's art is full of enigmas. Undoubtedly, one of the principal sources of his work was the culture of nineteenth-century lower-class urban population in France. On the other hand, he is known to have studied ancient Egyptian art, the Italian Quattrocento and medieval tapestries. He claimed that he was a votary of the Muses, and on a par with the laurel-crowned academicians, the Old Masters whom he copied at the Louvre, as well as the unsophisticated house painters who did signboards for Paris shops. Although such indiscriminate respect for virtually every field of artistic endeavour betrays an amateur's naivety, it also encourages closer examination of Rousseau's heritage.

Rousseau's highly distinctive style, marked by a clarity of form and colour and reinforced by the seemingly unnatural frozen postures and facial expressions, enabled him to impart an aura of eternity to the routine of everyday life. He delighted in looking at postcards, geographic atlases and postage stamps, and in strolling through the Botanical Gardens. His riotous imagination transmuted these impressions into dream journeys to exotic lands, full of fantastic plants and beasts. Excellent examples of his method are such paintings as *Jaguar Attacking a Horse* and *In a Tropical Forest. Struggle between Tiger and Bull*. Rousseau's landscapes present a specific vision of nature as a magnificent garden, a garden from a fairy-tale; they derive from the popular broadside and the rustic patchwork carpet. His exotic landscapes, with beasts locked in mortal combat, evoke memories of the fantastic Paradise of Bosch's altar wings where animals also devour one another.

The Pushkin Museum owns a genuine Rousseau masterpiece: the double portrait of Apollinaire and Marie Laurencin, which the painter himself entitled *The Poet and His Muse*. Indeed, one must look hard to recognize in the idol with the eyes of Marie Laurencin the woman who was the poet's source of inspiration. Yet it is undoubtedly this woman, herself an artist, albeit seen in the crooked mirror of civilization. Rousseau has attempted to portray here the features of a poet's muse, bewildered and lost in the hustle and bustle of the twentieth century. The landscape elements in this picture are more than mere decorations. The gillyflowers from a botanical atlas build a kind of hedge in front of the Poet and the Muse; full of life, their stems seem to grow visibly, their leaves straining outwards and their flower clusters assuming gigantic dimensions. This is the image of an animated world filled with inspiration: the flowers in the foreground symbolize the poet's immortal soul. *The Poet and His Muse*, one of Rousseau's most significant works, treats a great theme that is common to all of mankind.

The collection of paintings by the young Matisse allows art scholars to trace his evolution from his earliest efforts reminiscent of the Old Masters (e. g. *The Bottle of Schiedam*) to his first Fauve canvases. Although during his artistic career Matisse was infatuated with the Impressionists (as is evidenced by his still life *Blue Jug* and *Corsican Landscape. Olive Trees*), his early still lifes, on the whole, betray close links with Cézanne and Van Gogh — for instance, *Blue Pot and Lemon* and *Fruit and*

Coffee-pot. Prior to 1900 Matisse stayed within the mainstream of Post-Impressionist development. However, his still lifes with crockery, done at the beginning of this century, reveal areas of active colour, and flattened dimensions designated by merely two or three free-flowing strokes and patches of colour, and fused into a heavily saturated painterly matter, as in *Dishes and Fruit*. The landscape *Luxembourg Gardens* shows the influence of Gauguin's Tahitian canvases, marking the beginning of the next stage in Matisse's career — a generalization of natural motifs by means of open, intense colours. Not without reason, the artist's works done prior to 1905 are viewed as pre-Fauve. His first landscapes painted in Collioure around 1905—1906 exemplify his debt to the Neo-Impressionist techniques of Signac and Cross, which he tended to generalize to the utmost.

Whereas Matisse's early efforts may be designated as preparatory, as an impetuous evolution culminating in the creation of *The Dance* and *Music*, the young Picasso's Blue and Pink periods (1901—1905) are at once to be placed in the domain of modern art. Such Picasso masterpieces from Soviet collections as *Old Jew and a Boy* and *Girl on a Ball* signify the end of Post-Impressionism, and are part of the stylistic idiom of today. Such canvases as *The Absinthe Drinker*, *The Embrace* and *Harlequin and His Companion* closely relate to Gauguin, Toulouse-Lautrec and Munch; *Portrait of Soler* is comparable to Van Gogh, while *The Embrace, Old Jew and a Boy* and *Girl on a Ball* refer to the concepts of Spanish and French Symbolists, i.e. to the nineteenth century. Despite the daring structure of his works of this period, they manifest Picasso's undying faith in humane ideals and in the possibility of bettering man and his social environment by means of art.

Picasso's Blue and Pink periods constitute a brilliant chapter in the searchings and achievements of modern French art.

Marina Bessonova

PLATES

EUGÈNE BOUDIN. 1824—1898

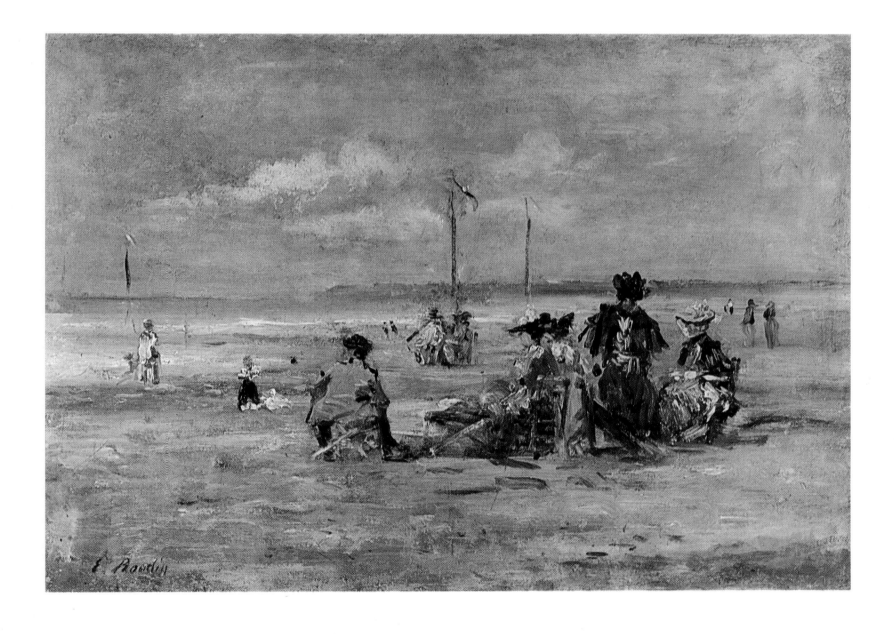

1 BEACH SCENE

Oil on panel. 23.5×33 cm

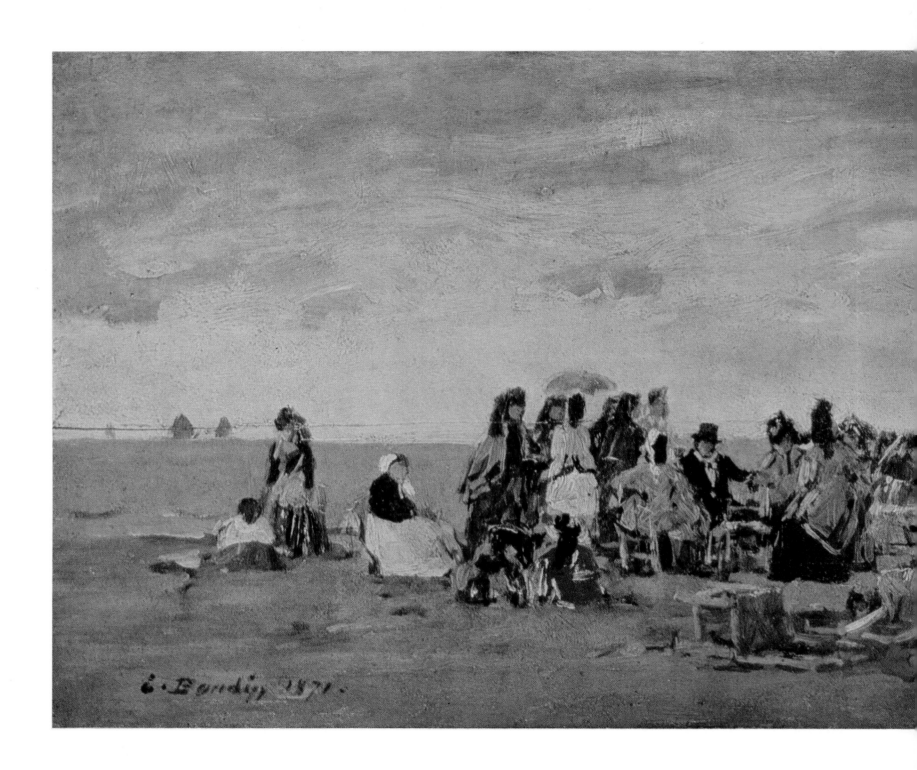

2 ON THE BEACH. TROUVILLE

Oil on panel. 19×46 cm

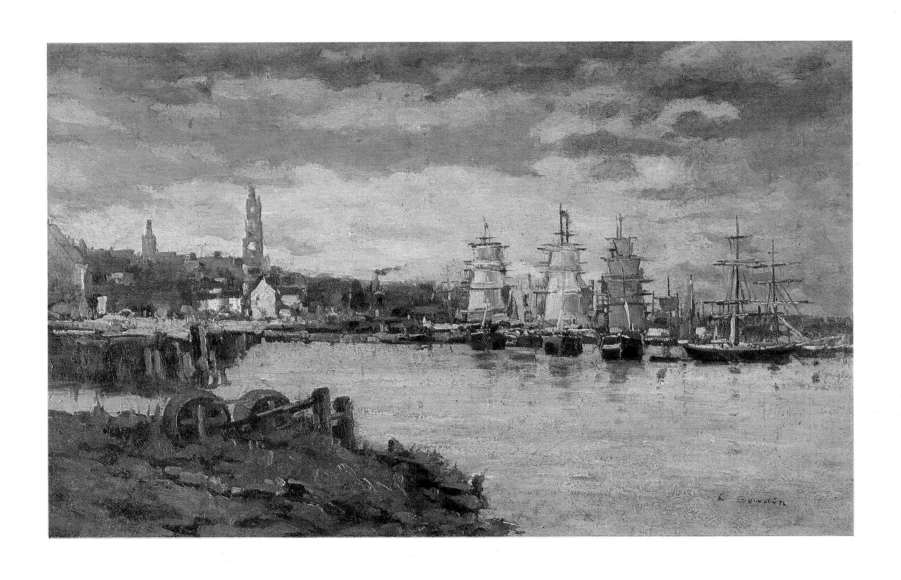

3 THE HARBOUR

Oil on canvas. 36×58 cm

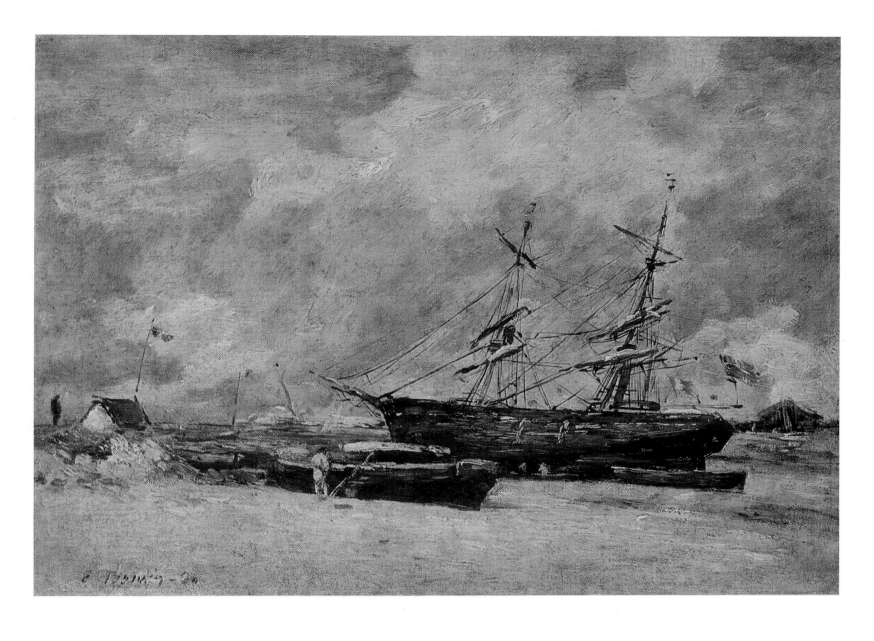

4 FISHING-BOATS ON THE SEASHORE

Oil on panel. 25×35 cm

manet_

ÉDOUARD MANET. 1832—1883

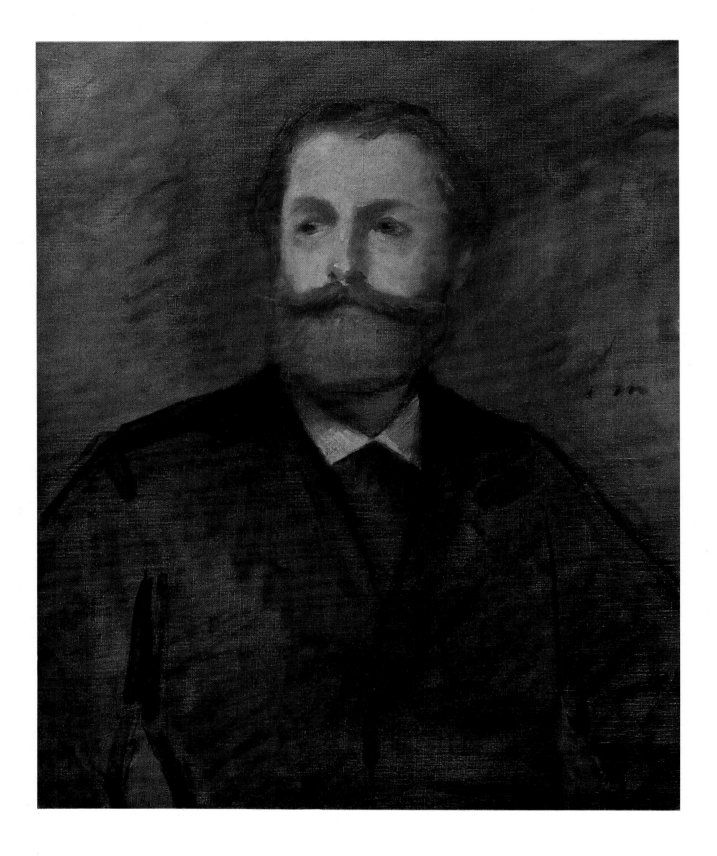

5 PORTRAIT OF ANTONIN PROUST

Oil on canvas. 65×54 cm

6 PORTRAIT OF MME JULES GUILLEMET

Black chalk, 31.3×22 cm

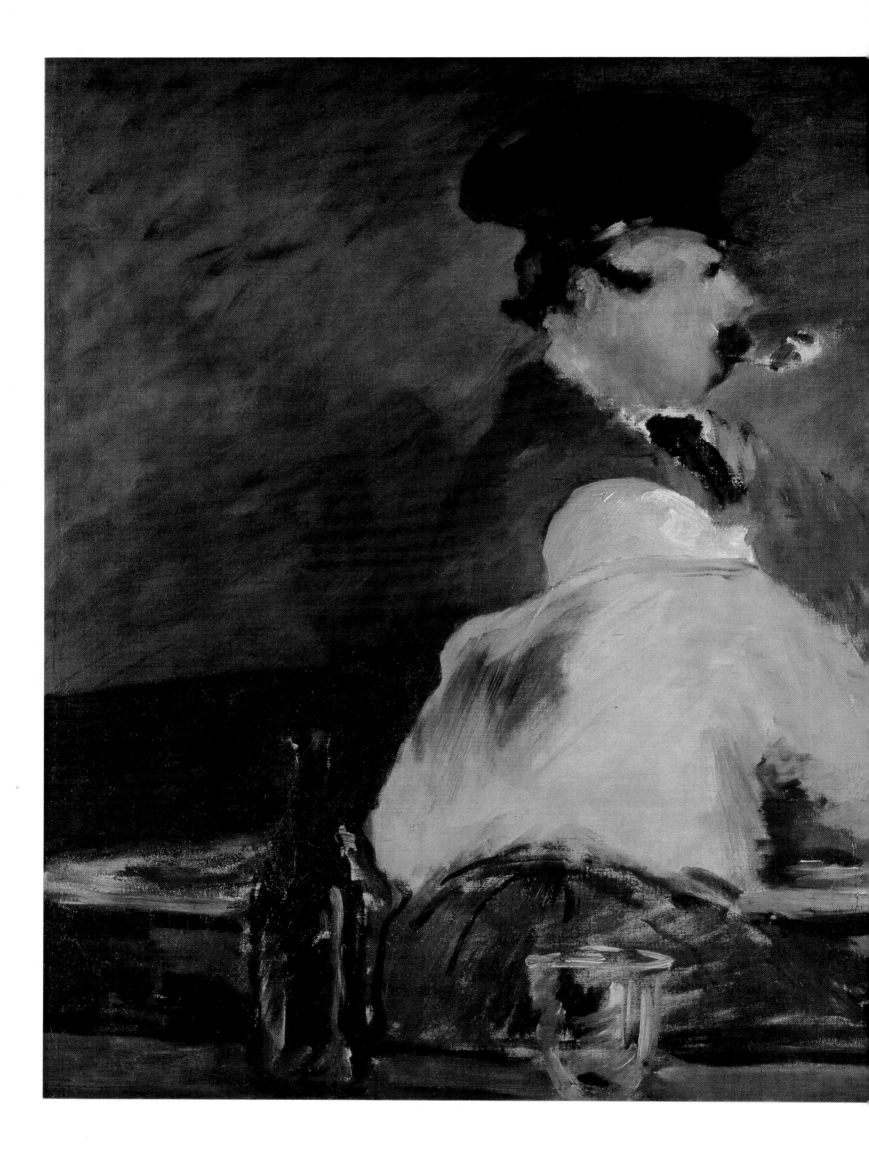

7 THE BAR

Oil on canvas. 72×92 cm

CLAUDE MONET. 1840—1926

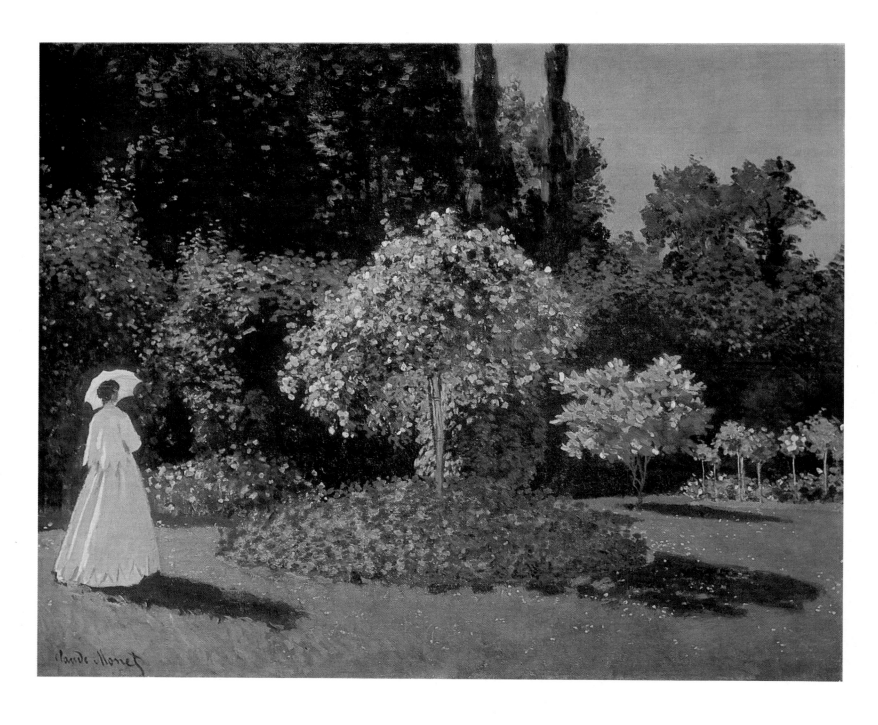

8 LADY IN THE GARDEN

Oil on canvas. 80×99 cm

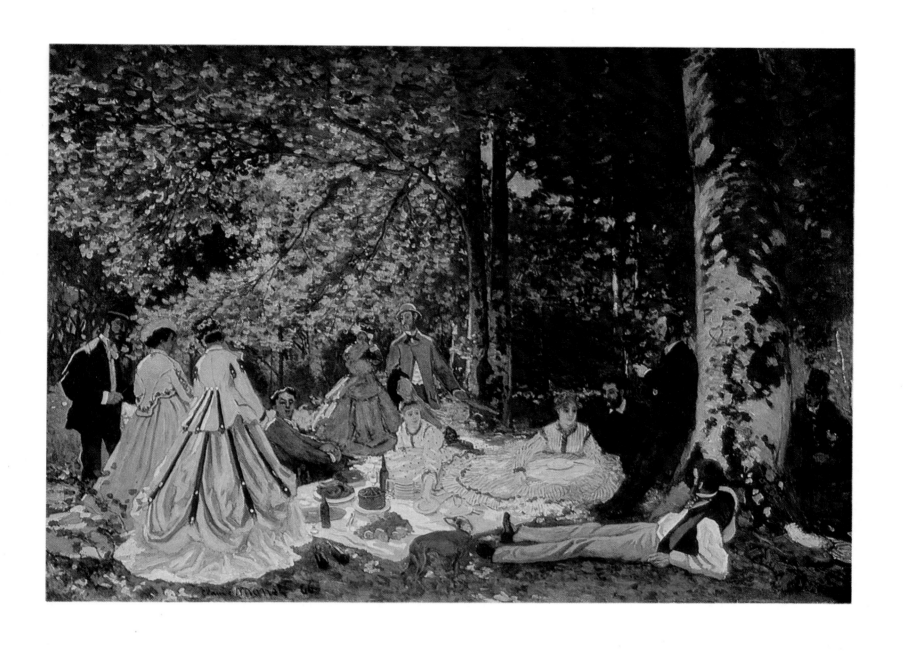

9, 10 LUNCHEON ON THE GRASS

Oil on canvas. 130×181 cm

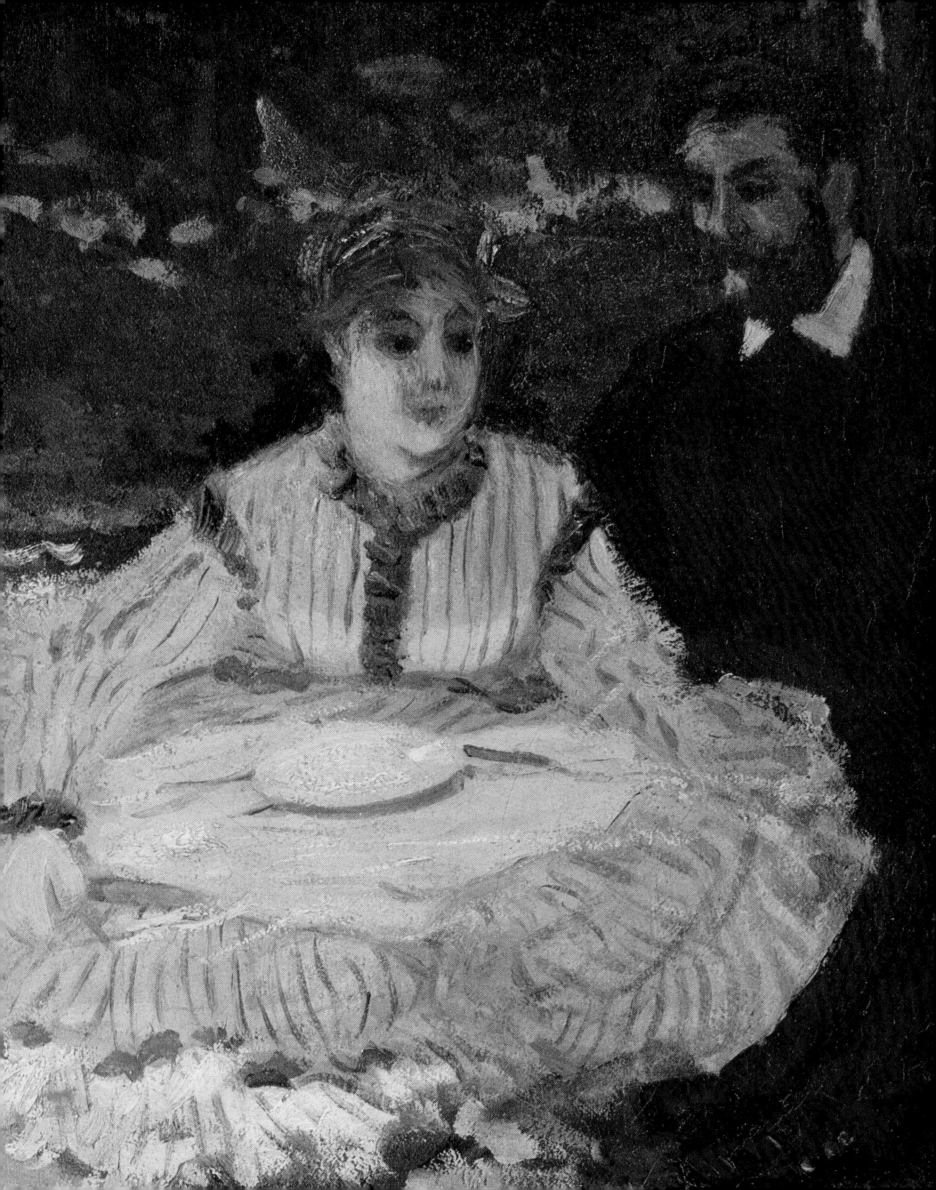

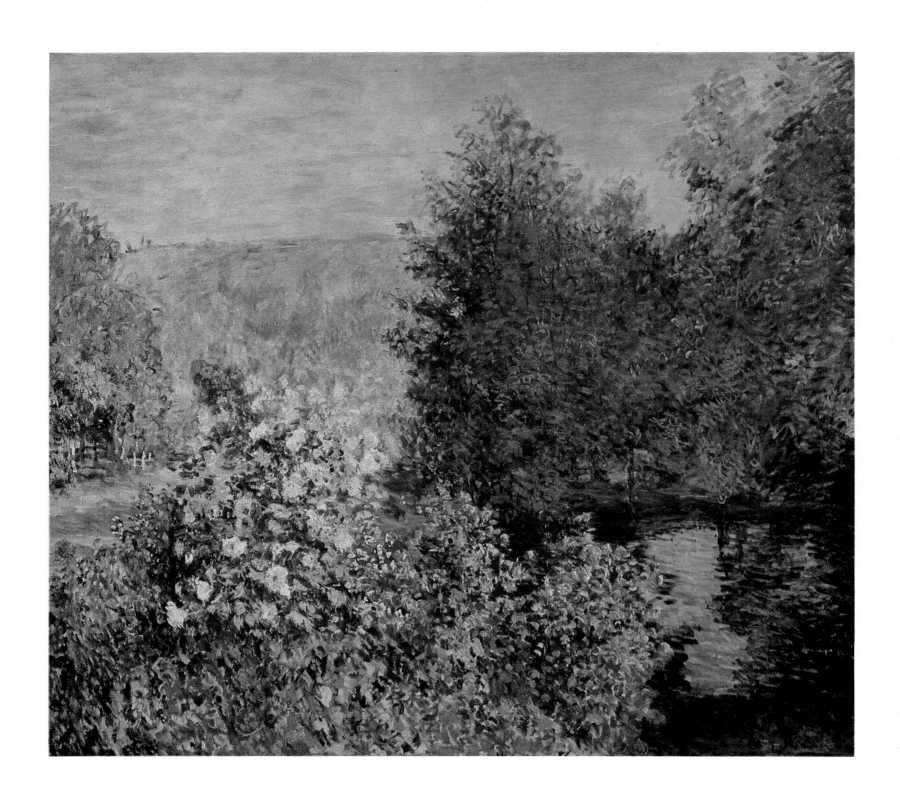

11 CORNER OF THE GARDEN AT MONTGERON

Oil on canvas. 173×193 cm

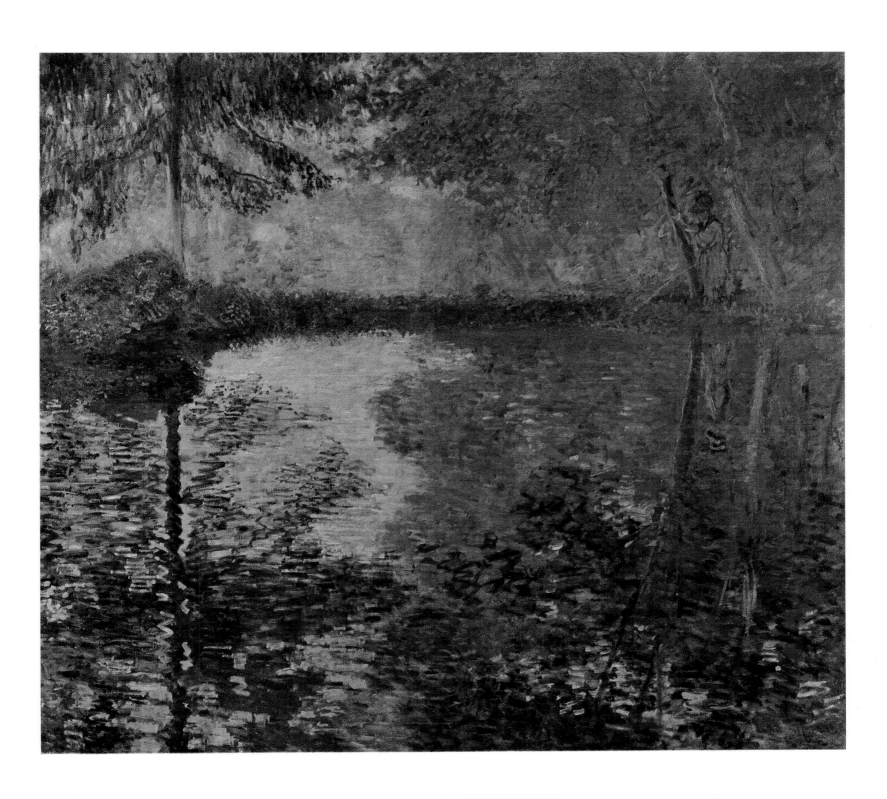

12 THE POND AT MONTGERON

Oil on canvas. 172×193 cm

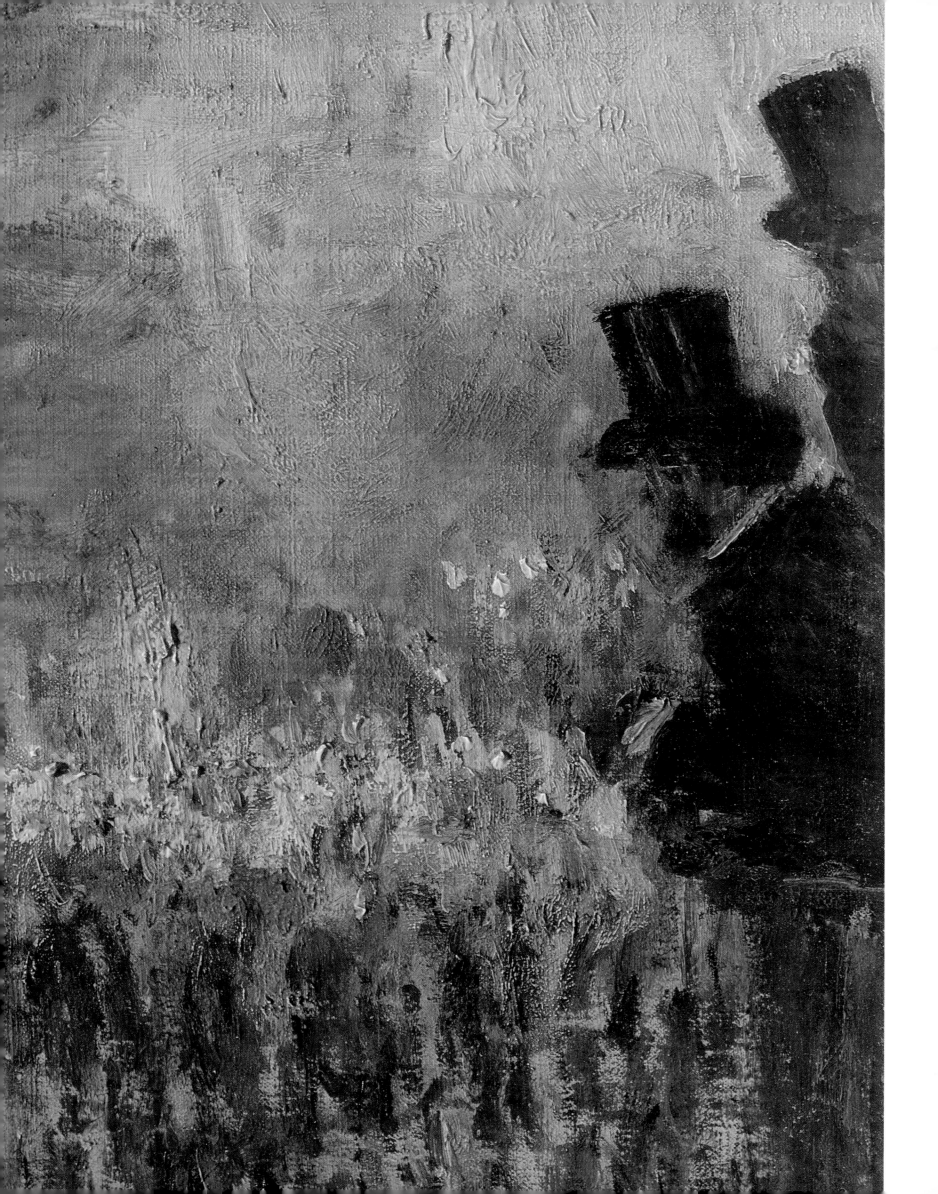

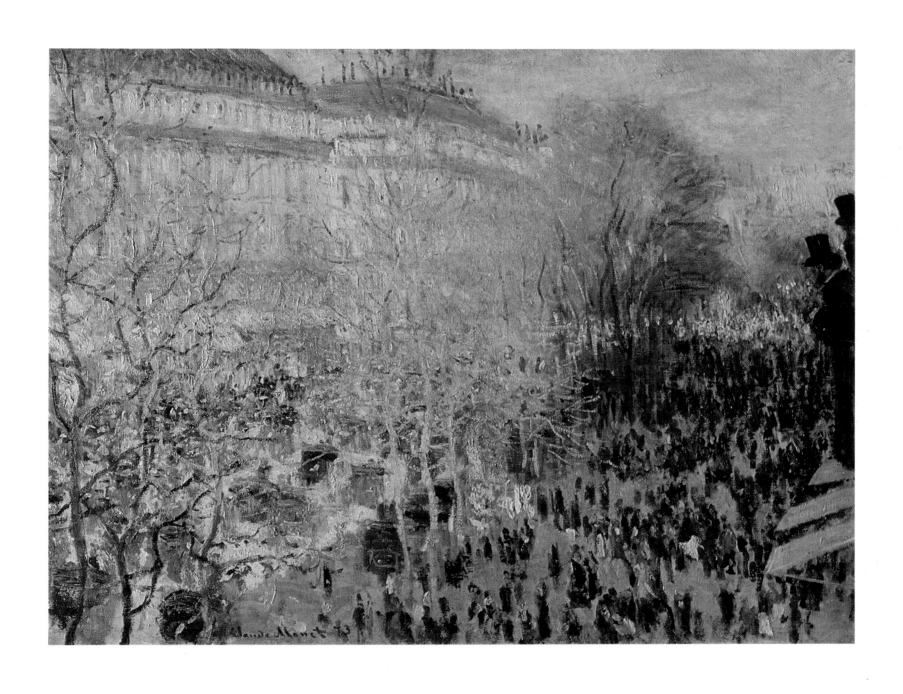

13, 14 LE BOULEVARD DES CAPUCINES

Oil on canvas. 61×80 cm

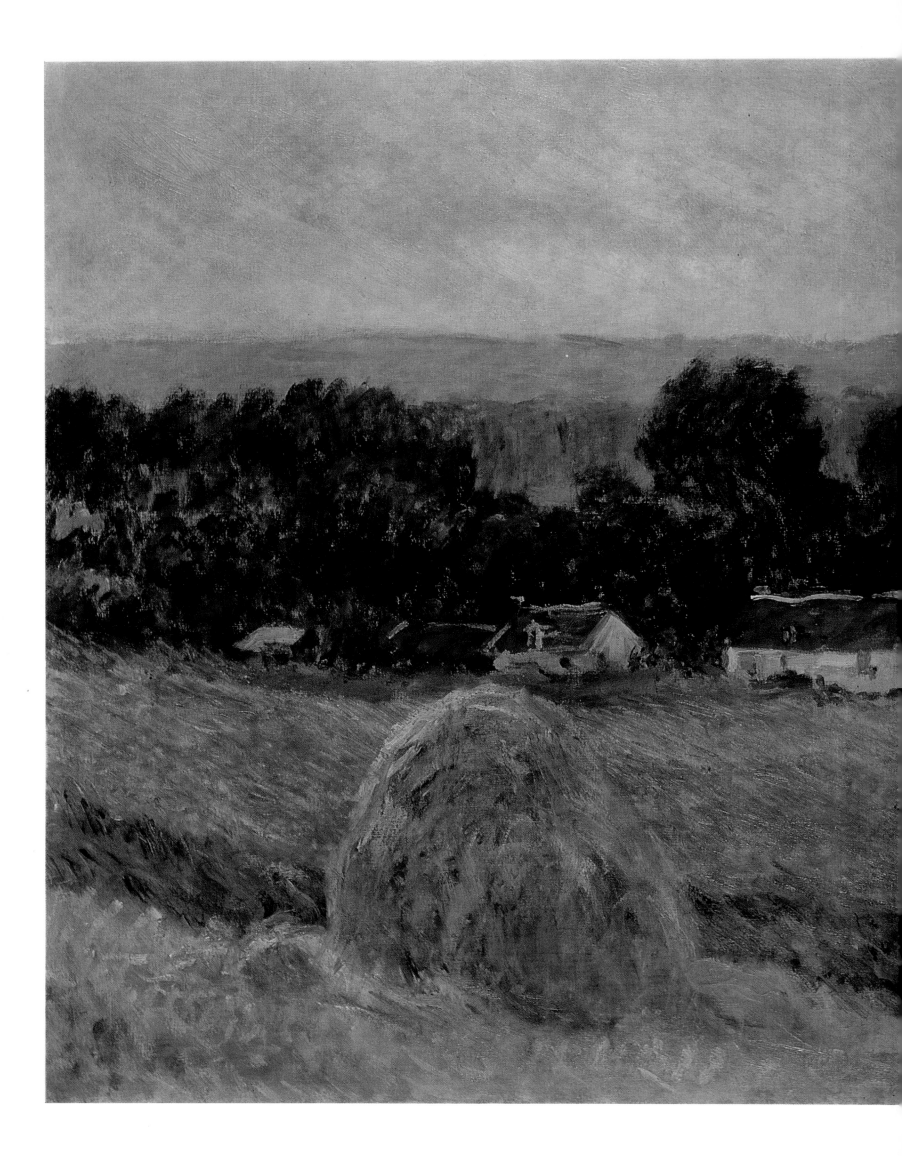

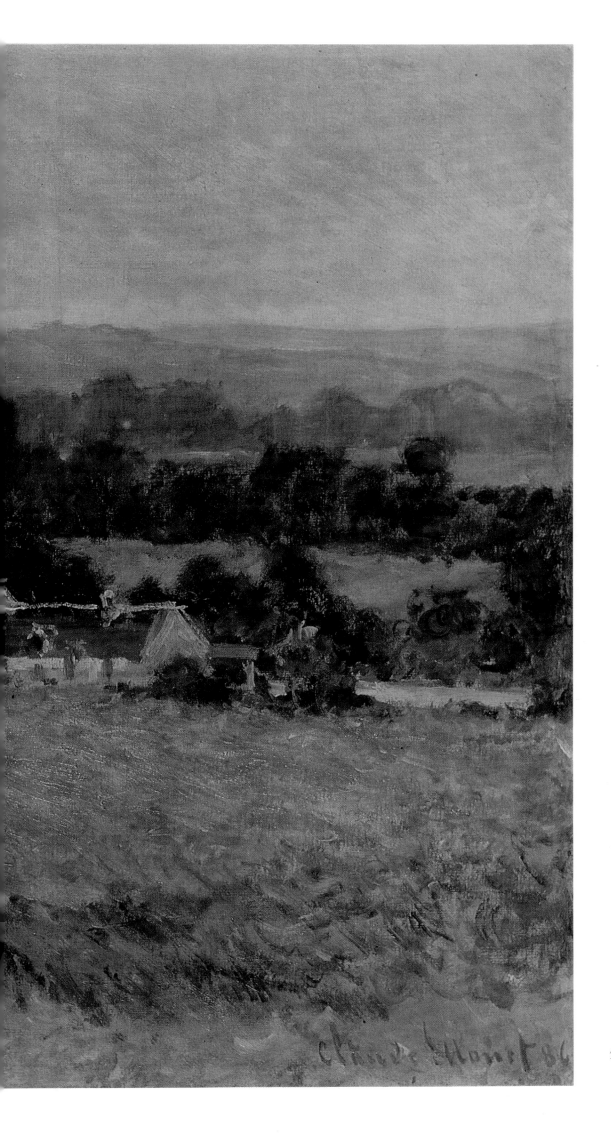

15 HAYSTACK AT GIVERNY

Oil on canvas. 61×81 cm

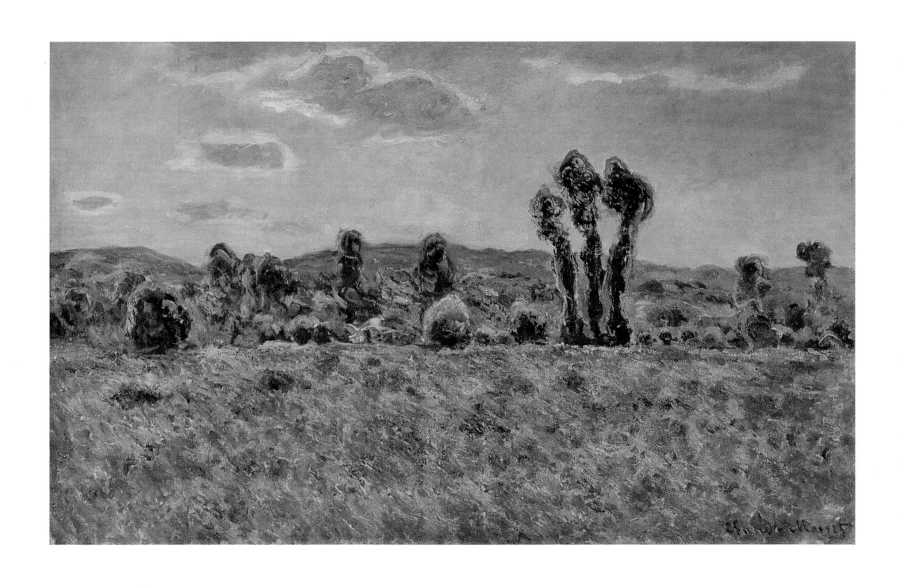

16 POPPY FIELD

Oil on canvas. 59×90 cm

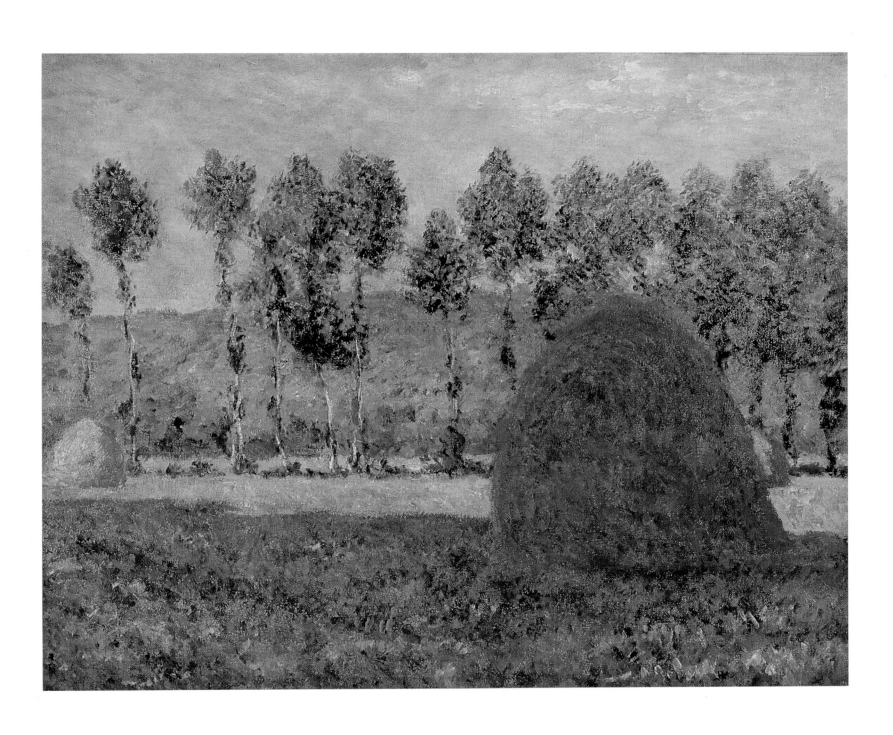

17 HAYSTACK AT GIVERNY

Oil on canvas. 64.5×81 cm

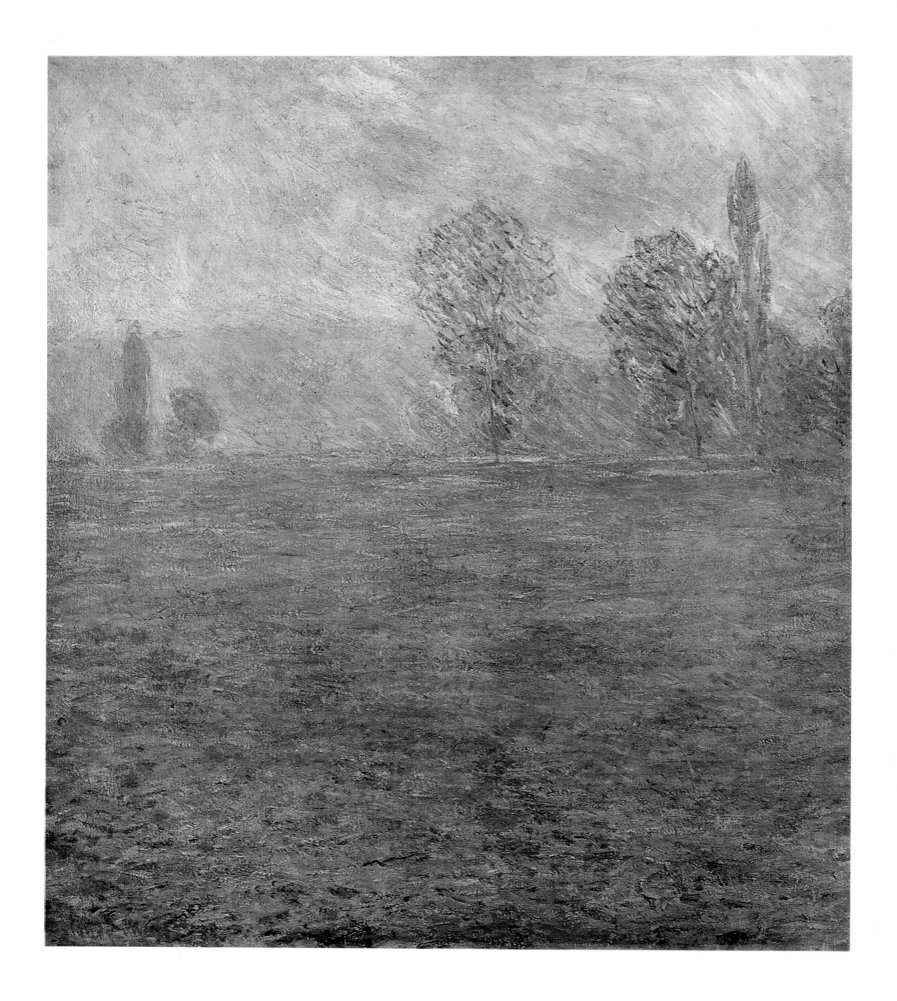

18 MEADOWS AT GIVERNY

Oil on canvas. 92×80 cm

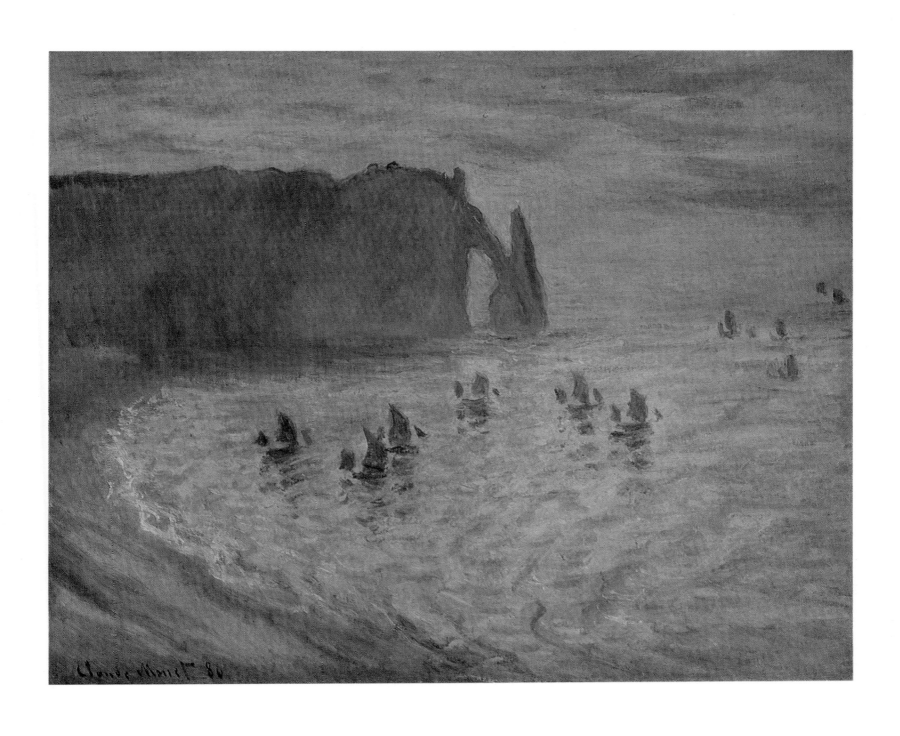

19 CLIFFS AT ÉTRETAT

Oil on canvas. 66×81 cm

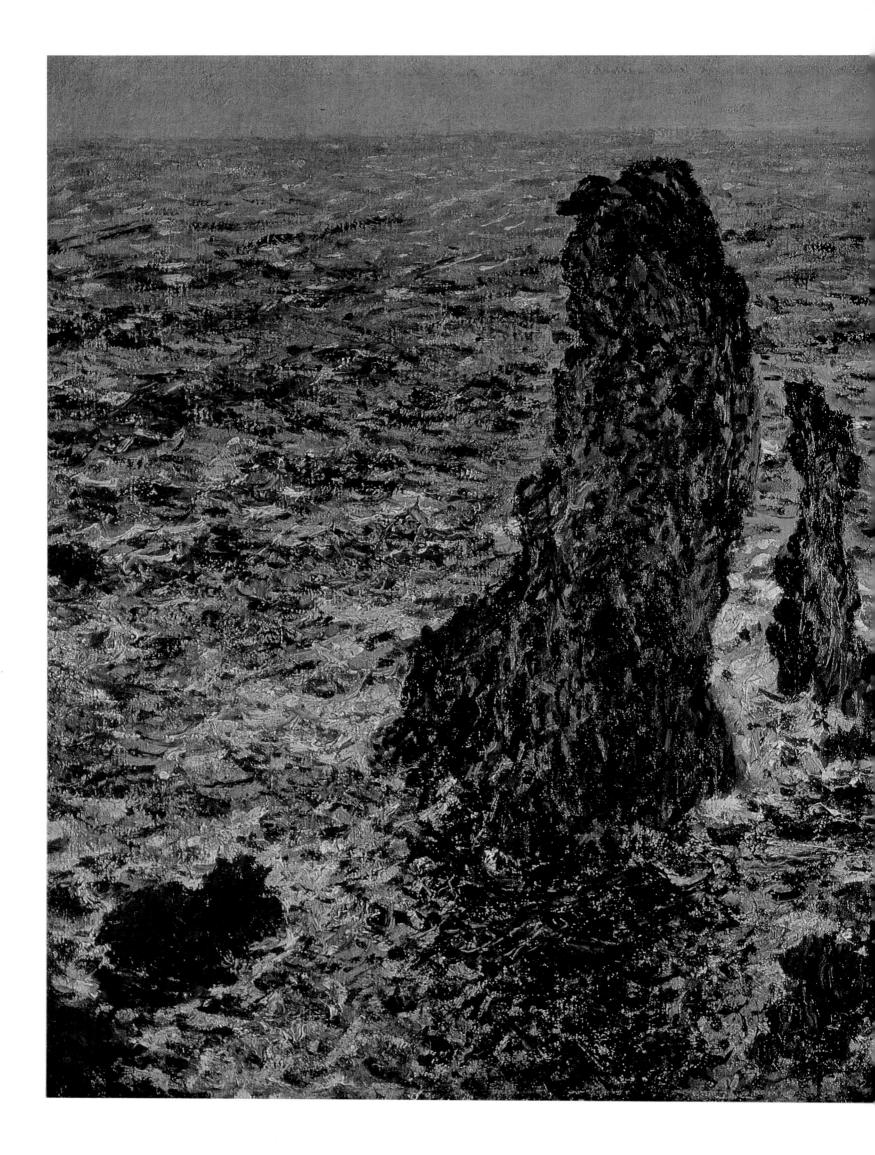

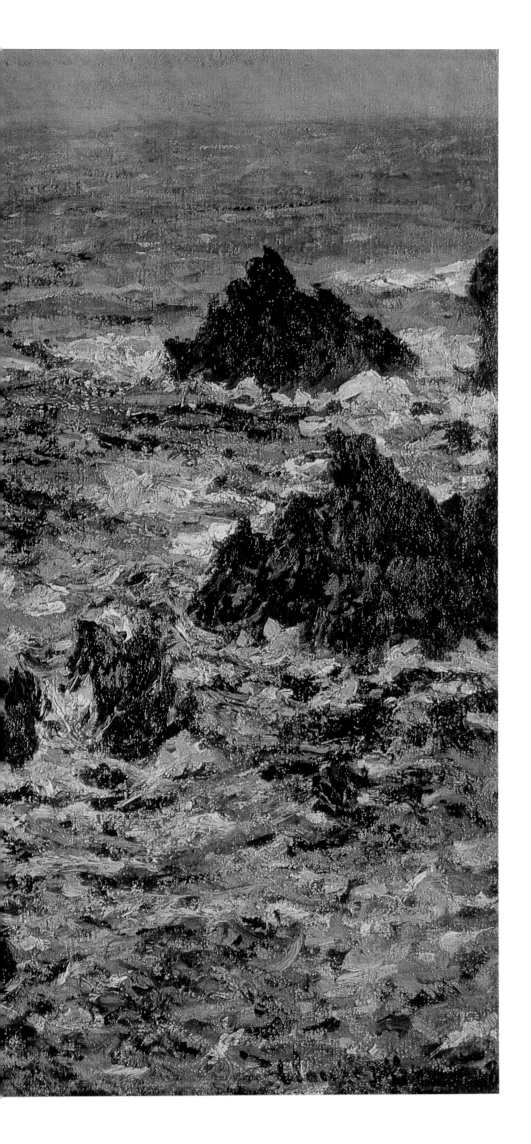

20 THE ROCKS OF BELLE-ÎLE

Oil on canvas. 65×81 cm

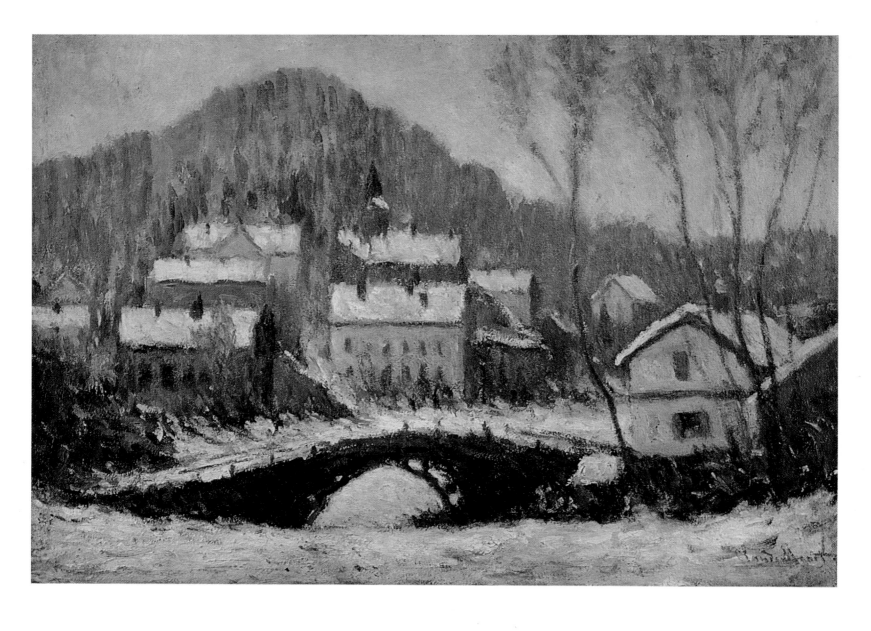

21 WINTER LANDSCAPE. SANDVIKEN

Oil on cardboard. 37×52.5 cm

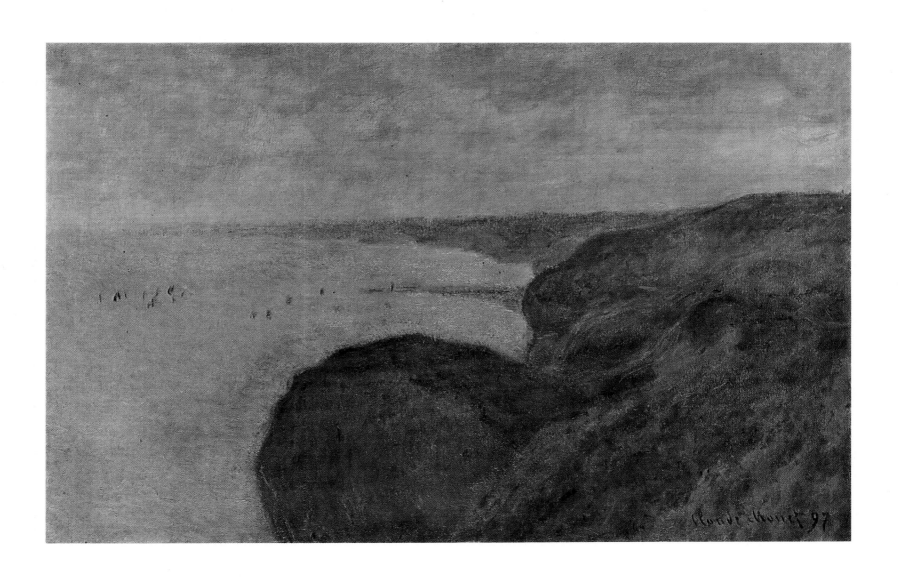

22 STEEP CLIFFS NEAR DIEPPE

Oil on canvas. 64.5×100 cm

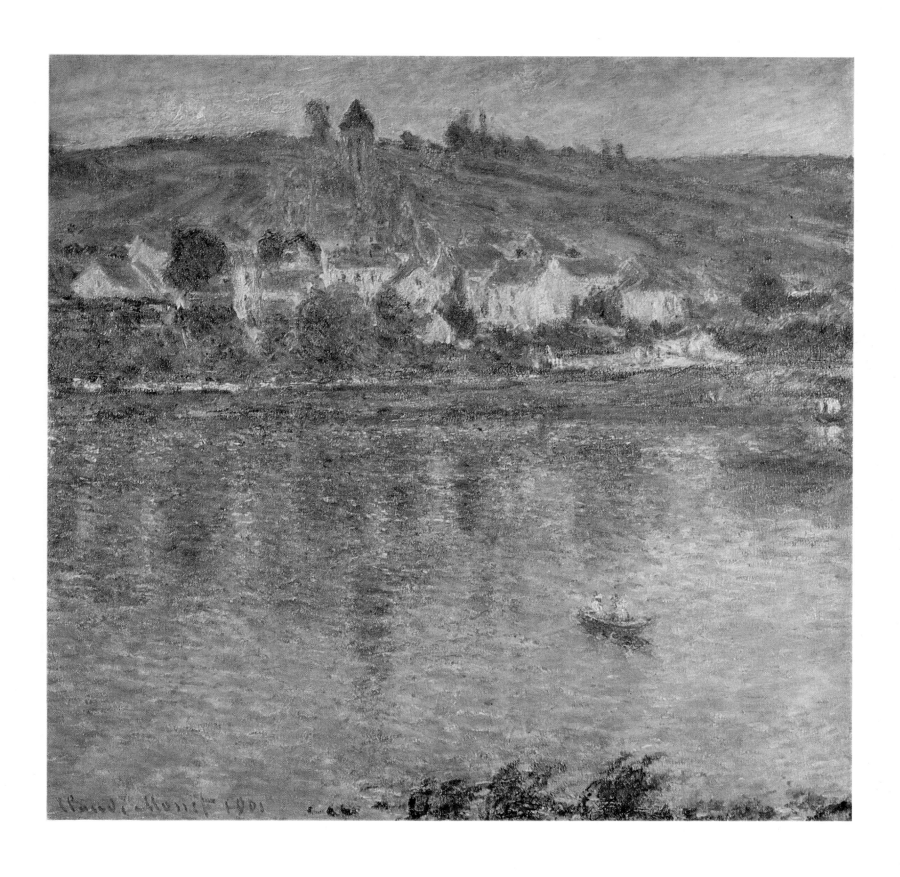

23, 24 VÉTHEUIL

Oil on canvas. 90×92 cm

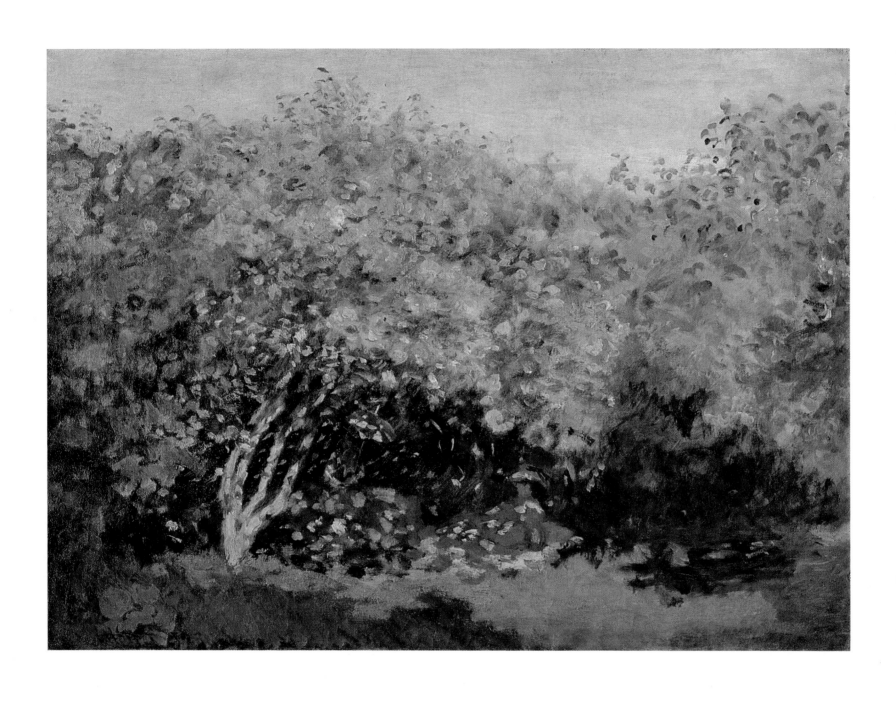

25 LILAC IN THE SUN

Oil on canvas. 50×65 cm

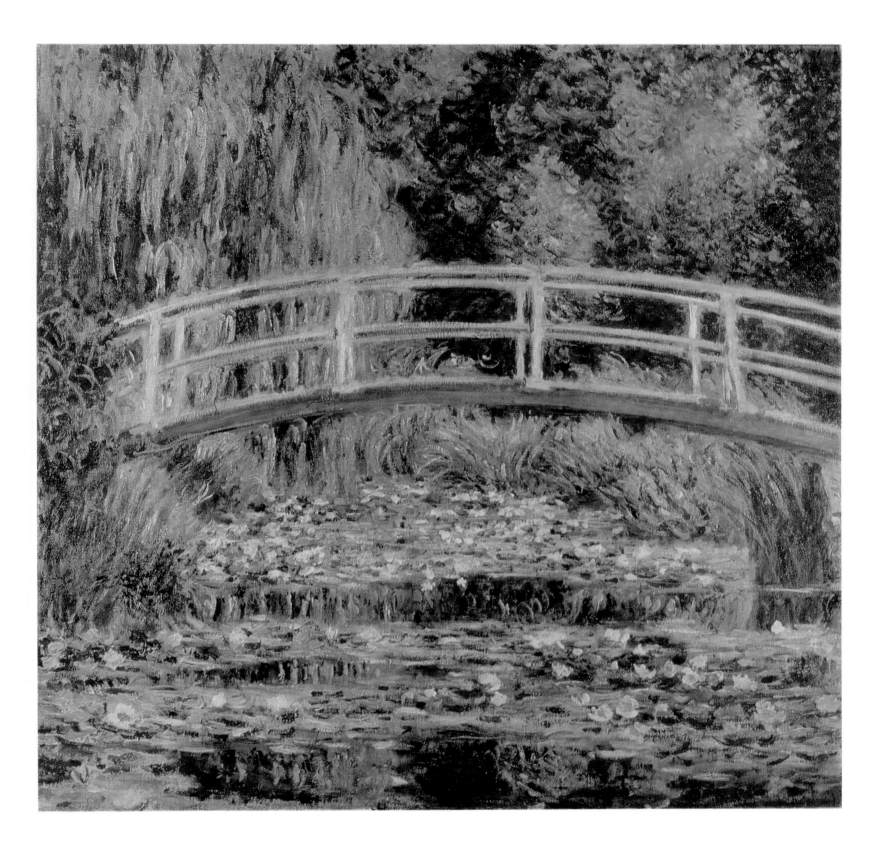

26 WHITE WATER-LILIES

Oil on canvas. 89×93 cm

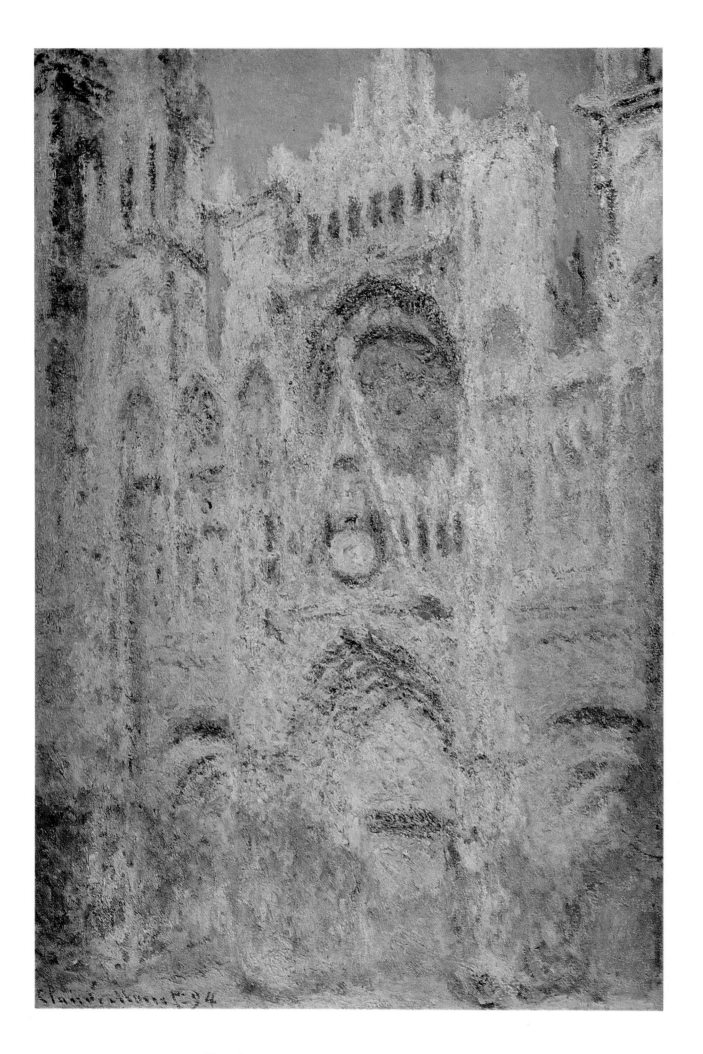

27 THE ROUEN CATHEDRAL AT SUNSET

Oil on canvas. 100×65 cm

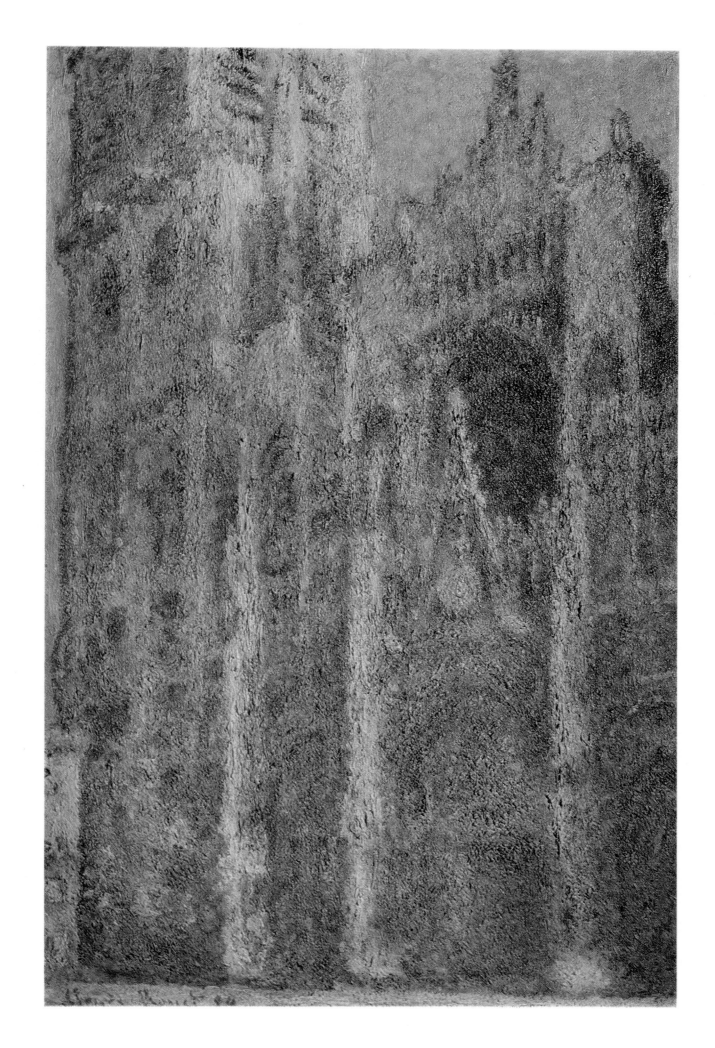

28 THE ROUEN CATHEDRAL AT NOON

Oil on canvas. 101×65 cm

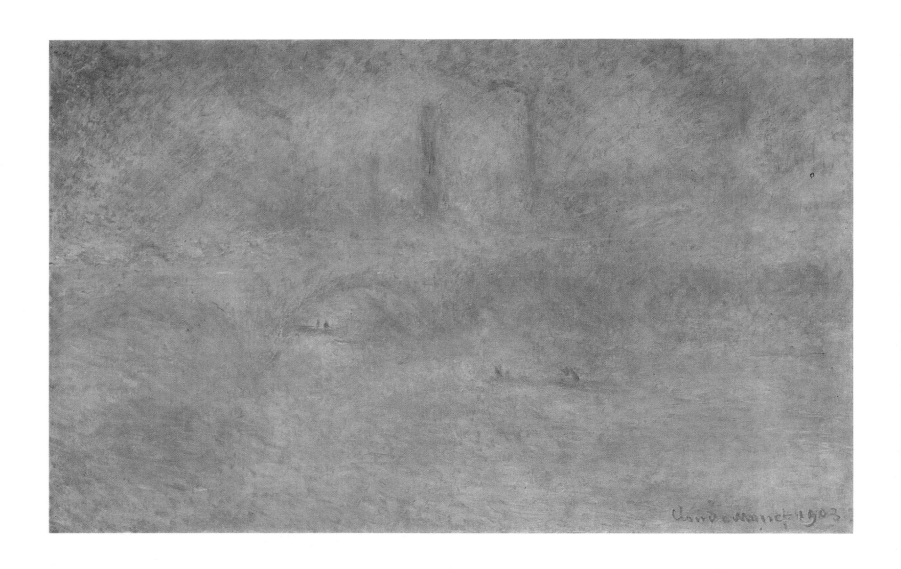

29 WATERLOO BRIDGE. EFFECT OF MIST

Oil on canvas. 65×100 cm

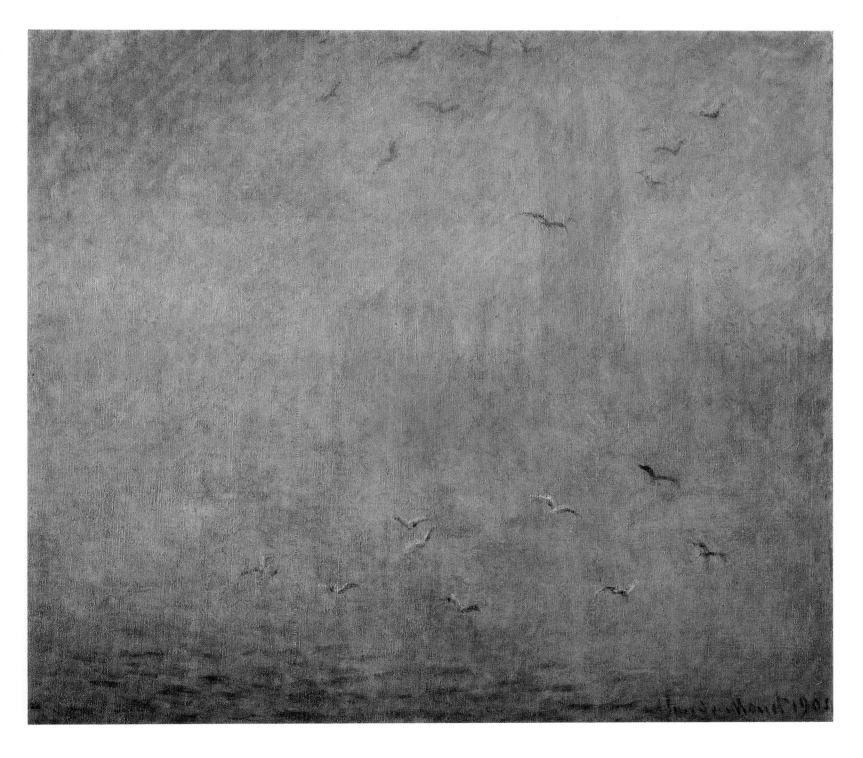

**30 SEAGULLS. THE RIVER THAMES IN LONDON.
THE HOUSES OF PARLIAMENT**

Oil on canvas. 82×92 cm

C. Pissarre

CAMILLE PISSARRO. 1830—1903

31 PLOUGHLAND

Oil on canvas. 49×64 cm

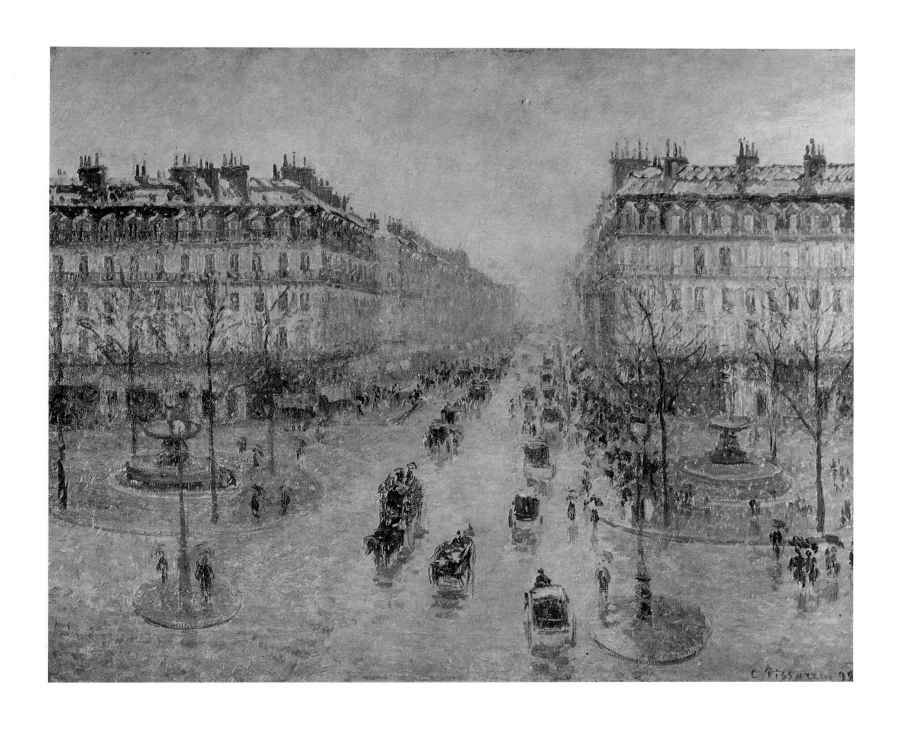

32, 33 AVENUE DE L'OPÉRA IN PARIS

Oil on canvas. 65×82 cm

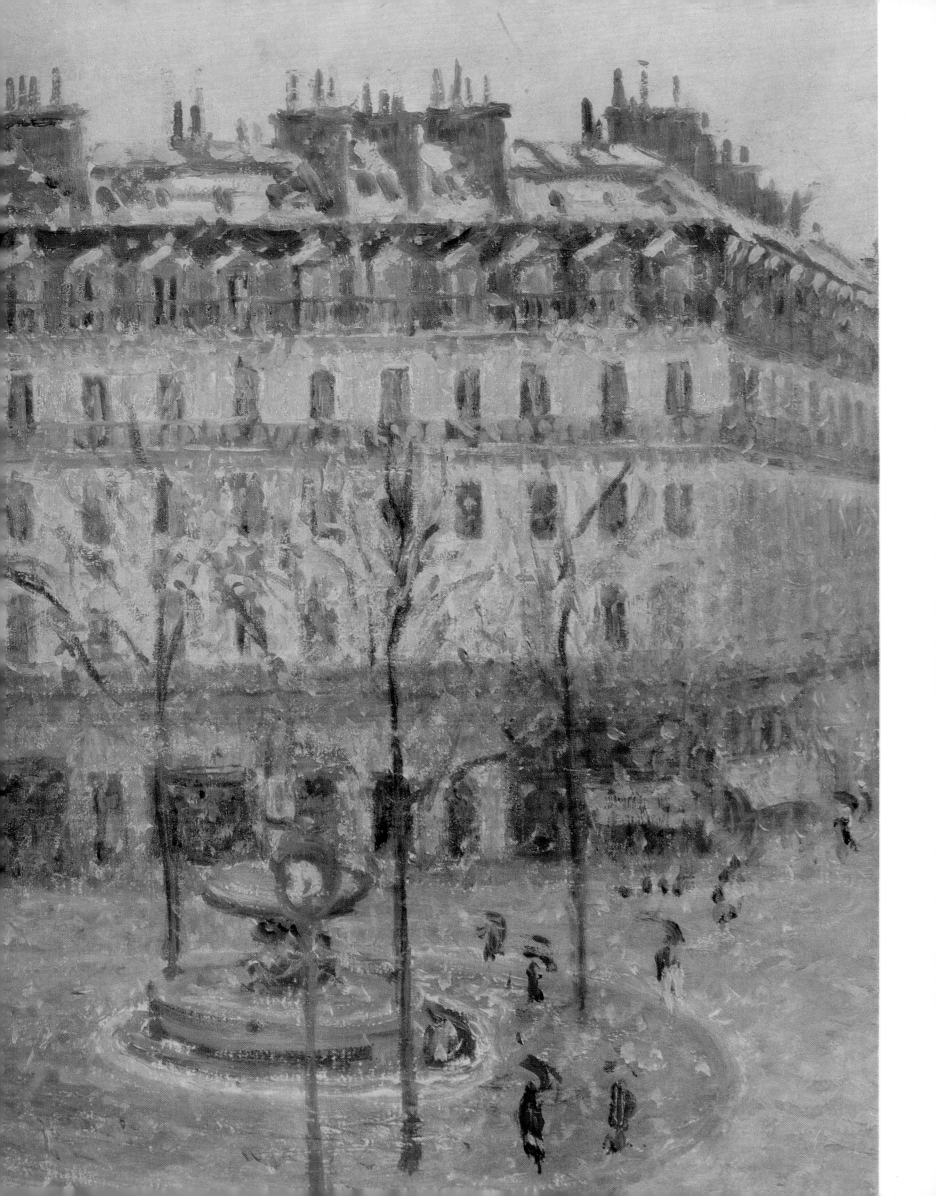

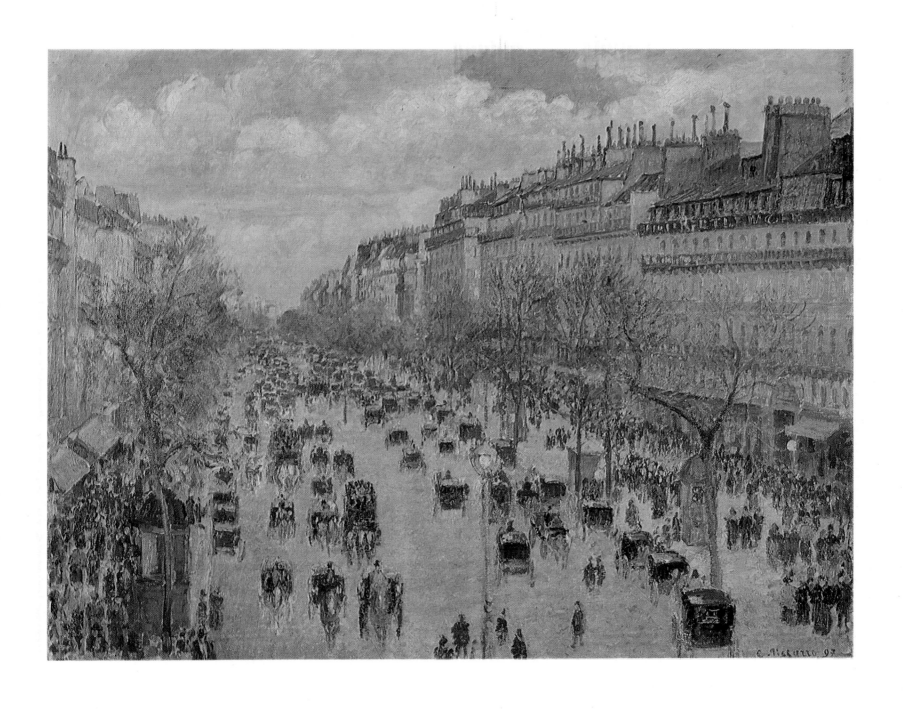

34, 35 BOULEVARD MONTMARTRE. AFTERNOON SUN

Oil on canvas. 73×92 cm

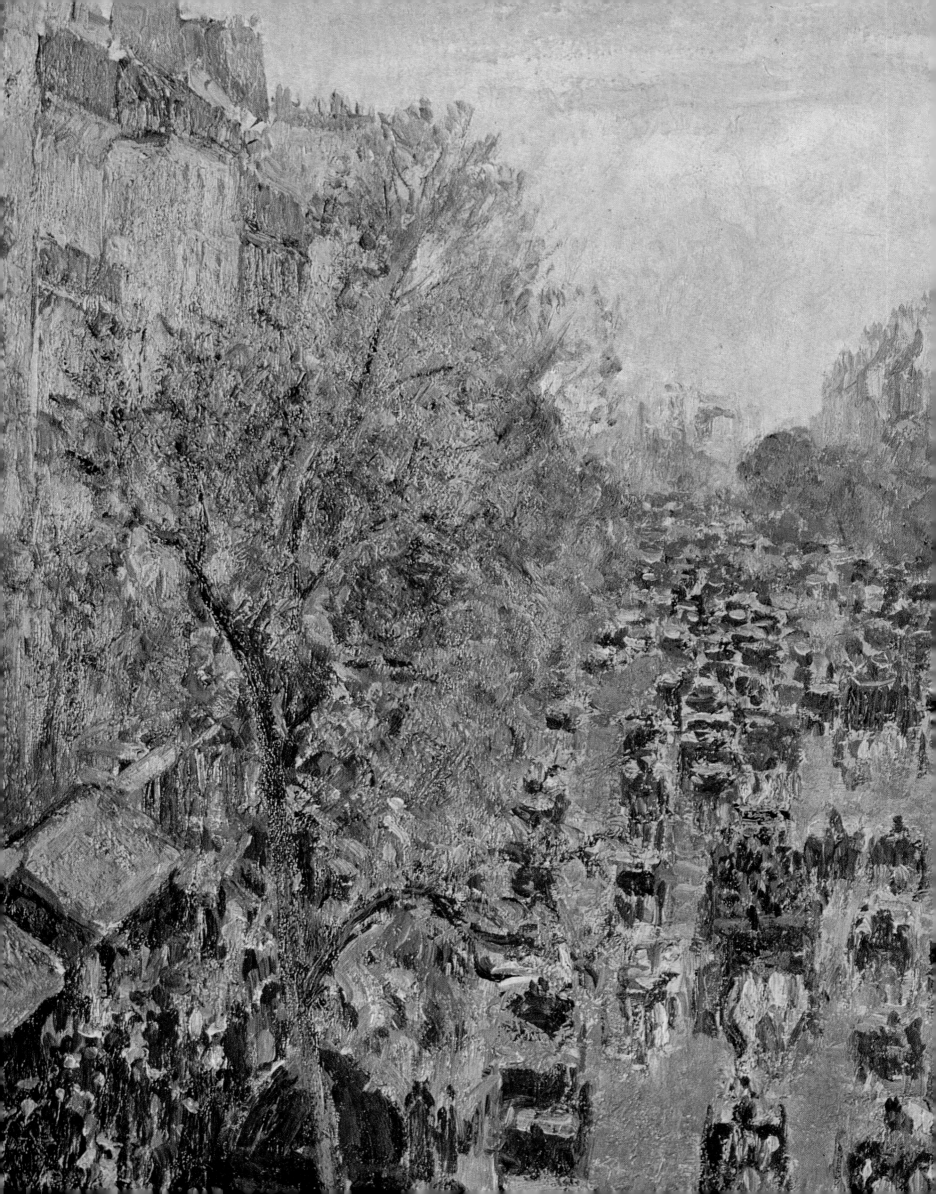

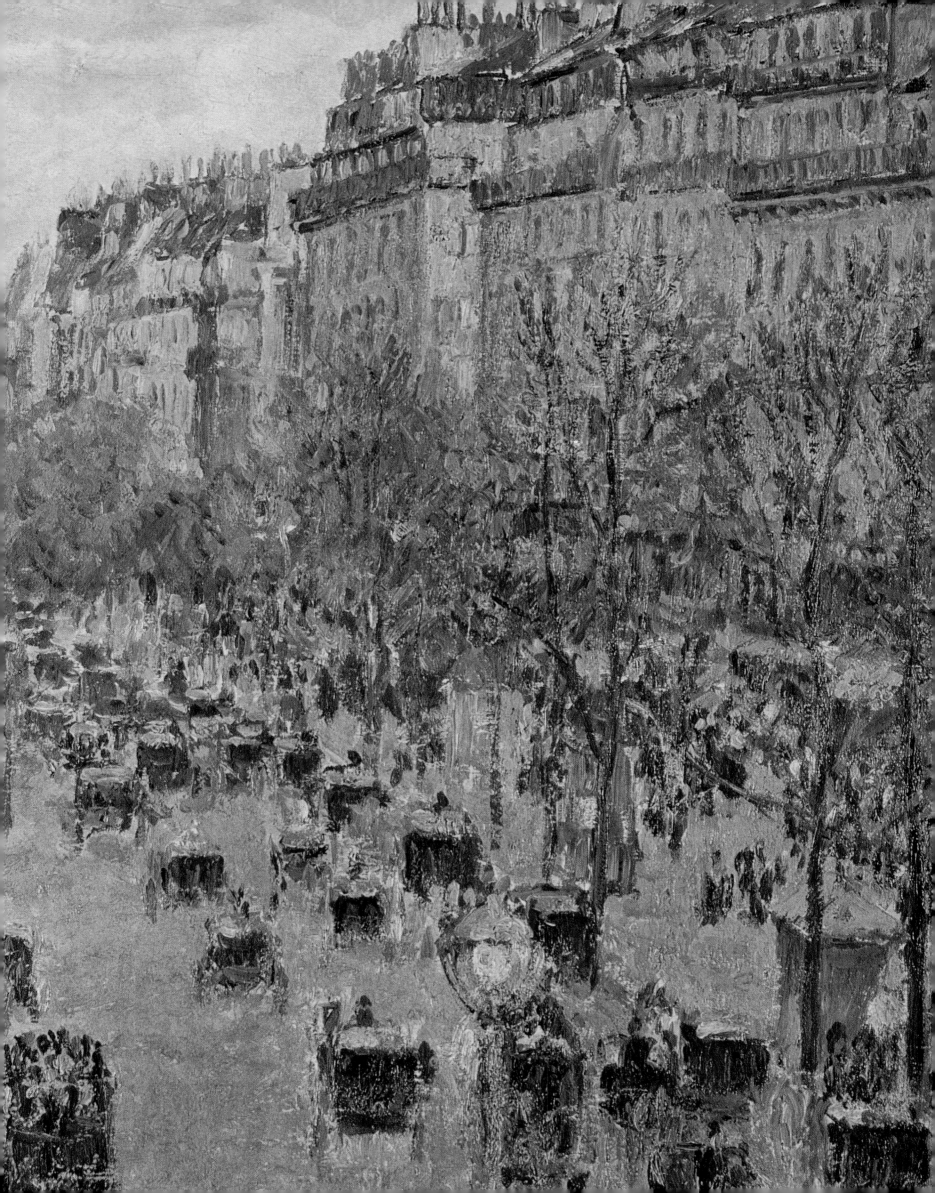

36 PLACE DU THÉÂTRE-FRANÇAIS. SPRING

Oil on canvas. 65.5×81.5 cm

37 AUTUMN MORNING AT ÉRAGNY

Oil on canvas. 54×65 cm

ALFRED SISLEY. 1839—1899

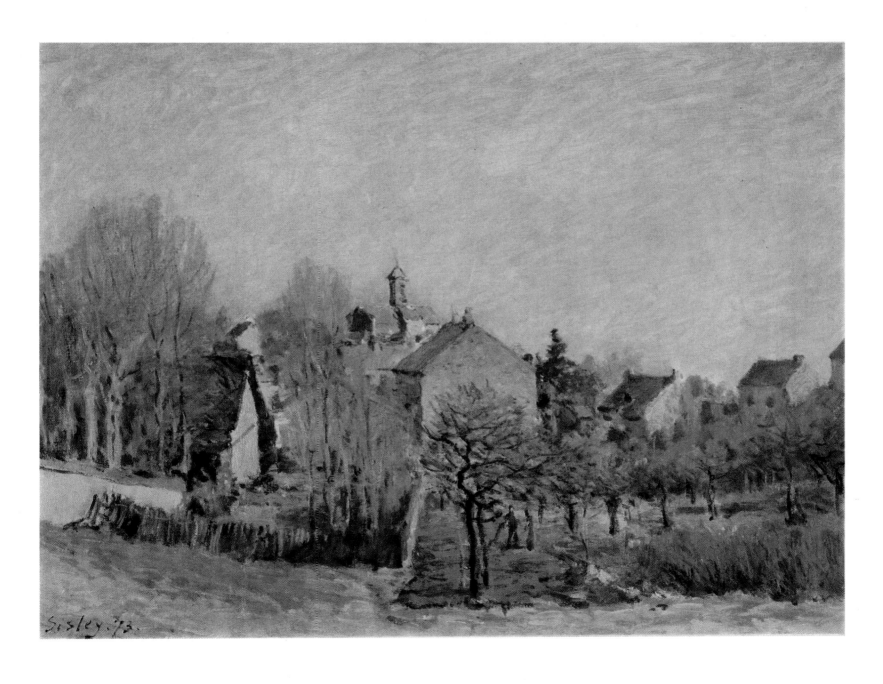

38 FROSTY MORNING IN LOUVECIENNES

Oil on canvas. 46×61 cm

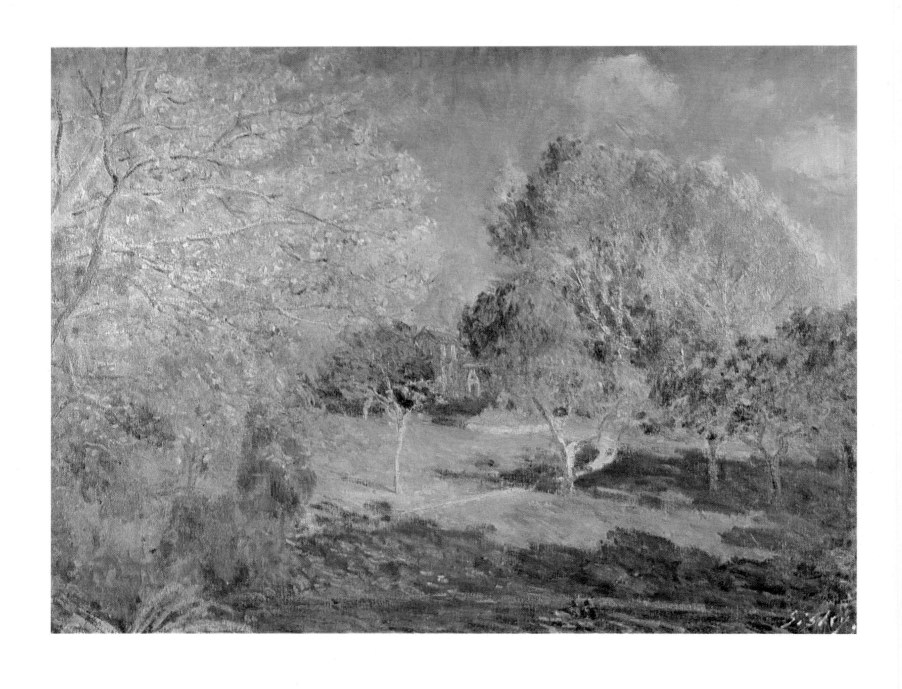

39 THE GARDEN OF HOSCHEDÉ

Oil on canvas. 56×74 cm

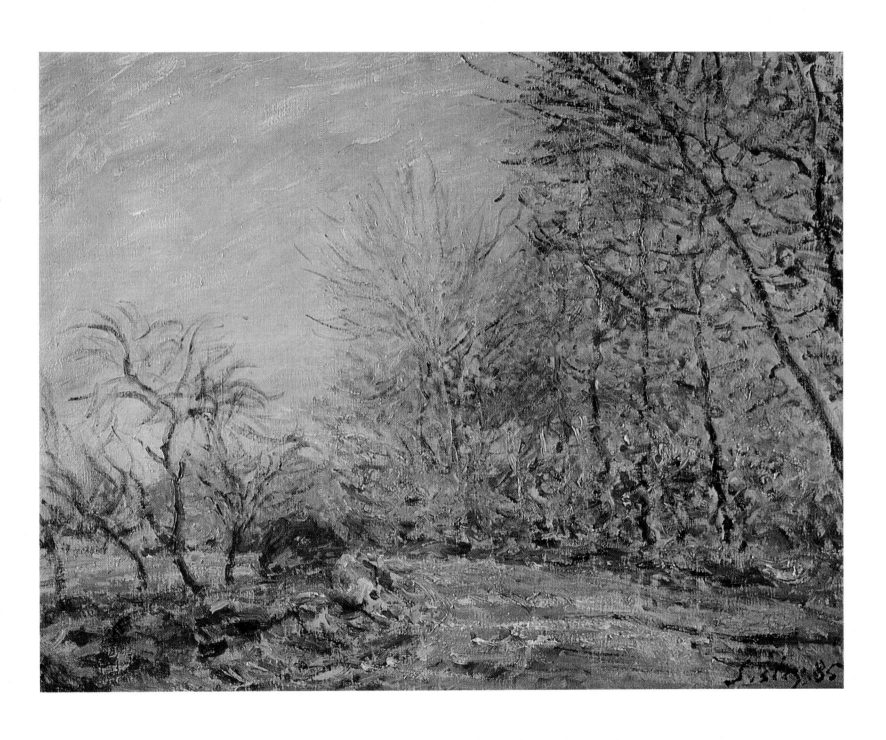

40 THE SKIRTS OF THE FONTAINEBLEAU FOREST

Oil on canvas. 60×73 cm

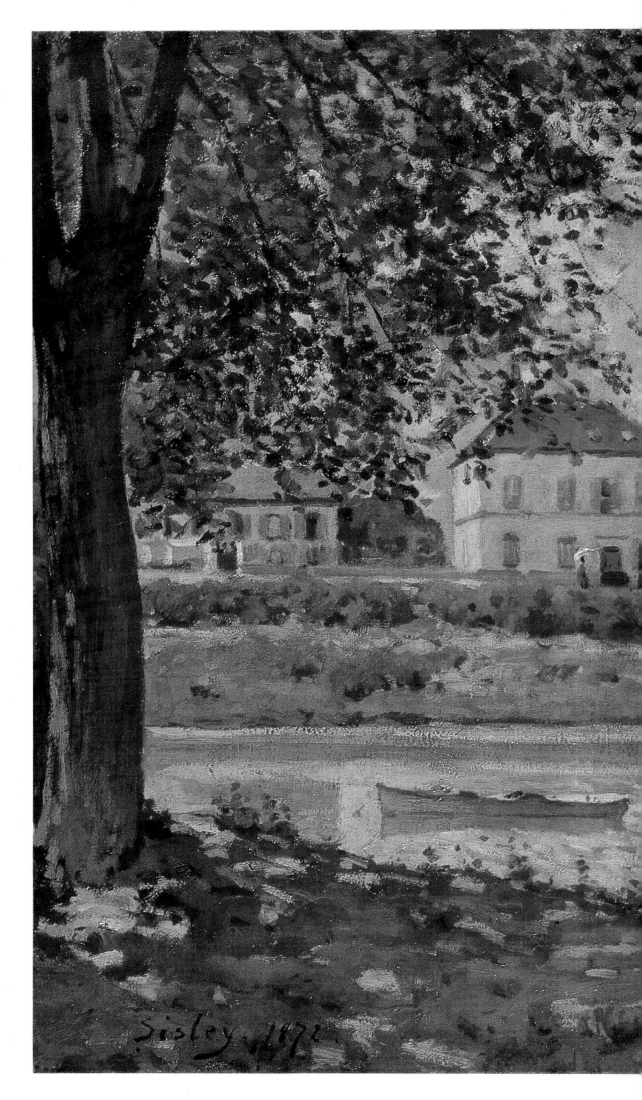

**41 VILLAGE ON THE SEINE.
VILLENEUVE-LA-GARENNE**

Oil on canvas. 59×80.5 cm

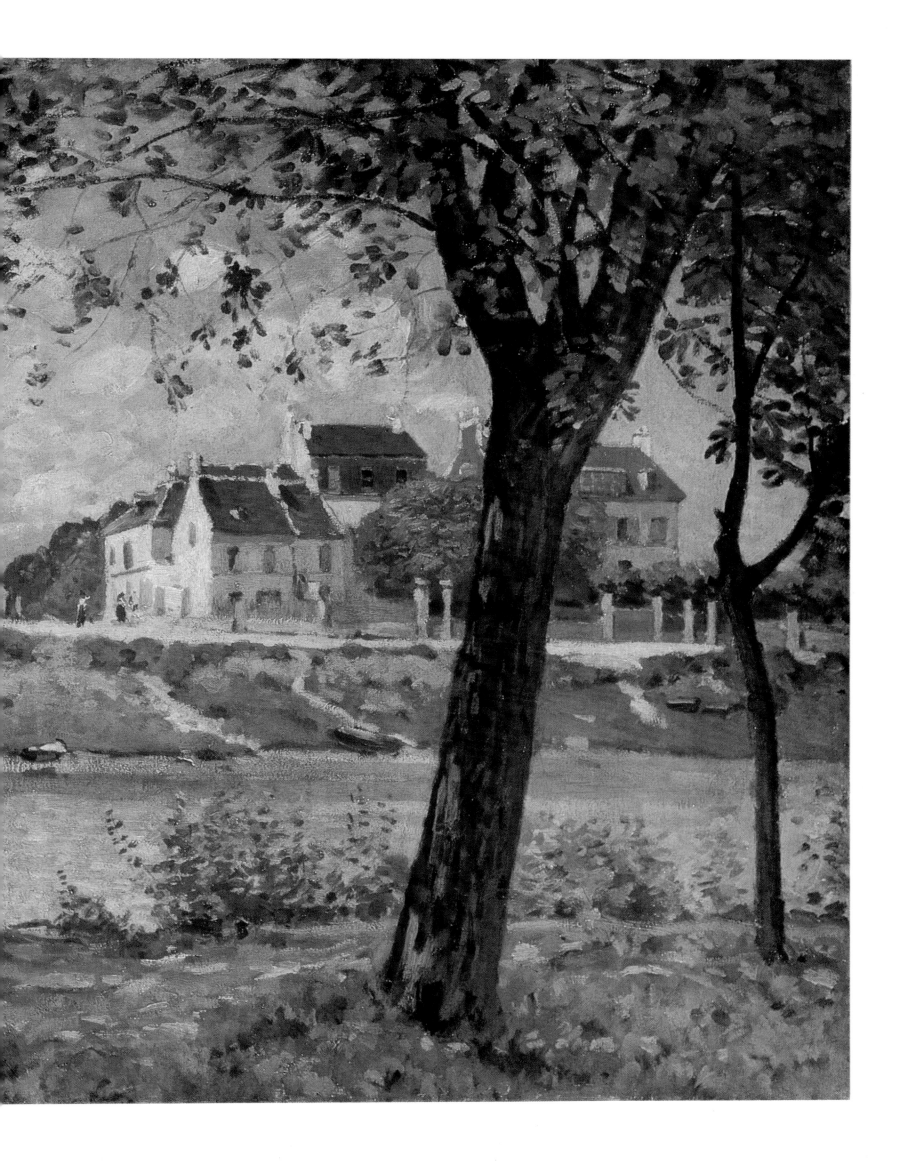

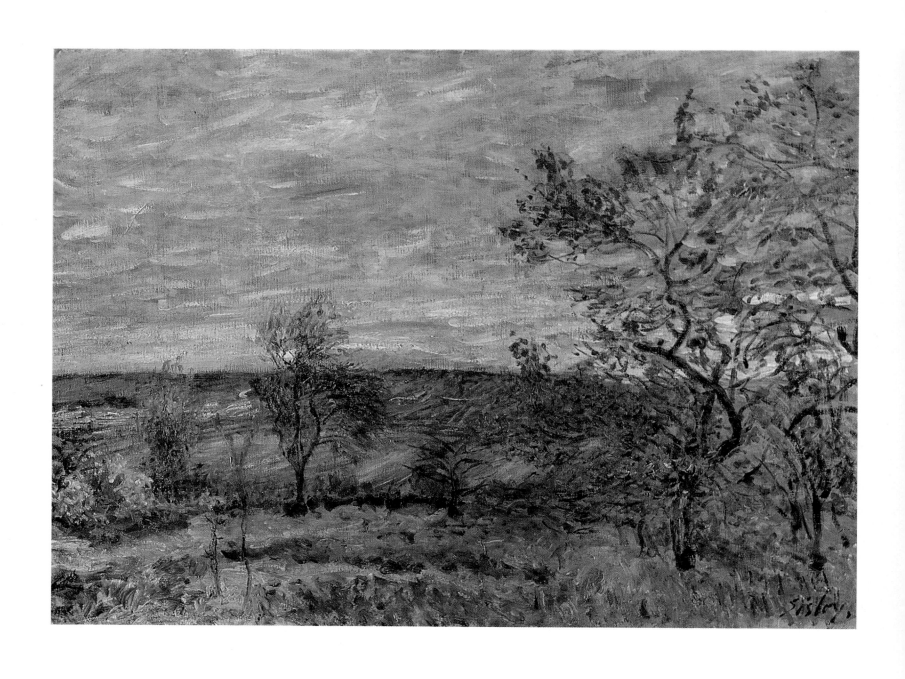

42 WINDY DAY AT VENEUX

Oil on canvas. 60×81 cm

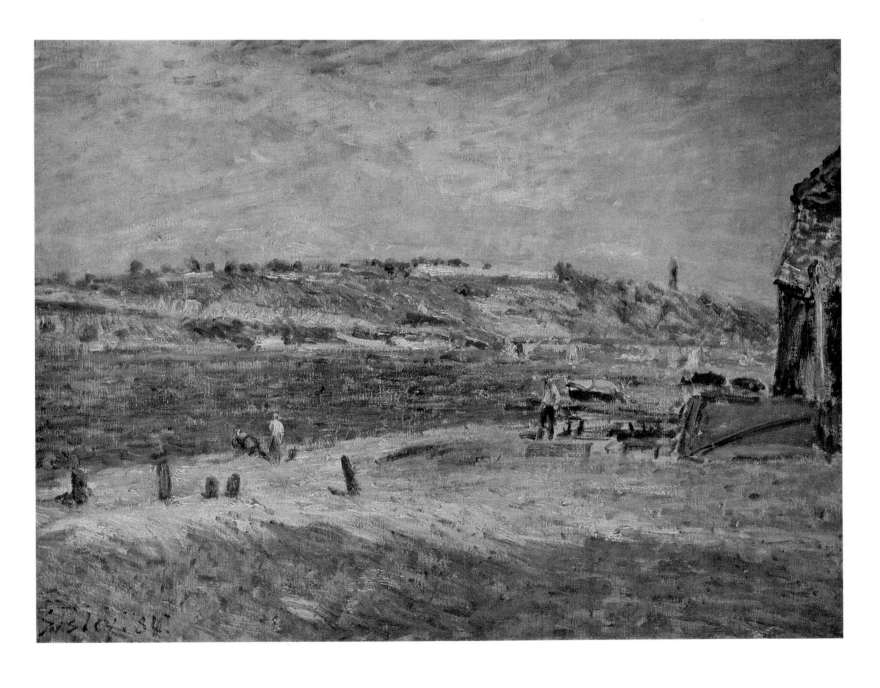

43 RIVER BANKS AT SAINT-MAMMÈS

Oil on canvas. 50×65 cm

PIERRE AUGUSTE RENOIR. 1841—1919

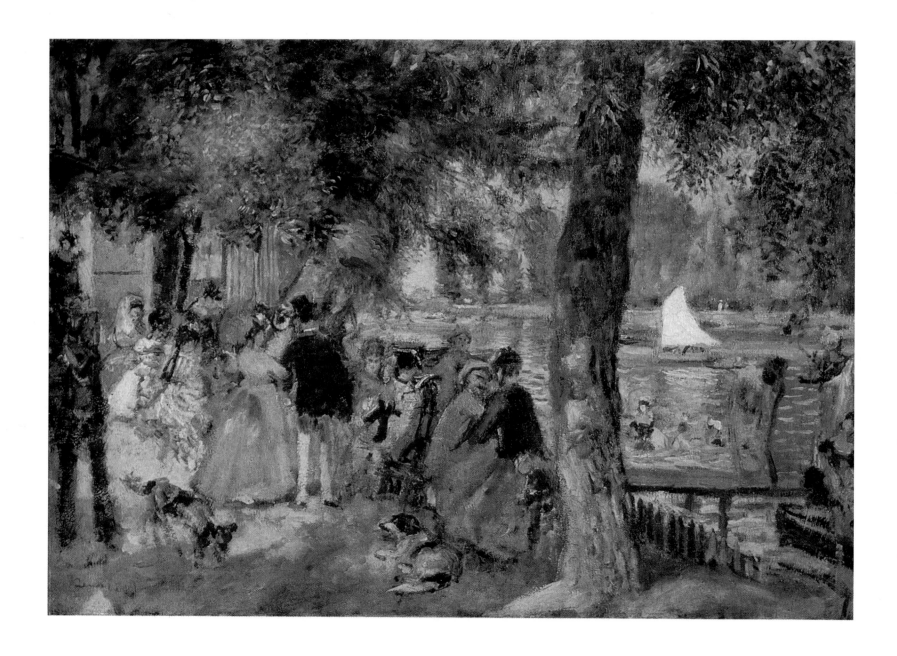

44, 45 BATHING ON THE SEINE. LA GRENOUILLÈRE

Oil on canvas. 59×80 cm

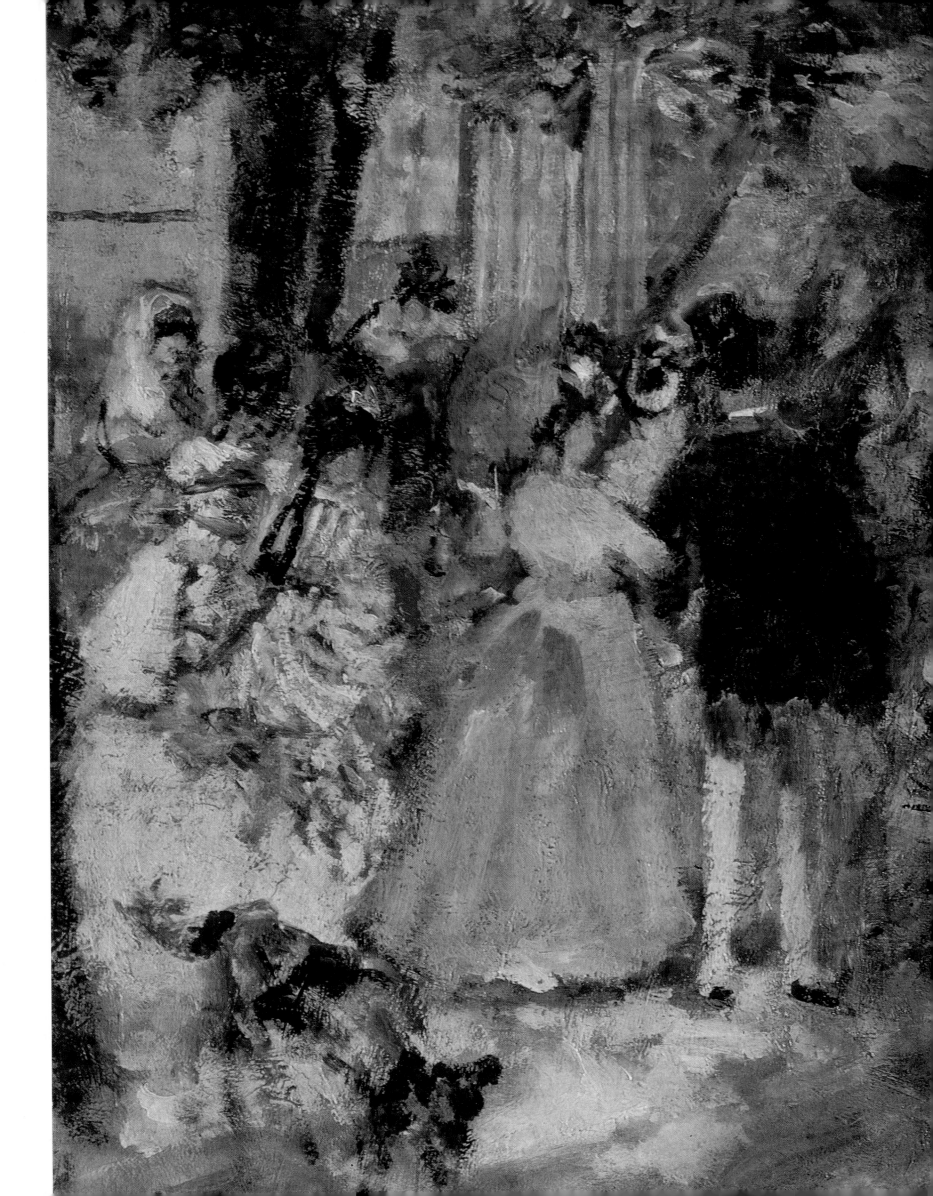

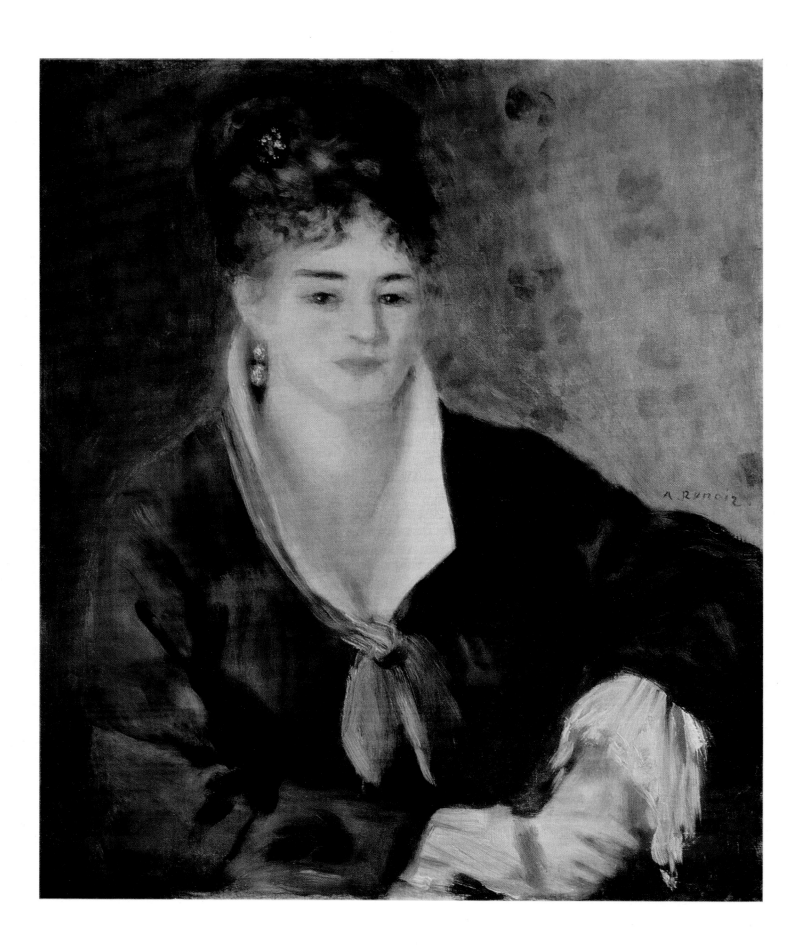

46 LADY IN BLACK

Oil on canvas. 63×53 cm

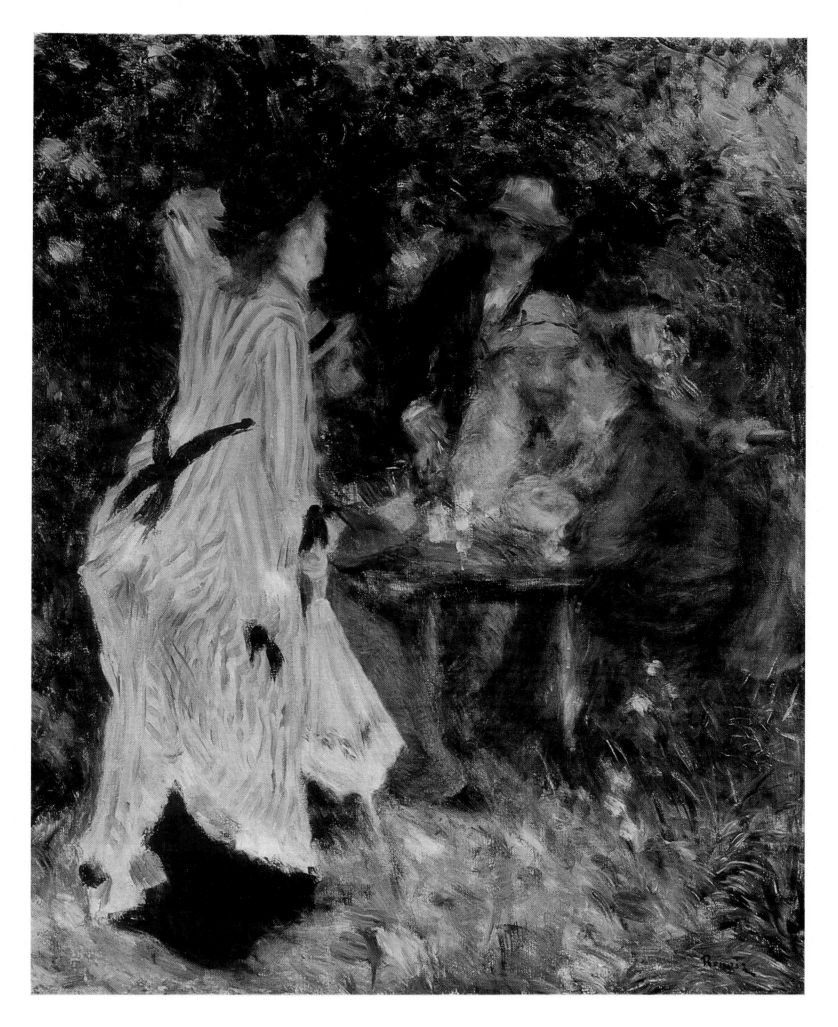

**47, 48 IN THE GARDEN. UNDER THE TREES OF THE MOULIN
DE LA GALETTE**

Oil on canvas. 81×65 cm

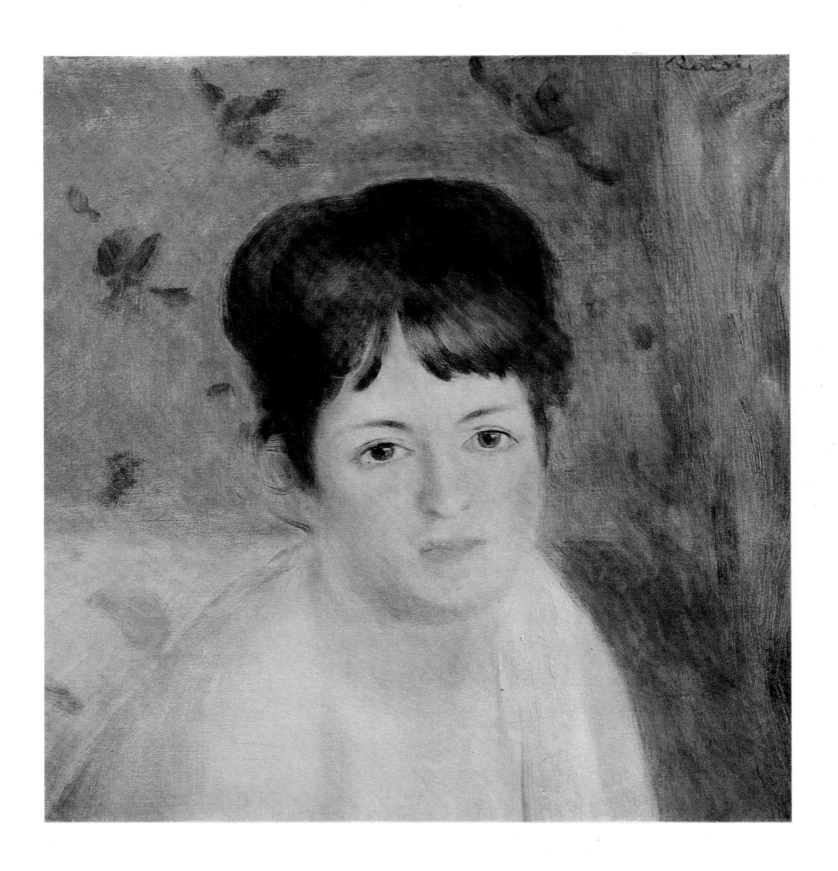

49 HEAD OF A WOMAN. Study

Oil on canvas. 38.5×36 cm

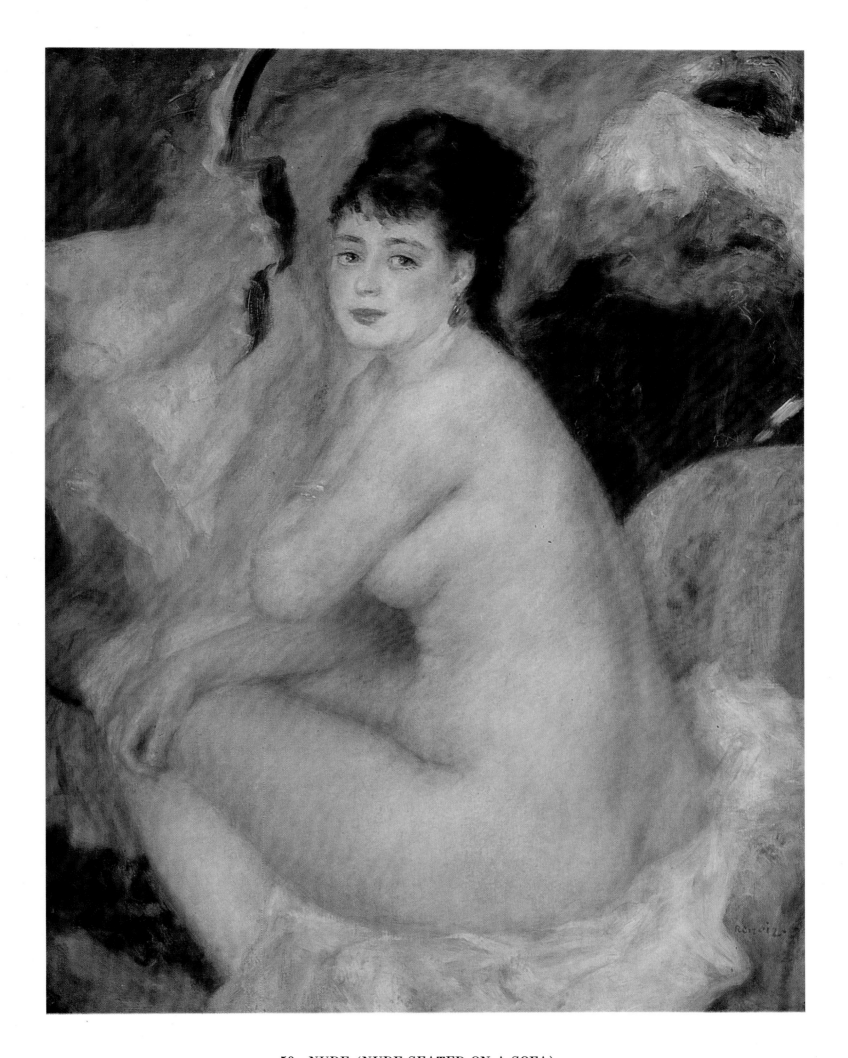

50 NUDE (NUDE SEATED ON A SOFA)

Oil on canvas. 92×73 cm

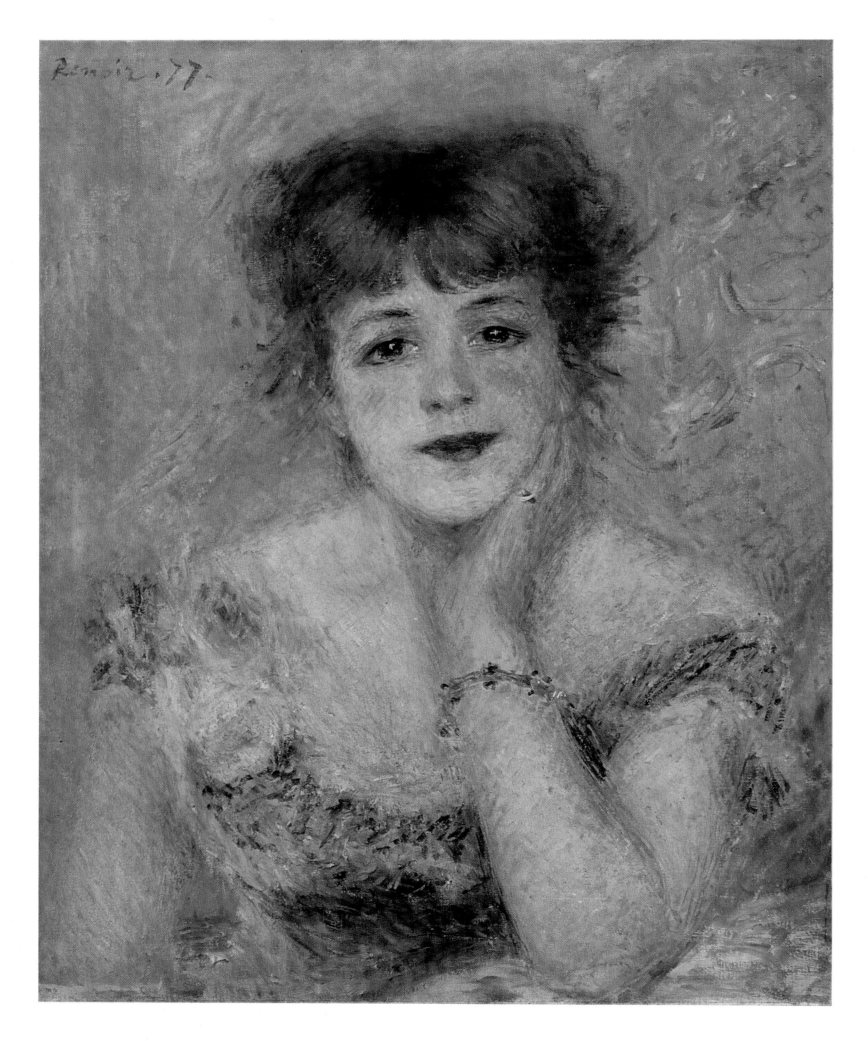

51 PORTRAIT OF THE ACTRESS JEANNE SAMARY. Study

Oil on canvas. 56×47 cm

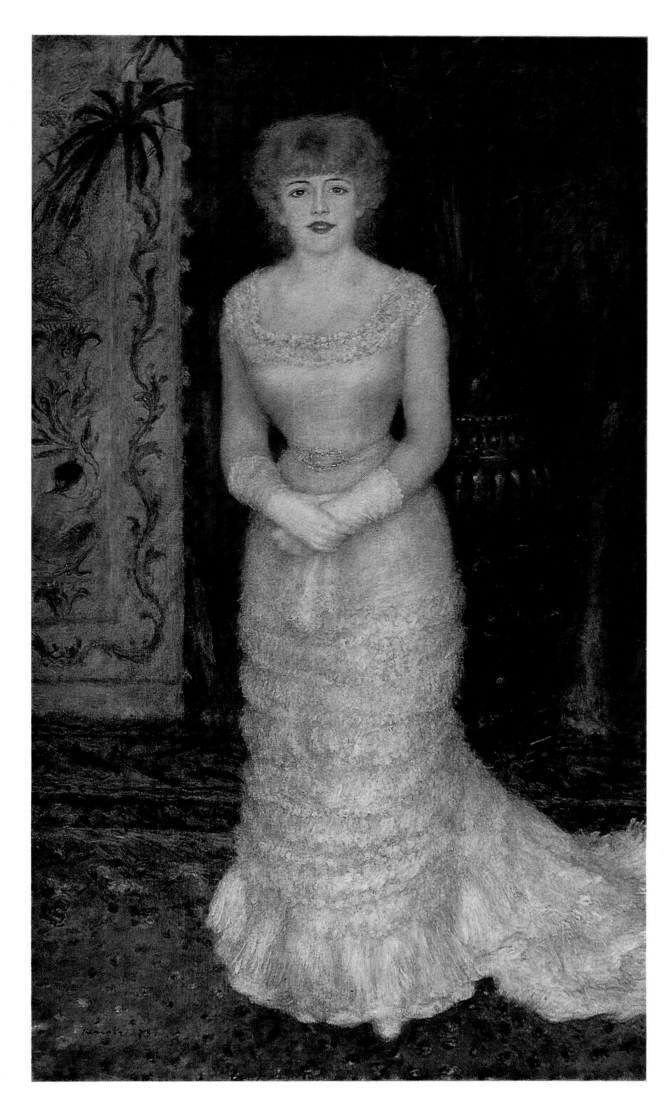

**52 PORTRAIT
OF THE ACTRESS
JEANNE SAMARY**

Oil on canvas. 173×103 cm

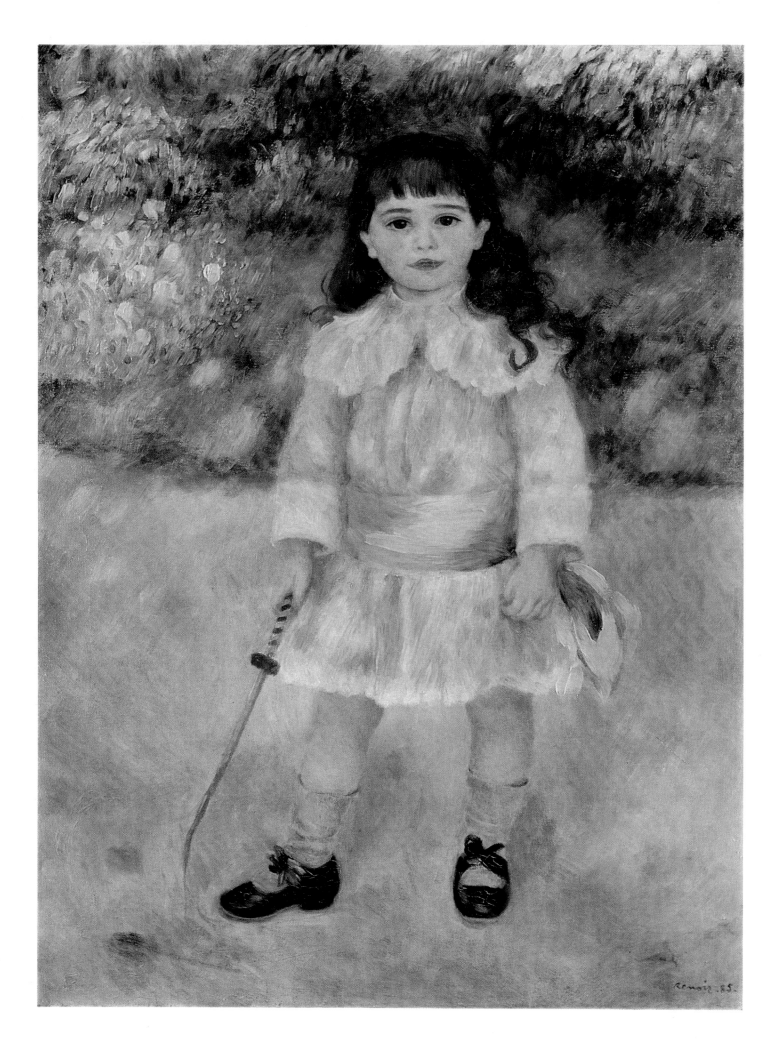

53 CHILD WITH A WHIP

Oil on canvas. 107×75 cm

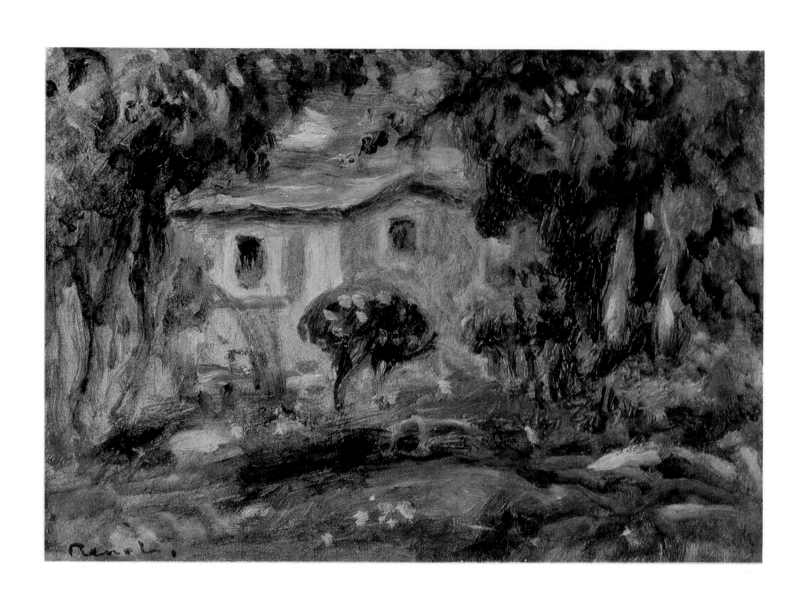

54 LANDSCAPE. LE CANNET

Oil on canvas. 14×19 cm

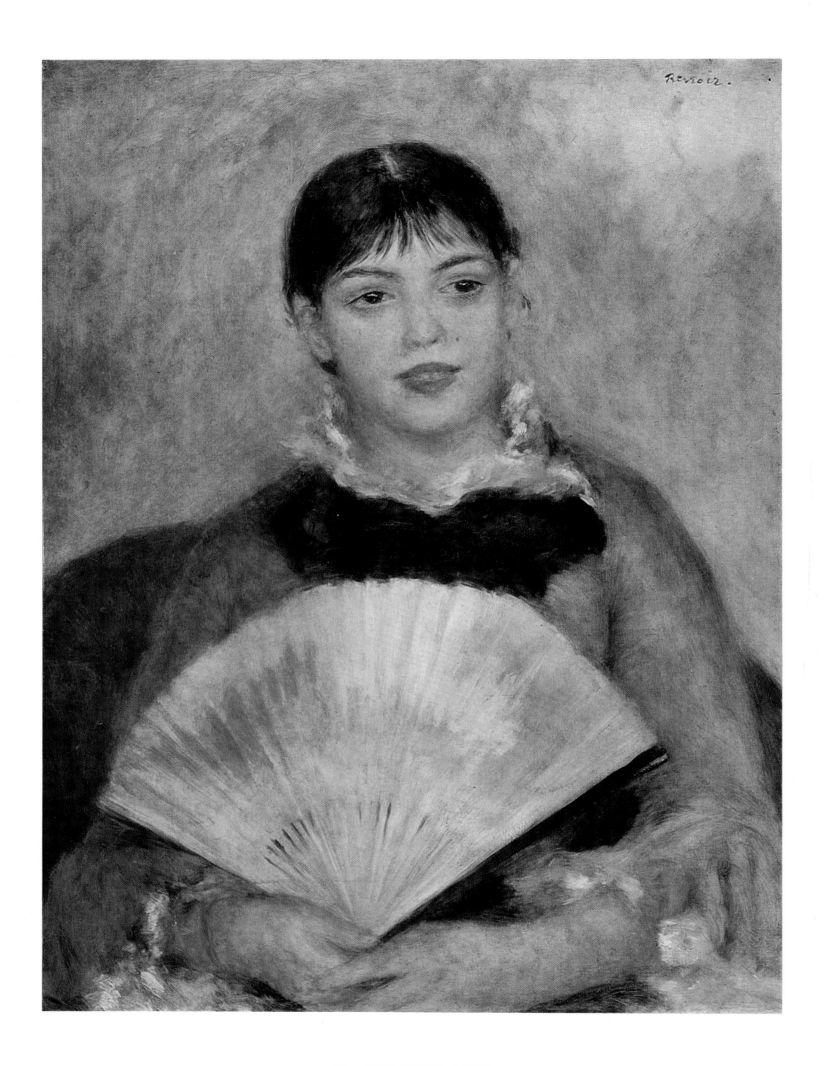

55 GIRL WITH A FAN

Oil on canvas. 65×50 cm

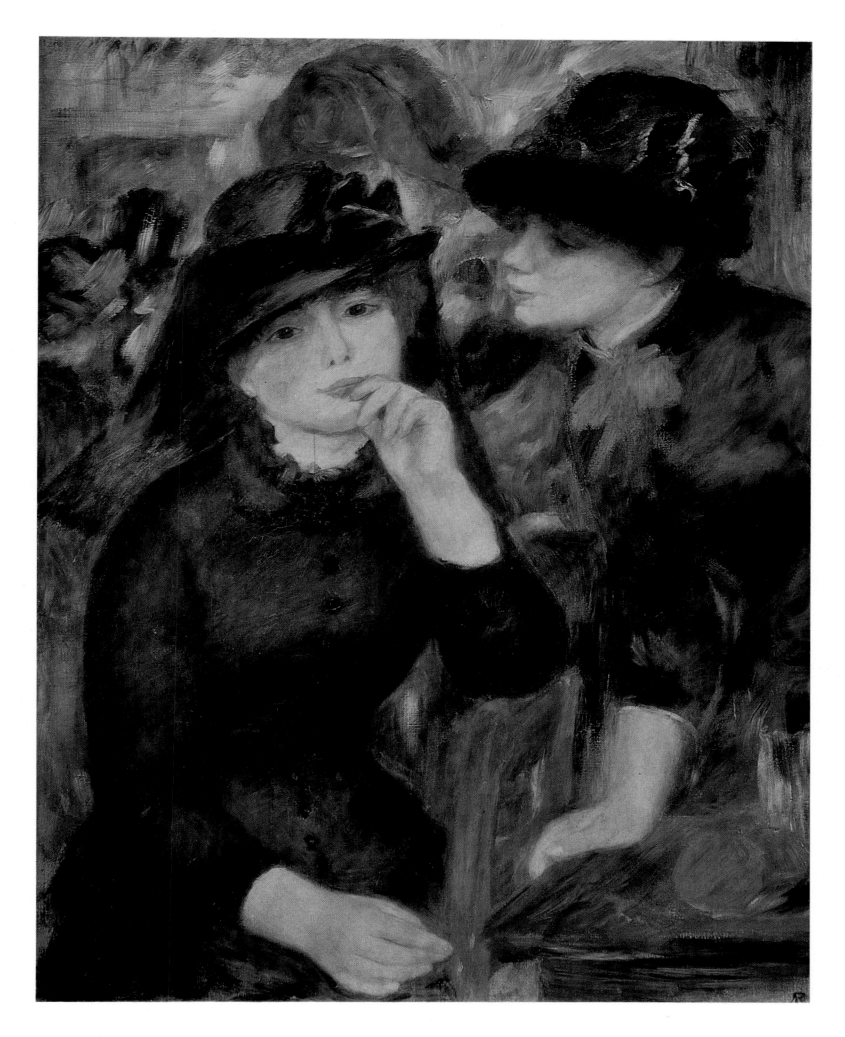

56, 57 GIRLS IN BLACK

Oil on canvas. 81.3×65.2 cm

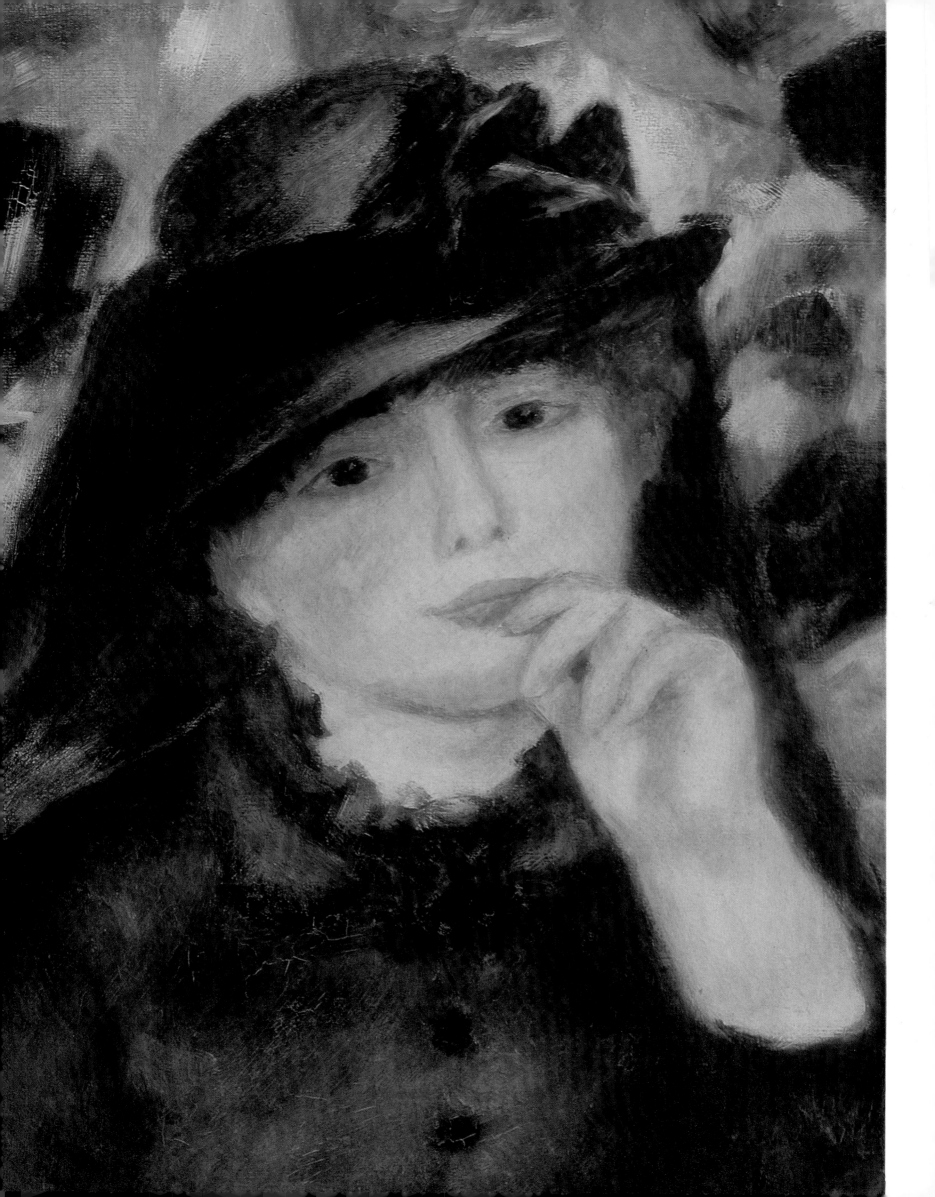

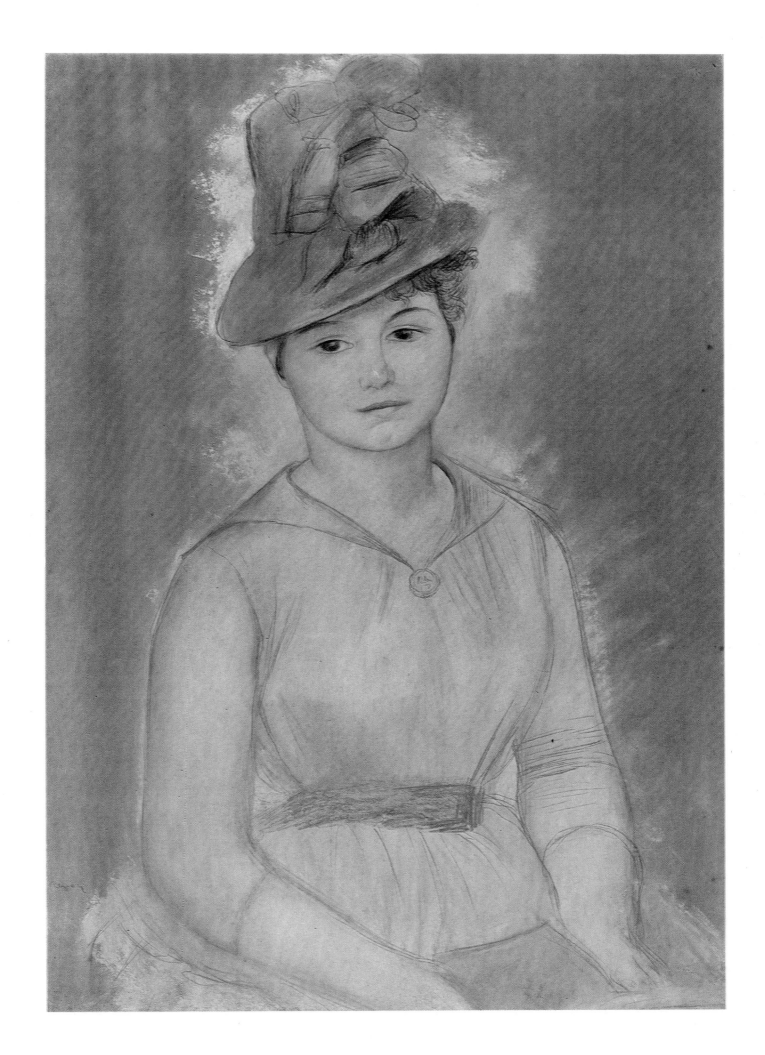

58 PORTRAIT OF AN UNKNOWN WOMAN

Red and white chalk, and lead pencil. 79×57.5 cm

59 WOMAN WITH A MUFF

Pen and Indian ink with touches of watercolour wash on laid paper. 45×30 cm

Degas

EDGAR DEGAS. 1834—1917

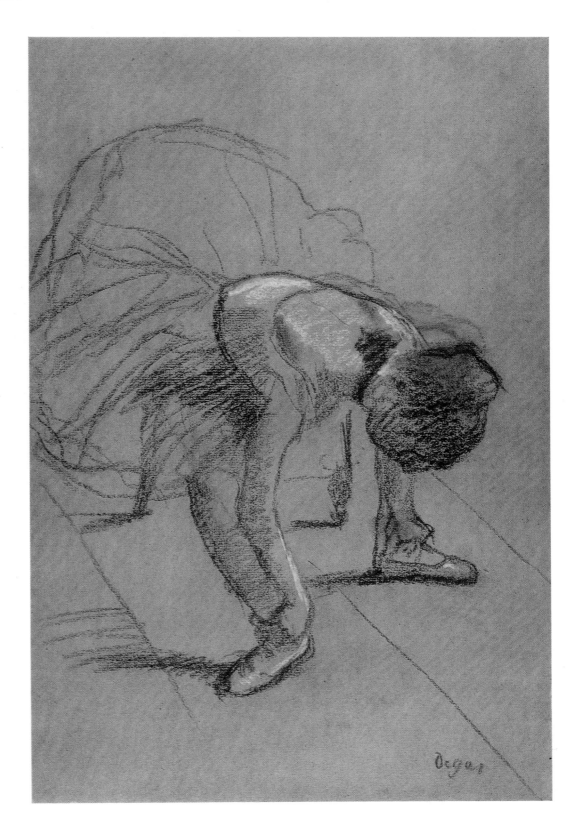

60 DANCER SEATED, ADJUSTING HER SHOES
Charcoal and pastel on grey paper. 47.3×30.5 cm

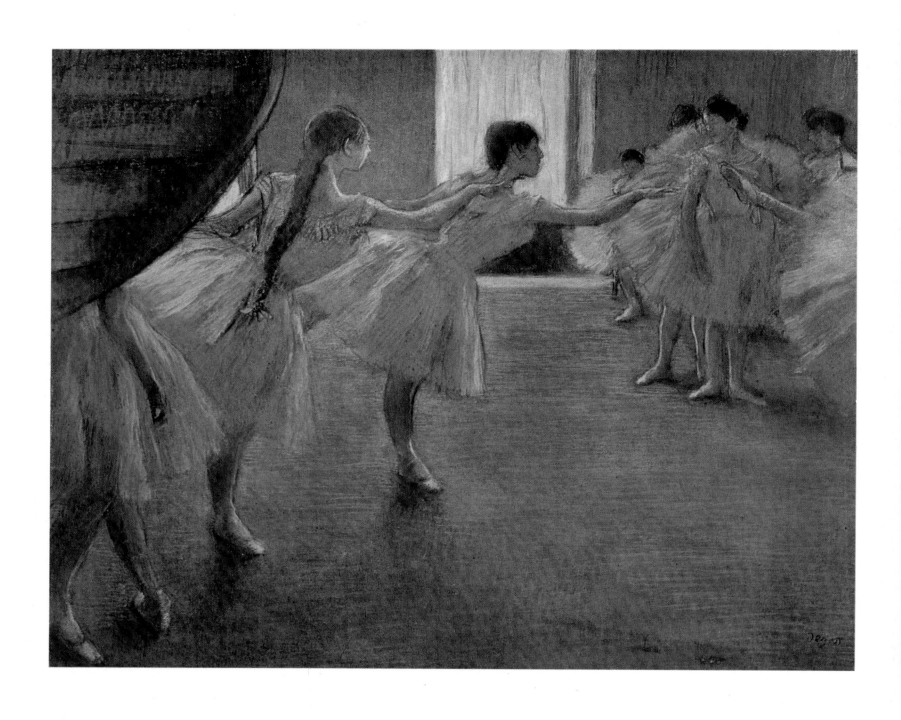

61 BALLET REHEARSAL

Pastel on cardboard. 50×63 cm

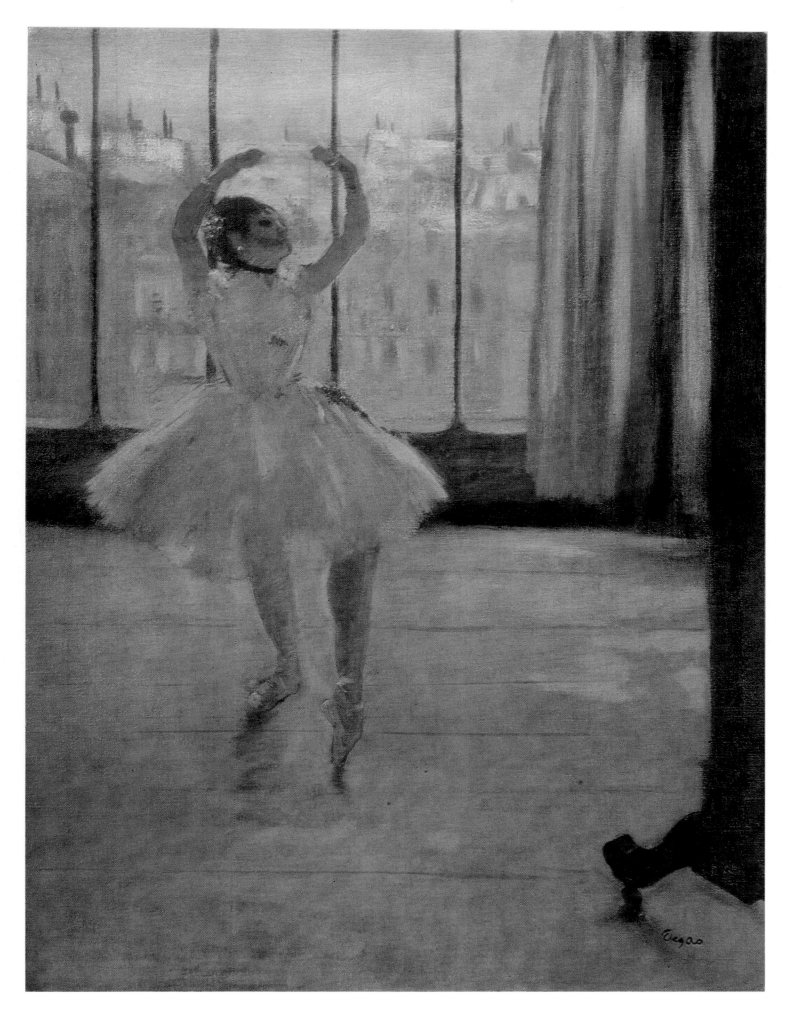

62 DANCER BEFORE THE WINDOW,
or DANCER POSING FOR A PHOTOGRAPHER

Oil on canvas. 65×50 cm

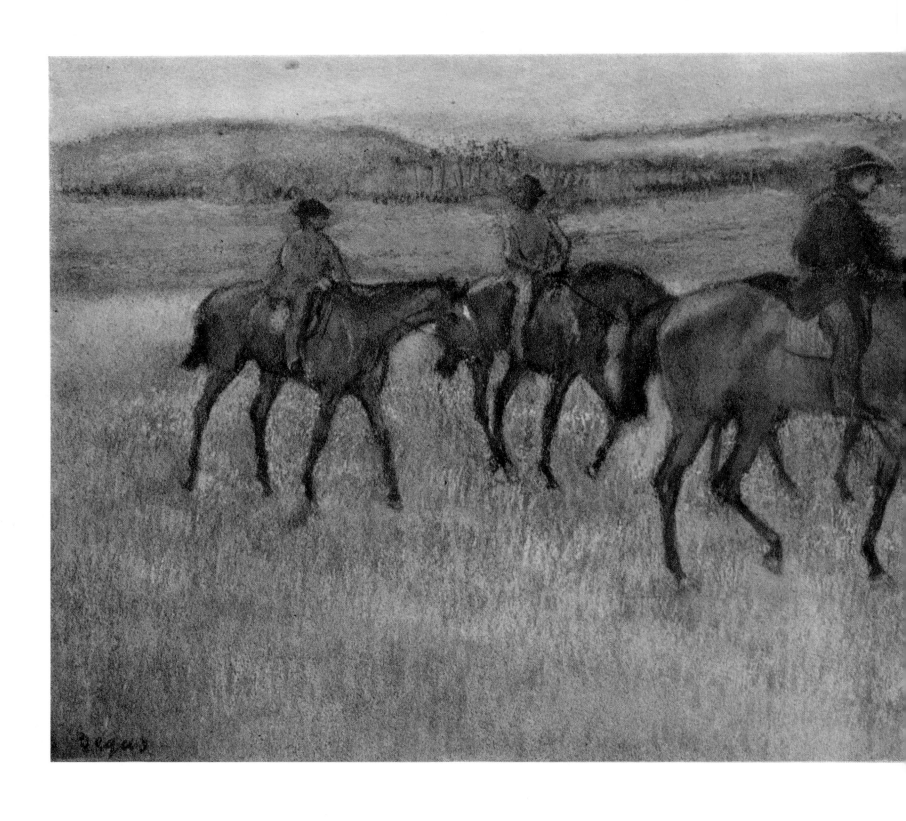

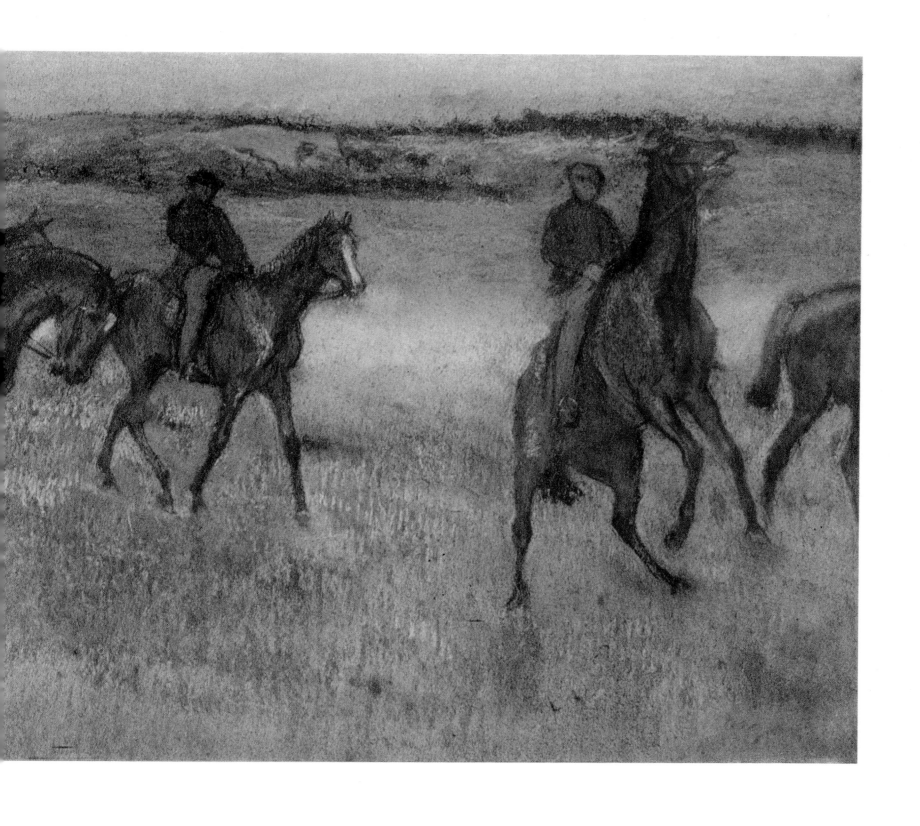

63 EXERCISING RACEHORSES

Pastel. 36×86 cm

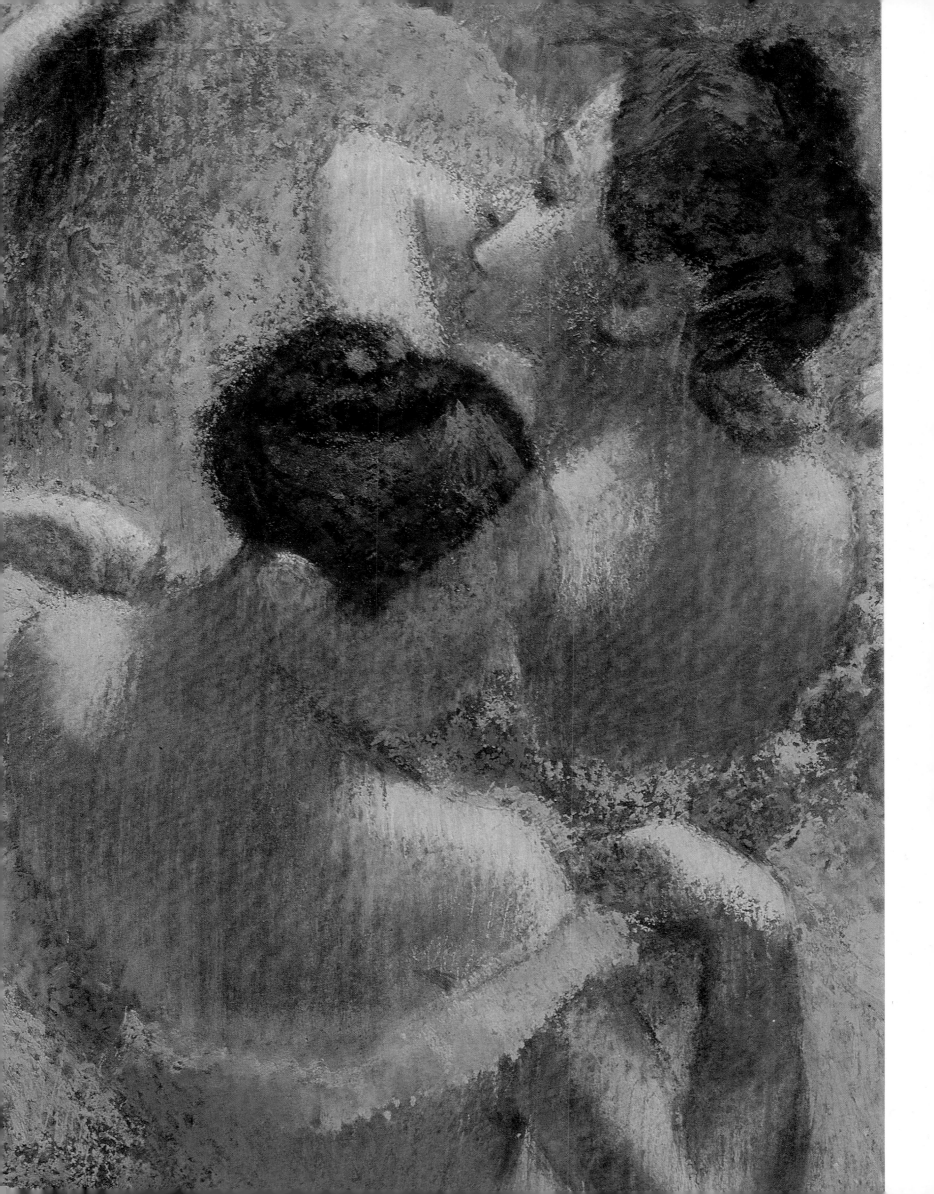

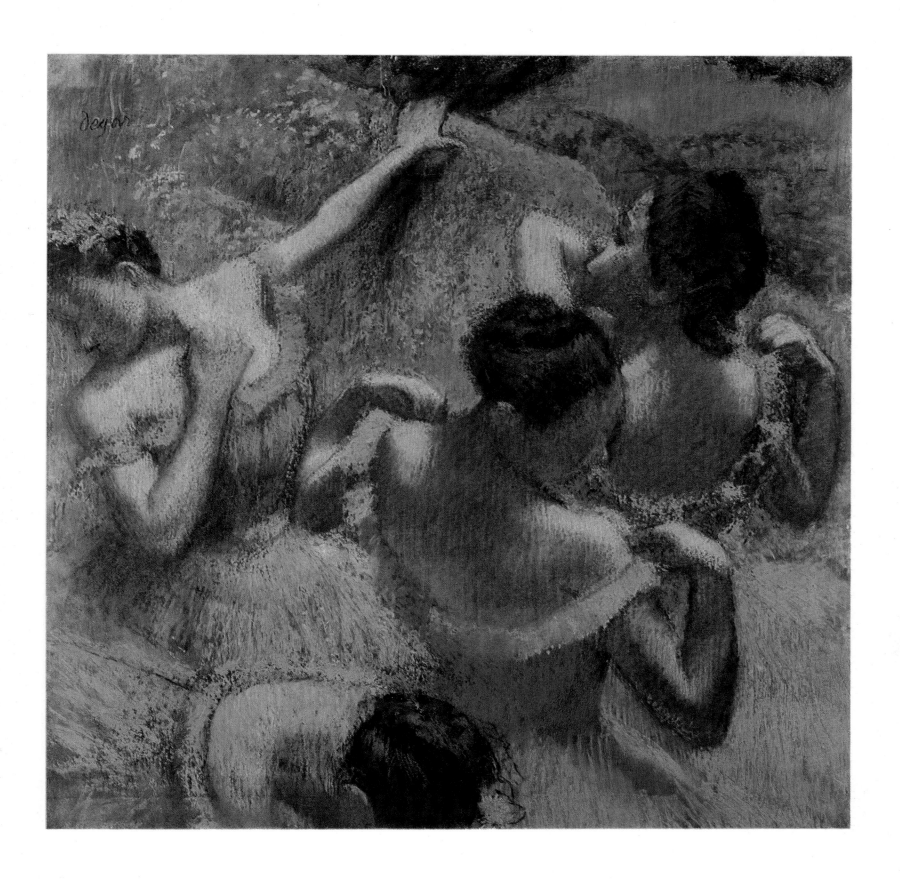

64, 65 BLUE DANCERS

Pastel. 65×65 cm

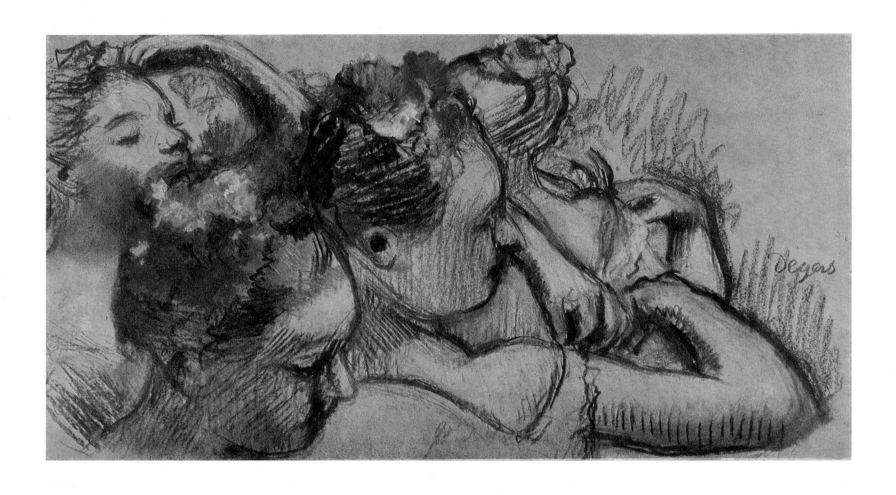

66 HEADS OF DANCERS

Pastel and charcoal on greyish buff paper mounted on cardboard. 31×55 cm

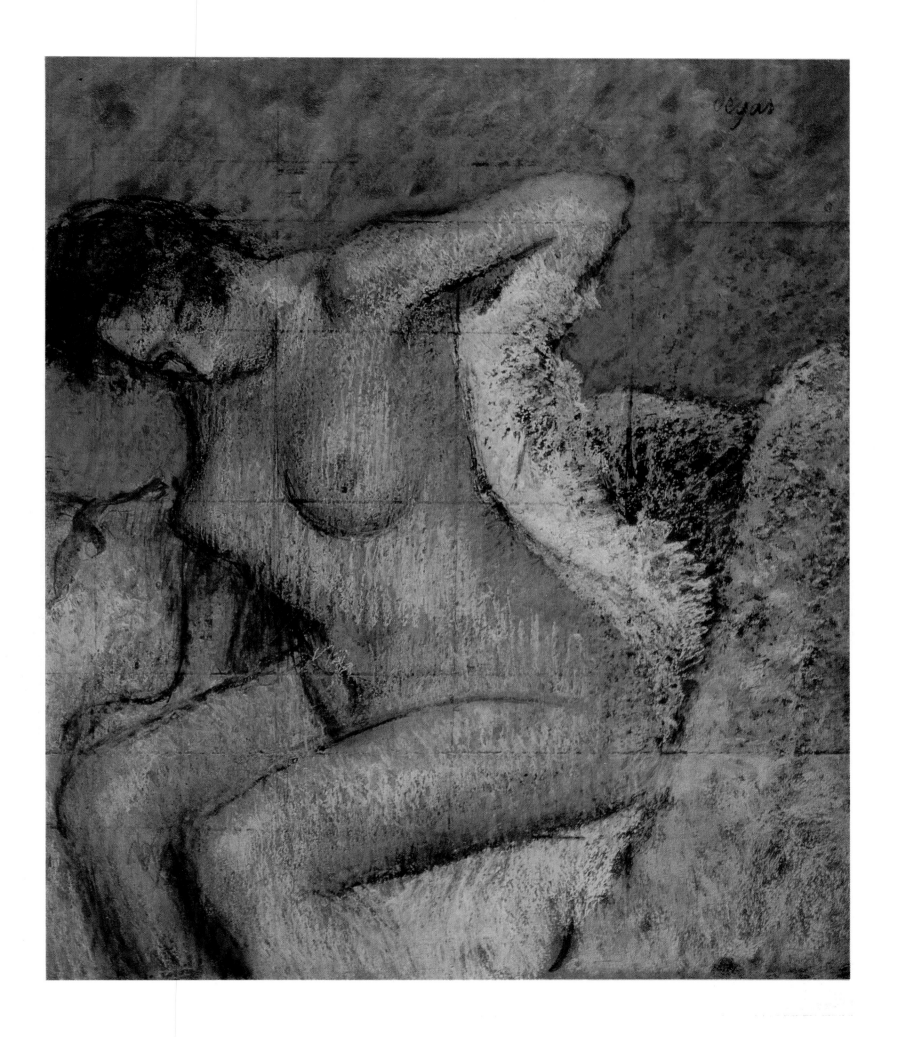

67 AFTER THE BATH

Pastel, gouache, tempera, and charcoal on grey paper mounted on cardboard. 82.5×72 cm

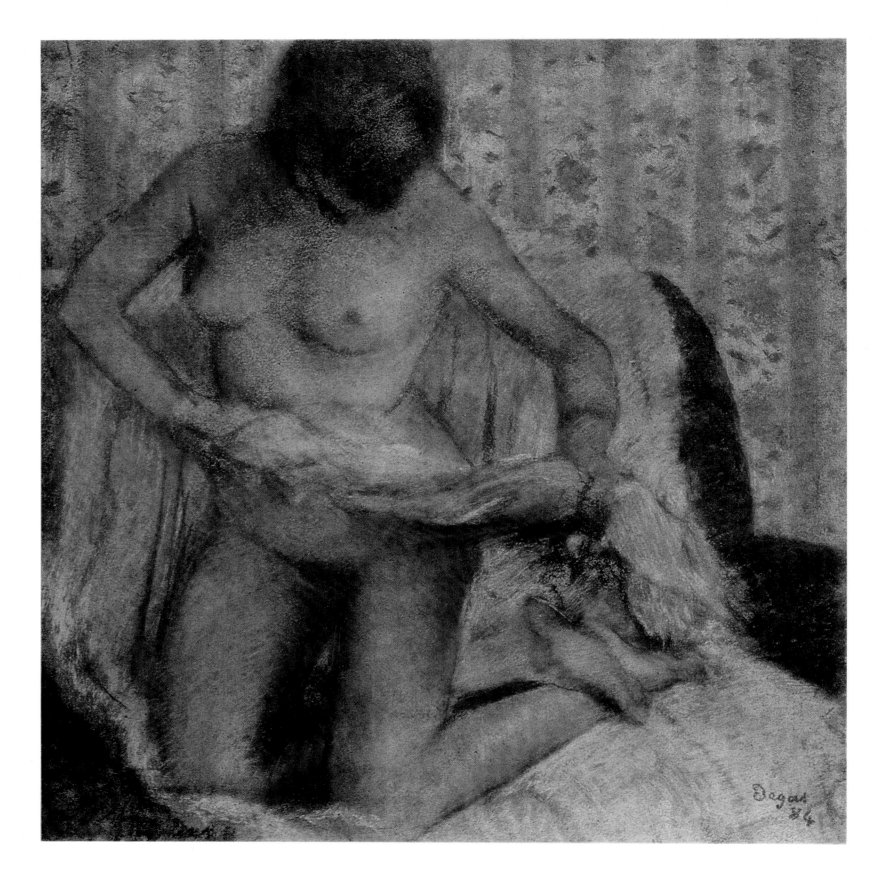

68 AFTER THE BATH

Pastel on paper mounted on cardboard. 50×50 cm

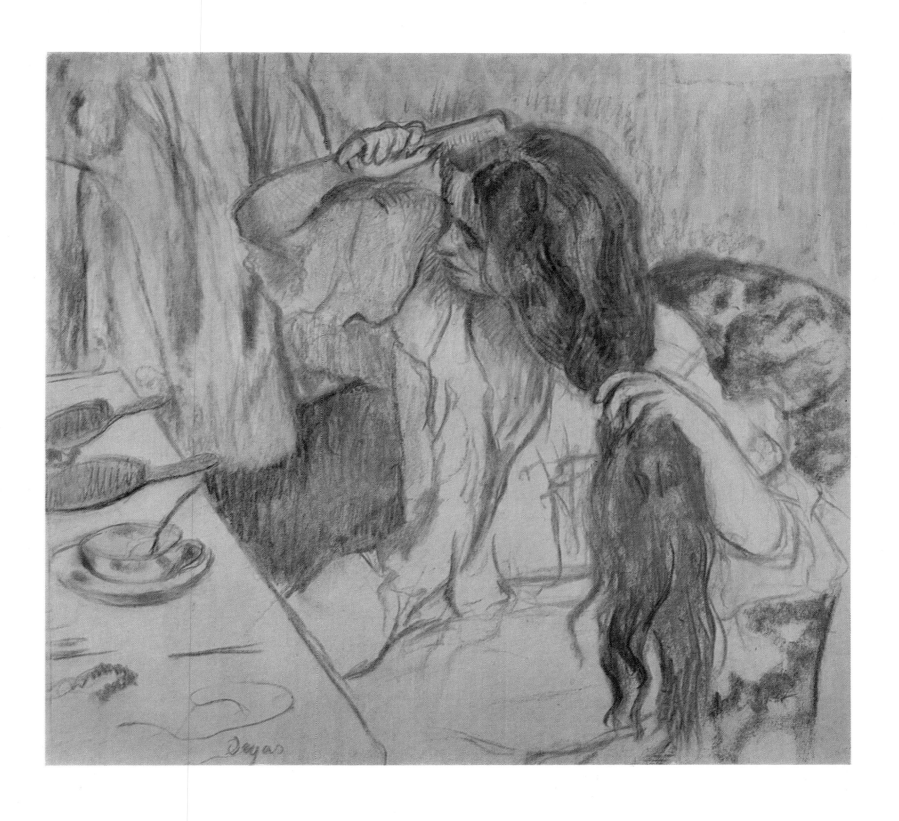

69 WOMAN AT HER TOILETTE

Pastel and charcoal. 56×59 cm

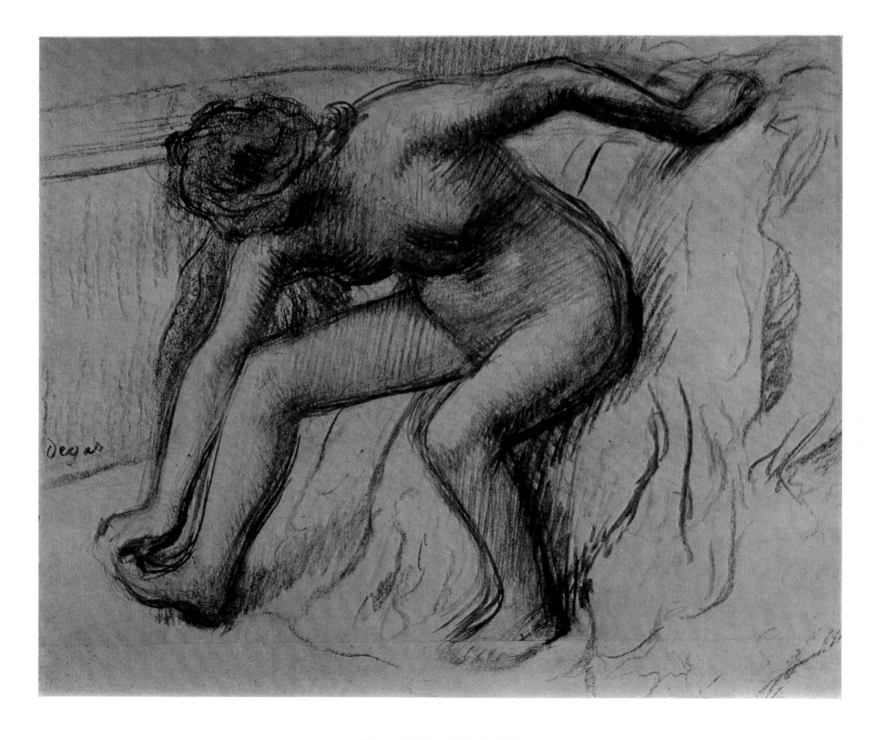

70 AFTER THE BATH

Charcoal and brown pencil (sepia?). 37×44 cm

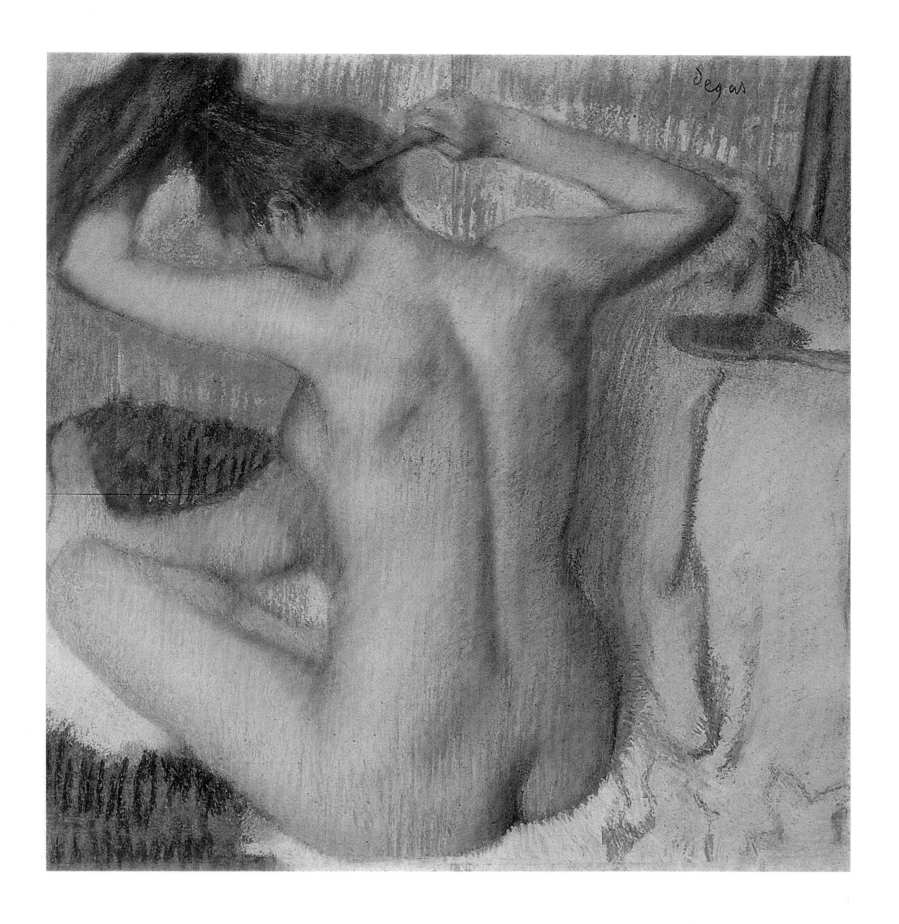

71 WOMAN COMBING HER HAIR

Pastel. 53×52 cm

ARMAND GUILLAUMIN. 1841—1927

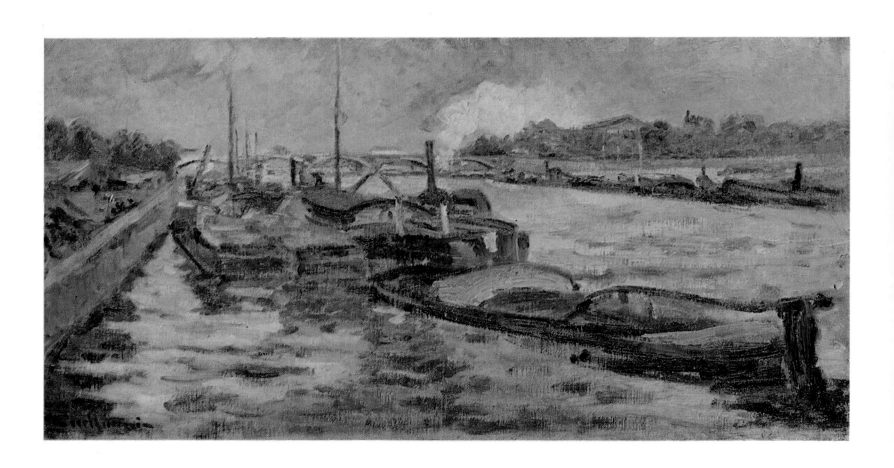

72 THE SEINE

Oil on canvas. 26×50 cm

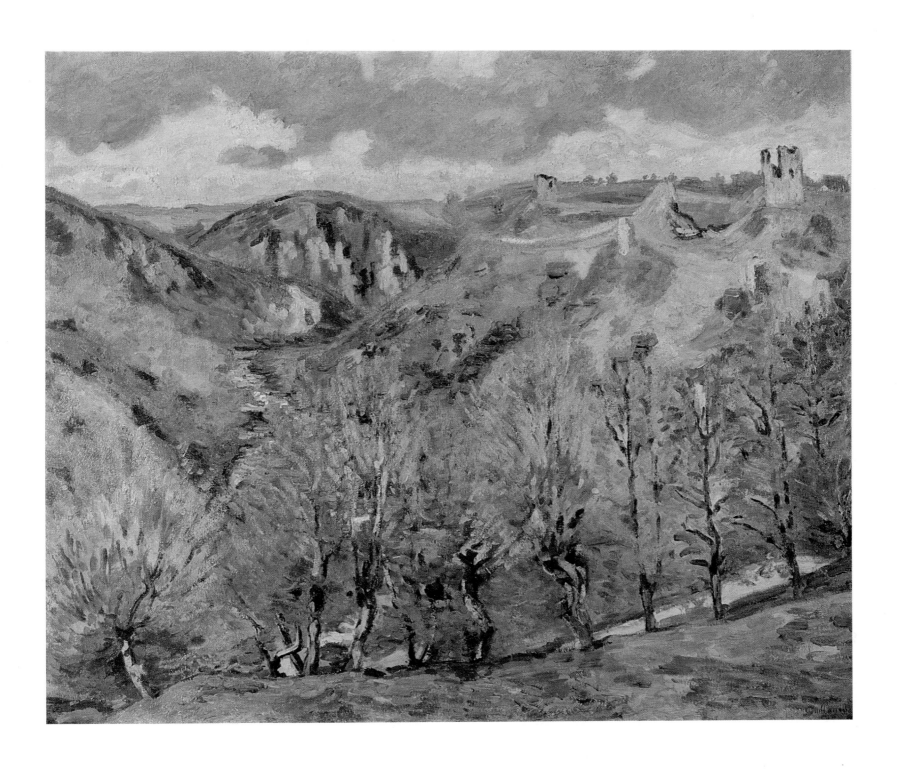

73 LANDSCAPE WITH RUINS

Oil on canvas. 79×93 cm

P. Cézanne

PAUL CÉZANNE. 1839—1906

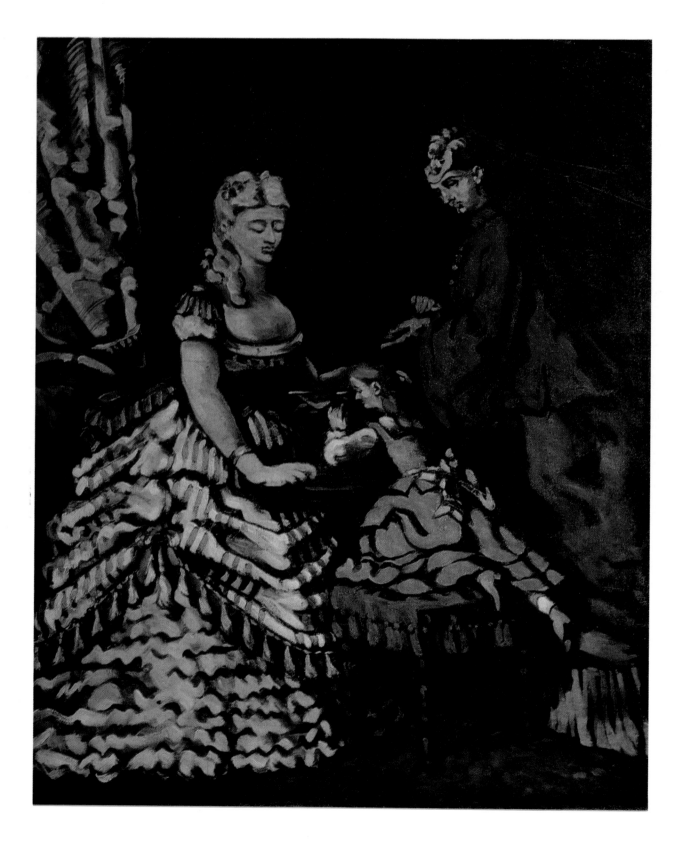

74 INTERIOR WITH TWO WOMEN AND A CHILD

Oil on canvas. 91×72 cm

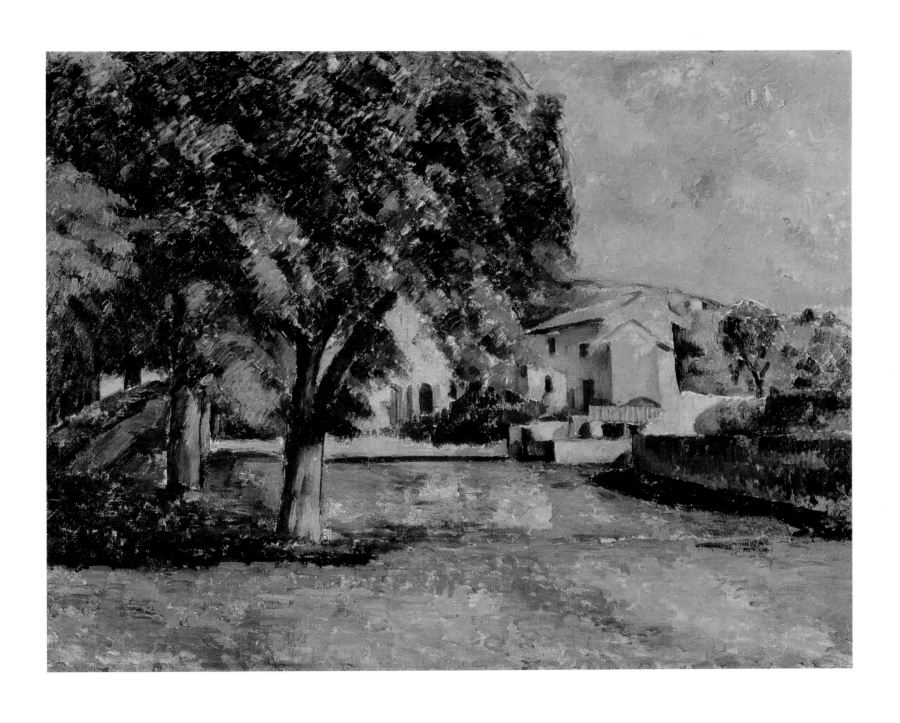

75 TREES IN A PARK

Oil on canvas. 72×91 cm

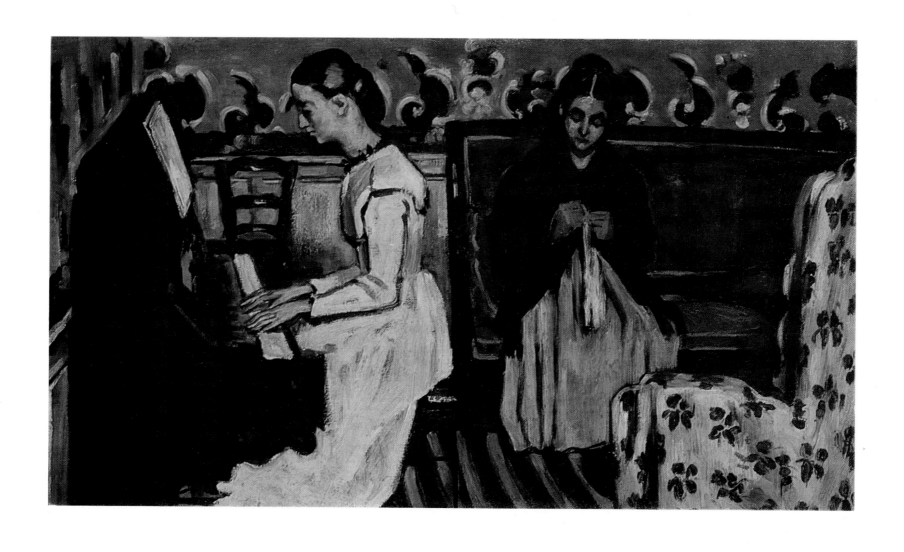

76, 77 GIRL AT THE PIANO (OVERTURE TO *TANNHÄUSER*)

Oil on canvas. 57×92 cm

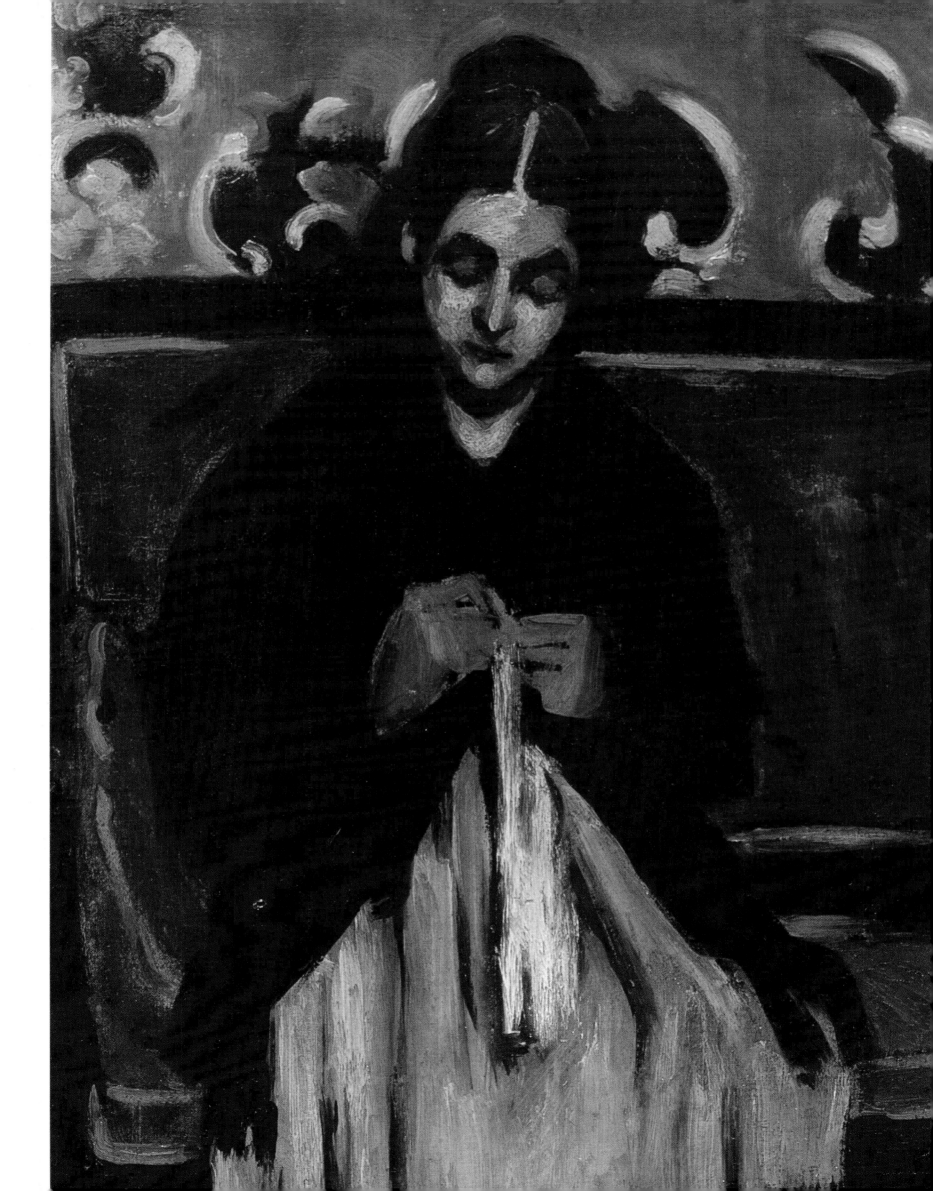

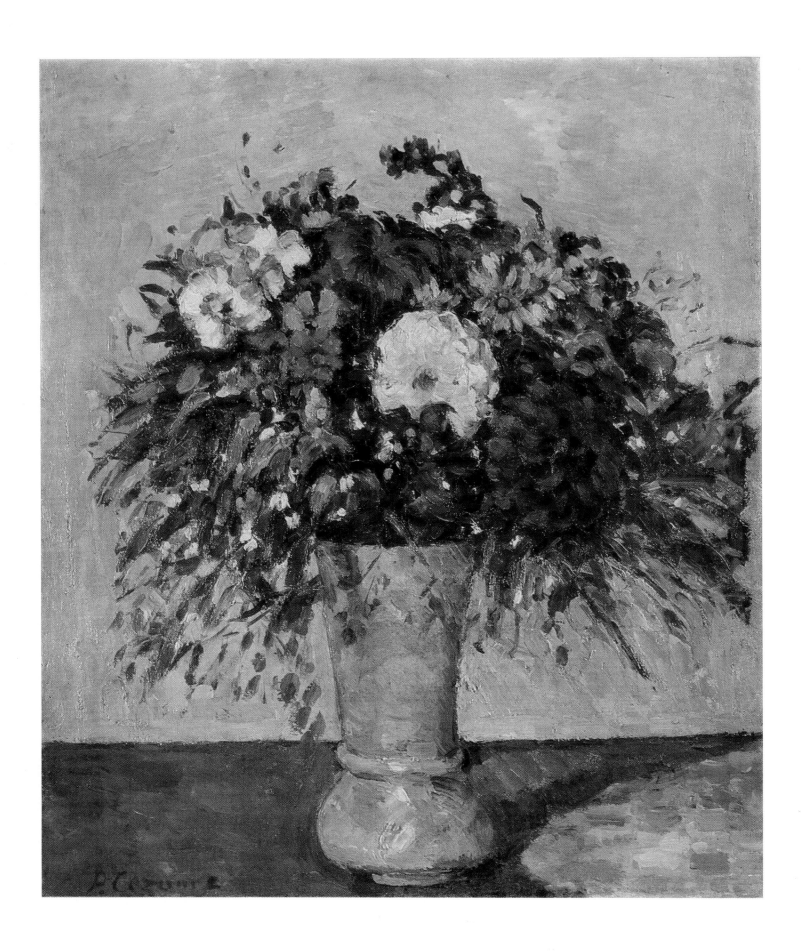

78 FLOWERS IN A BLUE VASE

Oil on canvas. 56×46 cm

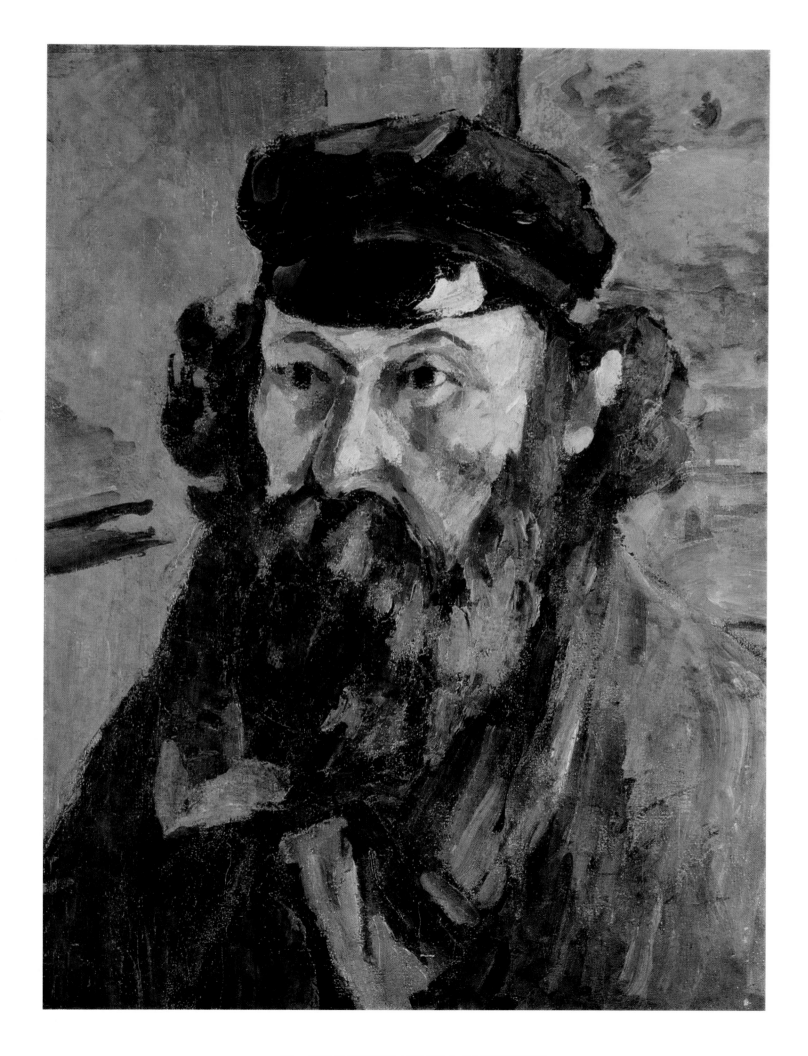

79 SELF-PORTRAIT IN A CASQUETTE

Oil on canvas. 53×38 cm

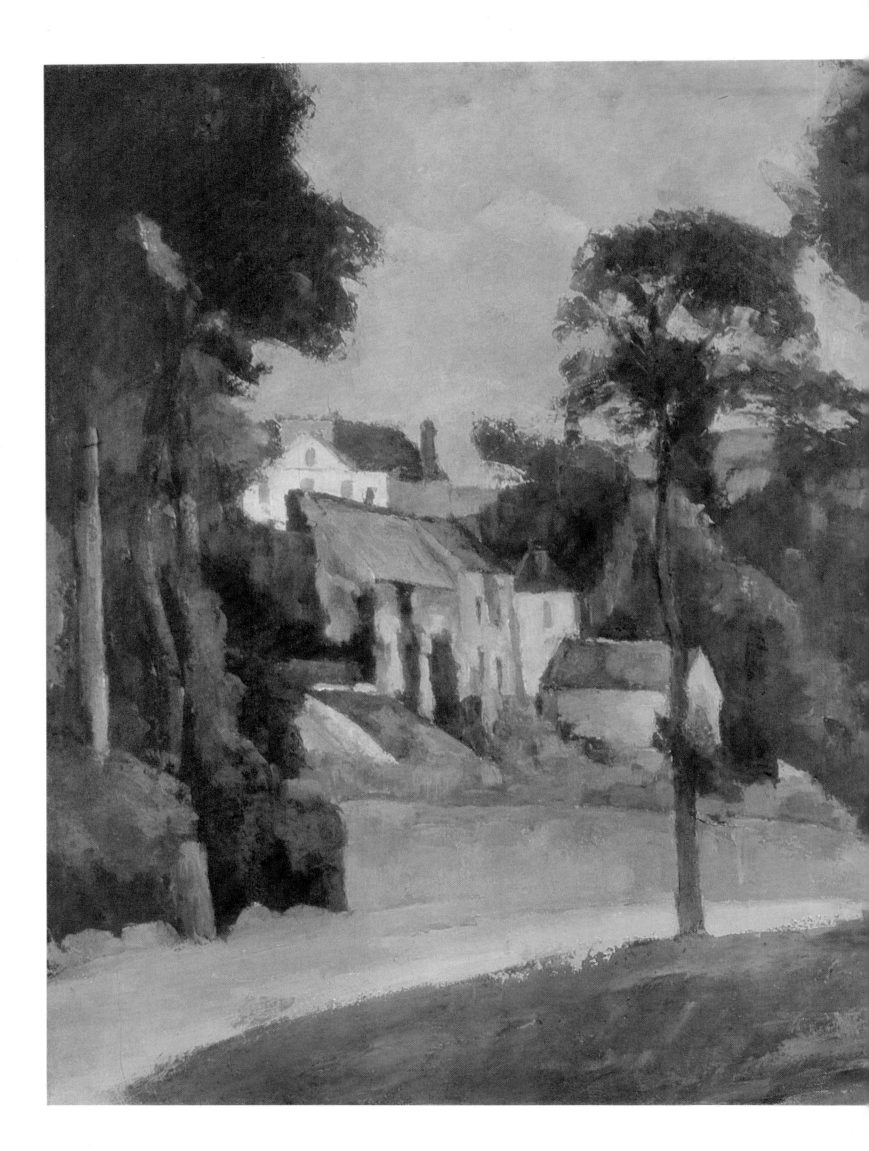

80 ROAD AT PONTOISE

Oil on canvas. 58×71 cm

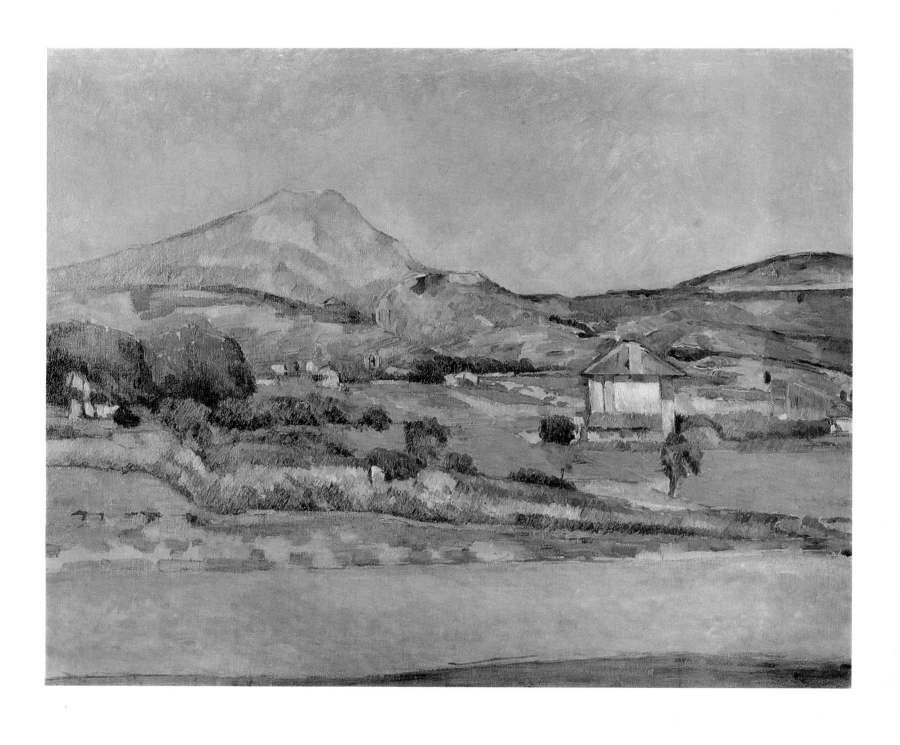

81 PLAIN BY MOUNT SAINTE-VICTOIRE

Oil on canvas. 58×72 cm

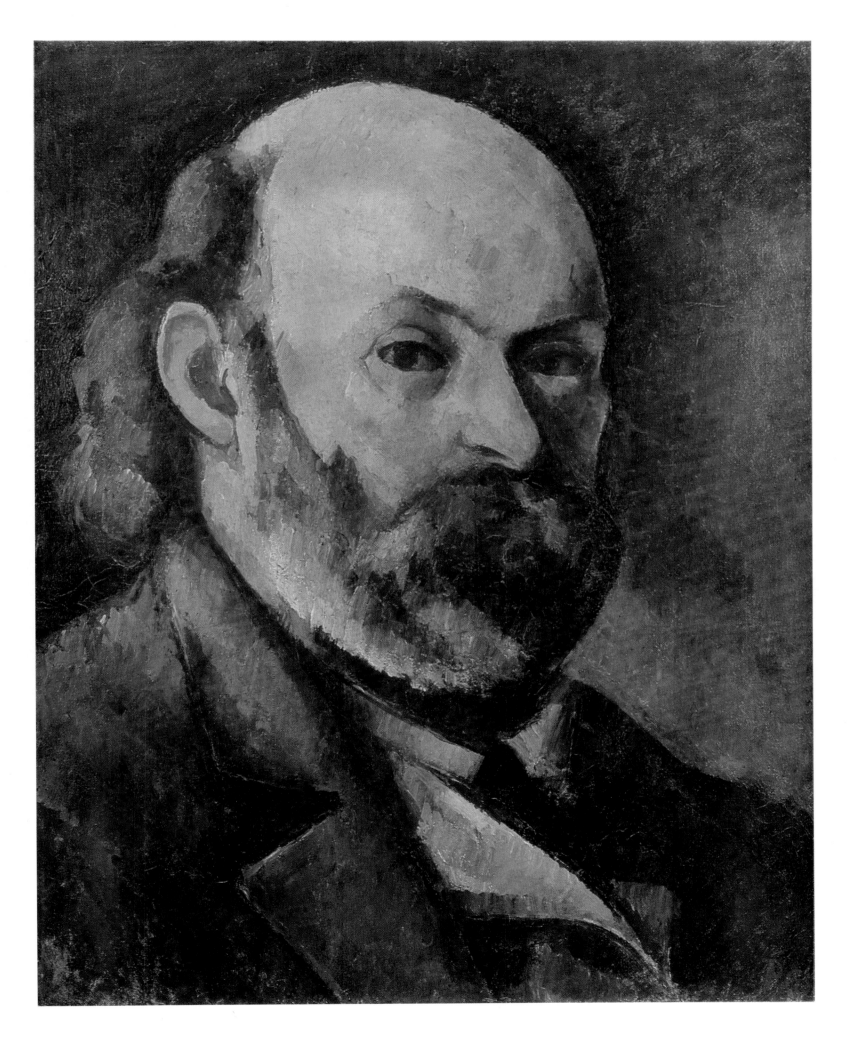

82 SELF-PORTRAIT

Oil on canvas. 45×37 cm

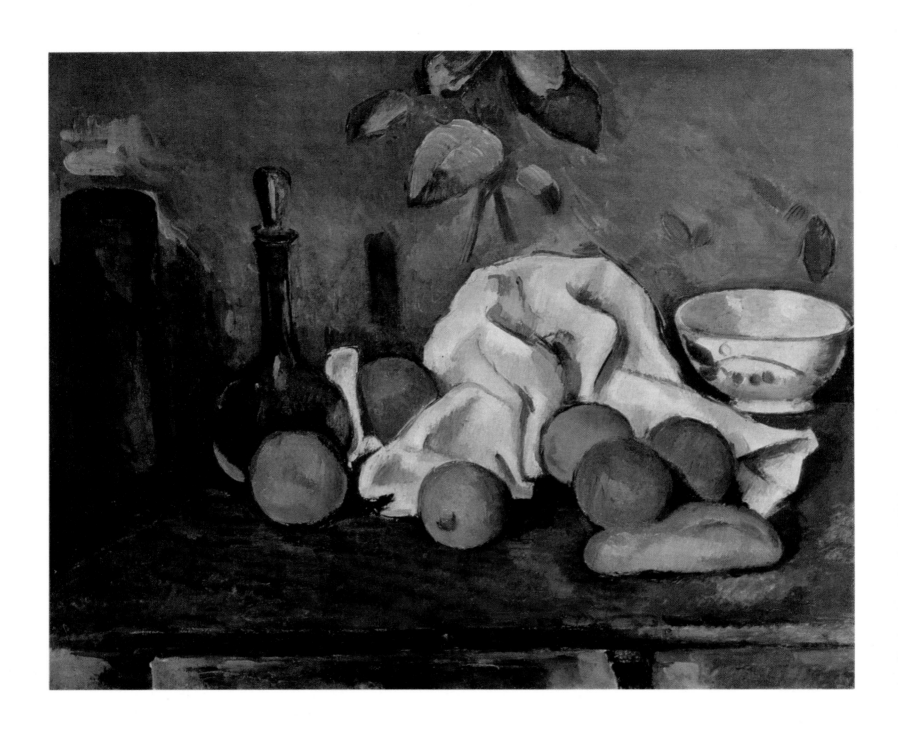

83 FRUIT

Oil on canvas. 45×54 cm

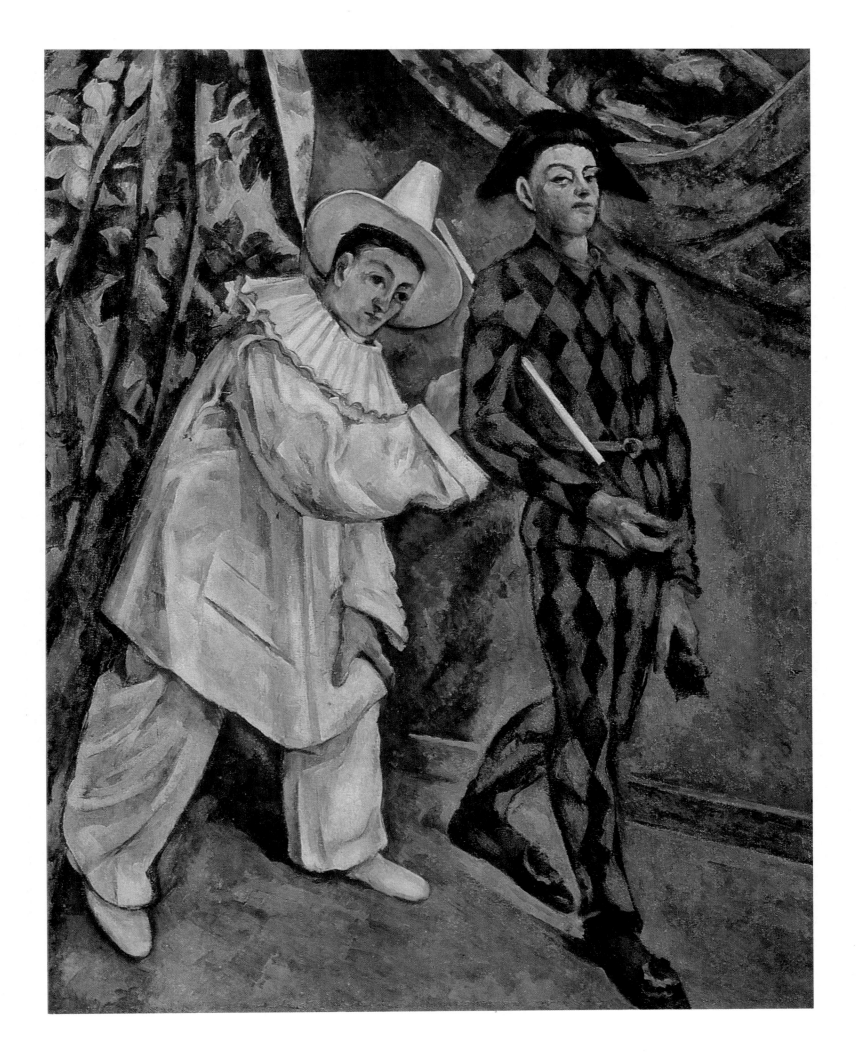

84, 85 PIERROT AND HARLEQUIN

Oil on canvas. 102×81 cm

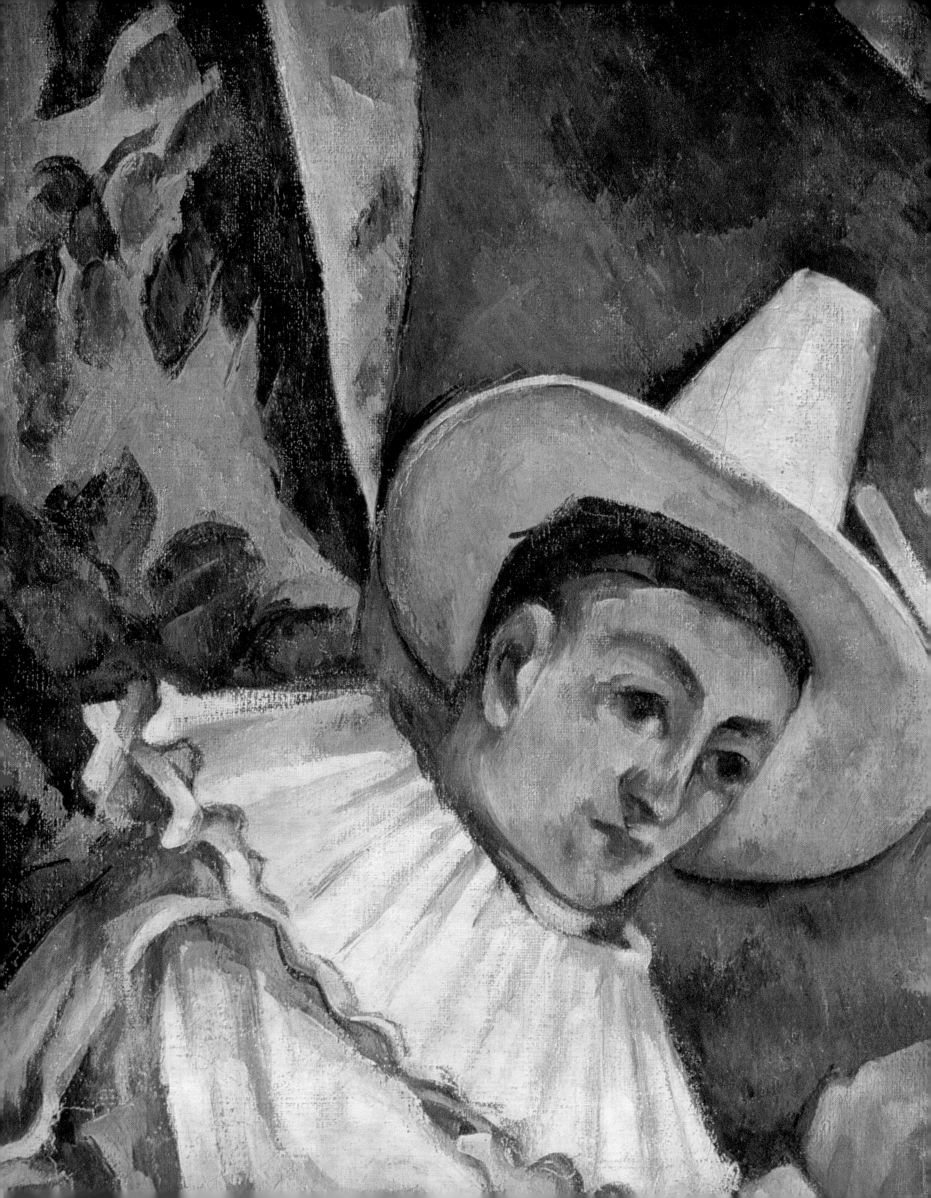

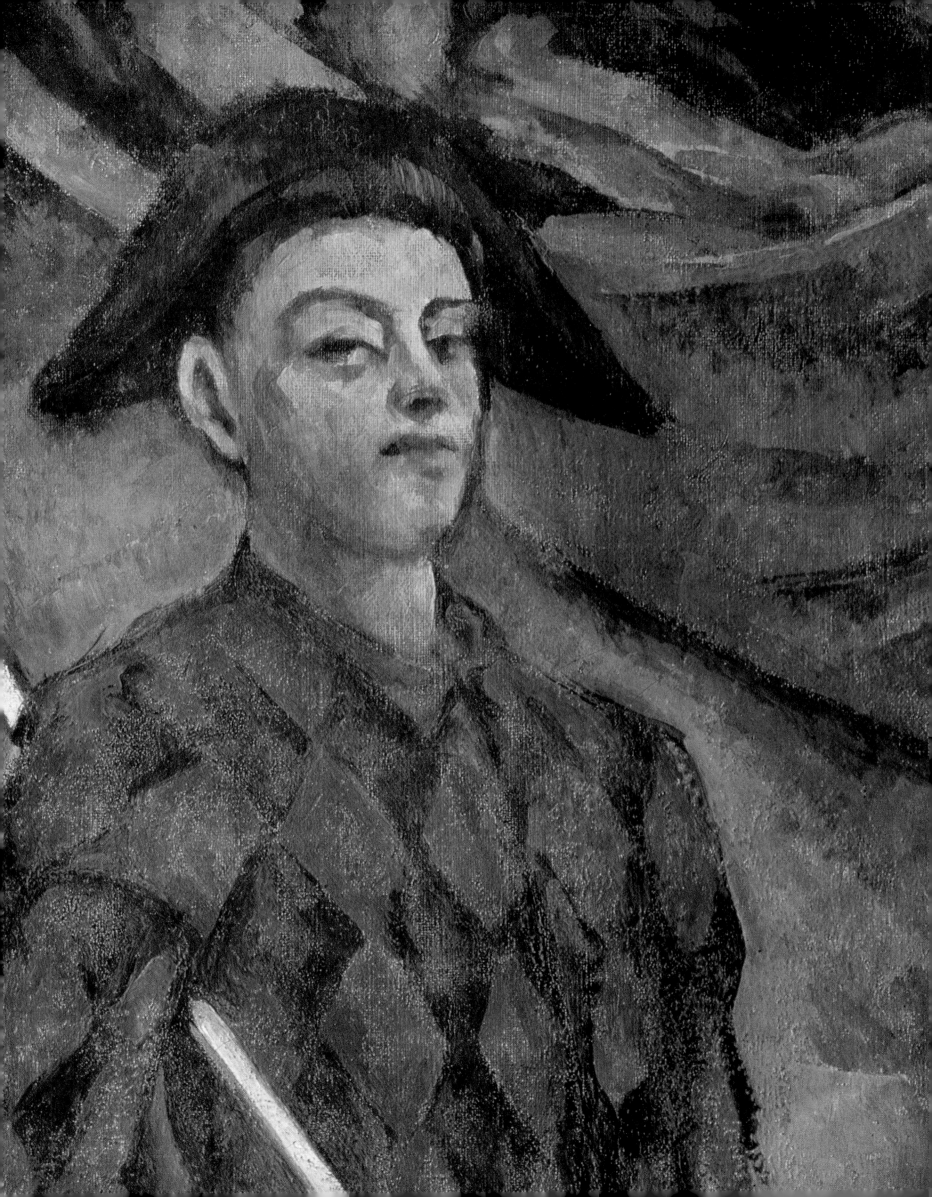

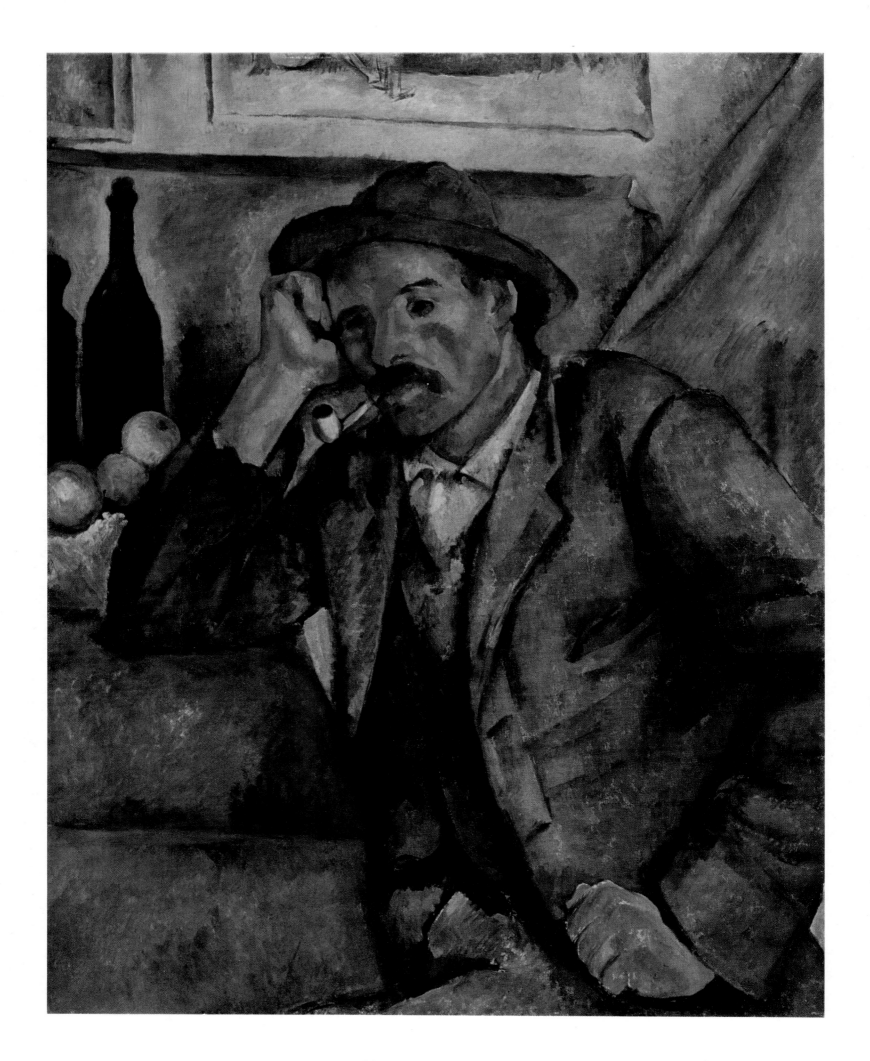

86 THE SMOKER

Oil on canvas. 91×72 cm

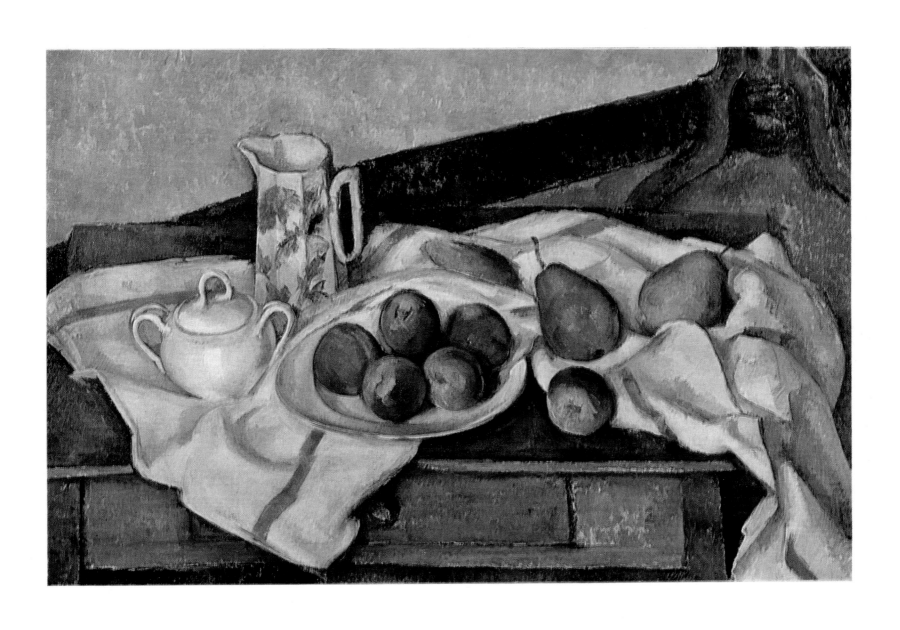

87 STILL LIFE WITH PEACHES AND PEARS

Oil on canvas. 61×90 cm

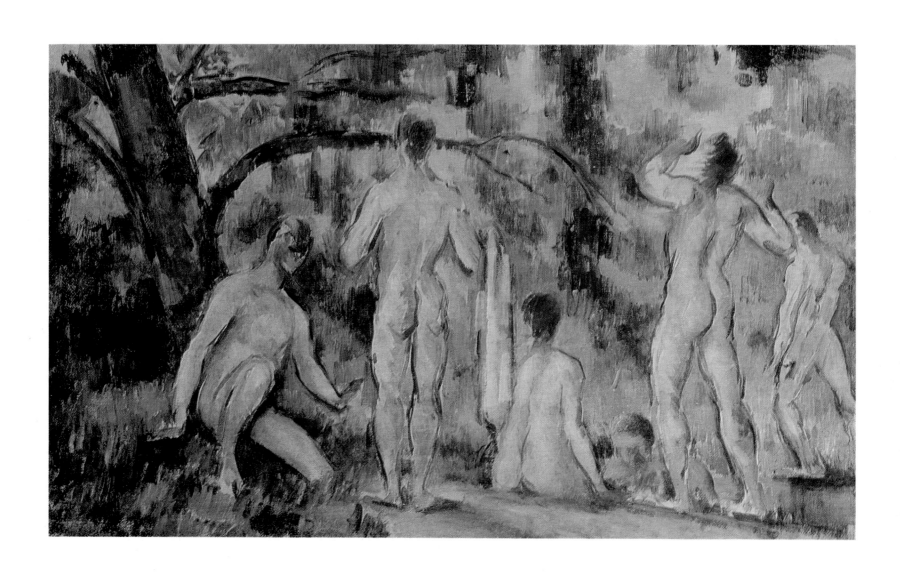

88 BATHERS. Study

Oil on canvas. 26×40 cm

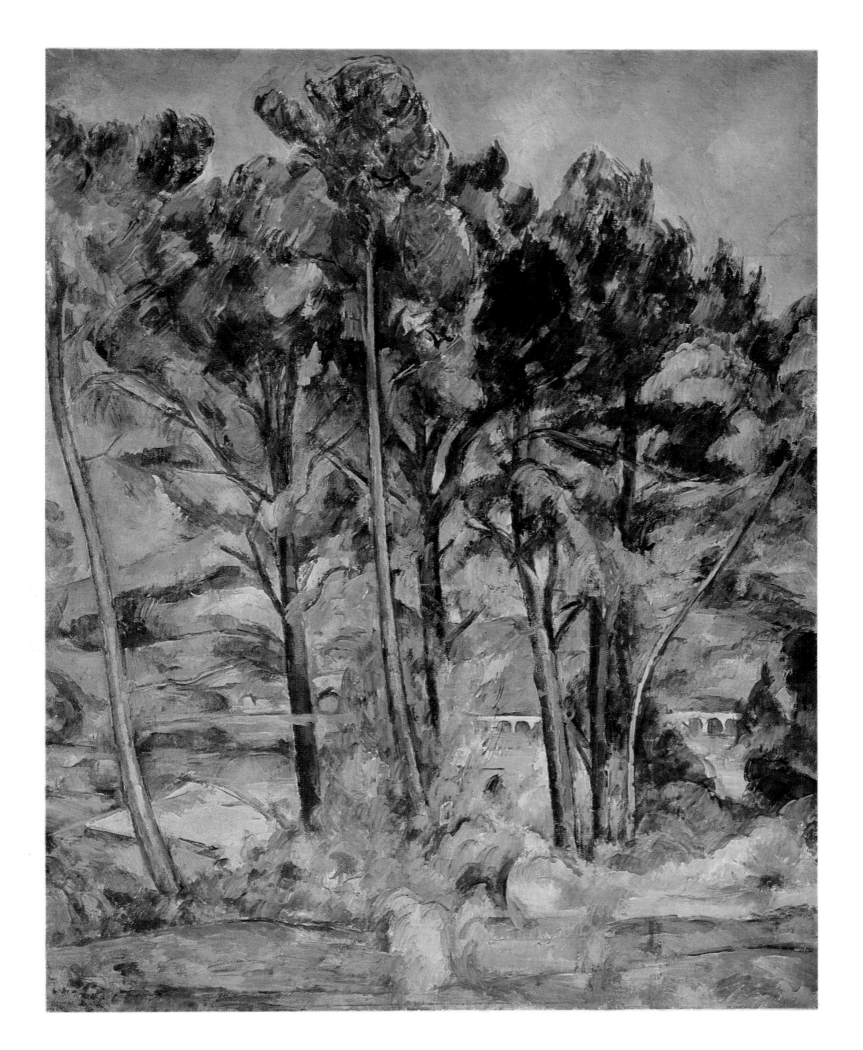

89 THE AQUEDUCT

Oil on canvas. 91×72 cm

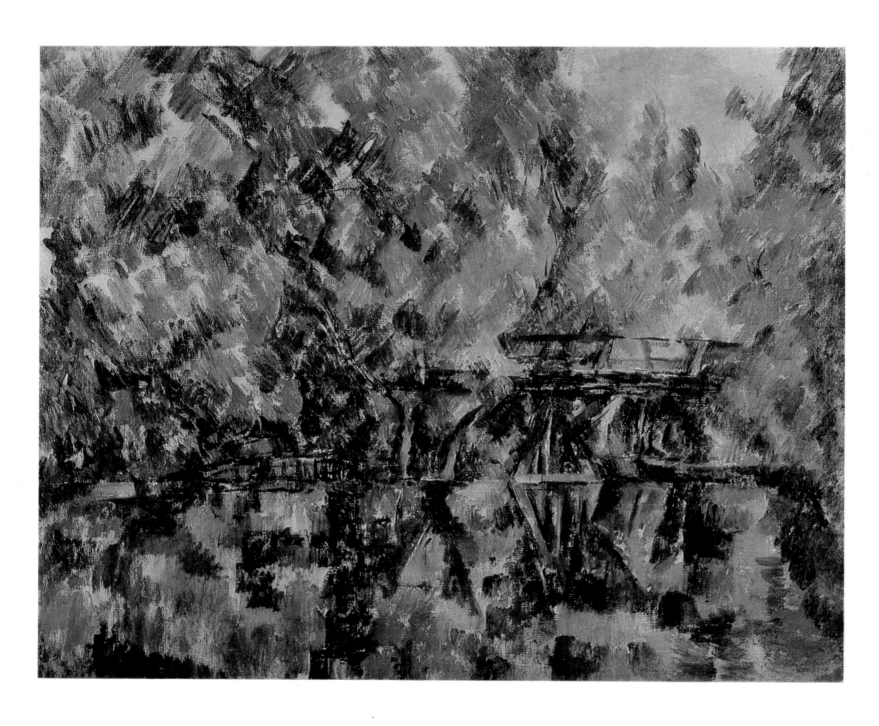

90 BRIDGE ACROSS A POND

Oil on canvas. 64×79 cm

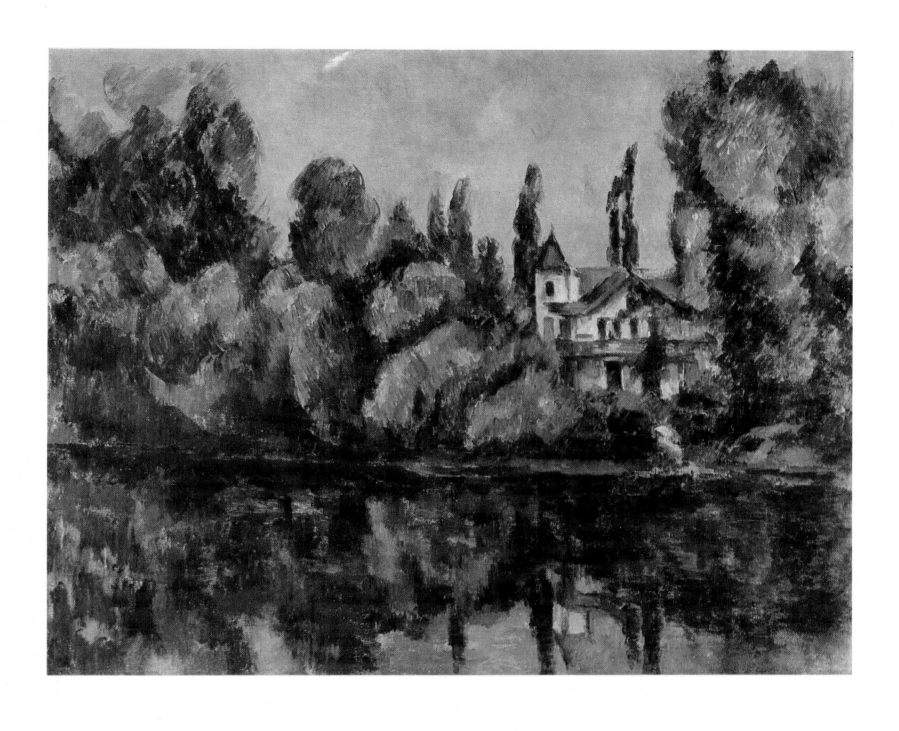

91 THE BANKS OF THE MARNE
(VILLA ON THE BANK OF A RIVER)

Oil on canvas. 65×81 cm

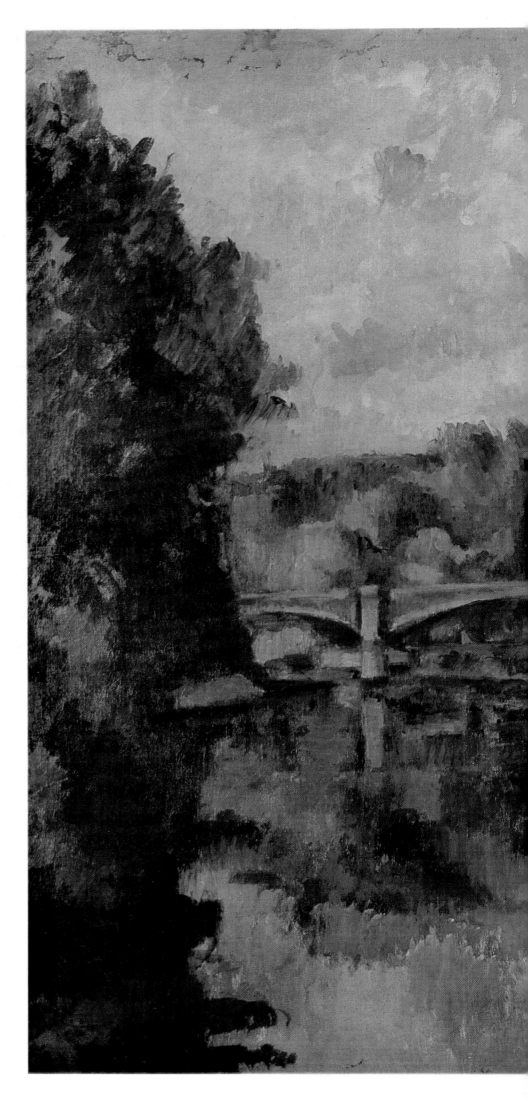

92 THE BANKS OF THE MARNE

Oil on canvas. 71×90 cm

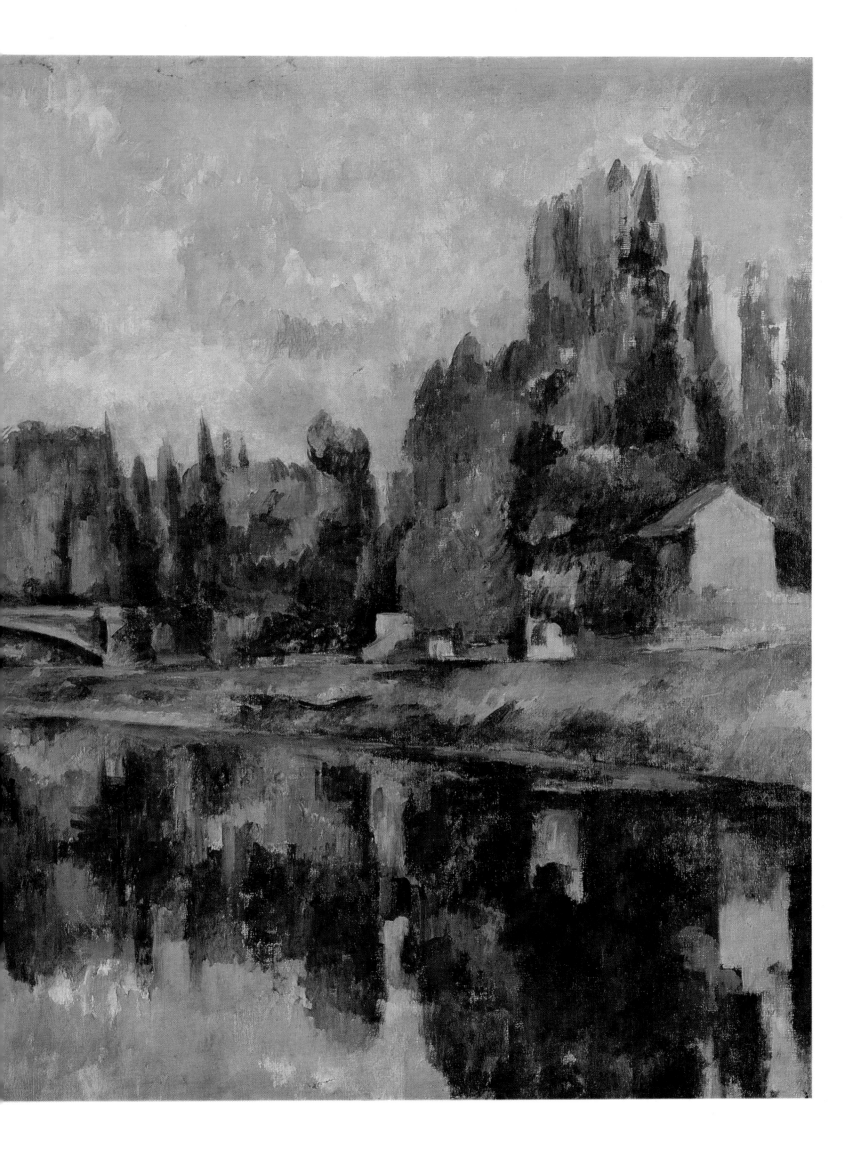

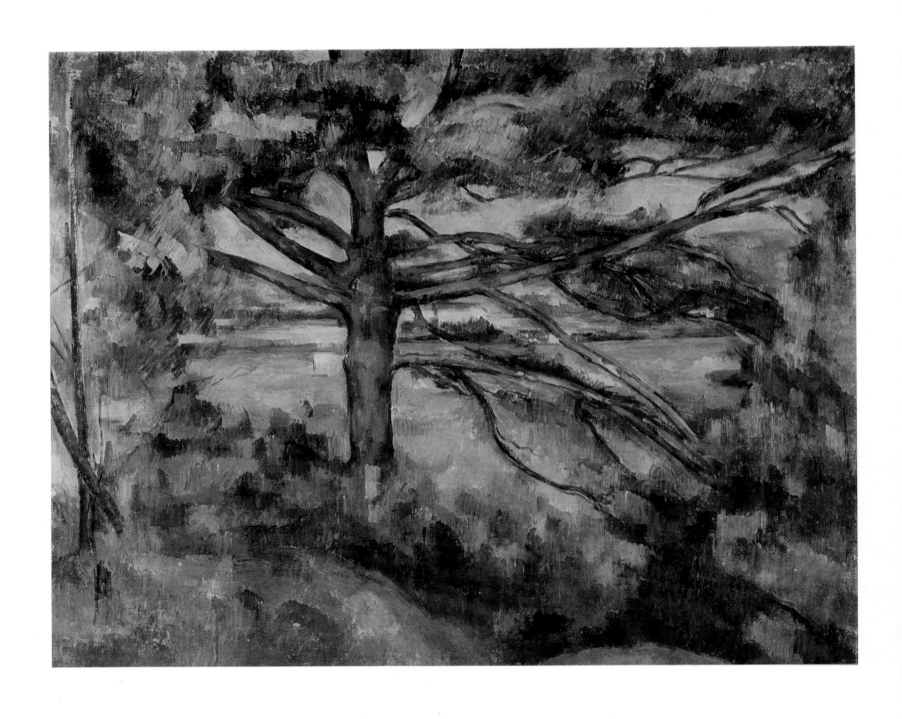

93 GREAT PINE NEAR AIX

Oil on canvas. 72×91 cm

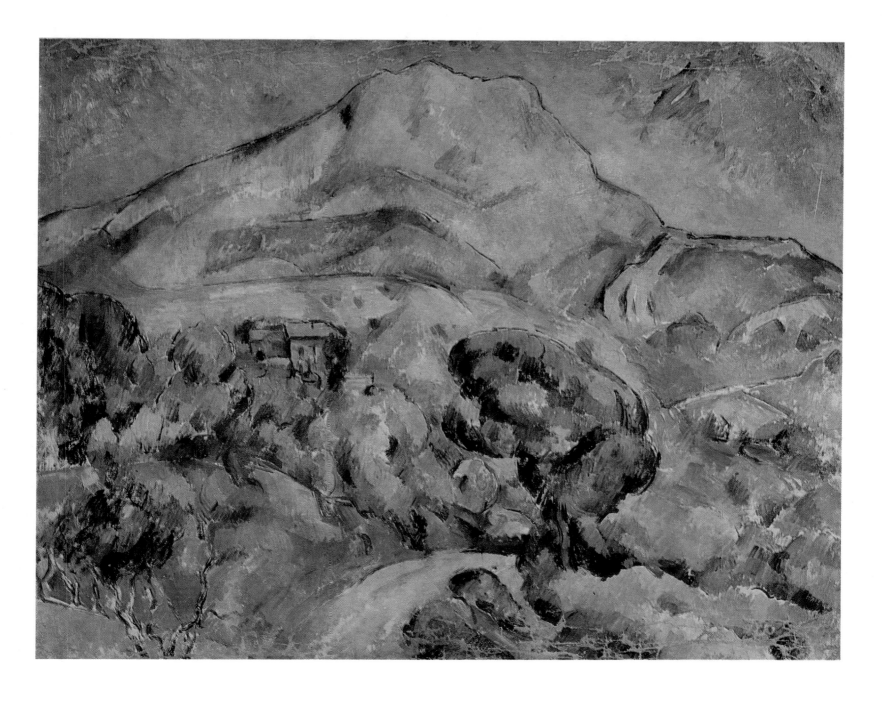

94 MOUNT SAINTE-VICTOIRE

Oil on canvas. 78×99 cm

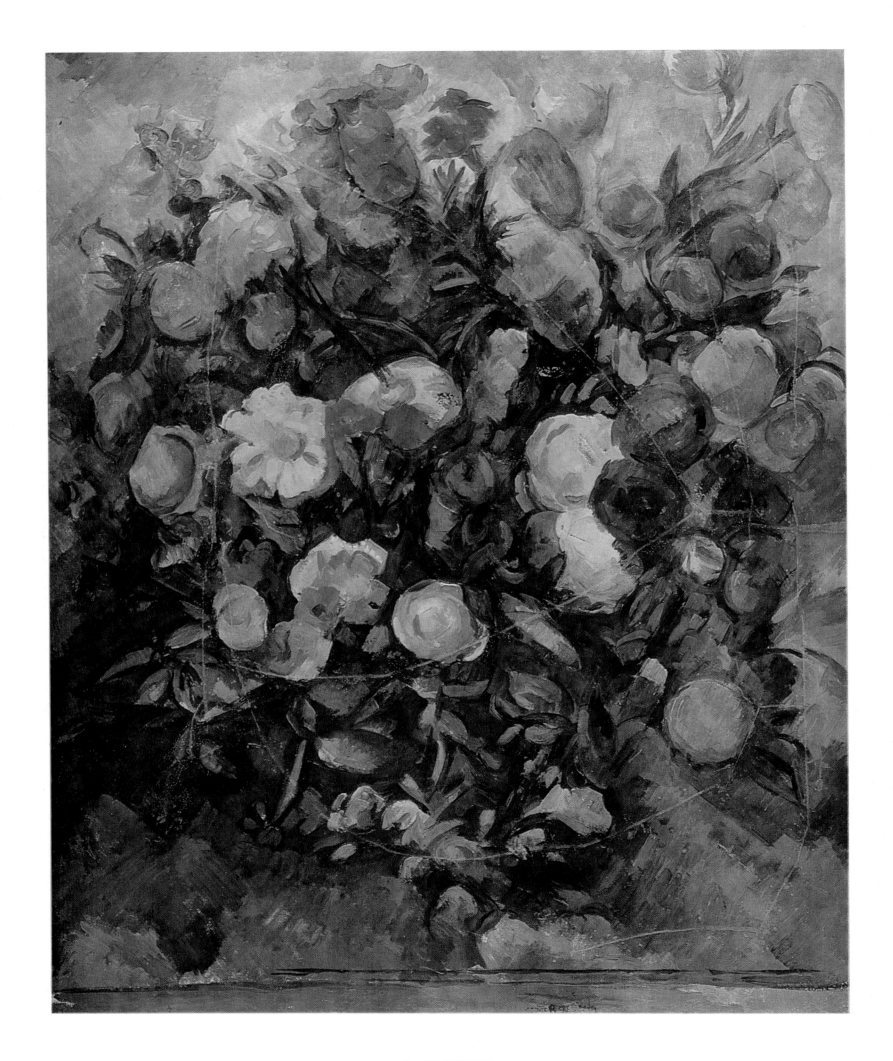

95 FLOWERS

Oil on canvas. 77×64 cm

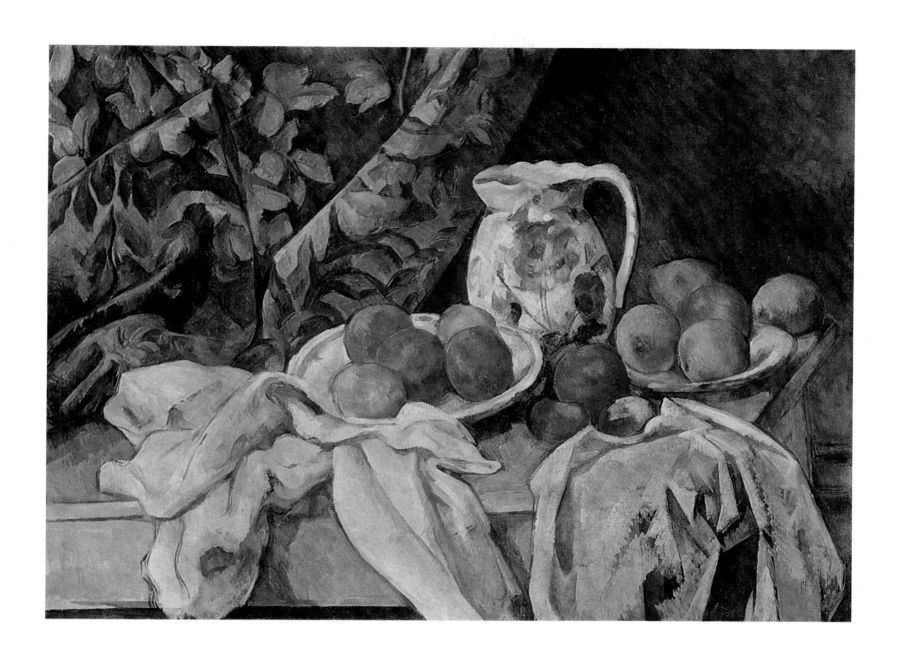

96, 97 STILL LIFE WITH CURTAIN

Oil on canvas. 54.7×74 cm

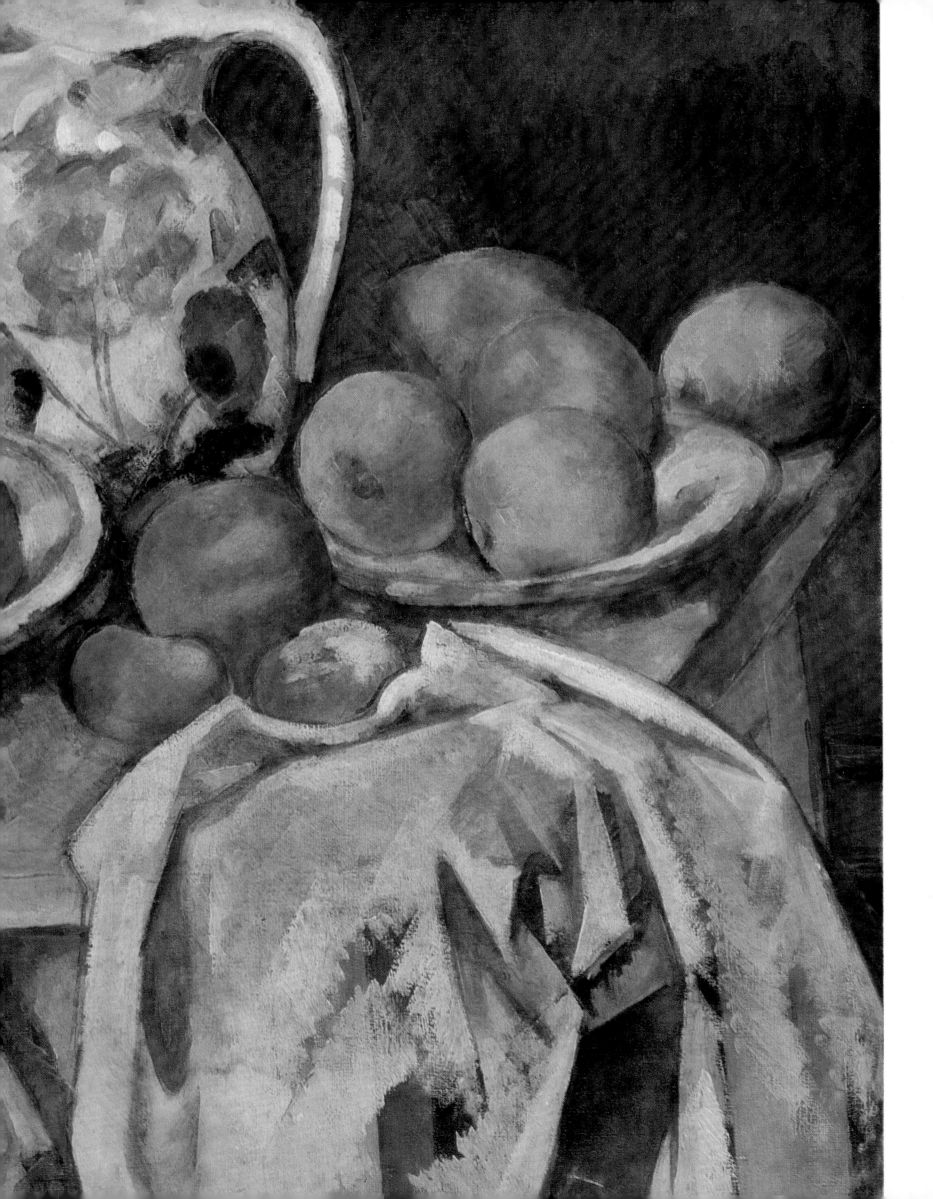

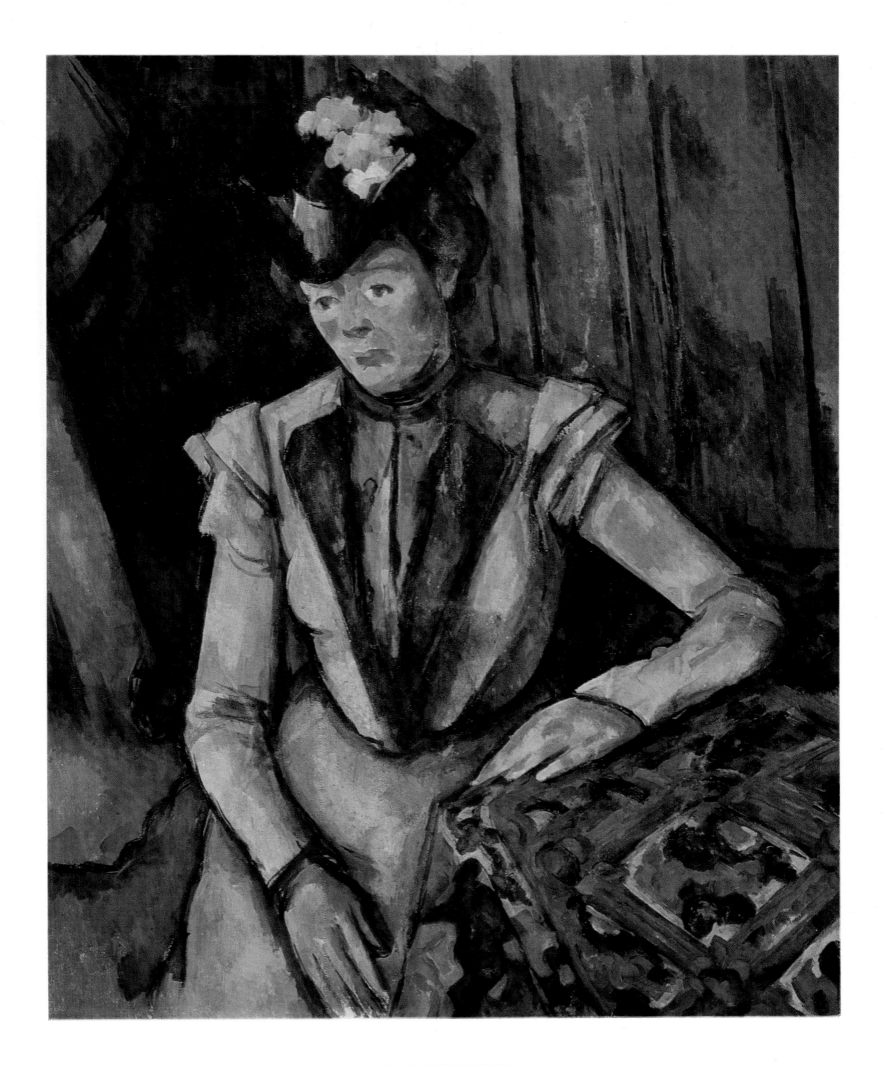

98 LADY IN BLUE

Oil on canvas. 88.5×72 cm

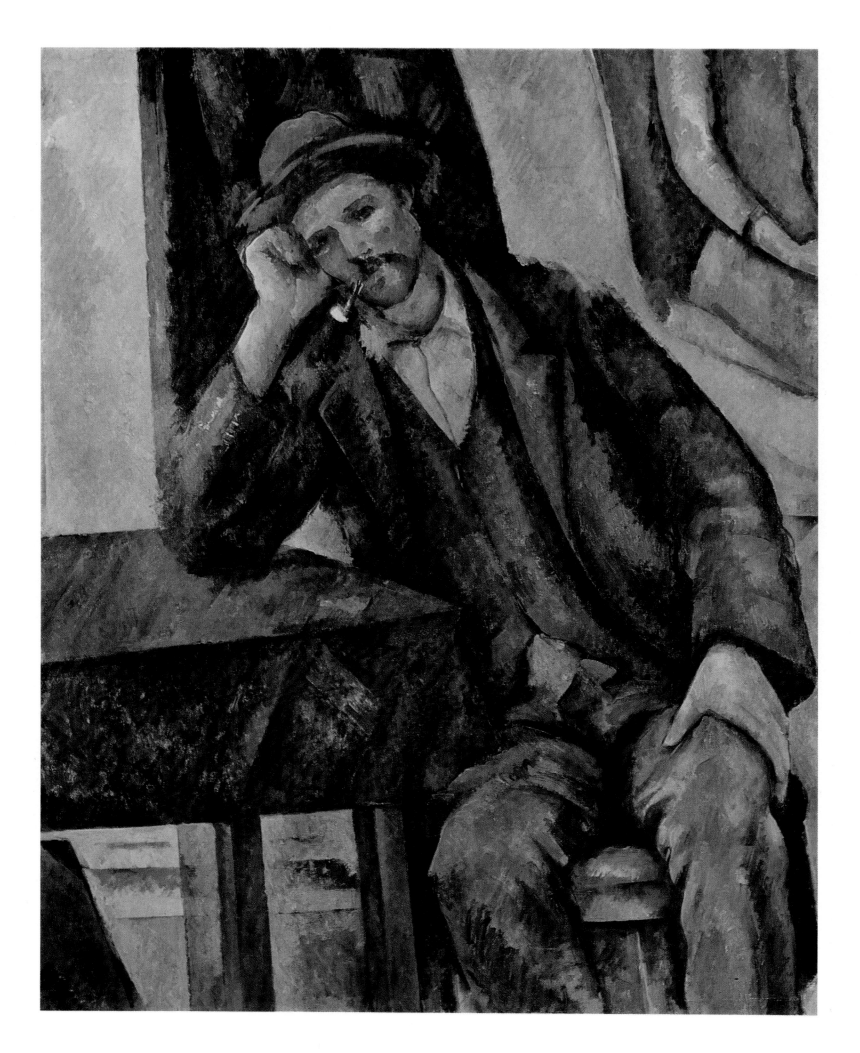

99 MAN SMOKING A PIPE

Oil on canvas. 91×72 cm

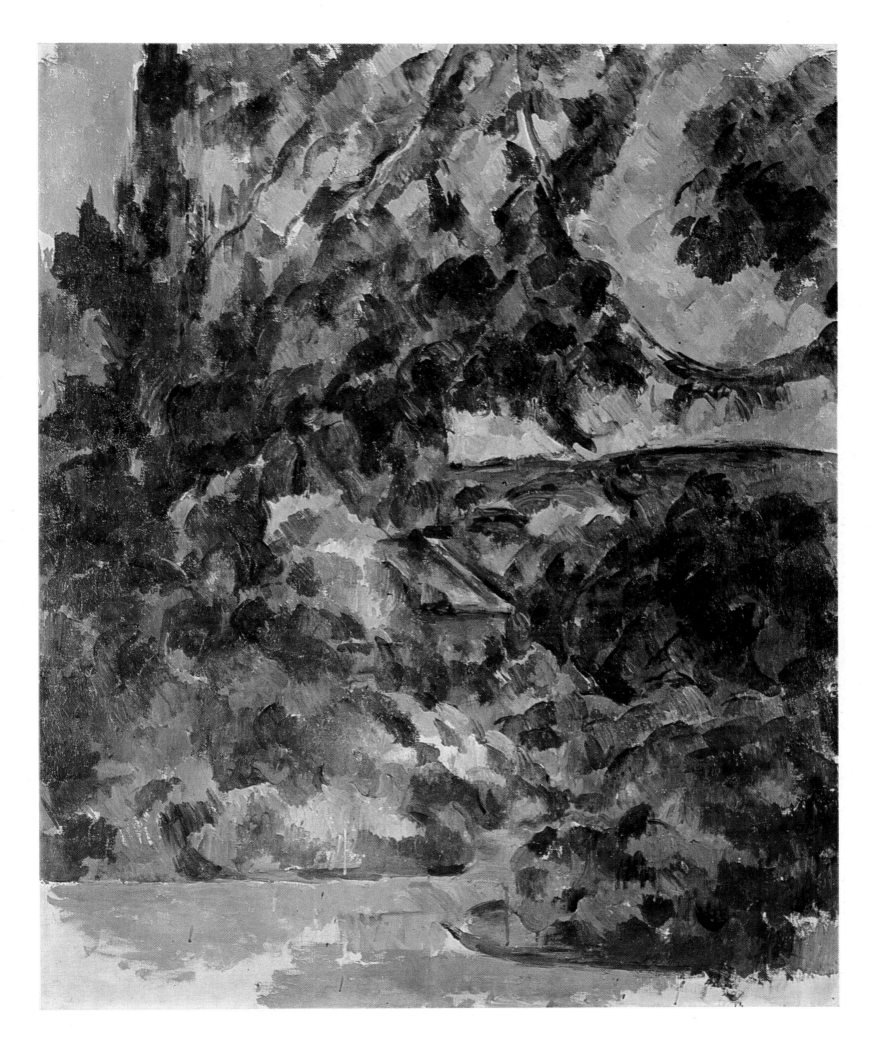

100 BLUE LANDSCAPE

Oil on canvas. 102×83 cm

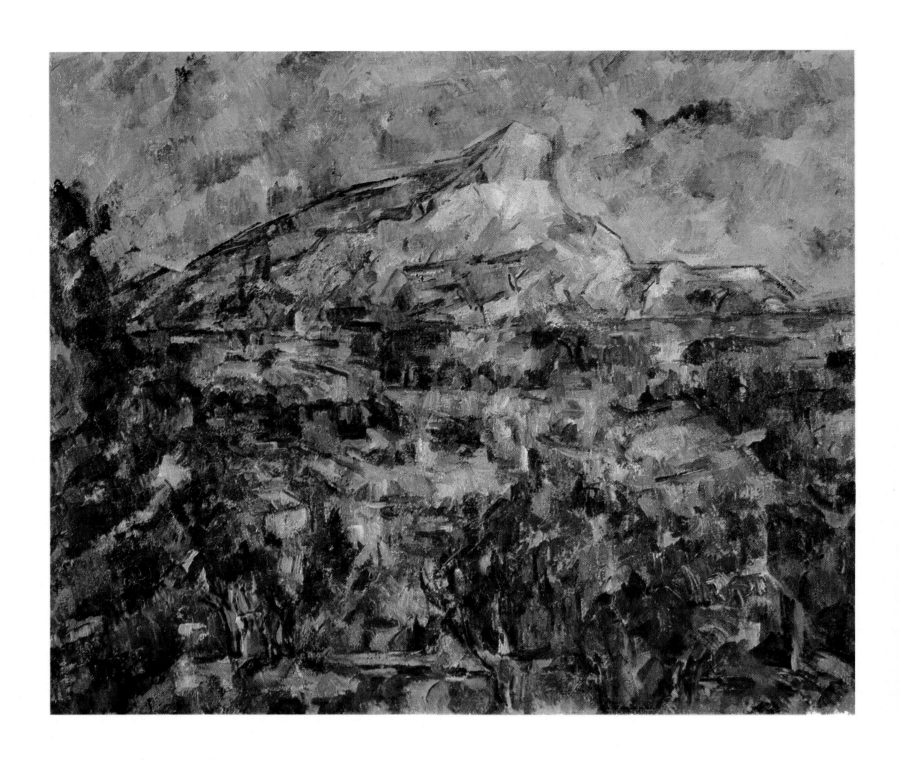

101 LANDSCAPE AT AIX (MOUNT SAINTE-VICTOIRE)

Oil on canvas. 60×73 cm

P. Signac

PAUL SIGNAC. 1863—1935

102 SPRING IN PROVENCE

Oil on canvas, mounted on cardboard. 26.5×35 cm

103 HARBOUR AT MARSEILLES

Oil on canvas. 46×55 cm

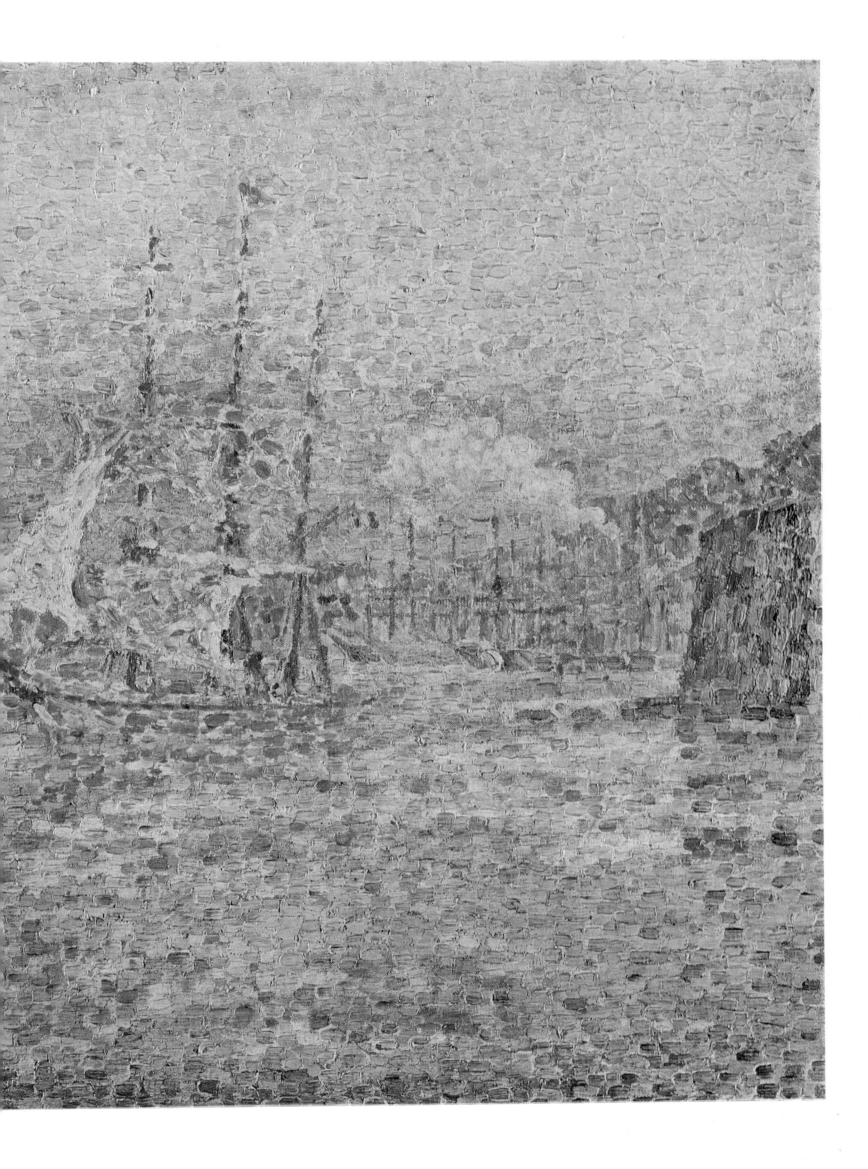

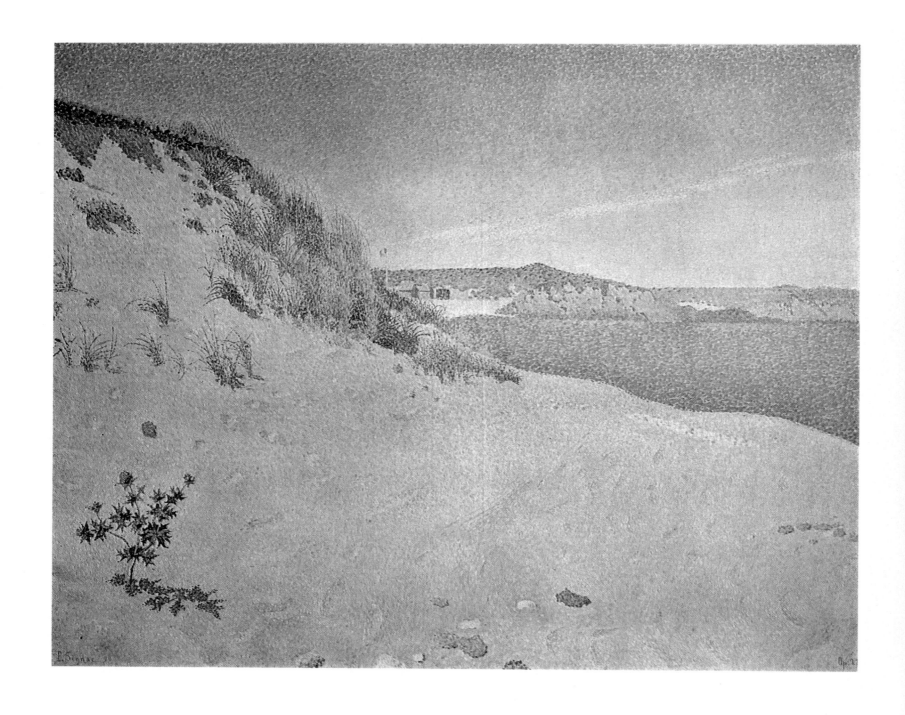

104 SANDY SEASHORE

Oil on canvas. 65×81 cm

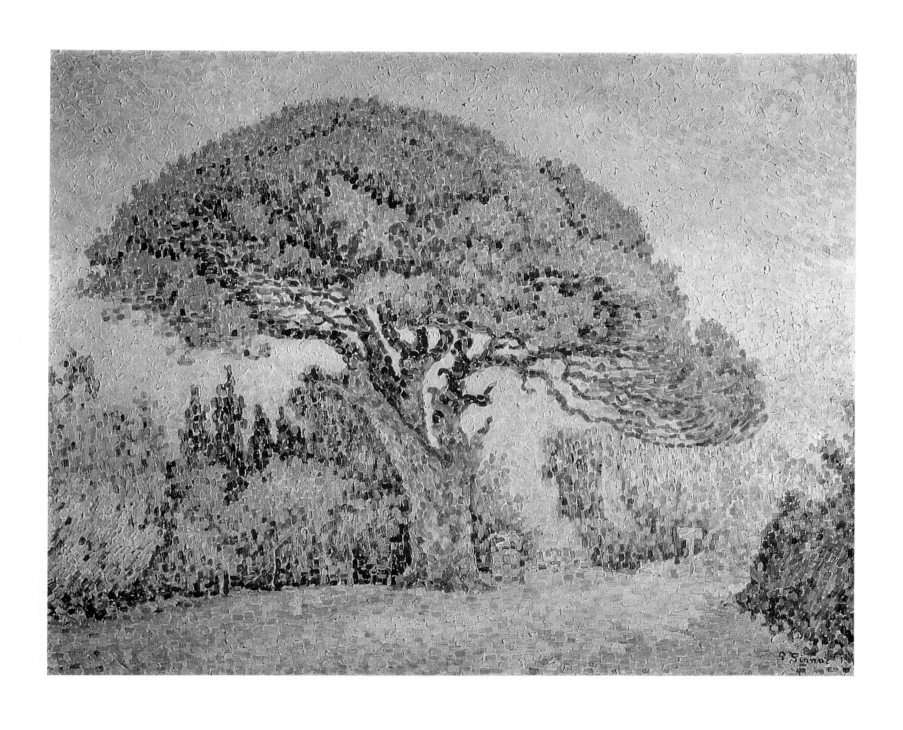

105 THE PINE TREE AT SAINT-TROPEZ

Oil on canvas. 72×92 cm

HENRI-EDMOND CROSS (DELACROIX). 1856—1910

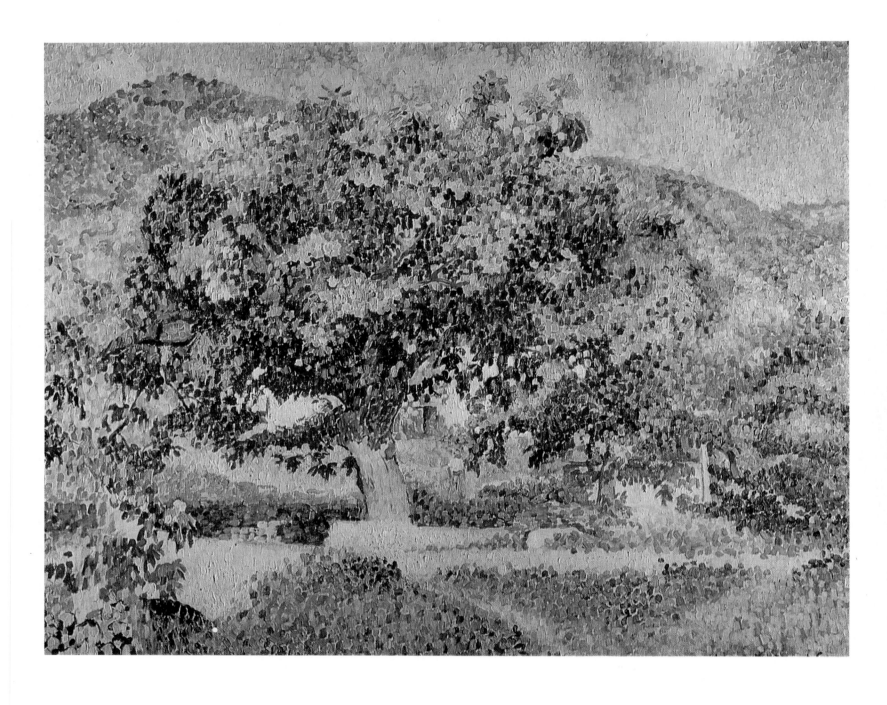

106 AROUND MY HOUSE

Oil on canvas. 61×79 cm

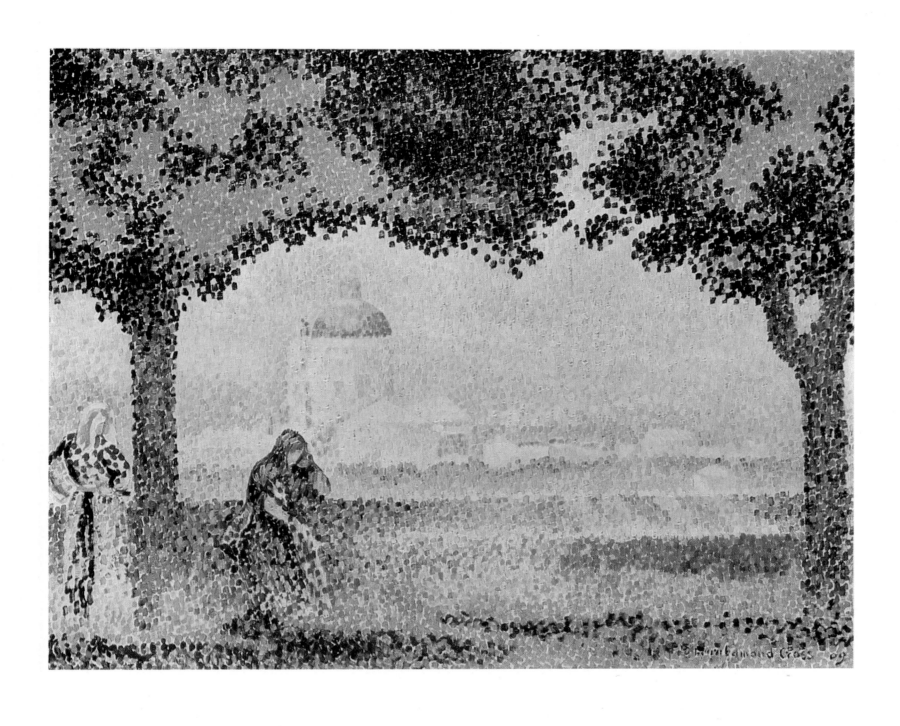

107 VIEW OF SANTA MARIA DEGLI ANGELI NEAR ASSISI

Oil on canvas. 74×92 cm

VINCENT VAN GOGH. 1853—1890

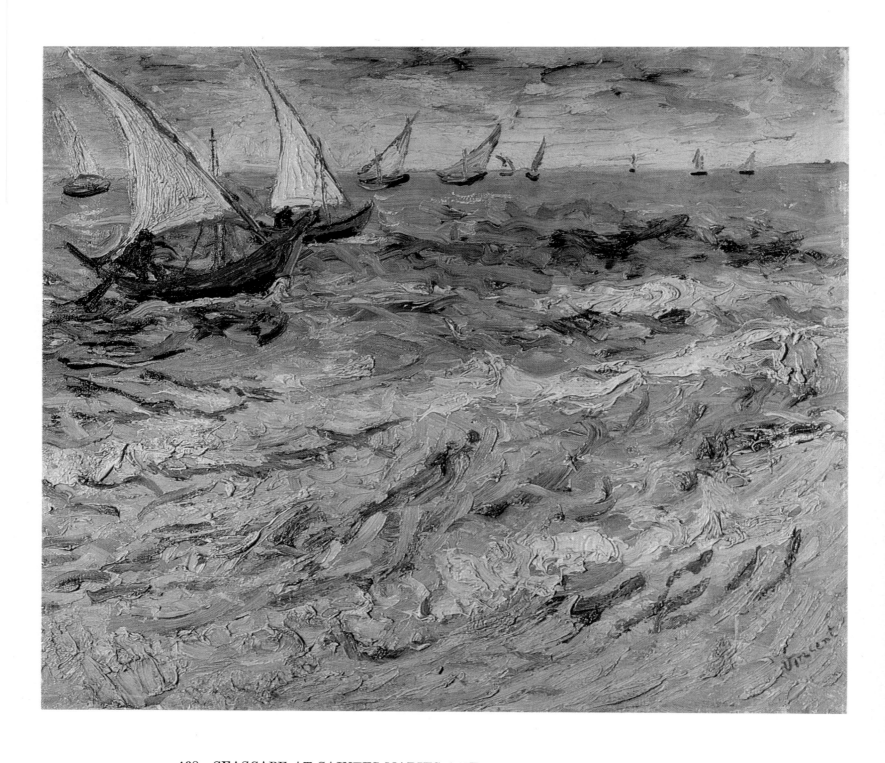

108 SEASCAPE AT SAINTES-MARIES (VIEW OF THE MEDITERRANEAN)

Oil on canvas. 44×53 cm

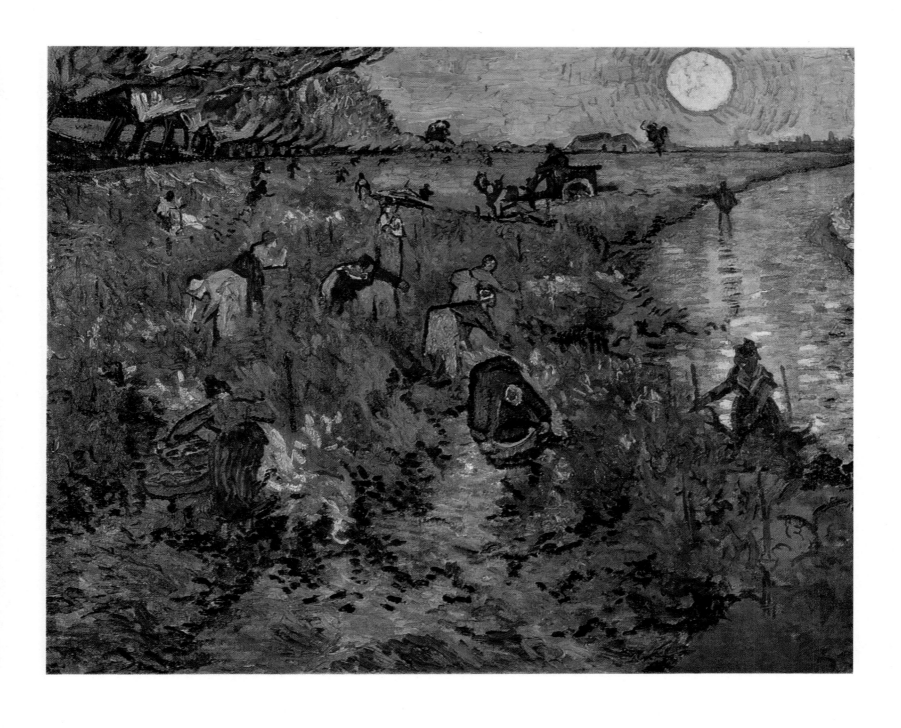

109, 110 THE RED VINEYARD AT ARLES

Oil on canvas. 73×91 cm

111 LA MOUSMÉ (PORTRAIT OF A YOUNG GIRL)

Indian ink, pen, reed pen, and pencil on paper. 33×25 cm

112 THE ARENA AT ARLES

Oil on canvas. 72×92 cm

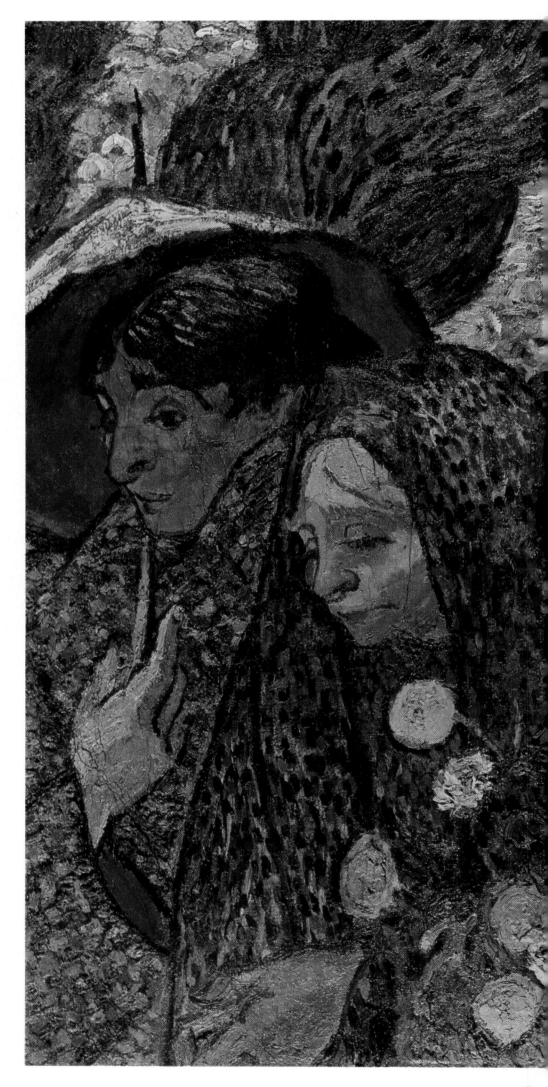

113 LADIES OF ARLES (REMINISCENCE
OF THE GARDEN AT ETTEN)

Oil on canvas. 73.5×92.5 cm

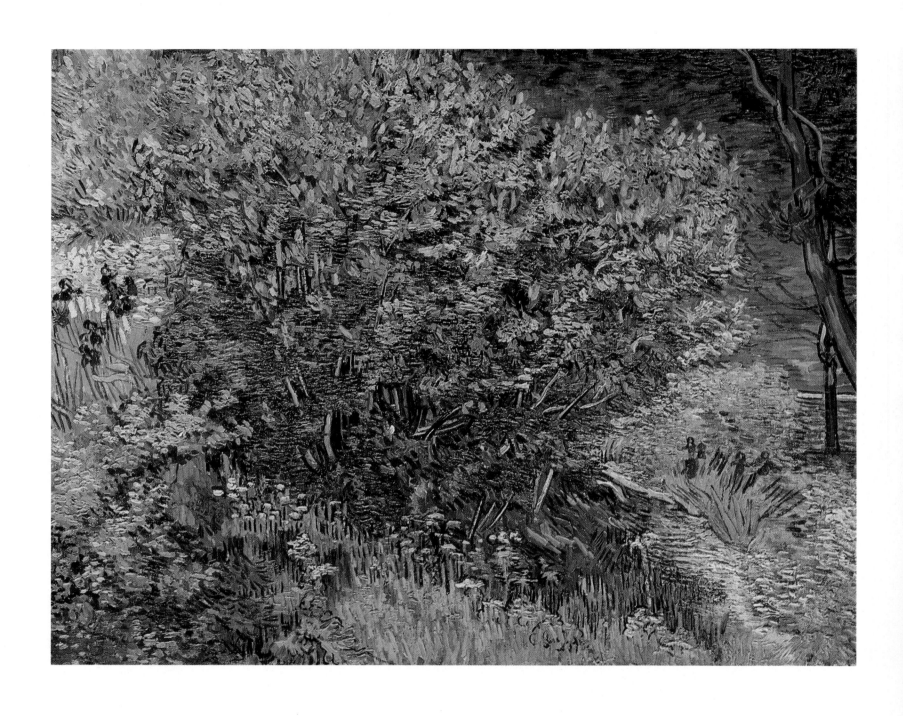

114 LILAC BUSH

Oil on canvas. 72×92 cm

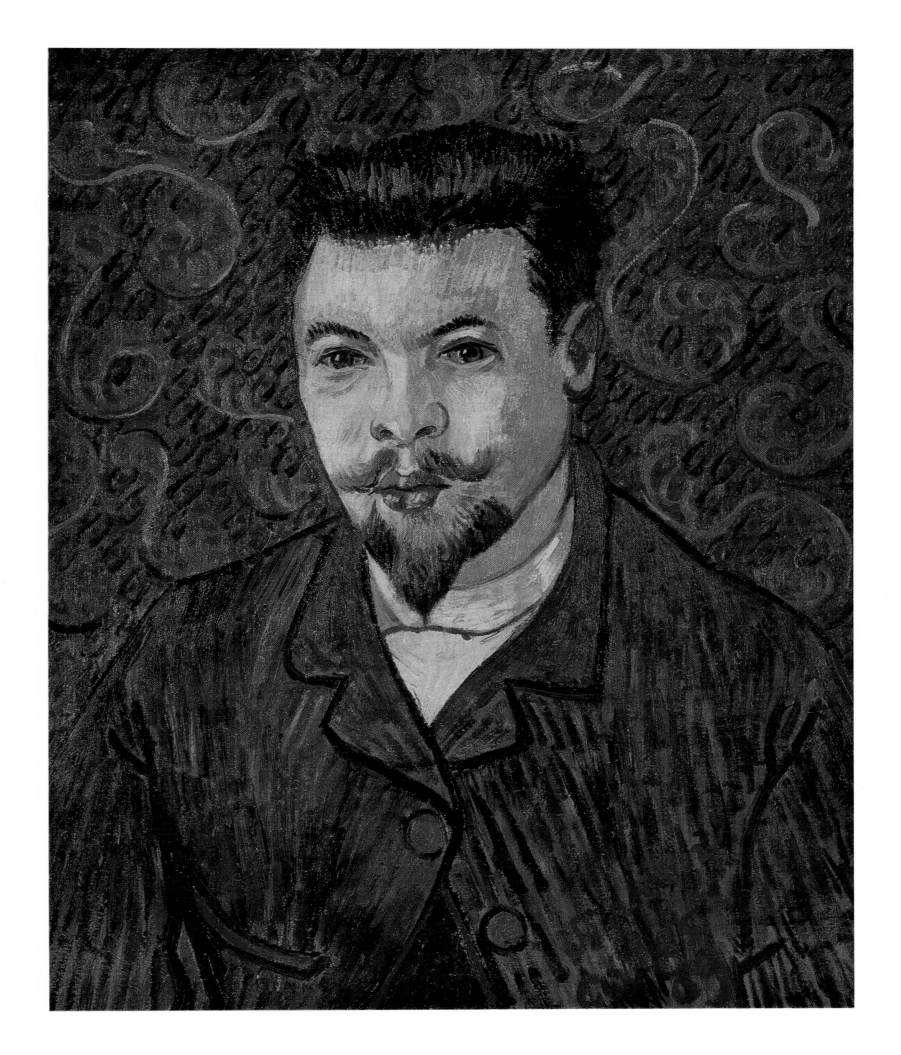

115 PORTRAIT OF DR. REY

Oil on canvas. 64×53 cm

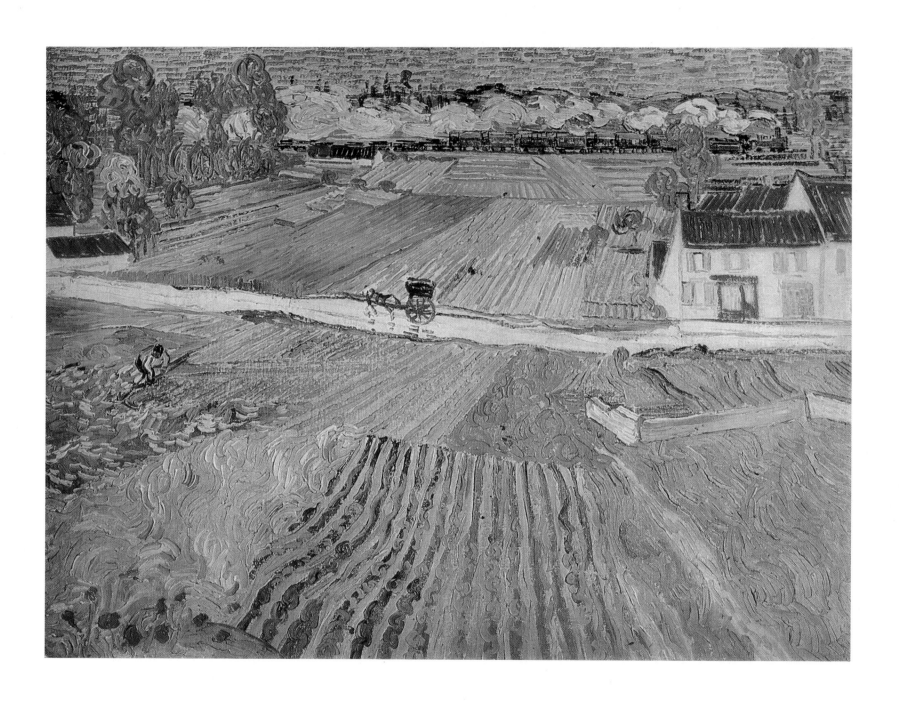

116 LANDSCAPE AT AUVERS AFTER THE RAIN
(FIELDS SEEN FROM A HEIGHT)

Oil on canvas. 72×90 cm

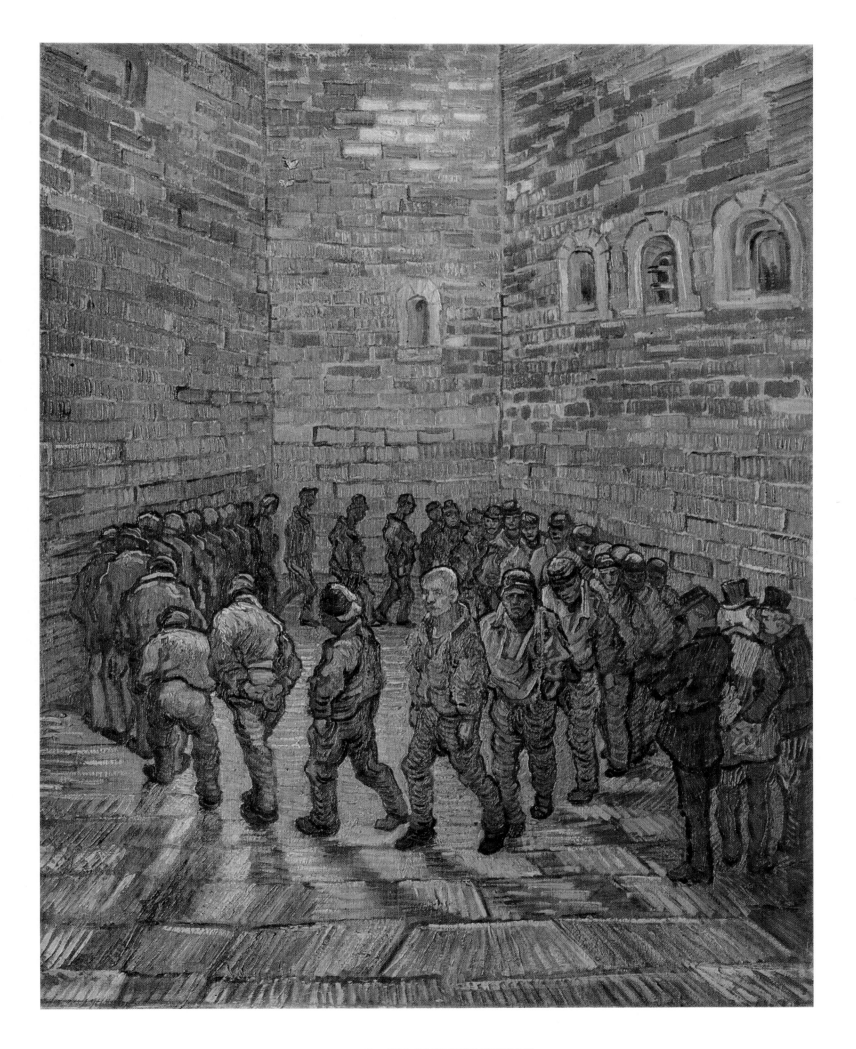

117 THE CONVICT PRISON

Oil on canvas. 80×64 cm

118 COTTAGES

Oil on canvas. 60×73 cm

PAUL GAUGUIN. 1848—1903

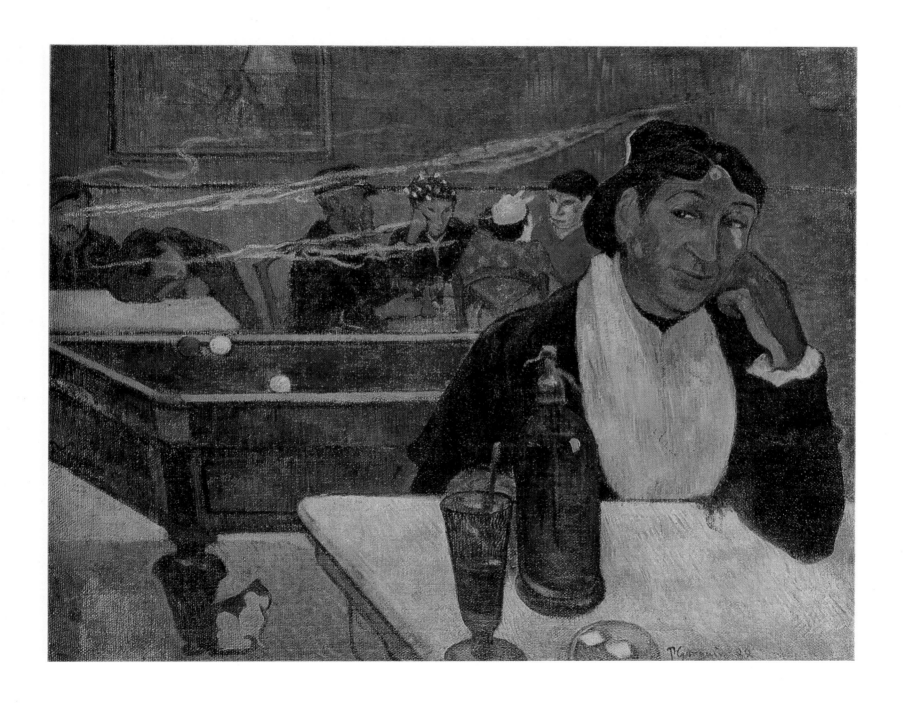

119 CAFÉ AT ARLES

Oil on canvas. 72×92 cm

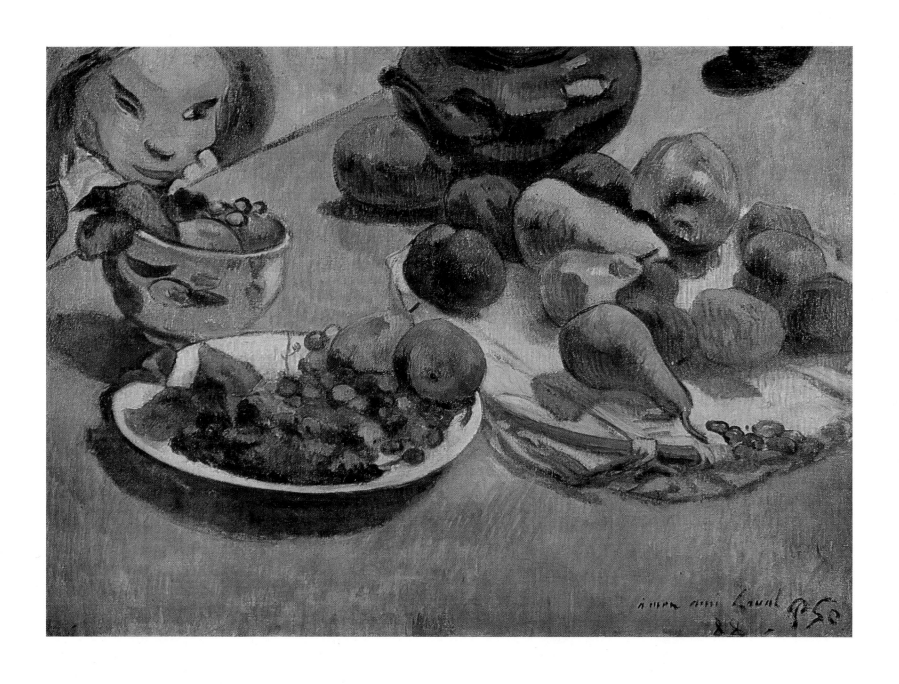

120 FRUIT

Oil on canvas. 43×58 cm

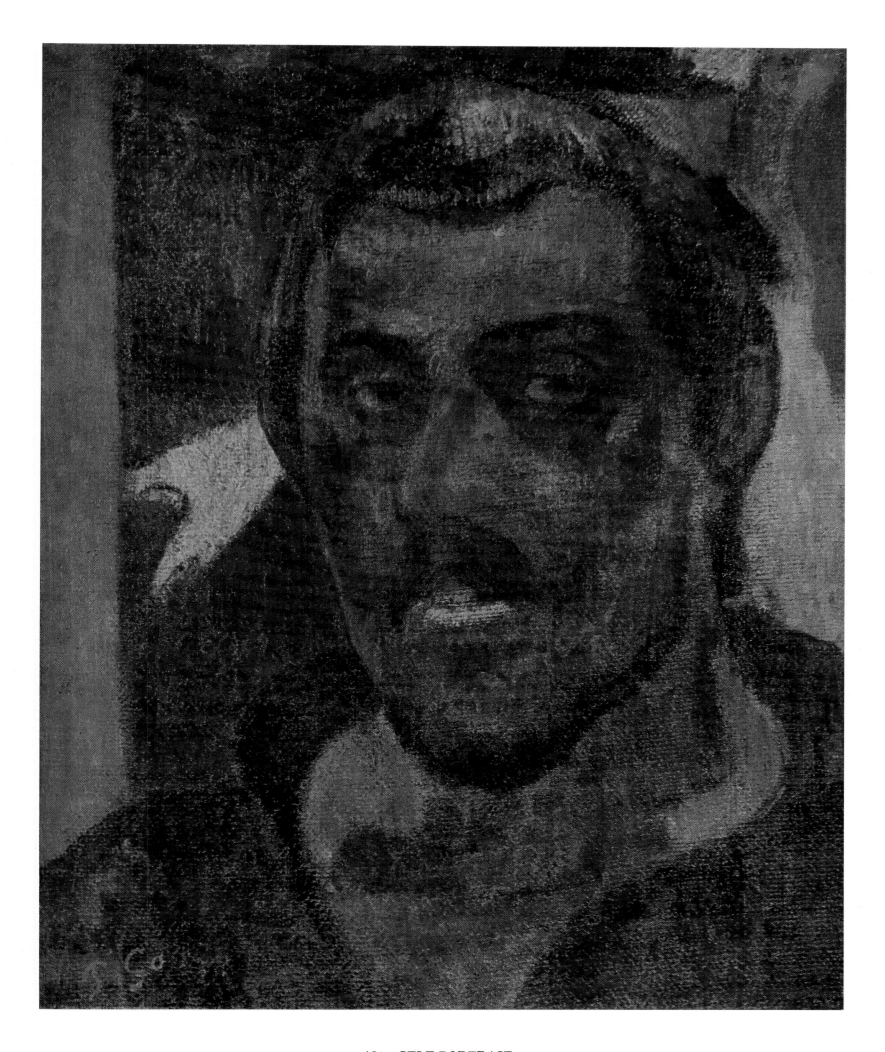

121 SELF-PORTRAIT

Oil on canvas. 46×38 cm

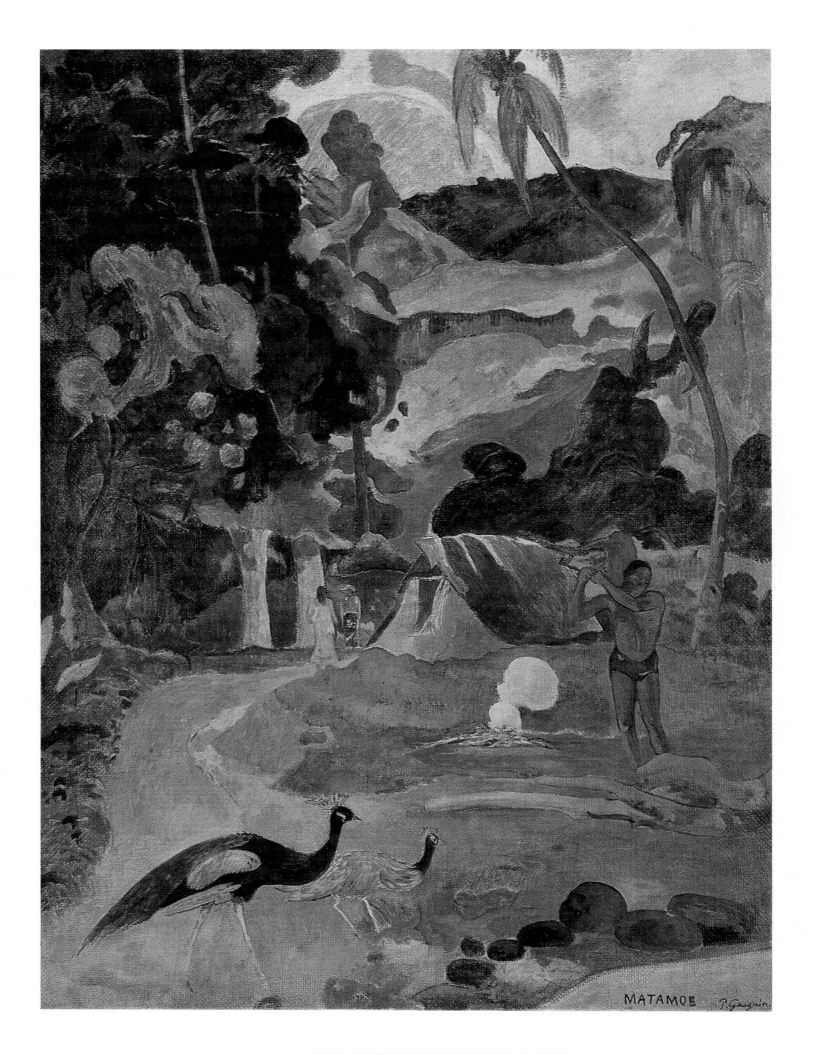

122 LANDSCAPE WITH PEACOCKS

Oil on canvas. 115×86 cm

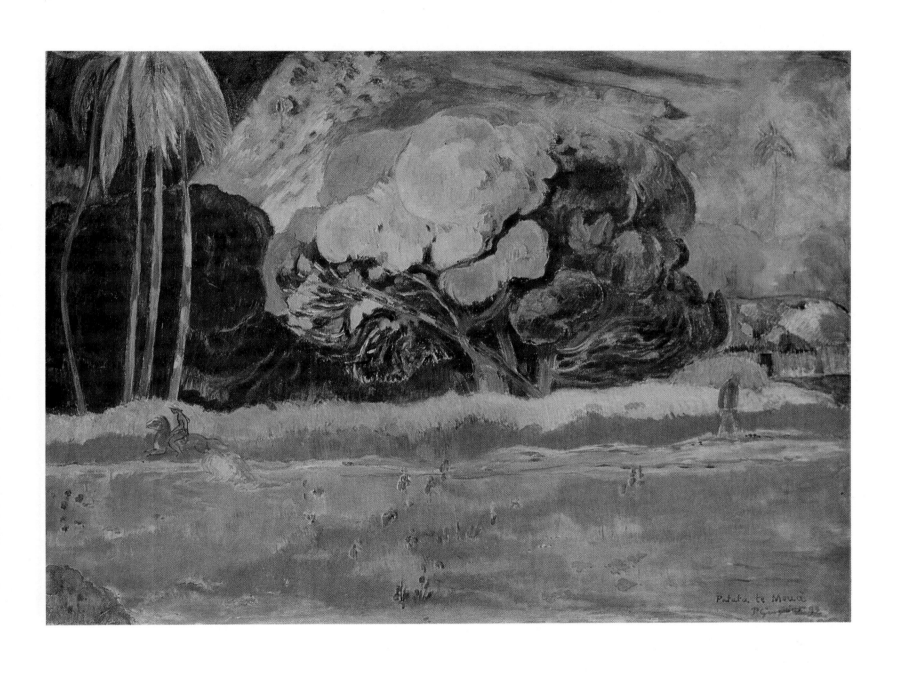

123 THE BIG TREE (AT THE FOOT OF A MOUNTAIN)

Oil on canvas. 67×91 cm

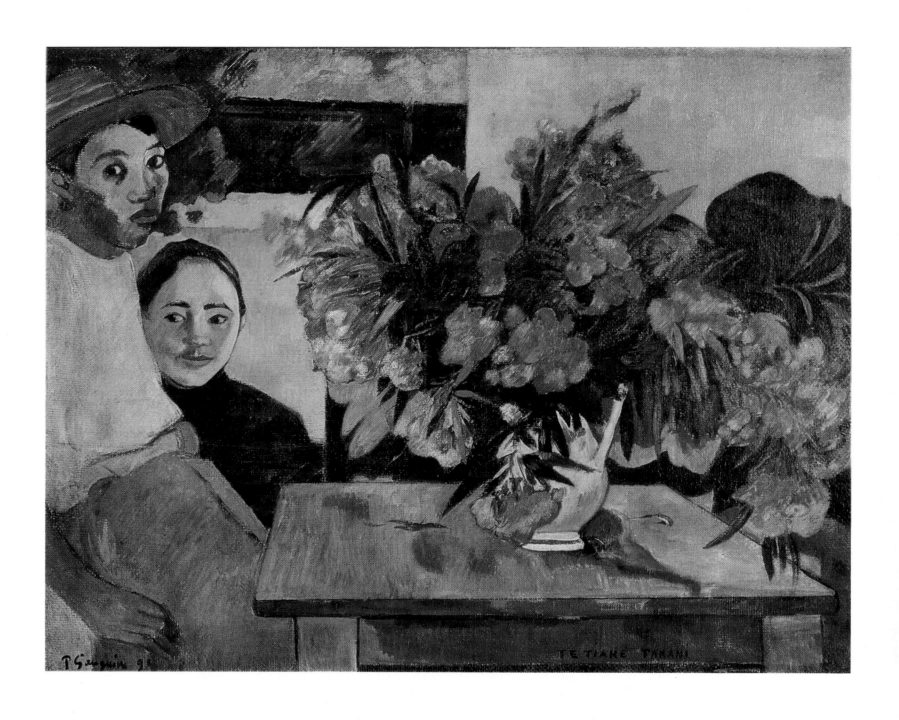

124 THE FLOWERS OF FRANCE

Oil on canvas. 72×92 cm

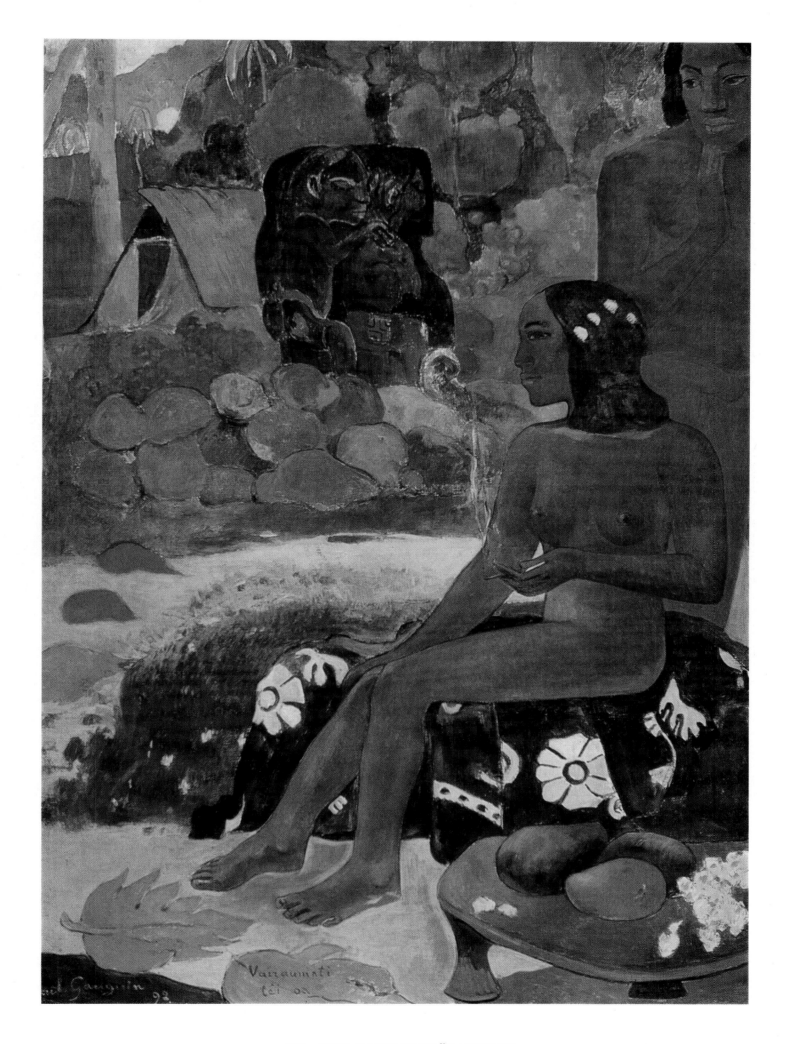

125 HER NAME IS VAÏRAUMATI

Oil on canvas. 91×68 cm

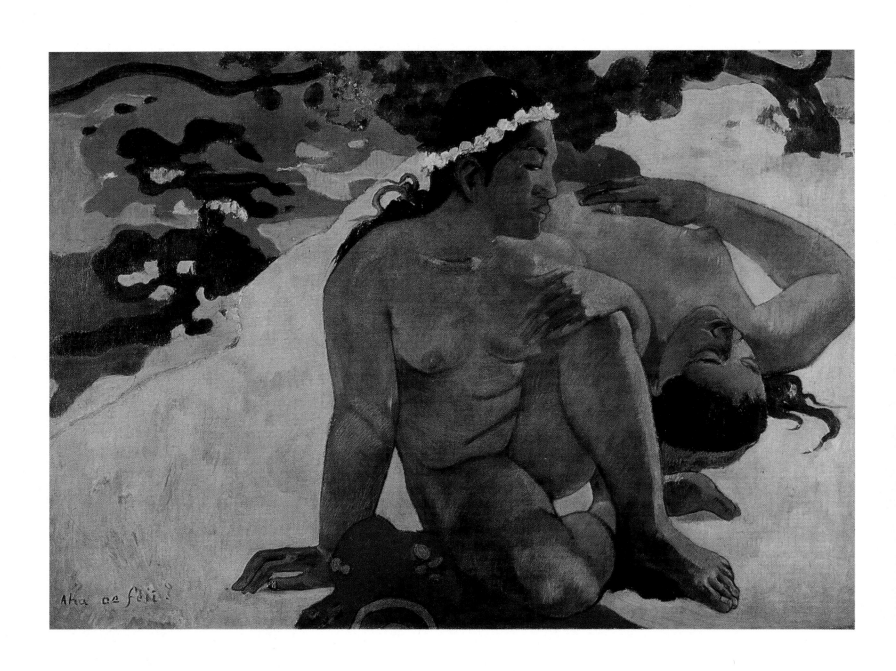

126 ARE YOU JEALOUS?

Oil on canvas. 66×89 cm

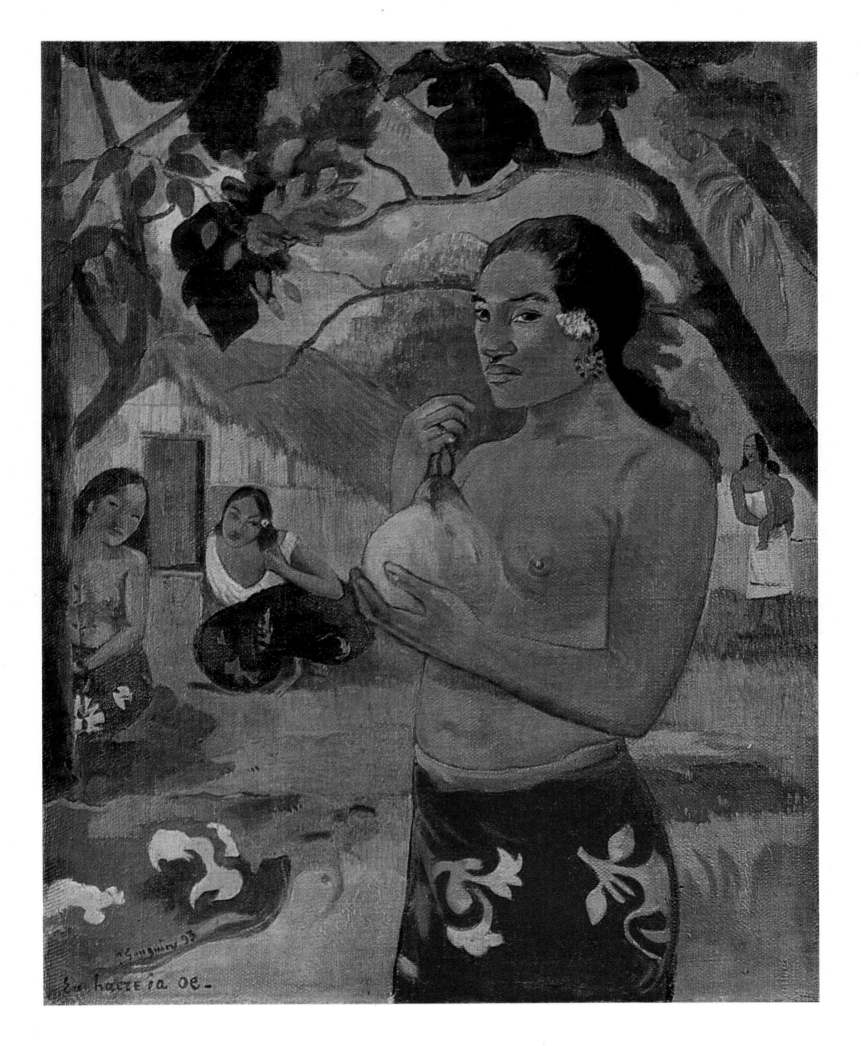

127 WOMAN HOLDING A FRUIT (WHERE ARE YOU GOING?)

Oil on canvas (relined). 92×73 cm

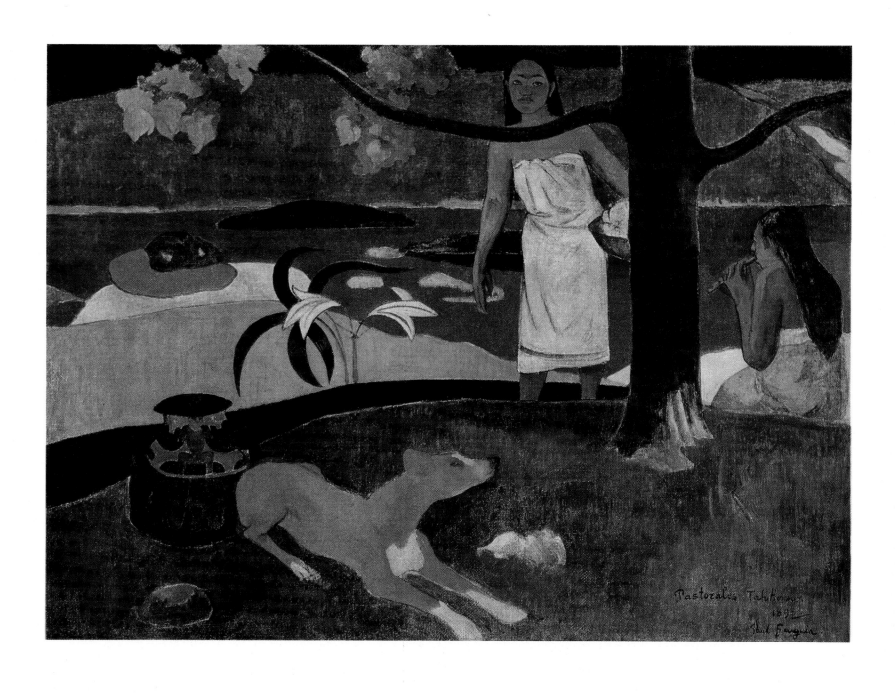

128 PASTORALES TAHITIENNES

Oil on canvas. 86×113 cm

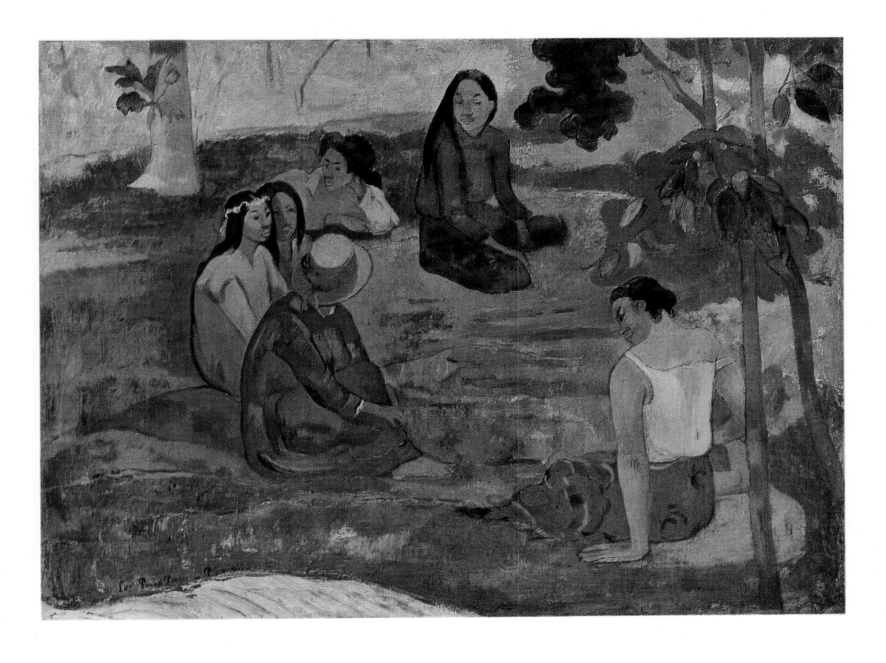

129, 130 CONVERSATION

Oil on canvas (relined). 71×92.5 cm

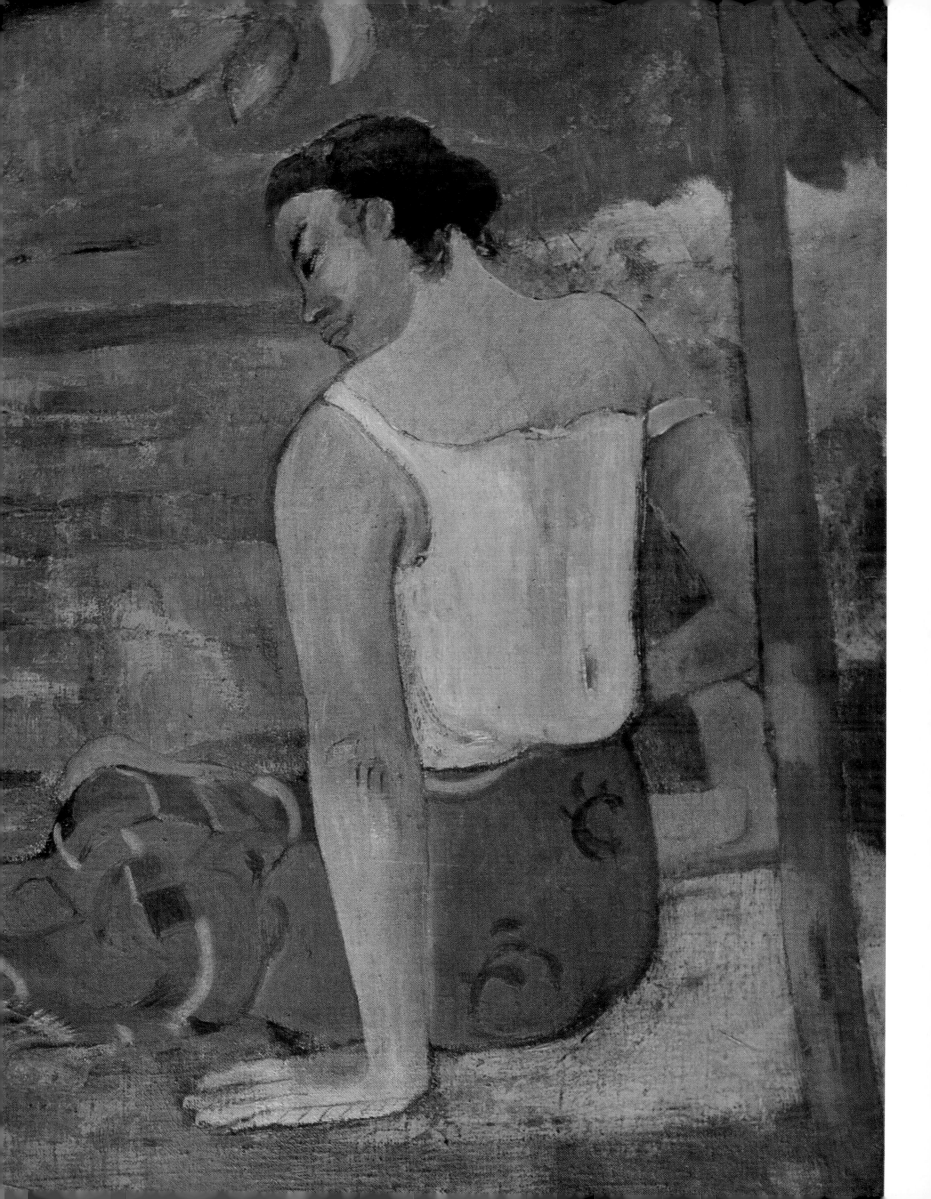

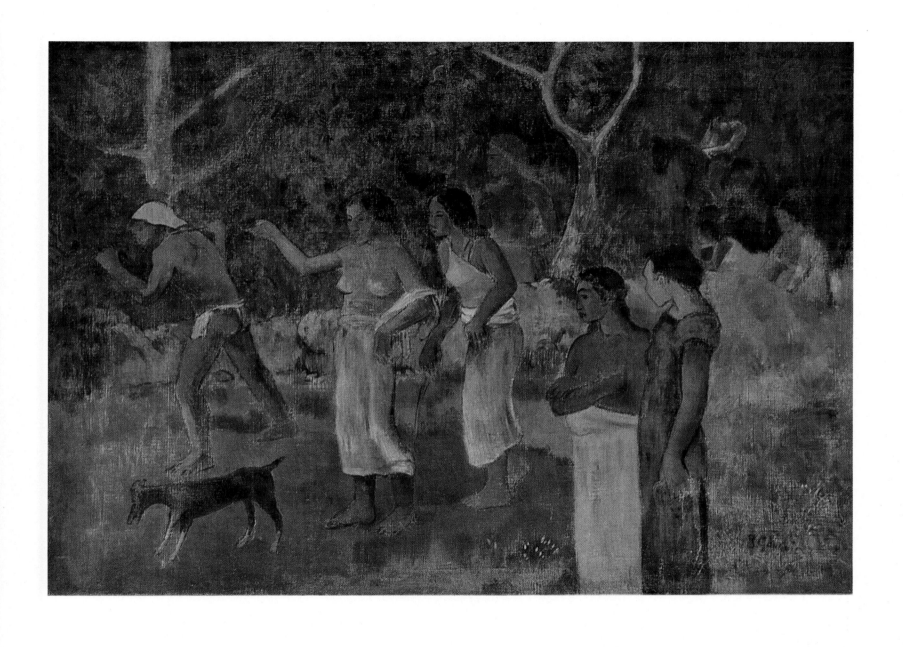

131 SCENE FROM TAHITIAN LIFE

Oil on canvas. 89×125 cm

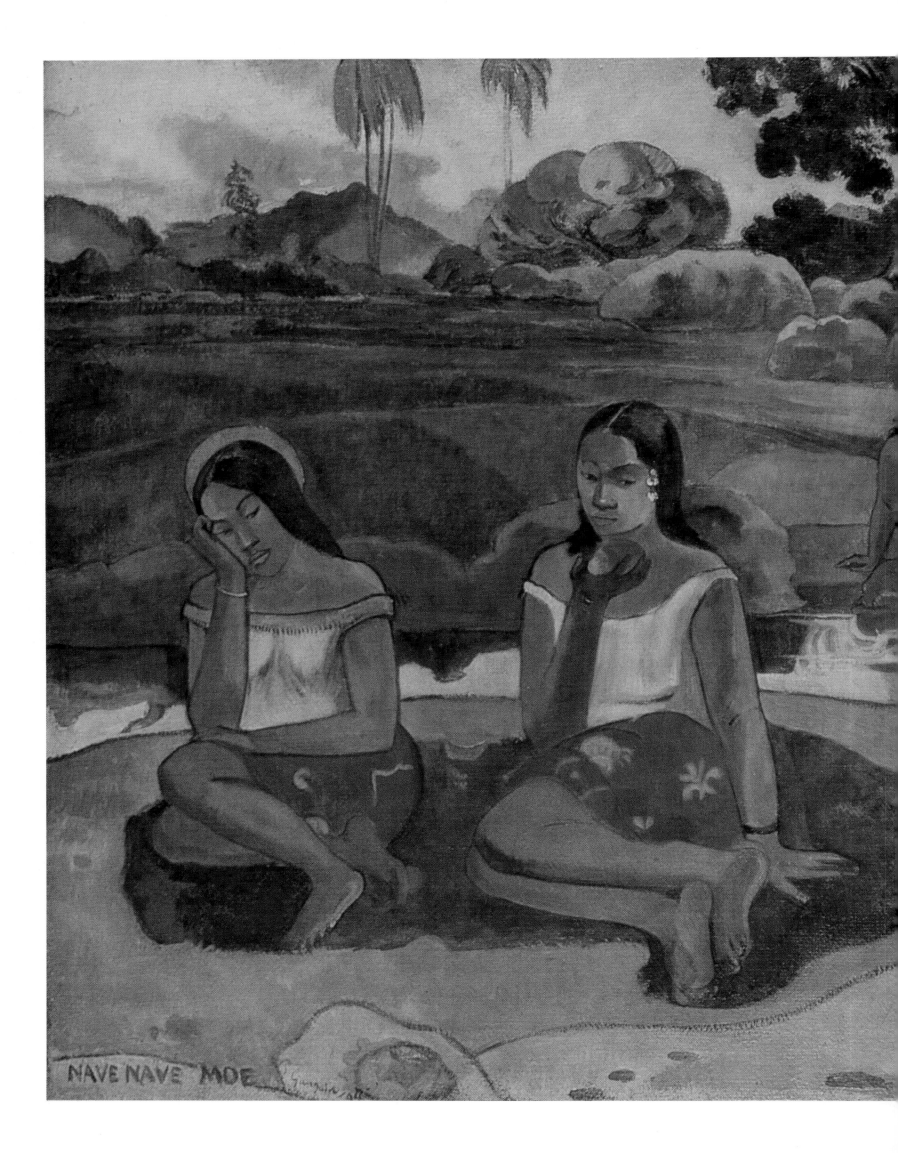

**132 SACRED SPRING
(SWEET DREAMS)**

Oil on canvas (relined). 73×98 cm

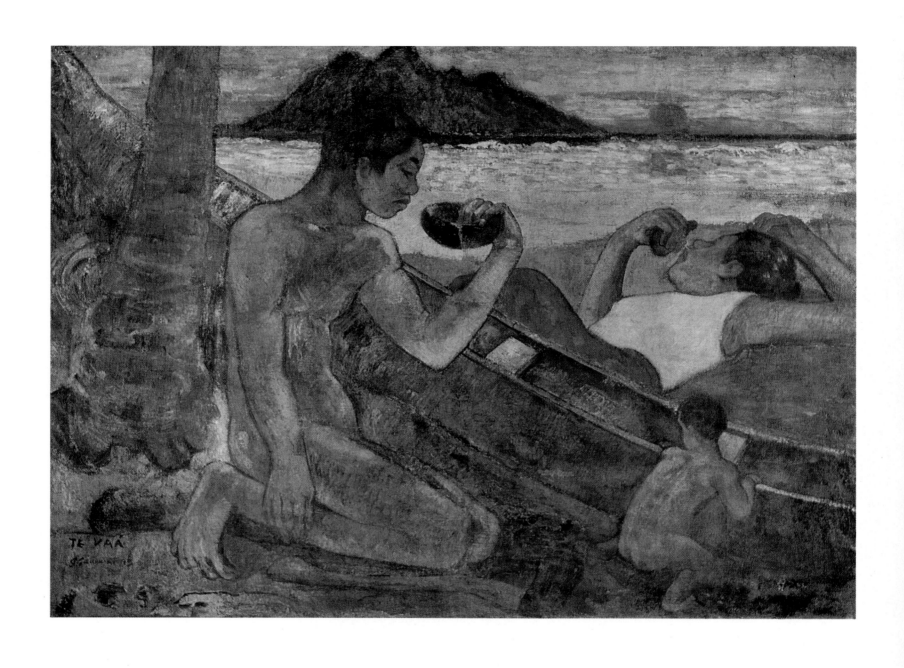

133 THE CANOE (A TAHITIAN FAMILY)

Oil on canvas. 96×130.5 cm

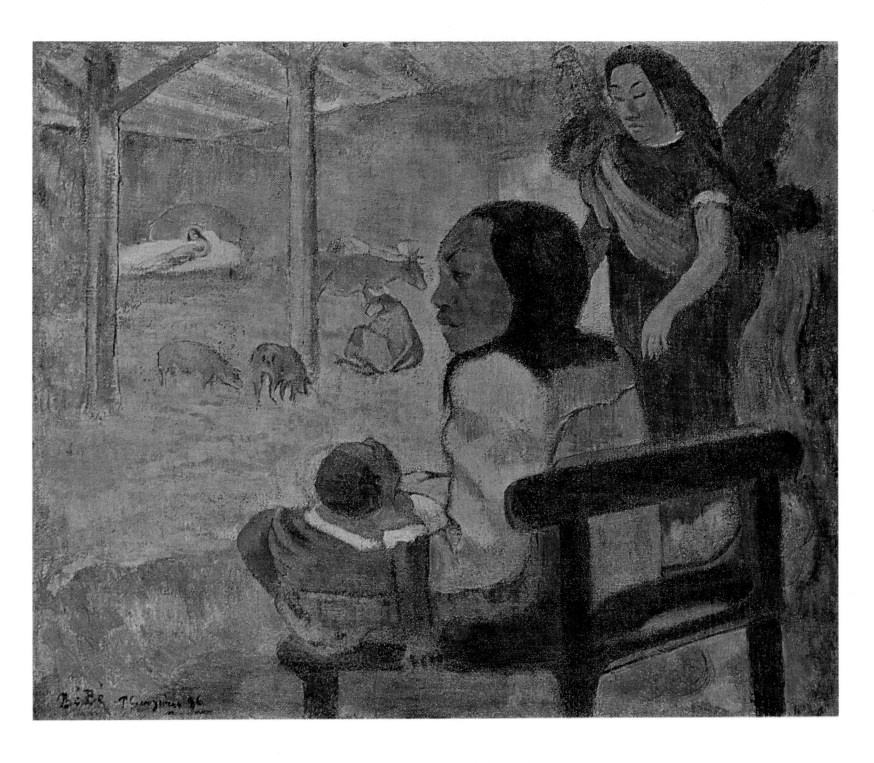

134 BABY (THE NATIVITY)

Oil on canvas. 66×75 cm

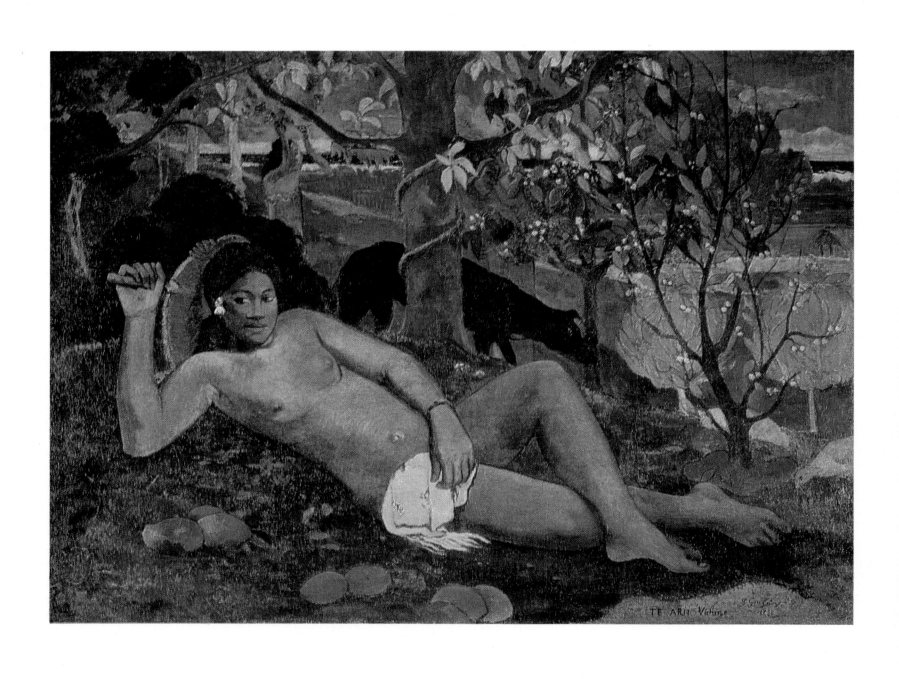

135 THE QUEEN (THE KING'S WIFE)

Oil on canvas. 97×130 cm

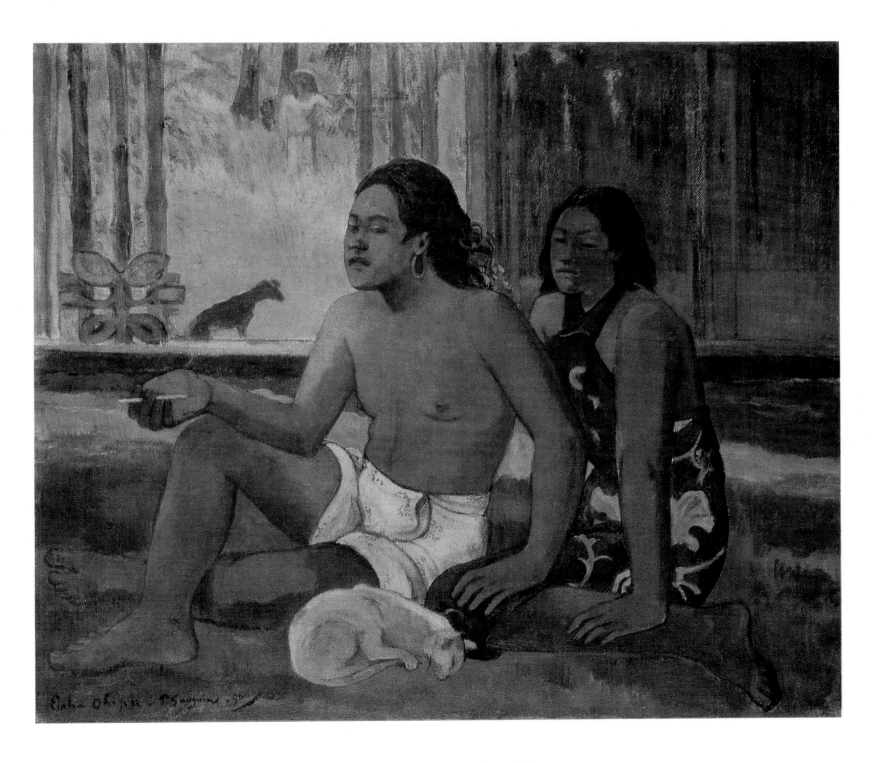

136 TAHITIANS IN A ROOM

Oil on canvas. 65×75 cm

137 MAN PICKING FRUIT FROM A TREE

Oil on canvas. 92×72 cm

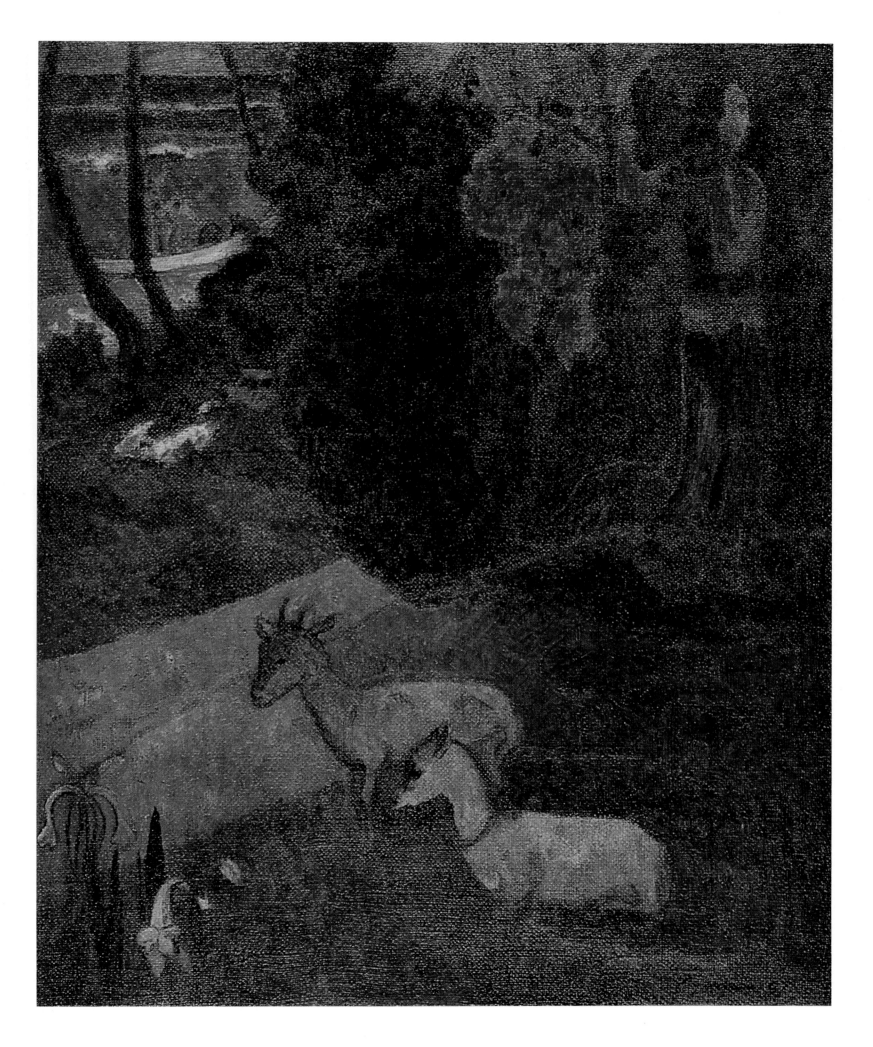

138 LANDSCAPE WITH TWO GOATS

Oil on canvas. 92×73 cm

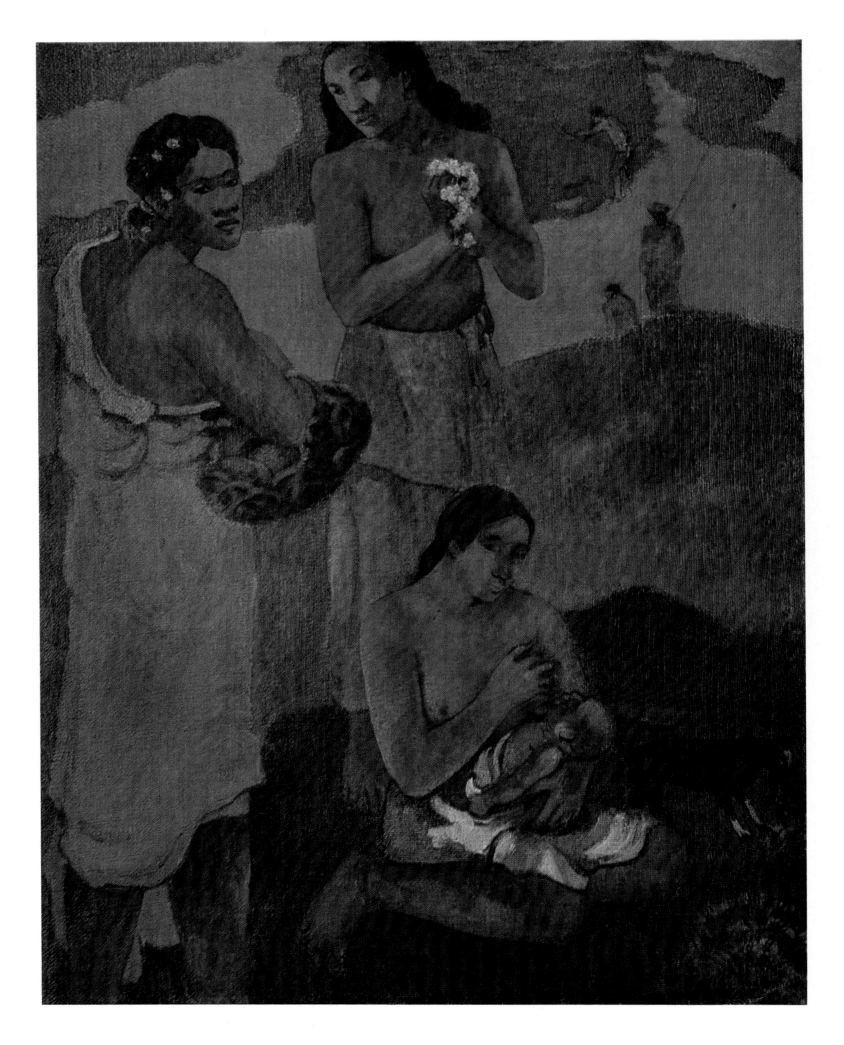

139 MATERNITY (WOMAN ON THE SHORE)

Oil on canvas (relined). 94×72 cm

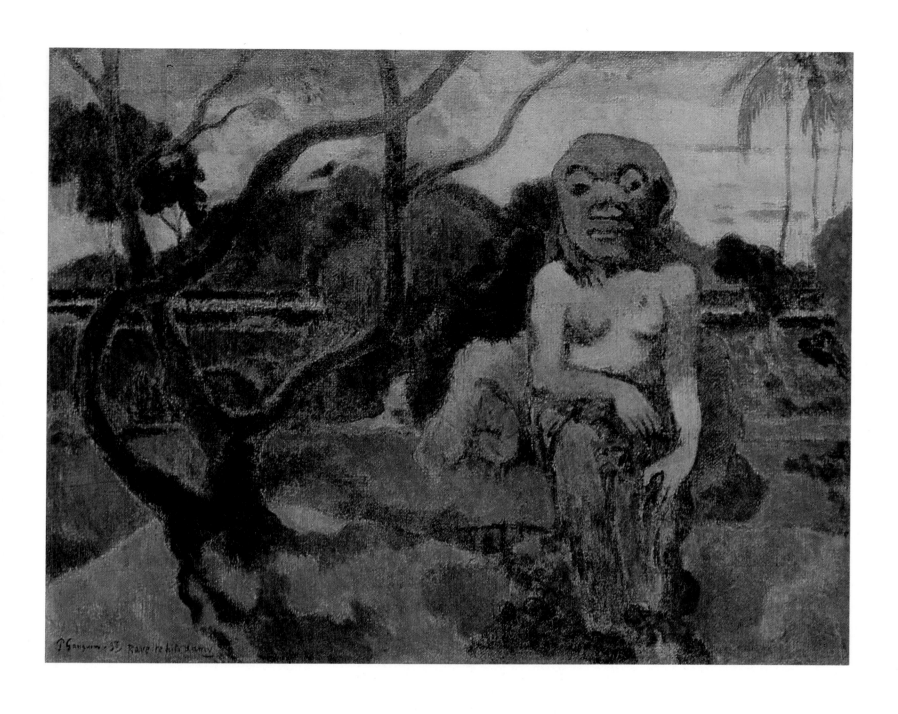

140 THE IDOL

Oil on canvas. 73×91 cm

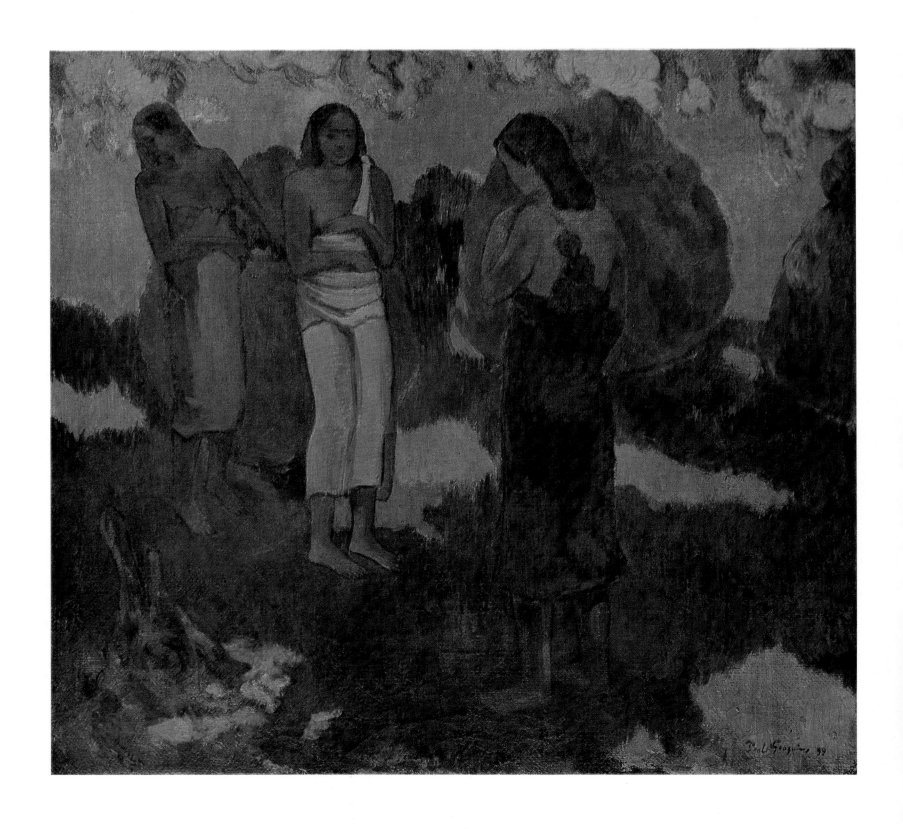

141 THREE TAHITIAN WOMEN AGAINST A YELLOW BACKGROUND

Oil on canvas (relined). 68×74 cm

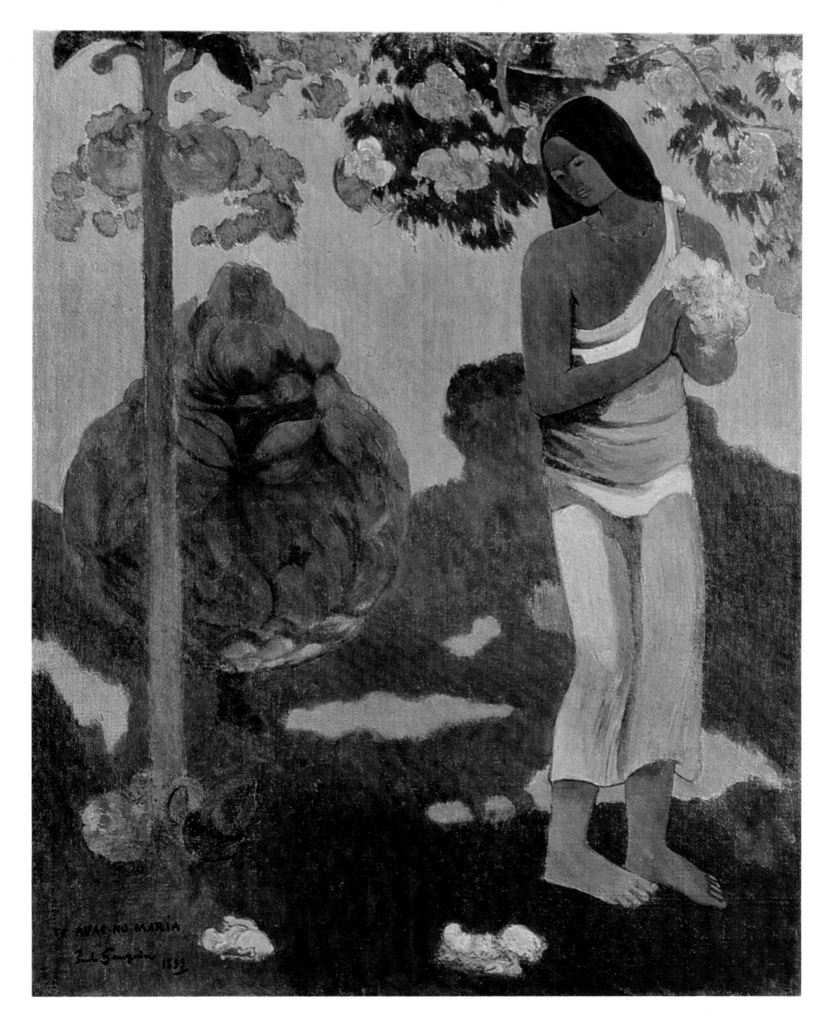

142 WOMAN CARRYING FLOWERS

Oil on canvas. 97×72 cm

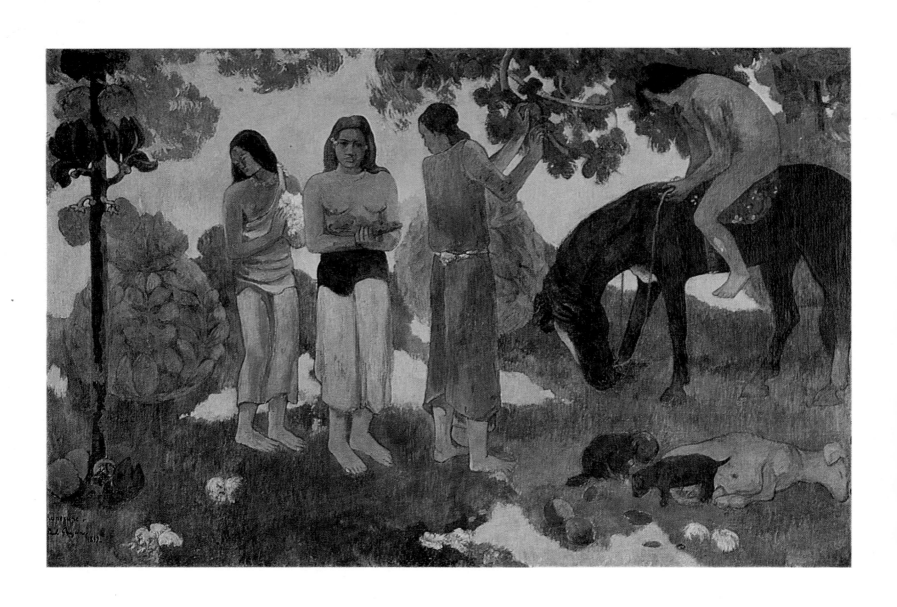

143 GATHERING FRUIT

Oil on canvas. 128×190 cm

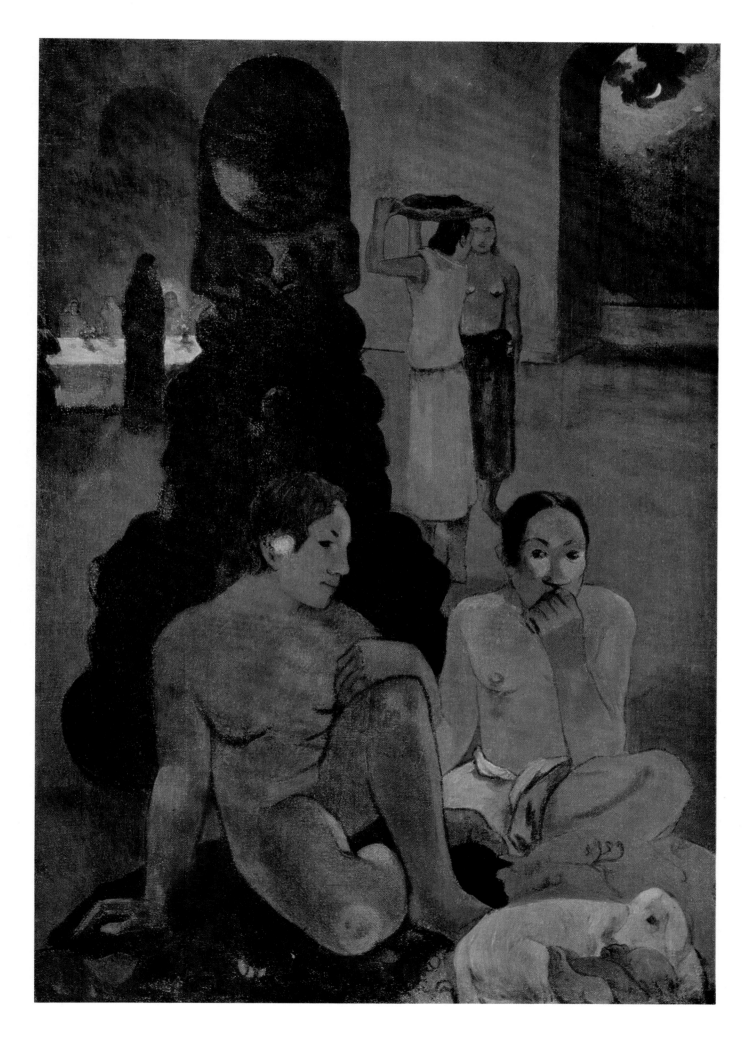

144 THE GREAT BUDDHA

Oil on canvas. 134×95 cm

145 SUNFLOWERS

Oil on canvas. 72×91 cm

146 STILL LIFE WITH PARROTS

Oil on canvas. 62×76 cm

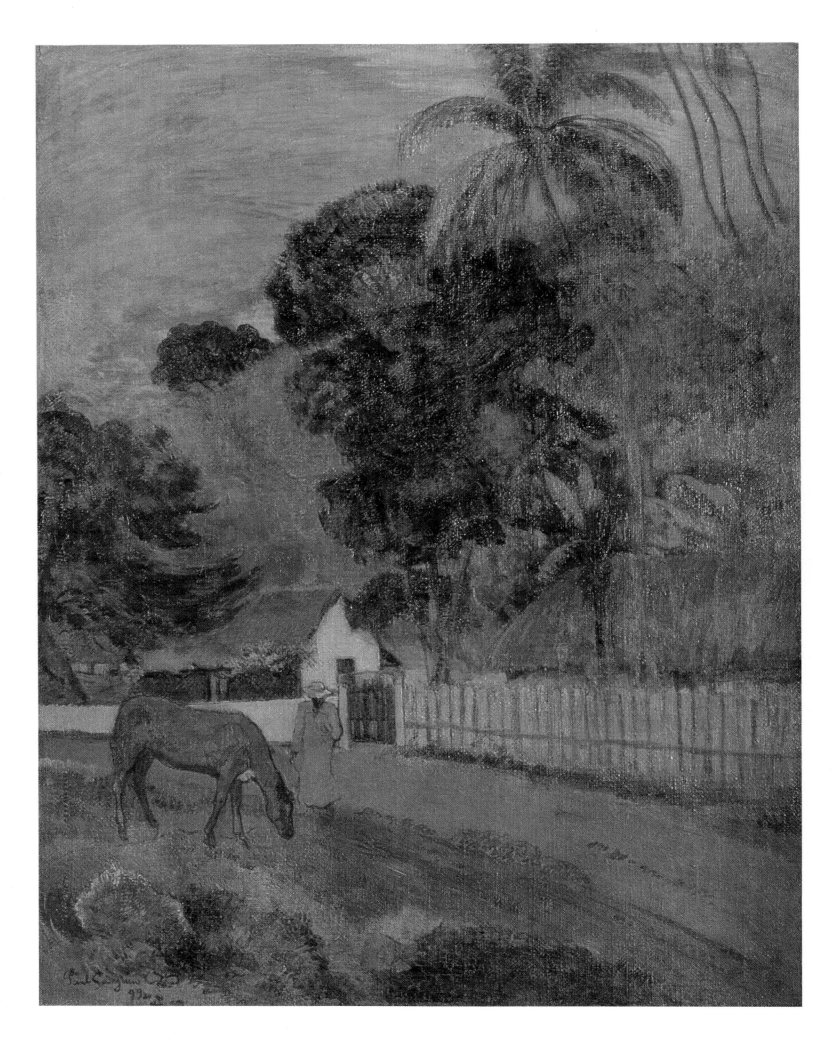

147 LANDSCAPE

Oil on canvas. 94×73 cm

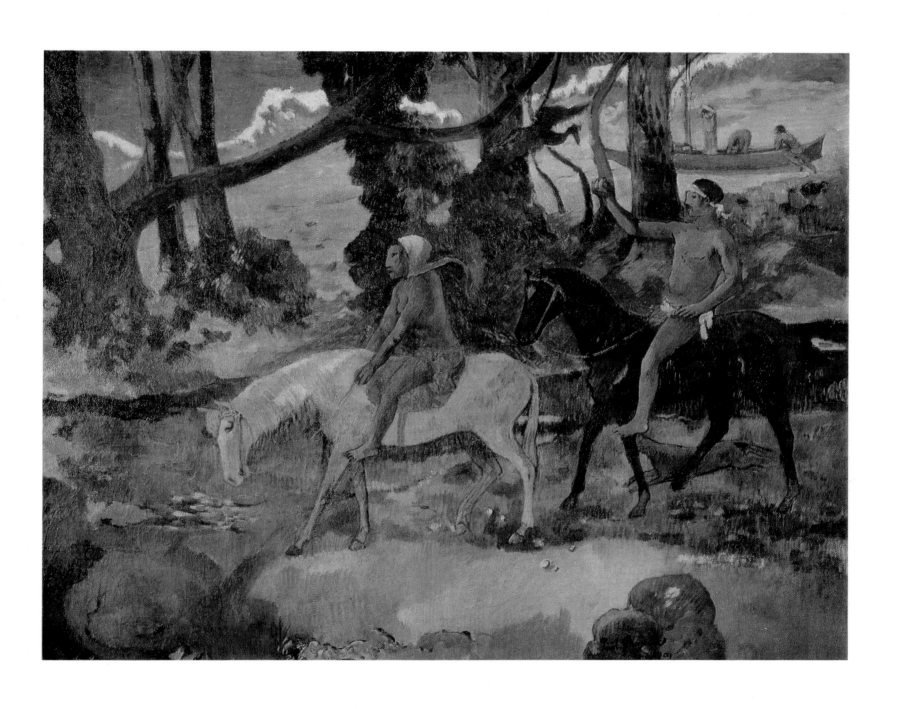

148 THE FORD (THE FLIGHT)

Oil on canvas. 76×95 cm

Rodin

AUGUSTE RODIN. 1840—1917

149 FEMALE FIGURE (thrown back)

Lead pencil and watercolour wash. 32.7×25 cm

150 NUDE FEMALE FIGURE (back view)

Pencil drawing touched with watercolours. 32.5×24.8 cm

HENRI ROUSSEAU. 1844—1910

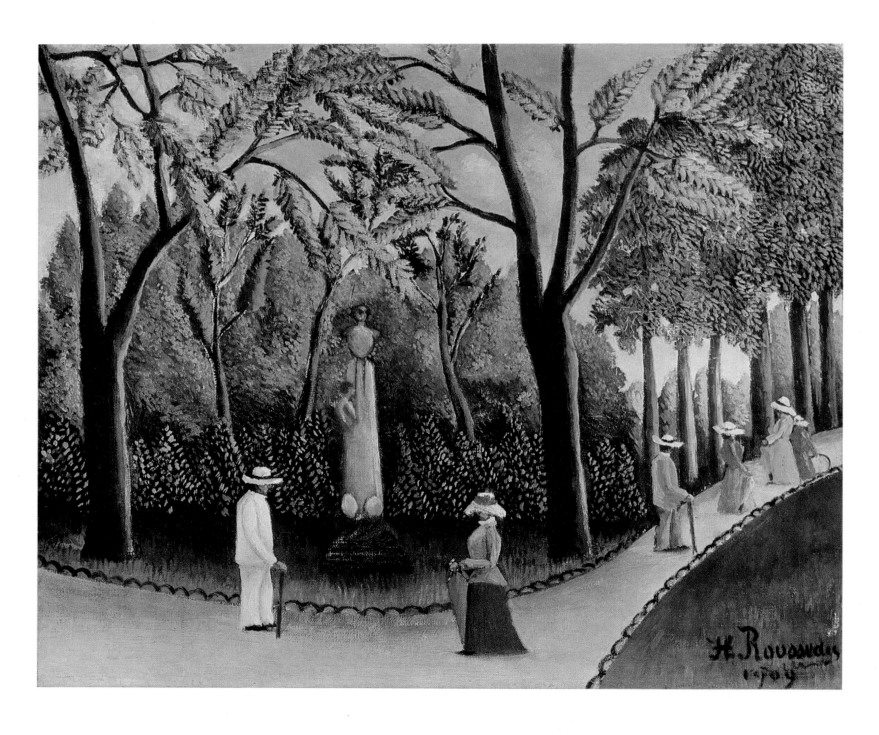

151 THE CHOPIN MEMORIAL IN THE LUXEMBOURG GARDENS

Oil on canvas. 38×47 cm

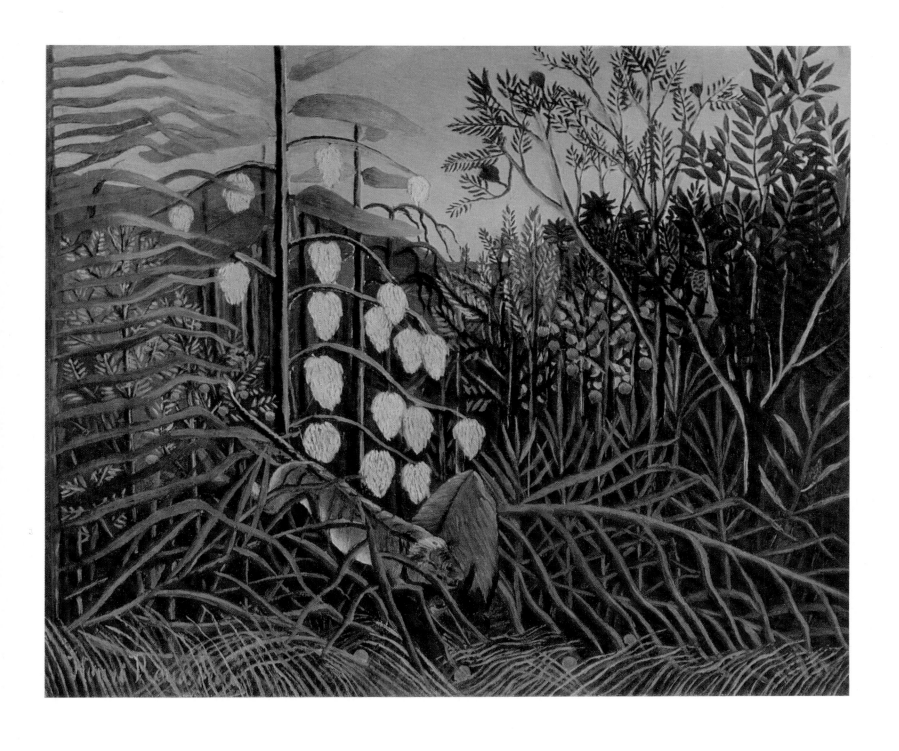

**152 IN A TROPICAL FOREST.
STRUGGLE BETWEEN TIGER AND BULL**

Oil on canvas. 46×55 cm

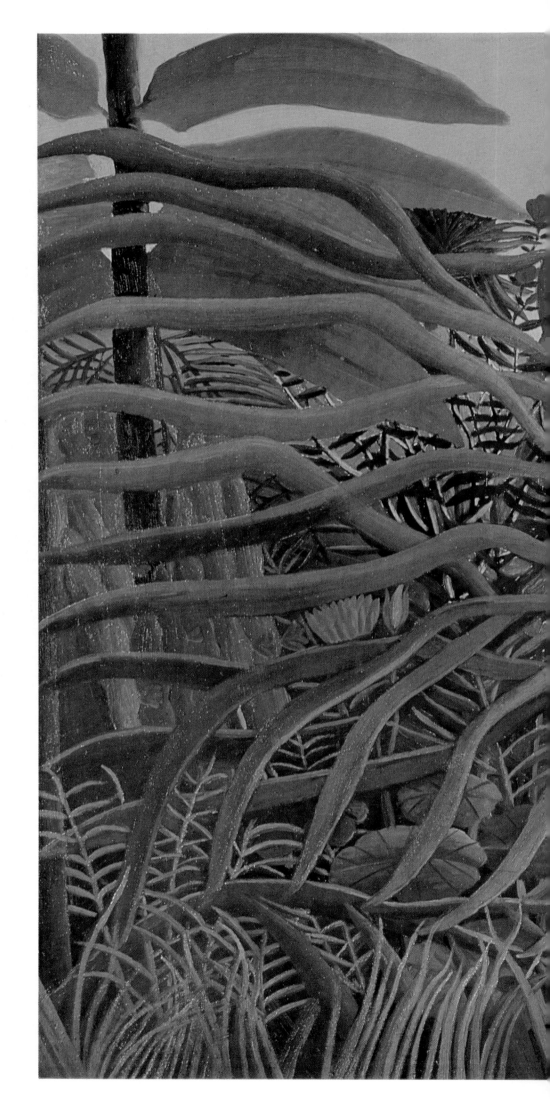

153 JAGUAR ATTACKING A HORSE

Oil on canvas. 90×116 cm

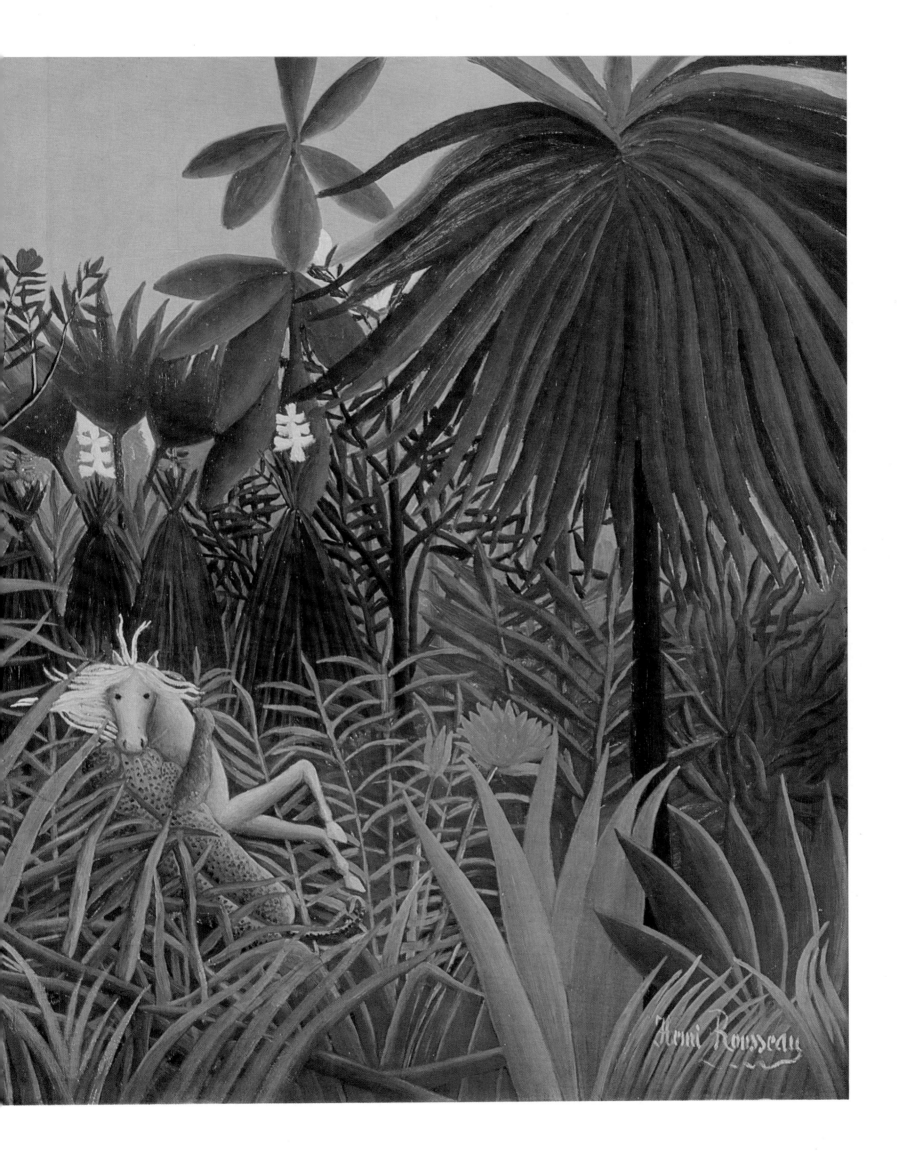

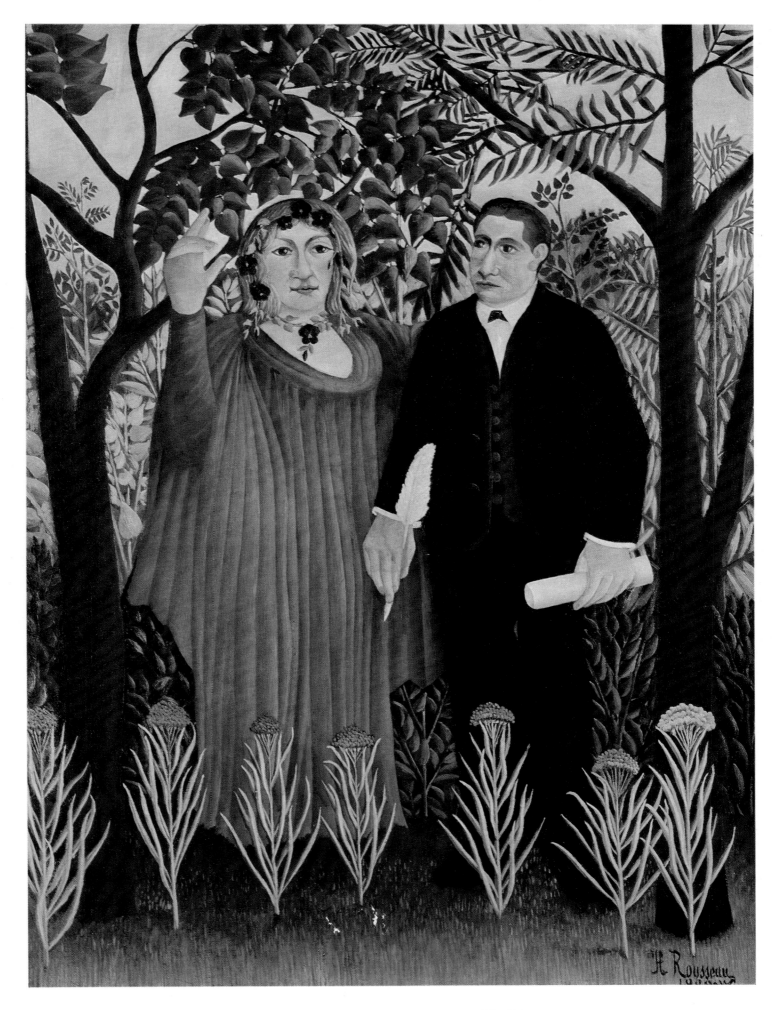

154, 155 THE POET AND HIS MUSE.
PORTRAIT OF APOLLINAIRE AND MARIE LAURENCIN

Oil on canvas. 131×97 cm

**156 VIEW OF THE FORTIFICATIONS TO THE LEFT
OF THE GATE OF VANVES**

Oil on canvas. 31×41 cm

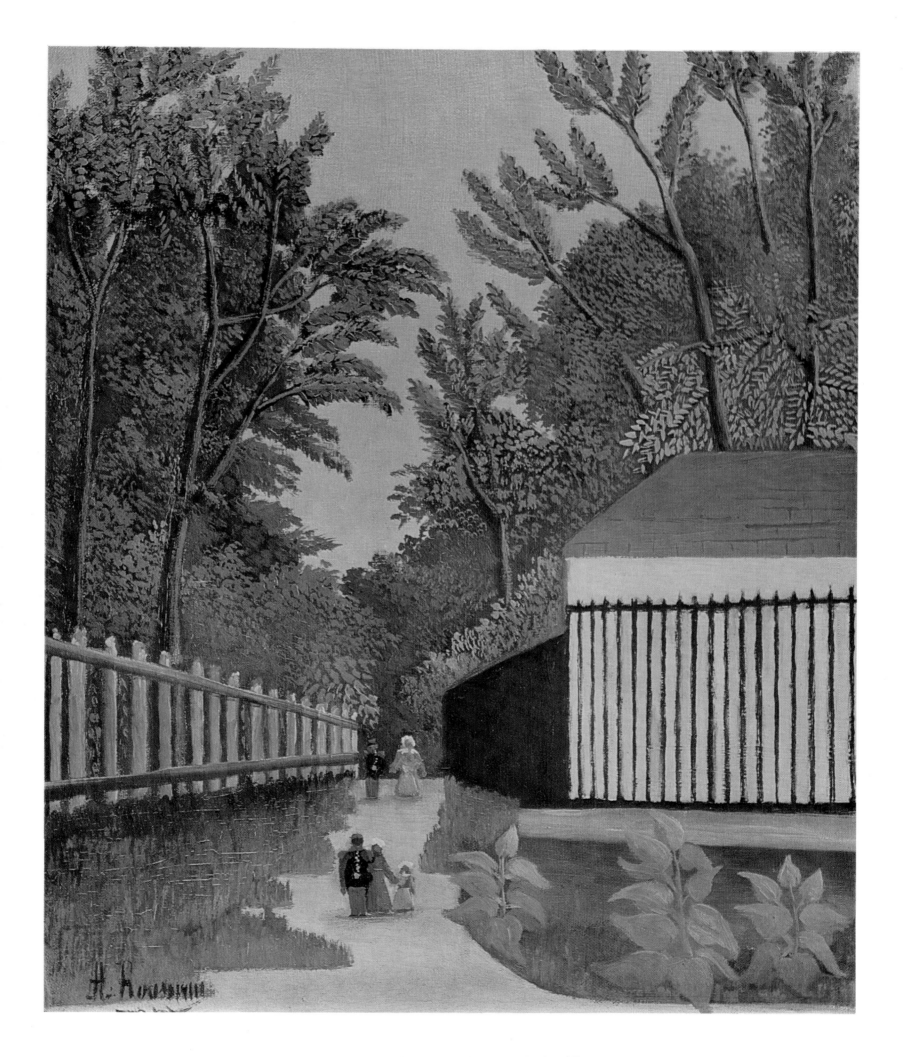

157 VIEW OF THE MONTSOURIS PARK

Oil on canvas. 46×38 cm

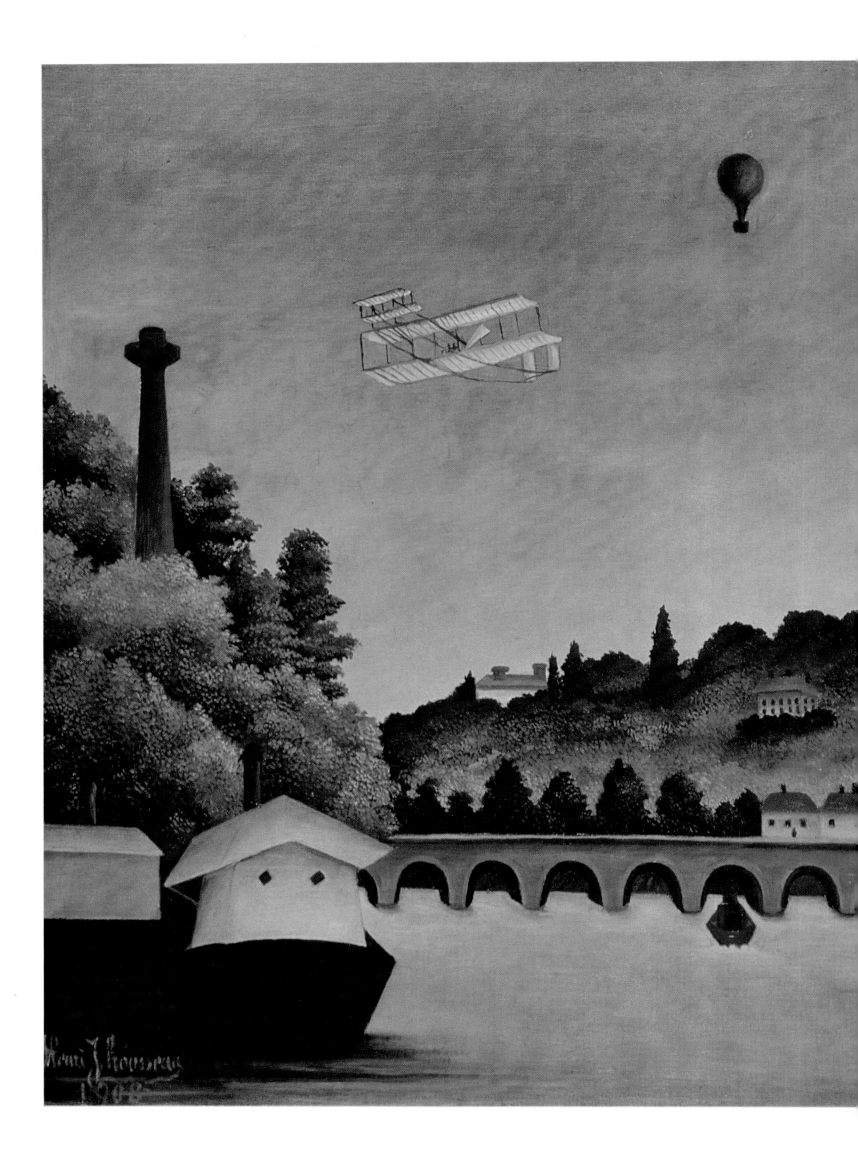

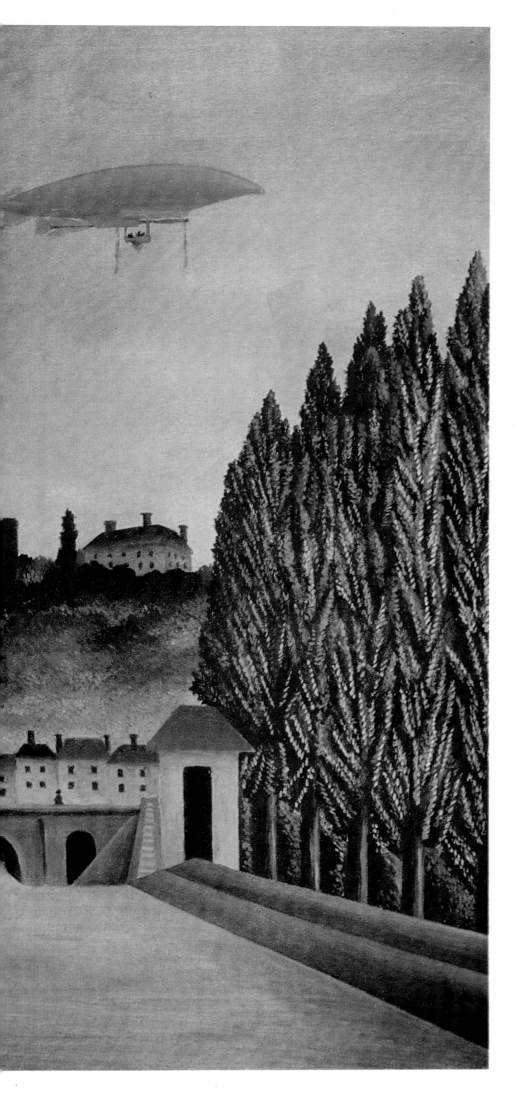

158 VIEW OF THE SÈVRES BRIDGE AND
THE HILLS OF CLAMART, SAINT-CLOUD,
AND BELLEVUE

Oil on canvas. 80×102 cm

HENRI DE TOULOUSE-LAUTREC. 1864—1901

159 WOMAN WITH A TRAY (BREAKFAST)

Black chalk. 40×52 cm

160 THE SINGER YVETTE GUILBERT

Tempera on cardboard. 57×42 cm

161 LADY BY THE WINDOW

Tempera on cardboard. 71×47 cm

PAUL HELLEU. 1859—1927

162 ON THE SOFA

Pastel, 50×68 cm

163 LADY IN WHITE

Oil on canvas. 82×66 cm

164 LADY IN PINK

White and red chalk and charcoal. 65.8×47.3 cm

JEAN-LOUIS FORAIN. 1852—1931

165 LEAVING THE MASQUERADE. BALL IN THE PARIS OPERA

Oil on canvas. 22×16 cm

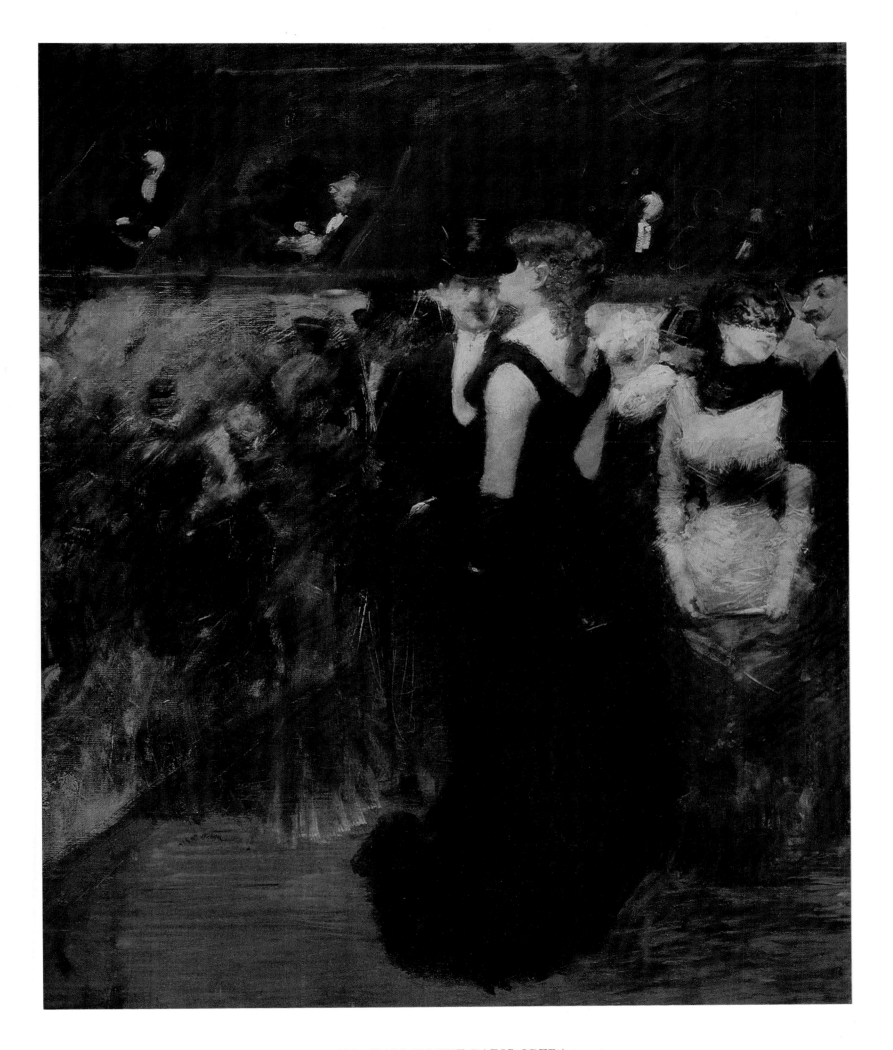

166 BALL IN THE PARIS OPERA

Oil on canvas. 74×61 cm

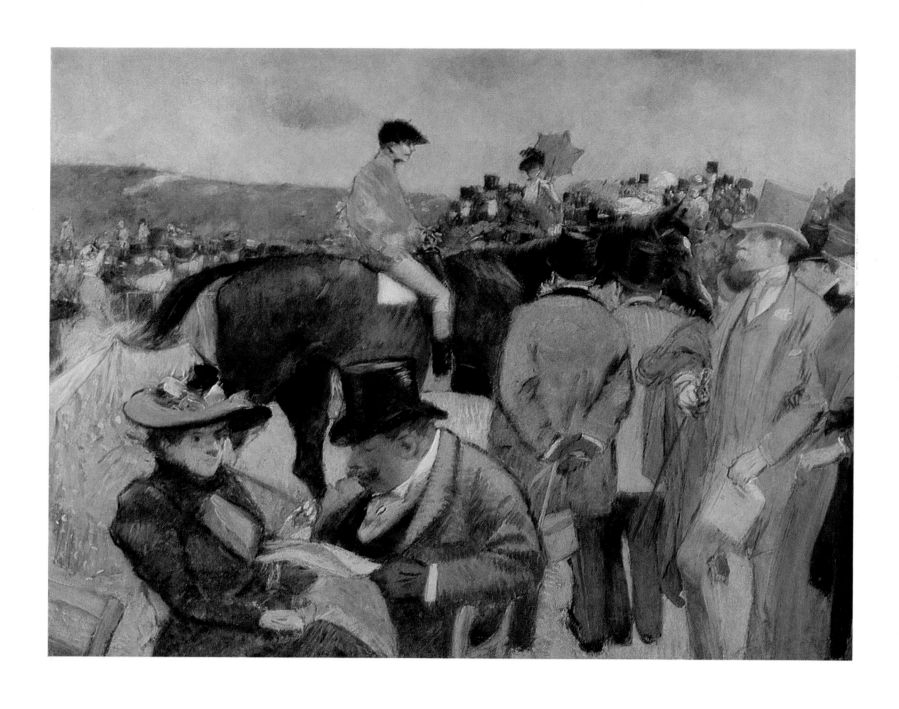

167 THE HORSE-RACE

Oil on canvas. 38×45 cm

168 MUSIC HALL

Oil on canvas. 50.5×61 cm

169 A THEATRE LOBBY

Gouache and pastel on cardboard. 90×72 cm

170 DANCER

Pastel on brownish-grey paper. 53×41 cm

171 I'M READY, DOCTOR

Indian ink, crayon and pencil. 44×36 cm

THÉOPHILE-ALEXANDRE STEINLEN. 1859—1923

172 DANCING-FLOOR IN A PARIS SUBURB

Chalk, graphite, and crayons. 33.5×54.3 cm

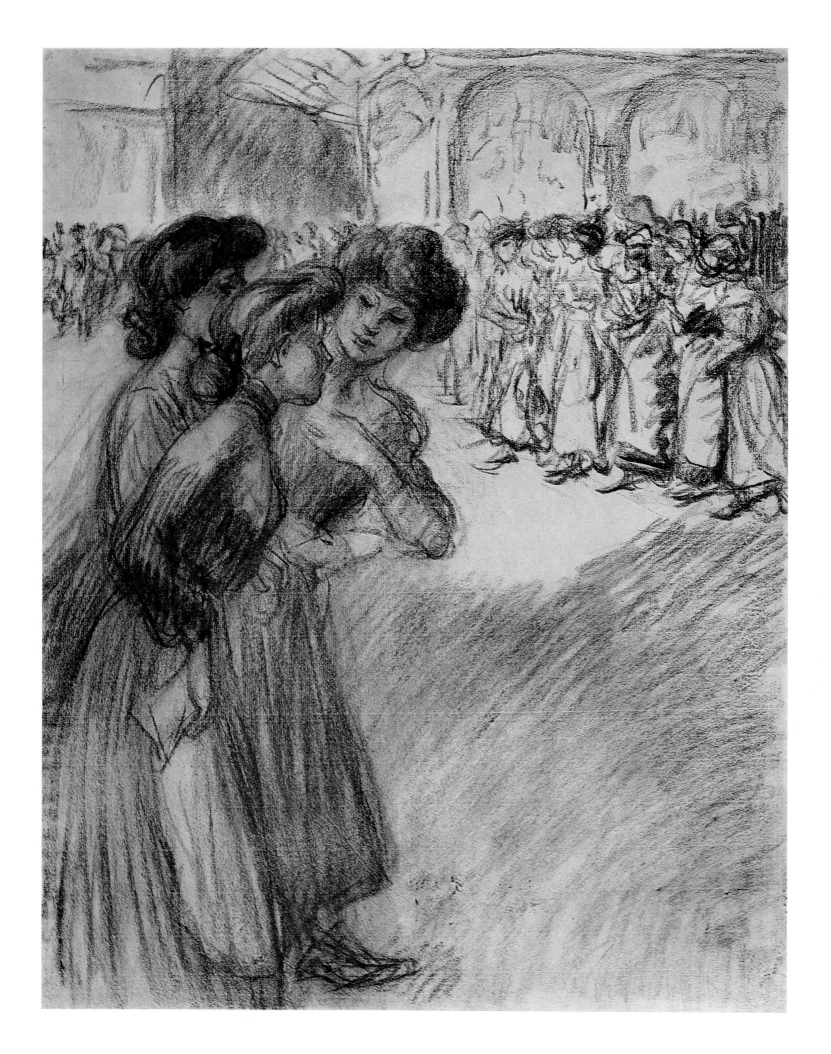

173 AFTER WORK

Charcoal drawing on laid paper. 63×48 cm

174 TWO CATS

Tempera on unprimed canvas. 61×64 cm

LOUIS LEGRAND. 1863—1951

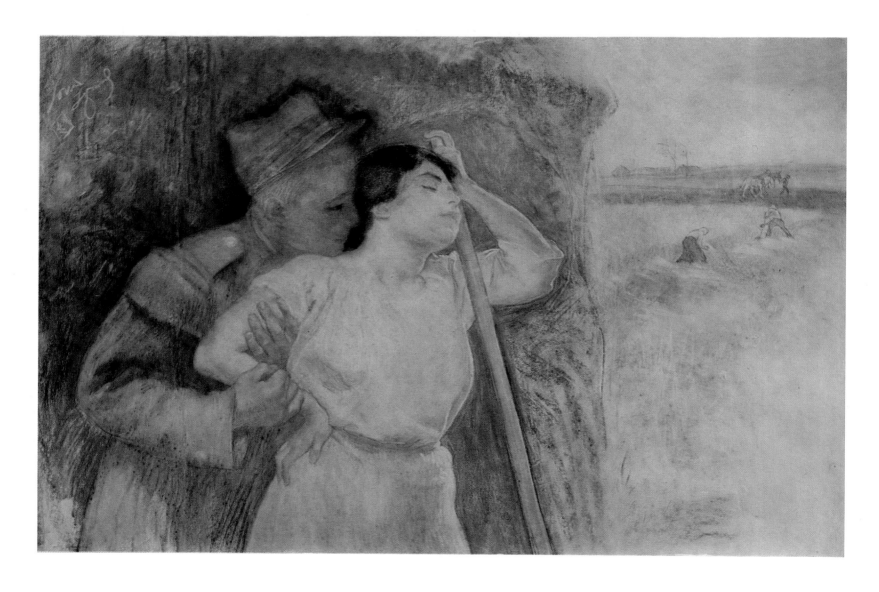

175 ON FURLOUGH

Black chalk and pastel on paper mounted on cardboard. 74×109 cm

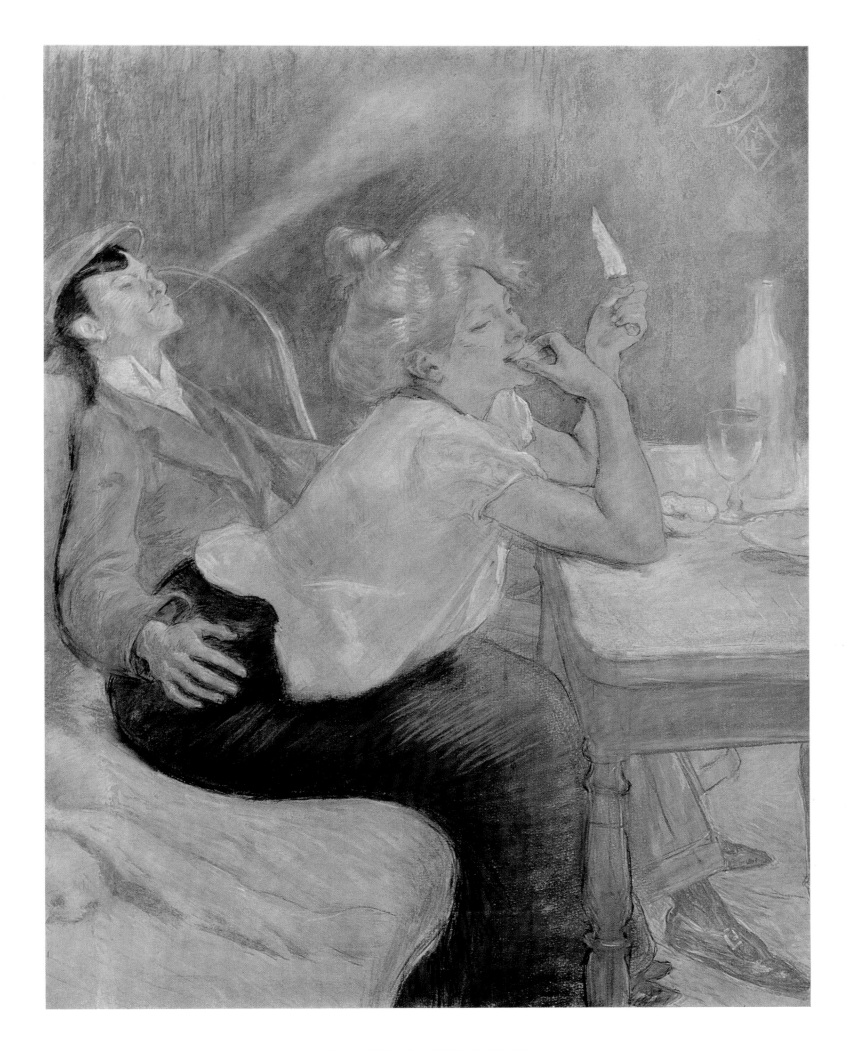

176 THE APACHE'S SUPPER

Charcoal and pastel. 63×49 cm

177 SELF-PORTRAIT

Black chalk and watercolour. 28×25 cm

G·MANZANA·

GEORGES MANZANA-PISSARRO. 1870—1961

178 ZEBRAS AT A WATERING-PLACE

Watercolour, gouache, and gold. 64.5×51.6 cm

ODILON REDON

ODILON REDON. 1840—1916

179 WOMAN LYING UNDER A TREE. Study

Tempera on canvas. 26×35 cm

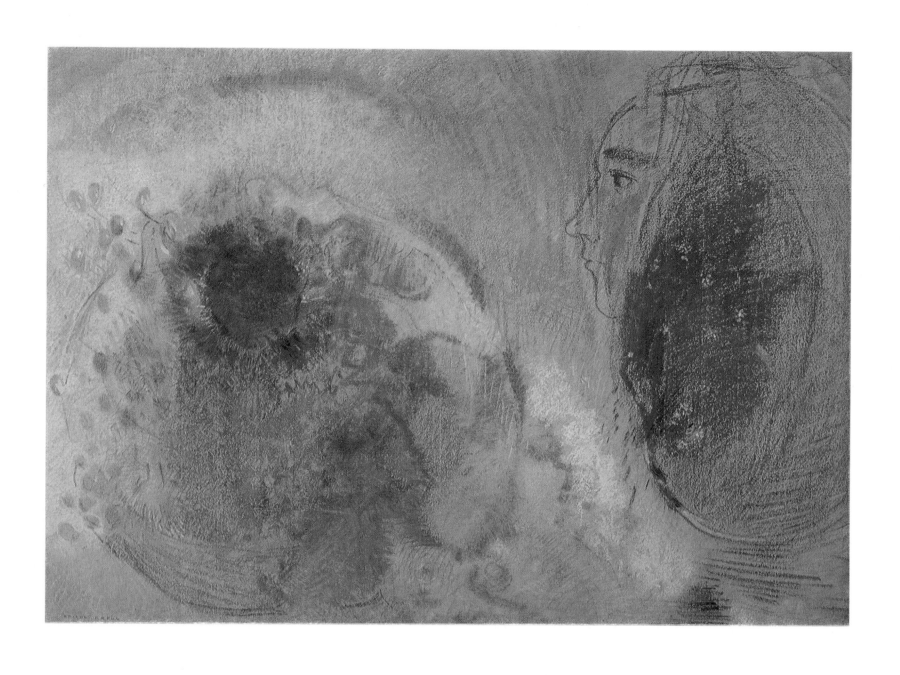

180 DAY AND NIGHT

Pastel on cardboard. 47×61 cm

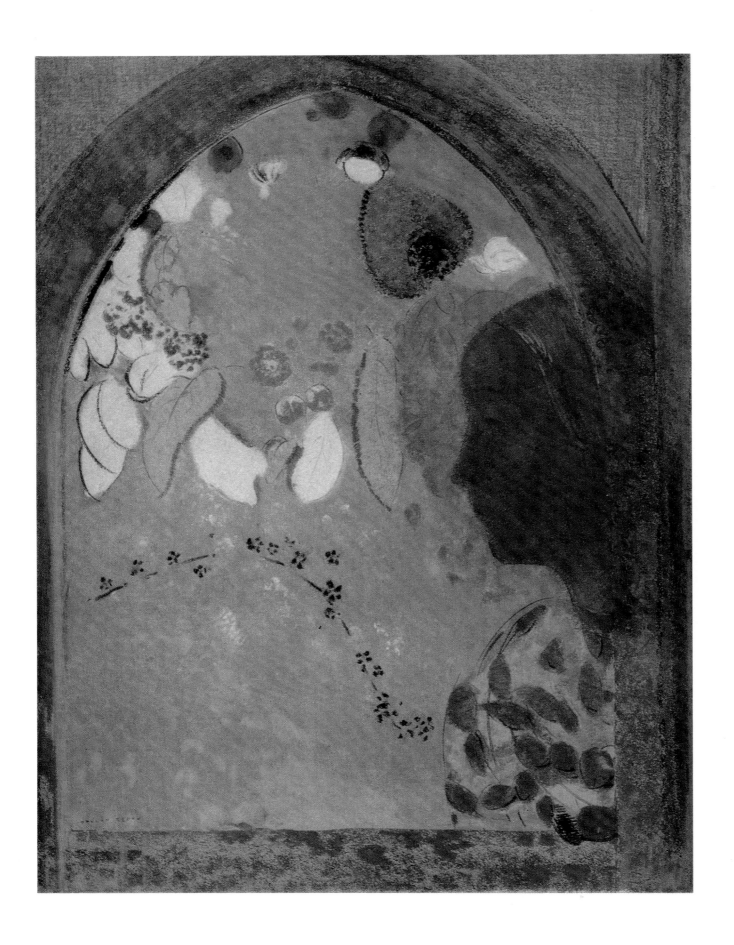

181 PROFILE OF A WOMAN IN THE WINDOW

Pastel on cardboard. 63×49 cm

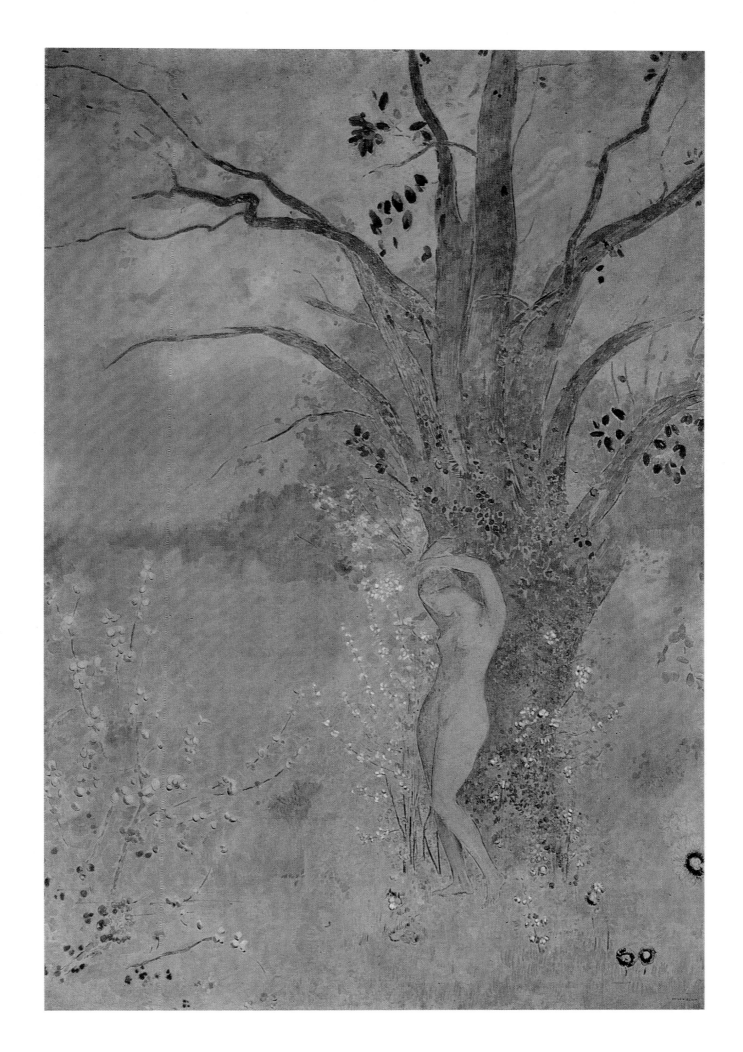

182 SPRING

Oil and tempera on canvas. 178×120 cm

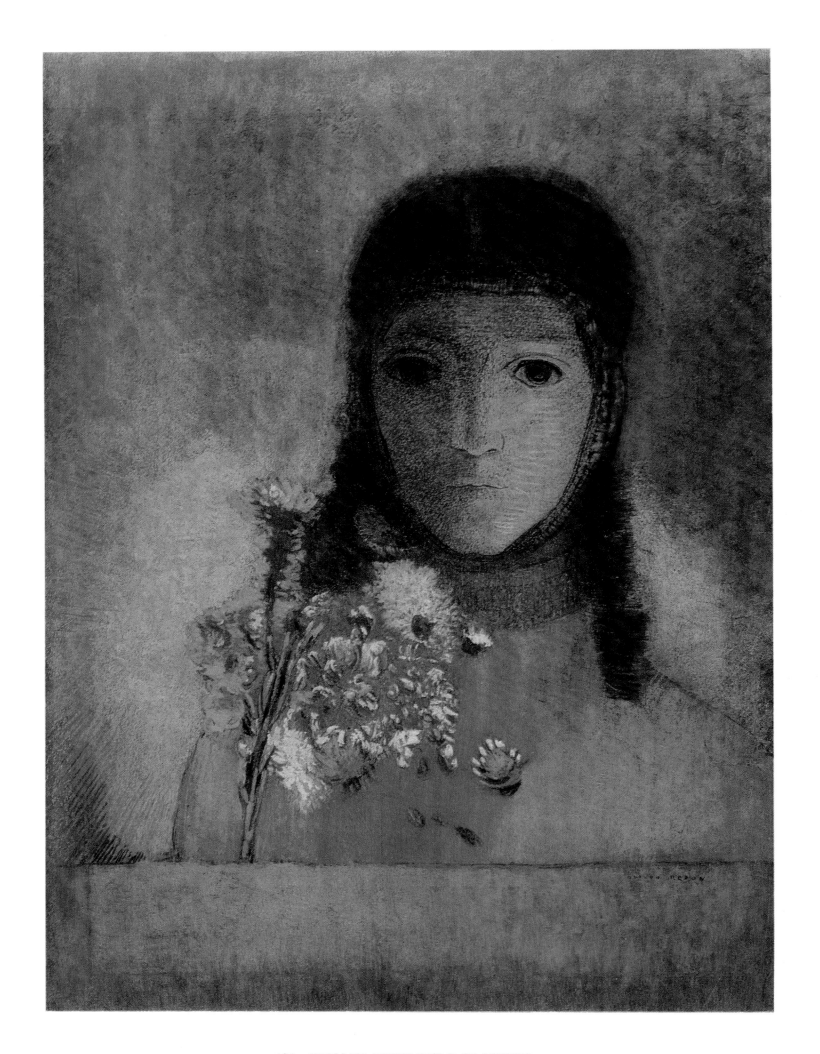

183 WOMAN WITH WILD FLOWERS
Pastel and charcoal on buff paper. 52×37.5 cm

184 DRAWING FOR THE COVER OF *THE BALANCE (VESY)* JOURNAL

Charcoal on yellowish paper. 44×29 cm

185

186

187

188

189

185—197 HEAD- AND TAILPIECES
FOR *THE BALANCE (VESY)* JOURNAL

190

191

192

193

194

195

196

197

KER XAVIER ROUSSEL. 1867—1944

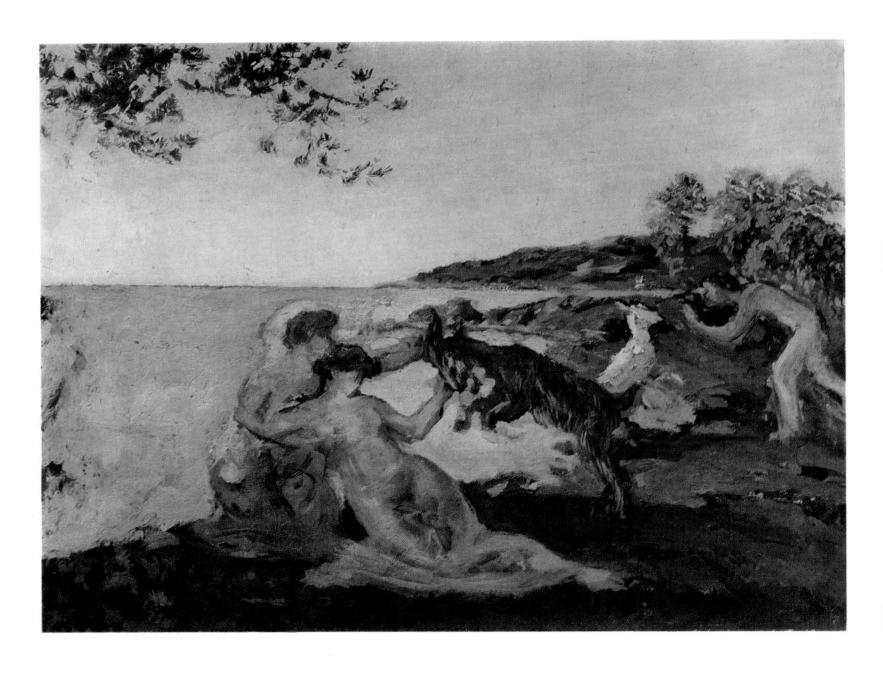

198 MYTHOLOGICAL MOTIF

Oil on cardboard. 47×62 cm

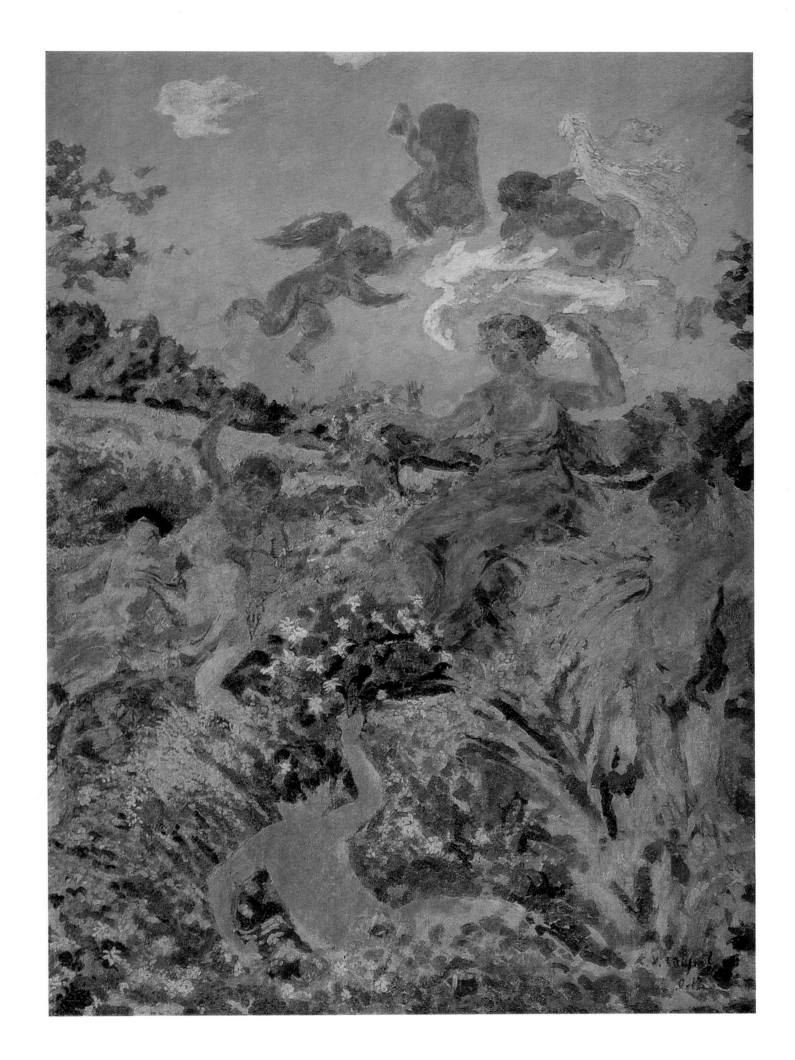

199 RURAL FESTIVAL. Decorative Panel

Oil on canvas. 166.5×119.5 cm

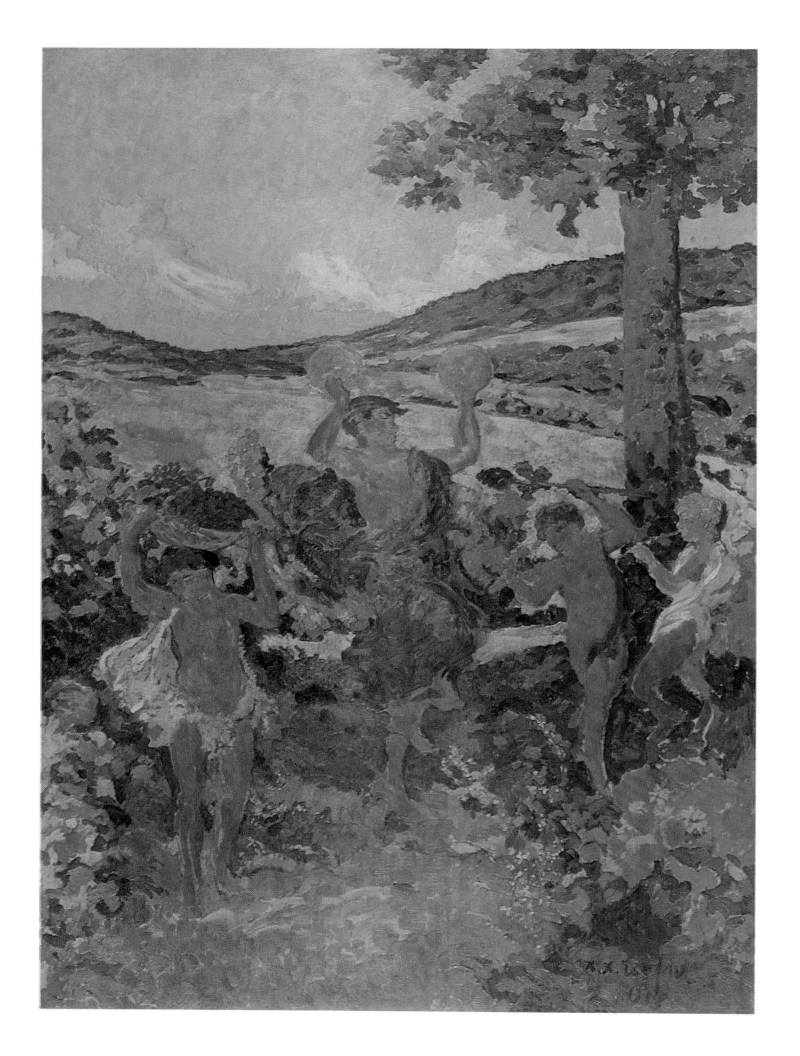

200 RURAL FESTIVAL. SUMMER

Oil on canvas. 164×123 cm

E Vuillard

ÉDOUARD VUILLARD. 1868—1940

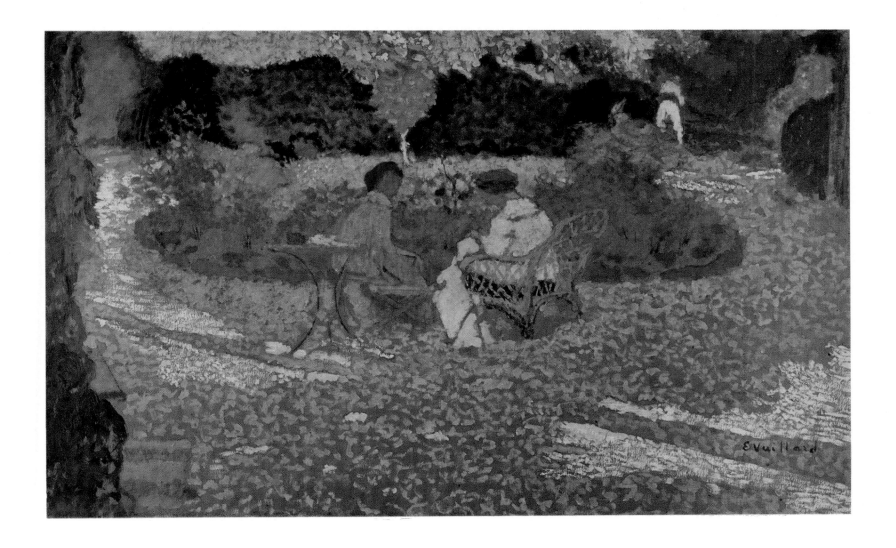

201 IN THE GARDEN

Tempera on cardboard. 51×83 cm

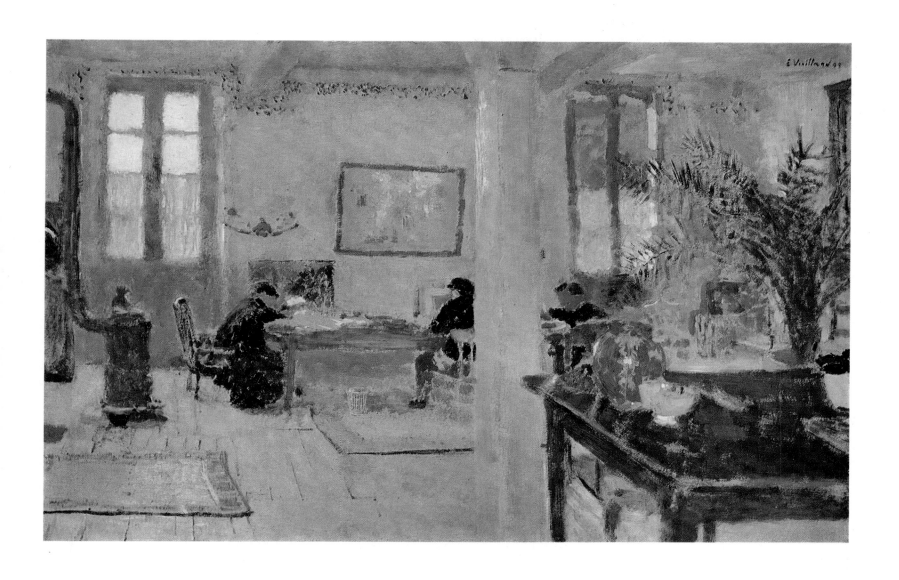

202, 203 THE ROOM

Oil on cardboard pasted on cradled panel. 52×79 cm

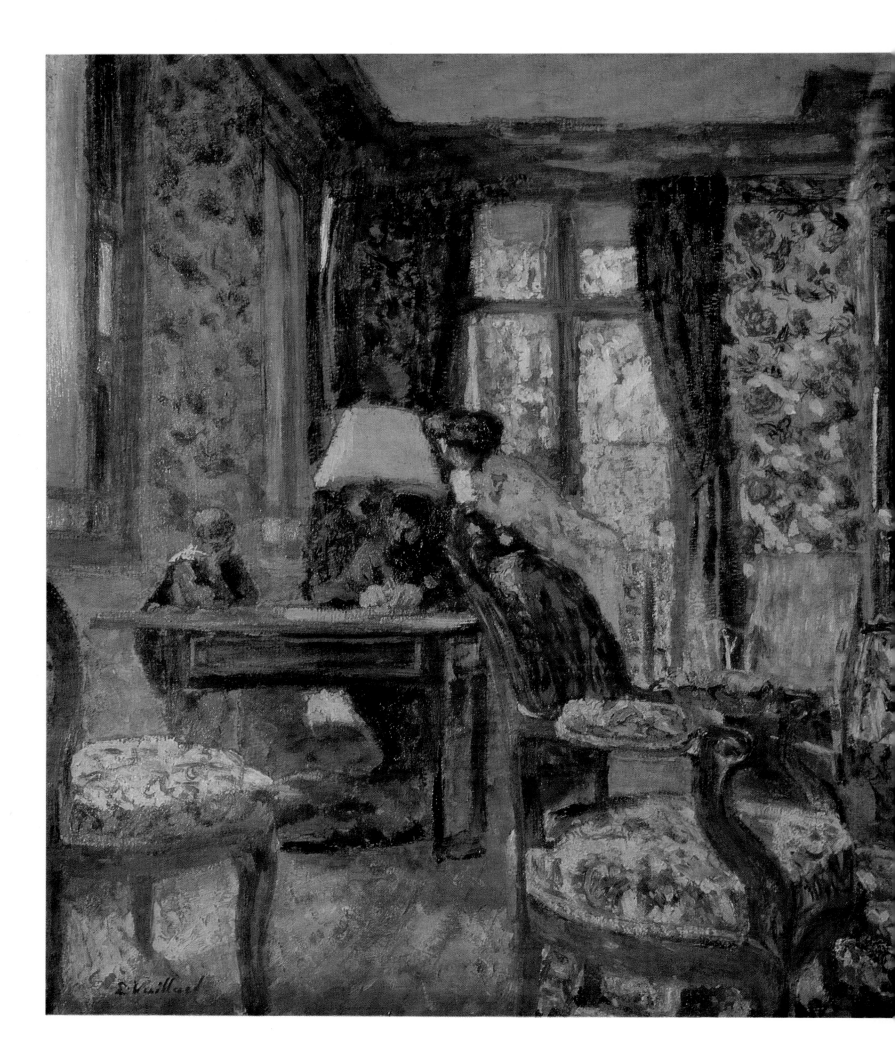

204　INTERIOR

Oil on cardboard. 50×77 cm

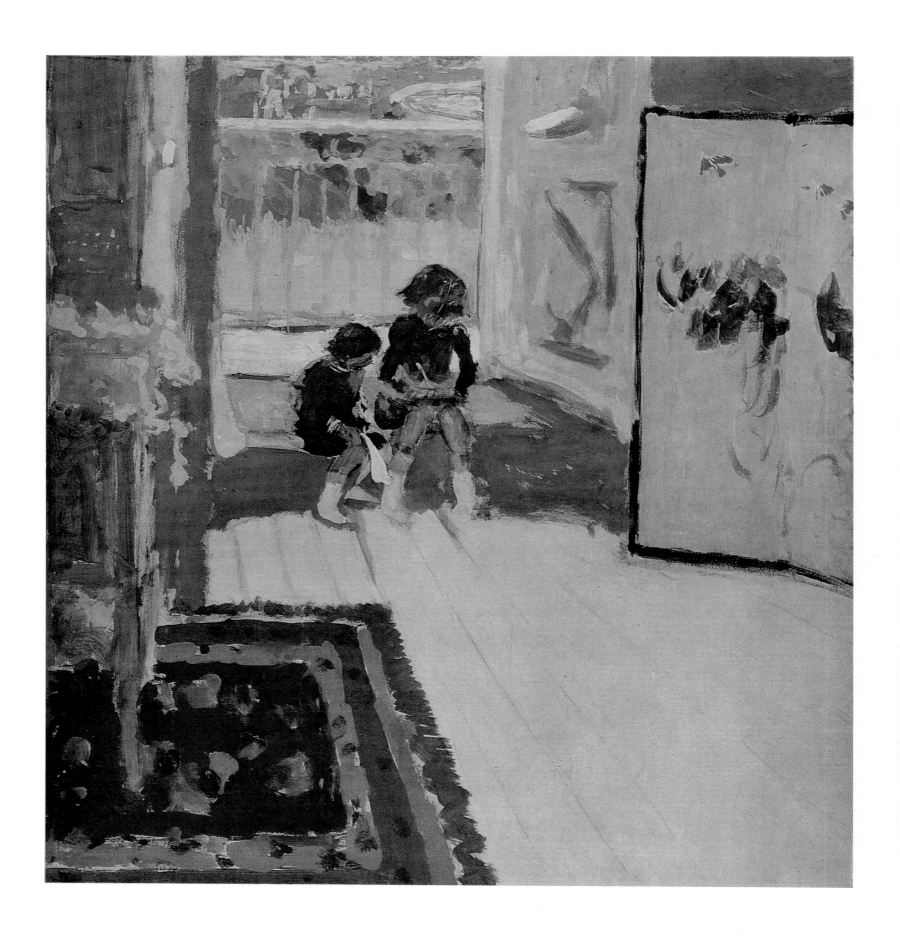

205　CHILDREN IN A ROOM

Gouache. 84.5×77.7 cm

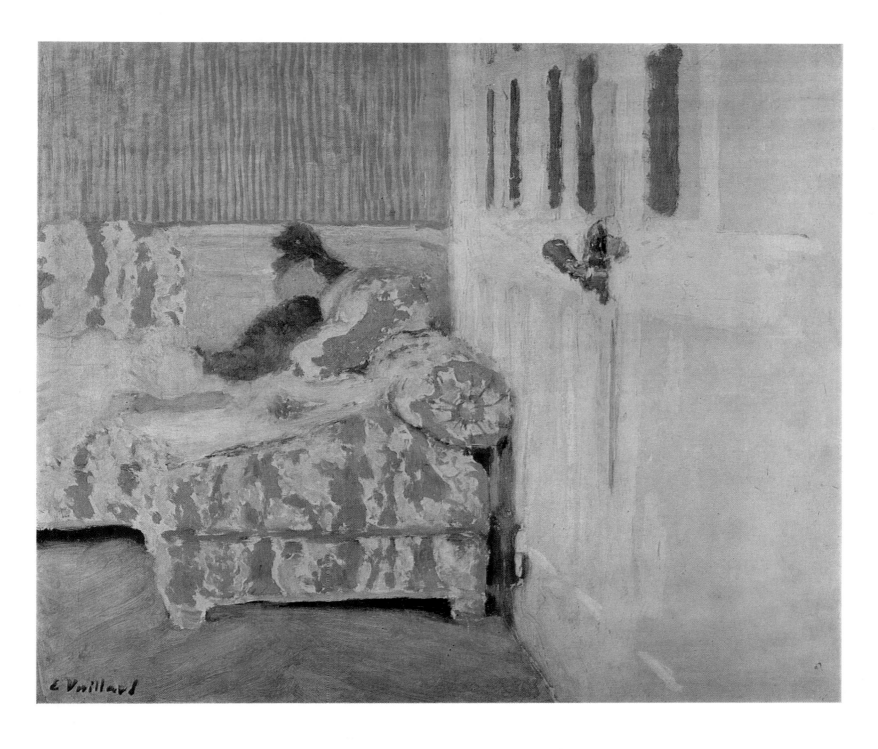

206 ON THE SOFA. WHITE ROOM

Oil on cardboard mounted on panel. 32×38 cm

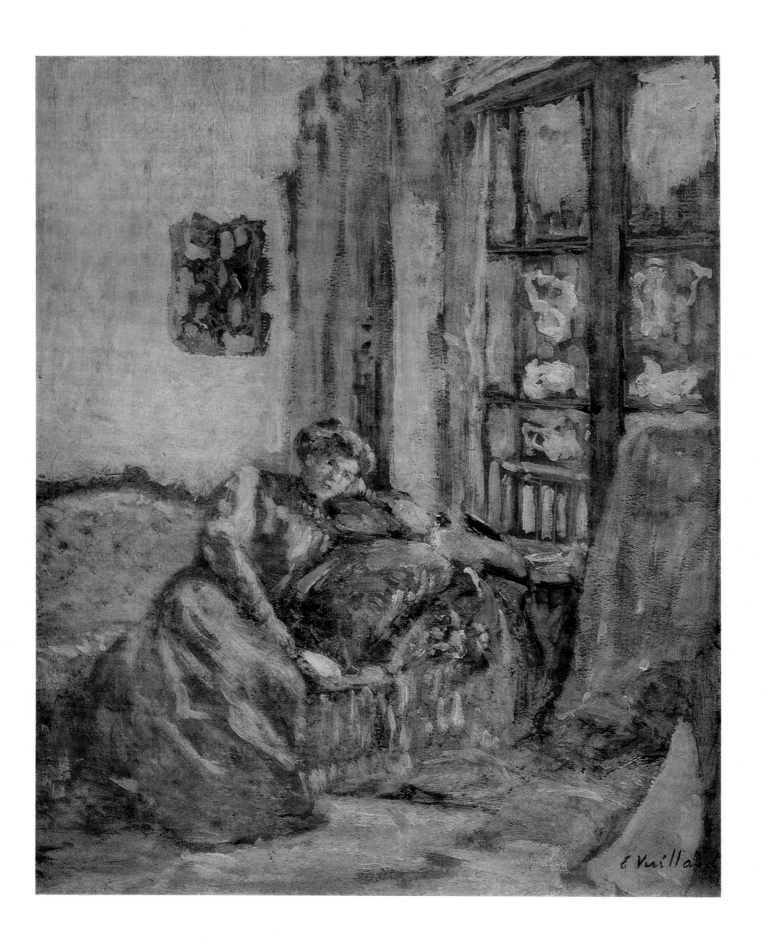

207 INTERIOR. LADY BY THE WINDOW

Oil on cardboard. 41×33 cm

PIERRE BONNARD. 1867—1947

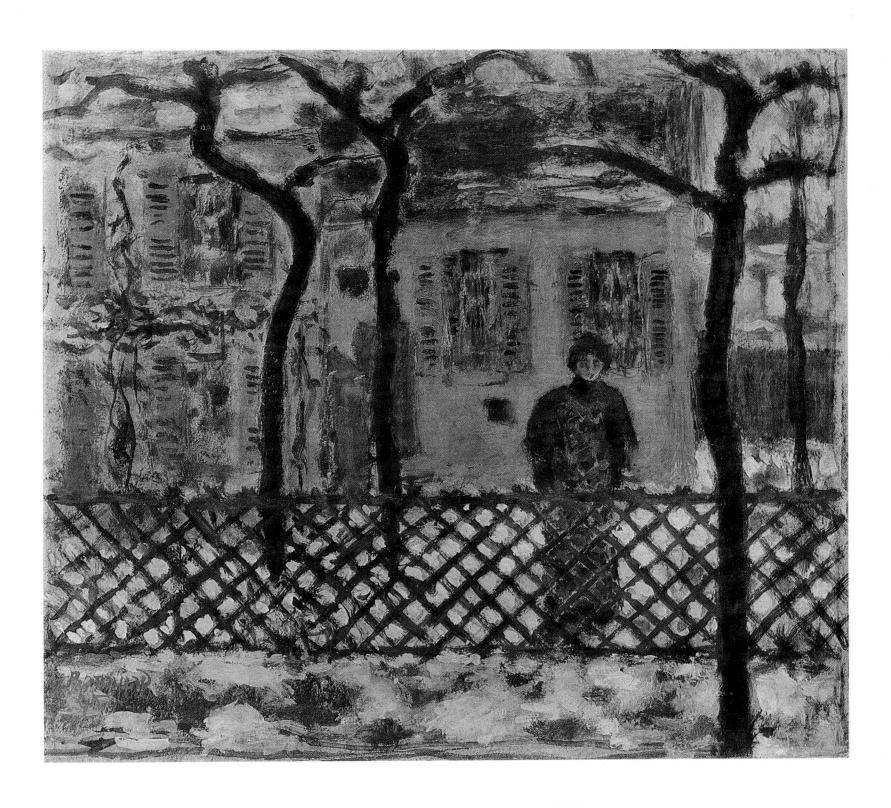

208 WOMAN STANDING AT A RAILING

Oil on cardboard. 31×35 cm

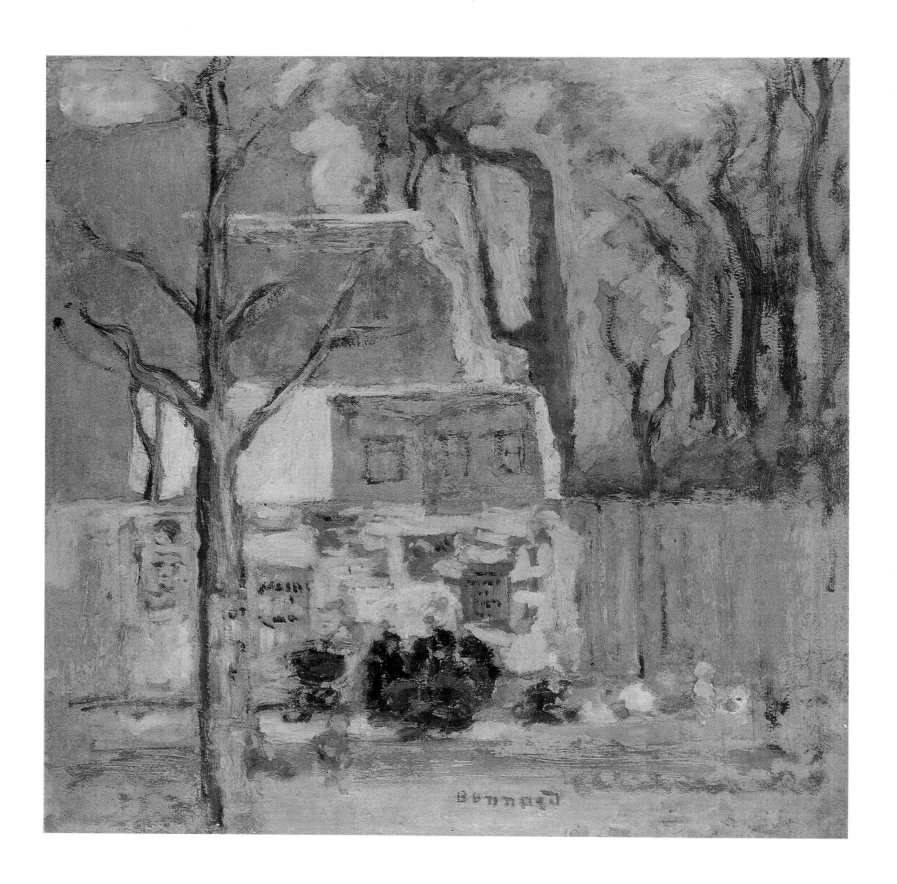

209 A CORNER OF PARIS

Oil on cardboard pasted on cradled panel. 51×51 cm

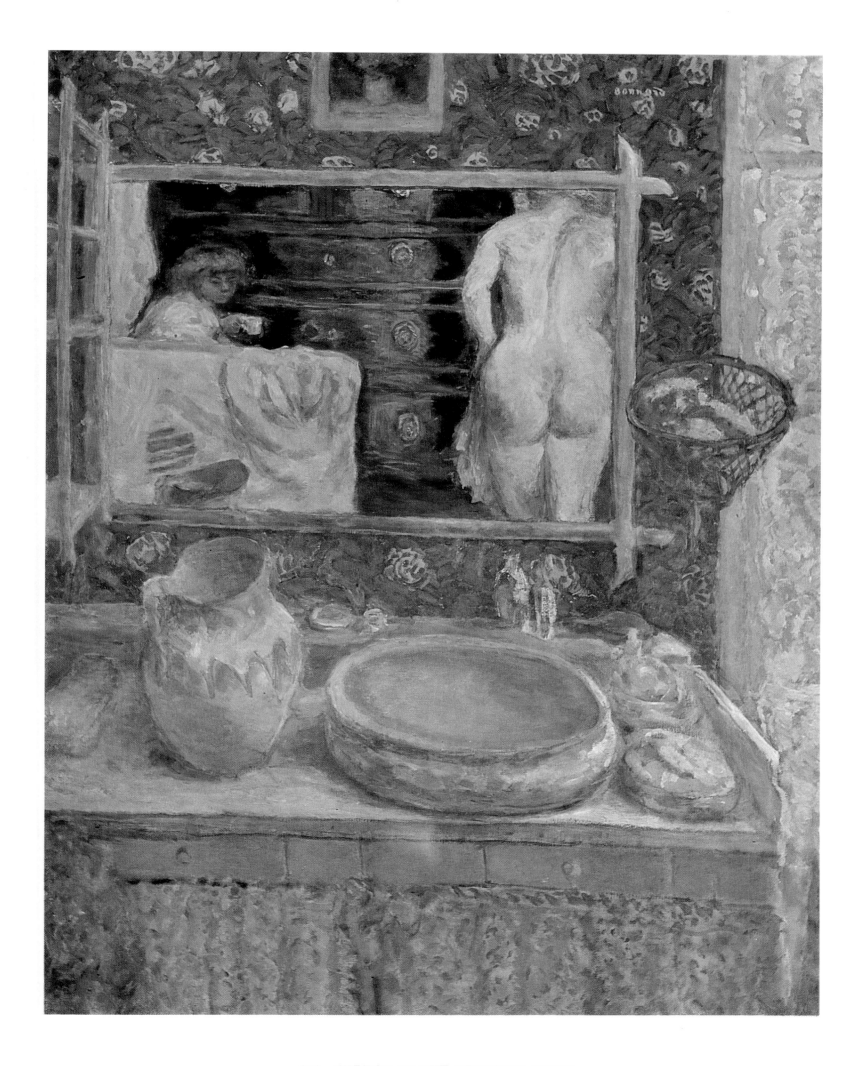

210 MIRROR IN THE DRESSING ROOM

Oil on canvas. 120×97 cm

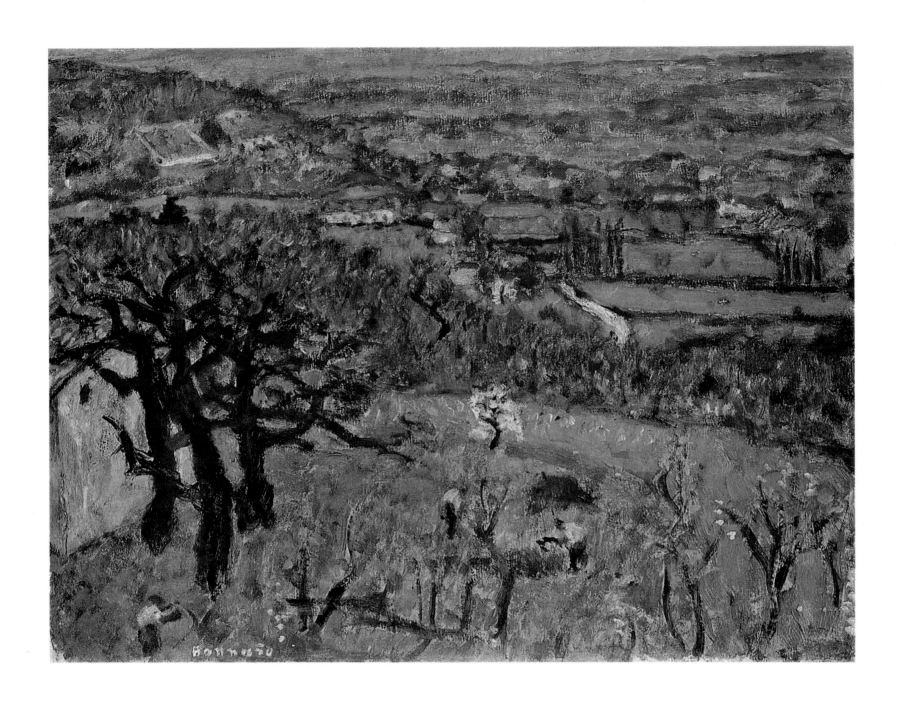

211 DAUPHINÉ LANDSCAPE. GREEN LANDSCAPE
Oil on cradled panel. 44×55 cm

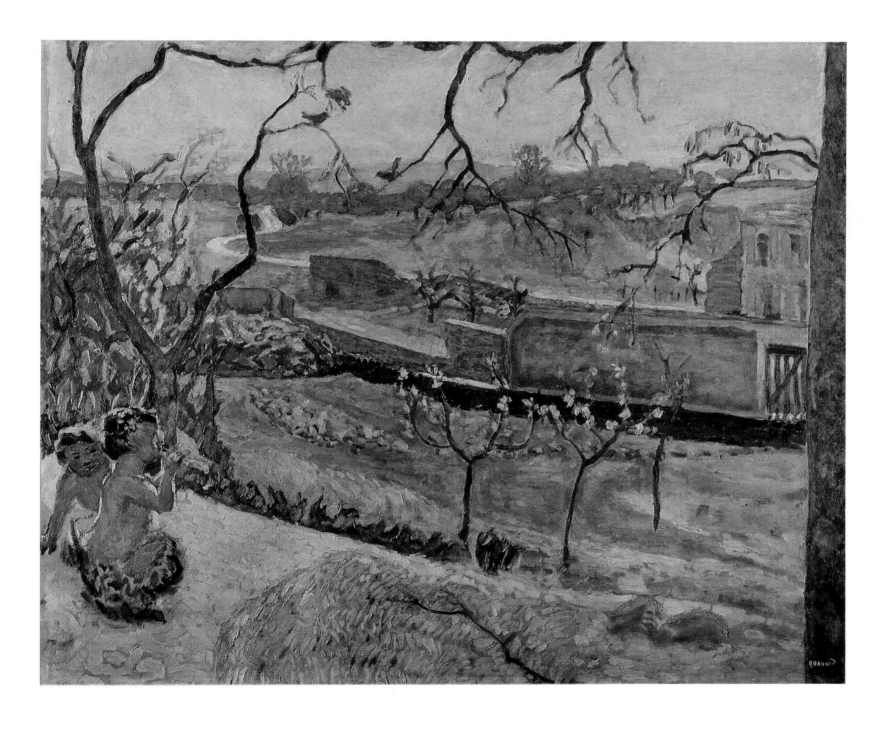

212, 213 EARLY SPRING. LITTLE FAUNS

Oil on canvas. 102.5×125 cm

214 LANDSCAPE WITH A GOODS TRAIN

Oil on canvas. 77×108 cm

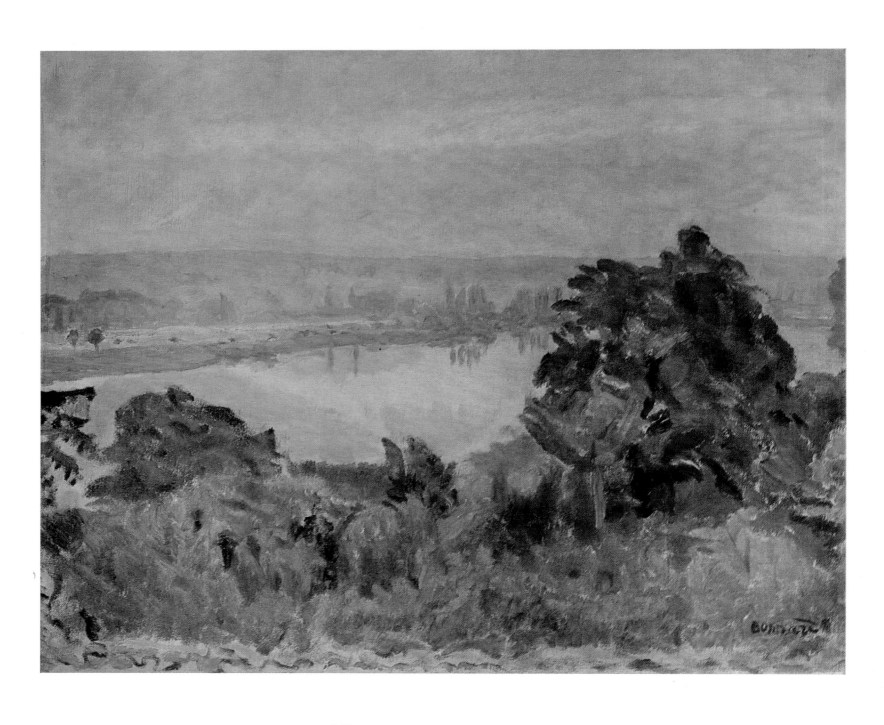

215 THE SEINE NEAR VERNON

Oil on canvas. 40.5×51 cm

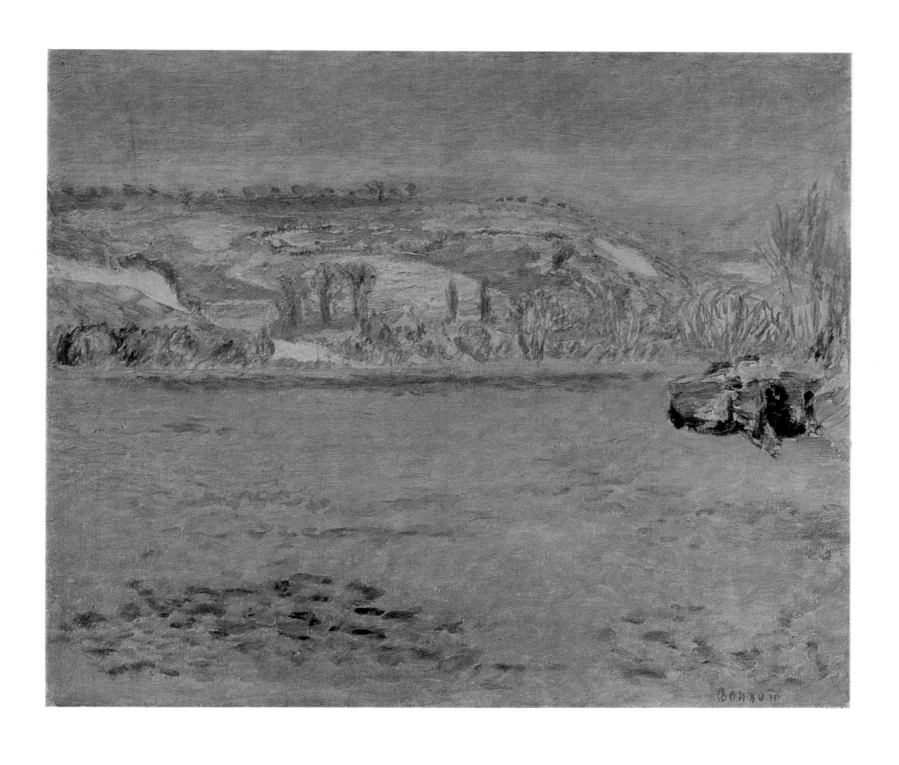

216 THE SEINE AT VERNONNET

Oil on canvas. 51×60.5 cm

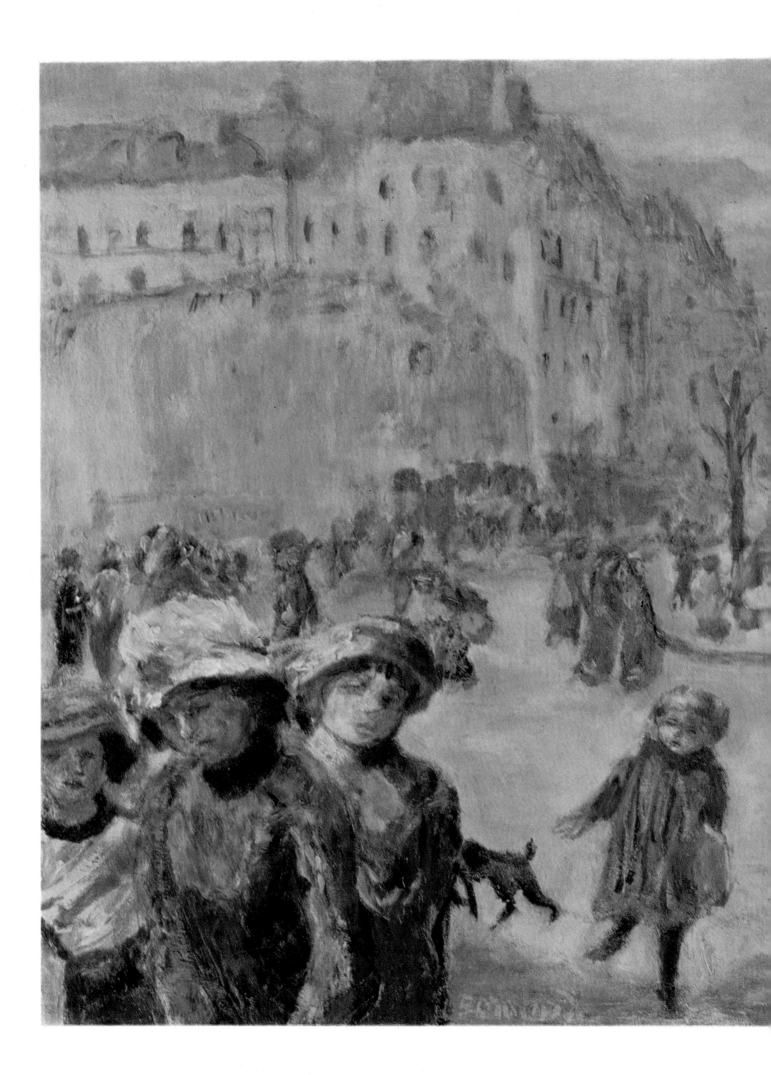

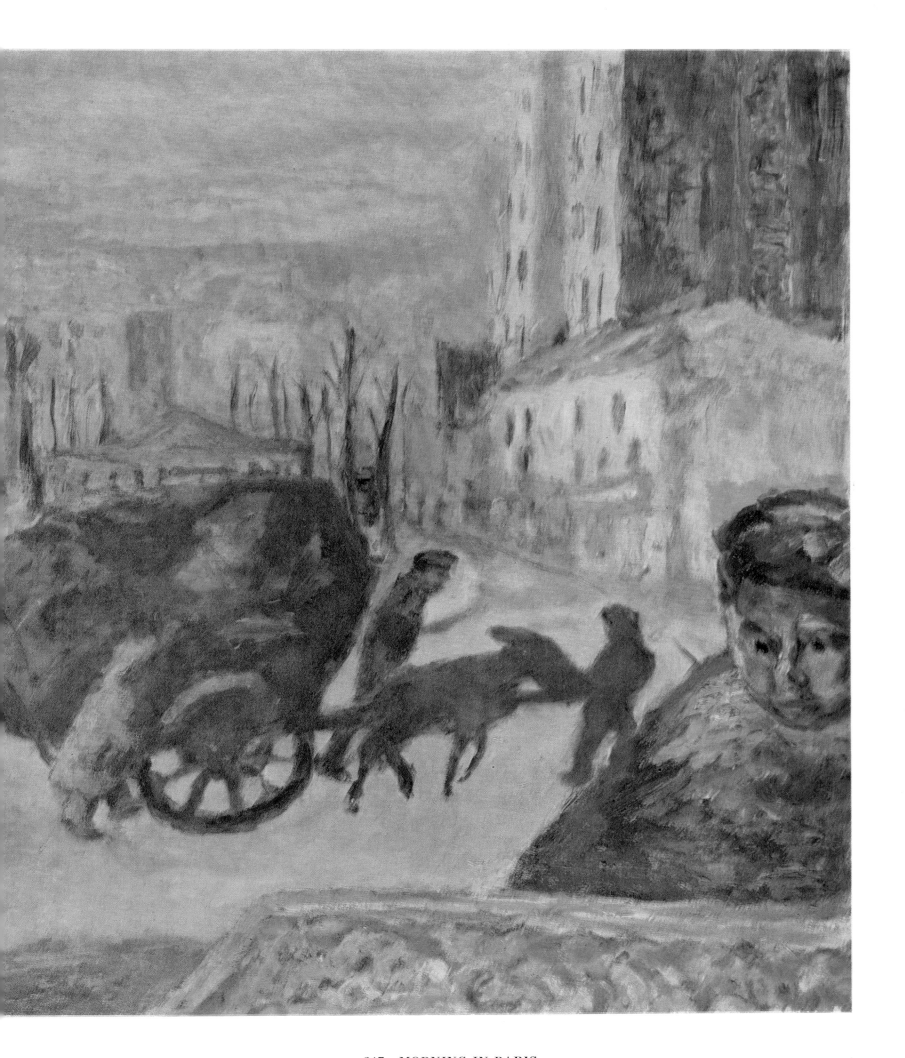

217 MORNING IN PARIS

Oil on canvas. 76.5×122 cm

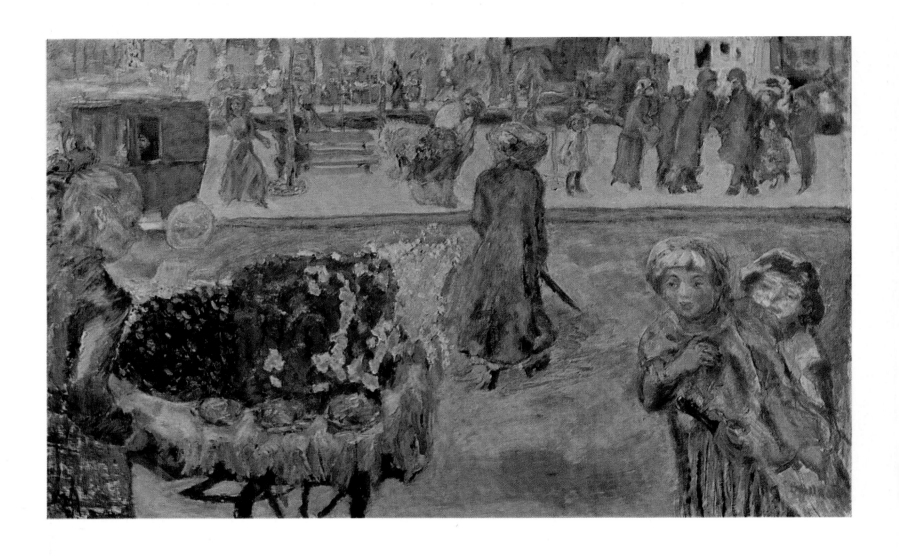

218, 219 EVENING IN PARIS

Oil on canvas. 76×121 cm

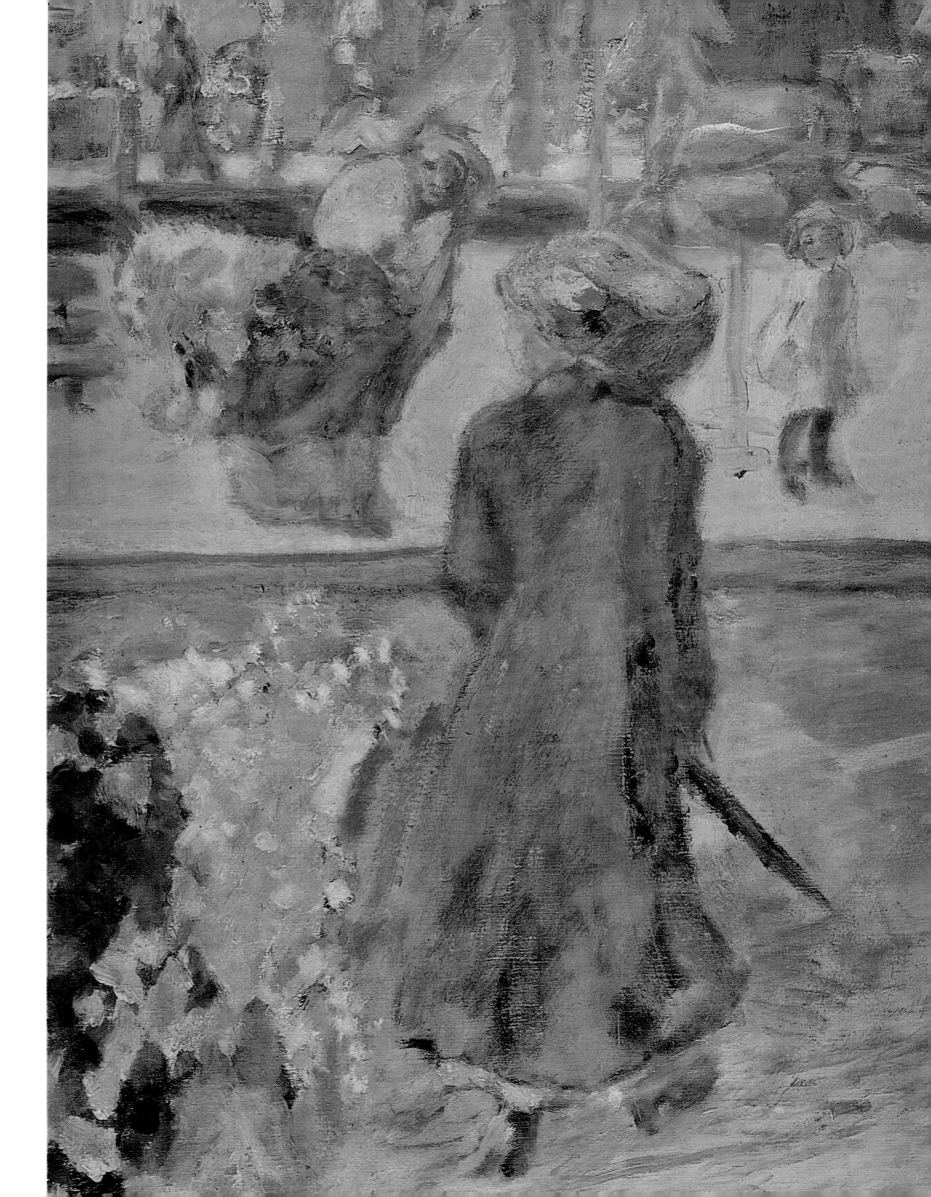

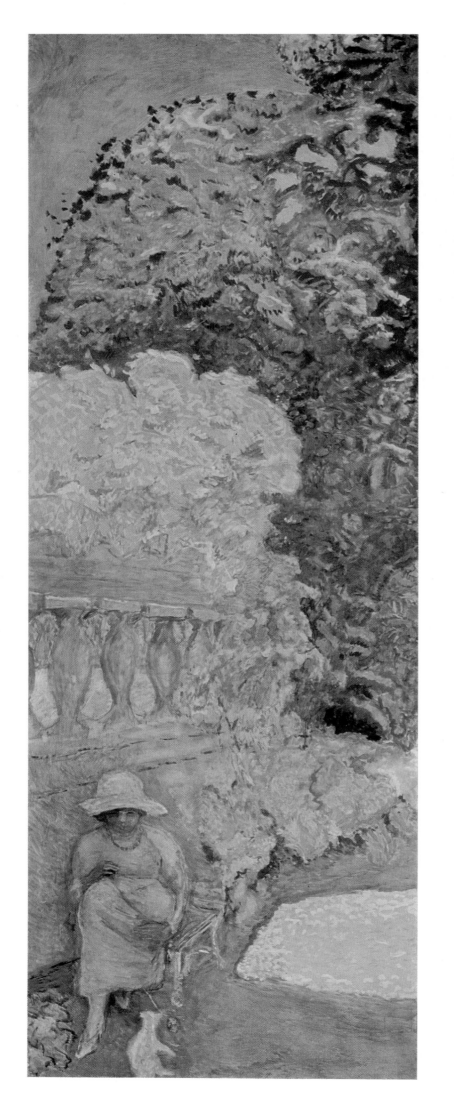
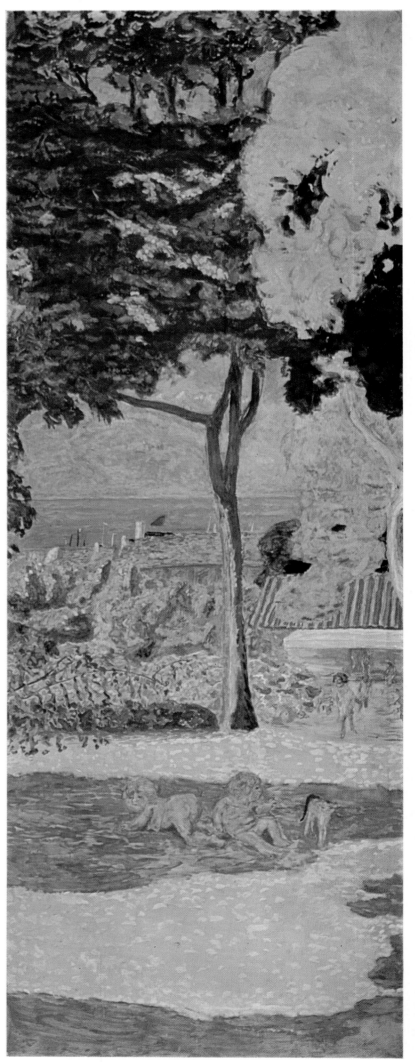

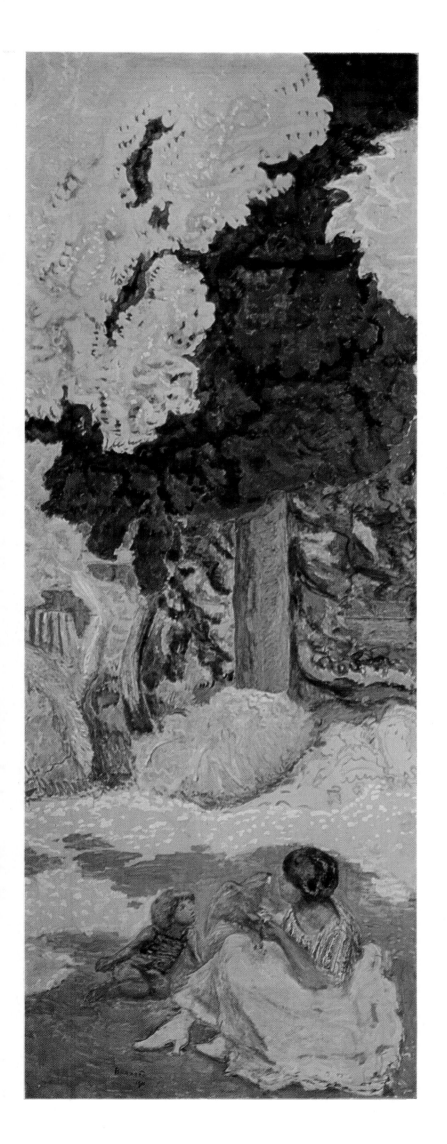

220—222 THE MEDITERRANEAN. Triptych

Oil on canvas. 407×149 cm (left-hand part);
407×152 cm (central part);
407×149 cm (right-hand part)

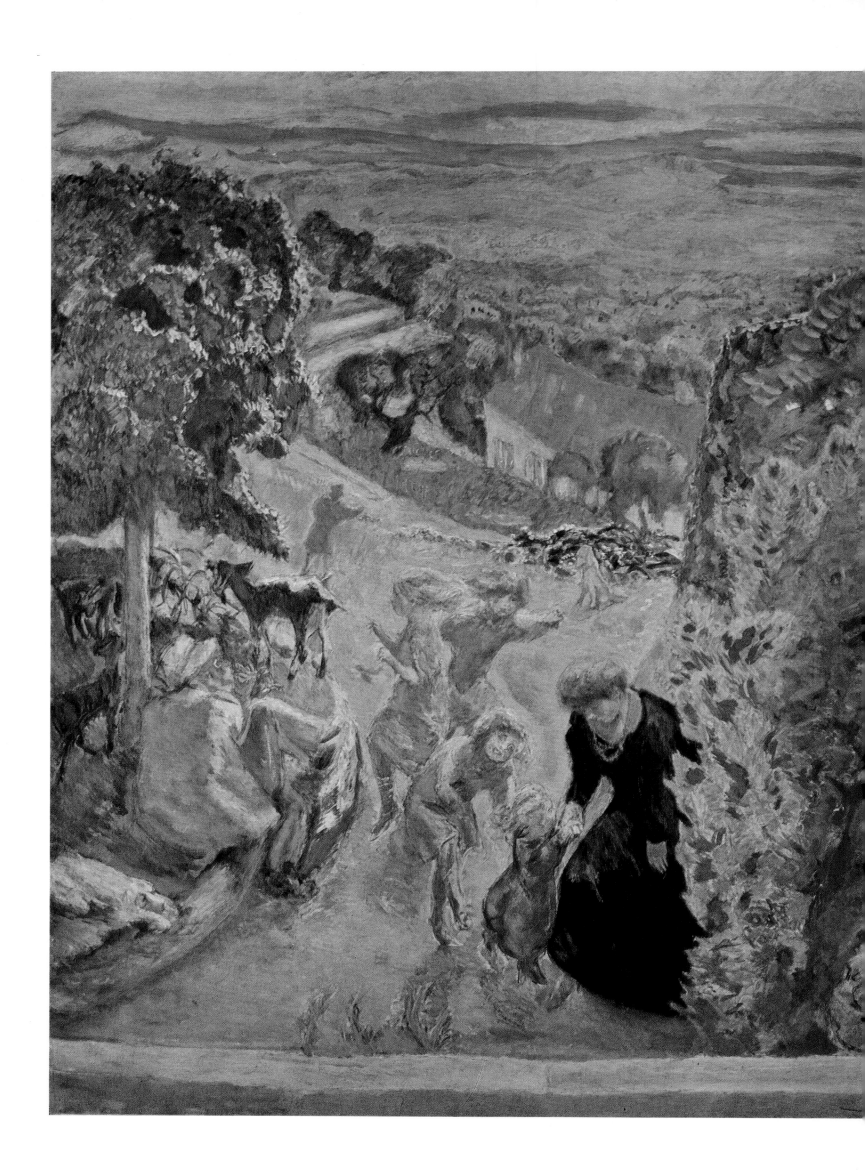

223 SUMMER. THE DANCE

Oil on canvas. 202×254 cm

224 AUTUMN (FRUIT PICKING)

Oil on canvas. 365×347 cm

225, 226 EARLY SPRING IN THE COUNTRY

Oil on canvas. 365×347 cm

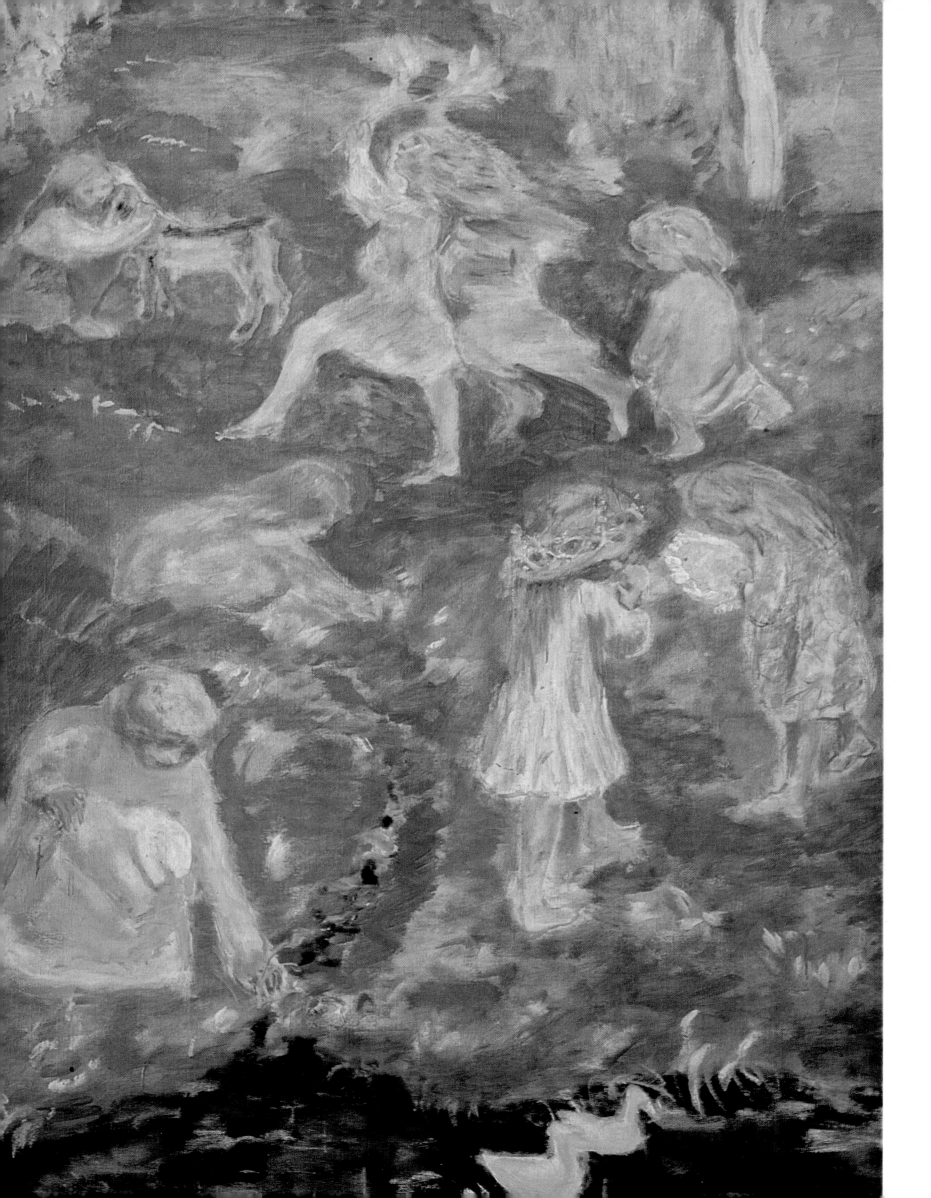

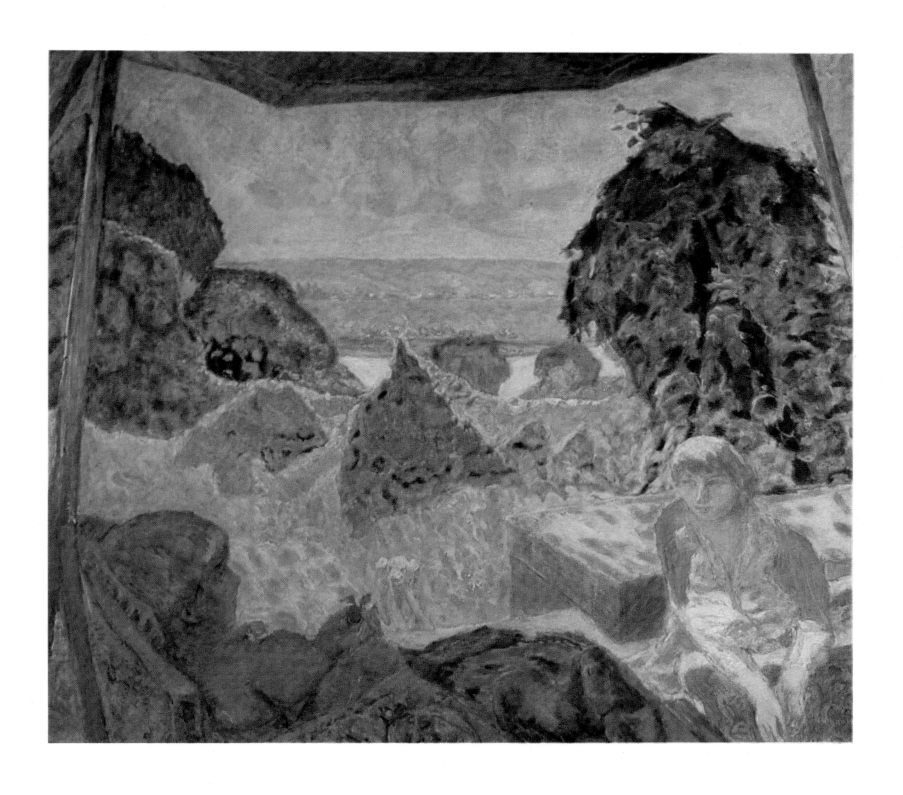

227 SUMMER IN NORMANDY

Oil on canvas. 114×128 cm

MAURICE DENIS. 1870—1943

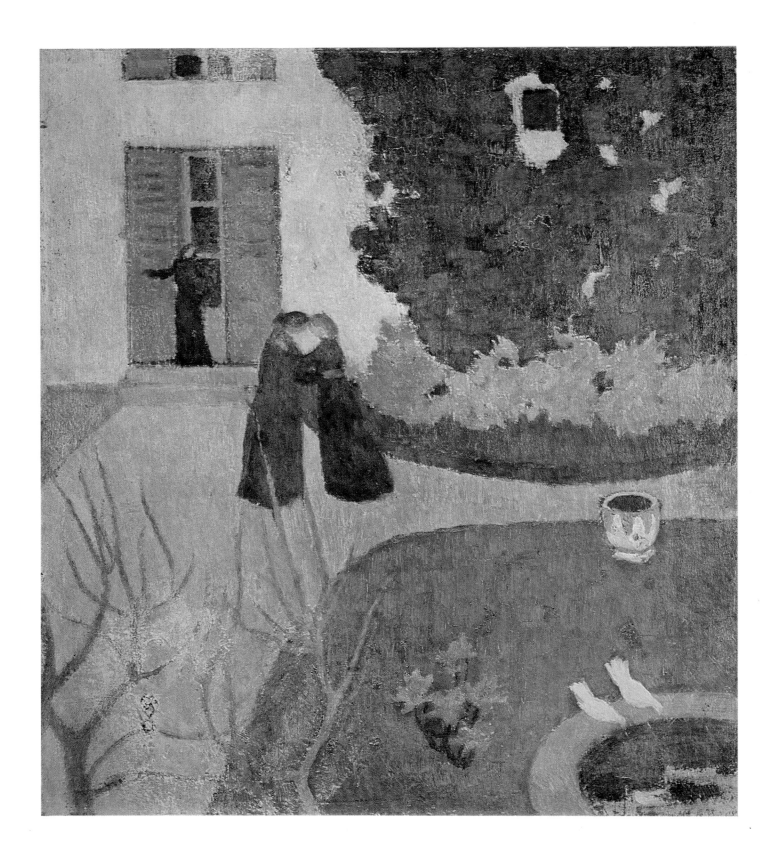

228 THE ENCOUNTER

Oil on cardboard. 37×32 cm

229 SACRED SPRING IN GUIDEL

Oil on cardboard. 39×39 cm

230 WEDDING PROCESSION

Oil on canvas. 26×63 cm

231, 232 THE VISITATION

Oil on canvas. 103×93 cm

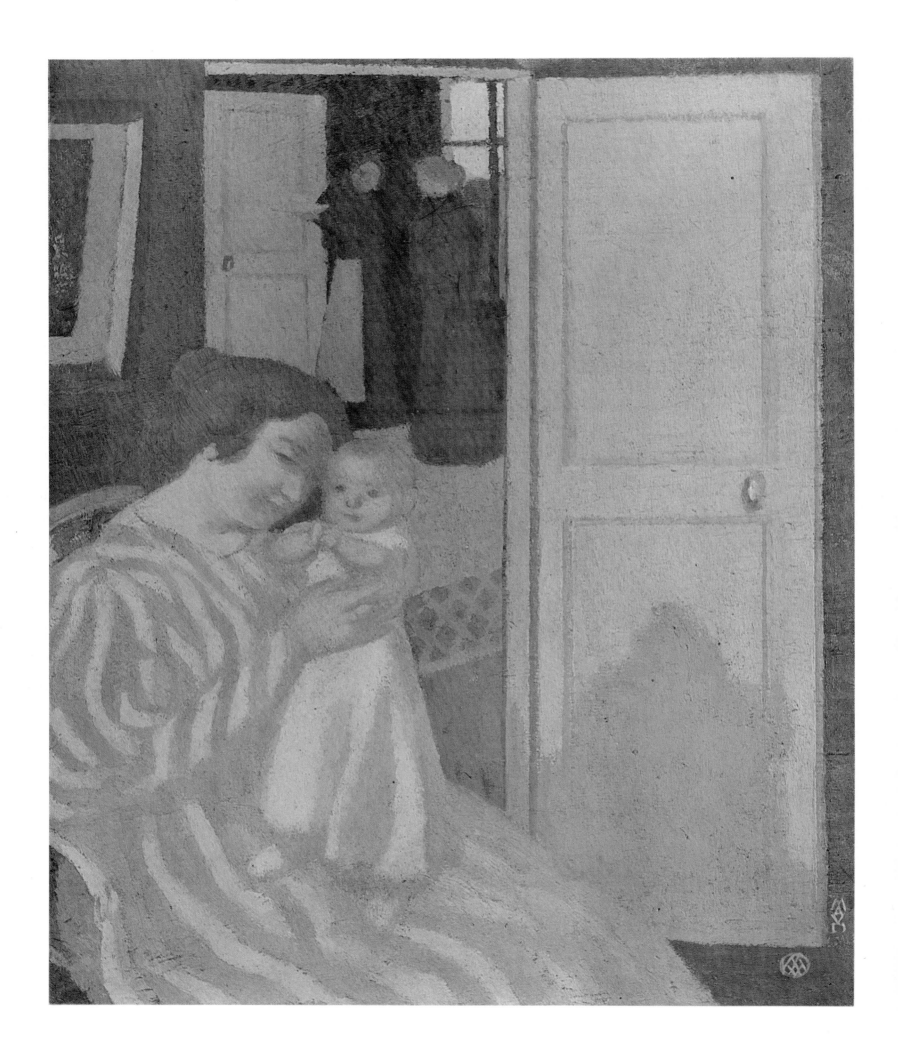

233 MOTHER AND CHILD

Oil on canvas. 46.5×39 cm

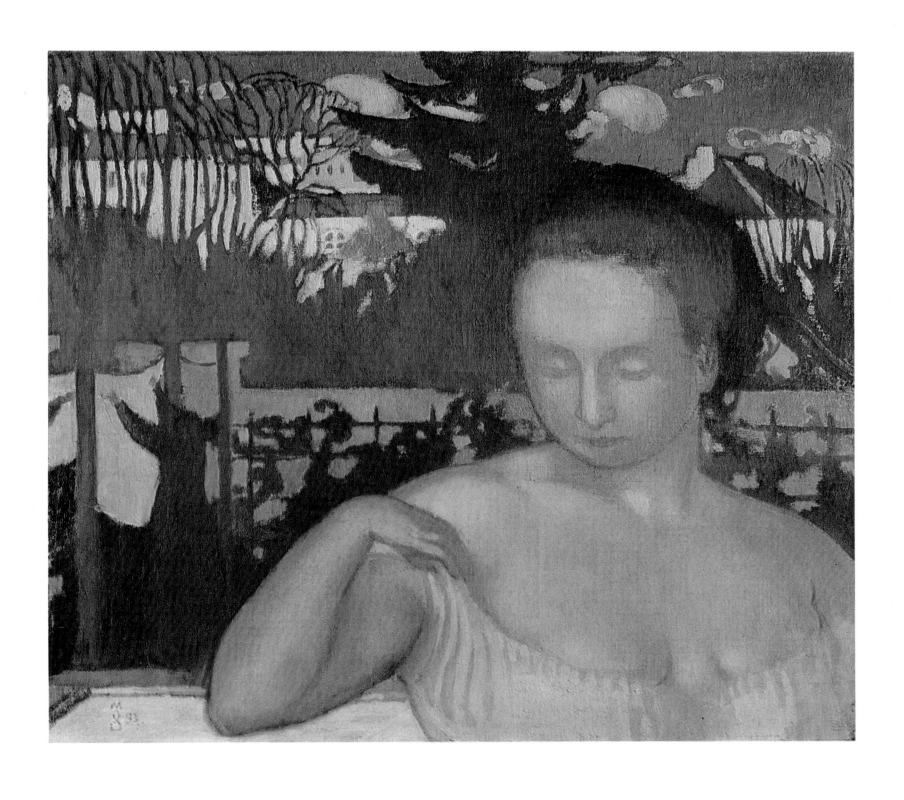

234 PORTRAIT OF MARTHE DENIS, THE ARTIST'S WIFE

Oil on canvas. 45×54 cm

235 FIGURES IN A SPRING LANDSCAPE. Sketch

Oil on cardboard. 26.3×39 cm

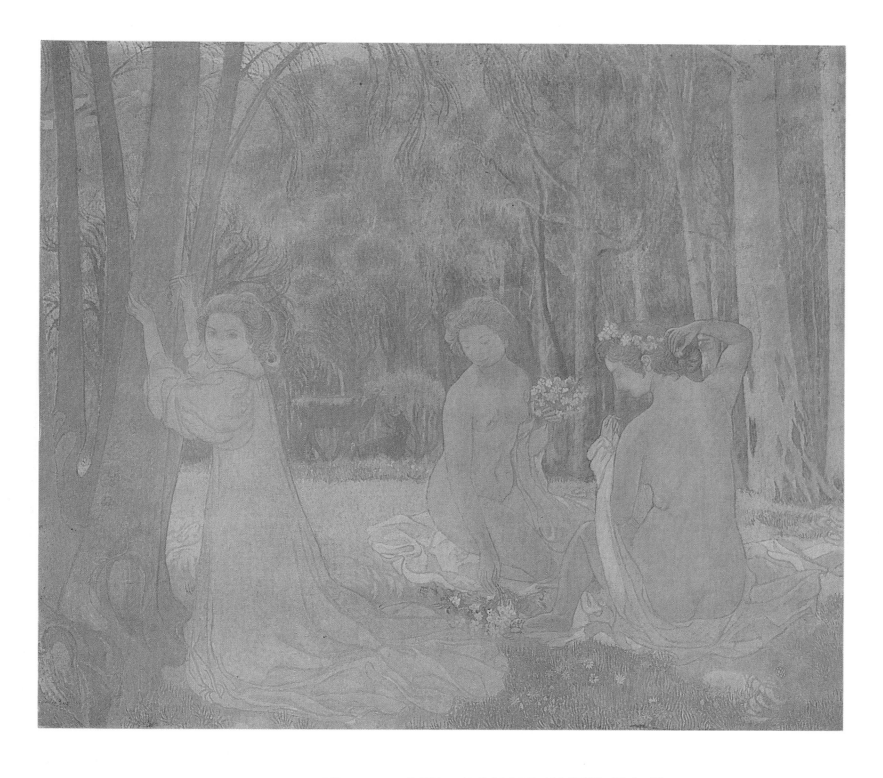

236, 237 FIGURES IN A SPRING LANDSCAPE (SACRED GROVE)

Oil on canvas. 157×179 cm

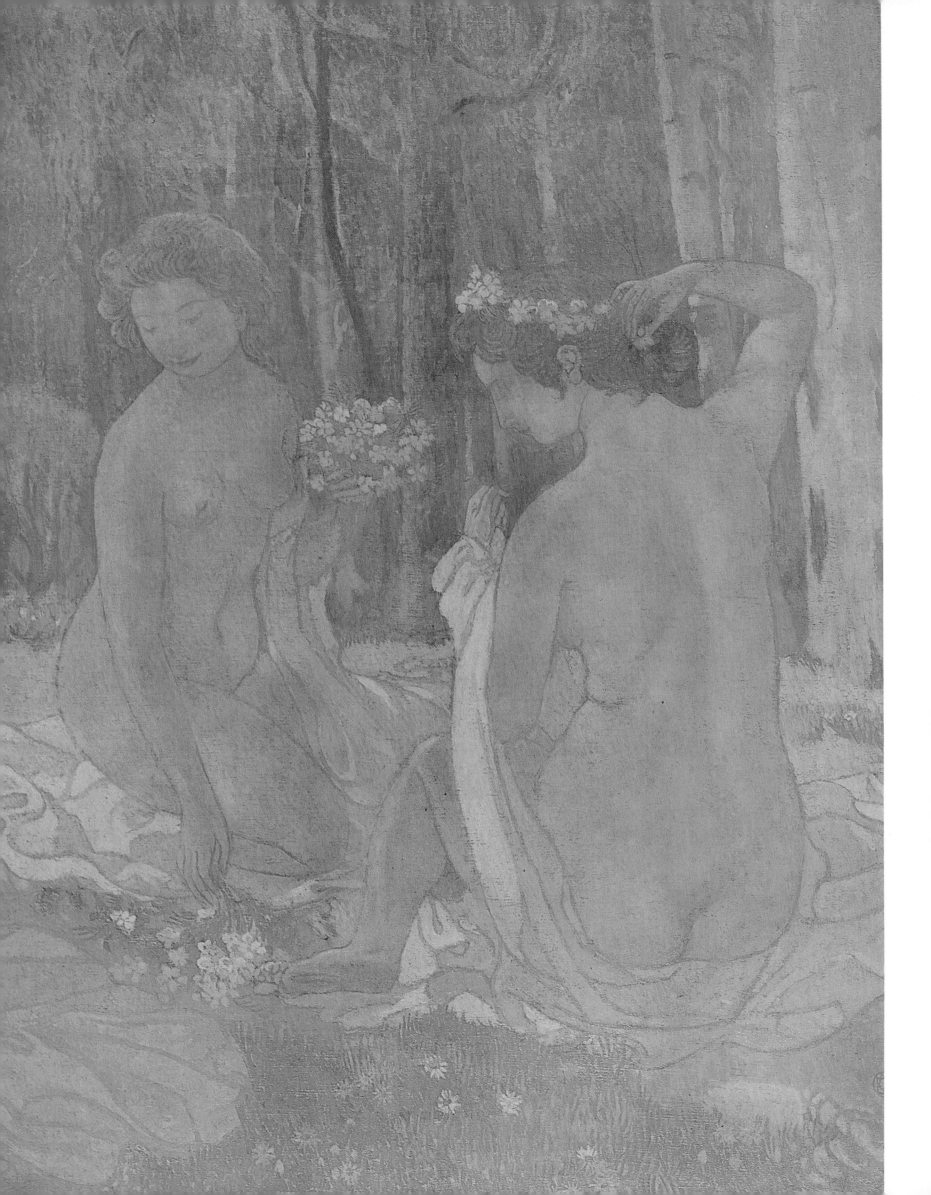

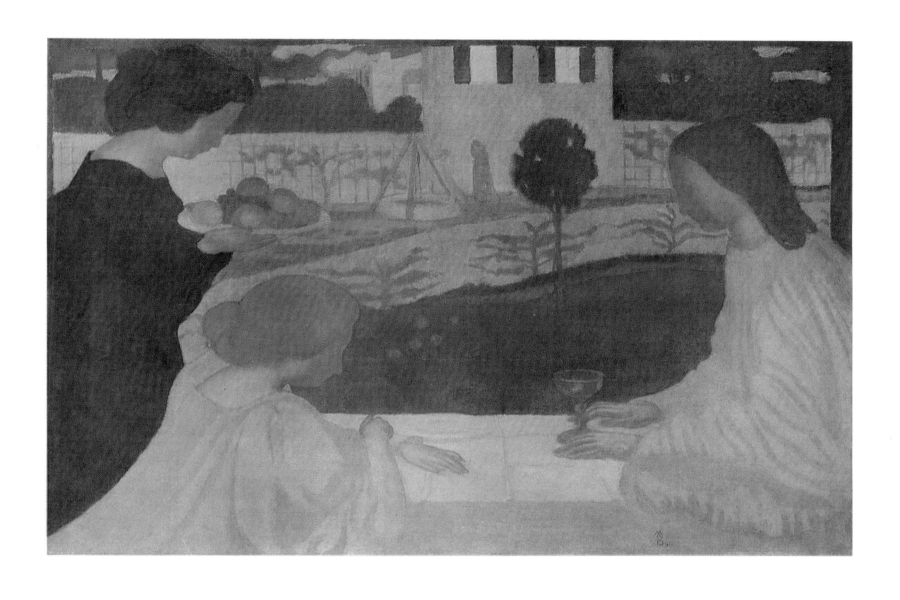

238 MARTHA AND MARY

Oil on canvas. 77×116 cm

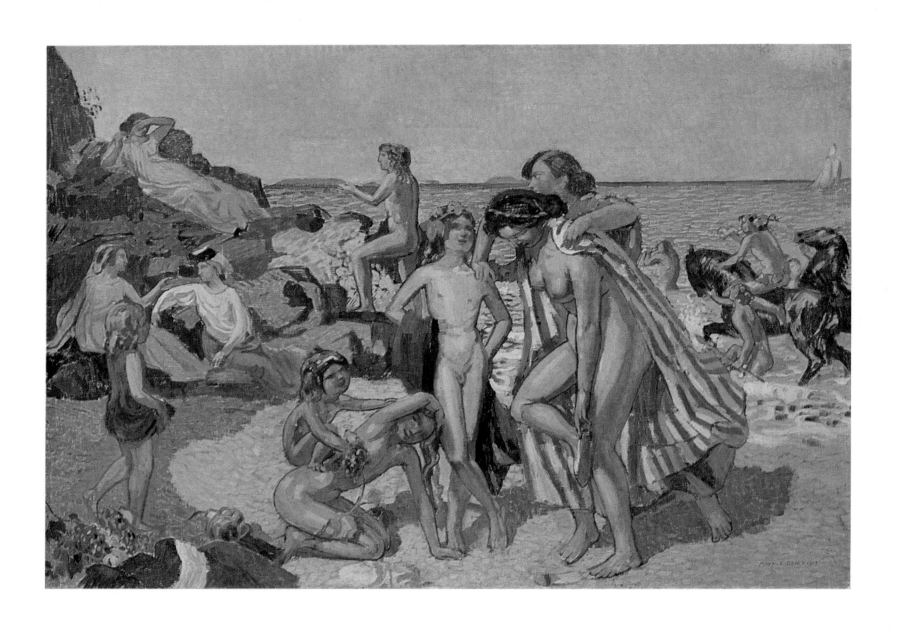

239 BACCHUS AND ARIADNE

Oil on canvas. 81×116 cm

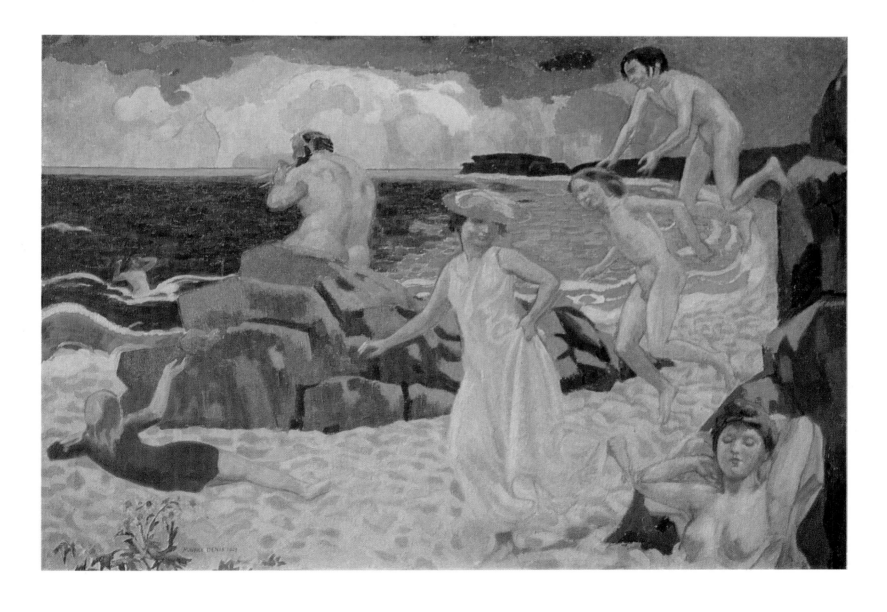

240 POLYPHEMUS

Oil on canvas. 81×116 cm

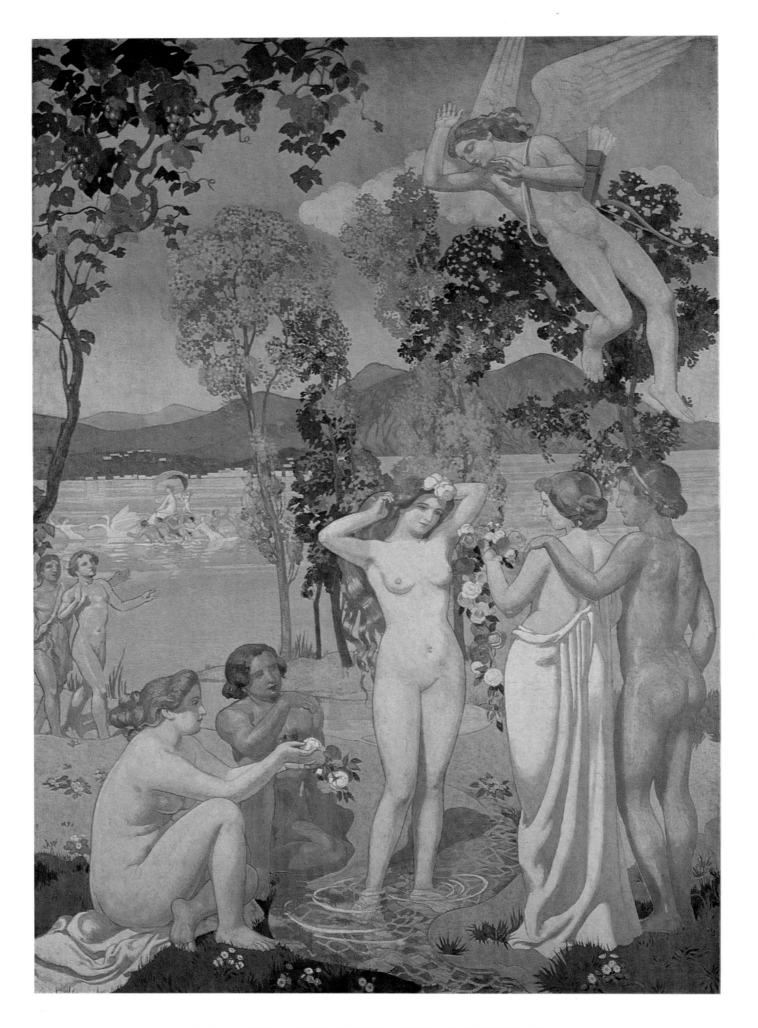

**247 PANEL 1: THE FLYING CUPID IS STRUCK BY
PSYCHE'S BEAUTY**

Oil on canvas. 394×269.5 cm

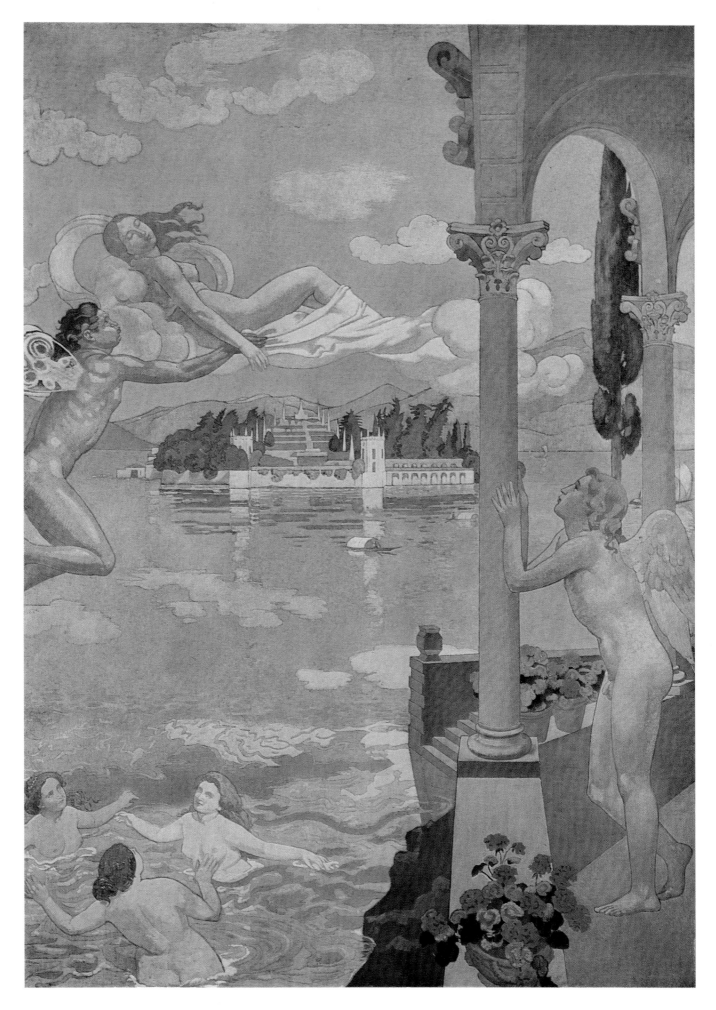

**248 PANEL 2: ZEPHYR TRANSPORTING PSYCHE
TO THE ISLAND OF DELIGHT**

Oil on canvas. 394×267.5 cm

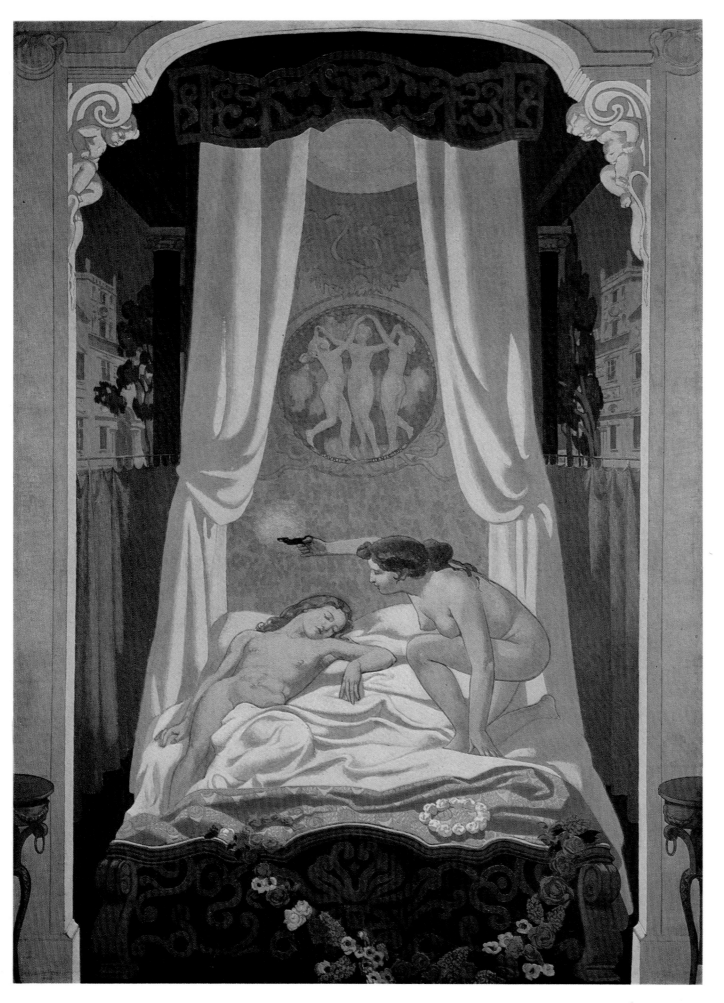

249 PANEL 3: PSYCHE DISCOVERS THAT HER MYSTERIOUS
LOVER IS CUPID

Oil on canvas. 395×274.5 cm

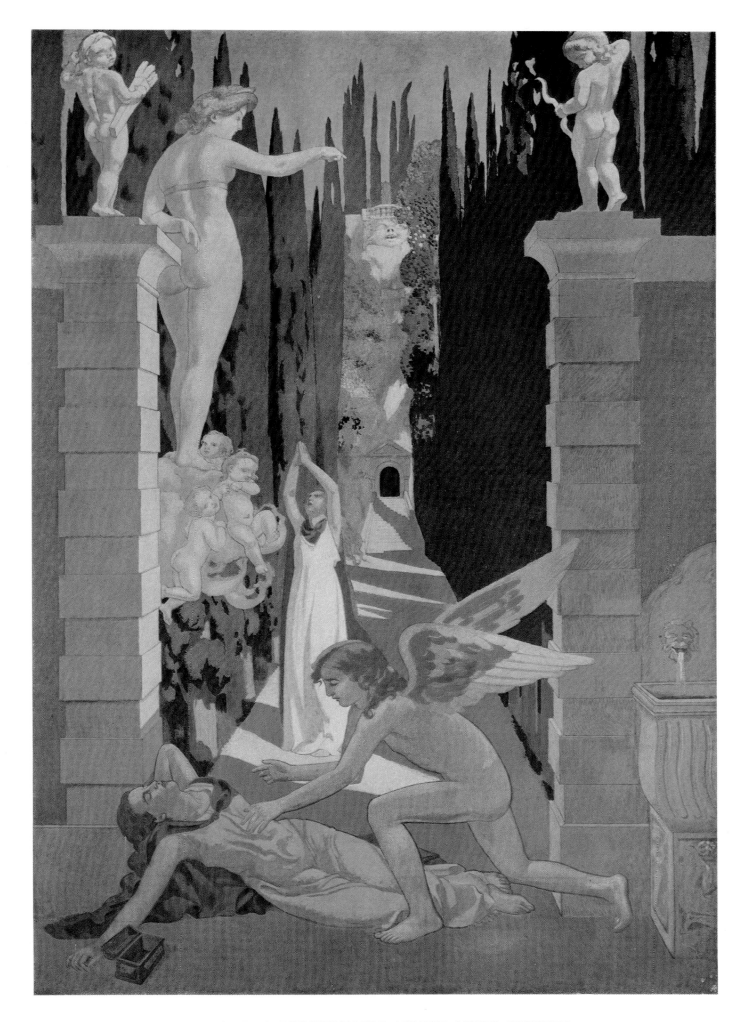

**250 PANEL 4: PSYCHE FALLS ASLEEP AFTER OPENING
THE CASKET CONTAINING THE DREAMS OF THE NETHER WORLD**

Oil on canvas. 395×273 cm

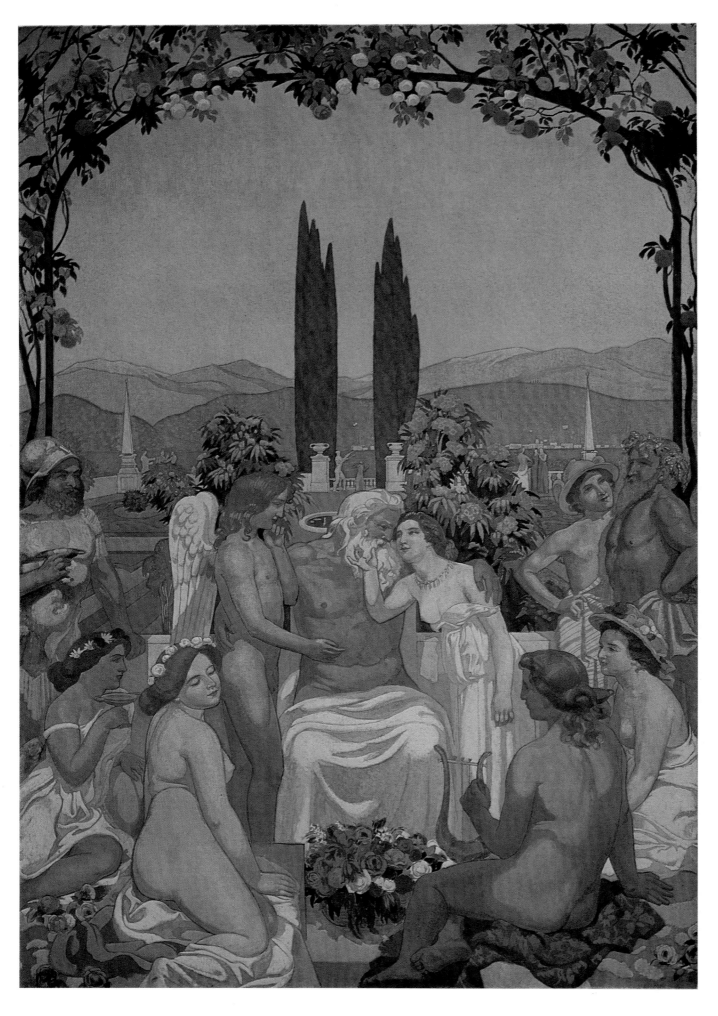

251 PANEL 5: IN THE PRESENCE OF THE GODS, JUPITER BESTOWS IMMORTALITY
ON PSYCHE AND CELEBRATES HER MARRIAGE TO CUPID

Oil on canvas. 399×273 cm

**252 PANEL 6: PSYCHE'S KIN BID HER FAREWELL ON
A MOUNTAINTOP**

Oil on canvas. 200×275 cm

253 PANEL 7: CUPID CARRYING PSYCHE UP TO HEAVEN

Oil on canvas. 180×265 cm

254 AT THE SEASIDE. THE GREEN BEACH

Oil on canvas. 97×180 cm

F.VALLOTTON.

FÉLIX VALLOTTON. 1865—1925

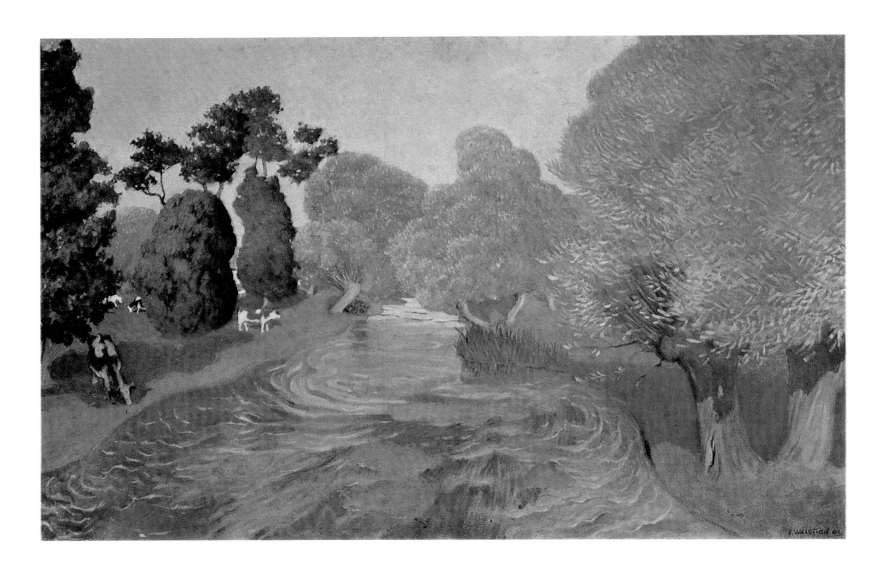

255 LANDSCAPE IN NORMANDY: ARQUES-LA-BATAILLE

Oil on cardboard. 67×103.5 cm

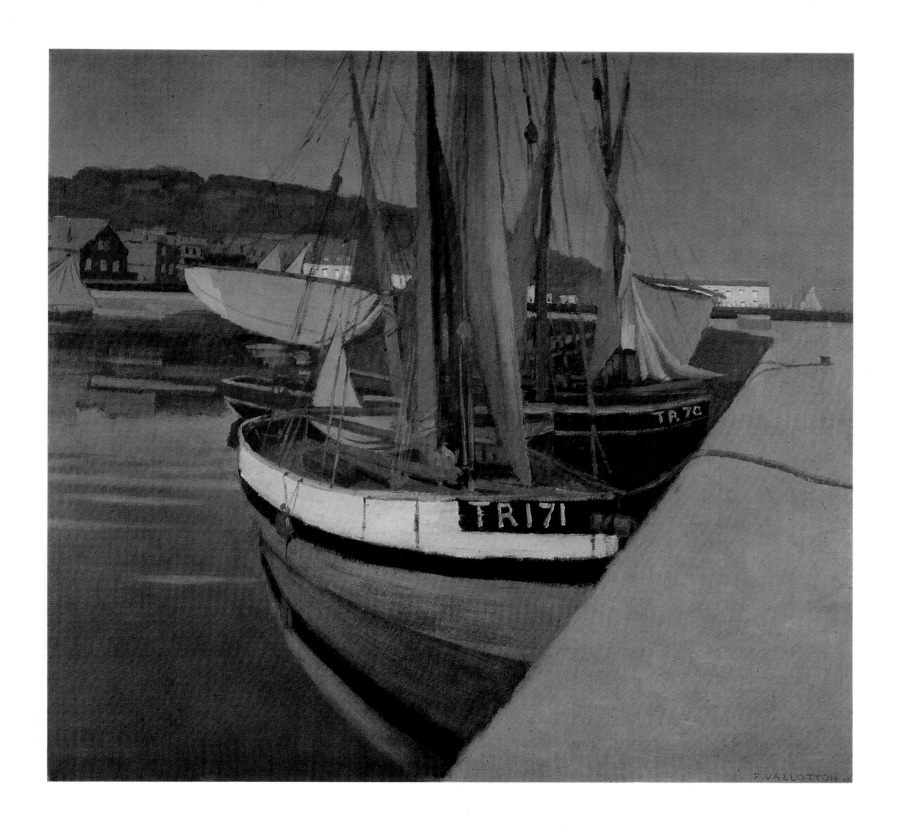

256 PORT

Oil on cardboard. 57×62 cm

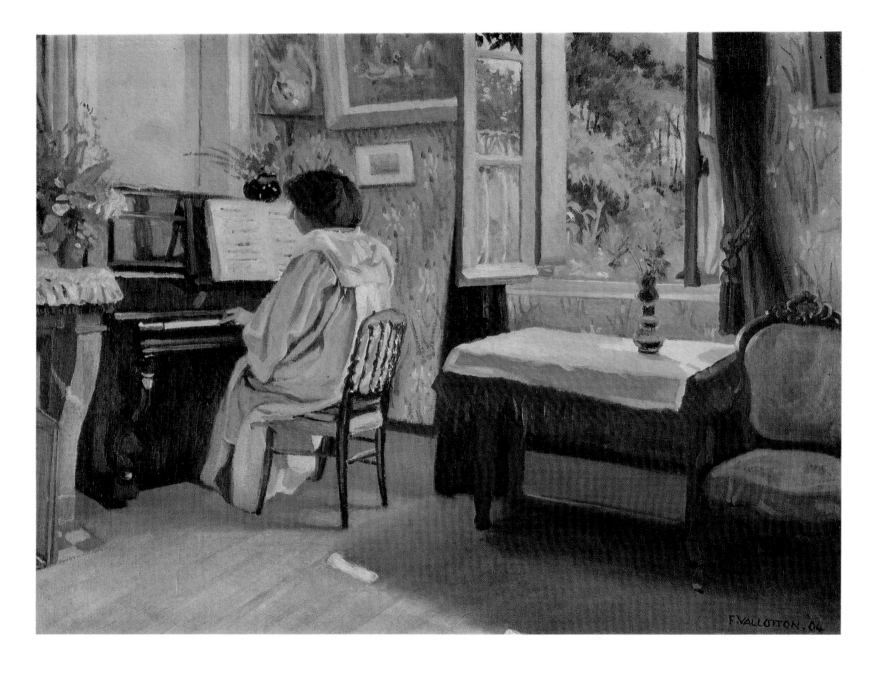

257 LADY AT THE PIANO (MME VALLOTTON)

Oil on canvas. 43.5×57 cm

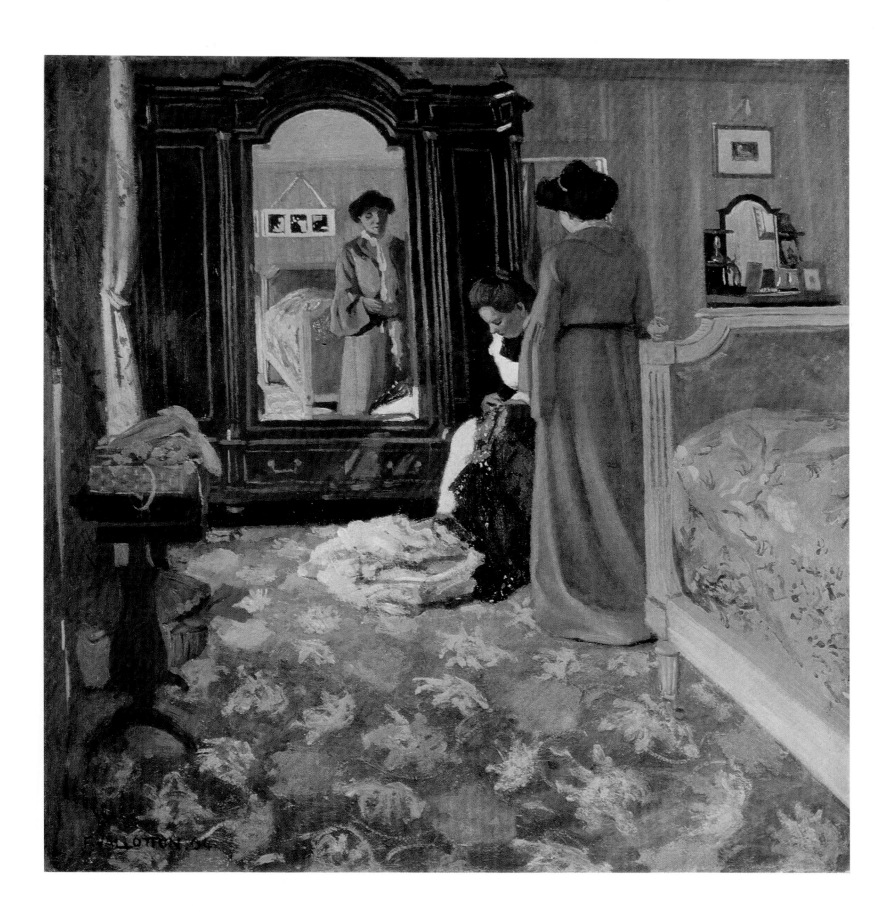

258 INTERIOR

Oil on cardboard. 61.5×56 cm

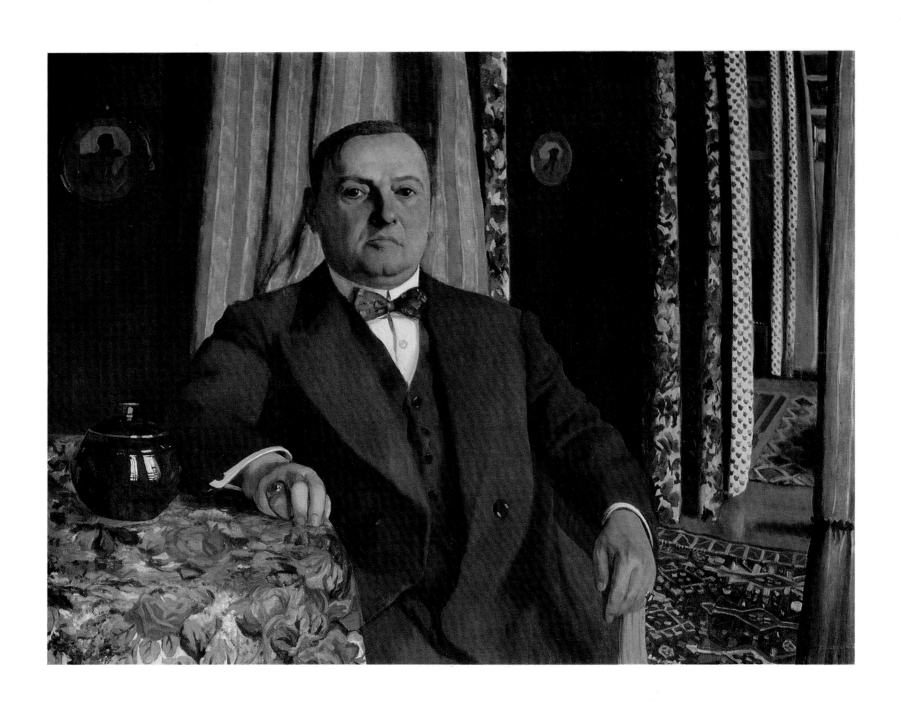

259 PORTRAIT OF GEORGES HASEN

Oil on canvas. 81.7 × 100.3 cm

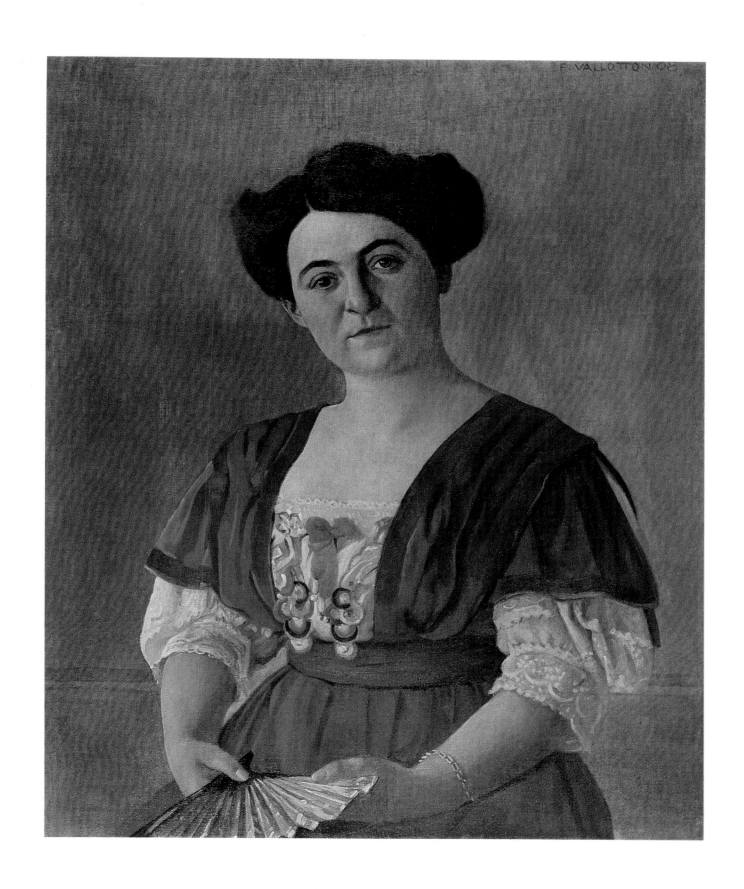

260　PORTRAIT OF MME GEORGES HASEN

Oil on canvas. 81.5×66 cm

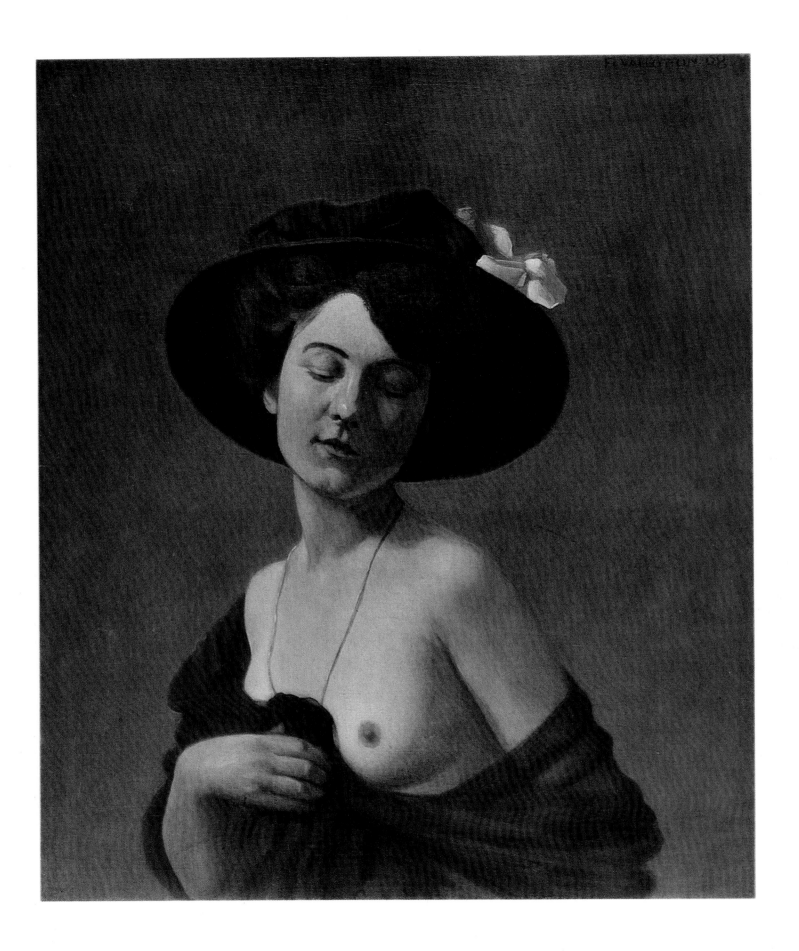

261 PORTRAIT OF A WOMAN IN A BLACK HAT

Oil on canvas. 81×64.8 cm

Rouault

GEORGES ROUAULT. 1871—1958

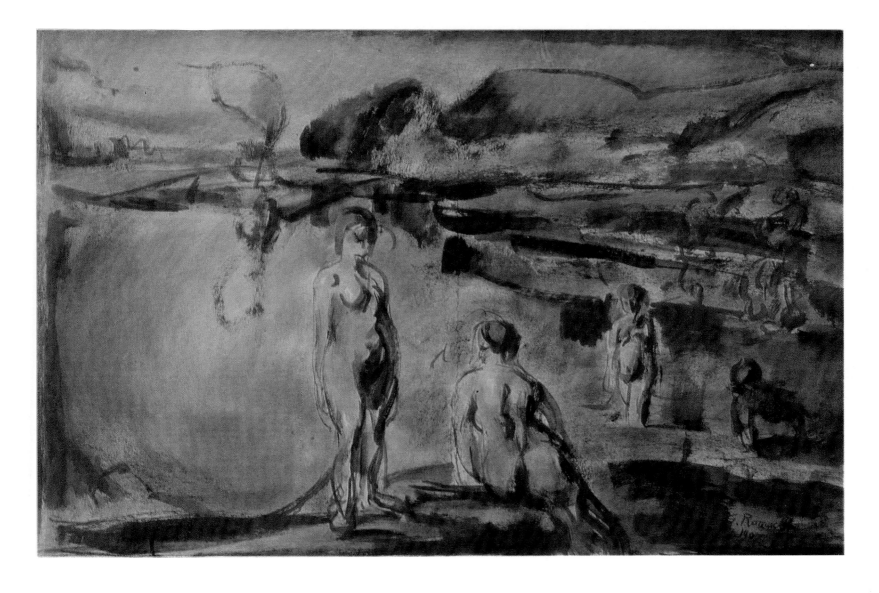

262 BATHING IN A LAKE

Watercolour and pastel. 65×96 cm

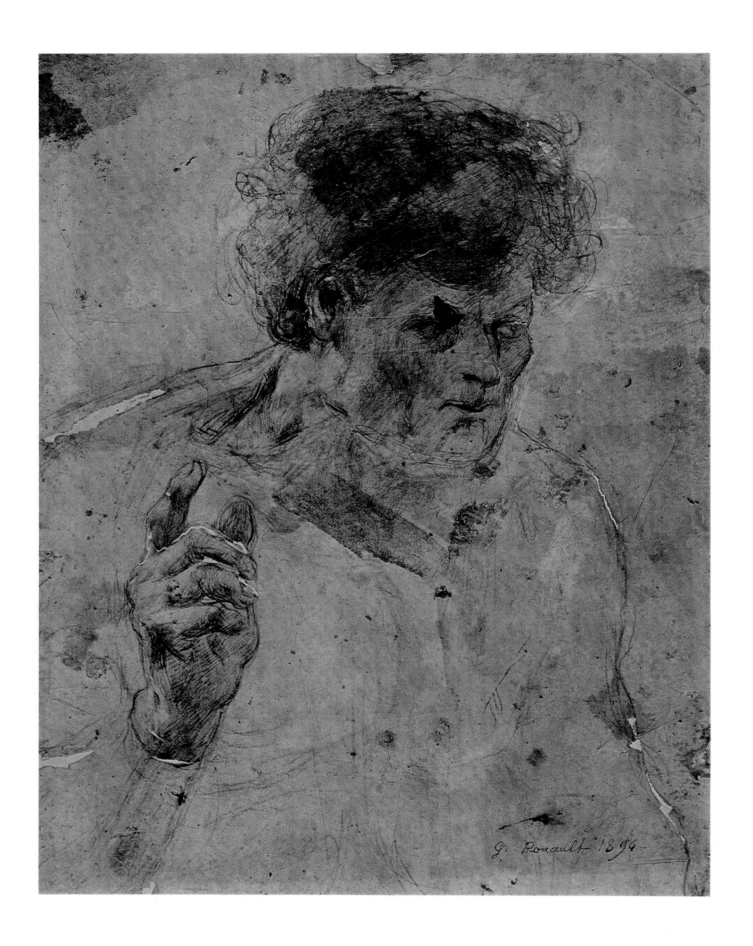

263 HEAD OF A MAN

Indian ink, pen and pencil on tracing paper mounted on cardboard. 27×21 cm

264 HEAD OF A CLOWN

Pastel, gouache and watercolour on paper mounted on cardboard. 43×27 cm

HENRI MATISSE. 1869—1954

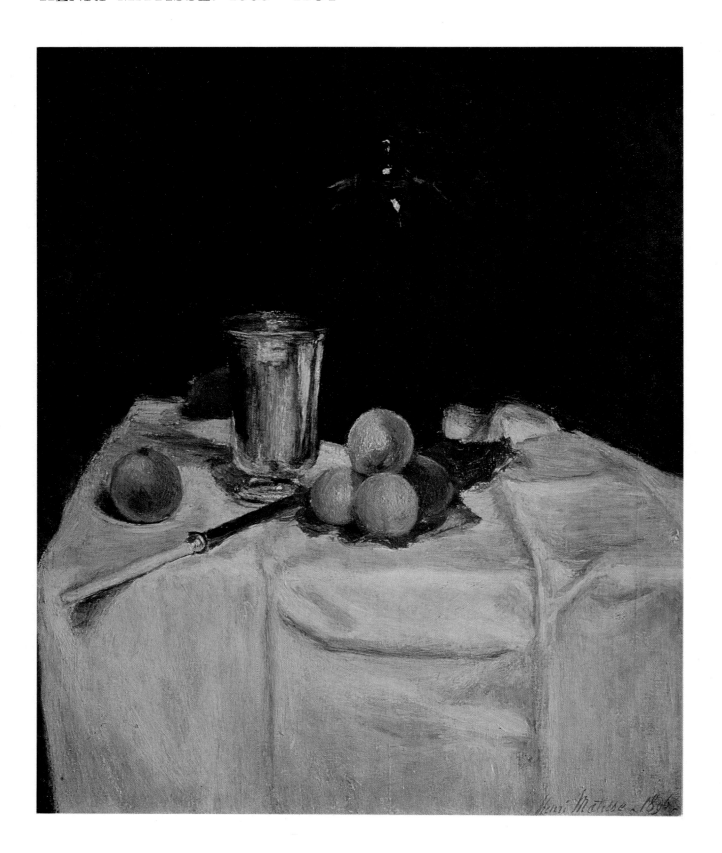

265 THE BOTTLE OF SCHIEDAM

Oil on canvas. 73.2×60.3 cm

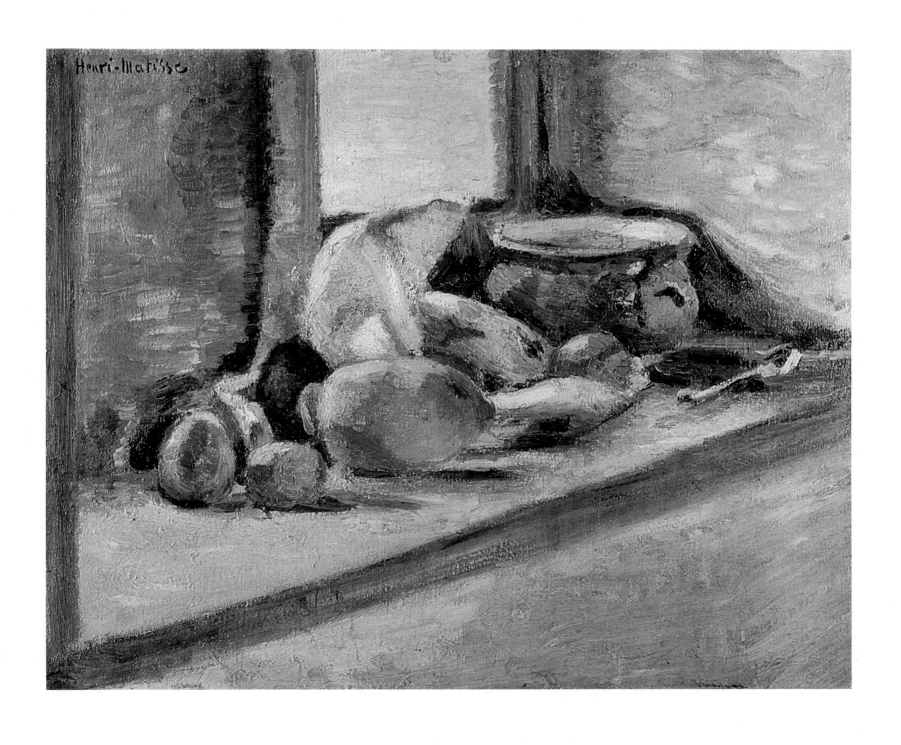

266 BLUE POT AND LEMON

Oil on canvas. 39×46.5 cm

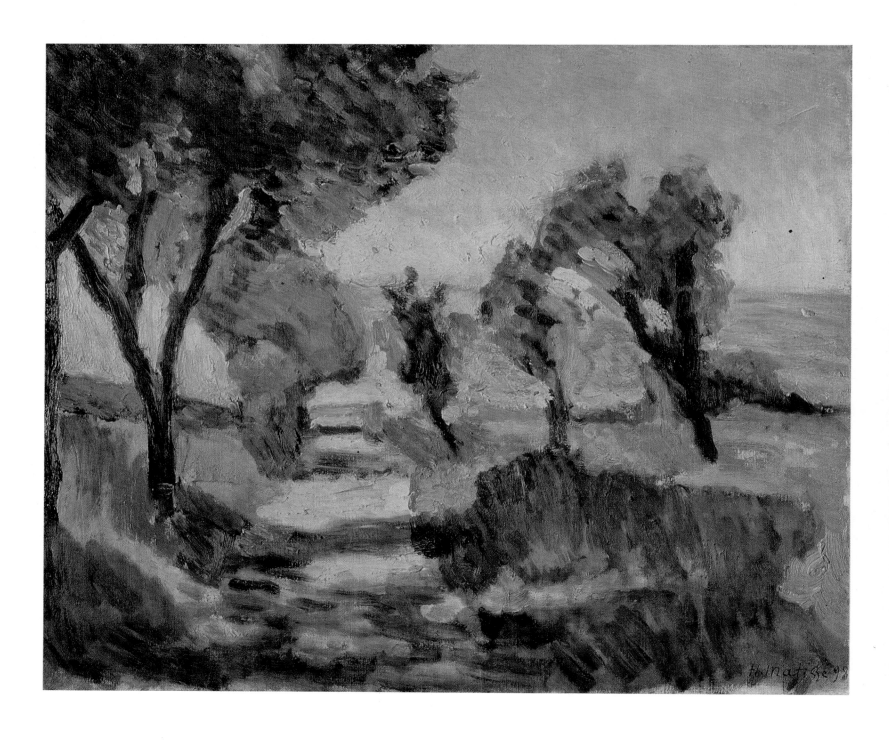

267 CORSICAN LANDSCAPE. OLIVE-TREES

Oil on canvas. 38×46 cm

268 THE LUXEMBOURG GARDENS

Oil on canvas. 59.5×81.5 cm

269 VASE OF SUNFLOWERS

Oil on canvas. 46×38 cm

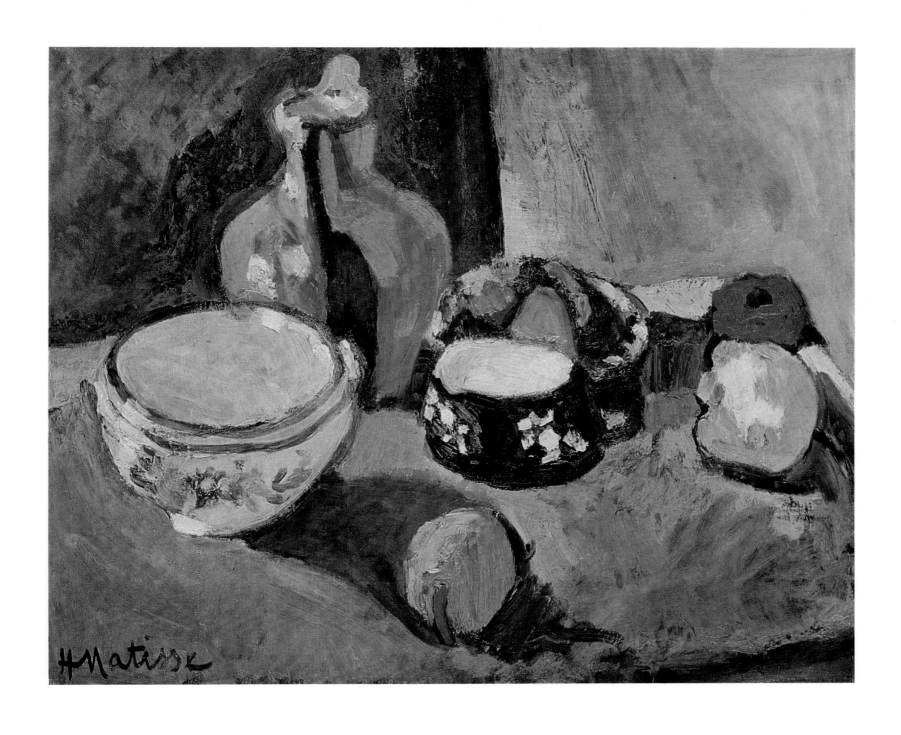

270 DISHES AND FRUIT

Oil on canvas. 51×61.5 cm

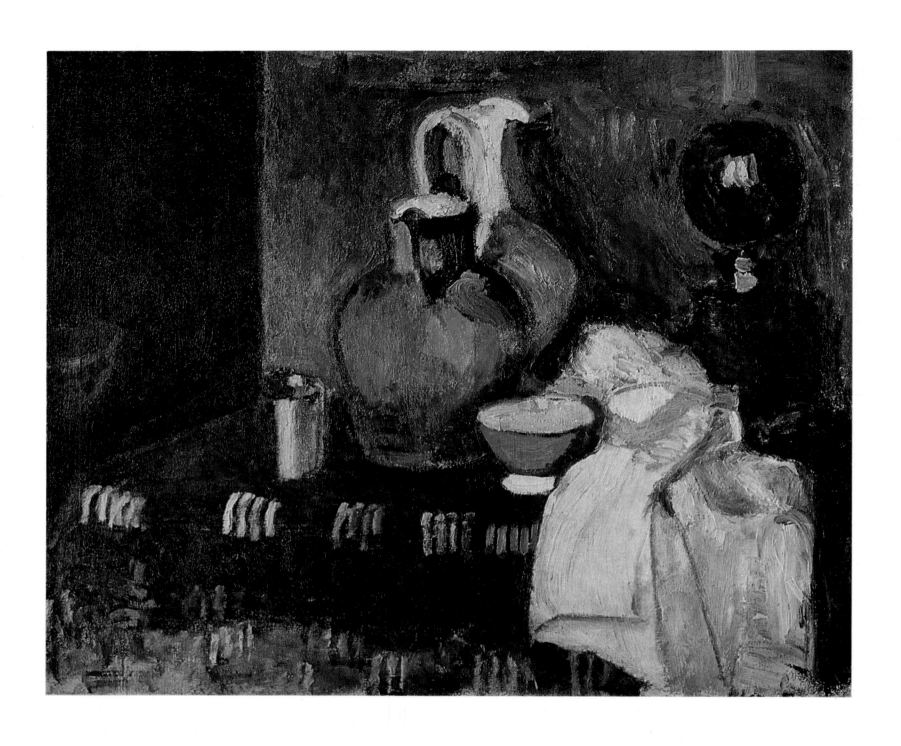

271 BLUE JUG

Oil on canvas. 59.5×73.5 cm

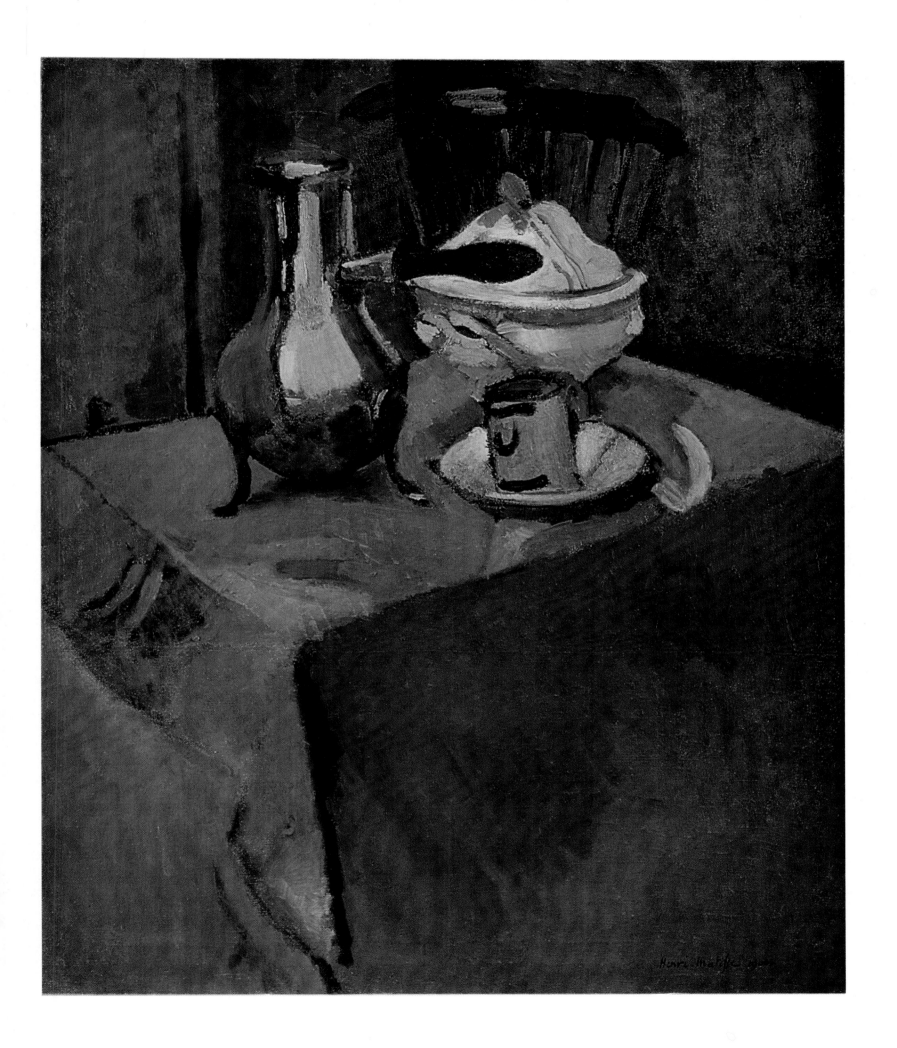

272 CROCKERY ON A TABLE

Oil on canvas. 97×82 cm

273 FRUIT AND COFFEE-POT

Oil on canvas. 38.5×46.5 cm

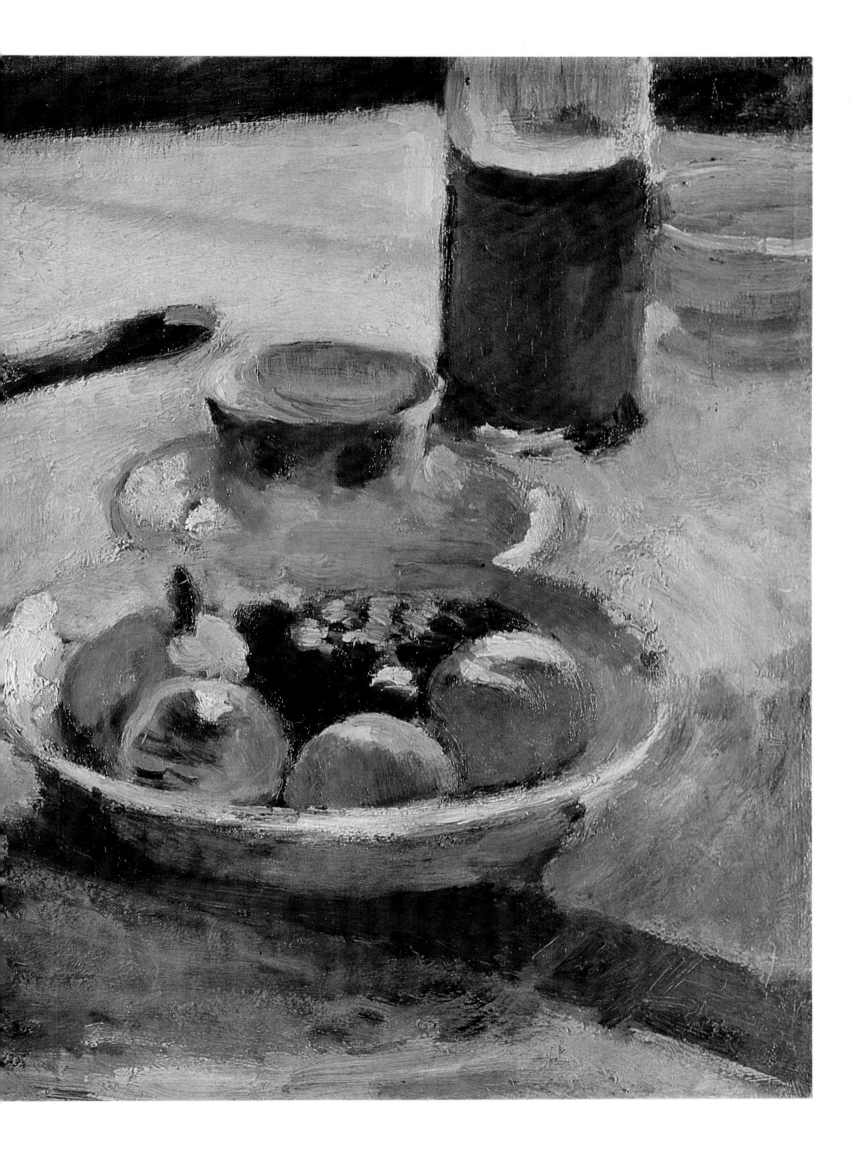

274 THE BOIS DE BOULOGNE

Oil on canvas. 65×81.5 cm

275 FISHERMAN (MAN WITH A FISHING-ROD)

Pen drawing in Indian ink. 30.3×48.7 cm

PABLO PICASSO. 1881—1973

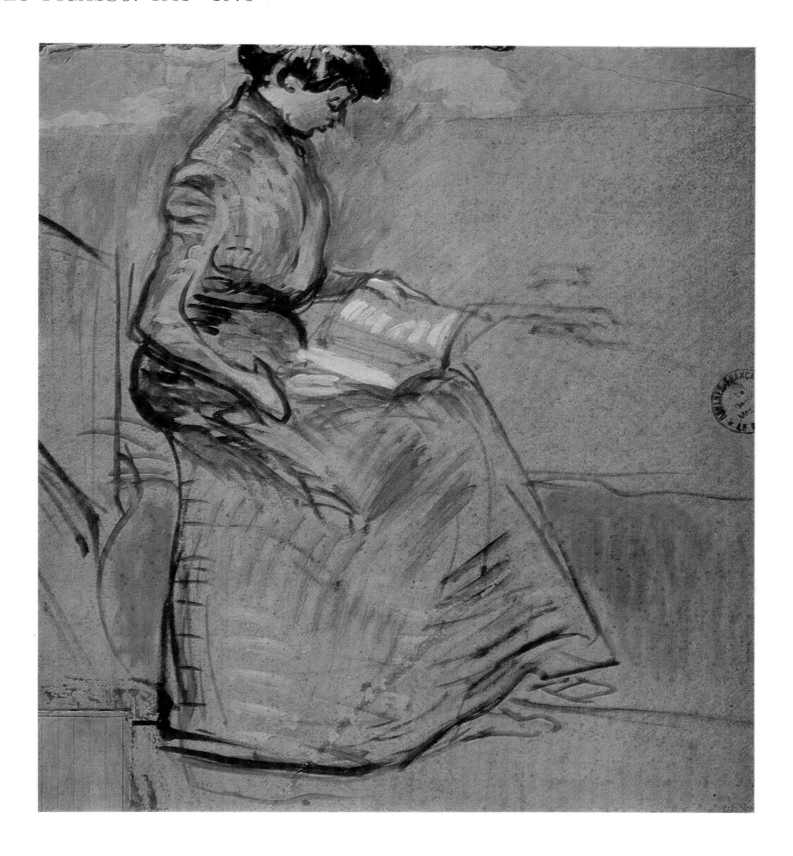

276 WOMAN READING A BOOK

Charcoal, watercolour and pencil on cardboard. 52×56 cm

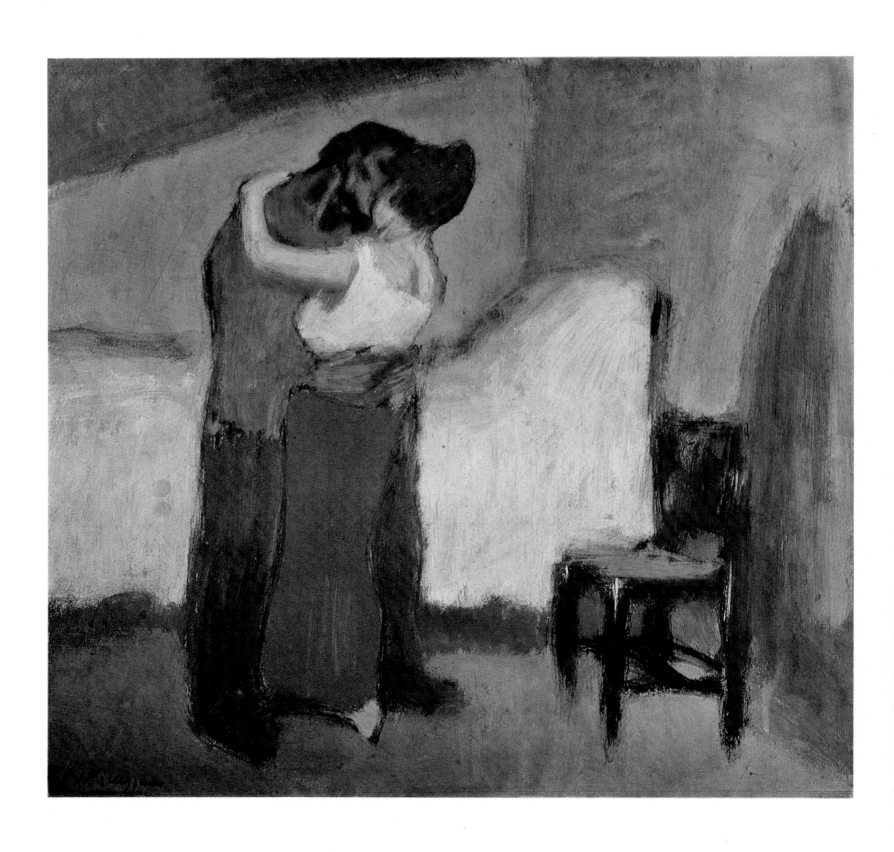

277 THE EMBRACE

Oil on cardboard. 52×56 cm

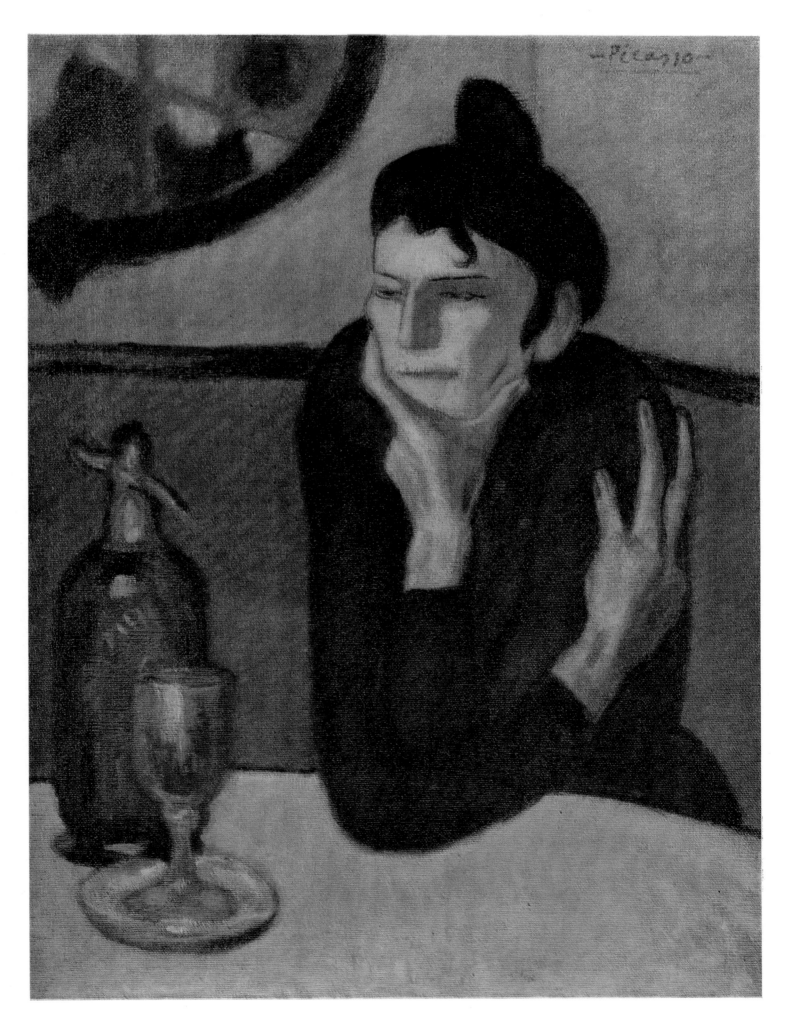

278 THE ABSINTHE DRINKER

Oil on canvas. 73×54 cm

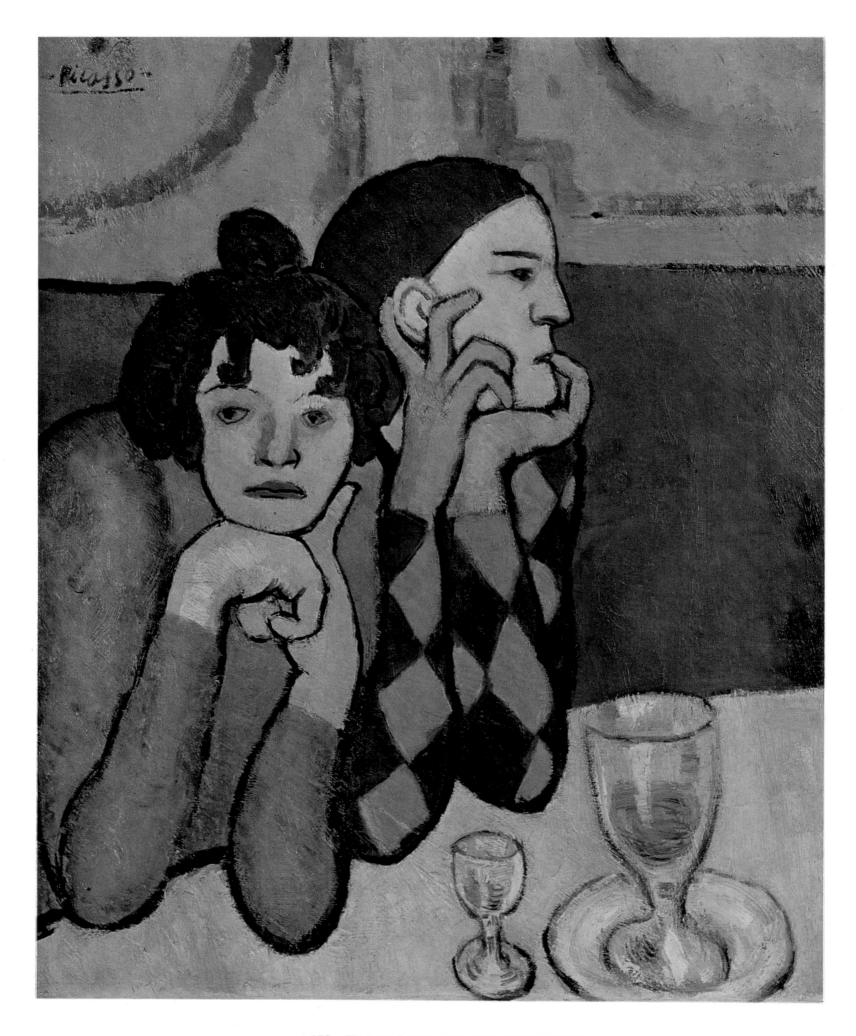

279 HARLEQUIN AND HIS COMPANION

Oil on canvas. 73×60 cm

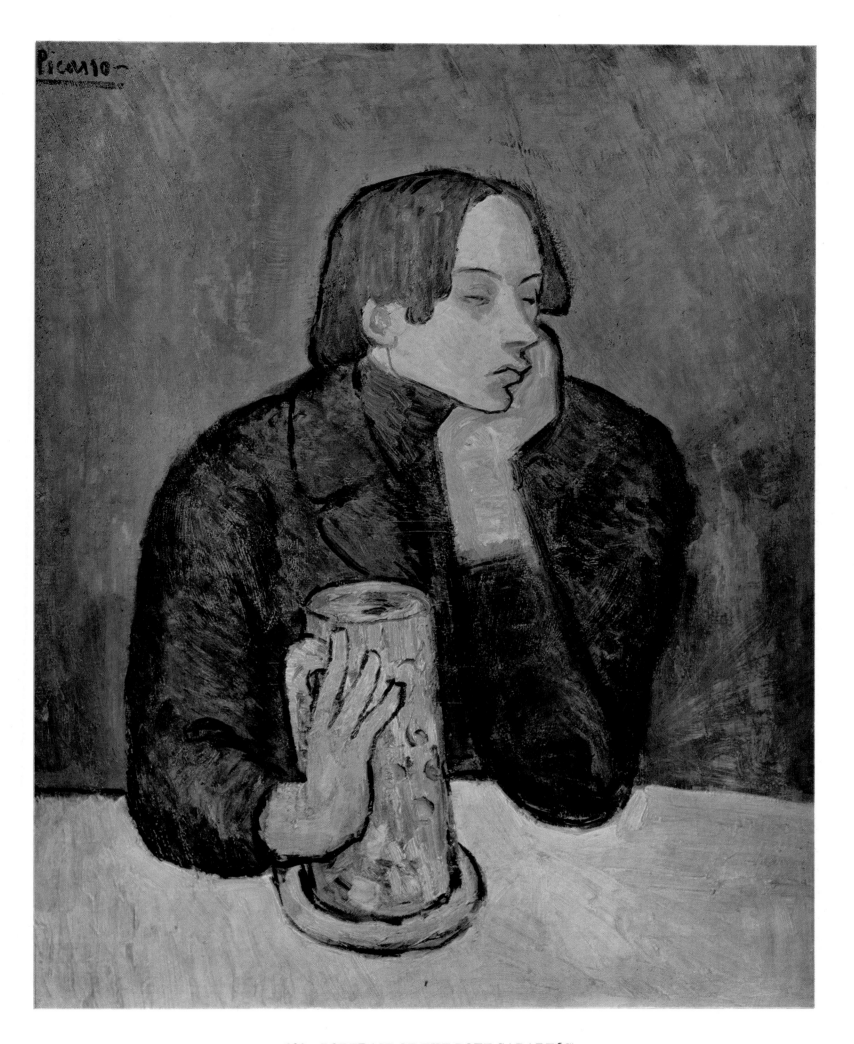

280 PORTRAIT OF THE POET SABARTÉS

Oil on canvas. 82×66 cm

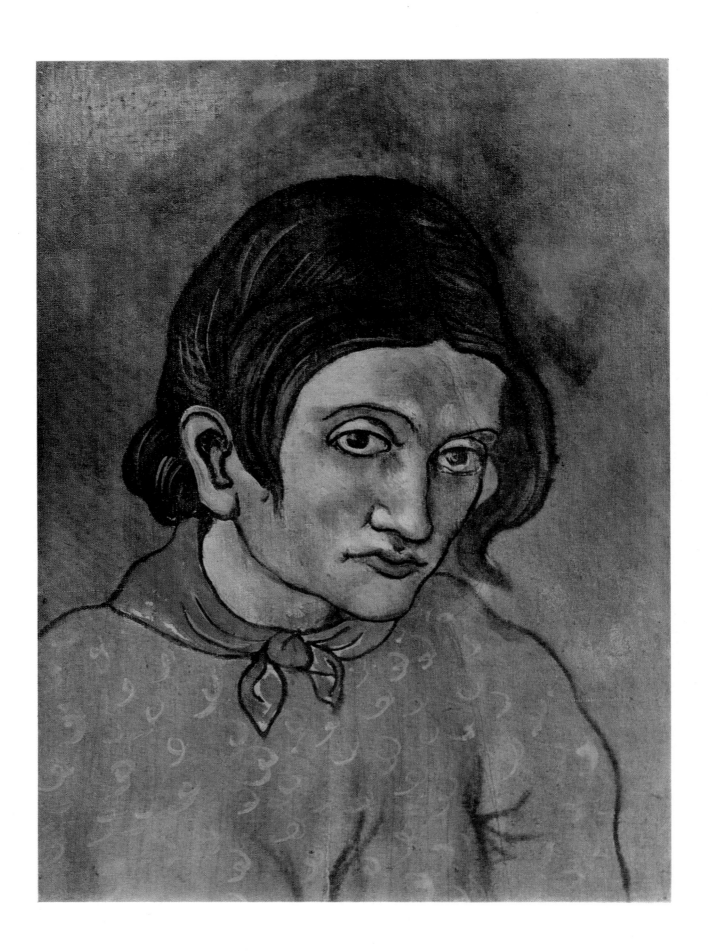

281 HEAD OF A WOMAN WITH A SCARF

Oil on canvas mounted on cardboard. 50×36.5 cm

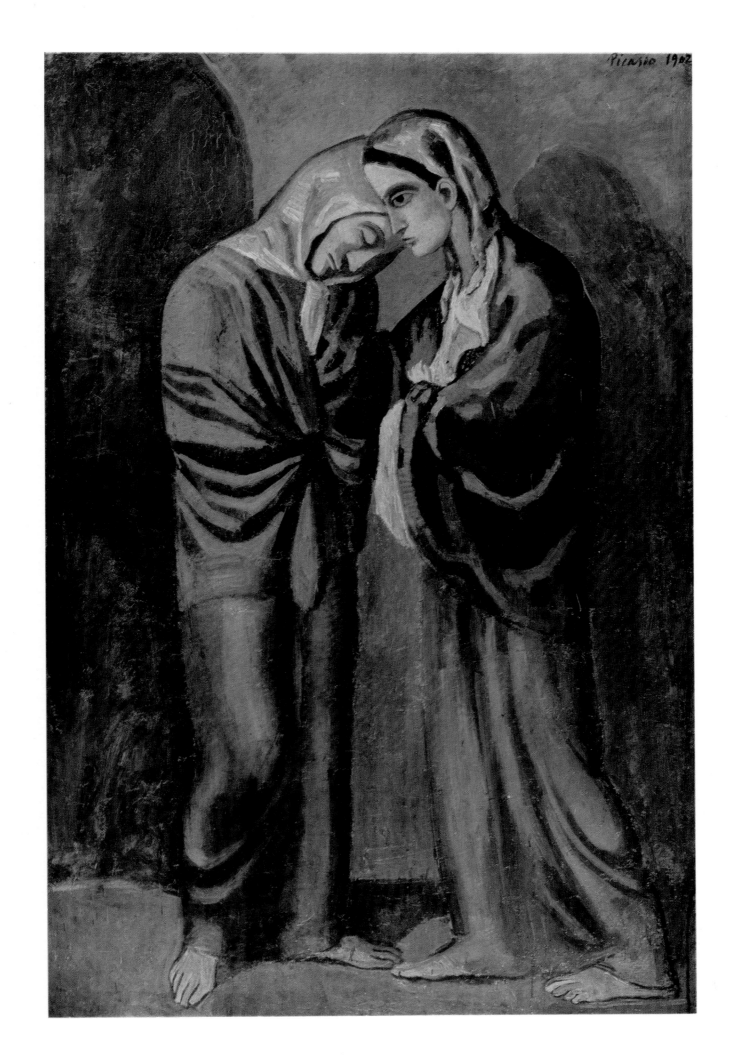

282 THE VISIT (TWO SISTERS)

Oil on panel. 152×100 cm

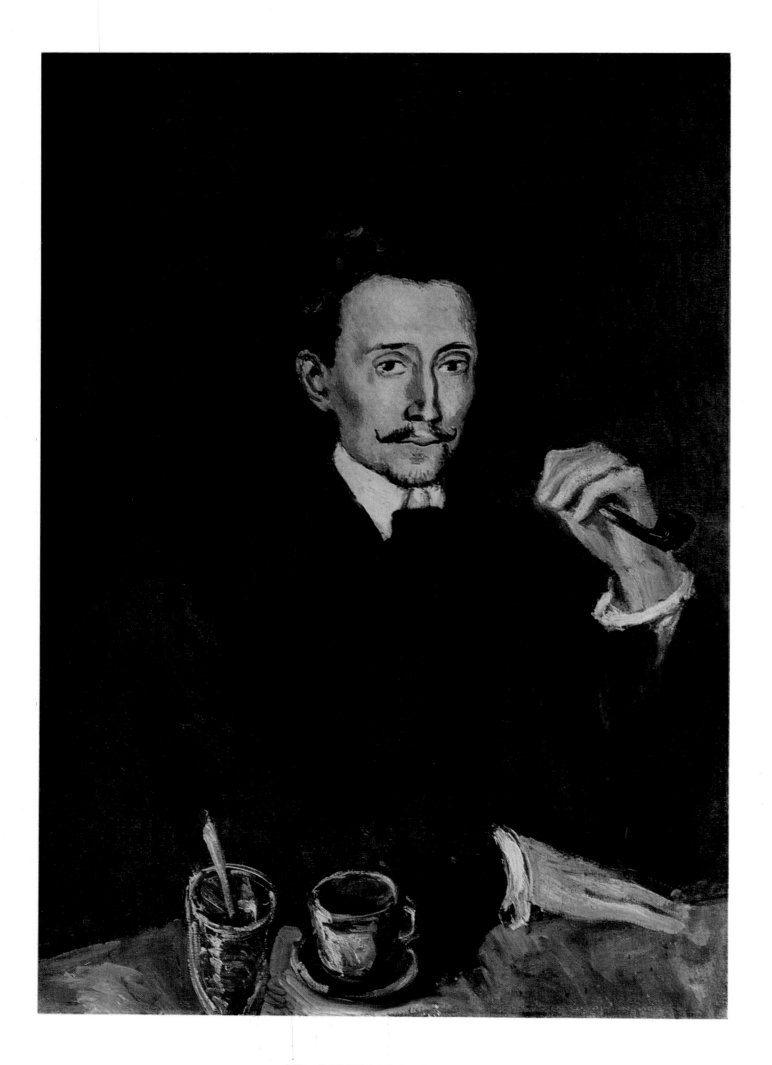

283 PORTRAIT OF SOLER

Oil on canvas. 100×70 cm

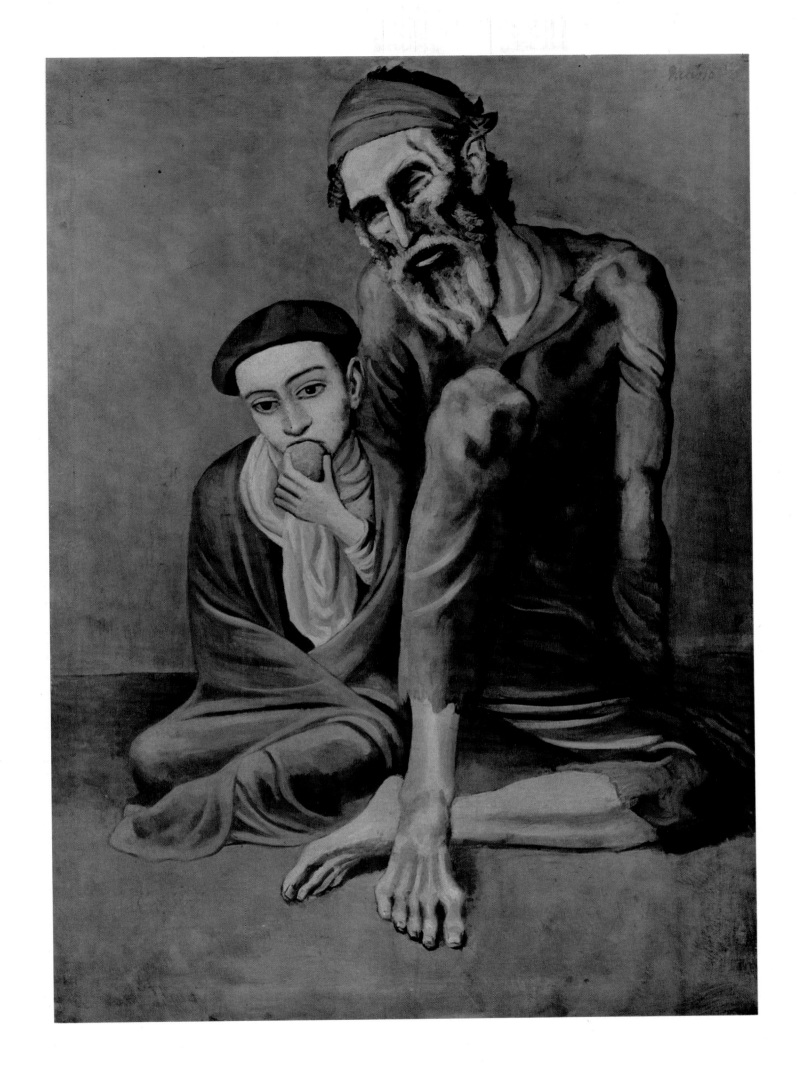

284 OLD JEW AND A BOY (BLIND BEGGAR WITH A BOY)

Oil on canvas. 125×92 cm

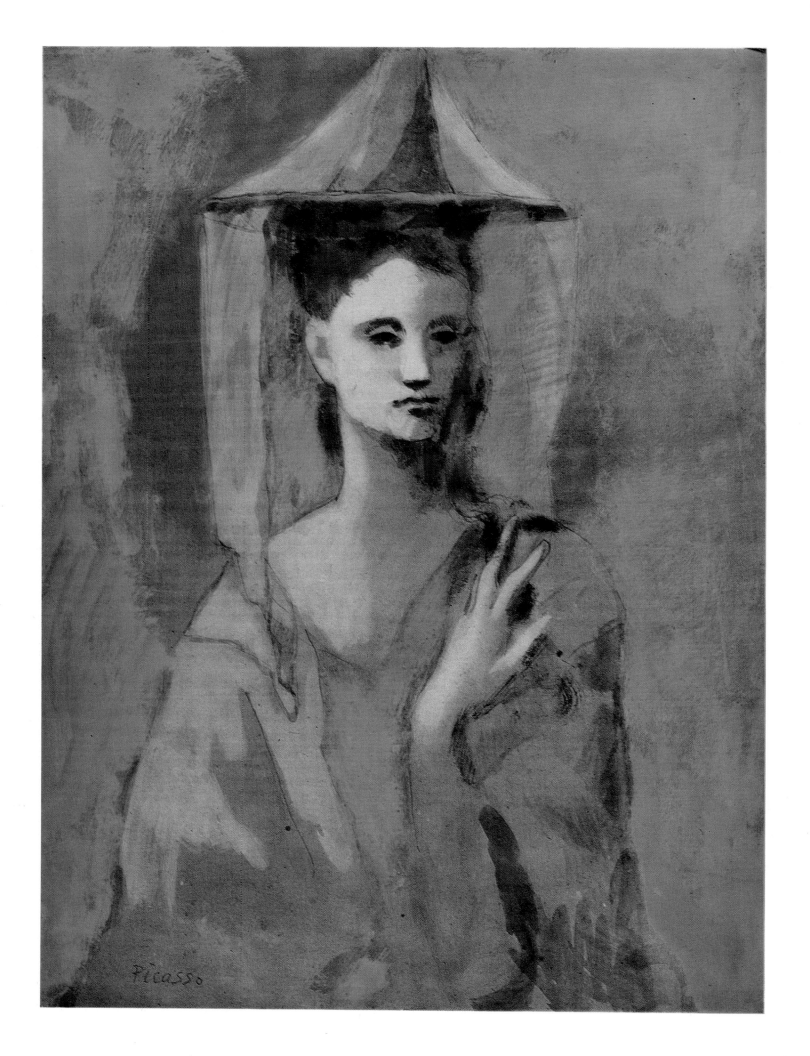

285 SPANISH WOMAN FROM MALLORCA

Tempera and watercolour on cardboard. 67×51 cm

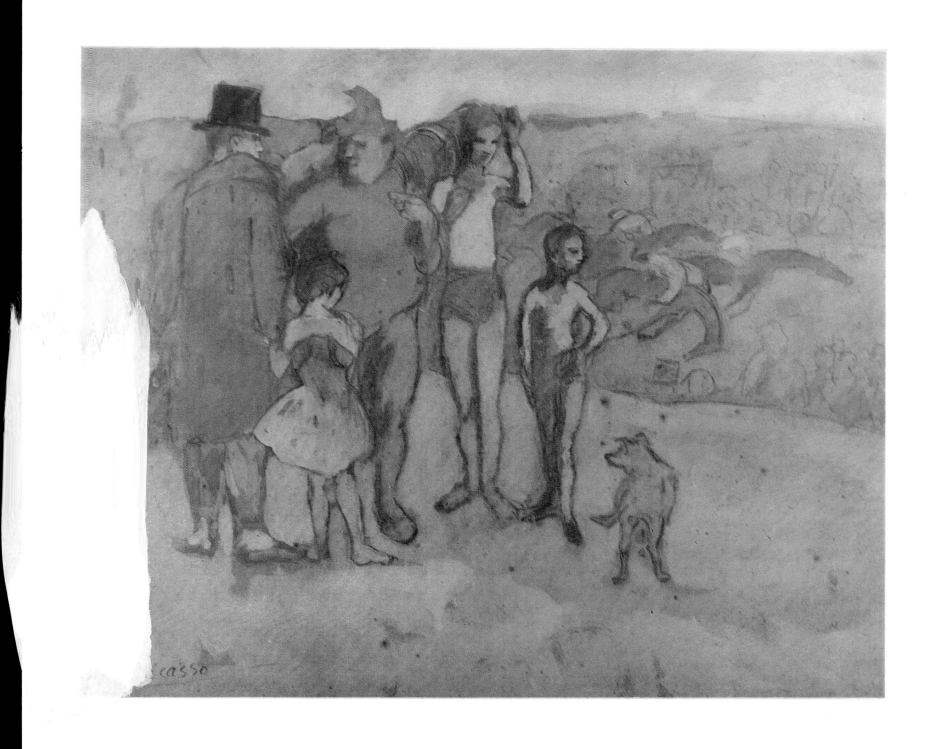

286 FAMILY OF SALTIMBANQUES (COMEDIANS)

Gouache on cardboard, 51.2×61.2 cm

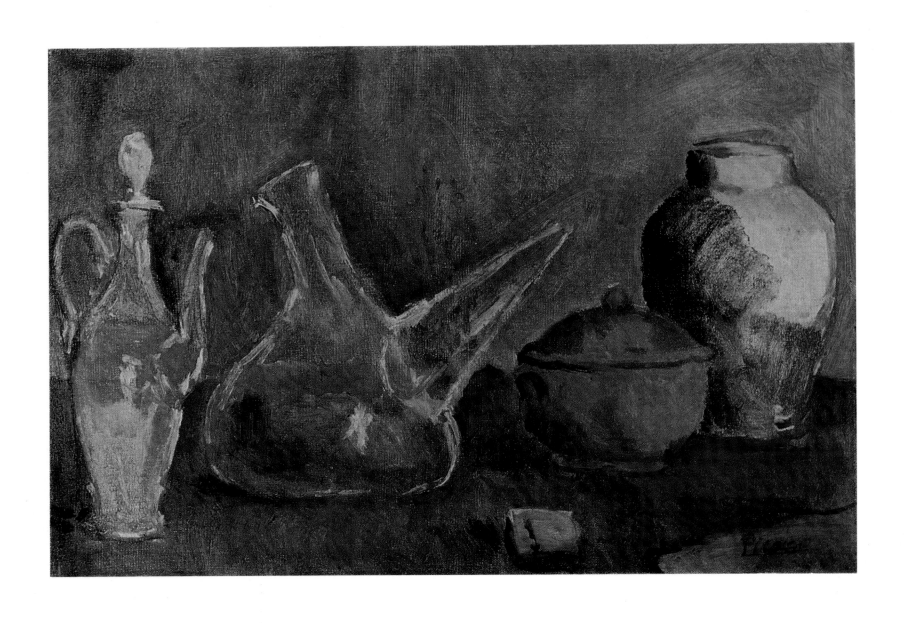

287 GLASSWARE. STILL LIFE WITH A PORRÓ

Oil on canvas. 38.4×56 cm

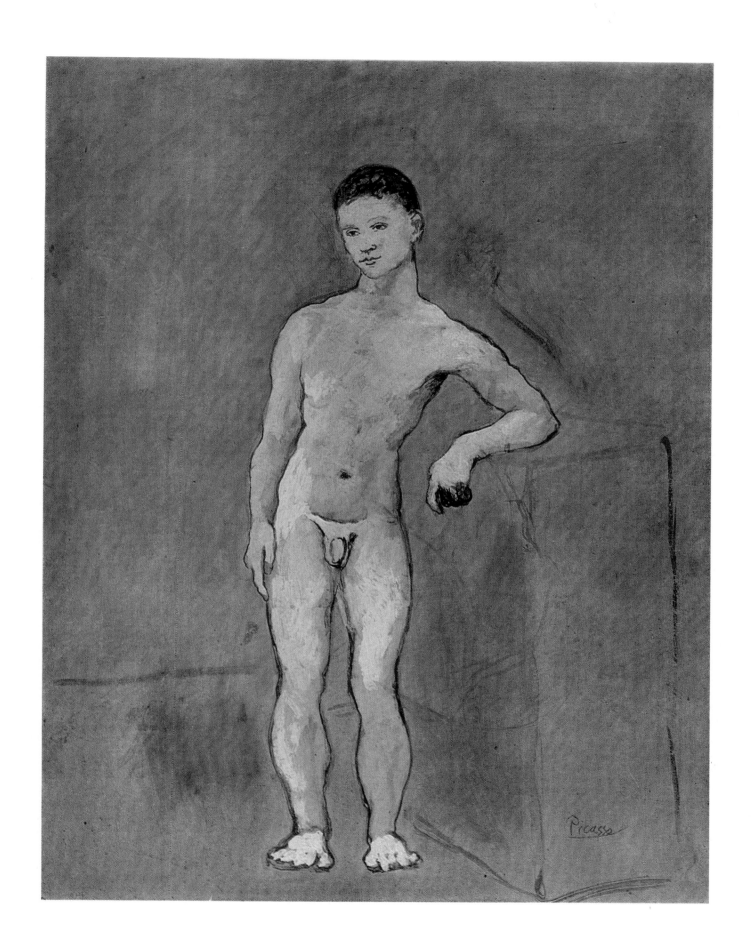

288 NUDE YOUTH

Gouache on brown cardboard. 67.5×52 cm

289, 290 HEAD OF AN OLD MAN IN A TIARA

Watercolour, Indian ink and pen on paper. 17×10 cm

291 TWO FIGURES AND A MAN'S HEAD IN PROFILE

Tempera on brown cardboard. 41×57 cm

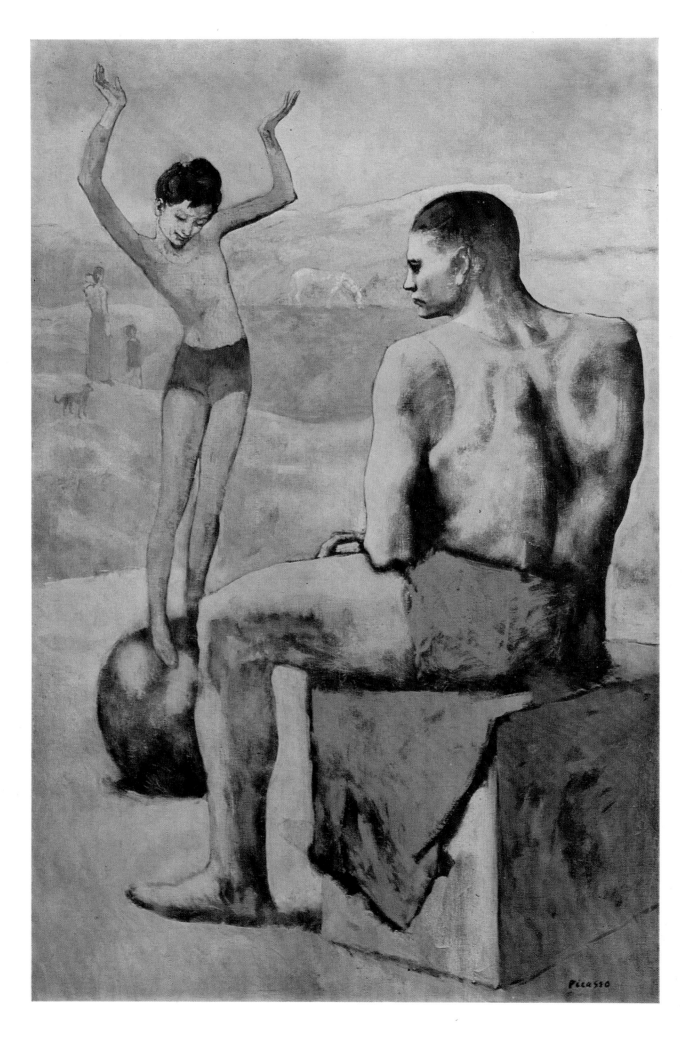

292 GIRL ON A BALL (YOUNG ACROBAT ON A BALL)

Oil on canvas. 147×95 cm

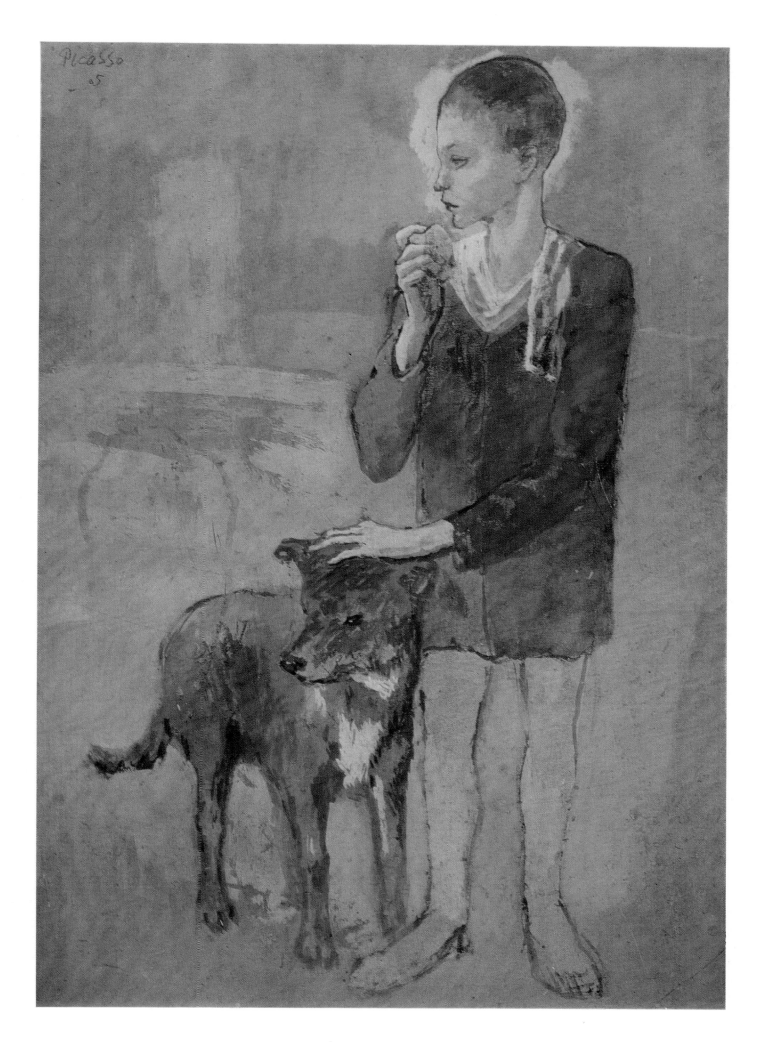

293, 294 BOY WITH A DOG

Gouache on brown cardboard. 57×41 cm

CATALOGUE

NOTES BY

ANNA BARSKAYA

1, 8, 11, 12, 15, 16, 18, 21, 22, 29, 34—36, 41—43, 46, 49, 52—55, 72, 76—79, 83,
86, 91, 93, 94, 96—98, 100, 103, 107, 112—114, 118, 123, 127—134, 137—142,
145, 151, 152, 156, 168, 198, 199, 202, 203, 208, 209, 211, 212—215, 217—222,
228—233, 235—239, 241—253, 255, 257—261, 266, 268—270, 272, 273

MARINA BESSONOVA

2, 4, 5, 7, 31—33, 37—40, 73, 104—106, 108—110, 115—117, 119—122, 124—126,
135, 136, 143, 144, 146—148, 153—155, 157, 158, 161—163, 165—167, 169,
180—182, 200, 201, 204, 206, 207, 210, 216, 234, 240, 254, 256, 262, 276, 277, 279,
280, 284—286, 292

EVGENIA GEORGIEVSKAYA

9, 10, 13, 14, 17, 19, 20, 23—28, 30, 44, 45, 47, 48, 50, 51, 56, 57, 61—65, 74,
75, 80—82, 84, 85, 87—90, 92, 95, 99, 101, 102, 160, 174—176, 223—227, 265, 267,
271, 274

ASIA KANTOR-GUKOVSKAYA

6, 60, 66—69, 71, 170, 172, 178, 179, 183, 205, 291, 293, 294

VILENA MKRTCHAN

3

KALERIA PANAS

58, 59, 70, 111, 149, 150, 159, 164, 171, 173, 177, 184—197, 263, 264, 275, 289, 290

ANATOLY PODOKSIK

278, 281—283, 287, 288

EUGÈNE BOUDIN. 1824—1898

1 BEACH SCENE
LA PLAGE

Oil on panel. 23.5×33 cm
Signed, bottom left: *E. Boudin*
Inv. No. 10028

Provenance: 1922 N. Altman collection, Leningrad;
since 1968 The Hermitage, Leningrad (acquired from
Altman's widow, I. Shchogoleva)

Judging by the costumes, the picture was painted in
the 1880s or early 1890s. It probably shows the beach
at Trouville, which the artist frequently depicted in
his canvases.

2 ON THE BEACH. TROUVILLE
LA PLAGE À TROUVILLE

Oil on panel. 19×46 cm
Signed and dated, bottom left: *E. Boudin 1871*
Inscribed, bottom right: *Trouville*
Inv. No. 3567

Provenance: P. Ettinger collection, Moscow; since
1950 The Pushkin Museum of Fine Arts, Moscow

Beginning with the 1860s Boudin painted views of
Trouville, Bordeaux, and Dauville beaches with
groups of people relaxing in smart clothes. The grey-
ish-brown palette of the Barbizon painters predomin-
ates in this picture, while the figures are rendered in
a sketchy manner characteristic of the Impressionists.

3 THE HARBOUR
PORT DE MER

Oil on canvas. 36×58 cm
Signed, bottom right: *E. Boudin*
Inv. No. 2589

Provenance: G. Zambakhchian collection; since 1947
The Art Gallery of Armenia, Yerevan (gift of the
collector)

The picture, painted in a free manner, is apparently
one of Boudin's later works. The high clouds and the
flitting light reflected on the mirror-like expanse of
water studded with sail-boats produce a sensation of
humid air. The silvery-grey colour scale imparts a
lyrical note to this strikingly fresh portrayal of nature.

4 FISHING-BOATS ON THE SEASHORE
BATEAUX DE PÊCHE AU BORD DE LA MER

Oil on panel. 25×35 cm
Signed and dated, bottom left: *E. Boudin-80*
Inv. No. 3497

Provenance: M. Morozov collection, Moscow; 1910
The Tretyakov Gallery, Moscow (gift of Morozov's
widow); 1925 Museum of Fine Arts, Moscow; 1930
Museum of Modern Western Art, Moscow; since 1948
The Pushkin Museum of Fine Arts, Moscow

A version of the picture with a flag-bedecked cot-
tage on the seashore, *Brick échoué devant le port de
Trouville* (see C. Roger-Marx, *Boudin,* Paris, 1927,
pl. 18; L. Cario, *Eugène Boudin*, Paris, 1928, pl. 43),
suggests that the Moscow sea-view was also done at
Trouville.

Despite the fact that the landscape was painted in
1880, its colour scale is dark, resembling that of Co-
rot rather than that of Claude Monet.

ÉDOUARD MANET. 1832—1883

5 PORTRAIT OF ANTONIN PROUST
PORTRAIT D'ANTONIN PROUST

Oil on canvas. 65×54 cm
Signed at right, by the shoulder: *E.M.*
Inv. No. 3469 J.-W. 378 [1]
Provenance: I. Ostroukhov collection, Moscow; 1918
Museum of Icon Painting and Painting, Moscow;
1929 Museum of Modern Western Art, Moscow; since
1948 The Pushkin Museum of Fine Arts, Moscow

Antonin Proust, a lifelong friend of Manet, was Minis-
ter of Fine Arts under the Third Republic. Manet
painted his portraits on more than one occasion.
A. Tabarant dates this portrait to 1877, Georges Wil-
denstein to 1880.
A large-scale sketch for this portrait is reproduced in
the Jamot and Wildenstein catalogue. In this sketch,
only the head, an exact repetition of the one in the
Moscow portrait, is worked out (J.-W. 337). Denis
Rouart and Daniel Wildenstein state that this sketch
was used as a source for a number of forgeries (R.-W.
I, 262). They suggest, without sufficient justification,
that the Moscow picture is also a forgery.

6 PORTRAIT OF Mme JULES GUILLEMET
PORTRAIT DE Mme JULES GUILLEMET

Black chalk. 31.3×22 cm
Signed, bottom right: *EM*
Inv. No. 43094

Provenance: Private collection, Leningrad; since 1938
The Hermitage, Leningrad

The artist's friends — Mme Guillemet, her husband
and her younger sister Marguerite — sat for Manet
on more than one occasion. Thus, the Guillemet coup-
le appears in the 1879 painting, *In the Hothouse*
(R.-W. I, 289), while the two sisters are portrayed
in a number of pencil drawings, watercolours and
pastels done between the late 1870s and 1882. The
Hermitage study is related to *Mme Jules Guillemet
Wearing a Hat* (R.-W. II, 36), a pastel portrait dated
ca. 1880, in which the artist achieved not only a
portrait likeness, but also produced an image of the
typical young Parisienne. This, incidentally, happens
to be the title chosen by Manet for another pastel
portrait — *Mme Jules Guillemet Bareheaded, or the
Parisienne* (R.-W. II, 37).

[1] See List of Abbreviations, p. 401.

7 THE BAR
LE "BOUCHON"

Oil on canvas. 72×92 cm
Inscribed, bottom right: *Certifié d'Ed. Manet V*ve *Ed. Manet*
Inv. No. 3443 J.-W. 292; R.-W. I, 275
Provenance: A. Tavernier collection, Paris; 1900 S. Shchukin collection, Moscow; M. Morozov collection, Moscow; 1910 The Tretyakov Gallery, Moscow (gift of Morozov's widow); 1925 Museum of Modern Western Art, Moscow; since 1948 The Pushkin Museum of Fine Arts, Moscow

Charles Sterling dates the Moscow canvas 1878. Anna Barskaya and Etienne Moreau-Nelaton put it at 1879. It can thus be related to such pictures as *The Waitress* (J.-W. 335; R.-W. I, 266B) and *At Père Lathuille's* (J.-W. 325; R.-W. I, 271). Done in quick, free brushstrokes, this study seems to provide a glimpse of Manet's daily stroll through Paris, during which he made sketches, picked up subjects, colours, and hues. Later he recreated on canvas the atmosphere in both its literal and figurative meaning — as a *plein-air* in which even the facial features are dissolved in the vibration of sunlight and as a social milieu with its particular "odour", to use Joris-Karl Huysmans's expression, to which the characters he depicted belonged.

Such compositional devices as the peculiar use of picture space, which is sharply cut off at the top, and the placing of a secondary figure in the focus — the smoker in a cap looking at the passers-by — give the viewer a general idea of the artistic solution of the whole picture. As in *The Waitress*, it is based on a view of life within which complex psychological conflicts are being played out. The white canvas priming in the unfinished figure of the man sitting with his back towards the viewer imparts a special luminosity to the canvas.

There are two drawings closely related to this picture: one, in pencil (R.-W. II, 508), almost exactly reproduces its central and right-hand portions. Anne Coffin Hanson dates it to 1878 (see *Edouard Manet: Philadelphia Museum of Art, The Art Institute of Chicago, November 1966 — February 1967. Catalogue by Anne Coffin Hanson*, pp. 184—185, No. 173). The other, in Indian ink (R.-W. II, 510), is almost identical with the Pushkin Museum canvas. Both drawings differ from the latter in one detail only: in them, the tree appears on the other side of the counter.

CLAUDE MONET. 1840—1926

8 LADY IN THE GARDEN
JEANNE-MARGUERITE LECADRE AU JARDIN

Oil on canvas. 80×99 cm
Signed, bottom left: *Claude Monet*
Inv. No. 6505 W. M. I, 68

Provenance: P.-E. and J.-M. Lecadre collection, Sainte-Adresse; 1880 Meunier collection, Sainte-Adresse (according to Maurice Thieullent, J.-M. Lecadre's grandson, Meunier acquired the painting in exchange for two Chinese vases); Lebas collection, Le Havre; 1893 P. Durand-Ruel Gallery, Paris; 1899 P. Shchukin collection, Moscow; 1912 S. Shchukin collection, Moscow; 1918 First Museum of Modern Western Painting, Moscow; 1923 Museum of Modern Western Art, Moscow; since 1930 The Hermitage, Leningrad

Judging by the style, the lady's costume, and the label of the Durand-Ruel firm on the back of the canvas (*Une dame au jardin. Sainte-Adresse*), the picture was painted in 1867. On June 25, 1867, Monet wrote to Frédéric Bazille from Sainte-Adresse: "I've done a lot of pictures, some twenty canvases in all — magnificent sea-views and figures, and gardens, and what not" (W. M. I, pp. 423, 424, letter 33). Among these twenty canvases was apparently *Lady in the Garden*. X-ray analysis has revealed beneath the upper layer of paint, in the central part of the picture, two male figures in summer clothes, standing one behind the other. In all probability *Lady in the Garden*, thematically related to the *Terrace at Sainte-Adresse* (W. M. I, 95) and *The Artist's Father, Adolphe Monet, in the Garden* (present whereabouts unknown), was originally conceived as an outdoor family scene. In the course of work on the picture Monet introduced into it the figure of a woman strolling in a flowering garden. The model was Jeanne-Marguerite Lecadre. The scene was painted at the Lecadre family estate, Le Coteau.

With its summary treatment of the dense foliage and circular and comma-shaped bright colour dabs of flowers on the tree and on the flowerbed, the Hermitage canvas is stylistically akin to Monet's works of 1867. The relationships of masses in the Hermitage picture, which facilitate its perception from one angle of vision, reveal, beyond doubt, the impact of photography which attracted Monet in the same year of 1867, when he worked on a sequence of Paris landscapes — *The Louvre Embankment* (W. M. I, 83), *Saint-Germain l'Auxerrois* (W. M. I, 84) and *The Infante's Garden* (W. M. I, 85).

The 4th Impressionist exhibition of 1879 presented a retrospective show of the artist's works and included, among others, his painting *The Garden*. This was obviously the Hermitage *Lady in the Garden*. The dating of this picture suggested by Daniel Wildenstein, namely the year 1866, is incorrect. It is also worth noting that the date 1867, given in the catalogue of the 1879 exhibition, was supplied by the artist himself, who, as follows from Caillebotte's letter, took part in the compilation of this catalogue (see G. Geffroy, *La Vie de Claude Monet*, vol. II, Paris, 1924, p. 41). In the study *Le Jardin en fleurs* (W. M. I, 69), Monet depicted part of the same landscape at Sainte-Adresse.

9, 10 LUNCHEON ON THE GRASS
LE DÉJEUNER SUR L'HERBE

Oil on canvas. 130×181 cm
Signed and dated, bottom left: *Claude Monet 66*
Inv. No. 3307 W. M. I, 62

Provenance: 1874 J.-B. Faure collection, Paris; 1901 P. Durand-Ruel Gallery, Paris; 1912 P. Cassirer collection, Berlin; 1913 S. Shchukin collection, Moscow; 1918 First Museum of Modern Western Painting, Moscow; 1923 Museum of Modern Western Art, Moscow; since 1948 The Pushkin Museum of Fine Arts, Moscow

In 1865, inspired by Manet's well-known painting of the same name, Claude Monet started work on his large canvas, *Luncheon on the Grass*. The picture was painted at Chailly-en-Bière. Monet was not satisfied with his finished canvas. He returned to Paris, leaving the picture with his landlord in pledge of his payment. Upon his return to Chailly, he found the canvas badly damaged by moisture and consequently cut it into three parts. The left-hand and central parts have survived; the first (W. M. I, 63a) is in the Louvre; the second (W. M. I, 63b) is in the Ekhnayan collection, Paris. Nothing is known of the right-hand part of the canvas. However, Monet apparently did not give up the idea of painting a large composition on the subject of a picnic in the open air. In 1866, he did a reduced version of the picture, which is evidently the one now in the Pushkin Museum. In scholarly literature the Moscow canvas is usually described as a sketch for the above-mentioned large painting. However, Monet's letters to his friend Frédéric Bazille give good grounds for assuming that the artist was working on that painting mainly in the summer of 1865, while the Moscow picture was painted a year later. In addition, X-ray and ultraviolet photographs show that the artist's signature and date, 1866, were put down on the Moscow canvas immediately after it was completed.

A comparison of the X-ray photographs of the Pushkin Museum picture and the extant fragments of the original composition in Paris supports the conclusion that the former is a later replica, not a sketch. This conclusion is also corroborated by an analysis of the painterly structure of these pictures. Whereas in the former the colour scale and the rendering of light are harmoniously integrated in a rich pictorial whole, in the latter the colour patches and the contrasts of light and shade are sharper and less harmonious.

The model for the female figures was Camille Doncieux, the artist's fiancée; the male figures were painted from Monet's friends, Albert Lambron and Frédéric Bazille (the latter posed for several figures, including one standing at left, another in the centre, by the tree, and one seated under the tree).

The picture demonstrates Monet's preoccupation with the problem of conveying the light-and-air medium and colour reflections, rather than with character drawing. He skilfully balances the colour accents — the white tablecloth in the centre, the refulgent green trimming of the lady's gown in the central group, and the red shawl on the grass at right. All the most tense patches of colour are distributed along the lower edge of the picture, close to the foreground. The in-depth unfolding of space is limited by the dense green wall of the forest which creates a solid background. The adherence to the dark tones in the shadows is a tribute to tradition and to Courbet.

The Moscow picture does not fully coincide with the original composition. Instead of the smiling bearded man in the group of seated figures in a Paris fragment (supposedly Courbet), we see here the young man with whiskers (apparently the painter Lambron); the dark tie of the man standing at extreme left is here replaced with a light-coloured one; the cut of the woman's dress in the centre of the left group has been changed, and the scarlet ribbon has disappeared from her corsage; moreover, she now wears a bonnet of a different style. In the central foreground of the Moscow version there is a dog, absent in the Paris picture. X-ray photographs of the left-hand part of the Louvre picture show that the three figures at left were originally painted in almost the same way as in the Moscow version.

The artist obviously attached great importance to *Luncheon on the Grass* since in his oil studies he devoted much effort to the landscape, without figures, and to separate groups of figures in a landscape. A study with two figures (W. M. I, 61) is relevant in this respect. Also extant is a charcoal drawing on grey-blue paper, in which Monet evidently conveyed the original idea of the entire composition (P. Mellon collection, Upperville, Va.).

J. Isaacson, in his monograph on *Luncheon on the Grass*, mentions another pencil drawing of the whole composition in Monet's unpublished sketchbook, bequeathed by his son Michel to the Musée Marmottan in Paris. A drawing in the Richard S. Davis collection depicting Camille Doncieux in a luxurious gown with a crinoline skirt also dates from 1865—66. This drawing was undoubtedly meant for the large painting. Although there is no unanimous opinion with regard to the Moscow picture — H. Adhémar, G. Bazin, J. Leymarie, J. Isaacson and A. Dayez-Distel describe it as a sketch (*Centenaire de l'Impressionnisme*, Paris, 1974, pp. 131—134), while Ch. Sterling and N. Yavorskaya accept it as a later replica of the large composition — its artistic merit cannot be contested.

11 CORNER OF THE GARDEN AT MONTGERON
COIN DU JARDIN À MONTGERON

Oil on canvas. 173×193 cm
Signed, bottom right: *Cl. M.*
Inv. No. 9152 W. M. I, 418
Pendant piece to No. 12

Provenance: E. Hoschedé collection, Montgeron (commissioned for the Château de Rottembourg); 1878 J.-B. Faure collection, Paris (purchased for 50 francs in the Hoschedé sale, Hôtel Drouot, 5—6 June; probably one of the four canvases not recorded in the sale catalogue; entered in the minutes of the sale as lot 15); 1900 Deposited at the P. Durand-Ruel Gallery, Paris; 1907 P. Durand-Ruel Gallery, Paris; 1907 I. Morozov collection, Moscow (bought for 40,000 francs on 14 May); 1919 Second Museum of Modern Western Painting, Moscow; 1923 Museum of Modern Western Art, Moscow; since 1948 The Hermitage, Leningrad

In the autumn of 1876, Monet worked in the Château de Rottembourg at Montgeron, fulfilling orders of Ernest Hoschedé, a patron and friend of the Impressionists. As the panel *White Turkeys* (W. M. I, 416), intended for the decoration of the Grand Salon of the Château, was dated 1877 by the artist, there is every reason to believe that two other canvases which are now in the Hermitage, *Corner of the Garden at Montgeron* and *The Pond at Montgeron*, were also produced in 1876 or 1877. Together with the painting *The Chase* (W. M. I, 433), they formed a series of four canvases.

During that period Claude Monet first tried his hand at decorative painting, and in this series he set himself a task quite unusual for the time — to create for a country residence works that would make a harmonious whole with the surrounding garden.

In order to solve this difficult task, Monet made use of preliminary sketches, which was contrary to his spontaneous manner of painting. Nevertheless in his large canvas *Corner of the Garden at Montgeron*, he managed to fully retain his fresh and keen sensation of nature in a state of luxuriant flowering, despite the fact that this picture is an almost exact repetition of his sketch *Rose Bushes in the Garden at Montgeron* (W. M. I, 416). This sketch (or possibly the Hermitage picture) was displayed at the 3rd Impressionist exhibition. In his review, Georges Rivière called it *Les Dahlias* and thought it one of the best works by Monet shown at the exhibition (see *L'Impressionniste*, 6 April 1877, No. 1).

12 THE POND AT MONTGERON
L'ÉTANG À MONTGERON

Oil on canvas. 172×193 cm
Signed, bottom right: *Cl. M.*
Inv. No. 6562 W. M. I, 420
Pendant piece to No. 11

Provenance: E. Hoschedé collection, Montgeron (commissioned for the Château de Rottembourg); 1878 A. Vollard Gallery, Paris; 1907 I. Morozov collection, Moscow (according to Vollard's receipt, purchased for 10,000 francs as *Bords de la rivière*); 1919 Second Museum of Modern Western Painting, Moscow; 1923

Museum of Modern Western Art, Moscow; since 1930 The Hermitage, Leningrad

In size, this picture is identical with *Corner of the Garden at Montgeron*, being one of the series of four decorative panels painted for Ernest Hoschedé in 1876—77. *The Pond at Montgeron*, or perhaps a sketch for it, was shown at the 3rd Impressionist exhibition in 1877, along with ten other Monet canvases owned by Hoschedé (probably under the title of *La Mare à Montgeron*). This composition (the picture itself or a sketch for it) was described by Georges Rivière in his review of the 1877 exhibition as follows: "...the bank of a pond, with big trees reflected in its deep dark blue waters" (see *L'Impressionniste*, 6 April 1877, No. 1). This description provides sufficient grounds for changing the title cited in Vollard's receipt. *The Pond at Montgeron* repeats the composition of a preliminary sketch down to the barely suggested silhouette of a lady with a fishing-rod, most probably Alice Hoschedé, the wife of Monet's patron. The sketch *Corner of the Pond at Montgeron* is reproduced in Wildenstein's catalogue (W. M. I, 419).

The decorative function assigned to this piece accounts for its specific texture. The picture is painted in broad, sweeping brushstrokes, completely out of tune with Monet's usual manner. *The Pond at Montgeron* may have figured in the Hoschedé sale in 1878 as one of the four canvases which were untitled, not listed in the auction catalogue, and sold for a mere trifle. They were entered in the minutes of the sale as lots 6, 7, 15, and 16 (see M. Bodelsen, "Early Impressionist Sales 1874—94 in the Light of Some Unpublished Procès-verbaux", *The Burlington Magazine*, June 1968).

13, 14 LE BOULEVARD DES CAPUCINES

Oil on canvas. 61×80 cm
Signed and dated, bottom, left of centre: *Claude Monet 73*
Inv. No. 3397 W. M. I, 292

Provenance: 1883 J.-B. Faure collection, Paris; 1907 P. Durand-Ruel Gallery, Paris; 1907 I. Morozov collection, Moscow; 1919 Second Museum of Modern Western Painting, Moscow; 1923 Museum of Modern Western Art, Moscow; since 1948 The Pushkin Museum of Fine Arts, Moscow

Among the vast number of town views painted by the Impressionists, there is hardly any one whose importance in the history of French nineteenth-century landscape painting can stand comparison with *Le Boulevard des Capucines*.

This picture, when displayed at the 1st Impressionist exhibition in Paris in 1874, precipitated a storm of criticism. Oscar Reuterswaerd and Charles Sterling believe that the Moscow canvas was the one shown at the exhibition, while John Rewald thinks it was an

earlier version, now in the Nelson Gallery and Atkins Museum of Fine Arts in Kansas City, U.S.A. (W. M. I, 293).

According to some experts, the Moscow painting shows the boulevard during a carnival. Monet abandoned here the meticulous handling of details in favour of small free brushstrokes which create the impression of everything dissolving in a haze. Space unfolds simultaneously in all directions: a little in depth along the diagonal, where the boulevard recedes; to the right and left along the horizontal; and, finally, towards the viewer. In other words, to the traditional conception of space in a landscape Monet opposes his own solution, aimed at gradually reducing its development in depth.

15 HAYSTACK AT GIVERNY
 MEULE DE FOIN PRÈS DE GIVERNY

Oil on canvas. 61×81 cm
Signed and dated, bottom right: *Claude Monet 86*
Inv. No. 6563 W. M. II, 1073

Provenance: 1905 S. Shchukin collection, Moscow; 1918 First Museum of Modern Western Painting, Moscow; 1923 Museum of Modern Western Art, Moscow; since 1931 The Hermitage, Leningrad

Haystack at Giverny was executed in 1886, evidently right after the artist's trip to Holland, where he painted his *Tulip Field, Holland* (W. M. II, 1067). Whereas in the latter picture Monet's primary concern was to convey the sensation evoked by the red tones of a field studded with flowers, in *Haystack* he strove to accentuate the vivid contrast between the green and saturated pink areas in the foreground. This was the second time that he turned to a landscape motif which had caught his eye a year before at Hamissicourt, a wasteland overgrown with poplars (W. M. II, 997). In the Hermitage canvas the haystack motif does not function as the pictorial pivot of the composition. The haystack almost merges with the yellow strip of grass; its colour is subdued by the resonant pinkish-green surfaces of the field. It serves here not as a form focusing light, but rather as a compositional device which gently interrupts the monotonous horizontal of the valley stretching up to the Bennecourt plateau. On the right, in the distance, is the blue line of the Jeufosse and Bonnières hills.

16 POPPY FIELD
 CHAMP DE COQUELICOTS

Oil on canvas. 59×90 cm
Signed, bottom right: *Claude Monet*
Inv. No. 9004 W. M. III, 1255

Provenance: G. Feydeau collection, Paris; 1901 Bernheim-Jeune Gallery, Paris (bought in the Feydeau sale, Hôtel Drouot, 11 February, lot 74); M. Morozov collection, Moscow; 1910 The Tretyakov Gallery, Moscow (gift of Morozov's widow); 1925 Museum of

Modern Western Art, Moscow; since 1948 The Hermitage, Leningrad

The poppy field theme never lost its attraction for the artist. Before going to Holland in 1886 and elaborating the colour scheme based on red tones which he subsequently used in his *Tulip Field, Holland* (W. M. II, 1067), Monet often depicted the golden-green expanse of fields with the scarlet flashes of poppies. Pictures such as *Poppies* (1873; W. M. I, 274), and *Poppy Field at Lavadourt* (1881; W. M. I, 677) may serve as examples.

In pictures on the poppy field theme done after 1886, the artist no longer cares about conveying the actual shape of the flowers; he dissolves them into a continuous massive flow of reds interspersed with greens. The Hermitage canvas is executed precisely in this manner. Its dating presents great difficulty. Wildenstein assigns the picture to 1890, linking it to a series of four landscapes with one and the same motif (W. M. III, 1251, 1252, 1253, 1254); two of them are dated by the artist 1890 and 1891 respectively. However, the Hermitage *Poppy Field* differs from this series in both motif and manner of execution. While in all the landscapes of this series Monet persistently depicts the slope of a hill in the right-hand part of the composition, just behind the trees, in the Hermitage canvas he unfolds the chain of hills along the entire horizontal of the picture, far away from the poplars. A forest visible in front of the hills is absent in the other landscapes of this series.

In terms of its painterly qualities the Hermitage canvas has a greater affinity with *Lucerne and Poppies* (W. M. III, 1146), dated 1887 by the artist and depicting a locality south of Giverny. This landscape is similar to the one in the Hermitage — above all in the treatment of the sky filled with small white-edged clouds. The thick multi-layered texture of paint, typical of the Hermitage canvas, can also be seen in some other Monet works of 1887, such as *The Barque* (W. M. III, 1154) and *Barque at Giverny* (W. M. III, 1151). Consequently, there is some reason to assume that the Hermitage picture was painted in 1887, when the artist worked on his *Lucerne and Poppies*.

17 HAYSTACK AT GIVERNY
 MEULE DE FOIN À GIVERNY

Oil on canvas. 64.5×81 cm
Signed, bottom left: *Claude Monet*
Inv. No. 3398 W. M. II, 900

Provenance: 1906 J.-B. Faure collection, Paris; 1907 P. Durand-Ruel Gallery, Paris; 1907 I. Morozov collection, Moscow (bought for 50,000 francs with other pictures by Monet); 1919 Second Museum of Modern Western Painting, Moscow; 1923 Museum of Modern Western Art, Moscow; since 1948 The Pushkin Museum of Fine Arts, Moscow

The earliest canvases with the haystack motif were probably painted in the mid-1880s. Wildenstein dates the Moscow picture to 1884. Many canvases from this series were produced in 1891 and are in private collections and museums in the U.S.A. (W. M. II, 901, 902, etc.). Although the Moscow picture was not dated by the artist, it is known that in March 1906 it was exhibited at Durand-Ruel's among seventeen other Monet works belonging to J.-B. Faure. In the exhibition catalogue, it was dated 1889. Some scholars believe that it was painted at a later date; thus, Marina Orlova argues that the entire *Haystacks* series came into being in 1891. Pataky Dénes dates it to 1899.

There is a certain similarity of motifs between the Moscow picture and another Monet painting, dated 1884 by the artist, from a private collection (W. M. II, 901); comparison of these two canvases gives good grounds for assuming that the Moscow picture was painted between 1884 and 1889.

In contrast to some works of the 1870s, e.g. *Lilac in the Sun* (No. 25), the colours of *Haystack at Giverny* do not lose their vibrant intensity in the sun. At the same time the artist remains loyal to the principles of Impressionism: his main task is to accurately convey the light effects at different times of day, to catch a transitory moment.

18 MEADOWS AT GIVERNY
 LES PRAIRIES À GIVERNY

Oil on canvas. 92×80 cm
Signed and dated, bottom left: *Claude Monet 88*
Inv. No. 7721 W. M. III, 1202

Provenance: 1889 P. Durand-Ruel Gallery, Paris (bought from the artist in July); 1892 D. Cochin collection, Paris; 1897 P. Durand-Ruel Gallery, Paris; 1899 S. Shchukin collection, Moscow; 1918 First Museum of Modern Western Painting, Moscow; 1923 Museum of Modern Western Art, Moscow; since 1943 The Hermitage, Leningrad

Meadows at Giverny is one of Monet's three canvases depicting the corner of the valley of Essarts south of Giverny and apparently painted in June 1888. Two other pictures of this group, *Promenade. Cloudy Weather* (W. M. III, 1203) and *Landscape with Figures* (W. M. III, 1204), differ from the Hermitage canvas in that they show in close-up the members of Monet's large family, the landscape serving merely as a backdrop.

19 CLIFFS AT ÉTRETAT
 LES FALAISES À ÉTRETAT

Oil on canvas. 66×81 cm
Signed and dated, bottom left: *Claude Monet 86*
Inv. No. 3308 W. M. II, 1046
Provenance: 1887 Sold by Monet to Boussod, Valadon & Co., Paris; 1889 Buglet collection, Paris; 1891

P. Durand-Ruel Gallery, Paris; 1893 Guy de Chollet collection, Paris; 1893 P. Durand-Ruel Gallery, Paris; 1898 S. Shchukin collection, Moscow; 1918 First Museum of Modern Western Painting, Moscow; 1923 Museum of Modern Western Art, Moscow; since 1948 The Pushkin Museum of Fine Arts, Moscow

Between 1883 and 1886 Monet frequently worked at Etretat, a resort town on the coast of Normandy, where he painted seascapes with a rock jutting out into the sea. One of these is the Moscow picture representing d'Aval with l'Aiguille seen from d'Amon near the Payen house (W. M. II, 624). The seascape's colour scheme is based on golden-yellow tones. The light blue and greenish sailing-boats introduce an additional colour accent into the picture, serving to emphasize its spatial relationships.

Monet painted views of Etretat even at an earlier date. Two more seascapes done there — *Stormy Sea at Etretat* (W. M. I, 127) and *A View at Etretat* (W. M. II, 828) — are in the Musée de l'Impressionnisme, Paris. The landscape *Sailing-boats Leaving the Port* (W. M. II, 1047) corresponds fairly closely with the Moscow picture. Both seascapes were painted from the same vantage point but in different weather conditions. There is also a drawing identical to the Moscow canvas (Musée Marmottan, Paris, Inv. No. 5131, f. 26v).

20 THE ROCKS OF BELLE-ÎLE
 LES ROCHERS DE BELLE-ÎLE

Oil on canvas. 65×81 cm
Signed and dated, bottom right: *Claude Monet 86*
Inv. No. 3310 W. M. II, 1084

Provenance: 1887 Sold by Monet to G. Petit; 1889 P. Aubry collection, Paris; 1897 P. Durand-Ruel Gallery, Paris; 1898 S. Shchukin collection, Moscow; 1918 First Museum of Modern Western Painting, Moscow; 1923 Museum of Modern Western Art, Moscow; since 1948 The Pushkin Museum of Fine Arts, Moscow

In September and October 1886, Monet worked on Belle-Île, a rocky island in the Atlantic off the south coast of the Breton peninsula, and it was there apparently that he painted the Moscow picture showing the rocks of Port-Coton.

The canvas is painted in vigorous, thick strokes which produce the sensation of the unceasing swirl of the waves and the eternal changeability of the sea.

In the same year the artist executed three more seascapes of Belle-Île (W. M. II, 1086, 1100, 1116). Closely related to the Moscow picture are several landscapes listed in the Wildenstein catalogue (W. M. II, 1085, 1087, 1088, 1089).

21 WINTER LANDSCAPE. SANDVIKEN
 PAYSAGE D'HIVER. SANDVIKEN

Oil on cardboard. 37×52.5 cm
Signed, bottom right: *Claude Monet*
Inv. No. 517

Provenance: K. Jurjans collection, Riga; since 1946 The Latvian SSR Museum of Foreign Art, Riga

At the end of January 1895, Monet took a trip to Scandinavia where the present picture was painted. It conveys beautifully the character of the northern Norwegian scenery and the atmosphere of a frosty, overcast day.

The picture's brushwork is rich and varied. The direction of strokes emphasizes the distinctive features of the visible forms; the forest-clad mountain is painted with short vertical strokes, the snow with horizontal ones, and the bridge with smooth curves accentuating its shape.

There are three more pictures on the same subject (W. M. III, 1397, 1398, 1399).

22 STEEP CLIFFS NEAR DIEPPE
 SUR LES FALAISES PRÈS DE DIEPPE

Oil on canvas. 64.5×100 cm
Signed and dated, bottom right: *Claude Monet 97*
Inv. No. 8992 W. M. III, 1467
Provenance: 1901 P. Durand-Ruel Gallery, Paris (bought from the artist on 27 November); 1903 S. Shchukin collection, Moscow; 1918 First Museum of Modern Western Painting, Moscow; 1923 Museum of Modern Western Art, Moscow; since 1948 The Hermitage, Leningrad

In January and February 1897, Monet painted the shores of the Channel near Dieppe. He produced a series of nine canvases, similar in motif and practically identical in size (65×100 cm).

Least of all interested in conveying the physical appearance of objects, Monet wanted to recreate the most elusive atmospheric effects: he rendered the subtlest nuances of colour at a moment when all forms lose their outlines in the early morning mist and all the world seems boundless in the fusion of the two elements, air and water.

The features characteristic of the Dieppe series (W. M. III, 1433, 1434, 1465, 1471) — the composition devoid of the supporting verticals so frequently used in Argenteuil views, the blurred forms, and intricately curved outlines — are all present in the Hermitage picture.

Daniel Wildenstein points out that Monet depicted in this series Val Saint-Nicolas, with the cliff overhanging the sea, between Dieppe and Pourville; one of the pictures, in fact, bears the title of *Val Saint-Nicolas* (W. M. III, 1465). Later on, Monet became less concerned with topographical accuracy, concentrating upon the ephemeral natural effects and often providing the sea, between Dieppe and Pourville; one of the time of day.

There is a drawing in Monet's sketchbook (Musée Marmottan, Paris, Inv. No. 5131, f. 26r), dated to the 1880s, which is very similar in motif to the Hermitage canvas.

23, 24 VÉTHEUIL

Oil on canvas. 90×92 cm
Signed and dated, bottom left: *Claude Monet 1901*
Inv. No. 3314
Provenance: Bernheim-Jeune Gallery, Paris; 1902 P. Durand-Ruel Gallery, Paris; 1902 S. Shchukin collection, Moscow; 1918 First Museum of Modern Western Painting, Moscow; 1923 Museum of Modern Western Art, Moscow; since 1948 The Pushkin Museum of Fine Arts, Moscow

The town is painted from the opposite bank of the river flowing near it, so that its buildings are seen as a mass of taut structures. Everything in the landscape seems enwrapped in a haze. Small brushstrokes, typical for this picture, create a homogeneous texture reminiscent of tapestry.

Claude Monet regularly painted views of Vétheuil after he moved there from Argenteuil. The majority of these views were created between 1878 and 1882. In 1883 the artist settled in Giverny, but time and again he returned to Vétheuil to work on already familiar motifs. Some of the most famous views of the town, including the one in the Moscow museum, were painted during his stay there in 1901.

Two other views of Vétheuil produced at the same time are in the Art Institute of Chicago.

25 LILAC IN THE SUN
 LILAS AU SOLEIL

Oil on canvas. 50×65 cm
Signed and dated, bottom left: *Claude Monet 73*
Inv. No. 3311 W. M. I, 204
Provenance: 1873 Sold by Monet to P. Durand-Ruel; about 1877 Sold by P. Durand-Ruel; 1891 P. Durand-Ruel Gallery, Paris; 1891 S. Shchukin collection, Moscow; 1918 First Museum of Modern Western Painting, Moscow; 1923 Museum of Modern Western Art, Moscow; since 1948 The Pushkin Museum of Fine Arts, Moscow

In the garden, under the blossoming lilac bush bathed in the dazzling sunshine, there loom the outlines of two female figures. However, these figures are far less important than the subtle, elusive play of sunbeams on the grass, on the ladies' dresses, the open parasol, and the flowering shrubs. The artist makes almost no use of glazes and more often than not applies opaque one-layered paints. The picture is essentially a study of light and colour and in this sense can be regarded as epitomizing Monet's artistic programme.

A 1873 version of the same dimensions, known under the title *Rest under the Lilac* (W. M. I, 203) and kept in the Musée de l'Impressionnisme, Paris, corresponds fairly closely with the Moscow canvas. The Paris version is thought to have been painted in Argenteuil. There are good reasons to suppose that the Moscow picture was produced there, too. In spite of the

fact that it is dated 1873 by the artist, Wildenstein thinks that it was painted in the spring of 1872. There is yet another 1872 version, *In the Garden*, closely related to the Moscow picture (W. M. I, 202).

26 WHITE WATER-LILIES
LES NYMPHÉAS BLANCS
Oil on canvas. 89×93 cm
Signed and dated, bottom right: *Claude Monet 99*
Inv. No. 3309
Provenance: S. Shchukin collection, Moscow; 1918 First Museum of Modern Western Painting, Moscow; 1923 Museum of Modern Western Art, Moscow; since 1948 The Pushkin Museum of Fine Arts, Moscow
Having taken up residence at Giverny in 1883, Monet bought a plot of land there and, after draining the waters of the Epte river, laid out a garden with several ponds in which he planted water-lilies of different colours. In 1903, he began a series devoted almost wholly to the ponds' water surface.
Among the landscapes painted at Giverny between 1898 and 1908, the most significant is a sequence consisting of forty-eight canvases under the collective title *Nymphéas. Paysages d'eau — Water-lilies. Landscapes of Water.*
In 1915, Monet once again turned to the water-lilies motif and painted several monumental canvases, which subsequently were installed in the Orangerie and Musée Marmottan in Paris.
The Moscow canvas, dated 1899, is among the earliest works of this series and, together with its version at the Musée de l'Impressionnisme, Paris — *Pool with Water-lilies. Green Harmony* — belongs to the best-known. Here Monet, dismissing his previous enthusiasm for the light effects and ephemeral effects of natural forces, displays his increasing interest in the decorative qualities of colour relationships. His brushstrokes assume a variety of forms, some of them resembling commas (the greenery by the water), others very thick dots (the water-lilies) or continuous lines accurately designating a Japanese footbridge spanning the pond.

27 THE ROUEN CATHEDRAL AT SUNSET [1]
LA CATHÉDRALE DE ROUEN, LE SOIR
Oil on canvas. 100×65 cm
Signed and dated, bottom left: *Claude Monet 94*
Inv. No. 3312 W. M. III, 1326
Provenance: 1898 P. Durand-Ruel Gallery, Paris; 1901 S. Shchukin collection, Moscow; 1918 First Museum of Modern Western Painting, Moscow; 1923 Museum of Modern Western Art, Moscow; since 1948

[1] This picture and the one that follows were repeatedly reproduced under wrong titles, *The Rouen Cathedral at Noon* and *The Rouen Cathedral at Night*, until V. Chesnokov succeeded in establishing the right time of the day for each painting.

The Pushkin Museum of Fine Arts, Moscow
Between 1892 and 1895, Monet produced a sequence of twenty canvases all showing Rouen Cathedral. The most interesting works of the series were painted in 1894, and the two Moscow pictures on this theme are of the same date.
In February 1892, Monet arrived in Rouen and took up residence in Fernand Lévy's house, opposite Rouen Cathedral. It was there that he painted the main canvases of the Rouen Cathedral series. The close vantage point from which the façade of the building was painted, conditioned the compositional arrangement of the Moscow pictures. The façade fills the whole canvas, so that the towers rising upwards are cut by its upper edge. The stone arches above the Cathedral's portals appear so weightless that we recognize them only from the light shadow they cast; the outline of the rose window dissolves in the light velvety shadow, the distinct boundaries between the separate parts of the building are no longer visible — everything has turned into a palpitating mesh of colours.
The setting sun sends rays at a right angle directly on to the Cathedral's façade, illuminating the cold stone wall and turning it into orange. The houses on the opposite side cast long shadows falling on the lower part of the façade.
One may well say that in his Rouen Cathedral series Monet brought his Impressionist method to a culmination. The series was shown in its entirety in the year of its completion (1895) at Monet's exhibition in the P. Durand-Ruel Gallery in Paris, and later was often displayed at various shows in France and abroad. Views of the Rouen Cathedral are now scattered in various museums of the world, and five of them belong to the Musée de l'Impressionnisme, Paris (W. M. III, 1319, 1321, 1346, 1355, 1360).
Daniel Wildenstein thinks that the Moscow picture was painted in 1892, along with other paintings listed in his catalogue (W. M. III, 1321—1325, 1327—1329). As to the date *94*, it was put by Monet on this picture, and on other canvases of the series, later.

28 THE ROUEN CATHEDRAL AT NOON [2]
LA CATHÉDRALE DE ROUEN, MIDI
Oil on canvas. 101×65 cm
Signed and dated, bottom left: *Claude Monet 94*
Inv. No. 3313 W. M. III, 1350
Provenance: 1898 P. Durand-Ruel Gallery, Paris; 1902 S. Shchukin collection, Moscow; 1918 First Museum of Modern Western Painting, Moscow; 1923 Museum of Modern Western Art, Moscow; since 1948 The Pushkin Museum of Fine Arts, Moscow
Depicted is the central part of the Cathedral's façade with a tower, lit by the oblique rays of the sun on top and immersed into shadow at bottom. The façade takes

[2] See note to No. 27.

up almost half of the canvas, so that it seems as if the artist painted it from very close quarters. Despite this, however, it is impossible to discern any detail of this Gothic edifice, any individual element of its construction; nor can one feel the texture of the stone. The artist shows the façade as a bulky mass, as a complex flat surface which permits him to concentrate upon the effects of lighting.

The sun is shining from the south, and the western façade of the Cathedral is immersed in shadow or half-shadow, with only some of the high-relief architectural details catching the sunlight. Several paintings similar to the Moscow canvas and also showing the western façade of the Rouen Cathedral at noon are in the Musée de l'Impressionnisme, Paris (W. M. III, 1346, 1355, 1360).

A multitude of blue, lilac and orange-golden patches make the façade resemble coloured lace permeated with light and air, both in its sunlit and shadowed parts.

According to Wildenstein, the Moscow picture, as well as the canvases closely related to it (W. M. III, 1345—1349, 1351—1361), was painted in 1893. In his opinion, Monet put the date 1894 on the pictures of this series later.

29 WATERLOO BRIDGE. EFFECT OF MIST
WATERLOO BRIDGE. EFFET DE BROUILLARD

Oil on canvas. 65×100 cm
Signed and dated, bottom right: *Claude Monet 1903*
Inv. No. 6545

Provenance: 1906 P. Durand-Ruel Gallery, Paris (bought from the artist on 16 November); 1907 I. Morozov collection, Moscow (bought for 18,000 francs); 1919 Second Museum of Modern Western Painting, Moscow; 1923 Museum of Modern Western Art, Moscow; since 1930 The Hermitage, Leningrad

In the autumn of 1899 and in the early spring of 1900 and 1901, Claude Monet visited the British capital, choosing the seasons when London fogs are the heaviest. From the balcony of his room at the Savoy he had an excellent view of the Thames, with Waterloo Bridge on the left, and the factory and steamship smokestacks beyond. This motif formed the basis of a group of canvases depicting Waterloo Bridge. After 1901 the artist stopped going to London and completed this cycle of paintings in his studio at Giverny. The series of London views produced between 1900 and 1905 is the most extensive in Monet's artistic legacy. It totals about one hundred works, scattered in various museums and private collections all over the world. Although the motif as such is not its key feature, the series is conventionally divided into three groups depicting, respectively, Waterloo Bridge, Charing Cross Bridge, and the Houses of Parliament. The first group, which includes the Hermitage picture, was evidently started in 1900 (judging from the date indi-cated by Monet for No. 9 in the catalogue of the exhibition held at the Durand-Ruel Gallery in 1904) and completed in 1903 at Giverny.

The Hermitage picture derived its title from the inscription on the back of Durand-Ruel's label: *Waterloo Bridge. Effet de brouillard.* A pastel entitled *Waterloo Bridge* and featuring the same landscape is in the Musée Marmottan, Paris (Inv. No. 5048).

30 SEAGULLS. THE RIVER THAMES IN LONDON. THE HOUSES OF PARLIAMENT
LES MOUETTES. LONDRES, LE PARLEMENT

Oil on canvas. 82×92 cm
Signed and dated, bottom right: *Claude Monet 1904*
Inv. No. 3306

Provenance: 1904 P. Durand-Ruel Gallery, Paris; 1904 S. Shchukin collection, Moscow; 1918 First Museum of Modern Western Painting, Moscow; 1923 Museum of Modern Western Art, Moscow; since 1948 The Pushkin Museum of Fine Arts, Moscow

The present picture, dated 1904, is among the works rounding up the series of London views.

There are few painters who have ever been able to convey the atmosphere of London as vividly as Monet. In 1904, this canvas was exhibited at the show in the Durand-Ruel Gallery in Paris.

CAMILLE PISSARRO. 1830—1903

31 PLOUGHLAND
TERRE LABOURÉE

Oil on canvas. 49×64 cm
Signed and dated, bottom left: *C. Pissarro 1874*
Inv. No. 3402 R.-V. II, 258

Provenance: Martin collection, Paris; A. Vollard Gallery, Paris; 1904 I. Morozov collection, Moscow; 1919 Second Museum of Modern Western Painting, Moscow; 1923 Museum of Modern Western Art, Moscow; since 1948 The Pushkin Museum of Fine Arts, Moscow

Browns and greys still predominate in the present picture, but the unmistakable stamp of a new technique is already clearly discernible: form is built up by successions of small brushstrokes instead of being modelled by light and shade, as was the case with the Barbizon painters. From 1872 to 1874 Pissarro and Cézanne painted landscapes in the environs of Pontoise. Pissarro was completely satisfied with his *Ploughland* and sent it with four other works to the exhibition of the Société Anonyme des Artistes Peintres, Sculpteurs, Graveurs (1st Impressionist exhibition).

32, 33 AVENUE DE L'OPÉRA IN PARIS
AVENUE DE L'OPÉRA. EFFET DE NEIGE

Oil on canvas. 65×82 cm
Signed and dated, bottom right: *C. Pissarro, 98*
Inv. No. 3323 R.-V. II, 1029

Provenance: P. Durand-Ruel Gallery, Paris; S. Shchukin collection, Moscow; 1918 First Museum of Modern Western Painting, Moscow; 1923 Museum of Modern Western Art, Moscow; since 1948 The Pushkin Museum of Fine Arts, Moscow

In 1898, Pissarro started a new series of Paris views. On 15 December 1897, he wrote to his son Lucien: "I... found a room at the Hôtel du Louvre with a magnificent view of the Avenue de l'Opéra and the corner of the Palais-Royal" (see *Camille Pissarro. Lettres à son fils Lucien*, Paris, 1950, p. 441).

The present picture was painted in the winter of 1898 from the window of the Hôtel du Louvre and is one of Pissarro's six well-known works on the same subject. Judging by its size, Pissarro used for it a canvas prepared in advance, as he did when painting his *Boulevard Montmartre* series. From the window of the Hôtel du Louvre the artist painted the Place du Théâtre-Français and the vista of the Avenue de l'Opéra. The six views of the Avenue de l'Opéra were a sequel to the cycle of townscapes he was commissioned to paint for Paul Durand-Ruel. In letters to his son, Pissarro informed him about this commission in detail. It came at a time when he abandoned Divisionism in favour of concrete landscape motifs.

A number of versions of the Moscow painting are known (R.-V. II, 1022, 1024—1026, 1028); the canvas *Avenue de l'Opéra. The Sun. Winter Morning* (R.-V. II, 1024) corresponds with it fairly closely.

34, 35 BOULEVARD MONTMARTRE. AFTERNOON SUN
BOULEVARD MONTMARTRE. APRÈS-MIDI, SOLEIL

Oil on canvas. 73×92 cm
Signed and dated, bottom right: *C. Pissarro 97*
Inv. No. 9002 R.-V. II, 993
Provenance: 1901 F. Depeau collection, Rouen (bought at a sale on 25 April, lot 42); M. Riabushinsky collection, Moscow; 1917 The Tretyakov Gallery, Moscow; 1925 Museum of Modern Western Art, Moscow; since 1948 The Hermitage, Leningrad

Pissarro began to paint his *Boulevards* series from the window of his room at the Grand Hôtel de Russie in February—April 1897, and completed it in his studio at Eragny at the end of April.

The *Boulevard Montmartre* series is the only one of its kind in Pissarro's entire œuvre, for never before or after did he reproduce so systematically and persistently the same street under such infinitely varying lighting conditions.

36 PLACE DU THÉÂTRE-FRANÇAIS. SPRING
PLACE DU THÉÂTRE-FRANÇAIS. PRINTEMPS

Oil on canvas. 65.5×81.5 cm
Signed and dated, bottom right: *C. Pissarro 98*
Inv. No. 6509 R.-V. II, 1032

Provenance: 1898 P. Durand-Ruel Gallery, Paris (bought from the artist on 2 June); 1898 P. Shchukin collection, Moscow; 1912 S. Shchukin collection, Moscow; 1918 First Museum of Modern Western Painting, Moscow; 1923 Museum of Modern Western Art, Moscow; since 1930 The Hermitage, Leningrad

Pissarro painted this picture in April, shortly before his departure for Eragny. Compared with other landscapes from this series, it shows considerable differences in composition.

37 AUTUMN MORNING AT ÉRAGNY
MATIN D'AUTOMNE À ÉRAGNY

Oil on canvas. 54×65 cm
Signed and dated, bottom left: *C. Pissarro 97*
Inv. No. 3403 R.-V. II, 1014
Provenance: G. Viau collection, Paris; 1907 I. Morozov collection, Moscow (bought in the Viau sale at the Durand-Ruel Gallery, Paris); 1919 Second Museum of Modern Western Painting, Moscow; 1923 Museum of Modern Western Art, Moscow; since 1948 The Pushkin Museum of Fine Arts, Moscow

The landscape was painted in the autumn of 1897. It is known that in February of the same year Pissarro came to the French capital to work on his *Boulevards* series. The landscapes, produced in the summer and autumn of 1897 in the suburbs of Paris, also signify Pissarro's departure from Divisionism and return to Impressionism, although modified by the Pointillist technique. Hence the manner of applying the paint on to canvas in thick dot-like dabs and the synthetic approach to the organization of the picture surface which is dominated by an all-uniting green tonality.

ALFRED SISLEY. 1839—1899

38 FROSTY MORNING IN LOUVECIENNES
GELÉE À LOUVECIENNES

Oil on canvas. 46×61 cm
Signed and dated, bottom left: *Sisley. 73*
Inv. No. 3420 Daulte, *Sisley* 57
Provenance: G. Strauss collection, Paris; 1902 P. Durand-Ruel Gallery, Paris (bought in the Strauss sale); 1903 I. Morozov collection, Moscow (purchased for 11,500 francs); 1919 Second Museum of Modern Western Painting, Moscow; 1923 Museum of Modern Western Art, Moscow; since 1948 The Pushkin Museum of Fine Arts, Moscow

Sisley's early landscapes, close in manner to the pictures of the Barbizon artists, were exhibited in the Salons of 1866, 1868, and 1870. Among these works is *Frosty Morning in Louveciennes*, whose composition and poetic mood of a cold and clear winter morning show the influence of Corot and Daubigny. However, the lightened palette, lyricism, and the freshness of sensation witness to the Impressionist approach to landscape. From 1871 until 1874, the modest Parisian

suburb Voisin-Louveciennes was a kind of creative laboratory for Sisley, one of the most lyrical Impressionists, who immortalized it in his work. Just as La Grenouillère at Chatou, Argenteuil, Vétheuil, and Giverny, it has become part of the poetic topography of Impressionism.

39 THE GARDEN OF HOSCHEDÉ
LE JARDIN D'HOSCHEDÉ

Oil on canvas. 56×74 cm
Signed, bottom right: *Sisley*
Inv. No. 3421 Daulte, *Sisley* 444

Provenance: J.-B. Faure collection, Paris; 1900 P. Durand-Ruel Gallery, Paris; 1904 I. Morozov collection, Moscow; 1919 Second Museum of Modern Western Painting, Moscow; 1923 Museum of Modern Western Art, Moscow; since 1948 The Pushkin Museum of Fine Arts, Moscow

The picture shows the garden of the villa of Ernest Hoschedé, a banker and publisher, who often invited Claude Monet and Sisley to stay and work in his Montgeron house. François Daulte dates the canvas to 1881.

The Garden of Hoschedé is a characteristic Sisley landscape, small in size, lyrical in mood and meticulous in execution. It clearly reflects the compositional devices favoured by the artist, such as the arrangement in the foreground of big tree-trunks or luxuriant tree-tops creating a sense of depth and emphasizing the scale. This device enabled Sisley to use the coloristic contrasts of the darker, more saturated masses of the foreground and the sunlit distances visible through them.

40 THE SKIRTS OF THE FONTAINEBLEAU FOREST
L'ORÉE DE LA FORÊT À FONTAINEBLEAU

Oil on canvas. 60×73 cm
Signed and dated, bottom right: *Sisley 85*
Inv. No. 3422 Daulte, *Sisley* 589

Provenance: G.-B. Faure collection, Paris; 1900 P. Durand-Ruel Gallery, Paris; 1905 I. Morozov collection, Moscow; 1919 Second Museum of Modern Western Painting, Moscow; 1923 Museum of Modern Western Art, Moscow; since 1948 The Pushkin Museum of Fine Arts, Moscow

A venue of the *plein-air* artists since the 1740s, the Forest of Fontainebleau served as a source of inspiration for the Impressionists as well.

The present landscape is done in impetuous brush-strokes quite characteristic of a number of Sisley's later works. In Daulte's catalogue it is listed as *Road in the Forest of Fontainebleau* (*Chemin dans la forêt de Fontainebleau*). The same subject is depicted in *Le long du bois en automne* (Daulte, *Sisley* 590). The Moscow picture differs from it by a freer manner of painting. Judging by the bare tree-branches, *The Skirts of the Fontainebleau Forest* was also painted

in autumn. Sisley apparently worked on different versions of this autumn landscape for several days under different weather conditions.

41 VILLAGE ON THE SEINE. VILLENEUVE-LA-GARENNE
VILLAGE AU BORD DE LA SEINE. VILLENEUVE-LA-GARENNE

Oil on canvas. 59×80.5 cm
Signed and dated, bottom left: *Sisley 1872*
Inv. No. 9005 Daulte, *Sisley* 40

Provenance: 1872 P. Durand-Ruel Gallery, Paris (bought from the artist on 24 August for 350 francs); 1898 P. Shchukin collection, Moscow (acquired by his brother, I. Shchukin); 1912 S. Shchukin collection, Moscow; 1918 First Museum of Modern Western Painting, Moscow; 1923 Museum of Modern Western Art, Moscow; since 1948 The Hermitage, Leningrad

Like most of his fellow landscape painters, Alfred Sisley spent much time in the suburbs of Paris. From 1871 to 1874 he lived in the village of Voisin-Louveciennes.

Along with countryside views around Louveciennes, Sisley's canvases of 1872 often depict the little town of Villeneuve-la-Garenne. The Hermitage picture, also known as *Village on the Seine*, is one of these canvases. Its composition — the landscape enclosed in a natural frame of trees — is the only instance of this kind in the artist's œuvre.

42 WINDY DAY AT VENEUX
LA CAMPAGNE À VENEUX

Oil on canvas. 60×81 cm
Signed, bottom right: *Sisley*
Inv. No. 6508 Daulte, *Sisley* 452

Provenance: 1883 P. Durand-Ruel Gallery, Paris (bought from the artist); 1905 I. Morozov collection, Moscow (acquired for 12,500 francs); 1919 Second Museum of Modern Western Painting, Moscow; 1923 Museum of Modern Western Art, Moscow; since 1931 The Hermitage, Leningrad

The mature and late periods of Sisley's artistic career were associated with Moret-sur-Loing. At a ten minutes' walk from Moret is the hamlet of Veneux-Nadon, where the artist spent about two years (1880 to September 1882). It was there that Sisley painted *Windy Day at Veneux*, dated 1882 by François Daulte.

43 RIVER BANKS AT SAINT-MAMMÈS
LA BERGE DE LA RIVIÈRE À SAINT-MAMMÈS

Oil on canvas. 50×65 cm
Signed and dated, bottom left: *Sisley 84*
Inv. No. 9167 Daulte, *Sisley* 513

Provenance: 1884 P. Durand-Ruel Gallery, Paris (bought from the artist on 24 March); 1907 I. Morozov collection, Moscow (acquired from Durand-Ruel

for 20,000 francs); 1919 Second Museum of Modern Western Painting, Moscow; 1923 Museum of Modern Western Art, Moscow; since 1948 The Hermitage, Leningrad

In 1884, Sisley lived at Sablons, in the vicinity of Moret-sur-Loing. *River Banks at Saint-Mammès* was apparently painted in the early spring of 1884, for it was bought by Paul Durand-Ruel on 24 March of that year. According to Daulte, Sisley drew the same view in his sketchbook which is kept in the Musée de l'Impressionnisme in Paris.

PIERRE AUGUSTE RENOIR. 1841—1919

44, 45 BATHING ON THE SEINE. LA GRENOUILLÈRE
BAIGNADE DANS LA SEINE. LA "GRENOUILLÈRE"

Oil on canvas. 59×80 cm
Signed, bottom left: *Renoir*
Inv. No. 3407

Provenance: A. Vollard Gallery, Paris; 1908 I. Morozov collection, Moscow (purchased for 20,000 francs); 1919 Second Museum of Modern Western Painting, Moscow; 1923 Museum of Modern Western Art, Moscow; since 1948 The Pushkin Museum of Fine Arts, Moscow

In the late 1860s and 1870s, Renoir often painted in Chatou and Bougival near Paris. Depicted here is a locale between these two little towns with a floating restaurant, known as La Grenouillère — a favourite meeting-place of the Parisians, described by Maupassant in his short story *Yvette*.

La Grenouillère shows Renoir's Impressionist method at its best. The townsfolk relaxing or promenading along the bank are seen mainly from the back, for they interested the artist merely as a picturesque group. Renoir takes delight in rendering the effects of the vibrating light and atmosphere in which the sharp contours of the figures and objects are dissolved. His interest in this subject may have been stimulated by the two similarly entitled pictures, *Luncheon on the Grass*, by Edouard Manet (1863) and by Claude Monet (1865—66). Manet and Monet liked to paint with Renoir in Chatou and its suburbs. Renoir turned to this subject on more than one occasion. Three other versions of *La Grenouillère* are in the Nationalmuseum, Stockholm, in the Berens collection, Hamburg, and in the Reinhardt collection, Winterthur. Kept in the Musée de l'Impressionnisme is *La Grenouillère* produced in 1879. The same restaurant figures appear in the famous painting *The Boatmen's Luncheon* (Daulte, *Renoir* 379).

Lionello Venturi believes that the Moscow picture was painted in September 1869; that is, at the same time as Claude Monet's landscape on the same subject. Denis Rouart and John Rewald also suggest this date.

46 LADY IN BLACK
DAME EN NOIR

Oil on canvas. 63×53 cm
Signed, middle right: *A. Renoir*
Inv. No. 6506 Daulte, *Renoir* 212

Provenance: S. Shchukin collection, Moscow; 1918 First Museum of Modern Western Painting, Moscow; 1923 Museum of Modern Western Art, Moscow; since 1930 The Hermitage, Leningrad

Lady in Black can be dated around 1876. François Daulte believes that this is a portrait of a certain Mlle Anna, a professional model. However, this supposition has not met with general acceptance. Other scholars are inclined to see in the woman portrayed Mme Georges Hartmann, wife of a well-known music publisher.

47, 48 IN THE GARDEN. UNDER THE TREES OF THE MOULIN DE LA GALETTE
LA TONNELLE. AU MOULIN DE LA GALETTE

Oil on canvas. 81×65 cm
Signed, bottom right: *Renoir*
On the back is a label with an inscription: *Sous la tonnelle. Moulin de la Galette 1875 — Nini à gauche debout, Monet derrière elle, Frank Lami debout au fond, à droite assis Cordier.*
Inv. No. 3406 Daulte, *Renoir* 197

Provenance: E. Mürer collection, Paris; G. Viau collection, Paris; 1907 I. Morozov collection, Moscow (purchased in the Viau sale); 1919 Second Museum of Modern Western Painting, Moscow; 1923 Museum of Modern Western Art, Moscow; since 1948 The Pushkin Museum of Fine Arts, Moscow

The picture is related to what was, in the opinion of critics, the most ambitious modern-life painting of the decade — *Le Moulin de la Galette*, 1876 (Daulte, *Renoir* 209), and can be considered a preliminary sketch for the latter.

According to the inscription on the back of the canvas, Renoir has depicted here his model Nini (standing on the left), Claude Monet (with a hat, in profile, on the left), the artist Charles Cordier (seated at the table), and the artist Frank Lami (standing in the background).

Several scholars identify the man standing in the background as Alfred Sisley, and the man seated at the table as Norbert Goeneutte. The picture was apparently painted in 1875—76, when Renoir worked on his *Moulin de la Galette*, probably in his studio in the Rue Cortot, or in the garden of the Moulin de la Galette, which the artist frequently visited with his friends at that time. Ambroise Vollard dates the picture 1880 (*Chefs-d'œuvre de la peinture française dans les musées de Léningrad et de Moscou. Catalogue de l'exposition, Bordeaux, Paris, 1965—66*, Nos. 68, 69). However, the date 1875—76 seems to be more convincing.

49 HEAD OF A WOMAN. STUDY
TÉTE DE FEMME. ÉTUDE

Oil on canvas. 38.5×36 cm
Signed, top right: *Renoir*
Inv. No. 7714 Daulte, *Renoir* 357

Provenance: A. Vollard Gallery, Paris; 1913 I. Morozov collection, Moscow (bought for 20,000 francs); 1919 Second Museum of Modern Western Painting, Moscow; 1923 Museum of Modern Western Art, Moscow; since 1935 The Hermitage, Leningrad

Renoir's portraits always reflect his own notions of female beauty and charm. These notions changed with the passage of time, and at each stage of his career the artist favoured one particular type of female beauty, modifying accordingly the individual features of his models. This peculiarity of Renoir's manner presents certain problems with regard to the identification of the sitters (especially when no documentary data is available), but at the same time allows us to date the portraits belonging to the artist's brush more or less accurately.

It is hard to say who is portrayed in the Hermitage study. The young woman resembles a number of the models who sat for Renoir in the 1870s. This may well be Mlle Anna (cf. No. 50), or the girl who posed for the painting *Head of a Woman* (Daulte, *Renoir* 118). One thing is clear: the Hermitage study was executed about 1876, the dating being based on the style of Renoir's works of that period. It is corroborated by the model's hairdo that can be seen in some of his portraits of 1876, as well as by the decorative leaf design in the background that occurs in several 1876 pictures, such as *Portrait of Victor Chocquet* (Daulte, *Renoir* 175) and *Portrait of Jeanne Durand-Ruel* (Daulte, *Renoir* 179).

50 NUDE (NUDE SEATED ON A SOFA)
FEMME NUE. TORSE D'ANNA

Oil on canvas. 92×73 cm
Signed and dated, bottom right: *Renoir. 76*
Inv. No. 3330 Daulte, *Renoir* 213

Provenance: E. Chabrier collection, Paris; 1896 P. Durand-Ruel Gallery, Paris; 1898 P. Shchukin collection, Moscow; 1912 S. Shchukin collection, Moscow; 1918 First Museum of Modern Western Painting, Moscow; 1923 Museum of Modern Western Art, Moscow; since 1948 The Pushkin Museum of Fine Arts, Moscow

Some art scholars, for instance Drucker, are inclined to see in this nude the same Mlle Anna who sat for Edouard Manet's *Nana*.

A study of this model is in the Musée de l'Impressionnisme (Daulte, *Renoir* 201). Another 1876 study, of almost the same size, now in the Kunsthistorisches Museum in Vienna (Daulte, *Renoir* 211), repeats the Moscow picture with slight variations in the pose of the nude and in the colour of the background.

In his representation of women in the nude Renoir abandons the traditional academic rules. He does not idealize the model but emphasizes her natural, sensuous beauty. The pink, warm colour of her skin stands out in contrast with the bluish-green background. This allowed some art critics to compare the model to a pearl in a shell and to give the canvas a second title, *The Pearl*.

According to John Rewald, the picture was displayed at the 2nd Impressionist exhibition in Paris in 1876 under the title *Study*.

51 PORTRAIT OF THE ACTRESS JEANNE SAMARY. STUDY
L'ACTRICE JEANNE SAMARY. ÉTUDE

Oil on canvas. 56×47 cm
Signed and dated, top left: *Renoir. 77*.
Inv. No. 3405 Daulte, *Renoir* 229

Provenance: Collection of P. Lagarde (husband of Jeanne Samary), Paris; 1903 P. Durand-Ruel Gallery, Paris; 1904 I. Morozov collection, Moscow; 1919 Second Museum of Modern Western Painting, Moscow; 1923 Museum of Modern Western Art, Moscow; since 1948 The Pushkin Museum of Fine Arts, Moscow

In 1877—78, Renoir often painted Jeanne Samary, an actress of the Comédie-Française, whose acquaintance he made in the house of the publisher Georges Charpentier. One of the actress's half-length portraits is to this day in the possession of that theatre. The Moscow canvas is thought to be a study for the formal full-length portrait of Jeanne Samary (No. 52), although it would be quite proper to regard it as a work of art in its own right, because in it the actress is painted in a different way and in an entirely different colour scale. Many scholars, John Rewald among them, hold the Moscow picture to be the finest Impressionist portrait ever done by Renoir.

52 PORTRAIT OF THE ACTRESS JEANNE SAMARY
PORTRAIT DE Mlle JEANNE SAMARY, EN PIED

Oil on canvas. 173×103 cm
Signed and dated, bottom left: *Renoir. 78*
Inv. No. 9003 Daulte, *Renoir* 263

Provenance: 1879 P. Durand-Ruel Gallery, Paris (bought from the artist for 1,500 francs); Prince Polignac collection, Paris; 1897 P. Durand-Ruel Gallery, Paris (bought from Prince Polignac for 4,000 francs); 1898 De La Salles collection, Paris; Bernheim-Jeune Gallery, Paris; M. Morozov collection, Moscow; 1910 The Tretyakov Gallery, Moscow (gift of Morozov's widow); 1925 Museum of Modern Western Art, Moscow; since 1948 The Hermitage, Leningrad

In the Hermitage picture, executed in 1878, Renoir created an impressive image of the actress standing against the decorative background of the theatre foyer. He painted this portrait hoping to display it in

the 1879 Salon. It was Jeanne Samary herself who helped him realize this hope.

According to Ambroise Vollard's account, based on the artist's words, a *rapin* who was to put a fresh coating of varnish on a canvas hanging beside the *Portrait of Jeanne Samary* did this, by mistake, with the Renoir portrait. Since Renoir had apparently retouched his picture before sending it to the exhibition and its paint was still wet, thick lumps of yellow varnish remained on the canvas. In the 1960s, they were removed by a Hermitage expert, Zinaida Nikolayeva, who restored the picture to its original state.

53 CHILD WITH A WHIP
L'ENFANT AU FOUET

Oil on canvas. 107×75 cm
Signed and dated, bottom right: *Renoir. 85*
Inv. No. 9006 Daulte, *Renoir* 471

Provenance: E. Goujon collection, Paris; A. Vollard Gallery, Paris; 1913 I. Morozov collection, Moscow (purchased for 42,000 francs); 1919 Second Museum of Modern Western Painting, Moscow; 1923 Museum of Modern Western Art, Moscow; since 1948 The Hermitage, Leningrad

Child with a Whip, executed in 1885, shows all the signs of the so-called Ingresque style, or *style aigre*, which Renoir evolved in the mid-1880s, having radically changed his manner of painting. At that time he departed from the depiction of instantaneous, fleeting motions and soft colour modulations, and began to focus on clearly defined colour surfaces.

The Hermitage picture, commissioned by Senator Goujon, is a portrait of his five-year-old son Etienne (1880—1945). A companion piece, *Girl with a Hoop*, which portrays the senator's daughter Marie, is in the National Gallery of Art in Washington (Daulte, *Renoir* 470).

54 LANDSCAPE. LE CANNET
PAYSAGE AU CANNET

Oil on canvas. 14×19 cm
Signed, bottom left: *Renoir*
Inv. No. 8926

Provenance: 1910 P. Durand-Ruel Gallery, Paris; 1912 Blot collection, Paris; Private collection, Moscow; 1918 Rumiantsev Museum, Moscow; 1925 Museum of Modern Western Art, Moscow; since 1948 The Hermitage, Leningrad

This little landscape, with the artist's house enclosed in a frame of trees, reveals features of Renoir's mature style. It looks as if he moulds his forms out of a soft, plastic material, fusing them into solid and at the same time fluid masses.

The date 1902, apparently put on the back of the canvas by its first owner (probably Durand-Ruel), may be considered authentic; it is supported by a comparison of the Hermitage picture with other works dated

the same year, for example *Le Cannet* (Barnes Foundation, Merion, Pa., U.S.A.).

55 GIRL WITH A FAN
JEUNE FILLE À L'ÉVENTAIL

Oil on canvas. 65×50 cm
Signed, top right: *Renoir*
Inv. No. 6507 Daulte, *Renoir* 332

Provenance: 1891 P. Durand-Ruel Gallery, Paris (bought from the artist on 21 July); 1908 I. Morozov collection, Moscow (bought for 30,000 francs); 1919 Second Museum of Modern Western Painting, Moscow; 1923 Museum of Modern Western Art, Moscow; since 1931 The Hermitage, Leningrad

Renoir painted his *Girl with a Fan* in 1881. While working on this picture, which is built upon vibrant colour combinations, the artist must have kept in mind the experiments of Michel Eugène Chevreul and his theory of colour classification. Be it as it may, the colour range of the picture comprises almost all of the primary and supplementary colours of Chevreul's spectrum — blues, lilacs, reds, yellows, and greenish-yellows.

The subject of the portrait is Alphonsine Fournaise, daughter of the owner of the floating restaurant, La Grenouillère, at Chatou.

There is a quarter-length portrait of the same model (Daulte, *Renoir* 277), which is probably a study for the Hermitage canvas. François Daulte erroneously considers this study to be a portrait of Jeanne Samary, evidently relying on the fact that the first owner of the study was Samary's husband, Paul Lagarde. Displayed at the 7th Impressionist exhibition of 1882, *Girl with a Fan* was ridiculed in the satirical review *Charivari* (9 March 1882).

56, 57 GIRLS IN BLACK
JEUNES FILLES EN NOIR

Oil on canvas. 81.3×65.2 cm
Signed, bottom right: *A R*
Inv. No. 3329 Daulte, *Renoir* 375

Provenance: S. Shchukin collection, Moscow; 1918 First Museum of Modern Western Painting, Moscow; 1923 Museum of Modern Western Art, Moscow; since 1948 The Pushkin Museum of Fine Arts, Moscow

In the 1880s, when Renoir broke away from the Impressionist manner, his drawing and contours became more palpable and his earlier small, dot-like vibrating strokes gave way to large patches of colour with all brushstrokes fused into a compact mass. This new technique is clearly demonstrated in *Girls in Black*, painted in the early 1880s. P. N. Feist dates it to 1880—82, which seems quite plausible.

There exists a study for the figure of the girl at left (Daulte, *Renoir* 376). Feist associates Renoir's *Portrait of an Unknown Woman*, done in red chalk (No. 58), with the same girl.

**58 PORTRAIT OF AN UNKNOWN WOMAN
PORTRAIT D'UNE INCONNUE**

Red and white chalk, and lead pencil. 79×57.5 cm
Signed in pencil, bottom left: *Renoir*
Inv. No. 10306

Provenance: M. Morozov collection, Moscow; 1910 The Tretyakov Gallery, Moscow (gift of Morozov's widow); 1925 Museum of Modern Western Art, Moscow; since 1948 The Pushkin Museum of Fine Arts, Moscow

Portrait of an Unknown Woman which, according to Feist, dates from 1882—85, is executed in a manner evolved by Renoir around 1883. It was at that time that he began to use red chalk which gave him a means of introducing a generalized outline and a restrained colour scale. To emphasize the three-dimensionality of the figure against the receding background Renoir made use of white-chalk highlights. Thanks to its painstaking execution, the portrait produces the impression not so much of a drawing as of a monochrome painting.

**59 WOMAN WITH A MUFF
LA DAME AU MANCHON**

Pen and Indian ink with touches of watercolour wash on laid paper with watermark *F. L. Bas.* 45×30 cm
Signed, bottom right: *ARenoir* (the artist's initials are intertwined)
Inv. No. 10443

Provenance: Prince de Wagram collection (?), Paris; I. Ostroukhov collection, Moscow; 1918 Museum of Painting and Icon Painting, Moscow; 1929 Museum of Modern Western Art, Moscow; since 1948 The Pushkin Museum of Fine Arts, Moscow

The work is done in the free, elegant manner of a hatched pen drawing. The watercolour wash of delicate blue gives a special refinement to the image of the young Parisienne. On the other hand, the very character of the drawing and a certain departure from the typically Renoir treatment of a model reveal the impact of Japanese prints (in April 1883, a big retrospective exhibition of Japanese art was held in Paris). These features are less evident in a pastel identical with the Moscow drawing, which is in the Metropolitan Museum of Art, New York. The Impressionist manner of the Moscow sheet gives reasons for believing that it was executed before the Metropolitan Museum pastel. There is another drawing of a lady with a muff in the Matthiesen collection in London.

EDGAR DEGAS. 1834—1917

**60 DANCER SEATED, ADJUSTING HER SHOES
DANSEUSE ASSISE RAJUSTANT SES CHAUSSONS**

Charcoal and pastel on grey paper. 47.3×30.5 cm
Signed, bottom right: *Degas*
Inv. No. 42160

Provenance: Art Salon of P. Cassirer, Hamburg; P. Durand-Ruel Gallery, Paris; I. Ostroukhov collection, Moscow; 1918 Museum of Painting and Icon Painting, Moscow; 1923 Museum of Modern Western Art, Moscow; 1935 The Hermitage, Leningrad

Degas derived a wealth of inspiration from the ballet, where the image is born of movement, of constantly changing postures of the human body. He picked up and worked out on paper or canvas only the most essential of the dancers' turns and gestures. It is not surprising therefore that the pose of a seated ballerina rubbing her tired legs or adjusting the straps of her shoes — the pose as justified backstage as the most intricate *pas* on the stage — arrested the artist's attention. Degas repeatedly used these motifs beginning with the 1870s. In its execution, manner of hatching, designation of shadows, and position of the figure in space, the Hermitage piece is most closely related to a drawing in the Musée Bonnat (Bayonne) and also to sketches depicting the dancer Méline Darde. A similar but more elaborate pastel is in the National Gallery of Victoria, Melbourne. A number of art historians have noted an affinity between the Hermitage pastel and the composition *The Rehearsal Room with a Double-bass* (Metropolitan Museum of Art, New York).

**61 BALLET REHEARSAL
DANSEUSES À LA RÉPÉTITION**

Pastel on cardboard. 50×63 cm
Signed, bottom right: *Degas*
Inv. No. 3276 L. 653

Provenance: S. Shchukin collection, Moscow; 1918 First Museum of Modern Western Painting, Moscow; 1923 Museum of Modern Western Art, Moscow; since 1948 The Pushkin Museum of Fine Arts, Moscow

After 1870 Degas constantly turned to the ballet theme. The Art Galleries and Museum in Glasgow possesses a canvas, *The Ballet Rehearsal* (L. 430), executed in the same years and corresponding fairly closely with the left-hand part of the Moscow picture. A pastel study is also known, in which the whole scene is drawn in a sharper and more graphic manner (L. 654). Several scholars date the Moscow *Ballet Rehearsal* to the 1880s. Fiorella Minervino puts it at 1881. However, the dating 1875—77 seems to be more reliable.

**62 DANCER BEFORE THE WINDOW, OR DANCER POSING FOR A PHOTOGRAPHER
DANSEUSE DEVANT LA FENÊTRE
OU DANSEUSE CHEZ LE PHOTOGRAPHE**

Oil on canvas. 65×50 cm
Signed, bottom right: *Degas*
Inv. No. 3274 L. 447

Provenance: G. Bram collection, Paris; A. Doria collection, Paris (1899 sale, lot 137); 1901 P. Durand-

Ruel Gallery, Paris; P. Cassirer collection, Berlin; 1901 S. Shchukin (or P. Shchukin) collection, Moscow; 1918 First Museum of Modern Western Painting, Moscow; 1923 Museum of Modern Western Art, Moscow; since 1948 The Pushkin Museum of Fine Arts, Moscow

This canvas was apparently painted between 1874 and 1877. A 1873 Paris version with three dancers before the window (L. 324) probably represents one of the artist's early efforts in treating this theme. The interior of this version corresponds exactly with that of the Moscow picture. The pose of the ballerina in two more works, the pastel *Dance Lesson* (L. 396) and a pencil drawing (see *The Burlington Magazine*, June 1963, pl. 19), also shows an affinity with the Moscow picture.

C. Roger-Marx dates the Moscow picture, the only oil painting by Degas found in Soviet museums, to 1878—79. It is also mentioned in the diary of Maurice Denis, who saw it during his visit to the Shchukin Gallery in Moscow in 1909 (see Maurice Denis, *Journal*, vol. 2 (1905—1920), Paris, 1957, p. 108).

63 EXERCISING RACEHORSES
 CHEVAUX DE COURSE
Pastel. 36×86 cm
Signed twice, bottom right and left: *Degas*
Inv. No. 3275 L. 597
Provenance: T. Duret collection, Paris; S. Shchukin collection, Moscow; 1918 Museum of Modern Western Painting, Moscow; 1923 Museum of Modern Western Art, Moscow; since 1948 The Pushkin Museum of Fine Arts, Moscow

In his early period Degas copied paintings by the Old Masters, frequently choosing battle scenes or history paintings with representations of horsemen. It is known that the artist copied Uccello's *Battle of San Romano* in the Uffizi Gallery in Florence, and possessed a 1828 sketch done by Delacroix for his canvas *Battle of Nancy* (1831—34).

When in the early 1860s the artist turned to the horse-racing theme, he was fairly well experienced in drawing and in depicting horses and riders. His interest in scenes of contemporary life was aroused, in large measure, by his contacts, in the 1860s, with the future Impressionists. It was at that time that Degas became attracted to horse-races, making a host of drawings of jockeys and horses, in which he attempted to capture their characteristic poses and movements. He also repeatedly treated the horse-racing theme in sculpture.

The Moscow pastel is usually dated 1880. Some more horse-racing scenes painted by Degas around that time are identical in size with the Moscow picture but show different groups of horsemen and variations in the background landscape. Closest to the Moscow picture is the pastel *Horsemen* (L. 597 bis).

Exercising Racehorses was bought by Sergei Shchukin not later than 1908, as it is mentioned in the description of the Shchukin Gallery in P. Muratov's book published in 1908.

During his stay in Moscow in 1909, Maurice Denis saw this picture in Shchukin's house, and made a note of it in his diary (see Maurice Denis, *Journal*, vol. 2 (1905—1920), Paris, 1957, p. 108).

64, 65 BLUE DANCERS
 DANSEUSES BLEUES
Pastel. 65×65 cm
On the back is a label with a printed note: *Durand-Ruel. Paris 16, Rue Laffitte New York 389 Fifth Avenue*, and an inscription in ink: *Degas n 4878. Danseuses bleues*
Inv. No. 3273 L. 1274
Provenance: P. Durand-Ruel Gallery, Paris; 1903 S. Shchukin collection, Moscow; 1918 First Museum of Modern Western Painting, Moscow; 1923 Museum of Modern Western Art, Moscow; since 1948 The Pushkin Museum of Fine Arts, Moscow

Dancers getting ready for the performance are often shown in Degas's pastels, oil paintings, and drawings. The rare harmony of colour and the beauty of the composition of the Moscow pastel make it probably the finest Degas work on this theme. Describing his visit to Sergei Shchukin, Maurice Denis wrote in his diary: "The blue Degas in the great hall is the most beautiful, most vibrant and fresh" (see Maurice Denis, *Journal*, vol. 2 (1905—1920), Paris, 1957, p. 108). There can be no doubt that Denis referred to the Moscow *Blue Dancers*.

In the Bibliothèque Nationale, Paris, there are three negatives made and used by Degas when he was painting the Moscow pastel. The figures in the picture are an exact repetition, although in reverse, of the dancers seen in these negatives. Two of the negatives show the same model. In the picture, this model appears twice, in the centre and on the right.

A canvas depicting the dancers full length, similar in colour scale but apparently of an earlier date, is in the Musée de l'Impressionnisme, Paris (L. 1014). Also close to the Moscow work is a pastel of 1899 (L. 1352) and a pastel with three dancers (L. 1344). There is a drawing for the right-hand figure in the Moscow picture (Museum of Fine Arts, Budapest). A drawing with four dancers, reproduced here under No. 66, and another study (L. 1311), show an affinity with the Moscow pastel. Lemoisne dates the *Blue Dancers* 1897.

66 HEADS OF DANCERS
 TÊTES DE DANSEUSES
Pastel and charcoal on greyish-buff paper pasted on cardboard. 31×55 cm
Signed, middle right: *Degas*
Inv. No. 42155 L. 1358

Provenance: A. Vollard Gallery, Paris; 1908 I. Morozov collection, Moscow; 1919 Second Museum of Modern Western Painting, Moscow; 1923 Museum of Modern Western Art, Moscow; since 1934 The Hermitage, Leningrad

In the second half of the 1890s, in his series of *Dancers*, Degas particularly often turned to compositions with three or four half-length figures. Such are his *Blue Dancers* (see No. 65), *The Dancers* (L. 1344), and many others. There is an affinity in style and composition between the Hermitage sheet and the pastel *Dancers Before Going on Stage* (L. 1352). In size the former coincides with the upper half of the latter. Although they may represent two versions (breast-length and knee-length), it is most probable that *Heads of Dancers* is a study worked out and partly copied in *Dancers Before Going on Stage* (the knee-length version of this composition). The Hermitage sheet, in its turn, was preceded by a number of sketches of the dancer at extreme left. The study-like character of the Hermitage piece is also confirmed by its manner of execution, which is freer than that of *Three Dancers*. Degas used here broad, seemingly casual cross-hatching, and a laconic colour scheme.

67 AFTER THE BATH
 APRÈS LE BAIN

Pastel, gouache, tempera, and charcoal on grey paper pasted on cardboard; squared up, with extensions at top and bottom. Overall dimensions: 82.5×72 cm
Signed, top right: *Degas*
Inv. No. 43787 L. 1179

Provenance: A. Vollard Gallery, Paris; 1907 I. Morozov collection, Moscow; 1918 Second Museum of Modern Western Painting, Moscow; 1923 Museum of Modern Western Art, Moscow; since 1948 The Hermitage, Leningrad

This pastel is one of Degas's works in which the demarcation line between drawing and painting is almost completely obliterated. A sharp outline seems to push the form out of its plane, making the viewer feel all its intrinsic corporeity. The particles of pastel chalks, combined with tempera, gouache, charcoal, and varnish, create a dense, multi-layered texture. An earlier version of the composition, related to the Hermitage pastel, dates from the mid-1880s (L. 886). There are several studies from around 1885 (L. 1180, 1180 bis), which can be regarded as preparatory drawings. Squared for transfer and extended at top and bottom, this pastel was obviously intended for further elaboration in a different medium or scale.

68 AFTER THE BATH
 APRÈS LE BAIN

Pastel on paper mounted on cardboard. 50×50 cm
Signed and dated, bottom right: *Degas 84*
Inv. No. 42156

Provenance: M. Morozov collection, Moscow; 1910 The Tretyakov Gallery, Moscow (gift of Morozov's widow); 1925 Museum of Modern Western Art, Moscow; since 1934 The Hermitage, Leningrad

In subject matter this pastel can be related to the pastels under the collective title *Sequence of Nudes, of Women Bathing, Washing, Drying, Wiping Themselves, Combing Their Hair or Having It Combed* that were shown at the 8th Impressionist exhibition of 1886. However, this theme began to attract Degas already in the late 1870s. As in his other pastels, the woman's facial features are not specified, for it is not her face that interests the artist but the structure of her body, her figure seen from a variety of unexpected angles.

69 WOMAN AT HER TOILETTE
 LA TOILETTE

Pastel and charcoal. 56×59 cm
Signed, bottom, left of centre: *Degas*
Inv. No. 43788 L. 976

Provenance: I. Ostroukhov collection, Moscow; 1918 Museum of Painting and Icon Painting, Moscow; 1929 Museum of Modern Western Art, Moscow; since 1949 The Hermitage, Leningrad

Just like its versions — a pastel sketch of a woman with black hair and *Woman in Red Peignoir Combing Her Hair* (L. 977, 978) — the Hermitage picture is usually dated 1889. The exact date, however, is of no special consequence, as this pastel reflects Degas's new attitude to form, typical of his later works. In these, a strongly pronounced graphic quality took the place of the earlier linear clarity in the Ingresque treatment of form. The hatching comes to dominate in his pastels; colour no longer moulds the form and does not even coincide with the contours, merely hinting at the local colouring.

70 AFTER THE BATH
 APRÈS LE BAIN

Charcoal and brown pencil (sepia?) on two pieces of paper pasted together. 37×44 cm
Signed, left, below middle: *Degas*
Inv. No. 10442 L. 1122

Provenance: Barbazanges collection, Paris; 1912 I. Ostroukhov collection, Moscow; 1918 Museum of Painting and Icon Painting, Moscow; 1929 Museum of Modern Western Art, Moscow; since 1948 The Pushkin Museum of Fine Arts, Moscow

After the Bath belongs to the same *Nudes* series as the Hermitage pastels (Nos. 67, 68, 71), although it is done in a more generalized, laconic manner characteristic of the artist's later charcoal drawings. In the 1890s, Degas did many sculptures, and this apparently explains the fact that the composition of this work is similar to a bas-relief, parallel to the plane of the sheet. The generalized character of the outline is

emphasized by the lack of detail and the almost mon-
ochrome colour scale enlivened by the brown hues
of the hair. The classical clarity of the flowing
rhythms conveys the soft motion of the woman's
figure. Degas's works of this kind found an ardent
admirer in Renoir, who compared them to the Parthe-
non sculptures.

71 WOMAN COMBING HER HAIR
FEMME SE PEIGNANT

Pastel. 53×52 cm
Signed, top right: *Degas*
Inv. No. 42154 L. 848

Provenance: Henri Wever collection, Paris; 1897
P. Durand-Ruel Gallery, Paris (bought in the Henri
Wever sale at the Georges Petit Gallery, Paris, 1—2
February 1897); 1898 P. Shchukin collection, Mos-
cow; 1912 S. Shchukin collection, Moscow; 1918 First
Museum of Modern Western Painting, Moscow; 1923
Museum of Modern Western Art, Moscow; since 1935
The Hermitage, Leningrad

In contrast to the pastel *After the Bath* (1884) paint-
ed in a somewhat naturalistic vein, à la Zola, *Wom-
an Combing Her Hair* is one of Degas's most har-
monious and at the same time innovative works from
this series. Its clear, well-defined contours and ele-
gant linear rhythm reflect a fidelity to Ingres's man-
ner. The soft modelling by light and colour, the clas-
sical finish of form and the perfection of the compo-
sitional scheme obscure the novelty of the artist's
approach to this conventional theme: thanks to a
complex, unusual vantage point, he widens the narrow
square of the picture, designating space, as it were,
and creates a completely natural atmosphere.
The Hermitage version is close to the 1885 pastel for-
merly owned by the composer Ernest Chausson
(L. 849), and was apparently executed in the same
year. Many of its stylistic features make it akin to
such works as *The Tub* (L. 872) and virtually never
occur in the artist's later productions, although he
painted similar compositions more than once.

ARMAND GUILLAUMIN. 1841—1927

72 THE SEINE
LA SEINE

Oil on canvas. 26×50 cm
Signed, bottom left: *Guillaumin*
Inv. No. 8904

Provenance: S. Shchukin collection, Moscow; 1918
First Museum of Modern Western Painting, Moscow;
1923 Museum of Modern Western Art, Moscow;
since 1948 The Hermitage, Leningrad

Judging by the muted greys, this canvas belongs to
the artist's early period and may be dated between
1867 and 1869, as it has a close affinity with *The
Barges* (*Les Péniches*) dated 1868 (see Ch. Gray,

Armand Guillaumin, Chester, Conn., 1972, fig. 7).
Later, in the 1870s, Guillaumin favoured a more vivid,
Impressionist colour scale. On the back of the can-
vas is a sketch of a river scene with a factory and
a smokestack (partly overpainted). It may well be
the factory at Ivry which the artist repeatedly depict-
ed at the beginning of his career. On the stretcher is a
pencil drawing of a harnessed horse that calls to mind
another sketch of a horse, dated 1867 (*ibid.*, fig. 5).

73 LANDSCAPE WITH RUINS
PAYSAGE AVEC RUINES

Oil on canvas. 79×93 cm
Signed, bottom right: *Guillaumin*
Inv. No. 3262

Provenance: S. Shchukin collection, Moscow; 1918
First Museum of Modern Western Painting, Moscow;
1923 Museum of Modern Western Art, Moscow; since
1948 The Pushkin Museum of Fine Arts, Moscow

After 1891 Guillaumin lived at Crozant in Norman-
dy, where he painted the ruins of an ancient castle
depicted in the Moscow picture. During the 1890s he
departed from Impressionism and concentrated upon
the decorative aspect of painting. This picture is paint-
ed with swift broad brushstrokes; its colour scale
is based on a juxtaposition of vivid open patches of
colour attesting to Guillaumin's affinity with the
Fauves. Judging by the manner of execution the land-
scape was done in the late 1890s or early 1900s.

PAUL CÉZANNE. 1839—1906

74 INTERIOR WITH TWO WOMEN AND A CHILD
SCÈNE D'INTÉRIEUR

Oil on canvas. 91×72 cm
Inv. No. 3490 V. 24

Provenance: A. Vollard Gallery, Paris; 1913 I. Moro-
zov collection, Moscow (bought for 35,000 francs);
1919 Second Museum of Modern Western Painting,
Moscow; 1923 Museum of Modern Western Art, Mos-
cow; since 1948 The Pushkin Museum of Fine Arts,
Moscow

Cézanne was fond of painting interior scenes, espe-
cially in the early period of his artistic career. It was
then, at the beginning of the 1860s, that he painted
his *Interior with Two Women and a Child*.
The background of the picture is dark, almost black.
Black is also used for the shadows on the faces and
folds of the dresses. The paint is applied in even lay-
ers, sometimes rather thick ones. The overall sombre
colour scale proves that this is one of Cézanne's ear-
ly works. Bernard Dorival dates it 1861 and believes
that Cézanne borrowed the female figures in crino-
line dresses from the review *L'Illustrateur de mode*.
Lionello Venturi supposes that the canvas depicts
Cézanne's mother and two sisters — Marie and Rose

(V. 1841, 1854), although the dark-haired Marie appears as a blonde in the painting (at left). In all probability the artist deliberately changed the colour of her hair. Cézanne painted his sisters again several years later in *The Promenade* (V. 119) and *Conversation* (V. 120).

75 TREES IN A PARK
LE JAS DE BOUFFAN

Oil on canvas. 72×91 cm
Inv. No. 3413 V. 462

Provenance: A. Vollard Gallery, Paris; 1911 I. Morozov collection, Moscow (bought for 28,000 francs); 1919 Second Museum of Modern Western Painting, Moscow; 1923 Museum of Modern Western Art, Moscow; since 1948 The Pushkin Museum of Fine Arts, Moscow

Bernard Dorival (see B. Dorival, *Paul Cézanne*, Paris, 1948, p. 5) mentions ten Cézanne landscapes with views of the Jas de Bouffan, his family estate, and ranks them with the finest portrayals of Provence. Lionello Venturi presumes that one of the studies of the same subject was done by the artist between 1865 and 1867 (V. 38). The Jas de Bouffan views are found in various collections all over the world (V. 47, 160, 162, 460, 461, 463, 465—67, 471, 476, 480, 488, 648, 649, 942, etc.). The Moscow picture shows the park and the buildings on the estate. Its colour range is built up of green, bluish and yellowish tones. The canvas is executed with small strokes of thin paint, thicker brushstrokes being used for the houses. Boris Ternovets and Anna Barskaya date it 1885; Venturi's dating, 1885—87, appears to be more correct.

76, 77 GIRL AT THE PIANO (OVERTURE TO *TANNHÄUSER*)
JEUNE FILLE AU PIANO (L'OUVERTURE DE *TANNHÄUSER*)

Oil on canvas. 57×92 cm
Inv. No. 9166 V. 90

Provenance: A. Vollard Gallery, Paris; 1908 I. Morozov collection, Moscow (bought for 20,000 francs); 1919 Second Museum of Modern Western Painting, Moscow; 1923 Museum of Modern Western Art, Moscow; since 1948 The Hermitage, Leningrad

This interior scene was painted around 1868—69 at the Jas de Bouffan, Cézanne's family estate. The girl at the piano and the woman sitting on the sofa are probably the artist's elder sister Marie and his mother, Anne-Elisabeth Auber. From the correspondence of Cézanne's friends, published by John Rewald and Alfred H. Barr, we know of two earlier versions of the picture. The first one depicted, besides the pianist, Cézanne's father sitting in an armchair and a boy on a sofa. In the autumn of 1866 Cézanne completed this version, but already on 6 January 1867, he again turned to this subject. The second version was ren-

dered in a lighter colour scale and in place of Cézanne's father portrayed Edouard Marion, the artist's friend (in profile).

The Hermitage canvas is the third and only surviving version of the picture, in which Cézanne reduced the number of characters to two, but retained the basic features of the original composition — the armchair, the piano, and the profile of the girl in white etched against the light blue panel. The figure of the father and the profile of Marion have been omitted and the boy has been replaced by the artist's mother. For the third painting, Cézanne must have chosen a new canvas, since X-rays have failed to reveal any trace of previous versions. The initial two versions were evidently destroyed by the artist, but the first one must have inspired a large profile portrait of Cézanne's father holding a newspaper (V. 25), and also two studies of a boy (V. 95, 109).

78 FLOWERS IN A BLUE VASE
BOUQUET DE FLEURS DANS UN VASE BLEU

Oil on canvas. 56×46 cm
Signed, bottom left: *P. Cézanne*
Inv. No. 8954 V. 182

Provenance: V. Chocquet collection, Paris; P. Durand-Ruel Gallery, Paris; 1905 S. Shchukin collection, Moscow; 1918 First Museum of Modern Western Painting, Moscow; 1923 Museum of Modern Western Art, Moscow; since 1948 The Hermitage, Leningrad

In the autumn of 1872, Cézanne settled in Auvers-sur-Oise. It was at this time that his Impressionist period began, the stage of direct contact with nature and keen observation of light reflections. This period was characterized by a distinct lightening of his palette. In Auvers, at Dr. Gachet's, an art connoisseur and a friend of many Impressionists, Cézanne painted a number of still lifes. The Hermitage *Flowers* is probably one of them. In its manner of execution, it shows a resemblance to *Bouquet of Dahlias in a Delft Vase* and can therefore be ascribed to approximately the same period, i. e. between 1873 and 1875 (V. 183). Probably done around this time is the still life in the Paul Durand-Ruel Gallery in New York (V. 181) that depicts the same vase. The Hermitage picture is signed by Cézanne, which is rarely the case with his works.

79 SELF-PORTRAIT IN A CASQUETTE
AUTOPORTRAIT À LA CASQUETTE

Oil on canvas. 53×38 cm
Inv. No. 6512 V. 289

Provenance: H. Havemeyer collection, New York; 1909 I. Morozov collection, Moscow (bought for 12,000 francs in P. Durand-Ruel's shop where it was sent for sale by Mary Cassatt); 1919 Second Museum of Modern Western Painting, Moscow; 1923 Museum

of Modern Western Art, Moscow; since 1930 The Hermitage, Leningrad

Lionello Venturi dates this canvas to 1873—75, which is undoubtedly correct, for in the *Portrait of Cézanne*, painted by Camille Pissarro in 1874, the artist's outward appearance differs very little from this self-portrait (R.-V. II, 58). Moreover, although it retains a rather sombre range of colours, characteristic of Cézanne's early works, the brushstrokes here are calmer and more flexible. Having departed from romantic expressiveness, Cézanne endowed his image with greater simplicity and austerity.

80 ROAD AT PONTOISE
LA ROUTE À PONTOISE

Oil on canvas. 58×71 cm
Inv. No. 3410 V. 172

Provenance: G. Viau collection, Paris; 1907 E. Druet collection, Paris; 1909 I. Morozov collection, Moscow; 1919 Second Museum of Modern Western Painting, Moscow; 1923 Museum of Modern Western Art, Moscow; since 1948 The Pushkin Museum of Fine Arts, Moscow

Up to 1877 Cézanne often painted at Auvers and at the nearby Pontoise. To some degree, his increasing preoccupation with landscape was due to the influence of Pissarro and other Impressionists. Working together, Pissarro and Cézanne frequently painted one and the same motif. It is quite possible that Cézanne conceived this canvas on Pissarro's advice (in any case, such is the opinion of Bernard Dorival). Also at Pontoise, Cézanne painted some views of the Quartier de l'Ermitage, which show a close analogy in motif to the Pushkin Museum picture (V. 170, 176). The most probable dating of the latter (also known as *Paysage de Gisors*, *Le Clos des Mathurins*, *Route de l'Ermitage, Pontoise*, and *Vue de l'Ermitage à Pontoise*) is 1875—77, although this date has not met with general acceptance. In the 1928 catalogue of the Museum of Modern Western Art, it was dated 1876. Nina Yavorskaya dates it the same year, while Rewald believes that it was done in 1873. Dorival and Venturi consider it to have been painted in 1875—77; Barskaya suggests 1876, and Feist, 1877. The light palette and the abundance of cold tones indicate that at that period Cézanne was close to Impressionism.

81 PLAIN BY MOUNT SAINTE-VICTOIRE
PAYSAGE DE SAINTE-VICTOIRE

Oil on canvas. 58×72 cm
Inv. No. 3412 V. 423

Provenance: A. Vollard Gallery, Paris; 1907 I. Morozov collection, Moscow; 1919 Second Museum of Modern Western Painting, Moscow; 1923 Museum of Modern Western Art, Moscow; since 1948 The Pushkin Museum of Fine Arts, Moscow

This landscape marks the beginning of a new stage in Cézanne's work, when he produced his finest canvases. Compared to his earlier landscapes, done in a near-Impressionist manner, this picture has clear-cut planes, with well-designated texture and volume of the individual components of the landscape; the colour remains dark, but acquires intensity.

Cézanne devoted an extensive series of his paintings, watercolours, and drawings to Mount Sainte-Victoire. The Moscow canvas displays the specific colour scale worked out for the whole series and built mainly upon deep blues, oranges and greens. Since the earth takes up a considerable part of the canvas, warm oranges are the predominant tones in the picture. In the later landscapes of this series Cézanne favoured sonorous, deep blues. Julius Meier-Graefe dates the picture around 1880. In all likelihood, however, it was painted between 1882 and 1885, when the artist worked a great deal in and around Aix. Venturi and Barskaya also support this dating.

In style, the Moscow canvas has an affinity with another view of Mount Sainte-Victoire (V. 424). There is a pencil sketch for the right-hand part of the Moscow painting (V. 1432).

82 SELF-PORTRAIT
PORTRAIT DE L'ARTISTE PAR LUI-MÊME

Oil on canvas. 45×37 cm
Signed, bottom right: *P. Cézanne*
Inv. No. 3338 V. 368

Provenance: A. Vollard Gallery, Paris; 1908 S. Shchukin collection, Moscow; 1918 First Museum of Modern Western Painting, Moscow; 1923 Museum of Modern Western Art, Moscow; since 1948 The Pushkin Museum of Fine Arts, Moscow

The modelling of the face is based upon expressive contrasts of green and orange. The manner of painting is a little stiff, the outlines are clear and well-defined. The paint is applied in a systematic brushstroke. In the opinion of Barskaya, the portrait was done in 1879, presumably in Paris. Ternovetz, Yavorskaya, and Genthon date it 1860. Venturi believes that it was done in 1879—82, while Rewald and Leonard have suggested the dating 1882—85. Several self-portraits similar to this one are known to have been painted between 1879 and 1885 (V. 365, 367, 371).

83 FRUIT
LES FRUITS

Oil on canvas. 45×54 cm
Inv. No. 9026 V. 337

Provenance: Private collection, New York; 1894 P. Durand-Ruel Gallery, New York; 1895 P. Durand-Ruel Gallery, Paris; 1903 S. Shchukin collection, Moscow; 1918 First Museum of Modern Western Painting, Moscow; 1923 Museum of Modern Western Art, Moscow; since 1948 The Hermitage, Leningrad

Cézanne produced two groups of still lifes represent-

ing variations of the same objects: a milk jug, a decanter, a painted bowl, and fruit. The Hermitage canvas belongs to the second group which Venturi dates 1879—82 (V. 337, 338, 340), for, in his view, the leaf-pattern wallpaper could have decorated either Cézanne's home at Melun — the artist spent several months in 1879 and the beginning of 1880 there—or his Paris apartment at No. 32, Rue de l'Ouest, where he moved with his wife and son in the spring of 1880. As in 1881 he was working mainly at Pontoise, and in 1882 he paid only brief visits to Paris, it may perhaps be reasonable to relate the Hermitage picture to 1879—80. At any rate, *Fruit* was doubtless painted at a time close to the 1880s, when two tendencies happily coexisted in Cézanne's work — an inclination to massive, Baroque forms and a penchant for the so-called "constructive stroke". At this time Cézanne was evolving his favourite colour scale of warm oranges and cool grey-blues, and his brushstroke was extremely flexible.

84, 85 PIERROT AND HARLEQUIN
MARDI GRAS

Oil on canvas. 102×81 cm
Inv. No. 3335 V. 552

Provenance: 1888 V. Chocquet collection, Paris; 1899 P. Durand-Ruel Gallery, Paris; 1904 S. Shchukin collection, Moscow; 1918 First Museum of Modern Western Painting, Moscow; 1923 Museum of Modern Western Art, Moscow; since 1948 The Pushkin Museum of Fine Arts, Moscow

Pierrot (left) and Harlequin (right) are characters from the Mardi-Gras carnival. The picture is painted in dense strokes clearly designating the cutlines. The melancholy, sad faces of the models and the uneasy, almost tragic mood are completely out of tune with the carnival theme, treated by Cézanne in a manner all his own. The artist concentrates on the play of contrasts even in the rendition of volumes, juxtaposing the models' costumes—the loose white clothes of Pierrot and the close-fitting garment of Harlequin. The models were Louis Guillaume (Pierrot) and Paul Cézanne Junior (Harlequin). On the evidence of the latter, this picture, also known as *Mardi gras*, was painted in 1888 in Cézanne's Paris studio in the Rue Val-de-Grâce. For the figure of Harlequin, Cézanne did three studies in oils (V. 553—555) and five drawings, four of which are mentioned by Venturi (V. 1079, 1473, 1486, 1622), while the fifth is published by Chappuis (A. Chappuis, *Dessins de Cézanne*, Lausanne, 1957, p. 81; *The Drawings of Paul Cézanne. A Catalogue Raisonné by Adrien Chappuis*, 2 vols., London, 1973, No. 944). In Chappuis's view, the three above-mentioned studies and one of the drawings were done not from the artist's son, but from some other model. A study most closely related to the Moscow canvas is in the Pellerin collection in Paris (V. 554).

Bernard Dorival refers *Pierrot and Harlequin* to a genre rarely tackled by Cézanne.

86 THE SMOKER
LE FUMEUR

Oil on canvas. 91×72 cm
Inv. No. 6561 V. 686

Provenance: A. Vollard Gallery, Paris; 1910 I. Morozov collection, Moscow (purchased for 35,000 francs); 1919 Second Museum of Modern Western Painting, Moscow; 1923 Museum of Modern Western Art, Moscow; since 1930 The Hermitage, Leningrad

During the 1890s Cézanne produced his *Card Players* and *Smokers* series. In all probability, the Hermitage picture and the painting housed in the Mannheim Municipal Art Gallery (V. 684) represent the same man. Although Cézanne signed the Mannheim canvas, thus expressing his satisfaction with the results, it is difficult to say which of the two canvases is better. The one in the Hermitage is perhaps more varied in colour and more austere in the character of the image. This is achieved by the fragment of a still life seen above the table, which not only enlivens the brown colour range of the canvas but also emphasizes the massive figure contrasted to the smaller forms of the objects from the still life. The still life exists as an independent picture, *Black Bottle and Fruit* (V. 71), painted in the early 1870s.

87 STILL LIFE WITH PEACHES AND PEARS
NATURE MORTE. PÊCHES ET POIRES

Oil on canvas. 61×90 cm
Inv. No. 3415 V. 619

Provenance: A. Vollard Gallery, Paris; 1912 I. Morozov collection, Moscow; 1919 Second Museum of Modern Western Painting, Moscow; 1923 Museum of Modern Western Art, Moscow; since 1948 The Pushkin Museum of Fine Arts, Moscow

The picture is built on a juxtaposition of different colours, with no classical light-and-shade modelling. The white objects — the tablecloth and the china — display especially fine tonal gradations. While other parts of the still life are painted in heavily applied strokes, the background is noticeably thinner, with the canvas visible under semi-translucent paint layers. Sterling dates the canvas prior to 1886. Venturi and Barskaya have put forward a view that it was painted in 1888—90, and Feist dates it to about 1889. A likely date for this canvas is 1888—90.

88 BATHERS. STUDY
ÉTUDE DE BAIGNEURS

Oil on canvas. 26×40 cm
Inv. No. 3414 V. 588

Provenance: A. Vollard Gallery, Paris; 1910 I. Morozov collection, Moscow; 1919 Second Museum of Modern Western Painting, Moscow; 1923 Museum of Mod-

ern Western Art, Moscow; since 1948 The Pushkin Museum of Fine Arts, Moscow

In the 1880s and 1890s, Cézanne repeatedly turned to the theme of bathers. Nude figures in outdoor settings seemed to him to be an embodiment of the harmonious, unbreakable unity of man and nature. He saw this motif as the most suitable for realizing his dream of a monumental composition that would convey his conception of the world. Cézanne sought ways for implementing this idea both in his large canvases and smaller studies. In the refinement and beauty of its colour harmony, the Moscow study ranks among his best works in this series. The Moscow canvas corresponds fairly closely with two more studies (V. 590, 591); its style shows a resemblance to a third study (V. 589). However, the latter is much smaller and is done in a more sketchy manner. The dating of the painting has been a matter of dispute. Meier-Graefe refers it to 1888; Barskaya, to the late 1880s or early 1890s; Venturi, Dorival and Feist, to 1892—94. The lightened palette and the abundance of blue tones speak in favour of the latter supposition.

In the collection of Paul Cézanne Junior there is a pencil drawing for the man in the centre of the study, standing with a towel in his hand. A sketch, dated 1885, for the standing figure with raised arms is in the collection of Adrien Chappuis. Both sketches have been published by Rewald (see *Correspondance de Paul Cézanne*, 1937, pl. 5; 2nd ed. 1978, pl. 7).

89 THE AQUEDUCT
 L'AQUEDUC
Oil on canvas. 91×72 cm
Inv. No. 3337 V. 477
Provenance: A. Vollard Gallery, Paris; S. Shchukin collection, Moscow; 1918 First Museum of Modern Western Painting, Moscow; 1923 Museum of Modern Western Art, Moscow; since 1948 The Pushkin Museum of Fine Arts, Moscow

Between 1885 and 1887, Cézanne painted a number of views of the Arc River Valley with a chain of mountains dominated by the top of Mount Sainte-Victoire (V. 452, 488, 913, 914). One of these landscapes is *The Aqueduct*.

A group of pine trees in the centre of the picture forms the vertical axis of the canvas and organizes the entire space of the landscape. The turbulent upward movement is emphasized both by the vertical format of the canvas and its colour range — from the dense warm orange-ochre hues of the foreground to the succulent greens of the tree-tops and the transparent cold blues of the mountains, with the cloudless southern sky in the distance. A sense of balance is created by the aqueduct, with the rhythmical pattern of its arches, and the chain of mountains with their soft, flowing outlines.

Charles Sterling dates the picture 1897—1900; René Huyghe, 1890—1900; Venturi and Barskaya, 1885—87; Feist thinks it was painted about 1887. 1885—87 seems a more likely date.

In the inventory of the Museum of Modern Western Art there is a note referring to this work (No. 206): "The painting was varnished by Henri Matisse while he stayed in Moscow (1913), at Sergei Shchukin's house." The date 1913 is incorrect, for Matisse visited Moscow and St. Petersburg in 1911.

Several drawings are known to relate to this landscape (V. 913, 914).

90 BRIDGE ACROSS A POND
 LE PONT SUR L'ÉTANG
Oil on canvas. 64×79 cm
Inv. No. 3417 V. 641
Provenance: A. Vollard Gallery, Paris; 1911 I. Morozov collection, Moscow; 1919 Second Museum of Modern Western Painting, Moscow; 1923 Museum of Modern Western Art, Moscow; since 1948 The Pushkin Museum of Fine Arts, Moscow

Most scholars, including Venturi, Barskaya and Feist, date the painting to 1888—90. It shows some stylistic connection with *The Banks of the Marne* (see Nos. 91, 92). The landscape is built upon a combination of various shades of greens, with the grey canvas showing through the thin layers of paint. Warm brown tones are concentrated in the centre of the composition and prevail in the representation of the bridge. The landscape, done in thin liquid paint, shows the orderly brushwork — similarly shaped strokes are applied at an angle to one another.

91 THE BANKS OF THE MARNE (VILLA ON THE BANK OF A RIVER)
 LES BORDS DE LA MARNE (VILLA AU BORD D'UNE RIVIÈRE)
Oil on canvas. 65×81 cm
Inv. No. 6513 V. 630
Provenance: H. Havemeyer collection, New York; 1909 I. Morozov collection, Moscow (bought for 18,000 francs in P. Durand-Ruel's art shop where it was sent for sale by Mary Cassatt); 1919 Second Museum of Modern Western Painting, Moscow; 1923 Museum of Modern Western Art, Moscow; since 1930 The Hermitage, Leningrad

The dating and identification of the subject have been arrived at through a comparison with the landscape painting in the Pushkin Museum of Fine Arts in Moscow (see No. 92), reproduced by Ambroise Vollard in his book on Paul Cézanne under the title *Les Bords de la Marne* and dated 1888.

In 1888, Cézanne repeated this subject in a watercolour (V. 395), a painting (V. 629), and in a landscape not included in Venturi's catalogue (now in the White House, Washington).

92 THE BANKS OF THE MARNE
LES BORDS DE LA MARNE

Oil on canvas. 71×90 cm
Inv. No. 3416 V. 632

Provenance: A. Pellerin collection, Paris; A. Vollard Gallery, Paris; 1912 I. Morozov collection, Moscow; 1919 Second Museum of Modern Western Painting, Moscow; 1923 Museum of Modern Western Art, Moscow; since 1948 The Pushkin Museum of Fine Arts, Moscow

Cézanne frequently painted the scenery of the Marne. The locality depicted in this landscape is the subject of at least five of his works, such as *The Banks of the Marne* (*Villa on the Bank of a River*) of the same year (see No. 91), canvases in the Paris collections of Georges Lecomte (V. 632) and Goldschmidt-Rothschild (V. 629), and also a watercolour sketch (V. 395). In all likelihood, the same locality appears in *Bridge at Mennecy*, or *Little Bridge* (V. 396).
The Banks of the Marne, also known as *Bridge at Puteaux* (Burger), *Bridge at Créteil* (Venturi), *Île de France. Bridge over the Marne* (Huyghe) and *Bridge over the Marne at Créteil* (Barskaya), displays all variations of green; the trees on the bank— large dense patches of colour — are rendered in a systematic brushstroke, while the blue summer sky is painted quite thinly, with the canvas showing through. The red roof of the little cottage and the green grass on the bank provide the most intensive colour accents. There is no attempt to convey the light-and-air medium, and the tree-tops are clearly reflected in the water.
The Banks of the Marne, striking for its extraordinary balance in composition and in the distribution of colour patches, is justly considered one of Cézanne's finest landscapes. Vollard, Venturi, Barskaya, and other specialists date it, almost certainly rightly, 1888. Novotny and Bell, however, believe it to have been painted between 1893 and 1895, or in 1893.

93 GREAT PINE NEAR AIX
GRAND PIN PRÈS D'AIX

Oil on canvas. 72×91 cm
Inv. No. 8963 V. 458

Provenance: A. Vollard Gallery, Paris; 1908 I. Morozov collection, Moscow (acquired for 15,000 francs); 1919 Second Museum of Modern Western Painting, Moscow; 1923 Museum of Modern Western Art, Moscow; since 1948 The Hermitage, Leningrad

Depicted is a tall pine in the Arc River Valley, south of Aix. According to Venturi, the picture was painted in 1885—87, because Cézanne is known to have produced another canvas similar in title and motif (V. 459) precisely at that time. However, the two landscapes widely differ in the manner of execution. The one formerly in the Georges Lecomte collection

(V. 459) can with certainty be dated to the 1880s, while the Hermitage canvas, as Nina Yavorskaya justly believes, was done ten years later. This viewpoint is supported by the reddish-brown colour scheme of the picture, a scheme favoured by Cézanne in the mid-1890s.
The pine tree also appears in a watercolour (V. 1024) and a pencil drawing (V. 1794).

94 MOUNT SAINTE-VICTOIRE
LA MONTAGNE SAINTE-VICTOIRE

Oil on canvas. 78×99 cm
Inv. No. 8991 V. 663

Provenance: A. Vollard Gallery, Paris; 1907 I. Morozov collection, Moscow (purchased for 20,000 francs); 1919 Second Museum of Modern Western Painting, Moscow; 1923 Museum of Modern Western Art, Moscow; since 1948 The Hermitage, Leningrad

In Cézanne's late period, Mount Sainte-Victoire was one of his favourite subjects. Although in his search for integrity and monumentality of representation Cézanne used to generalize his landscapes, they were always based on the topography of a given place. This enabled John Rewald and Leo Marschutz to identify the spot from which the artist painted the Hermitage picture, which, in turn, prompted Rewald to date it 1896—98, whereas the dating suggested by Venturi was less precise (1894—1900).
The same landscape appears in another Cézanne picture (V. 666), dated by Rewald around 1900.

95 FLOWERS
FLEURS

Oil on canvas. 77×64 cm
Inv. No. 3411 V. 75

Provenance: A. Vollard Gallery, Paris; 1909 I. Morozov collection, Moscow; 1919 Second Museum of Modern Western Painting, Moscow; 1923 Museum of Modern Western Art, Moscow; since 1948 The Pushkin Museum of Fine Arts, Moscow

This is a free copy from Delacroix's *Flowers*, a watercolour of 1847 (see A. Robaut, E. Chesneau, *L'œuvre complet d'Eugène Delacroix—peintures, dessins, gravures, lithographies*, Paris, 1885, No. 1042). Bernard Dorival points out that about 1890 Cézanne painted a copy of Delacroix's *Bouquet* (1848—50), which has an interesting history. John Rewald (see J. Rewald, "Chocquet et Cézanne", *Gazette des Beaux-Arts*, July—August 1969) states that Delacroix insisted on the inclusion of this watercolour in the posthumous sale of his works, and it was entered there as lot 614 (its subsequent owners were Peyron, Chocquet, Vollard and Cézanne; now it is in the Louvre). Cézanne evidently saw the watercolour while it was still in the Chocquet collection and was so charmed by it that he made Vollard, who had bought it in the Chocquet sale, give it to him (*ibid.*, pp. 88, 89 and

96). In 1904, Emile Bernard saw it in a bedroom in Cézanne's house at Aix (*ibid.*, p. 89). Barskaya believes that *Flowers* is one of Cézanne's last copies of the Delacroix watercolour. Venturi dates it to approximately 1900; Michel Hoog, one of the authors of the exhibition catalogue *De Renoir à Matisse*, to about 1902.

Cézanne held Delacroix in very high esteem and hoped to paint a picture paying homage to the genius of this artist.

**96, 97 STILL LIFE WITH CURTAIN
NATURE MORTE AU RIDEAU**

Oil on canvas. 54.7×74 cm
Inv. No. 6514 V. 731

Provenance: A. Vollard Gallery, Paris; 1907 I. Morozov collection, Moscow (purchased for 17,000 francs); 1919 Second Museum of Modern Western Painting, Moscow; 1923 Museum of Modern Western Art, Moscow; since 1930 The Hermitage, Leningrad

As is the case with most of Cézanne's works, *Still Life with Curtain* can only be dated approximately. Venturi believes that it was painted around 1895; Nina Yavorskaya refers it to the 1890s. The most convincing dating is 1898—99, suggested by Lawrence Gowing on the evidence of Joachim Gasquet's statement that Cézanne worked on large still lifes in the autumn of 1899 in Paris. John Rewald indicates the date as ca. 1899 (see *Cézanne. Les dernières années (1895—1906)*, Paris, 1978, pp. 118—119). This is all the more probable as leaf-pattern curtains occur in a number of the artist's Paris pictures.

**98 LADY IN BLUE
DAME EN BLEU**

Oil on canvas. 88.5×72 cm
Inv. No. 8990 V. 705

Provenance: S. Shchukin collection, Moscow; 1918 First Museum of Modern Western Painting, Moscow; 1923 Museum of Modern Western Art, Moscow; since 1948 The Hermitage, Leningrad

At the end of his life Cézanne painted a number of portraits, the most characteristic feature of which is the strained pose of the model, either full or half-face, seated with the hands clasped in his or her lap. These features lend the image a certain monumentality in spite of the otherwise ordinary appearance and dress of the sitter. Among such portraits are *Lady in Blue* and *Lady with a Book* (V. 703), in which the women are wearing identical dresses. The similarity of these two canvases points to both being produced not later than 1899, during the artist's long stay in Paris. John Rewald put forward a view that a model named Marie-Louise sat for both portraits. Georges Rivière says that the same model posed twice in Cézanne's Paris studio, first for an oil painting (V. 710), then for a large watercolour (V. 1091). In his book

on Cézanne, Ambroise Vollard mentions that the artist was painting a nude model at the time when he worked on his, Vollard's, portrait. Vollard also recalls that Cézanne painted two portraits from this model. His statement is further supported by a facial resemblance between the models in the large watercolour and in *Lady in Blue*.

**99 MAN SMOKING A PIPE
L'HOMME À LA PIPE**

Oil on canvas. 91×72 cm
Inv. No. 3336 V. 688

Provenance: A. Vollard Gallery, Paris; S. Shchukin collection, Moscow; 1919 First Museum of Modern Western Painting, Moscow; 1923 Museum of Modern Western Art, Moscow; since 1948 The Pushkin Museum of Fine Arts, Moscow

There are several paintings and sketches by Cézanne portraying a smoker at a table (No. 86 and V. 684, 1087). *Man Smoking a Pipe* is done in Cézanne's typical later manner and is built upon a combination of warm browns and cold bluish tones. The picture is executed in small strokes or patches of paint, applied in places with a palette knife. All contours are clearly defined. On the wall at the right, part of another painting by Cézanne can be seen.

Boris Ternovetz and Nina Yavorskaya date the canvas around 1890. The majority of scholars suppose that it was painted in 1885—90 (Venturi, Barskaya). One of the authors of the catalogue of the 1978 exhibition in Paris, Michel Hoog, notes that the sitter appears as the right-hand figure in the painting *Cardplayers* (V. 558; see *De Renoir à Matisse. 22 chefs-d'œuvre des musées soviétiques et français*, Paris, 1978). Theodore Reff thinks that the picture seen on the wall at right is the *Portrait of Mme Cézanne* (V. 528; see *Cézanne. Les dernières années...*, Paris, 1978). Venturi believes that this may be a somewhat modified version of the *Portrait of Mme Cézanne* painted between 1885 and 1890 (V. 523).

**100 BLUE LANDSCAPE
PAYSAGE BLEU**

Oil on canvas. 102×83 cm
Inv. No. 8993 V. 793

Provenance: A. Vollard Gallery, Paris; 1912 I. Morozov collection, Moscow (purchased for 35,000 francs); 1918 Second Museum of Modern Western Painting, Moscow; 1923 Museum of Modern Western Art, Moscow; since 1948 The Hermitage, Leningrad

The *Blue Landscape* was evidently painted in 1904—1906, when the artist began to explore the fluid relationships between the elements of the picture, creating an extremely deep pictorial space.

Lawrence Gowing believes that the picture is a view of the Fontainebleau Forest and accordingly dates it 1905, the year when Cézanne worked in the suburbs

of Paris. However, it is now difficult to determine the degree of topographical accuracy in the picture. John Rewald notes, for example, that a similar spot can also be found in the vicinity of Aix. For this reason Rewald dates the Hermitage canvas to 1904—1906. It is possible that the rent in the centre of the canvas (with loss of the paint layer and primer), now restored, was the result of a blow that the artist gave his picture in a moment of exasperation, which was characteristic of him.

101 LANDSCAPE AT AIX (MOUNT SAINTE-VICTOIRE)
PAYSAGE D'AIX (LA MONTAGNE SAINTE-VICTOIRE)

Oil on canvas. 60×73 cm
Inv. No. 3339 V. 803

Provenance: A. Vollard Gallery, Paris; S. Shchukin collection, Moscow; 1918 First Museum of Modern Western Painting, Moscow; 1923 Museum of Modern Western Art, Moscow; since 1948 The Pushkin Museum of Fine Arts, Moscow

Landscape at Aix is executed in bright radiant colours, with almost square brushstrokes. The valley and the trees are painted thickly, while the mountain and the sky are light and translucent. The picture is dominated by the sonorous blue tones which Cézanne favoured towards the end of his life.

Landscape at Aix is usually dated 1905 (Venturi, Barskaya). In the beauty and perfection of its colour scale and composition, it can justly be ranked among Cézanne's finest views depicting Mount Sainte-Victoire. The landscape appears in the portrait of Cézanne painted by Maurice Denis at Aix in 1905, in which Cézanne is depicted with his son and the artist Xavier Roussel. Incidentally, this made Venturi believe that the Moscow canvas was done in 1905. On the back, on the stretcher, there used to be a label with the words: *Exposition 1905*, and underneath, on the right: *Vollard, 6, rue Laffitte*, added in blue pencil. John Rewald (see *Cézanne. Les dernières années...*, Paris, 1978) dates the canvas to 1905 or 1906, and Theodore Reff (*ibid.*, p. 242) thinks that the picture was produced between 1902 and 1906.

In the inventory of the Museum of Modern Western Art, Moscow, there is the following note: "In 1913, Henri Matisse, during his stay with S. Shchukin in Moscow, varnished this picture." The date 1913 is incorrect, for Matisse visited Moscow in 1911.

PAUL SIGNAC. 1863—1935

102 SPRING IN PROVENCE
PRINTEMPS EN PROVENCE

Oil on canvas, mounted on cardboard. 26.5×35 cm
Signed and dated, bottom right: *P. Signac. 03*
Inv. No. 3419

Provenance: 1906 I. Morozov collection, Moscow; 1919 Second Museum of Modern Western Painting, Moscow; 1923 Museum of Modern Western Art, Moscow; since 1948 The Pushkin Museum of Fine Arts, Moscow

The picture is also known as *A Cottage* and is close to *Almond Tree in Blossom* in the Mme Ginette Signac collection. Chartraine-Hebbelinck points out that the Moscow canvas, under the title *A Cottage at Saint-Tropez*, was included in the exhibition "Interprétation du Midi" in Brussels in 1913 (see M. J. Chartraine-Hebbelinck, "Les lettres de Paul Signac à Octave Maus", *Bulletin des Musées Royaux des Beaux-Arts de Belgique*, 1969, 1, 2, p. 95, pl. 20).

103 HARBOUR AT MARSEILLES
LA SORTIE DU PORT DE MARSEILLE

Oil on canvas. 46×55 cm
Signed, bottom left: *P Signac*
Inv. No. 6524

Provenance: 1907 I. Morozov collection, Moscow (bought at the Salon des Indépéndants for 500 francs); 1919 Second Museum of Modern Western Painting, Moscow; 1923 Museum of Modern Western Art, Moscow; since 1930 The Hermitage, Leningrad

Paul Signac, like the other Divisionists, used to paint landscapes not from life but from preliminary drawings, sketches and watercolours. In this way he painted his *Harbour at Marseilles*, repeating the compositional arrangement of a similarly entitled canvas of 1898 (Museum Kröller-Müller, Otterlo). The two works depict the same landscape — a building with a tower at left, and a sailing ship in the centre — and have the same measurements, 46 by 55 cm. The similarity of subject and composition points to both pieces being painted on the basis of the same preliminary studies. However, in their treatment of colour, with an emphasis on the spatial effect in the Otterlo canvas and on the flat decorative quality in the Hermitage work, they differ widely from one another, relating to different stages of the artist's career. Françoise Cachin, his granddaughter, believes that the Hermitage picture was painted in 1906, when the artist returned to the Marseilles Harbour theme.

104 SANDY SEASHORE
BORD SABLONNEUX DE LA MER

Oil on canvas. 65×81 cm
Signed and dated, bottom left: *P. Signac 90*; inscribed, bottom right: *Op. 212*
On the back of the canvas there are two oil sketches by the author and the seal of the Tasset et Lhote firm.
Inv. No. 3342

Provenance: 1891 A. Verlaine collection, Moscow; 1891 S. Shchukin collection, Moscow; 1918 First Museum of Modern Western Painting, Moscow; 1923 Museum of Modern Western Art, Moscow; since 1948 The Pushkin Museum of Fine Arts, Moscow

In the early 1890s, Signac produced two series of four paintings each, *La Mer* and *Le Fleuve*. The Moscow canvas belongs to the first series, and at different times was known under different titles. Thus, the compilers of the catalogue of Signac's centenary exhibition in the Louvre (1963) refer to the artist's diaries where it is mentioned as *Le Port-Hue* (*Paul Signac. Catalogue*, Paris, 1963/64, p. 41). At the Exposition des "XX" in Brussels in 1891 and at the Exposition des Artistes Indépendants in the same year it figured as *Op. 212, Saint-Briac (Ille-et-Vilaine) août 1890*.

The picture shows the bay of Saint-Briac, surrounded by sandy hills. It is numbered (*Op. 212*), which is typical of Signac's paintings of those years. The work is done in the early Pointillist technique. Signac paid great attention to the rhythmical organization of the canvas, comparing it to a musical composition.

105 THE PINE TREE AT SAINT-TROPEZ
LE PIN, SAINT-TROPEZ

Oil on canvas. 72×92 cm
Signed and dated in green paint, bottom right: *P. Signac 1909*
Inv. No. 3341

Provenance: 1913 S. Shchukin collection, Moscow; 1918 First Museum of Modern Western Painting, Moscow; 1923 Museum of Modern Western Art, Moscow; since 1948 The Pushkin Museum of Fine Arts, Moscow

In 1907—1909, Signac treated this motif quite frequently. We know of a 1907 landscape, *The Bay* (*Pin parasol aux caroubiers*, Musée de l'Annonciade, Saint-Tropez), which is somewhat different from the Moscow picture. There are two sketches in pencil and watercolour for the latter, entitled *Le Pin Bertaud* (private collection, Paris).

HENRI EDMOND CROSS (DELACROIX). 1856—1910

106 AROUND MY HOUSE
PAYSAGE. AUTOUR DE MA MAISON

Oil on canvas. 61×79 cm
Signed, bottom right: *Henri Edmond Cross*
Inv. No. 3384 Compin 150
Provenance: Bernheim-Jeune Gallery, Paris; 1907 I. Morozov collection, Moscow (bought from the Cross exhibition at the Bernheim-Jeune Gallery); 1919 Second Museum of Modern Western Painting, Moscow; 1923 Museum of Modern Western Art, Moscow; since 1948 The Pushkin Museum of Fine Arts, Moscow

This is a typical example of Divisionism, the style Cross adopted under Signac's influence in 1891. Although the artist depicts a concrete tree against a background of mountains, the concern to record specific objects in this picture seems secondary to a desire to evoke poetic mood through colour harmony.

Worthy of note is the title under which the picture was displayed at the exhibition in the Bernheim-Jeune Gallery. For a long time it was literally — and erroneously — translated into Russian. "Autour de ma maison" does not at all denote the topography of the given scenery. Emile Verhaeren's *La Multiple splendeur*, a collection of poems published in 1906, i.e. a year before the Cross exhibition at Bernheim-Jeune's, includes a poem of this name, in which the poet describes the feelings evoked in him by the iridescent colours of his garden on a hot summer day. The Moscow work was apparently inspired by that poem, especially as Verhaeren was an intimate friend of Cross and other Neo-Impressionists and propagated their art in the Brussels journal *L'Art moderne*. The date of the poem and the fact that the landscape *Around My House* was on show at the 1907 exhibition help to ascertain the time of its execution as the summer of 1906 or of 1907. In all likelihood, it was painted in the artist's garden at Saint-Tropez.

107 VIEW OF SANTA MARIA DEGLI ANGELI NEAR ASSISI
L'ÉGLISE SANTA MARIA DEGLI ANGELI, PRES D'ASSISE

Oil on canvas. 74×92 cm
Signed and dated, bottom right: *Henri Edmond Cross 09*
Inv. No. 8891 Compin 221
Provenance: Bernheim-Jeune Gallery, Paris; S. Shchukin collection, Moscow; 1918 First Museum of Modern Western Painting, Moscow; 1923 Museum of Modern Western Art, Moscow; since 1948 The Hermitage, Leningrad

View of Santa Maria degli Angeli was painted in 1909, apparently from crayon sketches done at Assisi in 1908. The Hermitage canvas, one of the six pictures with views of Perugia and Assisi, is characteristic of the decorative style of Cross's late period.

VINCENT VAN GOGH. 1853—1890

108 SEASCAPE AT SAINTES-MARIES. VIEW OF THE MEDITERRANEAN
LA MER AUX SAINTES-MARIES

Oil on canvas. 44×53 cm
Signed, bottom right: *Vincent*
Inv. No. 3438 F. 417
Provenance: M. Morozov collection, Moscow; 1910 The Tretyakov Gallery, Moscow (gift of Morozov's widow); 1925 Museum of Modern Western Art, Moscow; since 1948 The Pushkin Museum of Fine Arts, Moscow

The picture was executed in June 1888 at the church-fortress Saintes-Maries-de-la-Mer on the Mediterranean, where Van Gogh came from Arles and stayed for eight days. There he painted several marine views (F. 415, 418) and did a number of pencil and reed-

pen drawings, of which *Sailboats Approaching the Shore* (F. 1430b) most closely resembles the picture from the Pushkin Museum, known also as *View of the Mediterranean.*

This was the time when Van Gogh took a keen interest in Japanese prints, particularly those of Hokusai. By means of vigorous, nervous dabs of paint pressed directly out of the tube, he paints the claw-like waves clutching the small boats which try to break through to the shore. His aim was not to record a particular state of nature or render a particular colour of the light-and-air medium, as was usually the case with the Impressionists, but to express his personal emotions.

109, 110 THE RED VINEYARD AT ARLES
LES VIGNES ROUGES D'ARLES

Oil on canvas. 73×91 cm
Inv. No. 3372 F. 495

Provenance: Tanguy collection, Paris; 1890 A. Boch collection, Brussels (bought from the Exposition des "XX" in Brussels for 400 francs); 1906/7 Prince de Wagram collection, Paris; E. Druet Gallery, Paris; 1909 I. Morozov collection, Moscow; 1919 Second Museum of Modern Western Painting, Moscow; 1923 Museum of Modern Western Art, Moscow; since 1948 The Pushkin Museum of Fine Arts, Moscow

According to information derived from a letter written by Van Gogh to his brother, Theo, he painted this picture at Arles in November 1888 (see *Verzamelde Brieven van Vincent Van Gogh*, 4 vols., Amsterdam, Antwerpen, 1952—54, 559, 561 [1]). The motif of grape-harvest under the all-melting Arlesian sun so strongly excited the artist that in October he painted *The Green Vineyard at Arles* (F. 475), and in November did the Moscow canvas, in which this theme found its most articulate expression. Compared to a number of works of the Arles period painted under Gauguin's influence and bearing the stamp of Divisionism, the Moscow picture is executed in a manner recalling that of Van Gogh's landscapes produced upon his arrival at Arles. *The Red Vineyard* is done in feverish brush-strokes so intensive in colouring that they seem to be a direct emanation on canvas of Van Gogh's emotional state, of that creative ardour which gripped the artist in the south of France.

Van Gogh was satisfied with this canvas and later sent it, with five other paintings, to the Exposition des "XX" which was held in Brussels in the early winter of 1890. It was at this exhibition that his works first received great critical acclaim. The Moscow canvas was the first to be sold in Van Gogh's lifetime.

111 LA MOUSMÉ (PORTRAIT OF A YOUNG GIRL)

Indian ink, pen, reed pen, and pencil on paper. 33×25 cm

Inscribed by the artist along the right-hand edge: *fond blanc teinté fortement de véronèse chairs gris jaune cheveux sourcils noirs yeux bruns jaquette rayée rouge sang & violet jupe fond bleu de roi gros pointillé orange jaune branche de laurier rose dans la main ruban vermillon dans les cheveux*
Inv. No. 10555 F. 1504

Provenance: E. Druet Gallery, Paris; N. Drouot collection, Paris (?); 1918 Museum of Fine Arts, Moscow; 1923 Museum of Modern Western Art, Moscow; since 1948 The Pushkin Museum of Fine Arts, Moscow

In his letters to his brother Theo (514) and Emile Bernard (see Vincent Van Gogh, *Lettres à Emile Bernard*, Paris, 1911, 12 [2]) the artist describes his picture of a *mousmé*, a Japanese teenage girl from a tea-house, whom he painted from a twelve-year-old Arlésienne named Adeline Ravoux (F. 431). Van Gogh took up this theme after reading Pierre Loti's book *Madame Chrysanthème*. The Moscow drawing may have been done for one of the dealers (Emile Bernard?) with whom Van Gogh corresponded at the time, in order to give him an idea of a newly completed picture. The meticulously detailed indications of colour in the artist's inscription apparently serve the same purpose.

There are two more drawings of the same model (F. 1503, 1722).

112 THE ARENA AT ARLES
LES ARÈNES D'ARLES

Oil on canvas. 72×92 cm
Inv. No. 6529 F. 548

Provenance: 1905 S. Shchukin collection, Moscow; 1918 First Museum of Modern Western Painting, Moscow; 1923 Museum of Modern Western Art, Moscow; since 1931 The Hermitage, Leningrad

The picture was painted in October—November 1888, as follows from the description of the bullfight which Van Gogh had seen in April of the same year (B. 3). A fully accomplished and highly original artist, Van Gogh nevertheless responded to the experiments of his friends, Gauguin and Bernard, and under their influence painted some pictures from memory rather than from life; among them were *The Dancing Hall at Folies-Arlésiennes* (F. 547) and *The Arena at Arles* (F. 548). These works show a clear debt to the Divisionism of the Pont-Aven school.

Following Gauguin, Van Gogh chose for this painting a coarse jute canvas which absorbs the oils and gives the picture a matt surface. Japanese prints, with their outstanding graphic qualities (of which Van Gogh was an ardent admirer), also must have been at the back of his mind when he painted this picture.

[1] Further on only the number of the letter will be given.

[2] In further references to this edition, the number of the letter is preceded by a B. (for Bernard), thus: B. 12.

113 LADIES OF ARLES (REMINISCENCE OF THE GARDEN AT ETTEN)
FEMMES D'ARLES (SOUVENIR DU JARDIN À ETTEN)

Oil on canvas. 73.5×92.5 cm
Inv. No. 9116 F. 496

Provenance: Julien Leclercq collection, Paris (?) (according to an inscription on the back: *Leclercq*); A. Schuffenecker collection, Paris; S. Shchukin collection, Moscow; 1918 First Museum of Modern Western Painting, Moscow; 1923 Museum of Modern Western Art, Moscow; since 1948 The Hermitage, Leningrad

This canvas, also known as *Women with Flowers* and *Promenade at Arles*, was executed at Arles in November 1888, when Van Gogh tried to rely on his memory and imagination rather than on direct observation of nature.

In November, Gauguin and Van Gogh worked on the subject of a promenade in a garden. Gauguin painted his picture *In the Garden of Arles* (W. G. 300), in which he portrayed a group of women wrapped in dark overcoats, walking in couples along the path of an autumn garden. Van Gogh, on his part, painted *Ladies of Arles* reflecting his impressions of the scenery of Provence and his recollections of the Dutch garden at his father's house at Etten, where he spent the summer of 1881. Incidentally, again under Gauguin's influence, he used a coarse jute canvas for the picture. Characteristically, Van Gogh told his brother Theo and sister Wilhelmine about his work on the picture. Enclosed in the letter to Theo (562) was a detailed drawing of the composition. However, whereas in the drawing the young woman's hair is combed to resemble the Japanese coiffure and she wears a plaid with a chequered pattern over her shoulders, in the painting her hair is dressed in the European style of the 1880s and the plaid is replaced by a shawl studded with multi-coloured dots, which introduces a note of disquiet. These differences between the drawing and the painting attest to the fact that at the time of writing the letter the image of the young woman had not yet crystallized in the artist's mind, while all the other elements of the composition had acquired their final form.

M. E. Tralbout, a noted authority on Van Gogh's work, states quite correctly that in the young woman's image Van Gogh fused together the facial features of three characters: his sister Wilhelmine (1888, F. 489), Mme Ginoux (1888, F. 488), and Kee Vos-Stricker, the artist's cousin. Van Gogh became friendly with Kee Vos-Stricker during his stay at Etten in 1881; he even asked for her hand but was not accepted. As a matter of fact, the features of the young woman show a certain resemblance to a photograph of Kee.

For the image of the old lady, Van Gogh used the portrait of his mother, painted from a photograph in October 1888 (F. 477).

114 LILAC BUSH
LE BUISSON DE LILAS

Oil on canvas. 72×92 cm
Signed, bottom left: *Vincent*
Inv. No. 6511 F. 597

Provenance: Julien Leclercq collection, Paris (?) (according to an inscription on the back: *Leclercq*); S. Shchukin collection, Moscow; 1918 First Museum of Modern Western Painting, Moscow; 1923 Museum of Modern Western Art, Moscow; since 1931 The Hermitage, Leningrad

In the La Faille catalogue of 1970, *Lilac Bush* is erroneously ascribed to the Arles period and dated August 1888 on the evidence of Van Gogh's letter to his brother Theo (524). In it, the artist mentions some studies "...which didn't come off in the least and remained unfinished, above all one big landscape with brushwood". It is hardly possible that Van Gogh would have thought so of his *Lilac Bush* on which he put his signature, something he did rarely enough. Antonina Izerghina, who suggested a new dating for this picture, believes that it was done in Saint-Rémy, on the very first days of the artist's stay in the Saint-Paul-de-Mausole asylum. She also substantiates her dating by Van Gogh's letter to his brother Theo (591): "I am working on two new subjects which I came across here in the garden — purple irises and a lilac bush."

The painting *Irises* (F. 608) is in a private collection in New York, and the one with the lilac bush is undoubtedly the Hermitage picture.

115 PORTRAIT OF DR. REY
PORTRAIT DU DOCTEUR REY

Oil on canvas. 64×53 cm
Signed and dated, bottom right: *Vincent Arles 89*
Inv. No. 3272 F. 500

Provenance: In the possession of Dr. Rey, Arles; 1900 A. Vollard Gallery, Paris; P. Cassirer Gallery, Berlin; 1908 E. Druet Gallery, Paris; 1908 S. Shchukin collection, Moscow; 1918 First Museum of Modern Western Painting, Moscow; 1923 Museum of Modern Western Art, Moscow; since 1948 The Pushkin Museum of Fine Arts, Moscow

Dr. Félix Rey was an interne at the Arles hospital where Van Gogh was confined after his first nervous breakdown, when he had cut off his ear. Resuming work in 1889, Van Gogh painted this portrait and presented it to Dr. Rey for whom he had the deepest respect. The doctor believed at the time that the portrait was a bad likeness, and did not think much of it. His colleagues, however, found that with the passage of time the doctor came to look more like his representation.

The Arles period proved to be crucial to the development of the artist's style. Van Gogh abandoned the small and calm brushstrokes of the Impressionists,

impastos which echoed Monticelli's works, and Divisionist meticulous flecks of paint, in favour of a new style based on a synthesis of painting and drawing, with the former borrowing from the latter its linear quality and flat planes. This eventually led to the creation of a new, almost *lubok*-like technique [1] that was radically different from the Impressionist one. During this period Van Gogh drew inspiration from painting portraits. *The Portrait of Dr. Rey* possesses all the salient features of Van Gogh's style: the impulsive strokes modelling the doctor's jacket and hair; the vigorous succulent lines contouring his figure and giving it a special expressiveness; and the background decorated with intricate patterns which also serve to bring to light the essence of the model's character.

116 LANDSCAPE AT AUVERS AFTER THE RAIN.
FIELDS SEEN FROM A HEIGHT
PAYSAGE D'AUVERS APRÈS LA PLUIE

Oil on canvas. 72×90 cm
Inv. No. 3374 F. 760
Provenance: Van Gogh—Bönger collection, Amsterdam; Bernheim-Jeune Gallery, Paris; 1909 E. Druet Gallery, Paris; 1909 I. Morozov collection, Moscow (bought from E. Druet); 1919 Second Museum of Modern Western Painting, Moscow; 1923 Museum of Modern Western Art, Moscow; since 1948 The Pushkin Museum of Fine Arts, Moscow
The picture was painted at Auvers in June—July 1890 (in one of Van Gogh's letters it is mentioned as *Fields Seen from a Height*), shortly before the artist's death. During the last two months of his life Van Gogh produced a number of landscapes showing the fields at Auvers. There exist two landscapes on the same motif, close in composition to the Moscow canvas (F. 781, 782). Yet only in the Moscow picture the fields are interrupted by the horizontal of a rain-washed road with a moving carriage and with cottages standing by the roadside. The composition of the landscape echoes Cézanne — it is constructed vertically and all its elements are presented frontally. A narrow strip of the sky reflected in the pools of the foreground seems to topple over the fields in the same way as the sun in the *Red Vineyard*. But whereas in this latter painting one is dazzled by the red-hot sun, *Landscape at Auvers*, done in transparent colours which give the canvas luminosity, seems to be flooded with evenly diffused light.

117 THE CONVICT PRISON
LA RONDE DES PRISONNIERS

Oil on canvas. 80×64 cm
Inv. No. 3373 F. 669
Provenance: Van Gogh—Bönger collection, Amster-

[1] *Lubok* was the Russian name for engraved or hand-drawn sheets done by self-taught artists, which were in circulation among the ordinary people and were notable for their simplified artistic form and style.

dam; Slavona collection, Paris; M. Fabre collection, Paris; 1906 E. Druet Gallery, Paris; 1909 Prince de Wagram collection, Paris; 1909 E. Druet Gallery, Paris; 1909 I. Morozov collection, Moscow (bought from E. Druet); 1919 Second Museum of Modern Western Painting, Moscow; 1923 Museum of Modern Western Art, Moscow; since 1948 The Pushkin Museum of Fine Arts, Moscow
While staying in the asylum at Saint-Rémy, Van Gogh made a number of oil copies of well-known paintings and engravings reproduced in the books which his brother Theo had sent to him. *The Convict Prison*, painted in February 1890, is a free copy of Gustave Doré's drawing engraved by N. J. Pisan for the book *London, a Pilgrimage by Gustave Doré and Blanchard Jerrold* (London, 1872, p. 136; 2nd French edition: Paris, 1876, p. 294).
Having preserved the compositional arrangement of Doré's drawing, Van Gogh nevertheless put more emphasis upon the expressiveness of the scene. An illustration of daily life in a London prison has been thus turned into a generalized image of human despair. The message is implied by the deep well of the prison courtyard and by the endless circular movement of the prisoners. In one of them, depicted in the foreground, with a bare head and hands tucked into his pockets, one can recognize the artist. The stay at the Saint-Rémy asylum evoked in Van Gogh reminiscences of Dostoyevsky's *Letters from the Dead House* that he had once read. An engraving of Doré's drawing which he came across by chance prompted Van Gogh to give a personal interpretation to this theme.

118 COTTAGES
LES CHAUMIÈRES

Oil on canvas. 60×73 cm
Inv. No. 9117 F. 750
Provenance: 1908 I. Morozov collection, Moscow (bought through the agency of E. Druet at a sale in the Hôtel Drouot in Paris for 5,685 francs on 16 May); 1919 Second Museum of Modern Western Painting, Moscow; 1923 Museum of Modern Western Art, Moscow; since 1948 The Hermitage, Leningrad
The title *Cottages* was first mentioned in the 1908 catalogue of the sale of modern paintings at the Hôtel Drouot. W. Scherjon and J. de Gruyter, taking into account Van Gogh's letter of 21 May 1890 to his brother Theo, suggested the title *Old Thatched Roofs*. Van Gogh wrote: "Now I have one study of old thatched roofs, with in the foreground a field of flowering peas and corn, at the back a hill..." (636). The Hermitage canvas was thus executed at the beginning of the artist's stay at Auvers.
As La Faille points out, Van Gogh's drawing *Sylvan Landscape with Houses* (F. 1640) depicts the same motif, although it differs from the Hermitage canvas in the luxuriant greenery surrounding the cottages.

PAUL GAUGUIN. 1848—1903

119 CAFÉ AT ARLES
AU CAFÉ

Oil on canvas. 72×92 cm
Signed and dated twice — on the table, bottom right, and on the billiard, bottom right: *P Gauguin 88*
Inv. No. 3367 W. G. 305
Provenance: A. Vollard Gallery, Paris; 1908 I. Morozov collection, Moscow (bought from A. Vollard); 1919 Second Museum of Modern Western Painting, Moscow; 1923 Museum of Modern Western Art, Moscow; since 1948 The Pushkin Museum of Fine Arts, Moscow

The picture was painted while Gauguin was staying with Van Gogh at Arles in November 1888. It depicts the interior of the Café de la Gare owned by J. Ginoux. The same motif was used by Van Gogh in his famous painting *The Night* (F. 463), in the foreground of which we see Mme Ginoux, wife of the café owner, who also sat for two portraits by Van Gogh (F. 488, 489). Both artists, Gauguin and Van Gogh, painted Mme Ginoux at the same time. At an hour's sitting Van Gogh did an oil portrait, while Gauguin made a drawing of her (T. E. Hanley collection, Bradford, Pa.). In a letter to Emile Bernard, Van Gogh wrote: "At the present moment Gauguin is working on a canvas with the same night café I have painted, but with figures we've seen in brothels" (B. 19a). A full description of that portrait may be found in Gauguin's letter to Bernard (see A. Meyerson, "Van Gogh and the School of Pont-Aven", *Konsthistorisk Tidskrift*, årgang XV, 1946, p. 144). Enclosed in this letter were some sketches of the future painting.

In the bearded man sitting at the table at left and wearing a casquette, one can easily recognize the postman Roulin, while the extreme left figure, cut by the frame, is undoubtedly the Zouave Milliet. Both men were the subjects of the well-known portraits by Van Gogh. Beside the postman are three prostitutes and on his left is the sleeping Bichart.

Although Van Gogh's influence is traceable in the choice of characters and in the use of local colours, this painting represents a vivid example of the synthetic style based on the interaction of colour and line: the contrasting, evenly painted zones of colour are outlined by curving arabesques.

In Gauguin's Arles sketchbook, there are several drawings of a woman resembling Mme Ginoux (R. Huyghe, *Carnet de Gauguin*, Paris, 1952, p. 19). A woman looking like her also appears in the foreground of Gauguin's picture *In the Garden of Arles* (W. G. 300) and in the zincograph *The Spinster* (Guérin 11).

120 FRUIT
NATURE MORTE AUX FRUITS

Oil on canvas. 43×58 cm
Inscribed, signed, and dated, bottom right: *A mon ami Laval P Go 88*

Inv. No. 3271 W. G. 288
Provenance: Charles Laval collection, Paris; E. Druet Gallery, Paris; S. Shchukin collection, Moscow; 1918 First Museum of Modern Western Painting, Moscow; 1923 Museum of Modern Western Art, Moscow; since 1948 The Pushkin Museum of Fine Arts, Moscow

The picture was painted in Brittany after Gauguin's return from the island of Martinique where he lived from April through December 1887. Gauguin presented the picture to his friend Charles Laval who had accompanied him to the island.

The figure in the upper left-hand corner is identical with the poor woman in *Vine Gatherers at Arles*, done in the same year (W. G. 304). This tragic personage appears in many of Gauguin's works, for example in a picture of 1894, *Village Drama* (W. G. 523). The presence of this figure in the Moscow still life creates a sense of mystery and anxiety, a sense enhanced by an unexpected cut of the composition by the frame. The enigmatic meaning of this seemingly commonplace still life speaks of Gauguin's symbolist leanings. The well-balanced distribution of forms and colour patches on the canvas's surface points to the artist's familiarity with Japanese prints and Art Nouveau painting.

The still life *Fruit*, just as *Still Life with a Whelp* (W. G. 293), anticipated the emergence of the so-called Synthetic style.

121 SELF-PORTRAIT
AUTOPORTRAIT

Oil on canvas. 46×38 cm
Signed, bottom left: *P Go*
Inv. No. 3264 W. G. 297
Provenance: G. Fayet Gallery, Paris; S. Shchukin collection, Moscow; 1918 First Museum of Modern Western Painting, Moscow; 1923 Museum of Modern Western Art, Moscow; since 1948 The Pushkin Museum of Fine Arts, Moscow

In this work Gauguin portrayed himself against the background of a window with a hardly discernible landscape which can be taken for a Tahitian one. To the left of his head is a bright yellow band, probably the frame of the window; to the right, beyond the window, the vague outline of a pink cottage (?) and a large red leaf. The saturated colour scale dominated by greens and ochre-yellows, as well as characteristic features of the Tahitian scenery, indicate that Gauguin executed this portrait in Tahiti, although Wildenstein, Rewald, Sterling and Douglas Cooper date it to 1888—90 and assign it to the artist's Breton period. In addition, the portrait is painted on a coarse sackcloth frequently used by Gauguin in Tahiti during the 1890s and quite identical to the one depicting *The Idol* (No. 140), an undisputable Tahitian picture done in 1898. It should be noted that by now the

paint layer of the portrait has become duller and the contours of the objects are rubbed, which makes it difficult to discern the details of the background. The changes in the paint layer have been caused by the decomposition of the upper coating film with wax as one of its ingredients.

In April 1903, Gauguin sent three paintings, including the present one, to his friend Daniel de Monfreid in Paris. He could hardly have taken a self-portrait of the Breton period with him on his travels. In this portrait Gauguin looks older and worn out. Its colour scale also suggests the idea that it was done during the artist's second stay in Tahiti, i.e. after 1895.

122 LANDSCAPE WITH PEACOCKS
PAYSAGE AUX PAONS

Oil on canvas. 115×86 cm
Inscribed, signed and dated, bottom right: *MATA-MOE P. Gauguin 92*
Inv. No. 3369 W. G. 484
Provenance: A. Vollard Gallery, Paris; 1907 I. Morozov collection, Moscow; 1919 Second Museum of Modern Western Painting, Moscow; 1923 Museum of Modern Western Art, Moscow; since 1948 The Pushkin Museum of Fine Arts, Moscow

Due to Gauguin's wrong Tahitian spelling, the title of the canvas was translated as 'Mort', 'Autrefois' and 'Etrangers'. But at the 1893 exhibition in the Durand-Ruel Gallery this picture was catalogued as *Mort*, a title supplied by the artist. Bengt Danielsson thinks that an excerpt from Gauguin's MS of *Noa Noa* may shed some light on the origin of this title. In this excerpt Gauguin described a scene when he, together with a Maori, hacked down a tree and destroyed it, imagining that he had "destroyed all the vestiges of civilized man" in him.

The figure of a Tahitian youth with the axe appears in another Gauguin painting (W. G. 430); it is borrowed from a frieze of the Parthenon — the artist had with him in Tahiti a set of photographs of the Parthenon friezes.

123 THE BIG TREE (AT THE FOOT OF A MOUNTAIN)
LE GRAND ARBRE (ADOSSÉ À LA MONTAGNE)

Oil on canvas. 67×91 cm
Inscribed, signed, and dated, bottom right: *Fatata te Mouà P Gauguin 92*
Inv. No. 8977 W. G. 481
Provenance: A. Vollard Gallery, Paris; 1908 I. Morozov collection, Moscow (bought for 800 francs); 1919 Second Museum of Modern Western Painting, Moscow; 1923 Museum of Modern Western Art, Moscow; since 1948 The Hermitage, Leningrad

At present, the canvas has two titles. One, *At the Foot of a Mountain*, was supplied by the artist; under the other, *The Big Tree*, the picture was known among Russian collectors. As Bengt Danielsson points out, it was painted in the village of Mataiea, on the southern coast of Tahiti, where Gauguin lived from the end of 1891 until the middle of 1893. During this period the motif of a big tree figured prominently in Gauguin's work; it occurs in a number of his canvases, sometimes as the main component of a landscape (W. G. 482), sometimes seen in the distance (1892, W. G. 467). Repeatedly depicted against this tree is the Moon Goddess Hina, e.g. in an oil painting (1893, W. G. 500), in a watercolour on sheet 59, part of the Paris MS of *Noa Noa*, and on a xylograph (Guérin 23, 24). It is symptomatic that upon his return to France in 1894 Gauguin painted his *Sacred Spring*, in which he once again depicted a large tree on the horizon (No. 132).

124 THE FLOWERS OF FRANCE
LES FLEURS DE FRANCE

Oil on canvas. 72×92 cm
Signed and dated, bottom left: *P. Gauguin 91*
Inscribed on the table, bottom right: *TE TIARE FARANI*
Inv. No. 3370 W. G. 426
Provenance: A. Vollard Gallery, Paris; I. Morozov collection, Moscow; 1919 Second Museum of Modern Western Painting, Moscow; 1923 Museum of Modern Western Art, Moscow; since 1948 The Pushkin Museum of Fine Arts, Moscow

The picture was painted during the first year of the artist's stay in Tahiti, and is permeated by a nostalgic feeling for the abandoned homeland. Hence the odd contrast between the full-blooded still life with the blossoming branches of the rose laurel and the sad facial expression of the islander wearing a hat. The treatment of the still life — a tabletop with a pitcher of large flowers — betrays the influence of Cézanne's lessons. The compositional structure of the picture and the arrangement of the figures, cut by the frame, reveal a debt to the traditions of Edouard Manet and Degas.

In Gauguin's notebooks there is a sketch for the figure of the young islander in a hat (see B. Dorival, *Paul Gauguin. Carnet de Tahiti*, Paris, 1954, f. 28v).
The Flowers of France was shown at the exhibition at Durand-Ruel's in 1893. Later the artist sent it to the Hôtel Drouot, where the sale of his pictures was held on 18 February 1895, shortly before his last departure for Tahiti. It is one of Gauguin's earliest works to bear a Tahitian inscription — the actual title of the canvas revealing its message. The device was later to become the artist's favourite. *Te Tiare Farani* is literally translated as 'the flowers of France' (see L.-J. Bouye, "Traduction et interprétation des titres en langue tahitienne inscrits sur les œuvres océaniennes de Paul Gauguin", *Gazette des Beaux-Arts*, 1956, p. 164).

125 HER NAME IS VAÏRAUMATI
ELLE S'APPELAIT VAÏRAUMATI

Oil on canvas. 91×68 cm
Signed and dated, bottom left: *Paul Gauguin 92 Tahiti*
Inscribed on the yellow leaf, bottom centre: *Vaïraumati têi oa*
Inv. No. 3266 W. G. 450

Provenance: 1895 Sale of Gauguin's pictures at the Hôtel Drouot, Paris (remained with the artist's family); S. Shchukin collection, Moscow; 1918 First Museum of Modern Western Painting, Moscow; 1923 Museum of Modern Western Art, Moscow; since 1948 The Pushkin Museum of Fine Arts, Moscow

The picture was painted during Gauguin's first Tahitian period, when the artist fell under the spell of old Maori legends. He relates the legend of the God Horo and the beautiful Vaïraumati in his book *Noa Noa* (Paul Gauguin, *Noa Noa*, Paris, 1924, pp. 127—129). While providing an illustration for this legend, the picture is filled with a new meaning.

Vaïraumati is sitting on a couch before a table laden with fruit. Beside her, enchanted by her beauty, stands Horo who has descended from Heaven. This scene is presented against a Tahitian landscape, with an ancient stone sculpture in the background. The ancient artist recreated there an episode from the same legend of Horo and Vaïraumati, which thus figures in the picture twice — the scene in the foreground appears to be a modern interpretation of this myth. Gauguin has depicted Vaïraumati in the guise of a contemporary Tahitian girl, as evidenced by the smoking cigarette which she holds in her hand. In his preface to *Noa Noa* (Paul Gauguin, *op. cit.*, p. 20), Charles Morice noted Gauguin's tendency to endow Tahitian *vahines* with divine qualities. To make his model look like a goddess, Gauguin depicted her in the pose of a priestess from an Egyptian frieze kept in the British Museum, the photograph of which he had brought to Tahiti. In the same year that frieze inspired him to paint *Te Matete* (W. G. 476), in which several female figures are shown in the pose of Vaïraumati. Another source which Gauguin used for his *Vaïraumati* was Puvis de Chavannes's well-known canvas *Hope* (Musée de l'Impressionnisme, Paris); in it, a nude is sitting on a bed of flowers in a spring landscape, holding a budding flower in her hand.

There exists another version of the Moscow canvas, showing Vaïraumati but without Horo or the Tahitian idol in the background. In that picture, entitled *Te Aa No Areois* (*The Origin of Areois*), the woman holds a budding flower in her left hand—the symbol of the clan's origin (W. G. 451). On the evidence of John Rewald, the model for this version was Tehura, Gauguin's first Tahitian wife. The same model is apparently depicted in the Moscow picture.

The Tahitian sculpture with Vaïraumati and Horo

also occurs in the background of *Sacred Spring*, or *Nave Nave Moe* (No. 132). Painted during Gauguin's stay in France in 1894, this picture is in fact the summing-up of his Tahitian impressions by means of symbolic images borrowed from his earlier Tahitian canvases. It is important to note that among these images we find some characters and details from the two works of 1892 in the Moscow Museum, namely *Are You Jealous?* (see No. 126) and the present picture. The main elements of these canvases, together with the big tree from the Hermitage painting (see No. 123) which, incidentally, can also be seen in the background of *Sacred Spring*, appear as the key components of Gauguin's vision of Noa Noa, the "promised land".

126 ARE YOU JEALOUS?
QUOI? TU ES JALOUSE?

Oil on canvas. 66×89 cm
Signed and dated on the red cloth, bottom centre: *P. Gauguin 92*
Inscribed, bottom left: *Aha oe feii?*
Inv. No. 3269 W. G. 461

Provenance: P. Durand-Ruel Gallery, Paris; Leclanché collection, Paris (bought in the sale of Gauguin's pictures at the Hôtel Drouot); 1908 S. Shchukin collection, Moscow; 1918 First Museum of Modern Western Painting, Moscow; 1923 Museum of Modern Western Art, Moscow; since 1948 The Pushkin Museum of Fine Arts, Moscow

Gauguin painted this picture in 1892, during his first Tahitian period. It shows a scene from Tahitian life which Gauguin described in the opening pages of his book *Noa Noa*: "On the shore, two sisters are lying after bathing, in the graceful poses of resting animals; they speak of yesterday's love and the morrow's victories. The recollection causes them to quarrel: 'What? Are you jealous?' " (see Paul Gauguin, *Noa Noa*, Paris, 1924, p. 13). To illustrate this episode, Gauguin produced a woodcut (Guérin 35) which shows the left-hand figure with a wreath of white flowers, and also a monotype and a watercolour (Rewald 39, 63), in which the characters are depicted in reverse.

An ordinary scene on a river bank was transformed by Gauguin's brush into a full-blooded image of exotic Tahitian landscape, a sign of another reality. The artist was satisfied with this canvas and thought it significant (see *Lettres de Gauguin à Daniel de Monfreid*, Paris, 1950, p. 59). On 8 December 1892, he sent it with several other pictures to Paris, for an exhibition in Copenhagen, asking not to sell the canvas for less than 800 francs (see *Lettres de Gauguin à sa femme et à ses amis*, Paris, 1946, pp. 236—237). Gauguin especially liked the composition of the painting and repeated the pose of the central figure in several other pictures — *Sacred Spring* (No. 132), *The Great Buddha* (No. 144), *And the Gold of Their Bod-*

ies (W. G. 596, in reverse). The left-hand figure in the Moscow picture *Tahitians in a Room* (No. 136) is also depicted in the same pose. All this indicates that *Are You Jealous?*, produced during Gauguin's second year in Tahiti, gave an impetus to the creation of a whole number of works. According to Field, Gauguin may have used for the pose of this figure a photograph from a statue of Dionysos (see Richard S. Field, "Gauguin: Plagiaire ou créateur?", in: *Gauguin*, Paris, 1961, pp. 140—169).

127 WOMAN HOLDING A FRUIT (WHERE ARE YOU GOING?)
LA FEMME AU FRUIT DE MANGUE (OÙ VAS-TU?)

Oil on canvas (relined). 92×73 cm
Signed, dated, and inscribed, bottom left: *P Gauguin 93 Eu haere ia oe.*
Inv. No. 9120 W. G. 1501
Provenance: A. Vollard Gallery, Paris; 1908 I. Morozov collection, Moscow (bought for 8,000 francs); 1919 Second Museum of Modern Western Painting, Moscow; 1923 Museum of Modern Western Art, Moscow; since 1948 The Hermitage, Leningrad

Woman Holding a Fruit is one of Gauguin's finest works of 1893. The date provided by the artist is contested by several art historians. Bernard Dorival and later Charles Sterling expressed the view that the picture was conceived and produced in 1892 and merely signed in 1893. In our opinion, this is hardly possible. A variant of this subject, closely related to the Hermitage canvas in composition, is in the Staatsgalerie, Stuttgart (W. G. 478). It is unquestionably the first version of the theme, still treated as an everyday scene and bearing an inscription *E Haere oe i hia*, which L.-J. Bouge and Bengt Danielsson translated as 'Where are you going?' (a greeting in Tahitian).
The Hermitage picture is perceived in an entirely different way. It is enlarged in width and reduced in height compared to the Stuttgart canvas. The main figure therefore appears closer to the centre and seems larger and more monumental, while the figures in the background are not linked with it as directly as in the Stuttgart canvas, merely serving as elements helping to reveal the symbolic meaning of the composition. For the image of the girl sitting in front of the cottage Gauguin used, probably deliberately, the figure from a 1892 painting, *When Will You Marry?* (W. G. 454), and on the right depicted a woman with a child in her arms. As a result the fruit, placed in the very centre of the composition, acquires a symbolic meaning of fertility and the continuity of life.

128 PASTORALES TAHITIENNES

Oil on canvas. 86×113 cm
Inscribed, signed, and dated, bottom right: *Pastorales Tahitiennes 1893 Paul Gauguin*

Inv. No. 9119 W. G. 470
Provenance: Bernheim-Jeune Gallery, Paris (as indicated by the firm's label with No. 15286 on the reverse); A. Vollard Gallery, Paris; 1908 I. Morozov collection, Moscow (bought for 10,000 francs); 1919 Second Museum of Modern Western Painting, Moscow; 1923 Museum of Modern Western Art, Moscow; since 1948 The Hermitage, Leningrad

According to a letter sent from Tahiti to Daniel de Monfreid, Gauguin completed this canvas in late December 1892 but dated it 1893 (see *Lettres de Gauguin à Daniel de Monfreid*, Paris, 1950, p. 131). Antonina Izerghina regarded *Pastorales Tahitiennes*, built upon a combination of the refined rhythm of linear arabesques and the flat zones of local colour, as a milestone in the artist's career.

129, 130 CONVERSATION
CONVERSATION (LES POTINS)

Oil on canvas (relined). 71×92.5 cm
Inscribed, signed, and dated, bottom left: *Les Parau Parau P Gauguin 91*
Inv. No. 8980 W. G. 435
Provenance: A. Vollard Gallery, Paris; 1907 I. Morozov collection, Moscow (bought together with *Landscape with a Parrot* for 1,500 francs); 1919 Second Museum of Modern Western Painting, Moscow; 1923 Museum of Modern Western Art, Moscow; since 1948 The Hermitage, Leningrad

In his first Tahitian period (from June 1891 to July 1893) Gauguin painted two works with nearly the same title: *Les Parau Parau* (the Hermitage) and *Parau Parau* (1892, now in the Whitney collection, W. G. 472). On 8 December 1892, the artist sent the first of these pictures to Paris, for an exhibition in Copenhagen. This may well have been the Hermitage canvas. According to D. Sutton, its measurements, given in the catalogue of the Copenhagen exhibition in Danish inches, practically coincide with those of the Hermitage picture. In this latter canvas, the theme is expressed more clearly, as the group of the conversing women is depicted in close-up, while in the painting from the Whitney collection it is shifted into the distance and dissolves in the landscape.
As was frequently the case with Gauguin, he transferred certain figures from an earlier (the Hermitage) composition to a later one; in *Parau Parau*, these are two women seated at left and a third, with her back turned to the viewer. The artist repeated some of the images in monotypes and in drawings. The figure of the woman in black, seated in the centre, appears in a monotype in reverse (Field, *Monotypes* 36); her head, in a drawing (Rewald 93); the woman wearing a hat, in a monotype in reverse (Field, *Monotypes* 44); finally, the figure of the first woman and the head of the second are depicted in a watercolour on sheet 173 of the Paris MS of *Noa Noa*.

131 SCENE FROM TAHITIAN LIFE
SCÈNE DE LA VIE TAHITIENNE

Oil on canvas. 89×125 cm

Partly obliterated signature, bottom right: *P Gauguin*
The date, *96*, is not traceable now, but must have been visible when the canvas was catalogued at the First Museum of Modern Western Painting in 1918.

Inv. No. 6517 W. G. 537

Provenance: 1910 S. Shchukin collection, Moscow; 1918 First Museum of Modern Western Painting, Moscow; 1923 Museum of Modern Western Art, Moscow; since 1930 The Hermitage, Leningrad

The painting belongs to Gauguin's second Tahitian period and is thematically related to a group of his works on the harvest theme: *Nave Nave mohana* (W. G. 548), *Man Picking Up Fruit from a Tree* (No. 137), and *Gathering Fruit* (No. 143).

A group of people setting out to gather in the harvest is perceived as a triumphal procession led by a man with a stick on his shoulder, and a horseman bringing up the rear. A man walking with vigorous strides first appears in this painting and occurs repeatedly in Gauguin's prints, including a woodcut on sheet 180 of the Paris MS of *Noa Noa* (Guérin 64), in which he is depicted in the opposite direction, with clusters of bananas. The same man is seen in a pen-and-bistre drawing (Rewald 125), and in three monotypes: *Return from the Hunt* (Field, *Monotypes* 96), *Adam and Eve* (Field, *Monotypes* 105) and, in the opposite direction, on page 153 of the MS *Avant et après* (Field, *Monotypes* 107). This image is borrowed from the figure of a warrior on Trajan's Column. It is possible that the theme of physical work is treated by Gauguin as the theme of the expiation of original sin. If this is so, it becomes clear why this image is included in the monotype *Adam and Eve*.

The woman with the raised arm, showing the way to the other participants in the procession, is borrowed from the Parthenon frieze. This figure reappears in a monotype in the MS of *Avant et après* (Field, *Monotypes* 112) and in the painting *L'Appel* (W. G. 612). In the lower right-hand part of the picture, the paints were washed out and the upper layer was damaged, probably during transportation by sea. The signature has suffered, too.

132 SACRED SPRING (SWEET DREAMS)
EAU DÉLICIEUSE

Oil on canvas (relined). 73×98 cm
Inscribed, signed, and dated, bottom left: *NAVE NA-VE MOE P Gauguin 94*
Inv. No. 6510 W. G. 512

Provenance: 1895 According to the sale catalogue, bought by A. Schuffenecker for 430 francs at the show-sale of Gauguin's works on 18 February (according to the minutes of the sale published in 1949, the picture was not sold and was returned to the ar-

tist); A. Schuffenecker collection, Paris; 1897 Dosbourg sale, Paris, 10 November, lot 16 (sold for 160 francs); Prince de Wagram collection, Paris; A. Vollard Gallery, Paris; 1907 I. Morozov collection, Moscow (bought for 8,000 francs); 1919 Second Museum of Modern Western Painting, Moscow; 1923 Museum of Modern Western Art, Moscow; since 1931 The Hermitage, Leningrad

One of the artist's major works, *Sacred Spring* was executed in France after Gauguin's first two years in Oceania. Presenting a generalized image of Tahiti, the picture was most likely painted in Paris at the beginning of 1894, following the stained-glass panels *Nave Nave* (W. G. 510) and *Tahitian Women in a Landscape* (W. G. 511), since already in April 1894 Gauguin moved to Pont-Aven and embarked again on painting his favourite Breton motifs.

The picture must have been conceived as a vision of Tahiti the "promised land", with its natural cycles embracing all forms of existence.

The task Gauguin set himself — to depict the three cardinal states of nature and human life — led him to a symbolic rendition of the concept. The lily probably denotes the untouched purity of the "enchanted island" (*l'île enchantée*). The women's images symbolize the different stages of human life. The young girl is sunk in a deep sleep, her feelings not yet awakened. The halo around her head is a sign of virginity. The elder girl holds a fruit which she is going to taste.

On the other side of the spring there are two women conversing. Their poses are so static that they seem rooted to the earth. One woman is turned to the right, the other to the left, their gazes thus embracing the entire expanse of the Promised Land. In the dim depths of the canvas, a group of Tahitians are dancing in ecstasy around gigantic idols. The colour scale gradually changes, fading towards the horizon.

The tree in the background frequently appears as the main component of Gauguin's Oceanian landscapes, being perhaps one of the symbols he chose for Tahiti's vigorous, uncultivated nature. Gauguin repeatedly depicted this tree in compositions with the Moon Goddess Hina (1892, W. G. 483; 1892, W. G. 467; 1893, W. G. 500). Furthermore, in his painting *Once* (W. G. 467), the goddess is shown against a tree, surrounded by dancing Tahitians. This persistent representation of the tree next to the Goddess Hina allows to assume that in *Sacred Spring* this tree, illuminated by the last rays of the sun, symbolizes the approaching moonrise. Moonlight was traditionally associated with the fear of the spirits of the dead, implied by the ritual dancing around the idols.

133 THE CANOE (A TAHITIAN FAMILY)
LA PIROGUE (FAMILLE TAHITIENNE)

Oil on canvas. 96×130.5 cm
Inscribed, signed, and dated, bottom left: *TE VAA P. Gauguin 96*

Inv. No. 9122 W. G. 544

Provenance: M. Morozov collection, Moscow; 1910 The Tretyakov Gallery, Moscow (gift of Morozov's widow); 1925 Museum of Modern Western Art, Moscow; since 1948 The Hermitage, Leningrad

The Tahitian words *te vaa* are translated by Danielsson as 'pirogue' or 'canoe'. In the Tretyakov Gallery catalogue of 1917, the picture was listed as *A Tahitian Family*, probably in conformity with the recommendations of M. Morozov's widow, who donated it to the Gallery. At present, the picture has two titles.

In 1896, Gauguin produced a version of this picture entitled *Poor Fisherman* (Art Museum, São Paulo, W. G. 545). The figure of the fisherman and the shape of the canoe are identical in the two paintings, but the landscapes are different. Moreover, the figures of the women and child are absent in the São Paulo canvas. Judging by its smaller size and incomplete elaboration of the theme, the Brazilian work may have been the first version of the Hermitage composition. For obvious reasons, at a later stage of his work on the subject, Gauguin rejected the original title, *Poor Fisherman*, as incompatible with his understanding of Tahitian life.

134 BABY (THE NATIVITY)
BÉ BÉ (LA NATIVITÉ)

Oil on canvas. 66×75 cm

Inscribed, signed, and dated, bottom left: *Bé Bé P Gauguin 96*

Inv. No. 6568 W. G. 540

Provenance: A. Vollard Gallery, Paris; S. Shchukin collection, Moscow; 1918 First Museum of Modern Western Painting, Moscow; 1923 Museum of Modern Western Art, Moscow; since 1931 The Hermitage, Leningrad

The title *Bé Bé*, written by the artist on the obverse, was one of the few French words commonly used by the Tahitians.

Bengt Danielsson and Françoise Cachin state that the subject of the Hermitage canvas, like the thematically similar *The Birth of Christ, the Son of God* (*Te Tamari no atua*) from the Bavarian State Picture Galleries (Neue Pinakothek) in Munich (W. G. 541), is connected with the birth, on 1 December 1896, of Gauguin's daughter by his second Tahitian wife, Pahura (the baby died soon after birth). The more plausible hypothesis would seem to be that these pictures, treating the Tahitian version of the evangelical legend of the Nativity of Christ, reflect Gauguin's ideas about the links between Christian and Eastern theological myths, including the Maori ones. Both pictures date to 1896 and are closely related in subject and in the use of motifs. The entire right-hand part of the Hermitage composition is included in the Munich picture, but shifted into the background to become a mere episode accompanying the main scene. The background

of the Hermitage composition — the stable with the animals and the woman — has been borrowed, in its turn, from the canvas in Munich. Richard S. Field thinks that Gauguin copied both motifs from a photograph of the picture *Inside the Manger* by the French artist Nicolas François Octave Tassaert (1800—1874). However, his suggestion seems erroneous as far as the Hermitage canvas is concerned.

It is interesting that the silhouette of the ox standing at right is borrowed from Gauguin's Breton picture of 1894 entitled *Christmas Eve* (W. G. 519) and brought to Tahiti by the artist in 1895. In a group of woodcuts, indirectly related to *Bé Bé*, one can easily trace Gauguin's idea of the fusion of Christian and Eastern religious beliefs. Thus the picture on a Tahitian subject, *Te Atua — Saintly Faces* (Guérin 61), is based on a Lamentation scene from the woodcut *Breton Calvary* (Guérin 68), in which the ox is identical with that in *Bé Bé*. Several of Gauguin's monotypes with representations of cows, pigs, etc., some of which are borrowed from *Bé Bé* (Field, *Monotypes* 76, 80), were executed in 1901—1902. These representations are apparently connected with the concept of a new Nativity scene, for which Gauguin painted, in 1902, a small multi-figure canvas, *The Nativity* (W. G. 621).

135 THE QUEEN (THE KING'S WIFE)
LA REINE (LA FEMME DU ROI)

Oil on canvas. 97×130 cm

Signed and dated on a light green zone, bottom right: *P. Gauguin 1896*; inscribed: *TE ARII Vahine*

Inv. No. 3265 W. G. 542

Provenance: 1903 G. Fayet Gallery, Paris; 1910 S. Shchukin collection, Moscow (bought for 30,000 francs); 1918 First Museum of Modern Western Painting, Moscow; 1923 Museum of Modern Western Art, Moscow; since 1948 The Pushkin Museum of Fine Arts, Moscow

The picture belongs to Gauguin's second Tahitian period. The artist described it in a letter to Daniel de Monfreid written in April 1896, adding a sketch in Indian ink and watercolour (see *Lettres de Gauguin à Daniel de Monfreid*, Paris, 1950, pp. 85, 86).

Gauguin sent the picture to Daniel de Monfreid to be sold, but it remained with the latter until the artist's death in 1903. In August of that year, Monfreid sold it for 1,100 francs to the Paris dealer Fayet.

In its complex fusion of conceptions, the present picture echoes *Her Name Is Vaïraumati* (No. 125). In Perruchot's opinion, it was painted from Pahura, Gauguin's second Tahitian wife (see H. Perruchot, *La Vie de Gauguin*, Paris, 1961, p. 301). In addition, the Queen's pose calls to mind that of Edouard Manet's *Olympia* which strongly impressed Gauguin. Like Olympia, Gauguin's Queen, in the guise of a young Tahitian *vahine*, defies the bourgeois prejudices by starting a dialogue with goddesses of past epochs. The

red fan which she holds in her hand is, according to Tahitian tradition, the sign of a kingly power, and at the same time an instrument of temptation. The mango tree under which she is lying symbolizes the Tree of the Knowledge of Good and Evil. Standing near it are two greybeards whom Gauguin later introduced into his programmatic work *Where Do We Come From? What Are We? Where Are We Going To?* (W. G. 561). Behind the queen there are some odd tree-like plants resembling either buds or fruits, swollen and ready to burst, run to seed or break into blossom. They cannot be identified with any actually existing plants, either European or tropical, and are accessories of Gauguin's "Paradise", intended to demonstrate their ability to bear seeds and fruit. For the first time they occur in the *Exotic Eve* (W. G. 389, 390). They also occur in *Gathering Fruit* (No. 143), in the panel *Faa Iheihe* (W. G. 569), and in the two Hermitage canvases (Nos. 141, 142), which all depict scenes in Paradise.

The Tahitian title of the picture is sometimes translated as *Woman with Mangoes*, *The Queen of Beauty*, or *The Woman of Royal Blood*.

There are two variants of the Moscow canvas; one of them, in oil, is entitled *La Femme aux mangos* (W. G. 543); the other is a watercolour (Rewald 100).

The Queen is depicted in the same pose in a pen drawing for Gauguin's MS of *Avant et après* (Rewald 99); in a woodcut (Guérin 62, in reverse), an impression of which Gauguin glued to his copy of the *Noa Noa* MS; in a cover for the review *Le Sourire* published by Gauguin on the island of Dominica (Guérin 78, in reverse); and in a monotype entitled *L'Esprit veille* (Rewald 121, in reverse).

The female figure in the left distance, picking a fruit, can be seen in several canvases (W. G. 459, 579, 622). It is worth noting that Gauguin conceived the composition of the painting, with its symbols of "Paradise lost", before his departure for Tahiti. The Ny Carlsberg Glyptothek owns a carved wooden relief, *Nude with a Fan*, produced by Gauguin in 1890, which almost exactly repeats the pose of the woman from the Moscow picture. As in the picture, the native Eve in the relief is lying under the big tree—the pivot of the whole composition; seen in the distance is the head of a barbaric devil.

136 TAHITIANS IN A ROOM
TAHITIENS DANS UNE CHAMBRE

Oil on canvas. 65×75 cm
Inscribed, signed and dated, bottom left: *Eiaha ohipa — P. Gauguin. 96*
Inv. No. 3267 W. G. 538
Provenance: A. Vollard Gallery, Paris; 1906 S. Shchukin collection, Moscow; 1918 First Museum of Modern Western Paintng, Moscow; 1923 Museum of Modern Western Art, Moscow; since 1948 The Pushkin Museum of Fine Arts, Moscow

The picture was painted in 1896, during Gauguin's second Tahitian period. The inscription was translated in different ways — as 'Do not do it', 'Do not work', or 'Do not smoke'. The left-hand figure appears in different versions of the painitng *Are You Jealous?* (No. 126), while the girls' poses are repeated in *And the Gold of Their Bodies* (W. G. 596). Most likely, Gauguin borrowed the poses of individual figures from the friezes of the Buddhist temple of Borobudur on Java, of which he had photographs.

While working on Polynesian subjects Gauguin often borrowed motifs and poses from friezes of Buddhist or Hindu temples, and also from Egyptian reliefs. The *couleur locale* was of little importance to the artist. By this time the idea of a non-European civilization had become central to his life as well as to his art. To become a slave of nature, of "what you see before your very eyes" was something that he feared most of all. We may assume that the girls' figures were painted from Gauguin's neighbours who used to visit his studio in Punaauia, but their gestures, reminiscent of Buddhist deities, give a more universal meaning to the picture. 'Do not work' is the most reliable translation of the picture's title, a title which implies a specific sense—the bliss of idleness and peace. A juxtaposition of the enclosed world of an interior with the boundless expanse of nature visible through the open door in the background can be found in yet another of Gauguin's works, *The Dream* (*Te rerios*), painted in the same year (W. G. 557).

137 MAN PICKING FRUIT FROM A TREE
HOMME CUEILLANT DES FRUITS DANS UN PAYSAGE JAUNE

Oil on canvas. 92×72 cm
Signed and dated, bottom left: *P. Gauguin 97*
Inv. No. 9118 W. G. 565
Provenance: 1898 Sent by the artist from Tahiti to Ambroise Vollard in Paris for sale on 9 December (apparently sold shortly thereafter, as it did not appear in the 1903 exhibition of Gauguin's works at the A. Vollard Gallery); S. Shchukin collection, Moscow; 1918 First Museum of Modern Western Painting, Moscow; 1923 Museum of Modern Western Art, Moscow; since 1948 The Hermitage, Leningrad

This canvas belongs to a group of Gauguin's works related to his large allegorical painting, *Where Do We Come From? Who Are We? Where Are We Going To?* (W. G. 561). This statement rests on a certain affinity between the Tahitian man with raised arms in the Hermitage canvas and the naked youth depicted in reverse at the centre of the above-mentioned allegory and also in a study for it (W. G. 560). The artist shows a man who is on the verge of renouncing the thoughtless joy of existence, extending his hand to the Tree of the Knowledge of Good and Evil. This figure must have fired Gauguin's imagination. It ap-

pears in a large preliminary drawing for *Where Do We Come From?* (Musée d'Art Moderne, Paris) and in the final version of this subject, done in 1903, this time with a female figure introduced into the picture (W. G. 635). The same man's figure is seen in the xylograph done for the title-page of his review *Le Sourire* and pasted in on page 186 of the Paris MS of *Noa Noa* (Guérin 73).

The Hermitage canvas corresponds fairly closely with several harvest scenes, such as *Nave Nave Mahana* (W. G. 548), *Scene from Tahitian Life* (No. 131), *Faa Iheihe* (W. G. 569) and *Gathering Fruit* (No. 143).

138 LANDSCAPE WITH TWO GOATS
PAYSAGE AUX DEUX CHÈVRES

Oil on canvas. 92×73 cm
Inscribed, signed, and dated, bottom right: *TARARI MARURU P Gauguin 97*
Inv. No. 7707 W. G. 562

Provenance: 1898 Sent by the artist from Tahiti to Ambroise Vollard in Paris for sale on 9 December; A. Vollard Gallery, Paris; M. Morozov collection, Moscow; 1910 The Tretyakov Gallery, Moscow (gift of Morozov's widow); 1925 Museum of Modern Western Art, Moscow; since 1934 The Hermitage, Leningrad

By its individual components, *Landscape with Two Goats* is linked to a number of works produced during Gauguin's second Tahitian period. Thus, the standing woman's figure, depicted in profile looking to the right, is undoubtedly identical with the woman seen near the idol in Gauguin's allegory of 1897, *Where Do We Come From? Who Are We? Where Are We Going To?* (W. G. 561).

The goats in the foreground are also found in another Hermitage canvas, *Man Picking Fruit from a Tree* (No. 137), which, in turn, is related to the above-mentioned allegory. The curved tree-trunks frequently occur in the artist's later works. All this testifies to the fact that the *Landscape with Two Goats* belongs to a group of paintings which are within the orbit of *Where Do We Come From?* and, without doubt, plays no small part in the system of Gauguin's imagery. This is also corroborated by a watercolour version of the Hermitage canvas, pasted into the Paris MS of *Noa Noa* between pages 61 and 63.

139 MATERNITY (WOMAN ON THE SHORE)
MATERNITÉ (FEMME AU BORD DE LA MER)

Oil on canvas (relined). 94×72 cm
Signed and dated, bottom right: *Paul Gauguin 99*
Inv. No. 8979 W. G. 581

Provenance: 1903 Sent by Gauguin from Atuona to Ambroise Vollard in Paris for sale (as No. 8 in the artist's list); A. Vollard Gallery, Paris; S. Shchukin collection, Moscow (apparently bought from Vollard in Paris in 1903 or 1904, as it was not exhibited at the Salon d'Automne of 1906); 1918 First Museum of

Modern Western Painting, Moscow; 1923 Museum of Modern Western Art, Moscow; since 1948 The Hermitage, Leningrad

Bengt Danielsson links the subject of the picture to the birth in 1899 of Emile Gauguin, the artist's son by Pahura. The theme of mother and child, however, underlies Gauguin's entire work of the Tahitian period, from the first year of his stay in Tahiti up to 1902. At times, the images of mother and child assume clear religious overtones (*Hail Mary*, 1891, W. G. 428; *Baby*, 1896, see No. 134; *The Birth of Christ, the Son of God*, 1896, W. G. 541; *The Nativity*, 1902, W. G. 621); at others, they are treated in a realistic manner (*Motherhood*, date of execution unknown, W. G. 582; *Gift-bearing*, 1902, W. G. 624). But even in the pictures of the latter group, the composition is interpreted as a sacred scene, evoking associations with the classical theme of gift-bearing. Hence the special role assigned to the woman standing in the centre with flowers in her hands, seemingly folded in prayer. This image, sometimes accompanied by the figure of another woman with a basket of fruit, occurs in different variations in a number of Gauguin's works with the motif of gift-bearing.

140 THE IDOL
L'IDOLE

Oil on canvas. 73×91 cm
Signed, dated, and inscribed, bottom left: *P Gauguin 98 Rave te hiti aamu*
Inv. No. 9121 W. G. 570

Provenance: 1898 Sent by the artist from Tahiti to Ambroise Vollard in Paris for sale on 9 December; A. Vollard Gallery, Paris; S. Shchukin collection, Moscow; 1918 First Museum of Modern Western Painting, Moscow; 1923 Museum of Modern Western Art, Moscow; since 1948 The Hermitage, Leningrad

Both in the Museum of Modern Western Art and in the Hermitage the painting has been known as *The Idol*. In art literature it is described as representing the Marquesan God Tiki or Takai. However, the subject of the Hermitage canvas does not resemble either Tiki or any idols whose wooden or stone effigies are often seen in Gauguin's Tahitian paintings. This is a monster with a deadly immobile face and a woman's body, iconographically related to the image of *oviri* (savage), present in many works of the artist's late period.

In 1894—95, during his stay in Paris after the first trip to Tahiti, Gauguin made a large ceramic sculpture with an inscription on its base, *Oviri*. It depicts a nude woman, with a lot of hair at the back of the head and none at the front, clasping a small animal to her breast. Apparently at the same time, the artist portrayed the same image in two monotypes (Field, *Monotypes* 30, 31) and two woodcuts (Guérin 48, 49). On the cardboard with two impressions of a wood-

cut (Guérin 48) is a dedicatory inscription in the artist's hand: *à Stéphane Mallarmé cette étrange figure cruelle énigme P Gauguin 1895.*

The Tahitian words on the obverse of the Hermitage canvas, *Rave te hiti aamu*, incorrectly translated by L.-J. Bouge as 'the presence of evil spirit', misled art historians and directed their search towards Tiki and Tupapau, gods who guarded the spirits of the dead. Danielsson, in his turn, established the exact meaning of the Tahitian words without clarifying the sense of the inscription as a whole (*rave* means 'to seize', *te hiti*, 'monster', and *aamu,* 'glutton'). He evidently had not compared the Tahitian title with another inscription accompanying the drawing *Oviri*, made by Gauguin in 1899 for his review *Le Sourire*, which runs as follows: *Et le monstre étreignant sa créature féconde de sa semence les flancs généreux pour engendrer Seraphitus Seraphita* (Guérin, p. XXVII). M. Bodelsen has traced the origin of the name of Seraphita in a Balzac novel in which the main protagonist is treated as an androgynous angelic being. This information, added to Gauguin's remarks in *Noa Noa* and his letters, makes it possible to interpret the image of *oviri* as a symbolic expression of the destruction of the artist's personality and its subsequent renewal in another capacity.

The inscription on the 1899 drawing of *oviri* and the Tahitian title of the Hermitage picture reveal the essence of the *oviri* image. This is the monster that brings destruction, death and, at the same time, gives birth to Seraphitus (masculine gender) and Seraphita (feminine gender), that is, a supreme harmonious creature free of the contradictions disrupting the world.

The Hermitage painting was first mentioned as *The Idol* by Yakov Tugendhold in his 1914 article describing Sergei Shchukin's collection, published in the Russian art magazine *Apollon* (1/2, p. 38). Before that, the canvas had another title derived from its prototype — the ceramic sculpture called *The Maori Woman* (see Jean de Rotonchamp, *Paul Gauguin*, Weimar, 1906, p. 136). In the catalogue of the Shchukin collection, the painting was listed as *Seated Nude Woman*.

141 THREE TAHITIAN WOMEN AGAINST A YELLOW BACKGROUND
TROIS TAHITIENNES SUR FOND JAUNE

Oil on canvas (relined). 68×74 cm
Signed and dated, bottom right: *Paul Gauguin 99*
Inv. No. 7708 W. G. 584
Provenance: 1903 Sent by Gauguin from Atuona to Ambroise Vollard in Paris for sale (as No. 10 in the artist's list); A. Vollard Gallery, Paris; *ca.* 1905 G. Stein collection, Paris; once again the A. Vollard Gallery (selected for purchase by the well-known Hungarian collector M. Nemes); 1910 I. Morozov collection, Moscow (bought from Vollard for 10,000

francs); 1919 Second Museum of Modern Western Painting, Moscow; 1923 Museum of Modern Western Art, Moscow; since 1934 The Hermitage, Leningrad

Three Tahitian Women against a Yellow Background is one of the four pictures executed in 1898—99 and displaying three common features: the presentation of the subject against a yellow background calling to mind medieval icon painting; the variation of an identical landscape motif (the dwarf tree with a round crown) which does not occur in any other of Gauguin's works; and the portrayal of a woman carrying flowers in her hands folded as if in prayer. In three of these paintings, *Faa Iheihe* (1898, W. G. 569), *Gathering Fruit* (No. 143) and the present picture, this figure is placed at the extreme left, while in the canvas *Woman Carrying Flowers* (No. 142) it is the main and only protagonist of the composition. Owing to this similarity, all four pictures could form a single decorative set despite their different size.

142 WOMAN CARRYING FLOWERS
FEMME TENANT DES FLEURS

Oil on canvas. 97×72 cm
Inscribed, signed, and dated, bottom left: *TE AVAE NO MARIA Paul Gauguin 1899*
Inv. No. 6515 W. G. 586
Provenance: 1903 Sent by Gauguin from Atuona to Ambroise Vollard in Paris for sale (as No. 9 in the artist's list); A. Vollard Gallery, Paris; S. Shchukin collection, Moscow; 1918 First Museum of Modern Western Painting, Moscow; 1923 Museum of Modern Western Art, Moscow; since 1930 The Hermitage, Leningrad

This picture belongs to the group of four paintings produced in 1898—99 and described under No. 141. The inscription made in the artist's hand, *Te avae no Maria*, was translated by Danielsson as 'the month of Mary'. In Catholic countries May is the month of worshipping the Virgin Mary and, at the same time, it is the month when nature is in full bloom. This image frequently occurs in Gauguin's late works.

143 GATHERING FRUIT
LA CUEILLETTE DES FRUITS

Oil on canvas. 128×190 cm
Inscribed, bottom left: *Ruperupe*; signed and dated under the inscription: *Paul Gauguin 1899*
Inv. No. 3268 W. G. 585
Provenance: 1903 Sent by Gauguin from Atuona to G. Fayet in Paris; G. Fayet Gallery, Paris; S. Shchukin collection, Moscow; 1918 First Museum of Modern Western Painting, Moscow; 1923 Museum of Modern Western Art, Moscow; since 1948 The Pushkin Museum of Fine Arts, Moscow

Together with *Where Do We Come From? What Are We? Where Are We Going To?* (W. G. 561) and *Faa Iheihe* (W. G. 569), this picture belongs to Gauguin's

programmatic works expressing his artistic credo. It displays the characteristic features of Gauguin's Synthetic style. The yellow background, that invariable foundation of Gauguin's world, is central to both composition and colour scheme. The yellow colour builds a gleaming wall behind the figures and suffuses the lower part of the composition, showing through the soil and forming the flowing patches reminiscent of golden clouds or pools of water. All habitual structural and conceptual relationships appear to be reversed. The whelps in the right lower corner, with the fruits scattered around, bring to mind Gauguin's first still life painted at Pont-Aven (W. G. 293). Rendered by decorative patches of colour, these young animals are perceived as unripe fruits. In this way Gauguin breaks the boundary between animate and inanimate nature, flattening the living creatures and turning them into ornamental elements. The ornament, in its turn, loses its static quality, assuming characteristics of a live body.

It looks as if the piece were cut out from some large composition developing in two directions — rightward, whence comes the horse, and leftward, beyond the slender tree with red fruit. The two female figures in the left-hand part of the painting — one of them is an exact repetition of Mary from the Hermitage picture (No. 142) — appear as saints on icons, standing out against the golden background in a conventional landscape. They are portrayed in poses borrowed from different parts of the friezes of the Buddhist temple of Borobudur on Java, of which Gauguin had photographs. The left-hand part of the Moscow picture — the Garden of Eden before the Fall — finds an exact counterpart in the London canvas *Faa Iheihe* (W. G. 569). The tempter in the centre appears also in the London picture, but the scene of Eve's temptation is absent. The tempter in a long *pareo* is picking a fruit, looking at the two women. In contrast to these, he and the horse are creatures of flesh and blood, not "saints".

The right-hand side of the Moscow picture (with a horse, a rider and whelps) symbolizes the Earth on which birth and death triumph by turns, and also repeats the corresponding part of *Faa Iheihe*. On the whole, *Gathering Fruit*, like *Where Do We Come From? What Are We? Where Are We Going To?* and *Faa Iheihe*, shows in allegorical form the history and destiny of the human race.

However, even in this programmatic panel there is an element which causes us to see in it another sense, far removed from deeper levels of meaning. Bengt Danielsson states that the word *Ruperupe* inscribed by Gauguin on the canvas should not be translated as 'fruit gathering' or 'luxuriant vegetation'. He established that this is the beginning of a song, *O Ruperupe Tahiti* ('O Tahiti, the blessed land'), which was popular among the colonists and local residents of Tahiti in Gauguin's lifetime. Gauguin painted

his *Gathering Fruit* during one of his recurrent crises which eventually ended in his decision to move to the Marquesas Islands. The world of Tahiti as a source of inspiration, as a "promised land" had already waned for the artist. In this context *Gathering Fruit* is partly a picture postcard inviting to visit the delectable islands, and partly the artist's bitter irony.

For his MS of *Avant et après* Gauguin did two drawings from this painting, *En route pour le festin* and *Changement de résidence*. An impression from the woodcut *Changement de résidence* was pasted into the Paris MS of *Noa Noa* (Guérin 66). One of the covers of *Le Sourire* presents the extreme left figure of the first drawing (Guérin 81). Two other central figures also repeatedly occur in Gauguin's canvases (W. G. 579, 583, 584).

144 THE GREAT BUDDHA
LE GRAND BUDDHA

Oil on canvas. 134×95 cm
Signed and dated, bottom left: *P. Gauguin 99*
Inv. No. 3368 W. G. 579
Provenance: G. Fayet Gallery, Paris; A. Vollard Gallery, Paris; 1908 I. Morozov collection, Moscow; 1919 Second Museum of Modern Western Painting, Moscow; 1923 Museum of Modern Western Art, Moscow; since 1948 The Pushkin Museum of Fine Arts, Moscow

Placed on a pedestal at the centre is the dark statue of Buddha, its front decorated with two carved figures of Tahitian idols facing each other. In this way the Tahitians usually depicted Hina, the Goddess of the Moon and Eternity, and Tefatou, the God of the Earth and Death, discussing the destiny of mankind doomed to death. It is probable that Gauguin used this ancient Maori myth as the subject for his picture. The left figure seated in front might be taken for Hina, while the figure at right resembles Tefatou. The sleeping dog with its pups at Tefatou's feet is probably the embodiment of all living beings whose destiny is pre-determined: according to the Tahitian beliefs, sleep is close, almost identical, to death. The sleeping dog with its pups also appears in the right-hand part of *Faa Iheihe* (W. G. 569) and in *Gathering Fruit* (No. 143).

In the distance, against the wall, is the scene of the Last Supper: we see the figure or Christ, with a halo, and the dark figure of Judas standing in front of the table. This confirms the programmatic character of the Moscow picture, whose message is clearly the inner kinship of all religions of the world.

The figure seated at right occurs in *Te rerioa* (*The Dreams*) (W. G. 557). The one at left and the figure wearing a long *pareo* and holding a dish over her head in the middle distance frequently appear in Gauguin's paintings (W. G. 459, 461, 512, 542, 543, 596, 622), watercolours and woodcuts.

145 SUNFLOWERS
LES TOURNESOLS

Oil on canvas. 72×91 cm
Signed and dated, bottom right: *Paul Gauguin 1901*
Inv. No. 6516 W. G. 603

Provenance: S. Shchukin collection, Moscow; 1918 First Museum of Modern Western Painting, Moscow; 1923 Museum of Modern Western Art, Moscow; since 1931 The Hermitage, Leningrad

In his letter of October 1898, Gauguin asked Daniel de Monfreid to send him sunflower seeds for his garden. This may be taken as evidence of the fact that *Sunflowers* (1901) was painted not in Atuona, as Albert Kostenevich assumes (see A. Kostenevich, *French Painting of the 19th and 20th Centuries in the Hermitage*, Leningrad, 1979, p. 98, in Russian), but in Tahiti, for Gauguin settled in Atuona, on the Island of Dominica, in September 1901. Naturally, he could not have had the time to grow a garden there like the one he had in Tahiti. One more circumstance supports the view that this work was executed prior to Gauguin's departure for the Marquesas Islands. There is an element of mysticism in the Hermitage picture, due to the presence of the All-Seeing Eye.

There exist four still lifes with sunflowers by Gauguin. In one of them (W. G. 604), the artist reproduced Puvis de Chavannes's *Hope*, as if expressing his faith in a better future.

146 STILL LIFE WITH PARROTS
LES PERROQUETS

Oil on canvas. 62×76 cm
Signed and dated, in a cartouche, on the tablecloth, bottom left: *Paul Gauguin 1902*
Inv. No. 3371 W. G. 629

Provenance: G. Fayet Gallery, Paris; E. Druet Gallery, Paris; 1910 I. Morozov collection, Moscow; 1919 Second Museum of Modern Western Painting, Moscow; 1923 Museum of Modern Western Art, Moscow; since 1948 The Pushkin Museum of Fine Arts, Moscow

This picture was painted in 1902 in Atuona, on the Island of Dominica (Marquesas Islands). The presence of separate strokes indicates that at the close of his artistic career Gauguin deviated from his Synthetic method. In the Heydt-Museum, Wuppertal, is a variant of this painting, which, judging by its incompleteness, may have preceded the Moscow picture (W. G. 630). Depicted in the background of *Still Life with Parrots* is a terracotta idol made by Gauguin (see Charles Morice, *Paul Gauguin*, Paris, 1920, p. 198). Morice thinks that it represents Hina, the Goddess of the Moon and Eternity, whose dialogue with Tefatou on the destinies of mankind was the subject of many Gauguin paintings, drawings and sculptures. Its inclusion in this canvas was obviously meant to impart some symbolic meaning to the picture. The vivid, ra-

diant colours, succulent modelling, and the separate strokes conveying the breath of life are contrasted with the implicit sombre symbolism of the still life. The dead game, the flowers falling from the tablecloth and the pumpkin water-bottle are all symbols of the transience of life. It should not be forgotten that this still life was painted immediately after Gauguin's departure, or rather flight, from Tahiti to the Island of Dominica, his last abode. The tablecloth with all the objects on it, including the statuette of Hina, seems to cover not a table but a travelling-trunk. Two more pictures, a still life (W. G. 631) and *Bouquet of Flowers* (W. G. 594), painted at the same period, portray a similar trunk-like object.

147 LANDSCAPE
PAYSAGE. LE CHEVAL SUR LE CHEMIN

Oil on canvas. 94×73 cm
Signed and dated, bottom left: *Paul Gauguin 99*
Inv. No. 3263 W. G. 589

Provenance: 1903 Sent by Gauguin from Atuona to Ambroise Vollard in Paris for sale (as No. 5 in the artist's list); A. Vollard Gallery, Paris; 1905 S. Shchukin collection, Moscow; 1918 First Museum of Modern Western Painting, Moscow; 1923 Museum of Modern Western Art, Moscow; since 1948 The Pushkin Museum of Fine Arts, Moscow

Although the *Landscape* was painted at the end of the artist's life, it still contains some traces of the Impressionist technique characteristic of Gauguin's earlier Tahitian works (cf. Nos. 124, 129). A similar manner distinguishes a number of his other landscapes and ethnographic scenes (W. G. 588, 595, 599, 600, 607, 637).

148 THE FORD (THE FLIGHT)
LE GUÉ (LA FUITE)

Oil on canvas. 76×95 cm
Signed and dated, bottom right: *Paul Gauguin, 1901*
Inv. No. 3270 W. G. 597

Provenance: Daniel de Monfreid collection, Paris; 1903 G. Fayet Gallery, Paris; 1906 S. Shchukin collection, Moscow; 1918 First Museum of Modern Western Painting, Moscow; 1923 Museum of Modern Western Art, Moscow; since 1948 The Pushkin Museum of Fine Arts, Moscow

The picture was painted in the Island of Dominica, two years before the artist's death. Disenchanted with the Tahitian "Paradise", already tainted by Western civilization, Gauguin more and more often treated the theme of the Tahitians' exodus from their land. The odd figure in a blue *pareo* and a pink kerchief on the head, riding a pale horse, may be interpreted as a symbolic image of death. The same figure, in reverse, appears in two monotypes, *Le Cauchemar* and *La Fuite* (Rewald 106, 107), in a watercolour (Rewald 108), and in the gouache *La Fuite* (National Gal-

lery, Washington). There is an assumption that this motif is borrowed from Albrecht Dürer's print *Knight, Death and the Devil*, a reproduction of which Gauguin brought with him to Tahiti.

AUGUSTE RODIN. 1840—1917

149 FEMALE FIGURE (THROWN BACK)

Lead pencil and watercolour wash. 32.7×25 cm
Signed in pencil, bottom left: *Aug Rodin*
Traces of inscriptions in pencil, right, below middle; illegible inscription crossed out by pencil, at the top edge, near centre
Inv. No. 10316
Provenance: M. Riabushinsky collection, Moscow; 1924 Museum of Modern Western Art, Moscow; since 1948 The Pushkin Museum of Fine Arts, Moscow

In character, it is one of the studies of movement, made by Rodin during the 1900s (see No. 150). But it also belongs to a group of drawings which could have served as sketches for sculptures; the inscriptions on the sheet seem to confirm this view. Despite slight washes of watercolour, the drawing looks monochromatic; the shading gives it a silvery gleam.

150 NUDE FEMALE FIGURE (BACK VIEW)

Pencil drawing touched with watercolours. 32.5 ×24.8 cm
Signed in pencil, bottom right: *Rodin*
Inv. No. 10705
Provenance: I. Ostroukhov collection, Moscow; 1934 Museum of Modern Western Art, Moscow; since 1948 The Pushkin Museum of Fine Arts, Moscow

This is one of the studies done in the 1900s and comprising a whole series of drawings of the human body. These figures, seemingly floating on the sheets of paper and designated by smooth, almost uninterrupted outlines, have little in common with Rodin's earlier sketches intended for sculptures. However, the high degree of generalization and the freedom with which Rodin renders the most complex of postures attest to his deep knowledge of human anatomy. The spontaneous character of this drawing is enhanced by the use of the flesh-colour washes which do not coincide with the figures' contours and seem to spread, quite arbitrarily, side by side with them —a device recurring in Rodin's drawings and later found in the works of many twentieth-century artists.

HENRI ROUSSEAU. 1844—1910

151 THE CHOPIN MEMORIAL IN THE LUXEMBOURG GARDENS
JARDIN DU LUXEMBOURG. MONUMENT DE CHOPIN

Oil on canvas. 38×47 cm
Signed and dated, bottom right: *H. Rousseau 1909*

On the back of the canvas was a label with the inscription in Rousseau's hand: *Vue du Luxembourg. Monument de Chopin. Composition*
Inv. No. 7716 B. 206; Vallier, p. 117
Provenance: 1909 A. Vollard Gallery, Paris (bought from the artist on 5 August, with two other paintings, for 190 francs); 1912 S. Shchukin collection, Moscow; 1918 First Museum of Modern Western Painting, Moscow; 1923 Museum of Modern Western Art, Moscow; since 1934 The Hermitage, Leningrad

In 1908, when Rousseau was painting *The Poet and His Muse* (see No. 154), he used for its background some views of the Luxembourg Gardens. In the following year he executed the present picture commissioned by Ambroise Vollard. The only Rousseau canvas entirely devoted to the Luxembourg Gardens, it belongs to an extensive group of the artist's works depicting Parisian parks and gardens.

152 IN A TROPICAL FOREST. STRUGGLE BETWEEN TIGER AND BULL
DANS LA FORÊT TROPICALE. COMBAT DU TIGRE ET DU TAUREAU

Oil on canvas. 46×55 cm
Signed, bottom left: *Henri Rousseau*
On the back of the canvas was a label with the inscription in Rousseau's hand: *Combat du tigre et du taureau. Reproduction de mon tableau exposé au Salon des Indépendants 1908. Henri Rousseau*
Inv. No. 6536 B. 196; Vallier 153
Provenance: 1909 A. Vollard Gallery, Paris (bought from the artist on 5 August, with two other paintings, for 190 francs); 1912 S. Shchukin collection, Moscow; 1918 First Museum of Modern Western Painting, Moscow; 1923 Museum of Modern Western Art, Moscow; since 1930 The Hermitage, Leningrad

From 1904 Rousseau repeatedly treated the theme of tropical forest. This canvas was painted in 1908 or 1909. Unfortunately the artist's inscription is rather vague, so that it remains unclear whether the date 1908 refers to the completion of the picture or to the time when its other version was exhibited at the Salon des Indépendants. Most likely Rousseau had painted is shortly before Ambroise Vollard bought it.
According to the inscription, the Hermitage canvas is a replica of another painting, *The Jungle. Tiger Attacking a Bull* (B. 195; Vallier 152). Rousseau, however, underestimated the Hermitage picture. Although it shows obvious resemblance to the original painting, it is not so much a reproduction as a version, with a number of new vivid details.

153 JAGUAR ATTACKING A HORSE
CHEVAL ATTAQUÉ PAR UN JAGUAR

Oil on canvas. 90×116 cm
Signed, bottom right: *Henri Rousseau*
Inv. No. 3351 B. 223; Vallier 250

Provenance: 1910 A. Vollard Gallery, Paris; S. Shchukin collection, Moscow; 1918 First Museum of Modern Western Painting, Moscow; 1923 Museum of Modern Western Art, Moscow; since 1948 The Pushkin Museum of Fine Arts, Moscow

This painting is one of Rousseau's numerous works depicting tropical plants and beasts of prey. Many contemporary art scholars are inclined to think that the artist painted his exotic canvases not during his travels abroad but in the Jardin des Plantes in Paris. Apart from this, Rousseau also used illustrated magazines, geographic atlases, postcards and stamps, though many of his tropical plants are products of his imagination.

A receipt given by the artist to Ambroise Vollard confirms that the picture was purchased in 1910. This date led Dora Vallier to suggest that it was painted in the same year.

154, 155 THE POET AND HIS MUSE. PORTRAIT OF APOLLINAIRE AND MARIE LAURENCIN
LA MUSE INSPIRANT LE POÈTE. APOLLINAIRE ET MARIE LAURENCIN

Oil on canvas. 131×97 cm
Signed and dated, bottom right: *H. Rousseau 1909*
Inv. No. 3334 B. 210; Vallier 227A

Provenance: 1909 A. Vollard Gallery, Paris (bought at the Salon des Indépendants for 300 francs); S. Shchukin collection, Moscow; 1918 First Museum of Modern Western Painting, Moscow; 1923 Museum of Modern Western Art, Moscow; since 1948 The Pushkin Museum of Fine Arts, Moscow

Depicted on this canvas are Guillaume Apollinaire (1880—1918), an outstanding French poet and art critic who was a close friend of Rousseau, and the painter Marie Laurencin (1885—1956).

The idea of painting a double portrait of them in the guise of a poet and his muse occurred to Rousseau after the banquet given in his honour by Pablo Picasso and other friends at the Bateau Lavoir in Montmartre. The poet André Salmon later recalled that Apollinaire, Jacob, and others had played burlesque parts at the banquet (see A. Salmon, *Souvenirs sans fin (1908—1920)*, Paris, 1956, pp. 48—65). By early 1909 the portrait had been finished and the artist exhibited it at the Salon des Indépendants under the title *La Muse inspirant le Poète* (Cat. No. 1385).

The flowers in the picture's foreground are meant to symbolize the Poet's immortal soul. Having completed the work, Rousseau came to realize that he had thoughtlessly painted gillyflowers instead of the intended Turkish carnations, so he did the entire composition again. This second version of *The Poet and His Muse*, which was finished in August 1909, found its way into Apollinaire's collection. Now it is in the Öffentliche Kunstsammlung, Basel (Vallier, 227B).

156 VIEW OF THE FORTIFICATIONS TO THE LEFT OF THE GATE OF VANVES
VUE DES FORTIFICATIONS À GAUCHE DE VANVES

Oil on canvas. 31×41 cm
Signed, bottom left: *Henri Rousseau*
On the back of the canvas was a label with the inscription in Rousseau's hand: *Vue prise commune de Vanves à gauche de la porte de ce nom. Septembre 1909. Henri Rousseau*
Inv. No. 6535 B. 207; Vallier 66

Provenance: A. Vollard Gallery, Paris; 1912 S. Shchukin collection, Moscow; 1918 First Museum of Modern Western Painting, Moscow; 1923 Museum of Modern Western Art, Moscow; since 1930 The Hermitage, Leningrad

The picture is dated September 1909 on the evidence of the inscription on the back of the canvas. This is one of the rare views of the Gate of Vanves where stood the custom-house in which Rousseau held the post of inspector; hence his nickname, Le Douanier. The Hermitage canvas is the third version of this landscape. The first, from the former collection of Robert Delaunay (B. 209), is a study painted in a free sweeping manner and, without doubt, directly from life. The second version, from the ex-collection of K. Glaser (B. 208), is close to the study in the disposition of all elements; Dora Vallier dates it 1896 and puts forward a view that a growing demand for Rousseau's paintings around 1910 prompted him to turn to his earlier works.

In the third version of this subject, which is in the Hermitage, the artist left the character of the locality unchanged, but introduced a number of new details, such as the telegraph poles or the tiny cottages beyond the bushes at right. The almost monochrome colour range is enlivened by the pink dab of a female figure placed in the very centre of the composition.

157 VIEW OF THE MONTSOURIS PARK
PROMENADE AU PARC MONTSOURIS

Oil on canvas. 46×38 cm
Signed, bottom left: *H. Rousseau*
Inv. No. 3332 B. 89; Vallier 245

Provenance: S. Shchukin collection, Moscow; 1918 First Museum of Modern Western Painting, Moscow; 1923 Museum of Modern Western Art, Moscow; since 1948 The Pushkin Museum of Fine Arts, Moscow

The canvas depicts a walk in the old Montsouris Park on the outskirts of Paris, near the Gate of Saint-Jacques. Rousseau painted a number of views of this park, which he passed on his way to the custom-house. In Rousseau's lifetime the park still retained a semirural appearance; from there one could have a view of the picturesque Chaumont hills. On the other hand, a railway station and a water reservoir were

quite close to this bit of natural scenery, and this must have also attracted Rousseau whose landscapes often include, and even focus upon, different "signs of civilization".

The Moscow picture is usually dated 1895, the year when, according to Wilhelm Uhde, a similarly entitled picture was on display in the Salon des Indépendants. Dora Vallier dates it 1910, assigning it to the artist's later period.

With regard to its spatial organization, the Moscow canvas is closely related to the canvases depicting Paris suburbs (B. 103, 113, 164, 167, 178).

158 VIEW OF THE SÈVRES BRIDGE AND THE HILLS OF CLAMART, SAINT-CLOUD, AND BELLEVUE

VUE DU PONT DE SÉVRES ET DES COTEAUX DE CLAMART, SAINT-CLOUD ET BELLEVUE

Oil on canvas. 80×102 cm

Signed and dated, bottom left: *Henri J. Rousseau 1908*

Inv. No. 3333 B. 197; Vallier 215A

Provenance: S. Shchukin collection, Moscow; 1918 First Museum of Modern Western Painting, Moscow; 1923 Museum of Modern Western Art, Moscow; since 1948 The Pushkin Museum of Fine Arts, Moscow

According to Dora Vallier, Rousseau painted this picture from a photograph which featured only the aeroplane. The balloon and the airship were added later. Rousseau keenly observed the trial flight of the airship *Patrie* which took place on 14 July 1907. Besides the Moscow canvas, the representation of this airship appears in two more pictures of 1907—8 (B. 184, 186; Vallier 203, 205A). There exists a study for the Moscow painting (B. 198; Vallier 215B). A picture similar to the Moscow canvas, although without the airship or aeroplane, *Paysage de la Seine à Meudon* (A. M. Voemef collection, Düsseldorf), was reproduced by Zervos (Ch. Zervos, *Henri Rousseau*, Paris, 1927, p. 92). Sterling suggests that it is the first version of the Pushkin Museum's picture.

HENRI DE TOULOUSE-LAUTREC. 1864—1901

159 WOMAN WITH A TRAY (BREAKFAST) FEMME AU PLATEAU (PETIT DÉJEUNER)

Black chalk. 40×52 cm

Signed in monogram in a circle, bottom right: *HTL*

Inv. No. 10305

Provenance: M. Morozov collection, Moscow; 1910 The Tretyakov Gallery, Moscow (gift of Morozov's widow); 1925 Museum of Modern Western Art, Moscow; since 1948 The Pushkin Museum of Fine Arts, Moscow

A drawing for one of the lithographs in the album *Elles*, published in 100 copies in 1896, which depicted scenes from the life of prostitutes in Parisian brothels. It consisted of ten sheets plus the title-sheet which

also served as an advertisement of the edition. The drawing shows Mme Baron and her daughter, Mlle Popo (Pauline). Lautrec used these models as subjects for other prints of the series. The drawing is essentially a sketch from life, based upon the contrast between the barely suggested main drawing and Pauline's head rendered in a deep black tone.

160 THE SINGER YVETTE GUILBERT LA CHANTEUSE YVETTE GUILBERT

Tempera on cardboard. 57×42 cm

Signed and dated, bottom left: *H T Lautrec 94* (*H, T* and *L* are in monogram)

Above the signature is a half-obliterated inscription: *A Arsène Alexandre*

Inv. No. 3446

Provenance: A. Alexandre collection, Paris; 1903 Bernheim-Jeune Gallery, Paris; M. Morozov collection, Moscow; 1910 The Tretyakov Gallery, Moscow (gift of Morozov's widow); 1925 Museum of Modern Western Art, Moscow; since 1948 The Pushkin Museum of Fine Arts, Moscow

Yvette Guilbert (1867—1944) posed for Lautrec on more than one occasion. The Moscow work, which shows the actress singing the song *Linger, longer, loo*, was the first sketch for her portrait which appeared in the 7th issue of the review *Le Rire* for 1894. Printed in a small number of copies, it was sent as a bonus to the subscribers. The sketch was intended for Arsène Alexandre, the editor of the review, and remained in his possession until 8 May 1903, when his collection was sold at the Georges Petit Gallery.

161 LADY BY THE WINDOW FEMME À LA FENÊTRE

Tempera on cardboard. 71×47 cm

Signed and dated, bottom left: *H T Lautrec 89* (*H, T* and *L* are in monogram)

Inv. No. 3288

Provenance: S. Shchukin collection, Moscow; 1918 First Museum of Modern Western Painting, Moscow; 1923 Museum of Modern Western Art, Moscow; since 1948 The Pushkin Museum of Fine Arts, Moscow

This is a study for Lautrec's painting *Au bal du Moulin de la Galette*, now in the Art Institute of Chicago. The head of the young woman with a chignon, in profile, and her upper body appear almost unchanged in the Chicago painting. Placed in the lower left foreground cut by a barrier separating the café tables from the dancing floor, she is allotted a central place in the cross-diagonal composition of the canvas. Her profile directly faces that of the artist Joseph Albert, who is portrayed at the table in the right-hand part.

G. M. Sugana identifies the model depicted in both the Moscow study and the Chicago painting with a certain Mlle Jeanne Fontaine. Her portrait, done by Toulouse-Lautrec and known as *Girl in a Mantlet*

Trimmed with Fur (Fille à la fourrure) is now in the famous Laroche collection in Paris (see *L'opera completa di Toulouse-Lautrec*, Milan, 1969, pls. 241A, 247).

PAUL HELLEU. 1859—1927

162 ON THE SOFA
SUR LE CANAPÉ

Pastel. 50×68 cm
Signed, bottom right: *Helleu*
Inv. No. 3432

Provenance: Dumont Gallery, Paris; P. Shchukin collection, Moscow; 1912 Russian History Museum, Moscow (bequeathed by P. Shchukin); 1922 Second Museum of Modern Western Painting, Moscow; 1923 Museum of Modern Western Art, Moscow; since 1948 The Pushkin Museum of Fine Arts, Moscow

The model resembles Alice Helleu, the artist's wife, whom he regularly painted in domestic surroundings or during promenades. Helleu hardly ever dated his works. The model's costume appears to be in the style of the mid-1890s, which allows to refer the Moscow pastel to the same period.

163 LADY IN WHITE
DAME EN BLANC

Oil on canvas. 82×66 cm
Signed, bottom right: *Helleu*
Inv. No. 3433

Provenance: Dede Gallery, Paris; P. Shchukin collection, Moscow; 1912 Russian History Museum, Moscow (bequeathed by P. Shchukin); 1922 Second Museum of Modern Western Painting, Moscow; 1923 Museum of Modern Western Art, Moscow; since 1948 The Pushkin Museum of Fine Arts, Moscow

This canvas is typical of Helleu's paintings, with his favourite motifs of elegant young women. In the foreword to the first edition of Helleu's works, R. de Montesquiou, who alongside with the Goncourt brothers and Octave Mirbeau, was an admirer of Helleu as draughtsman and engraver, called Helleu's œuvre a hymn to the *ewig Weibliche* (see R. de Montesquiou, *Paul Helleu. Peintre et graveur*, Paris, 1913, p. 52). The Moscow picture bears a slight resemblance to some paintings by Claude Monet, an artist whom Helleu held in the highest esteem. Most likely the woman depicted is the artist's wife Alice, whose representations appear in the engravings *L'Ombrelle* (ibid., pl. LX) and *La Robe à volants* (ibid., pl. LXI). The dress worn by the lady in the Moscow painting suggests that it was done between 1895 and 1900.

164 LADY IN PINK
DAME EN ROSE

White and red chalk and charcoal. 65.8×47.3 cm
Signed in pencil on the left, below centre: *Helleu*
Inv. No. 6247

Provenance: P. Shchukin collection, Moscow; 1912 Russian History Museum, Moscow (bequeathed by P. Shchukin); 1926 Museum of Modern Western Art, Moscow; since 1948 The Pushkin Museum of Fine Arts, Moscow

Helleu won his public reputation as creator of the so-called *têtes d'Helleu* — portraits of high-society belles, almost devoid of any individual characteristics. It was no accident that many of his portraits, instead of the names of the models, are designated by some conspicuous detail of their fashionable dresses, as *The Blue Bow (Le Nœud bleu)*, *The Hat with a Feather (Le Chapeau à plume)*, and so on. Also characteristic is the fact that Helleu, who in many ways shaped the tastes of the élite of the Belle Epoque, adhered to the specifically French tradition of multicoloured drawing.

JEAN-LOUIS FORAIN. 1852—1931

165 LEAVING THE MASQUERADE. BALL IN THE PARIS OPERA
À LA SORTIE DU BAL. UN BAL À L'OPÉRA

Oil on canvas. 22×16 cm
Signed, bottom left: *Forain*
Inv. No. 3348

Provenance: S. Shchukin collection, Moscow; 1918 First Museum of Modern Western Painting, Moscow; 1923 Museum of Modern Western Art, Moscow; since 1948 The Pushkin Museum of Fine Arts, Moscow

This is a small study for the right-hand group in the painting *Ball in the Opera* (private collection, Paris). Done from life or from Forain's preliminary sketches, it obviously shows a scene of seduction, reflecting — in the spirit of Emile Zola and Edouard Manet — the behind-the-scenes atmosphere at such balls. The study may be dated to the mid-1880s.

166 BALL IN THE PARIS OPERA
UN BAL À L'OPÉRA

Oil on canvas. 74×61 cm
Inv. No. 3430

Provenance: P. Durand-Ruel Gallery, Paris; P. Shchukin collection, Moscow; 1912 Russian History Museum, Moscow (bequeathed by P. Shchukin); 1922 Second Museum of Modern Western Painting, Moscow; 1923 Museum of Modern Western Art, Moscow; since 1948 The Pushkin Museum of Fine Arts, Moscow

This is another study for the *Ball in the Opera* (private collection, Paris). In contrast to the thoroughly elaborated composition of the painting, it is treated in a more summary manner and reflects, together with the study reproduced under No. 165, the artist's searchings for the types of main personages. A comparison of the study with the final version of the compo-

sition shows that the characters depicted in the foreground of the Moscow study appear in the final version almost in the same poses. Only the lady wearing a mask looks different—the fan she is holding in the painting is absent in the study.

It is probable that the idea of creating the *Ball in the Opera* was inspired by Edouard Manet's famous painting *At Père Lathuille's* (J.-W. 325; P.-W. I, 271) and especially by *The Masquerade in the Opera* (J.-W. 219; R.-W. I, 190A). The style of the picture and studies suggests a dating in the mid-1880s.

167 THE HORSE-RACE
LES COURSES

Oil on canvas. 38×45 cm
Signed, bottom right: *J. L. forain*
Inv. No. 3347

Provenance: 1899 S. Shchukin collection, Moscow; 1918 First Museum of Modern Western Painting, Moscow; 1923 Museum of Modern Western Art, Moscow; since 1948 The Pushkin Museum of Fine Arts, Moscow

The canvas conveys the hurly-burly characteristic of the horse-races, a subject which Forain frequently turned to under the influence of Degas. At the same time the picture shows that satirical approach to the event depicted which characterized the paintings of Forain, a former caricaturist. The canvas may be dated to the late 1880s or early 1890s.

168 MUSIC HALL
MUSIC-HALL. PROMENOIR

Oil on canvas. 50.5×61 cm
Signed, bottom right: *Forain*
Inv. No. 8996

Provenance: 1898 P. Durand-Ruel Gallery, Paris (bought from the artist for P. Shchukin); 1898 P. Shchukin collection, Moscow; 1912 Russian History Museum, Moscow (bequeathed by P. Shchukin); 1922 Second Museum of Modern Western Painting, Moscow; 1923 Museum of Modern Western Art, Moscow; since 1948 The Hermitage, Leningrad

Judging by the characters' costumes, the picture was painted in the 1890s.

169 A THEATRE LOBBY
FOYER AU THÉÂTRE

Gouache and pastel on cardboard. 90×72 cm
Signed, bottom right: *forain*
Inv. No. 3349

Provenance: P. Durand-Ruel Gallery, Paris; S. Shchukin collection, Moscow; 1918 First Museum of Modern Western Painting, Moscow; 1923 Museum of Modern Western Art, Moscow; since 1948 The Pushkin Museum of Fine Arts, Moscow

Forain is known as a painter of street and everyday scenes. He derived many of his subjects from the life of the court, cafés, circus, and theatre. The pastel reproduced shows a theatre lobby with a crowd of spectators in the background. From this crowd the artist picks out several characters who must have struck him as remarkable in some way, and builds a *mise-en-scène* around them. Judging by the dresses, the pastel was produced in the mid-1890s.

170 DANCER
DANSEUSE

Pastel on brownish-grey paper. 53×41 cm
Signed, bottom right: *forain*
Inv. No. 40404

Provenance: The Tretyakov Gallery, Moscow; S. Shchukin collection, Moscow; 1918 First Museum of Modern Western Painting, Moscow; 1923 Museum of Modern Western Art, Moscow; since 1935 The Hermitage, Leningrad

This pastel was executed not later than 1885 or the beginning of 1886, since in the spring of 1886 it was shown at an exhibition of French art in New York. The choice of both subject and medium reveals a debt to Edgar Degas. Compared to Degas's dancers, however, Forain's ballerina is rather static. Depicted against a neutral background, she looks not so much a ballet dancer as a model in ballet costume. A certain incompleteness in the rendition of her pose suggests that Forain intended to use it as a basis for some subject painting.

171 I'M READY, DOCTOR
JE SUIS À VOUS, DOCTEUR

Indian ink, crayon and pencil. 44×36 cm
Signed, bottom right: *forain*
Inscribed in Indian ink, bottom left: *Je suis à vous, docteur* (the inscription is crossed out with pencil)
Inv. No. 10309

Provenance: M. Morozov collection, Moscow; 1910 The Tretyakov Gallery, Moscow (gift of Morozov's widow); 1923 Museum of Modern Western Art, Moscow; since 1948 The Pushkin Museum of Fine Arts, Moscow

A drawing for one of the lithographs in Forain's album *La Comédie Parisienne* (Deuxième série, Paris, 1904, p. 161). The lithograph in this album bears an inscription: *A la cantonnade. — Dis donc... c'est ce que vous appelez une visite de digestion?* and is reproduced under the heading *Le Monde*. The inscription *Je suis à vous, docteur* is absent.

THÉOPHILE-ALEXANDRE STEINLEN. 1859—1923

172 DANCING-FLOOR IN A PARIS SUBURB
BAL DANS UN FAUBOURG DE PARIS

Chalk, graphite, and crayons. 33.5×54.3 cm
Signed, bottom right: *Steinlen*
Inv. No. 24979

Provenance: Private collection, Petrograd; since 1922 The Hermitage, Petrograd/Leningrad

The Hermitage sheet is related to a 1898 lithograph of the same title, which repeats its composition and colour scheme. In his drawings, including the present one, the vivid, poster-like style of Steinlen's graphic language, invariably combined with a clear, highly generalized idea, serves to express the artist's acute awareness of social injustice.

173 AFTER WORK
SORTIE D'ATELIER

Charcoal drawing on laid paper with watermark *MBM France*. 63×48 cm
On reverse, the artist's seal, bottom right (Lugt, *Supplement*, 2341b)
Inv. No. 6089

Provenance: 1926 Museum of Modern Western Art, Moscow; since 1948 The Pushkin Museum of Fine Arts, Moscow

Many of Steinlen's drawings, etchings and lithographs produced between 1890 and the early 1900s show seamstresses, laundresses, and milliners walking in noisy little groups along the streets of the workers' quarters in Paris.

The manner of execution and the character of the scene are typical of the artist's works of the early 1900s. Nina Kalitina, however, dates the drawing to the 1890s (see N. Kalitina, *Steinlen*, Moscow, 1959, No. 10, in Russian).

174 TWO CATS
DEUX CHATS

Tempera on unprimed canvas. 61×64 cm
Signed, bottom left: *Steinlen*
Inv. No. 3463

Provenance: Z. Domashneva collection, Moscow; 1921 The Tretyakov Gallery, Moscow; 1923 Museum of Modern Western Art, Moscow; since 1948 The Pushkin Museum of Fine Arts, Moscow

This is a sketch for the poster advertising Steinlen's one-man exhibition of 1894. There is also a colour lithograph on the same theme (see E. Crauzat, *L'Œuvre gravé et lithographié de Steinlen*, Paris, 1913, p. 492). According to Crauzat, Steinlen first did a drawing and then the Moscow tempera. As the poster was done in 1894, this tempera may be dated the same year.

LOUIS LEGRAND. 1869—1951

175 ON FURLOUGH
EN PERMISSION

Black chalk and pastel on paper mounted on cardboard. 74×109 cm
Signed, top left: *Louis Legrand*, with the artist's monogram in a rhomb

Provenance: 1904 I. Morozov collection, Moscow (bought at Pellet's shop in Paris); 1919 Second Museum of Modern Western Painting, Moscow; 1923 Museum of Modern Western Art, Moscow; since 1948 The Pushkin Museum of Fine Arts, Moscow

Louis Legrand is known as a painter of everyday scenes, one of which is this Moscow pastel depicting the meeting of a girl and a soldier who has come on furlough to his native village.

176 THE APACHE'S SUPPER
LE SOUPER DE L'APACHE

Charcoal and pastel. 63×49 cm
Signed, dated and monogrammed, top right: *Louis Legrand 1901*
Inv. No. 3388

Provenance: 1903 I. Morozov collection, Moscow (bought for 1,500 francs at the Salon de la Société Nationale des Beaux-Arts in Paris); 1919 Second Museum of Modern Western Painting, Moscow; 1923 Museum of Modern Western Art, Moscow; since 1948 The Pushkin Museum of Fine Arts, Moscow

Louis Legrand made an etching from this pastel (in reverse) in the drypoint technique (see C. Mauclair, *Louis Legrand, peintre et graveur*, Paris, s.a., p. 150, pl. 156).
The last two figures in the author's date are hardly legible, but it should probably be read as 1901.

177 SELF-PORTRAIT
PORTRAIT DE L'ARTISTE PAR LUI-MÊME

Black chalk and watercolour. 28×25 cm
Signed, bottom right: *Louis Legrand*
Inv. No. 10317

Provenance: M. Riabushinsky collection, Moscow; 1918 Museum of Fine Arts, Moscow; 1923 Museum of Modern Western Art, Moscow; since 1948 The Pushkin Museum of Fine Arts, Moscow

This is a drawing for a similarly entitled etching (see C. Mauclair, *Louis Legrand, peintre et graveur*, Paris, s.a., p. 177), in which it is reproduced in reverse. The shape of the armchair's back in the etching is slightly changed and above it is a decorative tree branch.
The drawing is highly finished and beautifully tinted by watercolour — the features characteristic of the Belle Epoque.

GEORGES MANZANA-PISSARRO. 1870—1961

178 ZEBRAS AT A WATERING-PLACE
ZÈBRES S'ABREUVANT

Watercolour, gouache, and gold. 64.5×51.6 cm
Signed, bottom right: *G. Manzana*
Inv. No. 42161

Provenance: A. Vollard Gallery, Paris; 1907 I. Morozov collection, Moscow; 1918 Second Museum of Modern Western Painting, Moscow; 1923 Museum of

Modern Western Art, Moscow; since 1934 The Hermitage, Leningrad

The Hermitage sheet belongs to an early cycle of decorative compositions exhibited in Paris in 1906 and 1907. The rhythm involving a linear arabesque with subdued shimmering colours dominates all the forms and unites the elegant outlines of the zebras and the woman's figure with an exotic fruit in her hands, the golden patterns on the water and the stripes of the animals' skin.

ODILON REDON. 1840—1916

179 WOMAN LYING UNDER A TREE. STUDY
ÉTUDE D'UNE FIGURE ÉTENDUE SOUS UN ARBRE

Tempera on canvas. 26×35 cm
Signed, bottom left: *Odilon Redon*
Inv. No. 43782

Provenance: S. Shchukin collection, Moscow; 1918 First Museum of Modern Western Painting, Moscow; 1923 Museum of Modern Western Art, Moscow; since 1948 The Hermitage, Leningrad

The Hermitage tempera may apparently be placed halfway between a "study for the author", made either from nature or in direct contact with nature, and a composition from the artist's imagination. In the Shchukin collection it was catalogued as *Man Lying under a Tree*. However, the figure under the tree can be perceived either as a man or as a woman. An oddly shaped patch of green on the figure's breast is vaguely reminiscent of a frog, which permits the assumption that the figure is invested with a certain symbolic quality, evidently connected with Redon's compositions on the themes from the life of Buddha, particularly with his pastel *The Death of Buddha* (formerly in the collection of Henri Matisse, Paris).

180 DAY AND NIGHT
LE JOUR ET LA NUIT

Pastel on cardboard. 47×61 cm
Signed, bottom left: *Odilon Redon*
Inv. No. 3451

Provenance: Tolstoi collection, Moscow (?); A. Strelkov collection, Moscow; 1925 Museum of Modern Western Art, Moscow; since 1948 The Pushkin Museum of Fine Arts, Moscow

From 1908 to 1911 Redon decorated the interiors of the Fontfroide Abbey. He painted two large panels for it, *Day* and *Night*. Since the present pastel unites the two titles, it might have been done in the process of work on the above-mentioned panels, i.e. between 1908 and 1911. It reflects the entire concept of Redon's interior decoration — the contrast of Light and Darkness, of Day and Night. In one of his earlier lithographic series, *Les Origines* (1883), there is a sheet depicting an austere female profile. The same

profile appears in the Moscow picture as a symbol of awakening from a nightmare.

In the lower right-hand part of his panel *Night* Redon painted the profile of a chimera. Earlier, in 1889, he depicted a chimera on the frontispiece of Jules Destrée's book *Les Chimères*, while in 1890 this image occurred in a series of prints illustrating *Les Fleurs du mal* by Baudelaire (Mellério 105, 203).

In the panel *Day* the image of Apollo in a chariot is identified with the sun bringing back daylight. In the Moscow pastel Apollo is replaced by a mysterious bouquet of flowers with blurred outlines.

181 PROFILE OF A WOMAN IN THE WINDOW
PROFIL DE FEMME À LA FENÊTRE

Pastel on cardboard. 63×49 cm
Signed, bottom left: *Odilon Redon*
Inv. No. 3327

Provenance: S. Shchukin collection, Moscow; 1918 First Museum of Modern Western Painting, Moscow; 1923 Museum of Modern Western Art, Moscow; since 1948 The Pushkin Museum of Fine Arts, Moscow

For the first time a profile of golden-haired Brunhild (Mellério 130) on the background of leaves and flowers occurs in Redon's 1894 series of lithographs relating to Richard Wagner's operas *Parsifal* and *Götterdämmerung*.

The present pastel, as well as another one, *Day and Night* (No. 180), was produced in the 1910s, when the artist devoted himself to decorative painting. In composition — a woman's profile placed against a lancet arch of the window — it recalls a sketch for a stained-glass panel, and it is quite possible that was what Redon intended it to be. A similar treatment of the theme (without the window) can be found in the pastel *Women with Flowers* (1903, private collection, New York), in the painting *Two Heads among Flowers* (1905, private collection, U.S.A.), and in the pastel *Ophelia* (1910, private collection, New York).

182 SPRING
LE PRINTEMPS

Oil and tempera on canvas. 178×120 cm
Signed, bottom right: *Odilon Redon*
Inv. No. 3328

Provenance: S. Shchukin collection, Moscow; 1918 First Museum of Modern Western Painting, Moscow; 1923 Museum of Modern Western Art, Moscow; since 1948 The Pushkin Museum of Fine Arts, Moscow

The canvas was painted during Redon's later period, when he began to introduce into his easel works nude figures in the guise of mythological characters. This may be exemplified by *Pandora* (*ca.* 1910, The Metropolitan Museum, New York), *The Birth of Venus* (*ca.* 1912, private collection, Paris), *Andromeda* (1912, private collection, New York), and other pictures.

The pose of the nude with her arms arched above her head resembles the pose of Andromeda in the picture from the New York collection. This provides good grounds for assuming that *Spring* was painted around 1910. The tree against which the nude leans does not appear in the above-mentioned canvases with classical goddesses, but occurs in a number of Redon's early drawings and lithographs done at his family estate Peyrelebade near Bordeaux (e.g. Mellério 120).

183 WOMAN WITH WILD FLOWERS
FEMME AUX FLEURS DES CHAMPS
Pastel and charcoal on buff paper. 52×37.5 cm
Signed, bottom right: *Odilon Redon*
Inv. No. 46438

Provenance: Private collection, Moscow; since 1975
The Hermitage, Leningrad

Iconographically, *Woman with Wild Flowers* is similar to pastels done in the black-and-white manner which Redon favoured until 1890. In the emotional respect, however, the image of the woman with wild flowers is most akin to *Jeanne d'Arc* (private collection, Paris) and can be perceived as a variation on the theme of the Maid of Orleans.

Redon's favourite combination of charcoal drawing with complementary pastels — yellow, green, and blue — is demonstrated most clearly in his works produced in the mid- and late 1890s.

184 DRAWING FOR THE COVER OF *THE BALANCE* (*VESY*) JOURNAL
Charcoal on yellowish paper. 44×29 cm
Signed, bottom right: *Od.R*
Inv. No. 10282

Provenance: S. Poliakov collection, Moscow; 1924
Museum of Modern Western Art, Moscow; since 1948
The Pushkin Museum of Fine Arts, Moscow

This drawing for the cover of the literary and critical journal of the Russian Symbolists consists of two parts, with the vertically placed lettering of the title on the left and the representation proper on the right. In the lower right-hand corner the artist drew the Libra, the sign of the Zodiac corresponding to, and serving as the symbol of, the journal's title.

The drawing was reproduced on the covers of three 1904 issues: in black tone (issue 4), in reddish-brown (issue 5), and in yellowish-brown (issue 6).

The commission to do these drawings came through Maximilian Voloshin, the Russian poet and artist who lived in Paris at the time. In addition to the cover and several head- and tailpieces executed by Redon, the 4th issue of *The Balance* published Voloshin's article on Odilon Redon, the French artist's autobiographical notes (*Redon about Himself*) and some materials under the heading *Redon in the Recollections of His Contemporaries*.

185—197 HEAD- AND TAILPIECES FOR *THE BALANCE* (*VESY*) JOURNAL

185 COMPOSITION VI: *PROFILE WITH A BLACK CIRCLE*
Indian ink and brush on cardboard. 22×15.7 cm; 13.8×12.7 cm [1]
Signed, bottom right: *Od. R.*
Inv. No. 10291

Reproduced in *The Balance*, 1904, 4, p. 9 as a tailpiece to the article *Redon about Himself*.

186 COMPOSITION VIII: *HEAD OF A WOMAN* *[2]
Indian ink and brush on laid paper. 31.5×23.8 cm; 5.8×4.7 cm
Signed, bottom right: *Od. R.*
Inv. No. 10292

Reproduced in *The Balance*, 1904, 4, p. 16 as a tailpiece to *Redon in the Recollections of His Contemporaries*.

187 COMPOSITION X: *GROTESQUE* *
Indian ink and brush on laid paper with watermark *MBM*. 31.4×24.1 cm; 11.5×9.2 cm
Signed, bottom right: *Od. R.*
Inv. No. 10294

Reproduced in *The Balance*, 1904, 4, twice — on the back of the frontispiece and on p. 78 as a tailpiece to the section *Reviews*.

188 COMPOSITION IX: *PAN* *
Indian ink and brush on Bristol board. 24.4×32.7 cm; 7.7×20.5 cm
Signed, bottom right: *Od. R.*
Inv. No. 10293

Reproduced in *The Balance*, 1904, 4, p. 17 as a headpiece to I. Rachinsky's article *Hugo Wolf*.

189 COMPOSITION II: *THE SETTING SUN* *
Indian ink and brush on laid paper. 20.8×24 cm; 9.1×12 cm
Signed, bottom right: *Od. R.*
Inv. No. 10285

Reproduced in *The Balance*, 1904, 5, p. 1 as a headpiece to Stanislaw Przybyszewski's article *Sons of the Earth*.

[1] Since in many drawings the image size is considerably smaller than the sheet size, dimensions are reproduced first for the sheet size and followed by those for the image size.
[2] The drawings marked with an asterisk bear inscriptions made at a later date in ink; in the reproductions published in *The Balance* they are absent.

190 COMPOSITION III: *NUDE* *

Indian ink and brush on laid paper with watermark *MBM*. 24×62 cm; 20.2×31.1 cm
Signed, top left: *Od. R.*
Inv. No. 10286

Reproduced in *The Balance*, 1904, 5, p. 17 as a head-piece to Viacheslav Ivanov's article *Nietzsche and Dionysus*.

191 COMPOSITION VII *

Indian ink and brush on laid paper. 23.8×30.9 cm; 7.8×24.1 cm
Signed, bottom left: *Od. R.*
Inv. No. 10287

Reproduced in *The Balance*, 1904, 4, p. 10 as a head-piece to *Redon in the Recollections of His Contemporaries*.

192 GIRL WITH A FLOWER *

Indian ink and brush on laid paper. 17.8×9.1 cm; 16.3×8 cm
Signed, bottom right: *Od. R.*
Inv. No. 10400

Reproduced in *The Balance*, 1904, 5, p. 3 as a tail-piece to Stanislaw Przybyszewski's article *Sons of the Earth*.

193 COMPOSITION XI: *HEAD OF A MAN* *

Indian ink and brush on greyish laid paper. 31.3×24.1 cm; 9.4×8.8 cm
Signed, bottom right: *Od. R.*
Inv. No. 10295

Reproduced in *The Balance*, 1904, 5, p. 16 as a tail-piece to Vasily Rozanov's article *On a Poem by Lermontov*.

194 COMPOSITION V: *MASK* *

Indian ink and brush on laid paper. 10.7×12.8 cm; 6×8 cm
Signed in monogram, bottom right: *OR*
Inv. No. 10290

Reproduced in *The Balance*, 1904, 4, p. 4 as a tail-piece to Maximilian Voloshin's article *Odilon Redon*.

195 COMPOSITION XII (HATCHED) *

Indian ink, pen and brush on laid paper with watermark *MBM*. 24.6×30.9 cm; 5.7×20 cm
Signed left of centre, bottom: *Od. R.*
Inv. No. 10296

Reproduced in *The Balance*, 1904, 4, p. 5, as a head-piece to the article *Redon about Himself*.

196 COMPOSITION I: *MARBLE BUST*

Indian ink and brush on yellowish paper. 21×25.8 cm; 11.2×12.5 cm
Signed, bottom right: *Od R*
Inv. No. 10289

Reproduced in *The Balance*, 1904, 5, p. 4 as a head-piece to Vasily Rozanov's article *On a Poem by Lermontov*.

197 COMPOSITION XIII: *PROFILE WITH A BLACK TRIANGLE*

Indian ink, brush and pen on Bristol board. 22.1×15.6 cm; 16.5×11.5 cm
Signed, bottom right: *Od. R.*
Inv. No. 10297

Reproduced in *The Balance*, 1904, 4, p. 29 as a tail-piece to I. Rachinsky's article *Hugo Wolf*.

KER XAVIER ROUSSEL. 1867—1944

198 MYTHOLOGICAL MOTIF
SUJET MYTHOLOGIQUE. LA CHÈVRE

Oil on cardboard. 47×62 cm
Inv. No. 9065

Provenance: Bernheim-Jeune Gallery, Paris (there is a label with the owner's name on the back of the cardboard); 1911 K. Nekrasov collection, Moscow (purchased through the agency of P. Muratov in Paris); S. Poliakov collection, Moscow; 1918 The Tretyakov Gallery, Moscow (purchased from Poliakov); 1925 Museum of Modern Western Art, Moscow; since 1948 The Hermitage, Leningrad

Mythological Motif may be dated only tentatively around 1905—1906, on the basis of the following indirect evidence: the women's hairstyle corresponding to the fashion of 1905—1906; the resonant bright colours of the bay — perhaps a fresh memory of the sky-blue Mediterranean coast along which Roussel travelled with Maurice Denis at the beginning of 1906; and the painterly technique in the treatment of the sky — the broad rectangular brushstrokes with well-defined edges — typical of a number of Roussel's works done in 1905—1906, possibly under the influence of Cross. This technique is especially evident in *View of Saint-Tropez*, dated 1906 by the artist (private collection, Paris). The media and similar measurements also point to a link between the Hermitage and Paris works. The subject of the Hermitage work is difficult to decipher. There is an assumption that it is related to the myth of the she-goat Amalthea, the wet-nurse of Zeus. It may also, however, be interpreted as a hint at the idyllic world of Arcadia.

199 RURAL FESTIVAL. DECORATIVE PANEL
FÊTE CHAMPÊTRE. PANNEAU DÉCORATIF

Oil on canvas. 166.5×119.5 cm
Signed and dated, bottom right: *K. X. Roussel 913*

Inv. No. 9165. Pendant piece to No. 200

Provenance: A. Vollard collection, Paris; 1913 I. Morozov collection, Moscow (purchased, together with its pendant, for 10,000 francs); 1919 Second Museum of Modern Western Painting, Moscow; 1923 Museum of Modern Western Art, Moscow; since 1948 The Hermitage, Leningrad

In 1911, Roussel painted two companion pictures which are regarded as the preliminary sketches for the curtain of the Théâtre des Champs-Elysées. They represent the bacchanalian dance during the grape-harvest festival. In the same year they were displayed at the Salon d'Automne in Paris. One of these pictures is in the Hermitage, the other, in the Pushkin Museum of Fine Arts in Moscow.

In 1913, after Ivan Morozov had bought both works, the artist repainted them in bright colours over the original muted greyish-browns. Traces of the original colour are still visible along the edges of the canvases. At the same time Roussel wrote the date, 1913, on both pictures, although they were executed two years earlier (see B. Ternovetz, *Letters, Diaries, Articles*, Moscow, 1977, p. 114, in Russian).

A canvas compositionally similar to the Hermitage picture (private collection, Paris) was exhibited under the title *Les Vendanges* in the Orangerie des Tuileries in Paris in 1968 (see *E. Vuillard — K. X. Roussel. Orangerie des Tuileries, 28 mai — 16 septembre 1968,* No. 282).

200 RURAL FESTIVAL. SUMMER
FÊTE CHAMPÊTRE. L'ÉTÉ

Oil on canvas. 164×123 cm
Signed and dated, bottom right: *K. X. Roussel 0.13*
Inv. No. 3408
Pendant piece to No. 199

Provenance: 1911 A. Vollard Gallery, Paris; 1913 I. Morozov collection, Moscow (purchased, together with its pendant, for 10,000 francs); 1918 First Museum of Modern Western Painting, Moscow; 1919 Second Museum of Modern Western Painting, Moscow; 1923 Museum of Modern Western Art, Moscow; since 1948 The Pushkin Museum of Fine Arts, Moscow

The canvas represents Ceres, the Roman goddess associated with summer, riding her chariot drawn by panthers and driven by naked boys.

ÉDOUARD VUILLARD. 1868—1940

201 IN THE GARDEN
AU JARDIN

Tempera on cardboard. 51×83 cm
Signed, bottom right: *E Vuillard*
Inv. No. 3447

Provenance: S. Shcherbatov collection, Moscow; 1918 Rumiantsev Museum, Moscow; 1924 Museum of Fine Arts, Moscow; 1925 Museum of Modern Western Art, Moscow; since 1948 The Pushkin Museum of Fine Arts, Moscow

In 1894—95, Vuillard worked on huge decorative panels for the dining-room in the house of Alexandre Natanson, a collector and one of the publishers of *La Revue blanche*. The present picture may belong to the same period. Although small in size, it is executed in the same decorative manner typical of Vuillard as the big panels installed in Natanson's house. In his *Jardins de Paris* series, which includes this tempera, Vuillard, striving to achieve a muted colour scale, lends his colours a special matt quality. In the Moscow picture this quality is enhanced by tempera which the artist used instead of oils.

202, 203 THE ROOM
INTÉRIEUR

Oil on cardboard pasted on a cradled panel. 52×79 cm
Signed and dated, top right: *E Vuillard 93 (99?)*
Inv. No. 6538

Provenance: P. Shchukin collection, Moscow; 1912 S. Shchukin collection, Moscow; 1918 First Museum of Modern Western Painting, Moscow; 1923 Museum of Modern Western Art, Moscow; since 1930 The Hermitage, Leningrad

The Room is dated by the artist, but the last digit of the date may be read either as 3 or 9, which makes it extremely difficult to accurately define the time of its execution. Its flat surfaces with concentrated areas of recession, the small human silhouettes in the distance, and the muted greys — these are all features that occur in Vuillard's canvases done in the late 1890s. It should be noted, however, that in the early 1890s Vuillard also made use of these devices.

204 INTERIOR
DANS LA CHAMBRE

Oil on cardboard. 50×77 cm
Signed, bottom left: *E. Vuillard*
Inv. No. 3366

Provenance: Bernheim-Jeune Gallery, Paris; 1904 I. Morozov collection, Moscow; 1919 Second Museum of Modern Western Painting, Moscow; 1923 Museum of Modern Western Art, Moscow; since 1948 The Pushkin Museum of Fine Arts, Moscow

In the late 1890s and early 1900s, Vuillard worked on a sequence of paintings known as *Personnages dans des intérieurs*.

In the man with a long beard, seated at the table in the depth of the picture, one can easily recognize the writer Tristan Bernard. The 1905 painting, *Salon of Tristan Bernard*, now at the National Gallery, Ottawa, shows the same crystal chandelier that is depicted in the Moscow picture. The similarity of details makes it plain that the *Interior*, executed in 1904, also represents the salon of Tristan Bernard.

205 CHILDREN IN A ROOM
ENFANTS DANS UN INTÉRIEUR

Gouache. 84.5×77.7 cm
Signed, bottom right: *E. Vuillard*
Inv. No. 42153

Provenance: Bernheim-Jeune Gallery, Paris; M. Zetlin collection, Moscow; Rumiantsev Museum, Moscow; 1924 Museum of Fine Arts, Moscow; 1925 Museum of Modern Western Art, Moscow; since 1934 The Hermitage, Leningrad

In a long sequence of works depicting the ordinary domestic interiors Vuillard established himself as an interpreter *par excellence* of home life, with its cosiness and peace.

The interiors, which he usually peoples with women and children, serve not as a background but as an emotional and intellectual milieu in which man lives and with which he is inseparably linked. To make this environment more alive, to fill it with light and air, the artist often employs the device of a window or a balcony as the backdrop.

This gouache is traditionally assigned to the year 1909, but in style it is related to the artist's works done in different years, especially to those of 1905—1907.

206 ON THE SOFA. WHITE ROOM
SUR LE SOFA. LA CHAMBRE BLANCHE

Oil on cardboard, mounted on panel. 32×38 cm
Signed, bottom left: *E. Vuillard*
Inv. No. 3441

Provenance: Bernheim-Jeune Gallery, Paris; A. Liapunov collection, Moscow; 1918 The Tretyakov Gallery, Moscow; 1925 Museum of Modern Western Art, Moscow; since 1948 The Pushkin Museum of Fine Arts, Moscow

This harmoniously composed study may be dated to 1890—93, when Vuillard painted on cardboard small interiors, such as *Two Doors* (*Les Deux portes*) or *The Open Door* (*La Porte ouverte*), both in private collections in Paris. In this study also the artist depicts a white door with a glazed top, whose huge dark handle is assigned an essential part in the composition. In keeping with the Nabis doctrines, Vuillard tried to achieve in his series of interiors an ultimate harmony of colour zones and a cohesive unity of volumes arranged on the picture plane. This series reveals his extraordinary sense of intimacy and his ability to impart significance to the most prosaic, commonplace motif. It is this ability that distinguished Vuillard from the other Nabis.

207 INTERIOR. LADY BY THE WINDOW
INTÉRIEUR. DAME À LA FENÊTRE

Oil on cardboard. 41×33 cm
Signed, bottom right: *E Vuillard*
Inv. No. 4256

Provenance: Max Kaganovitch collection, Paris; since 1977 The Pushkin Museum of Fine Arts, Moscow (gift of Max Kaganovitch)

The study is painted in an elegant silvery-pink colour scale typical of Vuillard. Its subject and execution have an affinity with compositions from the *Personnages dans des intérieurs* series on which the artist worked at the turn of the century. The model's costume and the way the colours are applied relate this study to such paintings as *La Chambre ensoleillée* (*ca.* 1908, The Minneapolis Institute of Arts, U.S.A.) and *Portrait de Claude* (1906, Musée d'Art Moderne de la Ville de Paris). Probably the study was done not earlier than 1906.

PIERRE BONNARD. 1867—1947

208 WOMAN STANDING AT A RAILING
DERRIÈRE LA GRILLE

Oil on cardboard. 31×35 cm
Signed and dated, bottom left: *Bonnard 95*
Inv. No. 7709 Dauberville I, 98

Provenance: M. Morozov collection, Moscow; 1910 The Tretyakov Gallery, Moscow (gift of Morozov's widow); 1925 Museum of Modern Western Art, Moscow; since 1934 The Hermitage, Leningrad

In composition, the Hermitage painting has no direct analogies in the artist's work. The device of using checked patterns as decorative elements, to which Bonnard so frequently resorted in 1895, later began to serve as the means of organizing a more complex space. In this picture the railing's squares, with the snowflakes visible through them, play the role of an element seemingly interrupting space but in actual fact binding it together. A similar device is employed in the canvas *Boats at Chatou* (1896, private collection, New York).

209 A CORNER OF PARIS
UN COIN DE PARIS

Oil on cardboard pasted on cradled panel. 51×51 cm
Signed, bottom, right of centre: *Bonnard*
Inv. No. 9025 Dauberville I, 332

Provenance: A. Vollard Gallery, Paris; 1906 I. Morozov collection, Moscow (bought at the same time as the *Dauphiné Landscape* — No. 211 — for 1,000 francs); 1919 Second Museum of Modern Western Painting, Moscow; 1923 Museum of Modern Western Art, Moscow; since 1948 The Hermitage, Leningrad

Ambroise Vollard mentioned the title of this picture in his letter of 28 June 1907 to Ivan Morozov (Archives of the Pushkin Museum of Fine Arts). Thematically it is closely related to many of Bonnard's early canvases depicting street scenes in Paris.

Boris Ternovetz puts the date of the picture at the early 1900s. J. and H. Dauberville, authors of the *catalogue raisonné* of Bonnard's paintings, suggest a

more precise date, 1905. As a matter of fact, in its painterly and compositional devices, the Hermitage study recalls some of the artist's works produced in 1904—1905, for instance *Paris View. Boulevard Clichy* (Dauberville I, 312). However, as these features are also present in Bonnard's earlier works, it seems more reasonable to suppose that *A Corner of Paris* was executed about 1904—1905.

210 MIRROR IN THE DRESSING ROOM
LA GLACE DU CABINET DE TOILETTE

Oil on canvas. 120×97 cm
Signed, top right: *Bonnard*
Inscribed on the reverse: *Glace cabinet de toilette. Ne pas vernir. P. Bonnard*
Inv. No. 3355 Dauberville II, 488

Provenance: 1908 Bernheim-Jeune Gallery, Paris; 1908 I. Morozov collection, Moscow; 1919 Second Museum of Modern Western Painting, Moscow; 1923 Museum of Modern Western Art, Moscow; since 1948 The Pushkin Museum of Fine Arts, Moscow

In 1900, Bonnard began to depart from the Art Nouveau style in favour of Impressionism. At this time he concentrated on interior scenes with nude models. In 1907—1910, the artist painted a series of canvases showing more often than not one and the same interior with a nude before a wash-stand: *Nude against the Light* (Dauberville II, 481), *Reflection in a Mirror* (Dauberville II, 486, 531), *Nude Before the Mirror* (Dauberville II, 484), *Mirror in a Green Room* (Dauberville II, 529). Between 1915 and 1920, Bonnard returned to this motif, which is evidenced by a picture entitled *The Dressing-table with the Bunch of Red and Yellow Flowers* (Dauberville II, 772).
Preoccupied with the problem of rendering the space of an interior, Bonnard each time resolves it in a different way. In the Moscow canvas, painted not later than 1908 (the year it was on display at the Bernheim-Jeune Gallery), the wash-stand becomes the main element of the composition. It takes up the entire surface of the picture, being somewhat shifted from the front into the depth and placed between the real space of the room and the one reflected in the mirror.
Evidently in all the works of the series, Bonnard aimed at conveying the intricate relationships between real and illusory space, in other words, at painting a "picture within picture". In this canvas he confronts the interior and the objects both with the space beyond the mirror and with the real environment.

211 DAUPHINÉ LANDSCAPE. GREEN LANDSCAPE
PAYSAGE EN DAUPHINÉ. PAYSAGE VERT

Oil on cradled panel. 44×55 cm
Signed, bottom left: *Bonnard*
Inv. No. 7757 Dauberville I, 331

Provenance: A. Vollard Gallery, Paris; 1906 I. Morozov collection, Moscow (bought at the same time as *A Corner of Paris* — No. 209 — for 1,500 francs); 1919 Second Museum of Modern Western Painting, Moscow; 1923 Museum of Modern Western Art, Moscow; since 1934 The Hermitage, Leningrad

Ambroise Vollard mentioned the title of this picture in his letter of 28 June 1907 to Ivan Morozov (Archives of the Pushkin Museum of Fine Arts).
The second title, *Paysage vert*, was inscribed on the reverse. Boris Ternovetz assigns the painting to the early 1900s. The Dauberville catalogue dates it 1905.

212, 213 EARLY SPRING. LITTLE FAUNS
PREMIER PRINTEMPS. LES PETITS FAUNES

Oil on canvas. 102.5×125 cm
Signed, bottom right: *Bonnard*
Inv. No. 9106 Dauberville II, 540

Provenance: 1909 Bernheim-Jeune Gallery, Paris (bought from the artist); 28 June 1909 A. Bernstein collection, Paris; 1911 Bernheim-Jeune Gallery, Paris (bought in the A. Bernstein sale on 9 June, Cat. No. 4); 1912 I. Morozov collection, Moscow (bought for 5,000 francs); 1919 Second Museum of Modern Western Painting, Moscow; 1923 Museum of Modern Western Art, Moscow; since 1948 The Hermitage, Leningrad

The dating of this canvas has been a matter of dispute. On Ivan Morozov's evidence, Félix Fénéon assigned it to 1903—1904. Charles Terrasse, Bonnard's nephew and an authority on the artist's work, dates it 1910. J. and H. Dauberville, on the strength of the documentary data, believe that the picture was painted in 1909. This dating is the most plausible, since *Early Spring. Little Fauns* stylistically agrees with several of Bonnard's landscapes executed in 1909, such as *Landscape with a Goods Train* (No. 214) or *Rainy Day* (Dauberville II, 547), which were dated 1909 by the artist and which depict the same terrain (Vernouillet). Moreover, just as in *Early Spring*, a distant background in these landscapes, built up by well-defined parallel zones, can be seen through the leafless branches and trunks of the trees. As regards the spatial organization and the depiction of the trees, a certain affinity with the Hermitage picture can also be found in Bonnard's two earlier works: the 1907 *Landscape* (Dauberville II, 469) and another *Early Spring* (Dauberville II, 508). Perhaps the latter was the artist's first attempt at realizing his concept of the awakening of nature. Unlike the Impressionists, who always linked the image of spring with a definite landscape motif, Bonnard treats this theme in an allegorical way.

214 LANDSCAPE WITH A GOODS TRAIN
LE TRAIN ET LES CHALANDS

Oil on canvas. 77×108 cm
Signed, bottom right: *Bonnard*
Inv. No. 6537 Dauberville II, 539

Provenance: 1909 Bernheim-Jeune Gallery, Paris (purchased from Bonnard); 1910 I. Morozov collection, Moscow (bought on 14 November for 3,500 francs); 1919 Second Museum of Modern Western Painting, Moscow; 1923 Museum of Modern Western Art, Moscow; since 1930 The Hermitage, Leningrad

As in the other works depicting the countryside at Vernouillet (No. 212), Bonnard unfolds here a vast panorama. The date, 1909, was written on the stretcher. At Bonnard's one-man show at the Bernheim-Jeune Gallery in March 1910, the canvas was entitled *Train and Barges*; in Russian art literature it is usually referred to as *Landscape with a Goods Train*. Apollinaire gave this picture a high appreciation.

215 THE SEINE NEAR VERNON
LA SEINE PRÈS DE VERNON

Oil on canvas. 40.5×51 cm
Signed, bottom right: *Bonnard*
Inv. No. 8700 Dauberville II, 419
Provenance: G. Hasen collection, St. Petersburg (?); I. Rybakov collection, Leningrad; since 1941 The Hermitage, Leningrad (gift of L. Rybakova, wife of the collector)

J. and H. Dauberville date the picture 1906 but make no attempt at identifying the locality. A number of compositional features seem to link this canvas with a group of Bonnard's landscapes of the Seine near Vernon (Dauberville II, 619, 650, 658, 659) executed in 1910 and 1911. They show, with minor variations, the bushes against the grey mirror-like surface of the river, its opposite bank enveloped in a light haze. Some of these works were exhibited in 1911 at Bonnard's one-man show at the Bernheim-Jeune Gallery under the titles *The Grey River Scene*, *The Seine at Vernon*, and *Clouds at Vernon* (Cat. Nos. 19—21). One of them, *The Grey River Scene*, like the Hermitage canvas, is painted on a grey ground (Dauberville II, 658: "huile sur la toile grise").

Most likely the Hermitage canvas was also displayed at the 1911 exhibition under No. 16 as *The Banks of the Seine*. In 1910 and 1911, Bonnard often visited Vernonnet (near Vernon) and Giverny, where he first rented a villa, Ma Roulotte, and then bought it in 1912 (see the painting *Ma Roulotte*, 1910; Dauberville II, 625). That the Hermitage picture was painted not later than 1911 follows from the fact that this was probably the painting displayed in January 1912 in the St. Petersburg exhibition "A Century of French Art" as the property of G. Hasen, a St. Petersburg collector.

216 THE SEINE AT VERNONNET
LA SEINE À VERNONNET

Oil on canvas. 51×60.5 cm
Signed, bottom right: *Bonnard*
On the stretcher of the canvas is the label of the

Bernheim-Jeune firm with the figures *1911*
Inv. No. 3357 Dauberville II, 639
Provenance: 1911 Bernheim-Jeune Gallery, Paris; 1913 I. Morozov collection, Moscow; 1919 Second Museum of Modern Western Painting, Moscow; 1923 Museum of Modern Western Art, Moscow; since 1948 The Pushkin Museum of Fine Arts, Moscow

There are two drawings by Bonnard which show a locality similar to the landscape depicted in this canvas. One of them was reproduced by Besson in his book (C. Besson, *Bonnard*, Paris, 1934, p. 4, pl. 4). The figures 1911 on the label apparently indicate the date of the picture's completion.

The Seine at Vernonnet was painted around 1911, a period when Bonnard showed an increasing interest in concrete landscape motifs and when he had finally abandoned the Art Nouveau style. There is a certain affinity in the manner of execution between the Moscow canvas and *Paysage de printemps* (Dauberville II, 626), bought by Bernheim-Jeune in the same year. While certainly reflecting an Impressionistic approach to the choice of the motif, the picture also demonstrates some decorative elements.

217 MORNING IN PARIS
LE MATIN À PARIS

Oil on canvas. 76.5×122 cm
Signed, bottom left: *Bonnard*
Inv. No. 9107 Dauberville II, 641
Pendant piece to No. 218

Provenance: 1910 Ivan Morozov, through the agency of the Bernheim-Jeune Gallery, offered Bonnard 5,000 francs for pictures portraying some aspects of Parisian life (receipt of 10 December, Archives of the Pushkin Museum of Fine Arts); 1912 I. Morozov collection, Moscow; 1919 Second Museum of Modern Western Painting, Moscow; 1923 Museum of Modern Western Art, Moscow; since 1948 The Hermitage, Leningrad

At the end of 1911 or the beginning of 1912, the pictures were ready, and before their dispatch to Moscow were displayed at Bernheim-Jeune's. In the manuscript catalogue (non-extant now) of his collection, Ivan Morozov listed them as *Morning (Le Matin)* and *Evening (Le Soir)*, the titles which have been since firmly established in art literature.

Both pictures are part of an extensive cycle of Paris views, begun by Bonnard almost at the very start of his career (*On the Boulevard*, 1893; Dauberville I, 49) and completed in 1912 with a large composition, *Place Clichy* (Dauberville II, 690). Owing to his extraordinary visual memory, the artist provided each painting with different characters, never repeating himself.

In *Morning* and *Evening*, Bonnard treats his figures with a gentle humour, evident, for example, in the funny profile of the flower-seller and in the pedestrians running into one another.

218, 219 EVENING IN PARIS
LE SOIR À PARIS

Oil on canvas. 76×121 cm
Signed, bottom right: *Bonnard*
Inv. No. 9105
Pendant piece to No. 217
Provenance and comments see under No. 217.

220—222 THE MEDITERRANEN. TRIPTYCH
LA MÉDITERRANÉE. TRIPTYQUE

220 LEFT-HAND PART

Oil on canvas. 407×149 cm
Inv. No. 9664

221 CENTRAL PART

Oil on canvas. 407×152 cm
Inv. No. 9663

222 RIGHT-HAND PART

Oil on canvas. 407×149 cm
Inv. No. 9665 Dauberville II, 657
Signed and dated, bottom, left of centre: *Bonnard, 1911*

Provenance: 1910 Ivan Morozov, through the agency of the Bernheim-Jeune Gallery, offered Bonnard 30,000 francs to fulfil his commission (25,000 for the triptych and 5,000 for the two pictures, *Morning in Paris* and *Evening in Paris*); 1911 I. Morozov collection, Moscow; 1919 Second Museum of Modern Western Painting, Moscow; 1923 Museum of Modern Western Art, Moscow; since 1948 The Hermitage, Leningrad

Bonnard produced this triptych taking for its basis his *Path at Saint-Tropez* (Dauberville II, 545). It presents a synthetic decorative image of the sunny, festive and happy "promised land" of many French artists. Hence the generalized title *The Mediterranean*, given to the triptych evidently by Bonnard himself, since he mentioned it in his letter to Ivan Morozov. In this letter, not dated, but apparently posted at the beginning of 1912 (Archives of the Pushkin Museum of Fine Arts), Bonnard asked the collector to send him a photograph of the interior of his Moscow house (the triptych was intended for its decoration).
The Mediterranean differs from Bonnard's earlier tripartite panels in its remarkably integral quality: the three parts form a single landscape which, despite its restrained colour scale of greens and browns, seems bathed in sunshine, thanks to a free, sketchy handling. The idea of creating a single composition made up of several panels probably occurred to Bonnard as early as 1907, when he painted a small diptych — *Mother and Child* and *Father and Daughter* (Dauberville II, 458, 459), linking the two panels by the same landscape. Its affinity with the Hermitage triptych can be traced in subject motifs (for example, the woman with a bird and the child by her feet).

In 1910, Morozov sent the artist the dimensions of the wall to be decorated, indicating that the panels were to be installed between the tapering semicolumns ornamented with volutes in the entrance-hall of his Moscow house.

223 SUMMER. THE DANCE
L'ÉTÉ. LA DANSE

Oil on canvas. 202×254 cm
Signed in light yellow colour on the green edge of the stool, bottom right: *Bonnard*
Inv. No. 3358 Dauberville II, 720
Provenance: Until 1913 Bernheim-Jeune Gallery, Paris; 1913 I. Morozov collection, Moscow (purchased for 12,000 francs); 1919 Second Museum of Modern Western Painting, Moscow; 1923 Museum of Modern Western Art, Moscow; since 1948 The Pushkin Museum of Fine Arts, Moscow

In its painterly manner and its light colouring, the picture is similar to Bonnard's large decorative panels (Nos. 220—222). Boris Ternovetz dates the canvas to 1911—12, while Nina Yavorskaya believes that it may have been done in 1913. J. and H. Dauberville suppose, almost certainly rightly, that 1912 is a more likely date.

224 AUTUMN (FRUIT PICKING)
L'AUTOMNE (LA CUEILLETTE DE FRUITS)

Oil on canvas. 365×347 cm
Inv. No. 3360 Dauberville II, 716
Pendant piece to No. 225
Provenance: 1913 I. Morozov collection, Moscow (each of the two pendant pictures purchased for 25,000 francs); 1919 Second Museum of Modern Western Painting, Moscow; 1923 Museum of Modern Western Art, Moscow; since 1948 The Pushkin Museum of Fine Arts, Moscow

The picture was painted on Ivan Morozov's commission in 1912, together with the panel *Early Spring in the Country* (No. 225), for the collector's Moscow house. Nina Yavorskaya assumes that its subject was inspired by the scenes of harvest-gathering which Bonnard observed on his mother's estate. The real scene, however, has been transformed by the artist's brush into a festive, yet not overly bright decorative panel shimmering with half-tones. Space develops along the vertical, as in Oriental scrolls, while the scene fills in the canvas, making it resemble a hand-woven carpet. There exists a sketch for this painting (Dauberville II, 715).

225, 226 EARLY SPRING IN THE COUNTRY
PREMIERS JOURS DE PRINTEMPS À LA CAMPAGNE

Oil on canvas. 365×347 cm
Inv. No. 3359 Dauberville II, 718
Pendant piece to No. 224

Provenance and comments see under No. 224.
There exists a sketch for this painting (Dauberville II, 717).

227 SUMMER IN NORMANDY
L'ÉTÉ EN NORMANDIE

Oil on canvas. 114×128 cm
Signed in light yellow colour, bottom right: *Bonnard*
Inv. No. 3356 Dauberville II, 695

Provenance: D. Cochin collection, Paris; 1913 Bernheim-Jeune Gallery, Paris; 1913 Druet Gallery, Paris; 1913 I. Morozov collection, Moscow (purchased for 6,000 francs); 1919 Second Museum of Modern Western Painting, Moscow; 1923 Museum of Modern Western Art, Moscow; since 1948 The Pushkin Museum of Fine Arts, Moscow

Summer in Normandy, which is usually dated to 1912, apparently preceded Bonnard's large panels devoted to autumn and spring (Nos. 224, 225). According to Ternovetz, Morozov dated the picture 1908.
Compared to the panels, in which the decorative element reigns supreme, this canvas retains all the features underlying the construction of a classical realist landscape.
The picture was evidently painted on the terrace of Bonnard's villa, Ma Roulotte, and shows in the foreground members of the artist's family and his pets.

MAURICE DENIS. 1870—1943

228 THE ENCOUNTER
LE RENCONTRE

Oil on cardboard. 37×32 cm
Signed in monogram, bottom left (along the vertical): *MAUD*
Inv. No. 7710

Provenance: M. Morozov collection, Moscow; 1910 The Tretyakov Gallery, Moscow (gift of Morozov's widow); 1925 Museum of Modern Western Art, Moscow; since 1934 The Hermitage, Leningrad

The subject of the Visitation (St. Luke, I:39—56) occurs quite often in Denis's work (cf. No. 231). The picture is executed in a manner characteristic of the early stage of the artist's career; space is constructed by means of large, evenly painted zones, without contouring; the figures are rendered as flat silhouettes.
The Encounter shows stylistic similarities with *Sun Spots on a Terrace*, which the artist dated October 1890 (private collection, Saint-Germain-en-Laye). The Hermitage canvas may also have been done about 1890.

229 SACRED SPRING IN GUIDEL
FONTAINE DE PÈLERINAGE EN GUIDEL

Oil on cardboard. 39×39 cm
Signed in monogram, bottom right (along the vertical): *MAUD*
Inv. No. 7711

Provenance: 1906 I. Morozov collection, Moscow (bought at the Salon des Indépendants for 850 francs); 1919 Second Museum of Modern Western Painting, Moscow; 1923 Museum of Modern Western Art, Moscow; since 1934 The Hermitage, Leningrad

In August 1905, Denis lived in Brittany. In his diary he wrote: "The small religious procession in Guidel, in the beautiful green and ever-fresh valley" (see Maurice Denis, *Journal*, vol. 2 (1905—1920), Paris, 1957, p. 20).
It is quite probable that in the autumn of 1905, impressed by what he had seen in Brittany, Denis painted a number of landscapes including *Sacred Spring in Guidel*.
In the spring of 1906, the artist sent this picture to the Salon des Indépendants.

230 WEDDING PROCESSION
PROCESSION NUPTIALE

Oil on canvas. 26×63 cm
Signed, bottom left: *M. Denis*
Inv. No. 8342

Provenance: Private collection; since 1939 The Hermitage, Leningrad

Wedding Procession is one of the works which were executed in the early 1890s and are thematically related to one another. This group includes such paintings as *The Wedding of Marthe and Maurice Denis* (1893; M. Denis collection, Saint-Germain-en-Laye), *Procession of the Brides* (1894; private collection, Paris), and others.
The date of the Hermitage picture — *ca.* 1893 — has been established by analogy with a 1892 painting, *Procession under the Trees* (Arthur G. Altschul collection, New York), which is very similar to *Wedding Procession* in composition, in the use of arabesques accompanying Denis's expressive lines, and in individual figures.
There is a preliminary pencil drawing for the Hermitage canvas in the former E. Druet collection, in which the composition of the canvas is worked out completely (U. Perrucchi-Petri, *Die Nabis und Japan*, Munich, 1976, p. 176, No. 122).

231, 232 THE VISITATION
LA VISITATION

Oil on canvas. 103×93 cm
Signed in monogram and dated, bottom centre (along the vertical): *MAUD 94*
Inv. No. 6575

Provenance: S. Shchukin collection, Moscow; 1918 First Museum of Modern Western Painting, Moscow; 1923 Museum of Modern Western Art, Moscow; since 1934 The Hermitage, Leningrad

The composition is based on the Biblical subject (St. Luke, I:39—56). The figures of Mary and Eliza-

beth stand out against a latticed pergola. The pergola, one of the characteristic elements in the works of the Nabis, is entwined by autumn flowers and leaves, symbols of fertility. In the middle distance is a carriage entering the gates, and in the far distance, the yellow building of a synagogue.

233 MOTHER AND CHILD
MÈRE ET ENFANT

Oil on canvas. 46.5×39 cm
Signed twice in monograms, one along the vertical, the other in the shape of a circle, bottom right: *MAUD*
Inv. No. 8893

Provenance: M. Morozov collection, Moscow; 1910 Tretyakov Gallery (gift of Morozov's widow); 1925 Museum of Modern Western Art, Moscow; since 1948 The Hermitage, Leningrad

In all likelihood, the picture was painted at the end of 1894 or beginning of 1895, and was directly connected with the birth of Jean-Paul, the first child to be born to Maurice Denis. The artist paid tribute to motherhood in a number of his canvases. The most important of these is *Visit to a Woman in Childbed, or the Birth of Jean-Paul*, dated 1895 by the artist (Jacqueline Gilson collection, Paris).
The picture is related in style to other Denis works of 1893—95. It clearly demonstrates the influence of the masters of the Quattrocento whose style the artist studied in Italy. This influence manifests itself in the interpretation of characters, in the creation of a special sacramental atmosphere, and in the manner of painting.

234 PORTRAIT OF MARTHE DENIS, THE ARTIST'S WIFE
PORTRAIT DE LA FEMME DE L'ARTISTE

Oil on canvas. 45×54 cm
Signed in monogram and dated, bottom left: *MAUD 893*
Inv. No. 3277

Provenance: S. Shchukin collection, Moscow; 1918 First Museum of Modern Western Painting, Moscow; 1923 Museum of Modern Western Art, Moscow; since 1948 The Pushkin Museum of Fine Arts, Moscow

The portrait is painted in Denis's characteristic decorative manner, notable for a subdued colour scale dominated by silvery-pink tones and a play of resilient, wavy lines. The artist uses here his favourite method of depicting a human figure against a landscape. This is the earliest work by Denis in the Moscow collection.

235 FIGURES IN A SPRING LANDSCAPE. SKETCH
FIGURES DANS UN PAYSAGE DE PRINTEMPS. ESQUISSE POUR LE TABLEAU

Oil on cardboard. 26.3×39 cm
Signed in monogram (in a circle), bottom right: *MAUD*
Inv. No. 10271

Provenance: since 1977 The Hermitage, Leningrad (gift of Dominique Maurice Denis, the artist's son)
This is a sketch for the similarly entitled picture (No. 236). It depicts the same view, but the representations of a deer and a doe have been omitted.

236, 237 FIGURES IN A SPRING LANDSCAPE (SACRED GROVE)
FIGURES DANS UN PAYSAGE DE PRINTEMPS (LE BOIS SACRÉ)

Oil on canvas. 157×179 cm
Signed twice in monograms, one on the left, on the tree-trunk, followed by the date: *MAUD 97*; the other in a circle, bottom right: *Maud*
Inv. No. 9657

Provenance: 1899 A. Vollard Gallery, Paris (bought for 1,000 francs); 1899 P. Shchukin collection, Moscow; 1912 S. Shchukin collection, Moscow; 1918 First Museum of Modern Western Painting, Moscow; 1923 Museum of Modern Western Art, Moscow; since 1948 The Hermitage, Leningrad

In the 1913 catalogue of Sergei Shchukin's collection the picture is referred to as *Sacred Grove*. However, on the back of the canvas there is an inscription: *Figures dans un paysage de printemps*. The indication of the season, which evidently had a special importance for the artist, makes it possible to interpret the subject. It occurs in the folklore of many European countries and is connected with the festival of Spring: the young girl personifying Spring foretells the names of her friends' future husbands.
In another, earlier sketch this interpretation seems to be fairly plausible: four young girls have turned their heads towards the kneeling girl writing a name on a tree-trunk. But in the process of work Denis apparently changed his mind and reduced the number of girls to three — in Ancient Rome the festival of Spring was devoted to the Three Graces. In addition, he introduced into his composition a deer, symbol of love and devotion (see Guy de Tervarent, *Attributs et symboles dans l'art profane*, Geneva, 1958, p. 65).
However, one should not ignore another and a deeper meaning of the picture's subject. Setting the scene in a forest glade fenced by a dense wall of trees, and giving it a character of a classical rite of worshipping a deity, Denis suggests at the same time that the object of the worship is art: the name the kneeling girl writes on the tree-trunk is that of the artist, a man belonging to the realm of art.

238 MARTHA AND MARY
MARTHE ET MARIE

Oil on canvas. 77×116 cm
Signed and dated, bottom, right of centre (along the vertical): *MAUD 96*
Inv. No. 9124

Provenance: S. Shchukin collection, Moscow; 1918 First Museum of Modern Western Painting, Moscow; 1923 Museum of Modern Western Art, Moscow; since 1948 The Hermitage, Leningrad

At first Denis drew a sketch for the composition on the back of the canvas. Then he repeated the scene on the obverse, expanding the dimensions of the painting by enlarging the stretcher frame with additional planks. Due to these changes, the figures seem to float into the composition, while in the sketch they are sharply cut off by the edges.

Seen in the background is the yellow building of a synagogue which appears in several of the artist's early pictures with religious content, e. g. *Garden of Wise Maidens* (1893, H. Lerolle collection, Paris), *The Visitation* (1894, Nos. 231—232), etc.

239 BACCHUS AND ARIADNE
BACCHUS ET ARIANE

Oil on canvas. 81×116 cm
Signed and dated, bottom right: *MAURICE DENIS 1907*
Inv. No. 6578. Pendant piece to No. 240

Provenance: 1906 I. Morozov collection, Moscow (bought for 4,000 francs from the artist in Saint-Germain-en-Laye); 1919 Second Museum of Modern Western Painting, Moscow; 1923 Museum of Modern Western Art, Moscow; since 1931 The Hermitage, Leningrad

In the summer of 1906, when Maurice Denis was painting *Bacchus and Ariadne*, Ivan Morozov visited him in his studio. The Moscow collector bought the not yet completely finished picture and commissioned the artist to paint a companion piece to it depicting *Polyphemus*, which was to be of the same size (No. 240). Before sending *Bacchus and Ariadne* to the Salon de la Société Nationale des Beaux-Arts in Paris, Denis put the date on it, 1907.

Both *Bacchus and Ariadne* and *Polyphemus* represent a blending of mythology and reality. It is supposed that among the people on the beach Denis depicted some of his relatives and friends who became, as it were, participants in a sort of pageant, playing Ariadne and Bacchus. These "beach pageants" may be also seen as allusions to the outdoor *tableaux vivants* on classical themes, entertainments that were popular in high society and among the artistic Bohemia at the turn of the century. All Denis panels with bathers on the beach are notable for their distinctive decorativeness and bright colour scheme, which at times make them akin to the popular print.

240 POLYPHEMUS
POLYPHÈME

Oil on canvas. 81×116 cm
Signed and dated, bottom left: *MAURICE DENIS 1907*
Inv. No. 3375. Pendant piece to No. 239

Provenance: 1907 I. Morozov collection, Moscow; 1919 Second Museum of Modern Western Painting, Moscow; 1923 Museum of Modern Western Art, Moscow; since 1948 The Pushkin Museum of Fine Arts, Moscow

In 1906, Ivan Morozov commissioned Denis to paint a companion picture to *Bacchus and Ariadne* (No. 239). The canvas was evidently completed in 1907, as follows from the artist's signature.

A girl in a transparent gown and straw hat, running along the beach, recalls a drawing entitled *Alphonsine* from the Kunsthalle, Bremen: the model was apparently the same. There are a number of paintings which are closely related to the two Moscow pictures: *Plage de Trestrignel* (private collection, France), *Grande plage* of 1903, and especially *Baigneuses* of 1905 reproduced by F. Fosca (see F. Fosca, *Maurice Denis*, Paris, 1924, pp. 37, 39).

241—253 THE STORY OF PSYCHE. DECORATIVE SERIES. ELEVEN PANELS AND TWO DECORATIVE STRIPES
HISTOIRE DE PSYCHÉ. DÉCORATION. ONZE PANNEAUX ET DEUX BORDURES

Inv. Nos. 9666—9670, 9693—9698, 10095, 10096
Provenance: 1908 I. Morozov collection, Moscow (done on commission for 50,000 francs); 1919 Second Museum of Modern Western Painting, Moscow; 1923 Museum of Modern Western Art, Moscow; since 1948 The Hermitage, Leningrad

In 1906 or at the beginning of 1907, Ivan Morozov, following Sergei Diaghilev's advice, visited Denys Cochin in Paris to take a look at how Maurice Denis painted the walls and ceilings of his house. Morozov was so much impressed by what he saw that he commissioned Denis to do five decorative panels for the music salon in his Moscow house, giving the artist complete freedom as to the choice of subjects. The latter decided on the story of Psyche from the *Metamorphoses* or *Golden Ass* (IV—VI) by Lucius Apuleius.

At the end of 1908, after the exhibition at the Salon d'Automne, the panels were brought to Moscow. Each panel was stretched over the frame, and put in its pre-arranged place; some were decorated with brocade ribbons. In January 1909, Maurice Denis saw them in Moscow, where he came for a fortnight upon Morozov's invitation. The artist touched up all the panels, toning down the overly bright paints so that they should match the colouring of the walls. He thought, besides, that the salon needed two more panels for the doors and four panels to be placed between the windows. He also judged it necessary to install large bronze sculptures in the four corners of the room, and persuaded Morozov to commission them from Aristide Maillol (these are *Pomona*, 1910; *Flora*, 1911; *Woman and Flowers*, 1912; *Female Figure*, 1912, now all in the Pushkin Museum of Fine Arts).

Denis completed his own work by the autumn of 1909. In addition, he made eight ceramic vases.

There are five sketches (oil on canvas, each 52 by 30 cm) in the Musée de l'Impressionnisme in Paris, which are identical in composition and colouring with the first five panels from the Morozov house. In all probability, they were done after the artist's trip to Italy and represent the second stage of his work on the panels.

241 PANEL 10, IN THE SHAPE OF A PILASTER, DEPICTING PSYCHE

Oil on canvas. 390×74 cm
Inv. No. 9697

242 PANEL 9, IN THE SHAPE OF A PILASTER, DEPICTING CUPID

Oil on canvas. 390×74 cm
Inv. No. 9696

243 PANEL 8, IN THE SHAPE OF A PILASTER, DEPICTING CUPID

Oil on canvas. 390×74 cm
Inv. No. 9695

244 PANEL 11, IN THE SHAPE OF A PILASTER, DEPICTING PSYCHE

Oil on canvas. 390×74 cm
Inv. No. 9698

Panels 8 and 9 were placed on the west wall of the room, while panels 10 and 11 flanked Panel 3, the central one. Panels 8—11 were glued onto the wall without ribbon decoration.

245 DECORATIVE STRIPE

Oil on canvas. 228.5×19.6 cm
Inv. No. 10095

246 DECORATIVE STRIPE

Oil on canvas. 228.5×19.6 cm
Inv. No. 10096

The decorative stripes were placed along the sides of the door.

247 PANEL 1: THE FLYING CUPID IS STRUCK BY PSYCHE'S BEAUTY
AMOUR S'ÉPREND DE LA BEAUTÉ DE PSYCHÉ, OBJET INNOCENT DU CULTE DES MORTELS ET DE LA JALOUSIE DE VÉNUS

Oil on canvas. 394×269.5 cm
Inv. No. 9666

248 PANEL 2: ZEPHYR TRANSPORTING PSYCHE TO THE ISLAND OF DELIGHT
ZÉPHYR SUR ORDRE DE L'AMOUR TRANSPORTE PSYCHÉ SUR UNE ÎLE DE DÉLICES

Oil on canvas. 394×267.5 cm
Inv. No. 9667

Used as the backdrop is a landscape of Isola Bella on Lago Maggiore.

249 PANEL 3: PSYCHE DISCOVERS THAT HER MYSTERIOUS LOVER IS CUPID
PSYCHÉ DÉCOUVRE QUE SON MYSTÉRIEUX AMANT EST AMOUR

Oil on canvas. 395×274.5 cm
Signed and dated twice, in the centre along the lower edge of the cartouche and in the left-hand lower corner: *MAURICE DENIS 1908*
Inv. No 9669

250 PANEL 4: PSYCHE FALLS ASLEEP AFTER OPENING THE CASKET CONTAINING THE DREAMS OF THE NETHER WORLD
SOUMISE PAR VÉNUS AUX PLUS DURES ÉPREUVES, PSYCHÉ POUR SON MALHEUR CÈDE UNE SECONDE FOIS À LA CURIOSITÉ: DANS CETTE EXTRÉMITÉ ELLE EST SECOURUE PAR L'AMOUR

Oil on canvas. 395×273 cm
Inv. No. 9668

Used as the backdrop is a corner of the Giusti garden in Verona.

251 PANEL 5: IN THE PRESENCE OF THE GODS, JUPITER BESTOWS IMMORTALITY ON PSYCHE AND CELEBRATES HER MARRIAGE TO CUPID
JUPITER EN PRÉSENCE DES DIEUX ACCORDE À PSYCHÉ L'APOTHÉOSE ET CÉLÈBRE SON HYMEN AVEC L'AMOUR

Oil on canvas. 399×273 cm
Inv. No. 9670

The scene is a large terrace at Isola Bella. Marthe Denis, with a wreath of white roses, posed for Venus (in the left foreground), while Bacchus was painted from Aristide Maillol — the bearded man with a wreath of vines at extreme right.

252 PANEL 6: PSYCHE'S KIN BID HER FAREWELL ON A MOUNTAINTOP
SES PROCHES ABANDONNENT PSYCHÉ SUR LE SOMMET DE LA MONTAGNE

Oil on canvas. 200×275 cm
Signed and dated, bottom left: *MAURICE DENIS 1909*
Inv. No. 9693

253 PANEL 7: CUPID CARRYING PSYCHE UP TO HEAVEN
AMOUR TRANSPORTE PSYCHÉ DANS LES CIEUX

Oil on canvas. 180×265 cm
Inv. No. 9694

For this panel the artist took the wrong measurements and, consequently, the panel's lower edge had to be folded. Panels 6 and 7, decorated with a ribbon of gold brocade, 5 cm wide, were glued to the wall.

254 AT THE SEASIDE. THE GREEN BEACH
AU BORD DE LA MER. PLAGE VERTE À PER-
ROS-GUIREC

Oil on canvas. 97×180 cm
Signed and dated, bottom left: *Maurice Denis 1909*
Inv. No. 3376

Provenance: 1910 I. Morozov collection, Moscow;
1919 Second Museum of Modern Western Painting,
Moscow; 1923 Museum of Modern Western Art, Mos-
cow; since 1948 The Pushkin Museum of Fine Arts,
Moscow

The picture was painted on the beach of Perros-Gui-
rec in the summer of 1909, following Denis's arrival
from Russia, and evidently was also intended for Mo-
rozov's house. In this canvas the artist has trans-
formed a real, concrete locality into something unreal
that evokes memories of Hellas.

The viewer's attention is arrested by two symmetrical
figures, a shepherd and a nude woman, recalling clas-
sical statues. Their poses betray the influence of Gau-
guin, whose art Denis admired (Nos. 126, 132, 144).
It is likely that the three women portrayed in the
canvas serve to symbolize the three ages of Man, a
subject that gained wide currency in contemporary
Symbolist works.

In 1909, when Denis was completing *The Story of
Psyche*, he conceived a new cycle of decorative pan-
els, *L'Age d'Or* (*The Golden Age*). *The Green Beach*
is one of the first canvases in which the Golden
Age theme, coloured by reminiscences of Gauguin, is
treated with the utmost clarity.

FÉLIX VALLOTTON. 1865—1925

255 LANDSCAPE IN NORMANDY: ARQUES-LA-BA-
TAILLE
PAYSAGE NORMAND, ARQUES-LA-BATAILLE

Oil on cardboard. 67×103.5 cm
Signed and dated, bottom right: *F. Vallotton. 03*
Inv. No. 4908 L. R. 508

Provenance: 1911 G. Hasen collection, St. Petersburg;
since 1921 The Hermitage, Petrograd/Leningrad

In 1903, Vallotton made a note in the register of his
works (*Livre de Raison*): "No. 508. 17 paysages faits
à Arques-la-Bataille". The Hermitage picture also
belongs to this group of works, as evidenced by the
inscription on the back: *Arques-la-Bataille*. There is
a drawing of this landscape (private collection, Par-
is), in which all the main elements of the composi-
tion are roughly outlined and the colours are desig-
nated ("ciel pâle rosé" etc.). It is possible that the Her-
mitage picture was exhibited in 1906 at Vallotton's
one-man show in the Bernheim-Jeune Gallery under
the title *Ruisseau. Normandie* (Cat. No. 43). This is
suggested by an inscription which has partly survived
on the back of the cardboard: *Galerie Bernheim-Jeune
...1906.*

256 PORT
UN PORT

Oil on cardboard. 57×62 cm
Signed, bottom right: *F. Vallotton. 01*
Inv. No. 3439 L. R. 466

Provenance: M. Morozov collection, Moscow; 1910 The
Tretyakov Gallery, Moscow (gift of Morozov's widow);
1925 Museum of Modern Western Art, Moscow; since
1948 The Pushkin Museum of Fine Arts, Moscow

This picture, evidently painted in 1901 at Honfleur,
belongs to a series of landscapes which Vallotton en-
titled *Paysages faits à Honfleur, ports, vergers, ar-
bres* (see Hedy Hahnloser-Bühler, *Félix Vallotton et
ses amis*, Paris, 1976, p. 285).

The landscape is painted from life and exemplifies
the artist's style and manner which evolved at the
start of this century. Both in his paintings and draw-
ings Vallotton was first and foremost concerned
with an orderliness of depiction, dispensing with de-
tail but preserving the essential features of a given
locality. *Port* is one of the "paysages composés", as
Vallotton himself dubbed them.

257 LADY AT THE PIANO (Mme VALLOTTON)
DAME AU PIANO (Mme FÉLIX VALLOTTON)

Oil on canvas. 43.5×57 cm
Signed and dated, bottom right: *F. Vallotton. 04*
Inv. No. 4860 L. R. 507

Provenance: 1911 G. Hasen collection, St. Petersburg
(bought from the artist for 650 francs through the
agency of P. Vallotton, Lausanne); 1921 The Hermit-
age, Petrograd/Leningrad; 1930 Museum of Modern
Western Art, Moscow; since 1948 The Hermitage,
Leningrad

This is one of the numerous interior scenes executed
in 1904. It shows a room in the villa in Varengeville,
where Vallotton spent the summer months. Seated at
the piano is his wife Gabrielle. The artist has depict-
ed her in the same pose and the same peignoir as in
Dining Room in a Country Villa Interior (L. R. 528).

258 INTERIOR
INTÉRIEUR

Oil on cardboard. 61.5×56 cm
Signed and dated, bottom left: *F. Vallotton. 04*
Inv. No. 4902 L. R. 523

Provenance: 1908 G. Hasen collection, St. Petersburg
(bought from the artist for 500 francs); since 1921
The Hermitage, Petrograd/Leningrad

This picture is one of a group of interior scenes, done
in 1904. Depicted is the bedroom in Vallotton's Paris
apartment. The artist's woodcuts hanging above the
bed are reflected in the mirror. Vallotton's wife, Gab-
rielle, sat for the woman dressed in a peignoir, while
the seamstress was painted from the model who is
portrayed in the same pose in *Interior: Housemaid*

Sewing a Yellow Gown (L. R. 513). The same bedroom appears in *Interior with a Woman in Red* (L. R. 511).

259 PORTRAIT OF GEORGES HASEN
PORTRAIT DE GEORGES HASEN

Oil on canvas. 81.7×100.3 cm
Signed and dated, top left: *F. Vallotton 1912+1*
Inv. No. 4901 L. R. 910

Provenance: 1913 G. Hasen collection, St. Petersburg; since 1921 The Hermitage, Petrograd/Leningrad

Vallotton painted the portrait of Georges Hasen, the St. Petersburg representative of a Swiss chocolate firm and a collector of twentieth-century paintings, during March 1913, when he stayed in Hasen's flat on Kamennoostrovsky Prospekt in St. Petersburg.
Judging by the date, 1912+1, supplied by the artist, it is possible to assume that he started work on the picture, probably from a photograph, already in 1912 in Paris.

260 PORTRAIT OF Mme GEORGES HASEN
PORTRAIT DE Mme GEORGES HASEN

Oil on canvas. 81.5×66 cm
Signed and dated, top right: *F. Vallotton 08*
Inv. No. 6765 L. R. 656

Provenance: 1908 G. Hasen collection, St. Petersburg (commissioned from the artist for 1,000 francs); since 1921 The Hermitage, Petrograd/Leningrad

In August 1908, Vallotton went from Paris to Switzerland. In an undated letter to his brother from Bern he mentioned three portraits: *Portrait of the Artist's Wife* (L. R. 655), *Portrait of Mme Hasen* (L. R. 656) and *Portrait of Mme Hahnloser* (L. R. 657). As follows from the letter, all portraits, including that of Mme Hasen, were painted in Switzerland.

261 PORTRAIT OF A WOMAN IN A BLACK HAT
PORTRAIT D'UNE FEMME EN CHAPEAU NOIR

Oil on canvas. 81×64.8 cm
Signed and dated, top right: *F. Vallotton 08*
Inv. No. 5108 L. R. 637

Provenance: 1911 G. Hasen collection, St. Petersburg (bought from the artist for 800 francs); 1921 The Hermitage, Petrograd/Leningrad; 1930 Museum of Modern Western Art, Moscow; since 1948 The Hermitage, Leningrad

GEORGES ROUAULT. 1871—1958

262 BATHING IN A LAKE
BAIGNADE

Watercolour and pastel. 65×96 cm
Signed and dated, bottom right: *G. Rouault 1907*
Inv. No. 3331

Provenance: E. Druet Gallery, Paris; 1913 S. Shchukin collection, Moscow; 1918 First Museum of Modern Western Painting, Moscow; 1923 Museum of Modern Western Art, Moscow; since 1948 The Pushkin Museum of Fine Arts, Moscow

From 1903 to 1914 Rouault painted almost exclusively watercolours and gouaches. Among his favourite subjects were clowns, prostitutes, bathers, and comedians. The present watercolour dates from 1907, i.e. from the artist's Fauve period, when he frequently exhibited at the Salon des Indépendants and the Salon d'Automne. The free drawing and a predominance of dark colours show the influence of Rembrandt, whose engravings Rouault carefully studied.
The artist's works from the early 1900s are dominated by a refulgent, variously nuanced blue which seems to emerge from the depth of his pictures. The dark contours of the figures and the shore, combined with the shimmering colour, betray the influence of the stained-glass artist with whom Rouault had worked in his youth.
In manner, *Bathing in a Lake* is similar to the watercolours *Versailles. A Fountain* (1905, private collection, France) and *La Barge* (1909, Musée des Beaux-Arts, Grenoble).

263 HEAD OF A MAN
TÊTE D'HOMME

Indian ink, pen and pencil on tracing paper mounted on cardboard. 27×21 cm
Signed and dated in Indian ink, bottom right: *G. Rouault 1894*
Inv. No. 10280

Provenance: 1908 V. Riabushinsky collection, Moscow; 1918 First Museum of Modern Western Painting, Moscow; 1923 Museum of Modern Western Art, Moscow; since 1948 The Pushkin Museum of Fine Arts, Moscow

This drawing obviously represents a head study for one of the figures of the Pharisees in Rouault's painting *Christ among the Doctors* (Unterlinden Museum, Colmar). It is probable that the drawing was exhibited at the Salon de la Société des Artistes Français in 1895 under No. 2715 as *Etude de tête. Dessin* (see P. Courthion, *Georges Rouault*, New York, s. a., p. 44). Although a life study, it anticipates the dramatic tension of the future image. In the picture the character was considerably altered, except for the expressive gesture of the uplifted arm which is repeated almost unchanged.

264 HEAD OF A CLOWN
TÊTE DE CLOWN

Pastel, gouache and watercolour on paper mounted on cardboard. 43×27 cm
Signed and dated, top right: *G Rouault 1904*
Inv. No. 14523

Provenance: Drouot Gallery, Paris; 1908 (?) V. Ria-
bushinsky collection, Moscow; B. Builov collection,
Moscow; since 1971 The Pushkin Museum of Fine
Arts, Moscow

This is one of Rouault's early pictures on the circus
theme. The artist's sympathy for the outcasts —
clowns, vagabonds, and prostitutes — manifests it-
self with the utmost power in his works done be-
tween 1903 and 1914.

In this drawing, as in many others, Rouault identifies
himself with the society's outcasts.

HENRI MATISSE. 1869—1954

265 THE BOTTLE OF SCHIEDAM
LA BOUTEILLE DE SCHIEDAM

Oil on canvas. 73.2×60.3 cm
Signed and dated, bottom right: *Henri Matisse. 1896*
Inv. No. 3392

Provenance: Bernheim-Jeune Gallery, Paris; 1911
I. Morozov collection, Moscow (purchased for 1,500
francs); 1919 Second Museum of Modern Western
Painting, Moscow; 1923 Museum of Modern Western
Art, Moscow; since 1948 The Pushkin Museum of
Fine Arts, Moscow

The picture was painted during Matisse's training at
the Ecole des Beaux-Arts under Gustave Moreau
(1895—96), who recommended his pupils to copy
Old Masters in order to get a better grasp of painterly
techniques.
The Bottle of Schiedam holds pride of place among
Matisse's early still lifes, such as *Still Life with
Peaches* (1895, Museum of Art, Baltimore), *Still Life
with a Black Knife* (1896, former Thénard collection,
Paris), and *Interior with a Top Hat* (1896, private
collection, Paris). The dark colour scale, the local col-
ours, the clear-cut outlines, the three-dimensional
construction of space, the meticulously delineated de-
tails and the use of colour values to render planes and
forms call to mind traditional still lifes. Yet there is
something in the picture's style that echoes Manet's
works.

266 BLUE POT AND LEMON
POT BLEU ET CITRON

Oil on canvas. 39×46.5 cm
Signed, top left: *Henri Matisse*
Inv. No. 7698

Provenance: E. Druet Gallery, Paris; 1908 I. Morozov
collection, Moscow (bought for 500 francs); 1919 Sec-
ond Museum of Modern Western Painting, Moscow;
1923 Museum of Modern Western Art, Moscow;
since 1934 The Hermitage, Leningrad

The picture was painted at the end of 1896 or the be-
ginning of 1897, and is probably one of the studies
for *The Dessert* (Niarchos collection, Paris), the large
canvas which Matisse exhibited in the spring of

1897 at the Salon de la Société Nationale des Beaux-
Arts as a member of that organization. If in his ear-
lier works of 1895—96 Matisse depicts predominantly
the objective world as an inseparable part of human
existence (the open door in the *Breton Serving Girl,*
the corner of a room in *Interior with a Top Hat,*
both in private collections, Paris), in his canvases of
1897 the artist's interest is focused on a new set of
problems. In the compositions of this year the object
serves first of all as a vehicle for expressing light and
colour relations. In *Blue Pot and Lemon* Matisse
does not place emphasis on the environment (the win-
dow is transformed into a light-coloured rectangle, the
wall into a picturesque background), nor does he con-
centrate his attention on individual objects. The di-
agonal construction of space induces the viewer not to
examine the objects but to let his glance skim along
the receding forms and perceive them as a conglom-
eration of muted colour dabs.

267 CORSICAN LANDSCAPE. OLIVE TREES
PAYSAGE CORSE. LES OLIVIERS

Oil on canvas. 38×46 cm
Signed and dated, bottom right: *H. Matisse 98*
Inv. No. 4108

Provenance: Vasseaux collection, Saint-Saëns; 1947
L. Delectorskaya collection, Paris (bought for 500,000
francs); since 1970 The Pushkin Museum of Fine
Arts, Moscow (gift of L. Delectorskaya)

The landscape was painted during Matisse's trip to
Corsica. Coming back home, he gave the picture to
Dr. Vasseaux, a childhood friend. Like his other works
done in Corsica, such as *The Courtyard of the Mill,
Ajaccio* (1898, Musée Matisse, Cimiez, Nice) or *Olive
Grove* (1898, Mrs. Philip N. Lilienthal collection,
Burlingame), this canvas shows a certain influence
of Impressionism.

268 THE LUXEMBOURG GARDENS
LE JARDIN DU LUXEMBOURG

Oil on canvas. 59.5×81.5 cm
Signed, bottom, right of centre: *Henri Matisse*
Inv. No. 9041

Provenance: E. Druet Gallery, Paris; S. Shchukin
collection, Moscow; 1918 First Museum of Modern
Western Painting, Moscow; 1923 Museum of Modern
Western Art, Moscow; since 1948 The Hermitage,
Leningrad

The picture was probably painted in 1901—1902,
when Matisse lived on the Quai Saint-Michel in Paris
and often painted the surrounding scenery. In its
colour scale, abounding in cold purples, *The Luxem-
bourg Gardens* is similar to *Dishes and Fruit*
(No. 270), dated 1901, and belongs to Matisse's pre-
Fauvist period. It is evidently an autumn scene ren-
dered in determinedly anti-naturalistic colours. Gau-
guin's influence is certainly felt in the use of the

muted tones of purple and yellow, the summary flat treatment of the objects, and even the choice of a coarse jute canvas which absorbs the oils, imparting a matt quality to the painted surface.

269 VASE OF SUNFLOWERS
TOURNESOLS DANS UN VASE

Oil on canvas. 46×38 cm
Signed, bottom right: *Henri Matisse*
Inv. No. 7706

Provenance: M. Zetlin collection, Moscow; 1918 Rumiantsev Museum, Moscow; 1924 Museum of Fine Arts, Moscow; 1925 Museum of Modern Western Art, Moscow; since 1934 The Hermitage, Leningrad

In all probability, Matisse painted this still life in 1898 during his stay in Corsica. Thanks to its broad impasto brushstrokes, with the white priming showing through them, and its subdued yellows, greens, and browns, the Hermitage canvas may be compared with *Sunset in Corsica* (1898, Arthur M. Sackler collection, New York) and with *Woman in a Purple Dress Reading* (Musée de Reims), which was also done in Corsica in 1898.

270 DISHES AND FRUIT
POTERIE ET FRUITS

Oil on canvas. 51×61.5 cm
Signed, bottom left: *HMatisse*
Inv. No. 7697

Provenance: S. Shchukin collection, Moscow; 1918 First Museum of Modern Western Painting, Moscow; 1923 Museum of Modern Western Art, Moscow; since 1934 The Hermitage, Leningrad

This still life is one of the most brilliant examples of Matisse's pre-Fauvist painting. On the basis of the inscription on the back of the canvas, *Henri Matisse 1901*, it is dated 1901. The purple and turquoise hues, the deep blues and orange-yellows of this picture call to mind the iridescent play of colours in Oriental enamels and ceramics.

Dishes and Fruit also marks the absorption of Cézanne's lessons, manifested in the overall system of organization and in the modelling of forms with colour contrasts.

271 BLUE JUG
LA CRUCHE BLEUE

Oil on canvas. 59.5×73.5 cm
Inv. No. 3393

Provenance: A. Vollard Gallery, Paris; 1909 I. Morozov collection, Moscow (bought for 2,000 francs); 1919 Second Museum of Modern Western Painting, Moscow; 1923 Museum of Modern Western Art, Moscow; since 1948 The Pushkin Museum of Fine Arts, Moscow

Although the still life is undated, it was apparently painted not later than 1899—1901, a transitional period in the artist's career.

Matisse conveys the three-dimensionality of space by building it around a well-defined vertical which divides the background in two parts (light greenish on the right and dark brown, almost black on the left), a horizontal formed by the table's edge, and a diagonal between them.

The compositional pivot of the picture is the blue jug painted in broad impasto strokes which accurately model its form. The resonant blue colour of the jug prevails over all the other components of the picture, demonstrating Matisse's increasing interest in colour. In the catalogue of the Salon des Indépendants of 1901, the year Matisse first exhibited his works there, we find under No. 668 a picture entitled *Pot bleu (nature morte)*, while the catalogue of the 1904 exhibition at the Vollard Gallery lists, under No. 20, *Nature morte au pot bleu*. Since there are no similarly named paintings in other collections, one may safely assume that the Moscow canvas was displayed at both shows.

272 CROCKERY ON A TABLE
VAISSELLE SUR UNE TABLE

Oil on canvas. 97×82 cm
Signed and dated, bottom right: *Henri Matisse 1900*
Inv. No. 6518

Provenance: S. Shchukin collection, Moscow; 1918 First Museum of Modern Western Painting, Moscow; 1923 Museum of Modern Western Art, Moscow; since 1930 The Hermitage, Leningrad

At the turn of the century Matisse gradually abandoned Impressionism. In his desire "to achieve greater stability", as he subsequently described his evolution, the artist turned to Cézanne's experience, borrowing from it the economy of form, the scarcity of detail, and the use of energetic generalized contours. All these features can be seen in *Crockery on a Table*, dated 1900.

273 FRUIT AND COFFEE-POT
FRUITS ET CAFETIÈRE

Oil on canvas. 38.5×46.5 cm
Signed, bottom left: *H Matisse*
Inv. No. 8892

Provenance: E. Druet Gallery, Paris; 1910 I. Morozov collection, Moscow (bought for 700 francs); 1918 Second Museum of Modern Western Painting, Moscow; 1923 Museum of Modern Western Art, Moscow; since 1948 The Hermitage, Leningrad

The inscription on the back of the canvas, *Pour M. Van de Velde*, suggests that the picture was originally intended for this Belgian architect.

This still life shows a certain resemblance to *The Dessert* (Niarchos collection, Paris). However, the colour of the Hermitage picture has become more intense and saturated while the forms have acquired corporeity and texture. Moreover, its impasto brushwork dif-

fers from the light Impressionist strokes of the Paris *Dessert*. Taking into account all these characteristics, one may reasonably suppose that the Hermitage still life was painted not earlier than 1899.

274 THE BOIS DE BOULOGNE
LE BOIS DE BOULOGNE

Oil on canvas. 65×81.5 cm
Signed and dated, bottom left: *Henri Matisse 1902*
Inv. No. 3300

Provenance: S. Shchukin collection, Moscow; 1919 First Museum of Modern Western Painting, Moscow; 1923 Museum of Modern Western Art, Moscow; since 1948 The Pushkin Museum of Fine Arts, Moscow

In 1902, Matisse, along with canvases done in vivid rich colours, painted some works in a more sombre palette. This latter group of paintings includes the present picture. Despite the predominantly dark tonality, the landscape is enlivened by occasional colour accents — in the sun, sky, and water.

Judging by the catalogues of the Salon des Indépendants, Salon d'Automne, and the Gallery of Ambroise Vollard, several pictures representing the Bois de Boulogne were on show in 1904. It is quite possible that the Moscow picture was among them.

275 FISHERMAN (MAN WITH A FISHING-ROD)
LE PÊCHEUR (L'HOMME À LA CANNE À PÊCHE)

Pen drawing in Indian ink. 30.3×48.7 cm
Signed in pencil, bottom right: *Henri Matisse*
Inv. No. 10260

Provenance: 1906 S. Shchukin collection, Moscow (gift of the artist); 1918 First Museum of Modern Western Painting, Moscow; 1923 Museum of Modern Western Art, Moscow; since 1948 The Pushkin Museum of Fine Arts, Moscow

This drawing was executed in the summer of 1905 at Collioure, a fishermen's settlement on the Mediterranean coast, not far from the Franco-Spanish border, where Matisse used to stay with his family. In 1905—1906, he worked here with André Derain. Some scholars believe that the drawing depicts Derain and Matisse, the first swimming, the second standing on the shore with a fishing-rod. The drawing was included in the sensational Fauve exhibition at the 1905 Salon d'Automne. The broken lines of this drawing may be perceived as the graphic version of the broad dynamic stroke characteristic of the Fauves. At the same time it reveals, probably to a greater extent than Matisse's paintings of those years, the emergence of features typical of the artist's later work.

PABLO PICASSO. 1881—1973

276 WOMAN READING A BOOK
FEMME LISANT UN LIVRE

Reverse of *The Embrace* (No. 277)

Charcoal, watercolour and pencil on cardboard. 52×56 cm
Inv. No. 3322

Provenance see under No. 277.

The sketch dates from 1895—1900. It is related to a series of drawings portraying Lola Ruiz Picasso, the artist's sister, and probably also depicts Lola. The representation of Lola reading a book occurs on a sheet with sketches of 1895, kept at the Picasso Museum in Barcelona. The woman from the Moscow picture recalls the model seen in a pastel and a painting executed in 1899—1900 in Barcelona (D.-B. I, 13, 17). The sketch was undoubtedly done in Barcelona at the same period.

277 THE EMBRACE
L'ÉTREINTE

Oil on cardboard. 52×56 cm
Signed, bottom left: *P. R. Picasso* (underlined)
Inv. No. 3322 Z. I, 26; D.-B. II, 14

Provenance: 1913 S. Shchukin collection, Moscow; 1918 First Museum of Modern Western Painting, Moscow; 1923 Museum of Modern Western Art, Moscow; since 1948 The Pushkin Museum of Fine Arts, Moscow

This work by the young Picasso is illustrative of his artistic aims and predilections. He fills an ordinary genre scene with a profound philosophical meaning.

There is a picture in a private collection, U.S.A., *Lovers in a Street*, also painted in Paris in 1900 (Z. I, 25; D.-B. II, 13). A pastel of the same title is in the Picasso Museum in Barcelona (Z. I, 24; D.-B. II, 12). In contrast to these two works, the scene of the Moscow picture is set in a small room, thanks to which it has a more enclosed and generalized character. The painting was most likely done in 1900, but later than the two versions of "street lovers".

The Embrace was painted not long before the onset of Picasso's Blue period. The subsequent development of the theme of human intimacy is clearly demonstrated in the 1902 Hermitage picture *The Visit* (No. 282) and in the famous canvas of 1903, *Life* (Z. I, 179; D.-B. IX, 13), which shows a couple of lovers against a wall with a picture also showing a couple of lovers. There was a charcoal sketch for the Moscow picture; its present whereabouts is unknown. Picasso returned to this theme once more — in 1903, he painted a pastel in which the figures are naked and the overall mood more tragic (Z. I, 161; D.-B. IX, 12).

278 THE ABSINTHE DRINKER
LA BUVEUSE D'ABSINTHE

Oil on canvas. 73×54 cm
Signed, top right: *Picasso* (underlined)
Inv. No. 9045 Z. I, 98; D.-B. VI, 24

Provenance: D.-H. Kahnweiler Gallery, Paris; 1911 S. Shchukin collection, Moscow; 1918 First Museum

of Modern Western Painting, Moscow; 1923 Museum of Modern Western Art, Moscow; since 1948 The Hermitage, Leningrad

The Absinthe Drinker, as well as *Harlequin and His Companion* (No. 279), was produced in the autumn of 1901 in Paris, on the threshold of the artist's Blue period.

Absinthe is a green alcoholic liquor containing oils of wormwood, of a bitter taste. The excessive use of it leads to dizziness, amnesia, and hallucinations.

It seems that Picasso wanted to show the alcoholic effect of absinthe, that is, giddiness and hallucinations, through the portrayal of a woman with an impenetrable face resembling a deathly pale, malicious mask, seated in a constrained pose.

279 HARLEQUIN AND HIS COMPANION
LES DEUX SALTIMBANQUES

Oil on canvas. 73×60 cm
Signed, top left: *Picasso* (underlined)
Inv. No. 3400 Z. I, 92; D.-B. VI, 20
Provenance: A. Vollard Gallery, Paris; 1908 I. Morozov collection, Moscow (bought for 300 francs); 1919 Second Museum of Modern Western Painting, Moscow; 1923 Museum of Modern Western Art, Moscow; since 1948 The Pushkin Museum of Fine Arts, Moscow

P. Daix rightly notes that the Moscow picture belongs to the most significant works by Picasso produced in 1901. It is closely related to his well-known canvases, *Woman with a Chignon* (Z. I, 96; D.-B. VI, 23) and *The Absinthe Drinker* (No. 278). Also in 1901, Picasso created his *Reclining Harlequin* (Z. I, 79; D.-B. VI, 22). While betraying a debt to Toulouse-Lautrec, Gauguin and Van Gogh, this picture shows that the young Picasso assimilated the legacy of these artists in his highly individual manner.

280 PORTRAIT OF THE POET SABARTÉS
PORTRAIT DU POÈTE SABARTÉS

Oil on canvas. 82×66 cm
Signed, top left: *Picasso* (underlined)
Inv. No. 3317 Z. I, 97; D.-B. VI, 19
Provenance: D.-H. Kahnweiler Gallery, Paris; 1910 (?) S. Shchukin collection, Moscow; 1918 First Museum of Modern Western Painting, Moscow; 1923 Museum of Modern Western Art, Moscow; since 1948 The Pushkin Museum of Fine Arts, Moscow

There are eight oil and pencil portraits by Picasso depicting his friend, the Spanish poet Jaime Sabartés (see J. Sabartés, *Picasso. Portraits et souvenirs*, Paris, 1946).

The Moscow portrait belongs to a group of pictures which were produced at the very beginning of Picasso's Blue period. In addition, it was one of the first pieces of this period done in oils.

X-ray examination of the picture has shown that the artist used for it one of his recent canvases with the representation of a seated child.

281 HEAD OF A WOMAN WITH A SCARF
TÊTE DE FEMME AU FICHU

Oil on canvas mounted on cardboard. 50×36.5 cm
Traces of an erased two-line inscription, top left: *a Henri Bloch Picasso*
Inv. No. 6573 Z. I, 66; D.-B. IX, 14
Provenance: S. Shchukin collection, Moscow; 1918 First Museum of Modern Western Painting, Moscow; 1923 Museum of Modern Western Art, Moscow; since 1930 The Hermitage, Leningrad

For all its realistic features, this small picture, resembling a tinted drawing, coloured in blue and red, is by no means a representation of a concrete model. This is a stylized image combining features of different faces.

282 THE VISIT (TWO SISTERS)
L'ENTREVUE (LES DEUX SŒURS)

Oil on panel. 152×100 cm
Signed and dated, top right: *Picasso 1902*
Inv. No. 9071 Z. I, 163; D.-B. VII, 22
Provenance: S. Shchukin collection, Moscow; 1918 First Museum of Modern Western Painting, Moscow; 1923 Museum of Modern Western Art, Moscow; since 1948 The Hermitage, Leningrad

In his letter of 13 July 1902 to his friend Max Jacob, Picasso wrote that he was painting a picture of a prostitute from the Saint-Lazare infirmary and a mother ("une putain de S. Lazare et une mère"). Enclosed was a drawing with the inscription *Two Sisters* (Z. VI, 436). Contrary to the general opinion, this was not a sketch for the Hermitage picture, but a drawing representing the state of the picture at the time of writing.

At present there exist six sketches for this painting: Z. XXI, 368; J. E. Cirlot, *Picasso: The Birth of a Genius*, London, 1972, No. 270; Z. XXI, 369; M. Raynal, *Picasso*, Paris, 1922, XIII; Z. XXII, 37; Z. VI, 435. The seventh drawing — J. E. Cirlot, *op. cit.*, No. 267 — may have served as a control study of the left-hand figure of the composition.

The traditional interpretation of the subject — a visit of a nun, a "sister of mercy", to a prostitute from the Saint-Lazare prison hospital — is due to the error in the reading of the above-mentioned letter in which the word *mère* has been for a long time misread as *sœur*. The right-hand woman is beyond doubt an allegorical representation of motherhood, as she holds a baby in her arms (in some sketches she is obviously pregnant), not of monasticism.

The subject of this picture reflects the impressions Picasso gained in Paris in the summer or autumn of 1901, when he visited the Saint-Lazare infirmary, while its medieval icon-like character is in full agree-

ment with the twenty-year-old artist's ideas concerning the sacred role of art.

The Visit is a characteristic work of the early Blue period; its message is mysterious despite various attempts to give it a genre-like or allegorical interpretation. From the greenish-blue, mystic darkness there loom two figures clad in garments which cannot be associated with any definite period; their faces are impersonal, the gestures slow, and the poses suggest grief. Everything bespeaks a symbolic, unreal event, a mystic ritual, as it were, an otherworldly meeting of "two sisters". These two opposite images — a mother and a whore — represent two metaphysical aspects of woman's essence: the spiritual and the carnal, the immortal and the mortal. Accordingly, the figure of the mother is saturated with the tense hues of ultramarine; it is modelled freely, the lines are smooth and fluid. In the figure of the prostitute, on the contrary, the morbid greenish-grey tones of raw clay predominate. The whole is criss-crossed with mournful shadows; the angular rhythms do not distort the general statuesque aspect.

The two female figures, two sisters, are not sisters in blood; nor are they merely the symbols of maternity and sterility, piety and vice. They are sisters in suffering, and reflect the *Weltschmerz* of Picasso's Blue period.

283 PORTRAIT OF SOLER
PORTRAIT DE SOLER

Oil on canvas. 100×70 cm
Signed and dated, top left: *Picasso 1903*
Inv. No. 6528 Z. I, 199; D.-B. IX, 22
Provenance: Soler collection, Barcelona; D.-H. Kahnweiler Gallery, Paris; S. Shchukin collection, Moscow; 1918 First Museum of Modern Western Painting, Moscow; 1923 Museum of Modern Western Art, Moscow; since 1930 The Hermitage, Leningrad

Soler is shown as a melancholy dandy. His refined face, slightly touched with warm colours, seems to emit luminosity, and his large nervous hands, rendered in green, phosphoresce in a dark blue vacuum of unreal space.

There are three Picasso drawings representing Soler: Z. XXI, 137; Z. XXII, 40; Z. VI, 115. All three drawings were done in 1903, although the last was wrongly dated 1897 by Zervos.

284 OLD JEW AND A BOY (BLIND BEGGAR WITH A BOY)
LE VIEUX JUIF

Oil on canvas. 125×92 cm
Signed, top right: *Picasso*
Inscribed on the reverse, on the stretcher, at top: *Picasso Calle de la Merced 3 piso 2° Barcelona Espagne*
Inv. No. 3318 Z. I, 175; D.-B. IX, 30
Provenance: 1913 S. Shchukin collection, Moscow; 1918 First Museum of Modern Western Painting, Mos-

cow; 1923 Museum of Modern Western Art, Moscow; since 1948 The Pushkin Museum of Fine Arts, Moscow

The picture was painted in 1903 in Barcelona, where Picasso lived in the early 1900s between his stays in Paris. In Barcelona he began to paint almost entirely in blue, representing mainly the poor and the suffering. Along with *Life* (Z. I, 179; D.-B. IX, 13) and *Old Guitarist* (Z. I, 202; D.-B. IX, 34), this picture is justly considered a key work of Picasso's Blue period.

285 SPANISH WOMAN FROM MALLORCA
ESPAGNOLE DE L'ÎLE DE MAJORQUE

Tempera and watercolour on cardboard. 67×51 cm
Signed, bottom left: *Picasso*
Inv. No. 3316 Z. I, 288; D.-B. XII, 34
Provenance: 1913 S. Shchukin collection, Moscow; 1918 First Museum of Modern Western Painting, Moscow; 1923 Museum of Modern Western Art, Moscow; since 1948 The Pushkin Museum of Fine Arts, Moscow

The present picture is a study for the figure at extreme right in Picasso's famous canvas *Family of Saltimbanques* of 1905 (Z. I, 285; D.-B. XII, 35). In contrast to this canvas, Picasso did not use any warm colours in the study, but instead left some parts of the light ochreous cardboard unprimed and unpainted. As is often the case with Picasso, the Moscow study is highly finished and may be accepted as a work of art in its own right. Another study for the above-mentioned canvas is also in the Pushkin Museum of Fine Arts, Moscow (see No. 286).

286 FAMILY OF SALTIMBANQUES (COMEDIANS)
LA FAMILLE DES SALTIMBANQUES
(LES BATELEURS)

Gouache and charcoal on cardboard. 51.2×61.2 cm
Signed, bottom left: *Picasso*
Inv. No. 10265 Z. I, 287; D.-B. XII, 33
Provenance: 1913 S. Shchukin collection, Moscow; 1918 First Museum of Modern Western Painting, Moscow; 1923 Museum of Modern Western Art, Moscow; since 1948 The Pushkin Museum of Fine Arts, Moscow

Painted at the beginning of 1905 in Paris, this is a study for the central part of Picasso's canvas *Family of Saltimbanques* (Z. I, 285; D-B. XII, 35; see also No. 285). According to Georges Boudaille, this is the original version of the composition. It represents five figures; the figure of the Spanish woman is missing and in place of the young Harlequin we see an elderly man wearing a top hat and holding a travelling-bag. The introduction of Harlequin in the picture and the omission of individual elements in the surrounding landscape show that Picasso began to transform his approach to the subject depicted, rejecting the genre treatment of a scene in favour of a more philosophical one.

287 GLASSWARE. STILL LIFE WITH A PORRÓ
VAISSELLE EN VERRE. NATURE MORTE
AU PORRÓN

Oil on canvas. 38.4×56 cm
Signed, bottom right: *Picasso*
Inv. No. 8895 Z. I, 343; D.-B. XV, 13
Provenance: D.-H. Kahnweiler Gallery, Paris;
S. Shchukin collection, Moscow; 1918 First Museum
of Modern Western Painting, Moscow; 1923 Museum
of Modern Western Art, Moscow; since 1948 The Her-
mitage, Leningrad

This small picture is one of the still lifes done by Pi-
casso in the mountain village of Gosol (the Spanish
Pyrenees) in the summer of 1906. The same Spanish
wine-vessel appears in a *Still Life with a Painting*
(Z. I, 342; D.-B. XV, 14), in a small watercolour en-
titled *Porró and Bunch of Grapes* (Z. XXII, 458), and
in two or three compositions done during that summer.
In 1918, in the inventory of the Shchukin collection,
Still Life with a Porró, due to the retort-like form of
this vessel, was listed as *Still Life. Chemical Bottles.*
The still life presents four objects of the peasant
household, arranged frontally, in a Zurbaran manner.
In the composition one can sense the hidden humour
characteristic of Picasso, who transforms this unpre-
tentious "nature morte" into a genre situation; two
couples, one of glass, the other of earthenware, "meet"
on the table as on a stage or on a village street.

288 NUDE YOUTH
GARÇON NU

On the reverse, sketch of a reclining nude woman and
a youth seated beside her
Gouache on brown cardboard. 67.5×52 cm
Signed, bottom right: *Picasso*
Inv. No. 40777 Z. I, 268; D.-B. XIV, 8
Provenance: S. Shchukin collection, Moscow; 1918
First Museum of Modern Western Painting, Moscow;
1923 Museum of Modern Western Art, Moscow; since
1930 The Hermitage, Leningrad

The study was done at the end of the Pink period,
when Picasso began to paint strong, robust human
bodies with proportions like those of classical heroes.
Figures of athletes had been present in Picasso's com-
positions at an earlier stage (cf. No. 292), but served
only to accentuate the frailty and feebleness of his
main protagonists.
The Hermitage piece is among the first studies of a
series of Paris and Gosol works, uncompleted com-
positions with youths leading or bathing horses,
done in the spring and summer of 1906 (Z. I, 264,
266; Z. II, 266, 267, 269, 270, etc.).

289, 290 HEAD OF AN OLD MAN IN A TIARA
TÊTE DE VIELLARD À LA TIARE

Watercolour, Indian ink and pen on paper. 17×10 cm
Inv. No. 10266 Z. I, 246

Provenance: S. Shchukin collection, Moscow; 1918
First Museum of Modern Western Painting, Moscow;
1923 Museum of Modern Western Art, Moscow; since
1948 The Pushkin Museum of Fine Arts, Moscow
The old man in the Moscow drawing is reminiscent of
characters appearing in Picasso paintings of the Blue
period. The tiara he wears is ornamented with a com-
plex design comprising nude figures, putti with gar-
lands, a dolphin and a horse. Characters in tiaras also
can be found in the artist's etchings of 1905 (*Salo-
me, The Dance*). More often than not these are repre-
sentations of buffoons. King Herod in *Salome*, for
example, is portrayed in the guise of a jester.

291 TWO FIGURES AND A MAN'S HEAD IN PROFILE
ÉTUDE DE DEUX FIGURES ET TÊTE D'HOMME
DE PROFIL

Reverse of the study *Boy with a Dog* (No. 293)
Tempera on brown cardboard. 41×57 cm
Provenance see under Nos. 293, 294.

The sketch was done in the late 1904 or early 1905.
This follows from the fact that the study *Boy with a
Dog* was executed on the cardboard's obverse not later
than the middle of May. Picasso might have conceived
several compositions with wandering acrobats, and
then worked them out in a number of versions. The
Hermitage sketch reflects the earliest stage of work
on these themes which found expression in the paint-
ing *Girl on a Ball* (No. 292).
In all other known studies — two drawings (Z. VI, 603,
604) and two watercolours (D.-B. XII, 18; Z. XXII,
p. 159) — Picasso made no use either of spontaneous
sketches from nature or of the initial compositional
concept, and renounced the horizontal format.

292 GIRL ON A BALL (YOUNG ACROBAT ON A BALL)
FILLETTE À LA BOULE

Oil on canvas. 147×95 cm
Signed, bottom right: *Picasso*
Inv. No. 3399 Z. I, 290; D.-B. XII, 19
Provenance: 1907 G. Stein collection, Paris; 1913
I. Morozov collection, Moscow (purchased for 13,500
francs); 1919 Second Museum of Modern Western
Painting, Moscow; 1923 Museum of Modern Western
Art, Moscow; since 1948 The Pushkin Museum of
Fine Arts, Moscow

In 1904, Picasso finally settled in Paris. During this
year and the next, which are usually referred to as his
Pink period, the artist frequently visited the Médrano
circus and became absorbed with the life of acrobats
and actors. His friendship with Max Jacob, Apollinaire
and André Salmon stimulated his interest in the cir-
cus and theatre people, which was reflected in many
works of the Pink period.
Girl on a Ball is thematically close to the *Family
of Saltimbanques* (Z. I, 285; D.-B. XII, 35) and also

dates to 1905. Artistic perfection makes it one of the major works of Picasso's Pink period.

The colour scale of this painting is built upon a juxtaposition of blue, pink, and silvery tones. Combined with Picasso's technique of applying thin layers of paint onto a coarse, almost unprimed canvas, it gives the picture its fresco-like appearance.

The characters of this painting occur in several other works of the Pink period. Thus, the figure of the young acrobat balancing on a ball, the young mother with a child, and the white horse are present in the *Family of Saltimbanques*, a watercolour of 1905 (Z. XXII, 159; D.-B. XII, 18), and in an engraving on the same subject and of the same date, executed in drypoint technique. The athlete portrayed in the Moscow picture appears in a 1905 gouache entitled *Athlete* (D.-B. XII, 20). The athlete and the young acrobat are also depicted in a watercolour of the same date, which is now in a private collection in New York (Z. I, 292; D.-B. XII, 14).

X-ray examination has revealed a male portrait overpainted in oils on the reverse of the canvas. The costume and the hairdo of the model, as well as his facial features and the turn of his head are completely identical with those of the artist's father as depicted in a watercolour belonging to the Picasso Museum in Barcelona (Z. I, 39). This watercolour is dated 1895—96.

The portrait of the artist's father on the reverse of the Moscow picture might have been painted at the same time and subsequently used by Picasso for the *Girl on a Ball*.

293, 294 BOY WITH A DOG
GARÇON AU CHIEN

On the reverse, a sketch of two figures and the head of a man in profile
Gouache on brown cardboard. 57×41 cm
Signed and dated, top right: *Picasso 05*
Inv. No. 42158 Z. I, 306; D.-B. XII, 16

Provenance: S. Shchukin collection, Moscow; 1918 First Museum of Modern Western Painting, Moscow; 1923 Museum of Modern Western Art, Moscow; since 1934 The Hermitage, Leningrad

The lyrical and somewhat melancholy mood of this study, as well as its greyish-blue colouring with delicate pink highlights and the browns of the cardboard showing through in some parts of the picture, are typical of Picasso's Pink period. It is undoubtedly linked to a series of sketches for the large-scale painting *Family of Saltimbanques*, started in Paris at the end of 1904 (Z. I, 285; D.-B. XII, 35), but is itself a work of high artistic merit. This and other existing sketches, among them those from Soviet museums (Nos. 285, 286), can give some idea of the original conception of this remarkable work.

Since a variant with two acrobats and a dog (Z. I. 300; D.-B. XII, 17), closely related to the Hermitage study, was painted not later than the beginning of February 1905 (from 25 February to 6 March it was exhibited at the Serrurier Gallery, and on May 15 it was reproduced in Apollinaire's article in *La Plume*), the Hermitage study was probably done about the same time or, judging by its stylistic features, somewhat earlier.

LIST OF EXHIBITIONS

Note: arabic numerals refer to catalogue entry numbers.

1874

Paris: I^{re} Exposition de la Société Anonyme des Artistes Peintres, Sculpteurs, Graveurs 14, 25, 31

1875

London, Society of French Artists. The Durand-Ruel Gallery in London 62

1876

Paris: 2e Exposition de la peinture 50

1877

Paris, avril: 3e Exposition de la peinture 11, 12, 50

1879

Paris, avril — mai: 4e Exposition de la peinture 8, 52

Paris, Palais des Champs-Elysées: Salon de 1879 52

1882

Paris, mars: 7e Exposition des Artistes Indépendants 55

1883

Paris, Galerie Durand-Ruel: Claude Monet 14

1886

Paris, avril — mai: 8e Exposition des Artistes Indépendants 68

New York, National Academy of Design: Works in Oil and Pastel by the Impressionists of Paris 170

1888

Paris, Galerie Durand-Ruel, 25 mai — 25 juin: Exposition des Impressionnistes 55

1889

Paris, Galerie Georges Petit, juin — juillet: Claude Monet et Auguste Rodin 14

1890

Bruxelles: 7e Exposition des «XX» 109

1891

Bruxelles, février — mars: 8e Exposition des «XX» 104

Paris: Exposition des Artistes Indépendants 104

1892

Paris, Galerie Durand-Ruel, mai: Auguste Renoir 55

1893

Copenhague: Société des Arts Libres 129

Paris, Galerie Durand-Ruel, novembre: Œuvres récentes de Gauguin 122, 123, 124, 125, 126, 128

1895

Paris, Hôtel Drouot: Exposition-vente des tableaux de Gauguin 125, 126, 129, 132

Paris, avril: Salon de la Société Nationale des Beaux-Arts 231

Paris, Galerie Durand-Ruel, mai: Claude Monet 27, 28

Paris, Galerie Vollard, novembre — décembre: Paul Cézanne 82, 92

1896

Paris, avril: Salon de la Société Nationale des Beaux-Arts 238

1897

Paris, avril: Salon de la Société Nationale des Beaux-Arts 235, 266

Bruxelles: 4e Exposition Esthétique Libre 132, 134, 137

1898

Bruxelles: 5e Exposition Esthétique Libre 223

Paris, Galerie Durand-Ruel, mai — juin: Camille Pissarro 32, 36

1899

Москва: Международная выставка журнала «Мир искусства» 167

Paris, Galerie Durand-Ruel, avril: Monet, Pissarro, Renoir et Sisley 55

1900

Paris, Exposition Universelle, avril — octobre: Centennale de l'Art Français 9, 47

1901

Berlin: Kunstausstellung Berliner Sezession III 114

Paris, avril — mai: Salon des Artistes Indépendants 271

1903

Wien: Entwicklung des Impressionismus in Malerei und Plastik, Sezession 9

Paris, Galerie Vollard, mars: Paul Gauguin 132, 134, 139, 140

Paris, octobre — décembre: Salon d'Automne, I^{re} exposition 176

1904

Bruxelles: 11e Exposition Esthétique Libre 52

Paris, Galerie Durand-Ruel, 9 mai — 4 juin: Claude Monet. Vues de la Tamise à Londres (1902—1904) 29, 30

Paris, Galerie Vollard, juin: Matisse 271, 274

Paris, 15 octobre — 15 novembre: Salon d'Automne, 2e exposition 48, 55, 81, 84, 86, 89, 204, 257

1904—1905

Dublin, Royal Hibernian Academy: Exhibition of the Pictures Presented and Lended 42

1905

Paris, 24 mars — 30 avril: Salon des Artistes Indépendants, 21e exposition 117

London, Grafton Galleries, January—February 55

Amsterdam, Stedelijk Museum, July — August: Van Gogh 116

Paris, 18 octobre—25 novembre: Salon d'Automne, 3e exposition 260

1906

Paris, Galerie Durand-Ruel: Dix-sept tableaux de Claude Monet de la collection Faure 11, 14, 17

Paris, mars—avril: Salon des Artistes Indépendants, 22e exposition 102, 229

Paris, Galerie Bernheim-Jeune, 4—17 mai: Félix Vallotton 255, 258

Berlin, Galerie Cassirer, September—Oktober; Stuttgart, Dezember: Monet, Manet 11, 14, 17

Paris, 6 octobre — 15 novembre: Salon d'Automne, 4e exposition 121, 122, 124, 132, 134, 135, 136, 144, 146, 148

Москва: XIII выставка Общества московских художников 184

1907

Mannheim, 1. Mai — 20. Oktober: Internationale Kunstausstellung 14

Paris, 20 mars — 30 avril: 23e Exposition des Artistes Indépendants 103

Paris, Galerie Bernheim-Jeune, 2 avril — 8 mai: Henri-Edmond Cross 106

Paris, 14 avril — 30 juin: Salon de la Société Nationale des Beaux-Arts 178, 239

Paris, 1—22 octobre: Salon d'Automne 74, 100

1908

Paris, Galerie Druet, janvier: Van Gogh 113

Paris, 1 octobre — 8 novembre: Salon d'Automne 198, 241—253

Москва: Салон журнала «Золотое Руно» 263, 264

1909

Paris, Galerie Durand-Ruel: Claude Monet. Nymphéas 26

Paris, Galerie Druet, 8—20 novembre: Vincent Van Gogh 115, 116, 117

1910

Paris, Galerie Bernheim-Jeune, 7—26 mars: Pierre Bonnard 214

Paris, Galerie Bernheim-Jeune, 17—18 mai: Henri-Edmond Cross 107

1912

Москва: Выставка «Сто лет французской живописи (1812—1912)», устроенная жур-

LIST OF ABBREVIATIONS

B.

J. Bouret, *Henri Rousseau*, Neuchâtel, 1961

Compin

J. Compin, *Henri-Edmond Cross*, Paris, 1964

D.-B.

P. Daix and G. Boudaille, *Picasso: The Blue and Rose Periods. A Catalogue Raisonné. 1900—1906*, Greenwich, Conn., 1967

Dauberville

J. et H. Dauberville, *Bonnard. Catalogue raisonné de l'œuvre peint,* 4 vols., Paris, 1965— 1974

Daulte, *Renoir*

F. Daulte, *Auguste Renoir. Catalogue raisonné de l'œuvre peint*, Lausanne, 1971

Daulte, *Sisley*

F. Daulte, *Alfred Sisley. Catalogue raisonné de l'œuvre peint*, Lausanne, 1959

F.

J.-B. de La Faille, *The Work of Vincent Van Gogh. His Paintings and Drawings*, Amsterdam, 1970

Field, *Monotypes*

Richard S. Field, *Paul Gauguin: Monotypes*

(published on the occasion of the exhibition at the Philadelphia Museum of Art), Philadelphia, 1973

Guérin

M. Guérin, *L'Œuvre gravé de Gauguin*, Paris, 1927

J.-W.

Manet (introduction par Paul Jamot, catalogue critique par Paul Jamot et Georges Wildenstein avec la collaboration de Marie-Louise Bataille), 2 vols., Paris, 1932

L.

P. A. Lemoisne, *Degas et son œuvre*, 4 vols., Paris, 1946—49

L. R.

Félix Vallotton, *Livre de raison* (published in: H. Hahnloser-Bühler, *Félix Vallotton et ses amis*, Paris, 1936)

Mellério

A. Mellério, *Odilon Redon. Catalogue de l'œuvre gravé*, Paris, 1913

Rewald

J. Rewald, *Gauguin. Drawings*, New York, London, 1958

R.-V.

L. Rodo-Pissarro, L. Venturi, *Camille Pissarro, son art, son œuvre*, 2 vols., Paris, 1939

R.-W.

D. Rouart, D. Wildenstein, *Edouard Manet. Catalogue raisonné*, 2 vols., Lausanne, Paris, 1975

V.

L. Venturi, *Cézanne, son art, son œuvre*, 2 vols., Paris, 1936

Vallier

Tout l'œuvre peint de Henri Rousseau (documentation et catalogue raisonné par Dora Vallier), Paris, 1970

W. G.

G. Wildenstein, *Gauguin. Catalogue*, Paris, 1964

W. M.

D. Wildenstein, *Claude Monet. Biographie et catalogue raisonné. Peintures*, vol. 1 (1840—1881), Lausanne, Paris, 1974; vol. 2 (1882—1886), 1979; vol. 3 (1887—1898), 1979

Z.

Ch. Zervos, *Pablo Picasso. Catalogue illustré*, 33 vols., Paris, 1932—1978

CATALOGUES AND PRINCIPAL WORKS ON 19TH- AND 20TH-CENTURY FRENCH ART IN SOVIET MUSEUMS

Каталог картин собрания С. И. Щукина, Москва, 1913

Каталог художественных произведений Городской галереи Павла и Сергея Третьяковых, Москва, 1917

Государственный музей нового западного искусства. Иллюстрированный каталог, Москва, 1928

Государственный музей изобразительных искусств имени А. С. Пушкина. Каталог картинной галереи. Живопись, скульптура, Москва, 1961

Государственный Эрмитаж. Западноевропейская живопись. Каталог, т. I (Италия, Франция, Испания, Швейцария), Ленинград, 1976

Маковский, С. «Французские художники из собрания И. А. Морозова», *Аполлон*, 1912, 3/4

Муратов, П. «Щукинская галерея (очерк из истории новейшей живописи)», *Русская мысль*, 1908, 8

Перцов, П. *Щукинское собрание французской живописи. Музей новой западной живописи*, Москва, 1921

Тугендхольд, Я. «Французское собрание С. И. Щукина», *Аполлон*, 1914, 1/2

Тугендхольд, Я. *Первый музей новой западной живописи (бывшее собрание С. И. Щукина)*, Москва, Петроград, 1923

French Painting from the Pushkin Museum of Fine Arts, Moscow. 17th to 20th Century (compiled and introduced by E. Georgievskaya and I. Kuznetsova), Leningrad, 1979

French Painting. Second Half of the 19th to Early 20th Century. The Hermitage, Leningrad (selection and notes by Anna Barskaya; introduction by Antonina Izerghina), Leningrad, 1975 (2nd ed. 1982)

The Hermitage, Leningrad. French 19th Century Masters (introduction and notes by A. N. Izerghina and the staff of the State Hermitage, Leningrad), Prague, Leningrad, 1968

Réau. L. *Catalogue de l'art français dans les musées russes*, Paris, 1929

Sterling, Ch. *Musée de l'Ermitage. La Peinture française de Poussin à nos jours*, Paris, 1957

Ternovetz, B. «Musée d'art Moderne de Moscou», *L'Amour de l'Art*, 1925, décembre

Western European Drawing. The Hermitage (general introduction and selection by Yury Kuznetsov), Leningrad, 1981

BOOKS, COLLECTIONS OF ARTICLES AND OTHER PUBLICATIONS CONTAINING REFERENCES TO 19TH- AND 20TH-CENTURY FRENCH ART IN SOVIET MUSEUMS

Бенуа, А. *Мои воспоминания*, т. 2, Москва, 1980

Константин Сомов. Письма. Дневники. Суждения современников, Москва, 1979

Рисунки западноевропейских художников XIX века. Альбом (сост. и авт. вступительной статьи В. Гращенков), Москва, 1961

Сокровища Эрмитажа. Альбом, Ленинград, 1968

Терновец, Б. «Новые поступления во Второй музей новой западной живописи в Москве», *Среди коллекционеров*, 1922, май—июнь

Терновец, Б. *Избранные статьи*, Москва, 1963

Терновец, Б. *Письма. Дневники. Статьи*, Москва, 1977

Трутовский, В. «Музей Петра Ивановича Щукина в Москве», *Художественные сокровища России*, 1902, 6

Тугендхольд, Я. *Проблемы и характеристики*, Санкт-Петербург, 1915

Яворская, Н., Терновец, Б. *Художественная жизнь Франции второй половины XIX века*, Москва, 1938

Эрмитаж. Графика (сост. и авт. вступительной статьи М. Доброклонский), Ленинград, 1961

Apollinaire, G. *Chronique d'art (1902—1918)*. Textes réunis avec préface et notes par L.-C. Breunig, Paris, 1960

The Arts, 1927, August

Champa, K. *Studies in Early Impressionism*, London, 1973

Ettinger, P. «Die modernen Franzosen in den Kunstsammlungen Moskaus», *Der Cicerone*, 1928, Januar (1. Teil), Februar (2. Teil)

French Painting of the 20th Century. The Pushkin Museum of Fine Arts Collection, Moscow (compiled and with notes by T. Borovaya), Leningrad, 1972

Gazette des Beaux-Arts, 1911, novembre

Gordon, Donald E. *Modern Art Exhibitions. 1900—1916*, 2 vols., Munich, 1974

Grautoff, O. «Die Sammlung Stschukin in Moskau», *Kunst und Künstler*, 1918, Dezember

Heilbut, E. «Die Wiener Impressionistenausstellung», *Kunst und Künstler*, 1907, Heft 5/6

Huysmans, J. *L'Art moderne*, Paris, 1902

Leymarie, J. *L'Impressionnisme*, Lausanne, 1955

Mauclair, C. *L'Impressionnisme*, Paris, 1904

Osborn, M. «Die junge Kunst in den russischen Museen und Sammlungen», *Der Cicerone*, 1924, September

Raynal, M. *La Peinture moderne*, Genève, 1953

Rewald, J. *The History of Impressionism*, New York, 1946 (2nd ed. 1961)

Rewald, J. *Post-Impressionism. From Van Gogh to Gauguin*, New York, 1962

Venturi, L. *De Manet à Lautrec*, Paris, 1953

Venturi, L. *Les Archives de l'Impressionnisme*, 2 vols., Paris, New York, 1939

MONOGRAPHS AND MAGAZINE ARTICLES ON INDIVIDUAL ARTISTS

Bonnard

L'Art décoratif, 1911, novembre

Besson, G. *Bonnard*, Paris, 1934

Coquiot, G. *Bonnard*, Paris, 1922

George, W. «Le Sentiment de l'antique dans l'art moderne», *L'Amour de l'Art*, 1935, février

Natanson, T. *Le Bonnard que je propose*, Genève, 1951

Negri, R. *Bonnard e i Nabis*, Milano, 1970

Rewald, J. *Pierre Bonnard*, New York, 1948

Salmon, A. *L'Art vivant*, Paris, 1920

Sterling, Ch. «Notice bibliographique de Bonnard», *L'Amour de l'Art*, 1933, avril

Terrasse, A. *Pierre Bonnard*, Paris, 1967

Terrasse, Ch. *Bonnard*, Paris, 1927

Vaillant, A. *Bonnard ou le bonheur de voir*, Neuchâtel, 1965

Werth, L. *Quelques peintures*, Paris, 1923

Cézanne

Бабаджан, В. *Сезанн. Жизнь, творчество, избранные отрывки из писем*, Одесса, 1919

Барская, А. «Несколько заметок о картинах Поля Сезанна», *Западноевропейское искусство* (сборник статей, посвященный 75-летию со дня рожде-

ния В. Левинсона-Лессинга), Ленинград, 1970

Муратов, П. *Сезанн*, Берлин, 1923

Нюренберг, А. *Поль Сезанн*, Москва, 1923

Яворская, Н. *Сезанн*, Москва, 1935

L'Amour de l'Art, 1936, mai (numéro spécial)

Barr, A. H. «Cézanne d'après les lettres de Marion à Morstatt. 1865—1868», *Gazette des Beaux-Arts*, 1937, janvier

Bell, C. *The French Impressionists*, London, New York, 1952

Bernard, E. *Souvenirs sur Paul Cézanne et lettres*, Paris, 1925; *The Arts*, 1927, August

Brion-Guerry, L. L. *Cézanne et l'expression de l'espace*, Paris, 1966

Burger, F. *Cézanne und Hadler*, München, 1913

Dorival, B. *Cézanne*, Paris, 1948

Dreyfus, A. «Paul Cézanne», *Zeitschrift für bildende Kunst*, 1913, N. F., 24. Jg.

Feist, P. H. *Paul Cézanne*, Leipzig, 1963

Genthon, J. *Cézanne*, Budapest, 1958

Gowing, L. *An Exhibition of Paintings by Cézanne*, Edinburgh, 1954

Huyghe, R. *Cézanne*, New York, 1962

Klingsor, T. *Cézanne*, Paris, 1924

Larguier, L. *Le Dimanche avec Paul Cézanne*, Paris, 1925

Leonard, K. *Paul Cézanne*, Hamburg, 1966

Loran, E. *Cézanne's Compositions*, Los Angeles, 1943

Mack, G. *Paul Cézanne*, New York, 1936 (2nd ed.)

Meier-Graefe, J. *Paul Cézanne*, München, 1913

Meier-Graefe, J. *Cézanne und sein Kreis*, München, 1922

Novotny, F. *Cézanne*, Wien, New York, 1937

L'opera completa di Cézanne. Presentazione di Alfonso Gatto. Apparati critici e filologici di Sandra Orienti, Milano, 1970

Paul Cézanne (compiled and introduced by Yekaterina Drevina), Leningrad, 1981

Paul Cézanne. Paintings from the Museums of the Soviet Union. The Hermitage, Leningrad; the Pushkin Museum of Fine Arts, Moscow (compiled and introduced by Anna Barskaya, Yevgenia Georgievskaya), Leningrad, 1983

Paul Cézanne. Correspondance recueillie par John Rewald, Paris, 1937 (2e éd. 1978); *Paul Cézanne. Letters* (edited by John Rewald), London, 1941

Pfister, K. *Cézanne. Gestalt, Werk, Mythos*, Potsdam, 1927

Rewald, J. *Cézanne. Sa vie, son œuvre, son amitié pour Zola*, Paris, 1939

Rewald, J., Marschutz, L. «Cézanne au Château-Noir», *L'Amour de l'Art*, 1935, janvier

Royère, J. «Paul Cézanne», *Kunst und Künstler*, 1912, 10. Jg.

Salmon, A. *Cézanne*, Paris, 1923

Vollard, A. *Paul Cézanne*, Paris, 1919 (autres éditions: 1914, 1924, 1938)

Waldmann, E. «Kunst des Realismus und Impressionismus», *Propyläen-Kunstgeschichte*, XV, 1927

Cross

Cousturier, L. «H. E. Cross», *L'Art décoratif*, 1913, mars

Cousturier, L. *H. E. Cross*, Paris, 1932

Fénéon, F. «Le Dernier carnet de H. E. Cross», *Bulletin de la vie artistique*, 1922, 15 mai

Degas

Эдгар Дега. Воспоминания современников, Москва, 1971

Дега. 1834—1917. Альбом репродукций (сост. и авт. вступительной статьи Б. Зернов), Ленинград, Москва, 1965

Edgar Degas (text and selection by Asia Kantor-Gukovskaya), Leningrad, 1982

Fiala, V. *Degas*, Praha, 1914

Grappe, C. *Edgar Degas* (Kunst der Gegenwart), Bd. III, Berlin, s.a.

Hausenstein, W. *Der nackte Mensch in der Kunst aller Zeiten und Völker*, München, 1913

Lettres de Degas, recueillies et annotées par M. Guérin, Paris, 1931 (2e éd. 1945)

L'opera completa di Degas. Presentazione di Franco Rassoli. Apparati critici e filologici di Fiorella Minervino, Milano, 1970

Roger-Marx, C. *Degas. Danseuses*, Paris, 1956

Rouart, D. *Degas à la recherche de sa technique*, Paris, 1945

Serullaz, M. *Degas. Femmes à leur toilette, blanchisseuses, modistes*, Paris, 1958

Vollard, A. *Degas*, Paris, 1924

Denis

Alexandre, A. «Un Peintre mystique au XXe siècle: Maurice Denis», *L'Art et les Artistes*, X, 1909/1910

Barazzetti-Demoulin, S. *Maurice Denis*, Paris, 1945

Chassé, Ch. *Les Nabis et leur temps*, Lausanne, Paris, 1960

De Fauville, J. «Maurice Denis», *La Revue de l'art ancien et moderne*, 33, 1913

Exposition Maurice Denis. Du 28 juin au 29 septembre 1963. Musée Toulouse-Lautrec, Albi. Catalogue, 1963

Exposition Maurice Denis. Orangerie des Tuileries. Catalogue, Paris, 1970

Hepp, P. «Le Salon d'Automne», *Gazette des Beaux-Arts*, 1908, 11

Meier-Graefe, J. *Entwicklungsgeschichte der modernen Kunst*, 3 vols., Stuttgart, 1904

Mithouard, A. «Maurice Denis», *Art et Décoration*, XXII, 1907

Monod, F. «*L'Histoire de Psyché* de M. Maurice Denis», *Art et Décoration*, XXIV, 1908

Pératé, A. *La Peinture aux Salons de 1897. Paris et Londres*, Paris, 1897

Sagard, A. *Peintres d'aujourd'hui. Les Décorateurs*, Paris, 1914

Verhaeren, E. «A Bruxelles. La Libre Esthétique», *La Revue Blanche*, 1898, mars

Gauguin

«Гоген. Художники Запада» (по Мейер-Графе составлено В. Цветаевой), *Искусство*, 1905, 2/3

Изергина, А. «Картина Поля Гогена *Семья таитян*», *Сообщения Государственного Эрмитажа*, XX, 1961

Кантор-Гуковская, А. *Поль Гоген. Жизнь и творчество*, Ленинград, Москва, 1965

Поль Гоген. Ноа-Ноа. Путешествие по Таити (перевод, ред. и вступительная статья Я. Тугендхольда), Москва, 1914 (2-е изд. 1918)

Поль Гоген. Письма. Ноа-Ноа. Из книги «Прежде и потом» (перевод с французского Н. Рыковой; сост., вступительная статья, прим. и общ. ред. А. Кантор-Гуковской), Ленинград, 1970

Beguin, S. «*Arearea*», *La Revue du Louvre et des Musées de France*, 1961, 4/5

Cachin, F. *Gauguin*, Paris, 1968

Danielsson, B. *Gauguins Söderhavsar*, Stockholm, 1964

Dorival, B. "Sources of the Art of Gauguin from Java, Egypt and Ancient Greece", *The Burlington Magazine*, 1951, April

Field, R. S. *Gauguin: plagiaire ou créateur?* (Collection «Génies et Réalité»), Paris, 1960

Four Americans in Paris. The Collection of Gertrude Stein and Her Family, New York, 1970

Gauguin, P. *Noa Noa*, Paris, 1924 (éd. définitive); Gauguin, P. *Noa-Noa*, Oxford, 1961

Gauguin: sa vie, son œuvre. Réunion de textes, d'études, de documents sous la direction et avec la collaboration de Georges Wildenstein, Paris, 1958

Gray, Ch. *Sculpture and Ceramics of Paul Gauguin*, Baltimore, 1963

Jaworska, W. *Gauguin et l'Ecole de Pont-Aven*, Neuchâtel, 1971

Landy, B. "The Meaning of Gauguin's *Oviri* Ceramic", *The Burlington Magazine*, 1967, April

Langer, A. *Paul Gauguin*, Leipzig, 1965

Leymarie, J. *Gauguin. Orangerie des Tuileries. Exposition du Centenaire. Catalogue*, Paris, 1949

L'opera completa di Gauguin. Introdotta da scritti del pittore e coordinata da C. N. Sugana, Milano, 1973

Paul Gauguin (compiled and introduced by A. Kantor-Gukovskaya), Leningrad, 1977

Rotonchamp, Jean de. *Paul Gauguin. 1848—1903*, Paris, 1925

Sutton, D. "Notes on Gauguin Apropos a Recent Exhibition", *The Burlington Magazine*, 1956, March

«Traduction et interprétation des titres en langue tahitienne inscrits sur les œuvres océaniennes de Paul Gauguin revues par L.-J. Bouge, ancien gouverneur de Tahiti», dans: *Gauguin, sa vie, son œuvre.* Réunion de textes, d'études, de documents sous la direction et avec la collaboration de Georges Wildenstein, Paris, 1958

Wiese, E. «Paul Gauguin. Zwei Jahrzehnte nach seinem Tode», *Junge Kunst*, 56, Leipzig, 1923

Manet

Верейский, Г. «Рисунок Эдуарда Мане. Новое приобретение Государственного Эрмитажа», *Искусство*, 1938, 5

Moreau-Nelaton, E. *Manet raconté par lui-même*, 2 vols., Paris, 1926

Richardson, J. *Edouard Manet. Paintings and Drawings*, London, 1958

Tabarant, A. *Manet et ses œuvres*, Paris, 1947

Tout l'œuvre peint d'Edouard Manet. Introduction par Denis Rouart, documentation par Sandra Orienti, Paris, 1970

Matisse

Матисс. Живопись. Скульптура. Графика. Письма. Альбом-каталог (авт. вступительной статьи А. Изергина), Ленинград, 1969

Aragon, L. *Henri Matisse, roman,* t. 1, Paris, 1971; Aragon, L. *Henri Matisse, a Novel*, London, 1971

Barr, A. *Matisse — His Art and His Public*, New York, 1951

Chefs-d'œuvre de Henri Matisse. Mai — juillet 1958. Galerie de MM. Bernheim-Jeune — Dauberville et Cie. Catalogue, Paris, 1958

Diehl, G. *Henri Matisse.* Notices par Agnès Humbert, Paris, 1954

Escholier, R. *Henri Matisse*, Paris, 1937

Henri Matisse (compiled and introduced by Albert Kostenevich), Leningrad, 1981

Henri Matisse. Dessins et sculptures. Musée National d'Art Moderne. 29 mai — 7 septembre 1975. Catalogue, Paris, 1975

Henri Matisse. Exposition du Centenaire. Avril — septembre 1970. Catalogue, Paris, 1970

Henri Matisse. Paintings and Sculptures in Soviet Museums (introduction by A. Izerghina), Leningrad, 1978

Lassaigne, J. *Matisse*, Genève, 1959

Monet

Барская, А. «Новые данные о картине Клода Моне *Дама в саду*», *Сообщения Государственного Эрмитажа*, XXVIII, 1967

Георгиевская, Е. *Клод Моне*, Москва, 1979

Картина Клода Моне «Зимний пейзаж» (автор текста М. Закке, технологический анализ картины А. Козорацкой), Рига, 1959

Орлова, М. «Клод Моне», *Искусство*, 1940, 6

Трутовский, В. «Музей Петра Ивановича Щукина в Москве», *Художественные сокровища России*, 1902, 6

Adhémar, H. «Modifications apportées par Monet à son *Déjeuner sur l'herbe* de 1865 à 1866», *Bulletin du laboratoire du Musée du Louvre*, 1958, 3

Adhémar, H. «Décoration pour le château de Rottembourg à Montgeron», dans: *Hommage à Claude Monet*, Paris, 1980

Alexandre, A. *Claude Monet*, Paris, 1921

Bazin, G. *L'Epoque impressionniste*, Paris, 1957

Besson, G. *Monet*, Paris, 1914

Catalogue de la 4e Exposition de la peinture … ouverte du 10 avril au 11 mai 1879 … Paris, 1879

Claude Monet (introduction by I. Sapego; catalogue by A. Barskaya and E. Georgievskaya), Leningrad, 1969

Claude Monet (compiled and introduced by Anna Barskaya), Leningrad, 1980

Dewhurst, W. *Impressionist Painting*, London, 1904

Hôtel Drouot. Vente de la collection Georges Feydeau, Paris, 11 février 1901

Elder, M. A. *Giverny chez Claude Monet*, Paris, 1924

Fels, F. *Claude Monet*, Paris, 1925

Fénéon, F. «Les Grands collectionneurs: Ivan Morosoff», *Bulletin de la vie artistique*, Paris, 1920, 15 mai

Grappe, G. *Claude Monet*, Paris, s. d.

Isaacson, J. *Monet*: Le Déjeuner sur l'herbe, New York, 1972

Leymarie, J. *L'Impressionnisme*, Genève, 1955

Mirbeau, O. *Claude Monet. Vues de la Tamise à Londres. Galerie Durand-Ruel, mai — juin 1904. Catalogue*, Paris, 1904

Moore, G. «Erinnerungen an die Impressionistenausstellung», *Kunst und Künstler*, 1907

L'opera completa di Claude Monet. 1870—1889. Introdotta da scritti del pittore e coordinata da Luigina Rossi Bortolatto, Milano, 1972

Pataky, D. *Monet*, Budapest, 1966

Poupel, F. «Histoire d'un Monet perdu et peut-être retrouvé», *Le Havre*, 1959, 16 avril

Regamey, R. «La Formation de Claude Monet», *Gazette des Beaux-Arts*, 1927, février

Reuterswaerd, O. *Monet*, Stockholm, 1948

Werth, L. *Claude Monet*, Paris, 1928

Picasso

Бабин, А. «О процессе работы Пикассо над картиной *Свидание*», *Сообщения Государственного Эрмитажа*, XLII, 1977

Бабин, А. «*Девочка на шаре* Пабло Пикассо», в кн.: *Античность. Средние века. Новое время*, Москва, 1977

Бабин, А. «Об оборотной стороне картины Пикассо *Любительница абсента*», *Сообщения Государственного Эрмитажа*, XLIII, 1978

Бабин, А. «Новые данные о *Портрете молодой женщины* П. Пикассо», *Сообщения Государственного Эрмитажа*, XLV, 1980

Графика Пикассо. Альбом (авторы очерков жизни и творчества И. Эренбург и М. Алпатов), Москва, 1967

Грищенко, А. *О связях русской живописи с Византией и Западом. XIII—XX века: Мысли живописца*, Москва, 1913

Кантор-Гуковская, А. «О наброске Пикассо в собрании рисунков Эрмитажа», *Сообщения Государственного Эрмитажа*, XLVI, 1981

Кузнецов, Ю. «От Дюрера до Пикассо», *Сообщения Государственного Эрмитажа*, XXXI, 1970

Прокофьев, В. «Пикассо. Годы формирования», в кн.: *Из истории классического искусства Запада*, Москва, 1980

Чулков, Г. «Демоны и современность. Мысли о французской живописи», *Аполлон*, 1914, 1/2

Barr, A. H. *Picasso: Fifty Years of His Art*, New York, 1950

Blunt, A., Pool, Ph. *Picasso: The Formative Years*, London, 1962

Cabanne, P. *Le Siècle de Picasso*, Paris, 1975

Cirici-Pellicer, A. *Picasso avant Picasso*, Genève, 1950

Cooper, D. *Picasso. Théâtre*, Paris, 1967

Daix, P. *Picasso*, Paris, 1964

Daix, P. *La vie du peintre Pablo Picasso*, Paris, 1977

Daix, P., Boudaille, G. *Picasso: The Blue and Rose Periods. A Catalogue Raisonné. 1900—1906*, Greenwich, Conn., 1967

Diehl, G. *Picasso*, Paris, 1960

Elgar, F. *Picasso: époques bleue et rose*, Paris, 1956

Elgar, F., Maillard, R. *Picasso*, Paris, 1955

Jaffe, H. L. C. *Pablo Picasso*, New York, 1964

Huyghe, R. «Le Cubisme», *L'Amour de l'Art*, 1933, 9

Kahnweiler, D.-H., Parmelin, H. *Picasso. Œuvres des musées de Léningrad et de Moscou*, Paris, 1955

Olivier, F. *Picasso et ses amis*, Paris, 1933

Penrose, R. *Picasso: His Life and Work*, London, 1958

Pablo Picasso (introduced by Herman Nedoshivin; compiled by Albert Kostenevich), Leningrad, 1979 (2nd ed. 1983)

Picasso (introduced by Ilya Ehrenburg; compiled by Albert Kostenevich), Leningrad, 1974

Reff, Th. "Themes of Love and Death in Picasso's Early Work", in: *Picasso: 1881—1973*, London, 1973

Rubin, W. (ed.). *Pablo Picasso. A Retrospective. Museum of Modern Art, New York*, Boston, 1980

Sabartés, J. *Picasso: portraits et souvenirs*, Paris, 1946

Starobinski, J. *Portrait de l'artiste en saltimbanque*, Genève, 1970

Sutton, D. *Pablo Picasso, peintures: époques bleue et rose*, Paris, 1955

Sutton, D., Lecaldano, P. *Picasso: Blue and Rose Periods*, London, 1971

Toklas, A. «L'Atelier de Gertrude Stein», *Gazette de Beaux-Arts*, 1934

Vallentin, A. *Pablo Picasso*, Paris, 1957

Zervos, Ch. *Pablo Picasso. Catalogue illustré*, 33 vols., Paris, 1932—1978

Pissarro

Камиль Писсарро. Письма. Критика. Воспоминания современников (перевод с французского; авт. вступительной статьи и примечаний К. Богемская), Москва, 1974

Camille Pissarro. Lettres à son fils Lucien, Paris, 1950

Coe, R. T. "Camille Pissarro in Paris. A Study of His Later Development", *Gazette des Beaux-Arts*, 1954, février

Pissarro (compiled and introduced by Mikhail Guerman), Leningrad, 1973 (2nd ed. 1979)

Redon

Кантор-Гуковская, А. «Пастель Одилона Редона», *Сообщения Государственного Эрмитажа*, XLV, 1980

Redon, O. *A soi-même*, Paris, 1922

Renoir

André, A. *Renoir*, Paris, 1923

Auguste Renoir (selection and introduction by Natalia Brodskaya), Leningrad, 1984

Daulte, F. *L'aquarelle française au XIXe siècle*, Fribourg, 1969

Drucker, M. *Renoir*, Paris, 1955

Duret, Th. *Renoir*, Paris, 1924

Duthuit, G. *Renoir*, Paris, 1923

Feist, P. H. *Auguste Renoir*, Leipzig, 1961

Geffroy, G. «Renoir — peintre de la femme», *L'Art et les Artistes*, X, 1909/1910

George, W. *Le Dessin français de David à Cézanne*, Paris, 1929

Meier-Graefe, J. *Auguste Renoir*, München, 1911

Meier-Graefe, J. *Renoir*, Leipzig, 1929

L'opera completa di Renoir nel periodo impressionista, 1869—1883. Introdotta da scritti del pittore e coordinata da Elda Fezzi, Milano, 1972

Perruchot, H. *La vie de Renoir*, Paris, 1964

Renoir, J. *Renoir*, Paris, 1962

Rivière, G. *Renoir et ses amis*, Paris, 1921

Rouart, D. *Renoir. Etude biographique et critique*, Genève, 1954

Terrasse, Ch. *Cinquante portraits de Renoir*, Paris, 1941

Vollard, A. *Tableaux, pastels et dessins de Pierre-Auguste Renoir*, 2 vols., Paris, 1918

Roussel

Gazette des Beaux-Arts, 1911, novembre

Henri Rousseau

«Художественные новости. Собрание С. И. Щукина», *Утро России*, 1913, 24 января

Bouret, J. *Le Douanier Rousseau*, Neuchâtel, 1961

Henri Rousseau (compiled and introduced by N. Brodskaya), Leningrad, 1977 (2nd ed. 1979, 3rd ed. 1983)

Unde, W. «Henri Rousseau et les primitifs modernes», *L'Amour de l'Art*, 1933, 8

Vallier, D. *Henri Rousseau*, Paris, 1961

Viatte, G. «Lettres inédites à Ambroise Vollard», *Art de France*, 1962, 11

Vallotton

Félix Vallotton. Documents pour une biographie et pour l'histoire d'une œuvre. Présentation, choix et notes de Gilbert Gaison et Doria Jakubec, 2 vols., Lausanne, Paris, 1974

Félix Vallotton. Ausstellung 1978—1979, Winterthur, 1978

Koella, R. «Le Retour au paysage historique. Zur Entstehung und Bedeutung von Vallottons später Landschaftsmalerei», *Jahrbuch des Schweizerischen Instituts für Wissenschaft*, Zürich, 1968/1969

Van Gogh

Дмитриева, Н. *Винсент Ван Гог: человек и художник*, Москва, 1980

Мурина, Е. *Ван Гог*, Москва, 1978

Петрочук, О. *Рисунки Винсента Ван Гога. Альбом*, Москва, 1974

Cabanne, P. *Van Gogh*, Paris, 1961

Clébert, J.-P., Richard, P. *La Provence de Van Gogh*, Aix-en-Provence, 1981

Doiteau, V., Leroy, E. «Vincent Van Gogh et le drame de l'oreille coupée», *Aesculape*, 1932, juillet

Hôtel Drouot. Catalogue de vente des tableaux modernes, Paris, 16 mai 1908

La Faille, J.-B. de. *L'Œuvre de Vincent Van Gogh. Catalogue raisonné*, 4 vols., Paris, Bruxelles, 1928

La Faille, J.-B. de. *Vincent Van Gogh*, Paris, Londres, New York, 1939

Leymarie, J. *Van Gogh*, Paris, New York, 1957

Roskill, M. "Van Gogh: Exchanges of Work with Emile Bernard", *Oud Holland*, 1971, 2/3

Roskill, M. *Van Gogh, Gauguin and the Impressionist Circle*, Greenwich (Conn.), London, 1970

Scherjon, W., Gruyter, J. *Vincent Van Gogh's Great Period: Arles, Saint-Rémy, Auvers-sur-Oise*, Amsterdam, 1937

Tout l'œuvre peint de Van Gogh. Documentation et catalogue raisonné par Pacio Lecaldano, 2 vols., Paris, 1971

Tralbout, M. E. *Vincent Van Gogh, le mal aimé*, Lausanne, Paris, 1969

Vincent Van Gogh (compiled and introduced by Nina Kalitina), Leningrad, 1974 (2nd ed. 1978)

INDEX

Note: arabic numerals in bold and roman type refer to catalogue entry numbers.

ИМПРЕССИОНИСТЫ И ПОСТИМПРЕССИОНИСТЫ
В МУЗЕЯХ СОВЕТСКОГО СОЮЗА

Альбом (на английском языке)

Издательство „Аврора". Ленинград. 1985
Изд. № 1360
По заказу фирмы Facts On File Publications, New York
Типография имени Ивана Федорова, Ленинград
Printed and bound in the USSR